EMILE MALE

Religious Art in France

THE THIRTEENTH CENTURY

A Study of Medieval

Iconography and Its Sources

BOLLINGEN SERIES XC · 2

PRINCETON UNIVERSITY PRESS

Copyright © 1984 by Princeton University Press
Published by Princeton University Press, Princeton, New Jersey
In the United Kingdom: Princeton University Press,
Guildford, Surrey

Translated from Emile Mâle, *L'Art religieux du XIIIe
siècle en France. Etude sur l'iconographie
du moyen âge et sur ses sources d'inspiration.*
Paris, Armand Colin. First edition 1898;
this volume has been translated from the
ninth edition (revised and corrected), 1958

Library of Congress Cataloging in Publication Data will
be found on the last printed page of this book

ISBN 0-691-09913-8

This is the second of several English translations of works by
Emile Mâle constituting number XC in Bollingen Series
sponsored by Bollingen Foundation

Clothbound editions of Princeton University Press books
are printed on acid-free paper, and binding materials are
chosen for strength and durability

Printed in the United States of America
by the Meriden Gravure Company, Meriden, Connecticut
Composed by Princeton University Press, Princeton, New Jersey

BOLLINGEN SERIES XC · 2

Studies in Religious Iconography by Emile Mâle
EDITED BY HARRY BOBER, TRANSLATED BY MARTHIEL MATHEWS

This Volume Has Been Edited by Harry Bober;
Consulting Editor, Sumner McKnight Crosby

PREFACE

In the Middle Ages, the purpose of art was to teach. All that was useful for man to know—the history of the world since its creation, religious dogma, the example of the saints, the hierarchy of virtues, the various sciences, arts, and crafts—was taught him by the stained glass windows of churches and the statues of their porches. Cathedrals might have been called by the touching name that printers gave to one of their first books: *Biblia Pauperum*. The simple and the ignorant, all who were called *sancta plebs Dei*, learned through their eyes almost everything they knew about their faith. The great religious figures they saw seemed to bear witness to the truth taught by the Church. It was as if the countless statues, arranged according to an established plan, were an image of the marvelous order imposed upon the world of ideas by St. Thomas Aquinas; thanks to art, the most elevated theological and scientific conceptions reached the humblest minds, even if in vague form.

But the meaning of these profound works grew dim. New generations, who had another conception of the world, no longer understood them. By the second half of the sixteenth century, the art of the Middle Ages had become an enigma. It was then that symbolism, the soul of our religious art, finally died.

The Church now blushed for the beloved legends Christianity had cherished throughout so many centuries. The Council of Trent put an end to the old artistic traditions. The theologian Molanus, in his *De historia sanctarum imaginum et picturarum* (Treatise on Holy Images), a book that fully expresses the spirit of the Council, shows he was unable to respond to the spirit of the works of the past.[1]

In the seventeenth and eighteenth centuries, when the Benedictines of St. Maur spoke of our ancient churches, they revealed a shocking ignorance for such great scholars. Montfaucon, in his *Monumens de la monarchie françoise*, looked for scenes from the history of France and for portraits of kings on the cathedral façades.

What is to be said of the simple tourists? They discussed the bas-reliefs and the statues of saints on the cathedrals as they might the monuments of India. Daydreamers thought they could read the secret of the philosophers' stone on the portal of Notre-Dame of Paris.[2] In the late eighteenth century, Dupuis saw in the zodiac of Notre-Dame an argument for his famous thesis that the sun is at the origin of all cults.[3] Lenoir,[4] his student, found the entire legend of Bacchus in a series of bas-reliefs devoted to St. Denis.

Laboriously, this century has had to recover the meaning of these medieval works that had become more obscure than hieroglyphics. Anyone who arrives unprepared at the portal of Amiens Cathedral or the north porch of Chartres cannot enter that closed world. He must have a guide. Since 1830, such great archeologists as Didron and Cahier have enabled us to penetrate deeply into these mysteries, but even so, secrets remain to be discovered. The need to coordinate their scattered research, to make it into a whole, also remains.

In fact, what I have attempted in this volume is to give systematic form to their research, and always, wherever I could, to complete it.

Such a work will be of use to historians of art. To study the art of the Middle Ages, and to deal only with the progress of technique without concentrating on the subject matter, as has sometimes been done, is a mistake; it is to confuse epochs.[5] Our sculptors of old did not have the same idea of art as a Benvenuto Cellini. They did not think the choice of subject a matter of indifference; they did not imagine that a statue was nothing more than a graceful arabesque whose purpose was to provide a moment's pleasure to the eye. In the Middle Ages, form always clothed a thought.[6] One might say that thought worked within matter and formed it. Form can never be separated from the idea that created and animated it. A thirteenth-century work, even when the workmanship is crude, interests us: we sense something there that resembles a soul.

Thus, if we are to have the right to judge the artists of the Middle Ages, we must begin by understanding what they were trying to do.

That is why the natural introduction to the study of medieval art is a systematic review of the subjects most favored by this art. Such an undertaking, the one we have set for ourselves, is vast, for the best of thirteenth-century thought was clothed in plastic form. Everything essential said by the theologians, encyclopedists, and interpreters of the Bible was expressed in stained glass and sculpture. We shall attempt to show how the artists translated the thoughts of the Church Doctors, and do our utmost to present a full picture of the abundant teaching the thirteenth-century cathedral furnished to all.

THE SHORTCOMING OF such a work of synthesis is that it does not give an adequate impression of the long process of artistic development that had gone on in the centuries preceding the thirteenth. It was certainly in the thirteenth century that Christian art most amply expressed medieval thought, and that is why I have chosen this period for study. But this art was not entirely a creation of the thirteenth century. A host of types, compositions, and ideas came from preceding centuries. The long evolution of Christian art is one of the most interesting subjects for study that a scholar can undertake, but it is also one of the most ticklish.

It would be most instructive to trace the representations of a particular personage or scene from the art of the catacombs through that of cathedrals. A careful study of a particular type whose development could be followed in chronological order through fifth-century mosaics, Byzantine miniatures, Carolingian ivories, Romanesque capitals, and thirteenth-century works, would reveal the subtlest changes in Christian thought. To take one example, we would see that the art of the catacombs did not dare to represent the crucified Jesus; that early Christian art showed him on a jeweled cross, with eyes open, head high, a crown on his head, as in triumph; but that the art of the late thirteenth century, which was less dogmatic but more humane, represented Jesus with eyes closed, his head drooping and arms extended. In short, it tried to move us to pity, speaking more to our feelings than to our minds.[7]

Such careful observation would reveal how fluid, mobile, and, in a word, living, medieval Christianity was. But such a study would require a lifetime. Didron, who undertook it, stopped after studying the Three Persons of the Trinity.[8] An honorable attempt was made by Comte Grimoüard de Saint-Laurent;[9] but in wishing to include in his *Guide de l'art chrétien* the entire development of art from its origins to the present, he was necessarily condemned to superficiality on almost all points, in spite of his very great learning.

The subject we have tried to treat is different. We have taken thirteenth-century art in itself, considering it as a living whole, a finished ensemble, and we have studied how it reflects the thought of the Middle Ages. In this way, we gain some idea of the majesty of the whole, of the truly encyclopedic breadth of medieval Christian art at its fullest flowering.

The thirteenth century is the center of our study. It was a time when art, with admirable boldness, tried to express everything. The iconography of even our richest Romanesque churches is poor when compared with that of our Gothic churches. The period we are concerned with is precisely that when the façades of the great cathedrals were conceived and made. Nevertheless, from time to time we shall have to turn to periods earlier or later than the thirteenth century. The old portal of Chartres, for instance, was carved about 1150; on the other hand, the exterior decoration of certain cathedrals such as Rouen and Lyon was finished only in the early fourteenth century. Consequently, it would be quite arbitrary to confine our study to the years between 1200 and 1300.

If we have limited ourselves to the study of French art, it is not because we are convinced that the art of neighboring countries followed different principles. On the contrary, thirteenth-century art has a truly ecumenical character: it was as universal as Christian teaching. We have been able to confirm for ourselves that at Burgos, Toledo, Siena, Orvieto, Bamberg, Fribourg, and Canterbury, the great subjects favored by medieval art

were conceived as they were at Paris or Reims. But we are also certain that nowhere was Christian thought expressed with such breadth and richness as in France. There is not a single ensemble of dogmatic work in all of Europe even remotely comparable to that of Chartres Cathedral. It was in France that medieval doctrine found its most perfect form. Thirteenth-century France was Christianity's consciousness. When we know Chartres, Amiens, Paris, Reims, Laon, Bourges, Le Mans, Sens, Auxerre, Troyes, Tours, Rouen, Lyon, Poitiers, Clermont, we have little to learn from foreign cathedrals. However, this does not prevent us from occasionally seeking an example in Germany, Italy, and England, in order to support a point. Nonetheless, French art remains the sole object of our study.

SUCH A WORK has not yet been undertaken in France.[10] A comprehensive study would have seemed premature to the archeologists who created the science of Christian iconography. But today, after more than seventy years of detailed studies, such an attempt will doubtless seem less rash. Monographs have been written on almost all our cathedrals, and although far from perfect, they give enough precise and well-considered information to allow certain general ideas to emerge. We have checked the accuracy of these works on the spot. Furthermore, since 1830, many reviews devoted solely to medieval art have also brought many valuable facts to light.

Foremost among these is the *Annales archéologiques*, which for more than twenty years, Didron animated with his own passion. Didron, an enthusiastic admirer of Victor Hugo, belonged to the romantic era: thus he brought to the study of the past almost as much imagination as learning. But even though he was sometimes mistaken, he communicated something of his fire to an entire generation of archeologists.

Le Bulletin monumental, founded by Caumont,[11] and the *Revue de l'art chrétien*, founded by Canon Corblet, are inexhaustible mines.

Father Cahier, with the help of a small number of collaborators and above all of a sensitive artist, Father Martin, published two learned collections: *Mélanges* and *Nouveaux Mélanges d'archéologie*.[12] No one in the nineteenth century knew the art of the Middle Ages better than Father Cahier. His *Vitraux de Bourges*[13] and his *Caractéristiques des saints dans l'art populaire*[14] are works of solid learning, marred unfortunately by their polemical tone and an artificial style.

Reviews such as *La Bibliothèque de l'Ecole des Chartes*, *La Revue archéologique*, and *La Gazette archéologique*, in which, it is true, medieval art is given only a small space, are not to be ignored.

Finally, provincial archeological societies which, after 1830, were founded in almost all French Départements in response to Caumont's ap-

peal, have published a multitude of *Bulletins* and *Mémoires*. These have been listed by Lasteyrie and Lefèvre-Pontalis.[15] The Société des Antiquaires de France, one of the oldest of the learned societies, deserves special mention. Its *Mémoires*, especially those published since 1840, are often of great interest.

These are the collections in which we have found some of the material for this book. But the monuments themselves have taught us more than books. We have looked at and looked at again all that we have spoken of here. Moreover, in Paris we were able to study at our leisure what we had been obliged to examine on the spot more rapidly than we would have wished. The Musée de Moulages of the Trocadéro contains many fragments. Also, three great collections of photographs and engravings gave us constant help. One is in the Bibliothèque du Trocadéro (Collection des Monuments Historiques),[16] another is in the Bibliothèque de l'Ecole des Beaux-Arts, and the third in the Cabinet des Estampes. The last, known by the name of Grande Topographie de la France, is composed largely of seventeenth- and eighteenth-century engravings and drawings; but its great advantage is that it makes known works that have disappeared and shows the state of monuments before their restoration.[17]

Thus, we were able to keep before us almost constantly the statues and bas-reliefs scattered over the whole of France.

The stained glass windows are a different matter. Only rarely, up to the present time, has anyone tried to reproduce them by photography. Fortunately, Father Cahier, in his *Vitraux de Bourges*, gave a veritable corpus of the principal windows of the thirteenth century. Lasteyrie, in his *Histoire de la peinture sur verre*, reproduced others.[18] Finally, such monographs as those of *Les Vitraux de Tours* by Bourrassé and Marchand,[19] *Les Vitraux du Mans* by Hucher,[20] *Les Vitraux de Laon* by Florival and Midoux,[21] and *Les Vitraux de Chartres* by Yves Delaporte and E. Houvet,[22] add many new plates to the collection.

Manuscripts with miniatures cannot be ignored. In them, we again find the rules obeyed by monumental art. Sometimes we even thought we had discovered that the miniaturists were the true creators of types adopted later by sculptors and glass painters. We are convinced that a careful study of miniatures would, in this respect, disclose many discoveries. But at the present time, such a study would be difficult. The catalogue of manuscripts in the Bibliothèque Nationale is too brief and does not allow for really methodical research. A catalogue of the miniatures from Latin manuscripts, begun by Bordier on the model of his catalogue of miniatures from Greek manuscripts, has remained unfinished.[23] To describe these innumerable illuminated manuscripts and then classify them into families and schools, tracing their relationships, will require

many years and the work of many generations of scholars.[24] On the other hand, the Bibliothèque de l'Arsenal, the Bibliothèque Sainte-Geneviève, and the Bibliothèque Mazarine all possess excellent descriptive catalogues which make the study of illuminated manuscripts very convenient. However, we have studied miniatures only insofar as they provide a better understanding of thirteenth-century statues and windows.

THERE ARE MANY PROBLEMS in such a study as we have undertaken. One must be pointed out at the outset. For more than two centuries, the statues and windows of our cathedrals have been destroyed or, what often amounts to the same thing, they have been restored.[25] The façades of Notre-Dame of Paris, the cathedral of Reims, and the cathedral of Bourges all bear the marks of restoration. A saint may have received a new head, or a Virtue new attributes. In almost all the churches, the windows have undergone the inept restorations of the eighteenth century. The order of subjects has been changed, and fragments of destroyed windows have served to patch neighboring ones. At Auxerre, for instance, panels from the legends of St. Eustace, and from the lives of St. Peter and St. Paul were distributed among various windows of the choir and side aisles. And this is a constant source of error.

From the point of view of scholarship, even the most intelligent restorations of our century are almost as annoying. Many mutilated windows have been so skillfully patched that at first glance we have trouble distinguishing the old from the new, and if we do not pay attention, we will be seeking the laws of medieval iconography in the pastiches of the nineteenth century. Fortunately, the works speak for themselves; color that is less vibrant, lines that are less sure, something unusual in the composition of the scenes, all warn us that we are looking at modern work. Consequently, preliminary critical work has to be done when we confront thirteenth-century art, the old has to be separated from the modern, and the true order restored when it has been changed. We hope that we have committed no errors of this sort.

Another problem is limiting oneself. Several chapters could have been twice their length. The one devoted to the Golden Legend (*Legenda aurea*) could have gone on endlessly if we had enumerated all the works of art in which the saints figure. But again, we do not claim to be writing a complete treatise on iconography. It has seemed to us that we need say only the essential and provide only enough examples to bring into relief the great controlling ideas of art.

OF ALL THE PROBLEMS we encountered, that presented by the study of the theological literature of the Middle Ages was perhaps the most serious.

To confront for the first time the great body of work written by the Church Doctors throughout ten centuries is to be overwhelmed by its vastness.

But closer examination of the commentators of the Scriptures, the liturgists, and the encyclopedists, reveals surprisingly that they repeat each other endlessly. Isidore of Seville summarized the Church Fathers, the Venerable Bede was inspired by Isidore of Seville, Rabanus Maurus by the Venerable Bede, Walafrid Strabo by Rabanus Maurus, and so forth. In the time when communications were difficult, books were rare, and ideas spread slowly, it seemed a worthy enough enterprise to summarize a famous book, extract the essential from various famous treatises, or even to reproduce almost unchanged the work of an ancient Church Doctor. Literary pride, an author's vanity, was unknown in the early Middle Ages; it was only too evident that a doctrine belonged not to the one who set it forth, but to the Church. To write a book at that time was in some way to perform one of the works of mercy, to make known the truth to others, by whatever means.

In the last analysis, the immense library of the Middle Ages is very small. A dozen well-chosen works could, if need be, almost replace the rest. All the commentators of the Old and New Testaments are summarized in the *Glossa ordinaria* of Walafrid Strabo, which Nicolas of Lyra completed in the fourteenth century. All the symbolic liturgy is in the *Rationale divinorum officiorum* of William Durandus. The spirit and method of the ancient sermon writers lives again in the *Speculum ecclesiae* of Honorius of Autun. Sacred history, as it was then understood, is contained in the *Historia scholastica* of Peter Comestor and in the *Legenda aurea* of Jacob of Voragine; secular history in the *Speculum historiale* of Vincent of Beauvais; all that was known of the physical world is summarized in the *Speculum naturale*, and all that was known of the moral world is in the *Summa theologica* of St. Thomas, which the *Speculum morale* had abridged.

A reader familiar with the books just listed would already have penetrated to the core of the medieval spirit. The Middle Ages, in fact, saw itself mirrored in these works and adopted them. And it is the esteem in which the Middle Ages held them that has signaled them to our attention.

Through the study of these works, whose classic character impressed us from the start, we were able to orient ourselves in the vast patristic literature of the Middle Ages: little by little, the other works grouped themselves around these. It is to them that we refer by preference, because they are truly "representative." The doctrines they expound and the legends they adopt had been accepted by everyone. Thanks to them, we

have been able to reduce substantially the number of our citations. Father Cahier, in *Les Vitraux de Bourges*, filled whole pages with these texts; he was satisfied only when he had traced a doctrine from St. Augustine through St. Thomas Aquinas. In this there is an affectation of erudition. One good example would have sufficed. When the *Glossa ordinaria* has spoken, what is the use in most instances of listening to other commentators of the Bible?

Nevertheless, we have not purposefully neglected other resources provided by the Patrology. Sometimes evidence had to be multiplied in order to prove that an opinion, which today seems extraordinary, was not an isolated case. And again, on certain points, we found that our guides were superficial; they had to be supplemented by other writers. But generally speaking, we have remained faithful to our method of going back to the famous compilers who summarized all the knowledge of the Middle Ages.

The literature in the vulgar tongue was of very little help. And in fact, what could we expect from it? The *Légendes des saints*, the *Images du monde*, the rhymed bestiaries are nothing but translations, often rather flat. The most beautiful and profound works of the Middle Ages were not translated, nor could they be. The language of the thirteenth century, which told stories with charm and strength and sang not without grace, was still not able to deal with abstract ideas. For a long time still, Latin was to remain the language of the thinkers. No one knows the Middle Ages who knows it only through popular literature.

For this reason, we did not stop with the timid adaptations of our French writers, but went straight to the sources.

Emile Mâle
[Paris 1898]

CONTENTS

Introduction

I

General Character of Medieval Iconography

The Middle Ages had a passion for order. It organized art as it organized dogma, human knowledge, and society. The representation of sacred subjects was a science with its own principles; it was never left to individual fantasy. Undoubtedly, at a very early date, this kind of theology of art[1] had already been reduced to a body of doctrine, because we can witness the artists' submission to it, from one end of Europe to the other and from the earliest times. The Church transmitted this knowledge to the secular sculptors and painters of the thirteenth century, and they religiously preserved the sacred traditions. As a result, medieval art, even in the centuries when it was most creative, retained the hieratic grandeur of the early art.

These are the general principles we must make known at the outset, and as briefly as possible.

I

The art of the Middle Ages is first of all a sacred writing whose elements every artist had to learn. He had to know that the circular halo placed vertically behind the head represented sainthood, and that the nimbus inscribed with a cross represented divinity. God the Father, Christ, and the Holy Spirit might never be represented without a cruciform nimbus surrounding their heads.[2] He learned that the aureole, light emanating from the whole person—a kind of halo surrounding the entire body, belonged to the Three Persons of the Trinity, the Virgin, and the souls of the blessed, and it expressed eternal beatitude. He had to know that bare feet were another sign by which God, the angels, Christ, and the apostles might be recognized, but that it would be truly improper to represent the Virgin or the saints with bare feet. In this sort of thing an error would be nearly as serious as heresy. Several symbols allowed the artist to express the invisible and represent what is beyond the domain of art. A hand enclosed in a cruciform nimbus issuing from the clouds,

The iconography of the Middle Ages is a kind of writing.

making the sign of benediction with the thumb and forefingers raised and the other two bent under, was the sign of divine intervention, the emblem of providence. Small figures of naked, sexless children, side by side in the folds of Abraham's cloak, signified the future life, eternal rest.

There were also signs, which the artist had to learn, for representing the visible world. Concentric lines, wavy and scalloped, represented the sky; parallel lines represented water, rivers, and the sea (fig. 1). A tree —that is, a stalk with two or three leaves at the top—indicated that the scene took place on earth. A tower with a gate signified a town; if an angel stood watch on the battlements, it was the Heavenly Jerusalem.[3] As we see, these are veritable hieroglyphs, a merging of art and writing.[4] The same spirit of order and abstraction informed heraldic art, with its alphabet, rules, and symbolism.

The artist had to be familiar with a myriad of precise details. He had to know the traditional type of the personages he was to represent. St. Peter, for example, must have curly hair, a thick short beard, and a tonsure. St. Paul must be partially bald, with a long beard. Certain details of costume were unchanging. Over her hair the Virgin must wear a veil, which was itself the symbol of virginity. Jews would be recognized by their cone-shaped hats.[5]

All these personages—their costumes unvarying, their type fixed—were placed in set scenes. However dramatic the action they were engaged in, all had to be planned in advance. No artist would have dared to change the composition of the great scenes of the Gospels. If he represented the Last Supper, he was not free to group the figures around the table according to his own fancy; he placed Christ and the apostles on one side, and Judas on the other.[6] If he represented Christ on the cross, he placed the Virgin and the lance bearer at his right, and St. John and the sponge bearer at his left.[7]

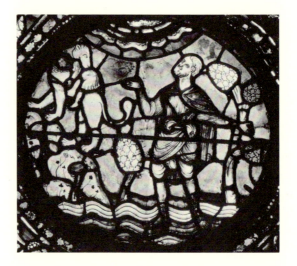

1. The sky, water, trees. Legend of St. Eustace (detail). Chartres (Eure-et-Loir), Cathedral of Notre-Dame. Nave, north side aisle, stained glass panel.

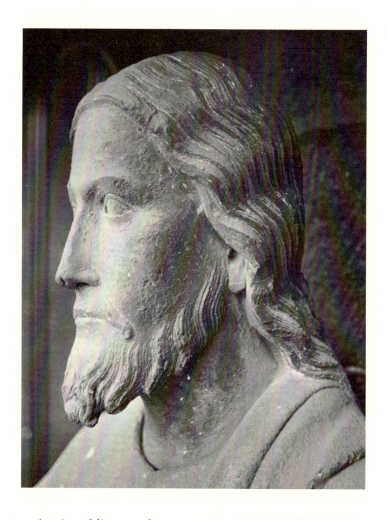

2. Christ. Amiens (Somme), Cathedral. West façade, central portal, detail of trumeau.

There is no point in adding to these examples. These will suffice to demonstrate in what sense medieval art can be said to be sacred writing.

Such signs and conventional compositions were very useful to the artists of the early Middle Ages. Thanks to them, some of the inadequacies of art could be compensated for. It was clearly much easier to draw a cruciform nimbus around the head of Christ than to express on his face the signs of divinity. The thirteenth century could undoubtedly have done without this kind of aid. The artists of Amiens, who were able to clothe the Teaching Christ of the portal with so much majesty, would have had no need for it (fig. 2). The sculptors of Chartres were able to express sainthood by other means than the nimbus; a virginal grace envelops St. Modeste (fig. 3), and St. Martin's great soul shines forth from his face.[8] Nevertheless, the thirteenth century, faithful to the past, did not abandon these signs, and strayed very little from the traditional compositions. This was because the devices used in religious art seemed by then to be articles of faith. The theologians consecrated with their authority the work of the artists. St. Thomas Aquinas, in his *Summa*, wrote a

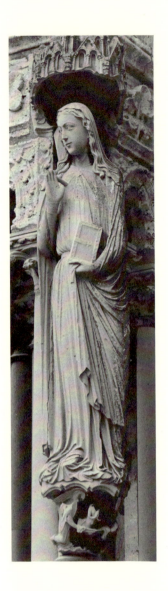

3. St. Modeste. Chartres (Eure-et-Loir), Cathedral of Notre-Dame. North transept, porch.

chapter on the nimbus and explained why it is the usual attribute of sainthood.[9] Art was considered to be one of the forms of the liturgy. William Durandus, the thirteenth-century liturgist, introduced various passages on holy images into his *Rationale divinorum officiorum.*[10]

The thirteenth century did well to conserve piously the elements of this ancient writing. By so doing, it attained the greatness that invests works on which centuries have collaborated. In the art of the time, there is something both impersonal and profound. We might say that such attitudes and such symbolic groupings were willed, desired by all. What is the sublime gesture of Jesus showing his wounds to mankind on the Day of Judgment if not the very conscience of Christianity? The thought of the theologians, the instinct of the crowd, the keen sensibility of the artists, all collaborated.

The art of the Middle Ages is like its literature; it owes less to conscious talent than to diffused genius. The personality of the individual artist does not always emerge, but innumerable generations of men speak through him. The individual, even when he is mediocre, is lifted high by the genius of these Christian centuries. From the Renaissance on artists broke away from the old traditions at their own risk and peril. When they were not superior, they found it hard to escape triviality and platitude in their religious works; and when they were great, they were not greater than the submissive old masters who naïvely expressed the thought of the Middle Ages. To the Christ cursing the damned, created by Michelangelo outside all tradition, it is quite possible to prefer the Christ displaying his wounds of the French cathedrals. By simply reproducing a consecrated model, the simple medieval artist created a profoundly moving work.

II

The second characteristic of medieval iconography is that it obeys a kind of sacred mathematics. Placement, arrangement, symmetry, and number all have extraordinary importance.

First of all, the entire church was oriented from east to west. This prescript goes back to the Early Christian era, since it is already to be found in the *Apostolic Constitutions*.[11] In the thirteenth century, William Durandus presented it as a rule to which there could be no exceptions. He said: "The foundations must be disposed in such a way that the head of the church will precisely indicate the east, that is to say, the part of the sky in which the sun rises at the equinoxes."[12] And in fact, hardly any examples can be cited of churches built from the eleventh through the sixteenth century that were not so oriented. This rule, along with other traditions of medieval art, was forgotten about the time of the Council of Trent; the Jesuits were the first to violate it.

In the church thus oriented, the cardinal points have their significance. The north, the region of cold and night, was usually devoted to the Old Testament. The south, warmed by the sun and bathed in full light, was devoted to the New Testament. True, there were many exceptions to the rule.[13] However, the representation of the Last Judgment was almost always placed on the west façade.[14] The setting sun illuminated this great scene of the last evening of the world. The medieval Church Doctors, who always had a taste for false etymologies, related *occidens* to the verb *occidere* (to kill): for them, the occident was the region of death.[15]

After orientation, artists as well as theologians were most preoccupied with hierarchy. Certain biblical passages very early led people to believe that the right was the place of honor. Was it not said in the Psalms, for

It is arithmetic. Mystical numbers.

example: *Adstitit regina a dextris tuis in vestitu deaurato* (The queen stood on thy right hand in gilded clothing . . .)?[16] In the *Shepherd* of Hermas, a book belonging to Early Christian literature, the right was already designated as the place given those to be honored. In fact, in the story of the third vision,[17] it says that the Church placed Hermas at her side, on a bench. When he wished to place himself on the right, she made a sign for him to go to the left, because the right was reserved for those who had suffered for the Name of God. Medieval theologians, in turn, had long insisted on the dignity inherent in the right side,[18] and artists also conformed to this well-established doctrine. When, for example, Jesus is represented among his apostles, St. Peter, the first in dignity, is placed on the right of the Master.[19] Also, in the scene of the Crucifixion or of the Last Judgment, the Virgin stands at the right of Christ, and St. John at the left.

Likewise, a higher place in the composition was considered to be more honorable than a lower place. Several curious arrangements result from this. The most striking of these is the figure of Christ in Majesty with the four beasts of the Apocalypse. The four animals who, as we shall explain later, are symbols of the evangelists, had been classified according to their dignity. They were placed in the following order, according to the excellence of their natures: the man, the eagle, the lion, and the ox. When they were to surround Christ in a tympanum, account had to be taken both of the dignity conferred by the higher position and by the right-hand side. Thus, the following arrangement and the one most commonly followed was arrived at: the winged man was placed at the top of the composition on the right of Christ, the eagle at the top left, the lion below on the right, and the ox in the lower left (fig. 4).

Respect for hierarchy was particularly evident when the blessed, who composed the Church Triumphant, were represented. On the Judgment portal of Notre-Dame of Paris, the saints arranged in the archivolts form concentric bands around Christ, as in Dante's *Divine Comedy.* Successively, we see the orders of patriarchs, prophets, confessors, martyrs, and virgins. Such a classification conforms to that adopted by the liturgy.[20] At Chartres, they went further: in the right bay of the south portal, which is devoted entirely to the confessors, the saints are classified in the archivolts as laymen, monks, priests, bishops, and archbishops. A sainted pope and, beside him, a sainted emperor, occupy the summit of the bay. They appear as the two keystones of the vault of the structure.[21]

Above the choirs of saints are the choirs of angels. The artists often arranged them in the order imagined by St. Dionysius the Areopagite, who was the first to describe the invisible world with the precision and magnificence that we find later in Dante.[22] His *On Celestial Hierarchy,* translated into Latin in the ninth century by Scotus Erigena and often

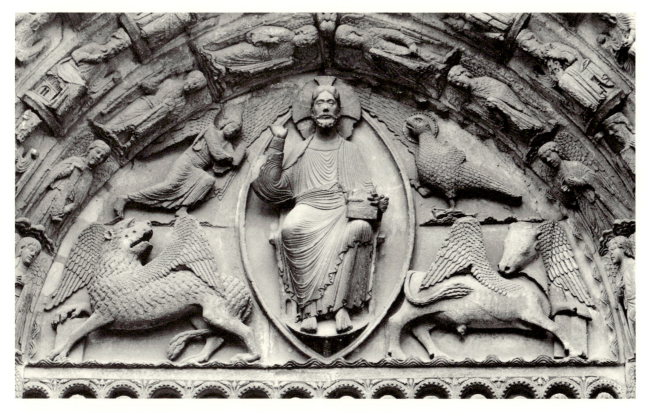

4. Christ and evangelist symbols. Chartres (Eure-et-Loir), Cathedral of Notre-Dame. West façade, central portal, tympanum.

commentated by the Church Doctors of whom Hugh of St. Victor[23] was most notable, inspired the artist who carved the nine choirs of angels on the south portal of Chartres. They are arranged in the following order: seraphim, cherubim, thrones, dominations, virtues, powers, principalities, archangels, and angels.[24] According to the doctrine of the Areopagite, all these celestial beings form great circles of light around God, and their brilliance is greater in proportion to their proximity to the source of light.[25] Consequently, at Chartres, the seraphim and the cherubim, because they are closest to the source of all warmth and all light, carry flames and balls of fire in their hands.

In the art of the Middle Ages, the concern for order extended even to the smallest details and was responsible for some rather ingenious arrangements. To give one example: on the socle supporting large statues, there is almost always a squatting figure. A superficial observer would be tempted to think this pure decoration; in reality, each of the personages thus represented has a direct relation to the principal figure. The apostles trample on the kings who persecuted them, Moses stands on the golden calf, the angels on the dragon of the abyss, Christ on the adder and the basilisk. Sometimes the emblem of the socle expresses not the idea of

triumph but something in the life or character of the hero. At Chartres, Balaam has a she-ass beneath his feet, the Queen of Sheba a Black loaded with the presents of Ophir (fig. 5), beneath the Virgin the burning bush[26] (fig. 6). The relation between the statue and the figure on the socle is so close that at Notre-Dame of Paris, thanks to historiated supports, we can reconstruct almost with certainty the large figures of the left portal.[27]

But of all the elements of composition, none was more favored than the principle of symmetry. In fact, symmetry was regarded as the visible expression of a mysterious harmony. To the twelve patriarchs and twelve prophets of the Old Law, artists placed in correspondence the twelve apostles of the New.[28] Opposite the four great prophets, they placed the four evangelists. At Chartres, a window of the south transept shows with symbolic boldness the four prophets, Isaiah, Ezekiel, Daniel, and Jeremiah carrying on their shoulders the four evangelists, St. Matthew, St. John, St. Mark, and St. Luke (fig. 7).[29] From this it was to be understood

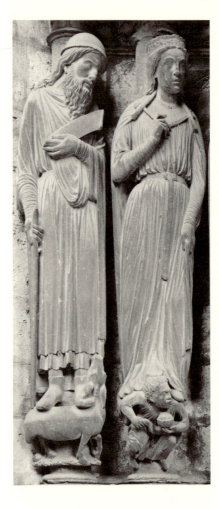 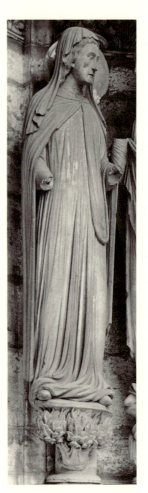

5. Balaam; the Queen of Sheba. Chartres (Eure-et-Loir), Cathedral of Notre-Dame. North transept, right portal, jambs.

6. The Virgin and the Burning Bush. Chartres (Eure-et-Loir), Cathedral of Notre-Dame. North transept, left portal, jambs.

that although the evangelists found a base of support in the prophets, they saw higher and farther. The four-and-twenty elders of the Apocalypse were often placed in correspondence to the twelve prophets and twelve apostles, and the Liberal Arts in correspondence to the Virtues.[30]

Such combinations presuppose a well worked-out belief in the virtue of number. And as a matter of fact, the Middle Ages never doubted that numbers were endowed with hidden powers. This doctrine came from the Church Fathers, who had no doubt taken it from the Neoplatonic schools in which the spirit of Pythagoras lived on. It is evident that St. Augustine considered numbers to be the thoughts of God. In many passages, he lets it be understood that each number has its providential meaning. "Divine Wisdom," he said, "can be seen in the numbers imprinted in all things."[31] The physical world and the moral world are built upon eternal numbers. We sense that the charm of the dance resides in rhythm, that is, in number; but not only this, beauty itself is a cadence, an harmonious number.[32] Thus, the science of numbers is the science of

7. Isaiah carrying St. Matthew. Chartres (Eure-et-Loir), Cathedral of Notre-Dame. South transept, stained glass panel beneath rose window.

the universe itself; numbers contain the secret of the world. Consequently, we must consider with respectful attention the numbers found in the Bible, for they are sacred and filled with mystery.[33] He who knows how to decipher them participates in the divine plan.[34]

Identical ideas are to be found in almost all the Church Doctors of the Middle Ages. To see their relationship, we have only to consult the *Liber formularum* of St. Eucherius for the fifth century, the *Liber numerorum* of Isidore of Seville for the seventh, the *De universo* of Rabanus Maurus for the ninth, and the *Miscellanea* of Hugh of St. Victor for the twelfth.[35] There we see that the same teaching was transmitted through the centuries in the same terms. The symbolic value of each number is stated dogmatically and then verified by the examination of passages from the Scriptures in which the number figures. The explanations do not vary, and we sense that we are in the presence of a body of doctrine.[36]

A few examples will give an idea of the system. All the theologians after St. Augustine explained in the same way the meaning of the number twelve. Twelve is the number of the Universal Church, and for profound reasons Jesus wished his apostles to number twelve. Twelve, in fact, is the product of three times four. Now three, which is the number of the Trinity and consequently of the soul made in the image of the Trinity, designates all spiritual things. Four, which is the number of the elements, is the image of material things, of the body, the world, which result from the combination of the four elements.[37] To multiply three by four is, in the mystical sense, to infuse matter with spirit, to announce to the world the truths of the faith, to establish the Universal Church, of which the apostles are the symbol.[38]

Such calculations were often more than merely ingenious: they attained true grandeur. Medieval thinkers were carried away by the number seven, which the Fathers had declared the most mysterious of all. They noticed first of all that seven, composed of four, the number of the body, and of three, the number of the soul, is the human number par excellence. It expresses the union of the two natures. Everything relating to man is ordered by series of seven. Human life is divided into seven ages. To each age is attached the practice of one of the seven virtues. We receive grace necessary to practice the seven virtues by addressing to God the seven petitions of the *Pater noster*. The seven sacraments sustain us in the exercise of the seven virtues and keep us from succumbing to the seven mortal sins.[39] Thus, the number seven expresses the harmony of the human being, but it also expresses the harmonious relation between man and the universe. The seven planets govern human destiny; each of the seven ages of life is under the influence of one of the planets. Thus, seven invisible bonds attach man to the whole of things.[40] Now the beautiful symphony composed of man and the world, the concert they

provide for God, will last for seven ages, six of which have already gone by.[41] In creating the world in seven days, God wished to give us the key to all of these mysteries.[42] Consequently, the Church celebrates the sublimity of God's plan by singing his praises seven times a day.[43] The seven tones of Gregorian music are, in the last analysis, the audible expression of universal order.[44]

There is no doubt that such conceptions captivated above all the mystical schools. We have only to glance at the *Arca Noe* of Hugh of St. Victor to gain an idea of the rapture with which he combines the symbolic numbers.[45]

Nevertheless, there is hardly one medieval theologian who did not seek in numbers the revelation of hidden truths. Some of their calculations recall those of the Cabala. To explain why the soul is united to the body forty-six days after conception, Honorius of Autun took the name of Adam and showed that the number 46 is written in it. For, if we transpose into number the Greek letters that make up the name, we have $a = 1, \delta = 4, a = 1, \mu = 40$. By adding up, we get the number 46, which represents the moment when the human being can be considered as formed.[46]

Of all the Church Doctors, the commentators on the Bible are the richest in mystical interpretations founded on numbers. For example, they explain that Gideon went into battle with three hundred companions for a profound reason, because in the number three hundred there is a mystery. In Greek, three hundred is designated by the letter Tau (T): now the T is the figure of the cross. Thus, beyond Gideon and his companions, we must see Jesus and his cross.[47]

We might give many other examples of such calculations, but these suffice to point out the mentality of the men of that time. We might say that in all the great works of the Middle Ages, there is something of this sacred arithmetic. Dante's *Divine Comedy* is the most famous example. That great epic is built on numbers. The nine circles of hell correspond to the nine stages of the mountain of purgatory and to the nine heavens of paradise. In a poem of such lofty inspiration, nothing was left to inspiration alone. Dante had decided in advance that each part of his trilogy would be divided into thirty-three cantos in honor of the thirty-three years of Christ's life.[48] In adopting the metrical form of the *terza rima*, he seems to have wished to invest the very foundations of his poem with the mystical number par excellence. He arranged the universe according to the laws of a sublime geometry. He placed the earthly paradise on the other side of the world, at the antipodes of Jerusalem; the tree that brought about man's downfall was exactly opposite the cross by which he was saved. Every detail is worked out with the same precision. His was the most ardent imagination that ever was, and it was also the most

submissive. Dante accepted the law of numbers as a divine rhythm obeyed by the universe; but as he meditated on numbers, he was filled with a sense of awe, and out of this brought forth a splendid poem. Beatrice herself became a number; in his eyes, she was the number nine, which has its root in the Holy Trinity.[49]

It was thus, *cum pondere et mensura*, that he constructed his invisible cathedral. Along with St. Thomas, he was the great architect of the thirteenth century. He might be represented with the rule and compass that we see on the gravestone of Maître Hugues Libergier, who built St.-Nicaise at Reims (fig. 8).[50]

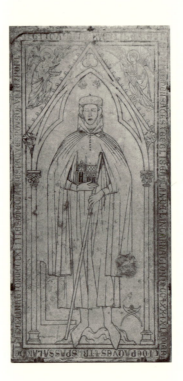

8. Tomb slab of Maître Hugues Libergier.
Reims (Marne), St.-Nicaise.

After what we have just said, it will seem only natural to look for traces of this sacred arithmetic in cathedrals. In fact, we believe that the science of numbers sometimes presided over the compositions of artists. However, we are far from seeing nothing but symbolic numbers everywhere. For example, there is nothing to prove that we must look for symbolic meaning in the triple division of the Gothic window, as certain rash archeologists would have us do.[51] But neither must we systematically discard, as another school does, all symbolism of this kind; that would show a misunderstanding of the true spirit of the Middle Ages.

There are times when the agreement of texts and monuments suggests probabilities that are almost certainties. The octagonal form of baptismal fonts, which was adopted in most ancient times and persisted throughout

the Middle Ages, was not due to pure chance. It is difficult not to see in it an application of the mystical arithmetic taught by the Church Fathers. For them, eight was the number of new life. It comes after seven which marks the limit assigned to man's life and the life of the world. Eight is like the octave in music; through it, everything begins again. It is the symbol of new life, of the final resurrection, and of the anticipated resurrection, which is baptism.[52]

We believe that such a doctrine, taught by the early Church Fathers, was not without effect. The basins of the oldest baptisteries of Italy and Gaul are almost always octagonal in shape;[53] and in fact, a little poem attributed to St. Ambrose seems to prove that this form was adopted deliberately because of its symbolic meaning. "To be worthy of its role," he said, "the baptistery must be octagonal. It is on the number eight that the edifice must be built in which holy baptism is performed and in which people regain salvation."[54] This tradition was long perpetuated. In the Middle Ages, baptismal fonts were often circular, but even more often they were octagonal.[55]

We think it not impossible to discover mystical numbers in other parts of the cathedral, but so far, such studies are little more than sketches, into which more imagination than method has gone.

III

Medieval art is a symbolic language, and this is its third characteristic. From the time of the catacombs, Christian art had spoken figuratively. It shows us one thing and invites us to see in it something more. The artist, the Church Doctors might have said, must imitate God who hid a profound meaning in the letter of the Scriptures, and who wished that nature itself be a form of instruction.

Thus, in medieval art there are intentions we must learn to interpret. When, for example, we see in the scene of the Last Judgment the foolish virgins at the left of Christ and the wise virgins at his right, we must understand that they are there to symbolize the damned and the saved. All the commentators of the New Testament teach us this, and they explain it by saying that the five foolish virgins symbolize the concupiscence of the five senses, and the five wise virgins the five forms of inner contemplation.[56] The four rivers of paradise, the Gehon, the Phison, the Tigris, and the Euphrates, pouring water from their urns toward the four cardinal points, are not represented for themselves; they symbolize the four evangelists who, like the four beneficent rivers, poured out their doctrine onto the world.

A figure from the Old Testament on the porch of a cathedral is only a prefiguration: it foretells Christ, the Virgin, or the future Church. At

It is symbolism. Art and liturgy.

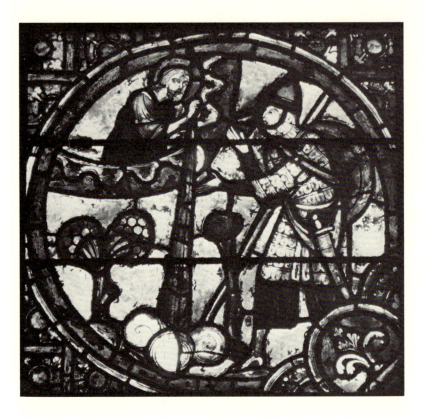

9. Gideon and the Fleece. Laon (Aisne),
Cathedral of Notre-Dame. Choir, stained
glass panel.

Chartres, Melchizedek, priest and king, carrying the bread and wine to
Abraham must recall to us another priest and king who offered bread
and wine to his apostles. At Laon, Gideon, calling down the dew from
heaven on the fleece he has spread on the ground, reminds us that the
Virgin was the symbolic fleece on whom the dew of heaven fell (fig. 9).

A seemingly insignificant detail can hide a symbol. The lion we see in
a window at Bourges, near the tomb from which the resurrected Christ
rises, is a figure of the Resurrection. In the Middle Ages, it was believed
that the lioness gave birth to young who seemed to be stillborn. For three
days the cubs gave no sign of life, but on the third day the lion came to
breathe on them and restore them to life. Thus, the apparent death of
the lion represents the sojourn of Christ in the tomb and its birth was an
image of the Resurrection.

Thus, in the art of the Middle Ages, all forms are endowed with spirit.

Such a conception of art presupposes a profoundly idealistic world
system and the conviction that history and nature are only a vast symbol.
We shall see, indeed, that this was in fact what the Middle Ages did
think. And it must not be thought that these ideas were solely those of
the great Church Doctors in the thirteenth century: the Church knew
how to transmit them to the great mass of people. The symbolism of the
cult familiarized the faithful with the symbolism of art. Christian liturgy,
like Christian art, was a constant: the same spirit informed both.

A nielle eft le pluls di
gue laterenut entre
les autres car il fu de
dieu home fanz au
tre moteu inftitue et
autrelli en tranfubition pour dari
tablement tonne et plus amoreule
ment diftritue quant ilhuailt dift

10. Priest elevating the Host. William Durandus, *Le Rational des divins offices de l'Eglise.* The Hague, Royal Library, ms. 78 D 41, fol. 72v.

Take as an example William Durandus' commentaries accompanying the account of a great Christian feast, Holy Saturday.[57] All the ceremonies performed on that day are filled with mystery (fig. 10).

The morning begins with the extinguishing of all the lamps in the church, to indicate that the Old Law which had lighted the world is henceforth abrogated. Then the celebrant blesses the new fire, the figure of the New Law. He has struck this fire from a flint to recall that Christ, as St. Paul said, is the cornerstone of the world. The bishop, the deacon, and all the congregation then move toward the choir and stop before the paschal candle. This candle, Durandus tells us, is a triple symbol. Unlighted, it symbolizes the "pillar of cloud" that guided the Hebrews during the day, as well as the Old Law, and the body of Jesus Christ. Lighted, it signifies the "pillar of fire" seen by the Israelites during the night, the New Law, and the glorified body of the resurrected Christ. The deacon alludes to this triple symbolism when he recites, before the candle, the words of the Exultet. But he emphasizes above all the resemblance of the candle to the body of Christ. He recalls that the pure wax had been produced by a bee both as chaste and as fecund as the Virgin, who had given birth to the Saviour.[58] To make visible the likeness between the candle and the divine body, he presses five grains of incense into the candle to recall both the five wounds of Christ and the spices bought by the holy women to embalm him. Finally he lights the

candle with the new fire, and all the lamps are lighted again in the church to represent the diffusion of the New Law throughout the world.

This is the first part of the ceremony. The second is devoted to the baptism of neophytes, which the Church performs on that day because, as Durandus says, it has seen the mysterious relation between the death of Christ and the symbolic death of the new Christian. Through baptism, the Christian dies to the world and is reborn with the Saviour. But before the catechumens are led to the baptistery, twelve texts taken from holy books, and related to the sacrament they are about to receive, are read to them. For example, the story of the Flood whose waters purified the world, the crossing of the Red Sea by the Hebrews, a symbol of baptism, and the passage from Isaiah about those who thirst. When the reading is finished, the bishop blesses the water. First he makes the sign of the cross over it; then he divides it into four parts and sprinkles it toward the four cardinal points, to recall the four rivers of the earthly paradise. Then he plunges the paschal candle, the image of the Saviour, into the water to remind us that Christ was plunged into the Jordan, and that by his baptism he sanctified all the waters of the world. Three times the bishop plunges the candle into the baptismal font to recall the three days that Christ spent in the tomb. Then the baptism begins, and the neophytes in their turn are plunged three times into the font so that they will know they have died to the world with Christ, are buried with him, and will be resurrected with him into eternal life.

We can see that every detail of such a ceremony has symbolic meaning.

But it is not only in such solemn ceremonies that the Church instructs and moves the people by its symbols. Every day it performs the sacrifice of the Mass, in whose moving drama there is nothing without its particular meaning. The chapters devoted by William Durandus to the explanation of the Mass are among the most astonishing of his *Rationale divinorum officiorum.*

Here, for example, is his interpretation of the first part of the divine sacrifice:[59] the grave and sorrowful chant of the Introit opens the ceremony; it expresses the long wait of the patriarchs and prophets. The choir of clerics becomes the very choir of saints of the Old Law who yearn for the coming of the Messiah they will never see. Then the bishop enters and, as it were, appears as the living figure of Christ. His arrival symbolizes the advent of the Saviour awaited by the nations. In high feasts, seven torches are carried before him to recall that, according to the word of the prophet, the seven gifts of the Holy Spirit rest upon the head of the Son of God. He advances under a triumphal canopy whose four bearers are interpreted as the four evangelists. Two acolytes walk at his right and left and represent Moses and Elijah, who appeared on

Mount Tabor at the sides of Christ. They teach us that Jesus had both the authority of the Law and the authority of the prophets.

The bishop sits down on his throne and remains silent. He seems to take no part in the opening of the ceremony. His attitude contains a lesson: his silence recalls that the first years of Christ's life were passed in obscurity and meditation. The subdeacon, meanwhile, has gone to the pulpit, and turning toward the right, he reads the Epistle aloud. In this, we glimpse the first act of the drama of Redemption. The reading of the Epistle is the preaching of St. John the Baptist in the wilderness. He spoke before the Saviour had begun to make his voice heard, but he spoke only to the Jews. Consequently, the subdeacon, the image of the precursor, has turned toward the north, the direction of the Old Law. When the reading is finished, he bows before the bishop, as the precursor had humbled himself before Christ.

The chant of the Gradual, which follows the Epistle, relates also to St. John the Baptist's mission: it symbolizes the exhortations to repent that he addressed to the Jews at the dawn of the new era.

Then the celebrant reads the Gospel. A solemn moment, for this is when the active life of the Messiah begins; his word is heard in the world for the first time. The reading of the Gospel is the symbol of his own preaching.

The Credo follows the Gospel, just as faith follows the proclamation of truth. The twelve articles of the Credo relate to the vocation of the twelve apostles.[60]

When the Credo is finished, the bishop rises and speaks to the congregation. In choosing this moment to instruct the faithful, the Church wished to remind them of the miracle of its own founding. It shows them how the truth, received at first only by the apostles, spread in one instant throughout the whole world.

Such is the mystical sense that William Durandus gives to the first part of the Mass. After this introduction, he arrives at the drama itself and at the sacrifice. But at this point his commentaries are so copious and his symbolism so rich that it is impossible in a simple analysis to give any idea of them. One would have to go to the original text. In any case, enough has been said to provide a glimpse of the spirit of the Middle Ages. One can imagine all that such a ceremony contained in the way of instruction, emotion, and life for the thirteenth-century Christian. With what power must such poetry have acted upon the sensitive soul of St. Louis. It explains his ecstasies and his tears. To anyone who broke into his contemplation he would say in a low voice, and as if coming out of a dream, "Where am I?" He had thought he was in the wilderness with St. John, walking beside Jesus.

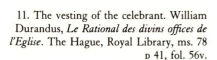

11. The vesting of the celebrant. William Durandus, *Le Rational des divins offices de l'Eglise*. The Hague, Royal Library, ms. 78 D 41, fol. 56v.

The books of the ancient liturgists, so scorned since the seventeenth century, must be counted among the most extraordinary of the Middle Ages.[61] Such powerful spiritual outpourings are to be found nowhere else. Reality vanishes; it is transfigured into spirit.

The vestments worn by the priest at the altar and the objects used in the ritual are also symbolic (fig. 11).[62] The chasuble, worn over all the other vestments, is the charity that is superior to all the precepts of the law and is in itself the highest law.[63] The stole, which the priest places around his shoulders, is the light yoke of the Saviour; and since it is written that every Christian must cherish this yoke, the priest kisses the stole when he puts it on and when he takes it off.[64] The bishop's miter with its two points symbolizes the knowledge he must have of both the Testaments: two ribbons are attached to recall that the Scripture must be interpreted according to the letter and the spirit.[65] The bell is the voice of the preachers. The framework from which it hangs is the figure of the cross. The rope made of three knotted strands signifies the triple meaning of the Scriptures, which must be interpreted in a triple sense: historical, allegorical, and moral. The act of taking the rope in the hand to ring the bell expresses symbolically a fundamental truth, that knowledge of the Scriptures must lead to action.[66]

Such constant use of symbolism is astonishing to anyone unfamiliar with medieval writers. But we must not pretend, as the eighteenth-century Benedictines did, to see nothing in it but a play of individual fantasy.[67] Such interpretations were no doubt never accepted as dogma; nev-

ertheless, it is remarkable that they seldom vary. For example, William Durandus, in the thirteenth century, attributed the same meaning to the stole that Amalarius had given it in the ninth century.[68] But what interests us the most is not so much the explanation in itself as the state of mind it presupposes; what is significant is the scorn for reality, the profound conviction that through the things of this world we can attain to pure spirit, we can glimpse God. This is the true true spirit of the Middle Ages.

For the art historian, there are no more valuable books than those written on the liturgy. Thanks to them, he learns to know the spirit that shaped the works of plastic art. For the artists were as skillful as theologians in spiritualizing matter: some of their creations were ingenious, some were touching, and others imposing.

For example, they gave the form of a fortified town with defense towers to the great chandelier of Aix-la-Chapelle. What is this city of light? The inscription tells us: the Heavenly Jerusalem. The beatitudes of the soul promised to the elect are represented among the battlements, beside the apostles and the prophets who guard the holy city (fig. 12).[69] Is this not a magnificent way to show the vision of John?

The artist who surmounted a censer with the image of the three young Hebrews in the fiery furnace knew how to make visible a beautiful thought (fig. 13).[70] The fragrance mounting from the brazier seemed to be the very prayers of the martyrs.

These pious workmen filled their work with all the tenderness of their souls.

12. Beatitudes (Righteousness). Detail of candelabrum of Frederick Barbarossa. Aachen, Palatine chapel.

13. The Three Hebrews in the Fiery Furnace. Censer, by Reiner. Lille (Nord), Musée des Beaux-Arts.

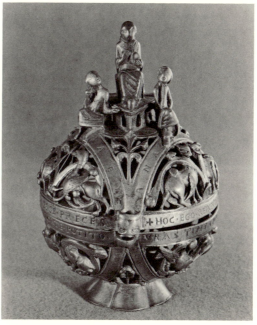

Another artist, more subtle, shaped the crook of a bishop's crozier into the form of a serpent holding a dove in its mouth. In this way, he wanted to recall to the shepherd the two virtues belonging to his ministry. "Hide the simplicity of the dove behind the prudence of the serpent," say the Latin verses carved on the pastoral staff.[71] Another crozier shows again a serpent, which threatens the Virgin with its powerless jaws; in the crook, the angel announces to the Virgin that she will give birth to the vanquisher of the serpent.[72]

The artists often translated exactly the doctrines taught by the liturgists. In the sanctuary of the Ste.-Chapelle, the sculptors placed against twelve columns the statues of the twelve apostles carrying consecration crosses. The liturgists teach us,[73] in fact, that when the bishop consecrates a church, he must mark with twelve crosses twelve columns of the nave or of the choir, to convey that the twelve apostles are the true pillars of the temple. This is symbolism made visible to the eye in the most felicitous of ways in the interior of the Ste.-Chapelle (fig. 14).[74]

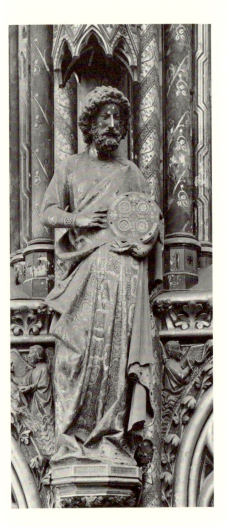

14. Apostle with the consecration cross.
Paris, Sainte-Chapelle.

All the furnishings used in thirteenth-century churches reveal how matter was informed by spirit. On the pulpit, the eagle of St. John spreads wide its wings to hold the Gospels.[75] Beautiful angels in long robes carry in procession crystal cylinders containing the bones of saints and martyrs. Virgins of ivory open, and in place of their hearts, reveal the story of the Passion.[76] A gigantic angel, on the chevet of the cathedral, dominated the entire town, casting over it something of the supernatural as it turned with the sun.[77]

From the foregoing we may conclude that medieval art is eminently symbolic, and that almost always its forms are a light covering for the spirit.[78]

These are the general characteristics of medieval iconography. The art of the Middle Ages is at one and the same time a form of writing, of arithmetic, and of symbolism. The result is a profound harmony. The arrangement of statues on the portal of a cathedral is a kind of music. Does it not have in it all the elements of music? Do we not find symbols grouped according to the law of numbers? And in the many symbols that we see behind the forms, do we not find something of the limitlessness of music? The spirit of the Middle Ages, which has long been misunderstood, was an harmonious spirit. Dante's *Paradiso* and the porches of Chartres are symphonies. No other art can so justly be called "frozen music" as the art of the thirteenth century.

II

Method Used for the Study of Medieval Iconography.
The *Speculum Majus* of Vincent of Beauvais

The thirteenth century is the century of Encyclopedias. In no other epoch were so many *Summas, Mirrors,* and *Images of the World* published. Then St. Thomas Aquinas coordinated all Christian doctrine; Jacob of Voragine collected into one body all the famous legends of the saints; William Durandus summarized all the liturgists who had preceded him; Vincent of Beauvais included in his work universal knowledge. The Christian world was fully conscious of its own genius. The conception of the universe elaborated during preceding centuries had arrived at its final expression. The Universities which had been founded in all of Europe, and above all the young University of Paris, believed it possible to construct the definitive edifice of human knowledge, and they set about it with ardor.[1]

Now while the Church Doctors were building the intellectual cathedral that would shelter all of Christianity, the stone cathedrals were being built as visible images of it. Into them the Middle Ages put all its conviction. In their way, the cathedrals were *Summas, Mirrors,* and *Images of the World.* They were the most perfect expression possible of the ideas of an age. In them, all Christian doctrines found plastic form. This is what we would like to demonstrate.

The difficulty is to group into logical order the innumerable works of art that a cathedral offers for study. Do we have the right to arrange the facts in our own way, following the plan that seems to us the most harmonious? I do not think so. Here we must set aside our modern habits of mind. If we try to impose our categories on the ideas of the Middle Ages, the chances are that we will be wrong. Thus, we shall take our method from the Middle Ages itself, from one provided for us by Vincent of Beauvais. The four books of his *Mirror* will be the four divisions of our study.

If St. Thomas had the most powerful intellect of the Middle Ages, that of Vincent of Beauvais was certainly the most comprehensive. In him resided all the learning of his time. He was a prodigious worker, and

like Pliny the Elder, passed his life in reading and making extracts.[2] St. Louis had opened his splendid library to him, and there he found nearly all the books that could be obtained in the thirteenth century. He was called *librorum helluo* (the book-eater). Sometimes the sainted king would visit him at the Abbaye de Royaumont, and he loved to hear him talk of the marvels of the universe.

It was probably toward the middle of the century that Vincent of Beauvais brought out the great *Mirror*, the *Speculum majus*, that seemed to his contemporaries the supreme and highest effort of human knowledge. Even today it is difficult not to admire so colossal a work.[3]

The knowledge possessed by Vincent of Beauvais was immense, but he was not overwhelmed by it. He was able to dominate his learning. The plan he adopted is the most imposing that a medieval man could imagine. Vincent of Beauvais' plan is the very plan of God, as it appears in the Scriptures.

The work is divided into four parts: the *Mirror of Nature*, the *Mirror of Knowledge*, the *Mirror of Morals*, and the *Mirror of History*.[4]

In the *Mirror of Nature* all the realities of the world are reflected in the order in which God created them. The days of creation mark the different chapters of this great encyclopedia of nature. The elements, minerals, vegetation, and animals are successively listed and described. All the truths and all the errors transmitted by antiquity to the Middle Ages are found there. But naturally it is to men, the work of the sixth day, that Vincent of Beauvais devoted the most space, for man is the center of the world, and the world was made only for him.

The *Mirror of Knowledge* opens with the story of the drama which explains the enigma of the universe, the history of the Fall. Man fell, and henceforth he can find salvation only through a redeemer. But by himself he can begin to lift himself up again, and through learning prepare himself for grace. In learning there is a living spirit, and to each of the seven arts corresponds one of the seven gifts of the Holy Spirit. After setting forth this great and humane doctrine, Vincent of Beauvais reviews all the branches of learning. He does not omit even the mechanical arts, for by working with his hands, man begins the work of his redemption.

The *Mirror of Morals* is closely related to the *Mirror of Knowledge*. In fact, the purpose of life is not knowledge, but action. Knowledge is only a means of arriving at virtue. This leads to a learned classification of the vices and virtues, in which we find the method, the divisions, and sometimes even the expressions of St. Thomas Aquinas, for the *Mirror of Morals* is nothing more than an abridgment of the *Summa*.

The *Mirror of History* comes last. Humanity in the abstract has been studied, and now comes humanity in the flesh. We are shown man in

action, under the eye of God. He struggles, suffers, invents the sciences and the arts; sometimes he opts for vice and sometimes for virtue in the great battle of the soul, which composes the entire history of the world. It is hardly necessary to point out that for Vincent of Beauvais as for St. Augustine, Paul Orosius, Gregory of Tours, and all the other historians of the Middle Ages, true history was the history of the Church, the history of the City of God which began with Abel, the first of the just. There is a people belonging to God: its history is the pillar of light that illuminates the shadows. As for the history of the pagan world, it is worth study only in relation to the other; it has only synchronistic value. It is true that Vincent of Beauvais was not above telling of the rise and fall of empires, and it even pleased him to speak of the philosophers, scholars, and poets of the Gentiles; but such chapters are really digressions. His controlling idea is something else. The unity of his work lies in the continuity of the saints of the Old and the New Laws: through them, and them alone, the history of the world can be explained.[5]

This is the way the thirteenth-century encyclopedia is conceived. The enigma of God, man, and the world is completely solved. The system was so perfect that there was nothing left for medieval man to discover. Until the Renaissance, succeeding centuries added not one line.

Therefore, such a book is the surest guide we can have for the study of the controlling ideas of thirteenth-century art. It is difficult not to notice striking analogies between the general plan of the *Speculum majus* and the porches of the cathedral of Chartres, for example. The innumerable figures decorating the portals can all be grouped under four headings: nature, knowledge, morality, and history. Didron was the first to say this, in his masterly introduction to his *Histoire de Dieu*.[6] However, he was not certain that the men of genius who conceived this great decorative ensemble had been inspired directly by Vincent of Beauvais' book, although the porches of Chartres and the *Speculum majus* are almost contemporary. But what difference does it make? It is quite evident that the plan of the *Speculum majus* does not belong specifically to Vincent of Beauvais, but to the entire Middle Ages. In it were the forms that had been impressed upon every reflective mind in the thirteenth century. The same spirit planned the chapters of the *Mirror* and the statues of cathedrals: consequently, it is quite legitimate to look in one for the secret of the others.

The four great divisions of Vincent of Beauvais will therefore be ours. We shall try to read on the façades of cathedrals the four books of the *Mirror of the World*. We shall discover all four there, and we shall decipher them in turn and in the very order in which the encyclopedist presents them. In this way, each detail will find its place, and the harmony of the whole will be revealed.

Book One

SPECULUM NATURALE: THE MIRROR
OF NATURE

I

Vincent of Beauvais' *Speculum naturale* is majestically simple. As we have said, it is a commentary on the seven days of creation, and it studies the creatures in the order of their appearance. Into the biblical framework, Vincent of Beauvais introduced all the knowledge of antiquity; thanks to him, Pliny, Aelianus, Dioscurides, although it was not their intention, sang the glory of the God of Genesis.

In fact, this plan did not originate with Vincent of Beauvais; it had been followed since the Early Christian era. The Greek and Latin Church Fathers arranged the whole of their knowledge of the universe by following the order of Creation: to each day they devoted a chapter of their books. In the West, the most famous *Hexaemeron* or discourse on God's work was written by St. Ambrose, and it became the model for all works of this kind.[1] Thus, Vincent of Beauvais invented nothing; in this as in all his work, he was simply the faithful interpreter of tradition.

The *Speculum naturale* in abridged form is carved on most of our cathedrals. Chartres (fig. 15), Laon, Auxerre, Bourges, and Lyon all show us the work of the seven days.[2] There we see that the imagination of the artists was both economical and synthesizing. At Chartres, a lion, a lamb, a goat, and a heifer represent all the animals; a fig tree and three other indeterminate plants represent the diversity of vegetation (fig. 16).[3] There is grandeur in summarizing in five or six bas-reliefs the boundless universe. Many naïve details have great charm: at Laon, God, seated, reflects profoundly before separating the darkness from the light, and counts on his fingers the number of days needed to finish his work. Farther along, when he has completed his work, the Creator sits down to rest like a good workman who has used his day well, and leaning on his staff, he goes to sleep.

However, it would be justifiable to find these few figures to be an inadequate representation of the richness of the universe and so to tax the thirteenth-century artists with timidity and lack of ability if the plant and animal world really occupied so small a place in the cathedrals. But we have only to raise our eyes to see the grapevine, the raspberry bush laden with fruit, and the long shoots of the wild rose clinging to the archivolts. Birds sing among the oak leaves, others perch on the buttresses. Animals from distant lands—lions, elephants, camels, and native animals —hens, squirrels, and rabbits, brighten the bases of portals. Monsters, fastened by their stone wings, clamor in the upper regions.

How little do the old masters, deserve the charge of incompetence and sterility. Never have artists been more impassioned by the beauties of nature. Their cathedrals are movement and life itself. For them, the Church was the ark that welcomed all creatures. What is more, the works

The Middle Ages conceived the world as symbol. The origins of this conception. The "Clavis" of Melito (*Melitonis clavis sanctae scripturae*). The bestiaries.

of God were not enough: they imagined a whole world of terrifying beings; but they imagined them so realistically that their monsters seem to have lived in the primeval ages of the world.

Thus, the chapters of the *Speculum naturale* are inscribed everywhere: on the pinnacles, the balustrades, the archivolts, and on the least capital.

What is the meaning of all these plants, animals, and monsters? Are they the product of fantasy, or do they have real meaning? Do they teach us some great mysterious truth? Since all the statues and reliefs that we shall study conceal a thought, may we suppose that these too are symbolic?

To answer all these questions, we must first understand what idea the Middle Ages had of nature and of the world.

What is the visible universe? What is the meaning of the innumerable multitude of forms? What did they think—the monk contemplating in his cell, and the Church Doctor meditating as he walked in the cathedral cloister before the hour of his lecture? Is the world only appearance? Does it have reality? In the Middle Ages, the response would have been unanimous: the world is a symbol. The universe is a thought which God carried within himself in the beginning, as an artist carries in his soul the idea of his work. God created, but he created through his Word, or through his Son. It was the Son who accomplished the thought of the Father, who transformed potentiality into act. The Son is the real creator.[4] Imbued with this doctrine, medieval artists always represented the Creator in the person of Christ.[5] Didron was astonished and Michelet indignant—mistakenly—that they found no image of the Father in the cathedral.[6] According to the theologians, God the Father created *in principio*, that is, *in verbo*, through his Word, his Son.[7] Jesus was the author both of Creation and of Redemption.[8]

Thus, the world can be defined in this way: "An idea of God realized by the Word." If such be the case, each being conceals a divine thought. The world is an enormous book written by the hand of God, in which each being is a word filled with meaning.[9] The ignorant look about them, see figures and mysterious letters, and understand nothing of their meaning. But the knowing rise from the visible to invisible things: by reading nature, they read the thought of God. Consequently, knowledge consists not in studying things in themselves, but in uncovering the teaching that God has placed for us in things; for as Honorius of Autun said, "Each creature is a shadow of the truth and of life." In the depths of each creature are inscribed the figure of the sacrifice of Jesus, the idea of the Church, and the image of the vices and the virtues. The moral world and the visible world are one.

These are the mystical thoughts that came into the minds of the Church Doctors when they contemplated nature. Adam of St. Victor, in the refectory of his monastery, held a walnut in his hand and thought:

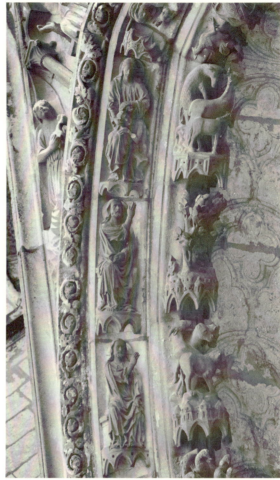

"What is a walnut if not the image of Jesus Christ? The green, fleshy covering is his flesh, his humanity. The wood of the shell is the wood of the cross on which that flesh suffered. But the meat of the nut, which is food for mankind, is his hidden divinity."[10]

Peter of Mora, cardinal and bishop of Capua, meditated on the roses in his garden. He was not moved by their pagan beauty; he was pursuing his own thoughts. He said, "The rose is the choir of martyrs, and again, it is the choir of virgins. When the rose is red, it is the blood of those who died for the faith, and when it is white, it is virginal purity. It blooms among thorns, just as the martyrs live among heretics and persecutors and the pure virgin shines in the midst of iniquity."[11]

17. Separation of waters from the waters; darkness and light; earth and the waters. Chartres (Eure-et-Loir), Cathedral of Notre-Dame. North transept, porch, archivolts.

As Hugh of St. Victor watched a dove, he thought of the Church. "The dove," he said, "has two wings, just as for the Christian there are two kinds of life, the active and the contemplative. The blue wing feathers are the thoughts of heaven. The subtle gradations of the rest of the body, the changing colors that remind us of a rough sea, symbolize the ocean of human passions in which the Church sails. Why does the dove have eyes of a beautiful golden yellow? Because yellow, the color of ripe fruit, is the very color of experience and maturity. The yellow eyes of the dove symbolize the wisdom with which the Church regards the future. And finally, the dove has red feet because the Church proceeds through the world, its feet in the blood of the martyrs."[12]

Marbodius, bishop of Rennes, thought about precious stones and discovered mysterious correspondences between their colors and the things of the soul. The beryl shines like water over which the sun passes and it warms the hand that holds it. Is this not the image of the Christian?

Christ is the sun who warms and illuminates him to his very depths. The red amethyst seems to cast flames; it is the image of the martyrs who, while spilling their blood, prayed for their tormentors.[13]

In the world, everything is symbol. The sun, the constellations, the light, the night, the seasons, all speak a solemn language (fig. 17). What did medieval man think about in winter, when the days grew short and the night seemed determined to triumph forever over light? He thought of the long centuries of half-light before Christ's coming, and understood that light and darkness also have their role in the divine comedy. He called these weeks of December the weeks of Advent (*Adventus*), and through liturgical ceremonies and readings explained the waiting of the ancient world. And the Son of God was born at the winter solstice, just at the moment when the light begins to reappear and increase in the world.[14] Moreover, the entire year is made in the image of man: it relates the drama of life and death. Spring, when the world is renewed, is the image of baptism which renews man when he comes into the world. Summer is a symbol; its burning heat and its light remind us of the light of another world, of the radiance of charity in eternal life. Autumn, the season of harvests and grape-picking, is the redoubtable symbol of the Last Judgment, of the great day when we shall reap what we have sown. And winter is the shadow of death awaiting man and the world.[15] Thus, the reflective man walked in a forest of symbols, under a sky peopled with ideas.

Are these nothing but individual interpretations, mystical fantasies born of the exaltation of the cloister, or are we in the presence of a system and an ancient tradition? We have only to read through the works of the medieval Church Fathers and Doctors to answer the question. Never has doctrine been more solidly worked out and more universally accepted.

The doctrine goes back to the beginnings of the Church and is based on the text of the Bible itself.[16] In the Scriptures, as the Fathers interpreted them, the material world is a constant figure for the moral world. Each of God's words contains both the visible and the invisible. The flowers whose perfumes make the lover of the Song of Songs faint, the precious stones decorating the rational of the high priests, the wild animals who pass before Job are both reality and symbol. The cedars, the terebinths, the white summits of Lebanon are thoughts. To interpret the Bible is to understand the harmony that God established between the soul and the universe. The key to the Scriptures is the key to these two worlds.

The interpretations of the Church Fathers, adopted by the early Church Doctors, were passed on from book to book until the end of the Middle Ages. We can trace this symbolic teaching through the centuries in the *Formularium* of St. Eucherius (*Formularium spiritualis intelligen-*

tiae ad Veranium), in the *De universo* and *Allegoriae in sacram Scriptu-ram* of Rabanus Maurus,[17] in the *De bestiis et aliis rebus* attributed to Hugh of St. Victor, in the *Liber in distinctionibus dictionum theologi-calium* of Alain de Lille, and in the *Gregorianum* of Garnier of St. Victor Many other names could be cited.[18]

The most curious work of this kind is the anonymous compilation, composed in the ninth or tenth century, of fragments borrowed from the Latin Church Fathers. This compilation was called the *Key* of Melito (*Clavis scripturae in lingua latina*) and was attributed to the famous Bishop of Sardis. Despite what J. B. Pitra has said about it, the attribution cannot be upheld.[19] But whatever may be the date of the book, it is very interesting. It is an encyclopedia of nature in which man, metals, flowers, and animals are studied in turn. All the objects are listed with their sym-bolic meaning, and the principal passages of the Bible in which these objects are named accompany each interpretation.

Let us open this unusual book to the chapter on plants. Roses, said the Pseudo-Melito, signify the blood of the martyrs, and it is in this sense that the passage from Ecclesiastes must be interpreted: "Open up your petals, like roses planted near running waters."[20] Nettles signify the power of vice, as in the verse from Isaiah: "Thorns and nettles shall grow up in its houses," or again, the itching of earthly desires, as in an-other passage from the same prophet: "I passed by the field of the sloth-ful man, . . . and behold it was all filled with nettles . . ." [Proverbs 24:30,31].[21] Chaff symbolizes sinners: Job said, "They shall be as chaff be-fore the face of the wind . . ." [21:18].[22]

The difficulty is that the same object can stand for different things. For example, the lily sometimes signifies the Saviour, sometimes the saints, sometimes the brilliance of the heavenly home, sometimes chastity.[23] But the author had foreseen this, and shows us how, according to Scriptural passages, the animals, flowers, and stones are to be taken in one sense or in another.

There was perhaps not one sermon writer or medieval theologian who did not use the mystical method. Personal fantasy, moreover, infinitely enriched the original theme, as we have seen in the chapter by Hugh of St. Victor on the dove, but imagination never strayed completely from the traditional interpretations.[24]

Thus, to the men of the Middle Ages, the world was a book with a double meaning that could be deciphered with the help of the Bible.

Of all the symbolic works devoted to nature, the bestiaries are certainly the strangest. Paganism and Christianity collaborated on these extraordi-nary books. In them we find both the animal fables that Ctesias, Pliny, and Aelianus collected, and the mystical commentaries added by the early Christians.

The symbolic bestiary, the famous *Physiologus*, of which the original text is lost, goes back to the very origins of Christianity, probably to the second century.[25] Ancient Greek, Armenian, and Latin texts prove that the *Physiologus* was known all over the Christian world.[26]

Very early, the people of the West translated it into their own languages. In the eleventh century, it was translated into German; in the early twelfth, into French by the Anglo-French poet, Philippe de Thaon.[27] A century later, William the Norman translated it again.[28] The condemnation pronounced by Pope Gelasius against the *Physiologus* kept no one from reading and citing the bestiary.[29] Moreover, for authority it had the Fathers of the Church, St. Augustine, St. Ambrose, and St. Gregory the Great, all of whom frequently borrowed from it. That is why sermon-writers like Honorius of Autun did not hesitate to draw from it symbolic or edifying explanations. As for learned men, Vincent of Beauvais, Bartholomaeus Anglicus, and Thomas of Cantimpré not only did not disdain these fables but ranked them as scientific truth.[30]

Thus, the Middle Ages made the ancient *Physiologus* of the Orient their own; they mingled it with all their own conceptions of the world, with their religious exegesis, even into their dreams of love.[31] It became the very substance of the era.

One example will give an idea of the composite character of the book. The ancients had told that the elephant was the most frigid of the animals, and could couple with a female only when it had eaten mandragora (fig. 18). The female, they said, gathered the plant herself at sunrise

18. Griffin, elephant. Bestiary. Oxford, Bodleian Library, ms. Ashmole 1511, fol. 15v (detail).

and presented it to the male. The Christian writer took over this story which had amused the pagans, and revealed its hidden meaning. The elephant and his female symbolize Adam and Eve in the earthly paradise. The mandragora is the fruit given by the woman to man. When he had eaten of it, Adam, who until then had not known the desires of the flesh, knew Eve and conceived Cain.[32] Thus it was God's desire that the history of the Fall should remain inscribed on earth, and it could be found even in the habits of animals.

As we see, the most unreliable knowledge of antiquity and the most questionable Christian exegesis came together in the bestiaries.

The author of the *Physiologus*, whoever he was, must have invented a great deal himself. He is hardly ever upheld by the traditional symbolism founded on the Bible, for the animals mentioned by the *Physiologus* are fabulous monsters such as the griffin, the phoenix, the unicorn, or the animals of India unknown in the Old Testament. He must then have imagined most of the moral interpretations accompanying the descriptions of the animals. His symbolism was nonetheless held to be valid, and the Middle Ages changed none of it.

And furthermore, no one dreamed of verifying the accuracy of the stories of the *Physiologus*. The idea of things always had more reality for medieval man than the things themselves. It is clear why these mystical centuries had not the least idea of what we call science. The study of things in themselves had no meaning for the thinking men of the time. How could it have been otherwise when the world was conceived as the language of the Word, of which each being was one word? To distinguish the eternal truths that God wished each thing to express, to find in each creature a shadow of the drama of the Fall and Redemption—such was the task of the learned men who observed nature. Roger Bacon, the most scientific spirit of the thirteenth century, concluded, after describing the seven envelopes of the eye, that God wished to imprint in us the image of the seven gifts of the Holy Spirit.[33]

II

Animals represented in cathedrals sometimes have symbolic meaning. The four beasts that represent the evangelists. The window at Lyon; the frieze at Strasbourg. The influence of Honorius of Autun; the role of the bestiaries.

To what extent did art conform to this philosophy of the world, and in what measure are the animals decorating the cathedrals symbolic? This is the question we must now examine, and it is a delicate one on which archeologists have not always been able to restrain their imaginations.

Works of art with animals to which a mystical meaning can be attached are few in number, but their character is such that comparison with the texts leads to some certain conclusions.

The four beasts surrounding the image of Christ on the portals of so many churches comprise the first category of representations the sym-

bolic sense of which cannot be doubted. The motif of the four animals—man,[34] eagle, lion, and ox—very frequent in the Romanesque period, became rarer in the thirteenth century; it continued, however, to appear. The four animals are found, for example, on the door of the Last Judgment at Notre-Dame of Paris. True, they no longer have the amplitude and heraldic pride of those at Moissac; they no longer occupy the tympanum, but are modestly concealed in the lower parts of the portal.

What is the meaning of these four beasts? From early Christian times, it had been accepted that the man, the eagle, the lion, and the ox, first seen by Ezekiel beside the river Chebar and again, later, by St. John around the throne of God, symbolized the four evangelists. In the early Church, on Wednesday of the fourth week of Lent, the meaning of the four mysterious beasts was explained to the catechumens, whose baptism was drawing near. They were taught that the man was the symbol of Matthew, the eagle of John, the lion of Mark, and the ox of Luke, and it was explained why.[35]

The following centuries accepted this explanation, but they also imagined new ones. In the twelfth century, it was believed that the four creatures had three meanings: they symbolized, at the same time, Jesus Christ, the evangelists, and the virtues of the elect.

It will not be beside the point to explore this world of subtle ideas in which theology mingles with the science of the bestiaries. Nothing could better induct us into the spirit of medieval symbolism.

We could easily find all the necessary texts in the works of the contemporary theologians,[36] but we prefer to call upon even more solemn testimony. In the twelfth century, on the day of the feast of the Evangelist Luke, in certain French churches it was customary to read a curious commentary that explained the symbolism of the beasts to its finest nuances. Several manuscript lectionaries have preserved this passage.[37] They do not tell us where it came from, but we have happily found it in the commentary of Rabanus Maurus on Ezekiel.[38] In adopting the interpretations of Rabanus, the Church consecrated them with its authority.

The four beasts, the lectionary says, signify first the four evangelists. Matthew has man as attribute because he begins his Gospel with the genealogical list of Christ's ancestors according to the flesh. The lion symbolizes Mark who, in his first lines, speaks of the voice crying in the wilderness. The ox, animal of sacrifice, symbolizes Luke, who begins his Gospel with the sacrifice offered by Zachariah. The eagle is the symbol of John because at the very outset he takes us to the heart of the divine, just as the eagle, alone of all the animals, looks directly at the sun. In this last feature, we recognize the natural history of the bestiaries.[39]

The same animals symbolize Christ. If we reflect, we will recognize in them four moments in the life of the Saviour, and four great mysteries.

The man recalls the Incarnation and reminds us that Jesus really became a man. The ox, the sacrificial animal of the Old Law, recalls the Passion, the sacrifice that the Redeemer made of his life for all mankind. The lion is the symbol of the Resurrection. Here again we come upon the fabulous science of the bestiaries: the lion, in fact, was thought to sleep with its eyes open.[40] This, the lectionary tells us, is a symbol of Christ in the tomb: "The Redeemer, in fact, seemed to sleep in death, as his humanity demanded, but by virtue of his divinity he remained immortal, and was awake."[41] The eagle is the figure of the Ascension: Jesus rose to heaven as the eagle rises to the clouds. In a clear formulation of its teaching, the lectionary says that Jesus was a man in being born, an ox in dying, a lion in being resurrected, an eagle in rising to heaven.[42]

But the four beasts have a third meaning. They express the virtues necessary for salvation. Each Christian, on the way to divine perfection, must at the same time be a man, an ox, a lion, and an eagle. He must be a man because man is the rational animal and only he who advances in the way of reason merits the name of man; he must be an ox because the ox is the victim immolated in sacrifices, and the true Christian, in renouncing all the pleasures of the world, sacrifices himself; he must be a lion because the lion is the brave animal par excellence, and the just man who has renounced everything fears nothing in this world, for of him it is written: ". . . the just, bold as a lion, shall be without dread." Lastly, he must be like the eagle, because the eagle soars in the heavens and looks into the sun without lowering its eyes, and the Christian must contemplate eternal things face to face.

Such is the Church's teaching on the four beasts. Only one of these explanations, that which assimilated the apocalyptic beasts to the evangelists, survived the Middle Ages. The other two met the fate of all the old mystical theology and in the time of the Reformation were completely forgotten. But even the Protestants remained faithful to tradition with respect to the first meaning and retained it. In the seventeenth century, Rembrandt painted the sublime St. Matthew, now in the Louvre, who listens with all his soul to the eternal words which an angel in the shadows murmurs in his ear.

After this discussion, there can be no doubt that animals sometimes played a symbolic role in medieval art. In the example studied, the texts enable us to interpret the monuments with certainty.

There are other cases in which we cannot be so certain. In the cathedral of Lyon there is a famous window that attracted the attention of archeologists very early. Father Cahier reproduced it[43] and attempted to explain it; but he was unable to identify the book that had inspired it. Guigue and Bégule, in their recent monograph on the cathedral of Lyon, fared no better. The Lyon window is too important to the subject we are con-

cerned with and is too closely connected with a great theological work of the twelfth century for us not to describe it with some care.

This mystical work is conceived as follows (fig. 19). Beginning at the bottom (which is the way almost all windows must be read), there is first a medallion devoted to the Annunciation. In two small medallions placed in the border, and clearly very closely related to the principal subject, are represented, in one, the prophet Isaiah holding a scroll with these words: *Ecce virgo concipi(et)*, and in the other, a girl seated on a unicorn and holding a flower (fig. 20). The second medallion contains the Nativity; the cartouches of the border are devoted to the burning bush of Moses and the fleece of Gideon. Christ on the cross fills the third medallion: the sacrifice of Abraham and the brazen serpent accompany it. The Resurrection is the subject of the fourth medallion: the whale vomiting forth Jonah, and a lion with its cubs, flank the principal scene (fig. 21). The other medallions are devoted to the Ascension: Jesus rises to heaven while the apostles with raised heads contemplate him. The cartouches of the border represent a bird, which an inscription names *kladrius* (fig. 22), perched beside the bed of a sick man, and an eagle with its eaglets (fig. 23), and lastly, angels.

Father Cahier was right in saying that each scene in the small cartouches is a figure or symbol of the events from the New Testament that occupy the large medallions. For example, the sacrifice of Abraham and the brazen serpent raised up by Moses are figures of the sacrifice of Christ, and by design are placed alongside the Crucifixion.[44] He also rightly remarked that several subjects had been taken from the bestiaries and that the artist sought to explain the principal mysteries of the faith through these animals: for example, the eagle was placed beside the Ascension, and the lion beside the Resurrection.

All of this is perfectly correct, but Father Cahier did not discover that there was a single source for all this symbolism. This great composition did not issue from the imagination of a mystical artist inspired by the reading of bestiaries and theological commentaries. It was taken entirely from one of the most famous works of the Middle Ages, the *Speculum ecclesiae* of Honorius of Autun, which it faithfully translates. The artist invented nothing; he only remembered. It is in this book that we find the precise meaning that must be attributed to each of the mystical animals of the Lyon window.

The *Speculum ecclesiae* of Honorius of Autun is a collection of sermons for the principal feasts of the year. So that his Latin would be graven more easily on the memory of preachers, Honorius gave it a kind of primitive rhythm: each sentence rhymes with the preceding. In the *Speculum ecclesiae* there are true theological strophes quite comparable to the epic couplets of the *chansons de geste*. It is possible that its mo-

notonous music contributed to the success of the book. Written at the beginning of the twelfth century,[45] it was still very much read in the thirteenth.[46] Few books better express the spirit of their time; as its title says, it is the mirror of the twelfth-century Church. The mystical method is preferred above all others, and by means of ingenious symbols the whole world is made to bear witness to the truth of the faith. Honorius of Autun always proceeds in the same way. In each of the sermons written for the principal feasts, he begins with the great event in the life of the Saviour that the Church commemorates on that day, and then he finds in the Old Testament the events relating to and prefiguring it; lastly, he chooses symbols from nature itself and seeks to find even in the habits of animals the shadow of the life or death of Christ.

This method is the same followed by the glass painter in the Lyon window. With the aid of a theologian, he had composed his work from several sermons by Honorius of Autun. To illustrate the mystery of the Annunciation and of the Nativity, he chose four symbolic examples from the two sermons Honorius of Autun devoted to these feasts:[47] the prophecy of Isaiah that a Virgin would give birth, the bush that burned without being consumed, the fleece of Gideon wet with dew, figure of virginal maternity,[48] and lastly, the fabulous story of the unicorn. In fact, Honorius saw in the unicorn a symbol of the Incarnation. In summarizing briefly the bestiaries, he said: "The unicorn is a very wild animal, so wild in fact that only a virgin can capture it. When the animal sees her, it comes to her, sits on her lap, and lets itself be taken. The unicorn is Christ, and the horn growing out of the center of its forehead symbolizes the invincible strength of the Son of God. He rested in the womb of a virgin and let himself be taken by hunters, which is to say that he took on human form in the womb of Mary and consented to give himself over to those who hunted him." In the Lyon window, the young girl, as a sign of victory, is mounted on the beast she has just captured, and in her hand holds a flower, the symbol of purity (fig. 20).[49]

The third medallion, devoted to the death of Christ on the cross, is accompanied by two symbolic scenes: the sacrifice of Abraham and the brazen serpent. These are precisely two of the figures which, among others, Honorius of Autun used in the two sermons he devoted to the Passion.[50]

The medallion of the Resurrection is flanked by the whale of Jonah, ancient image of the tomb in which the Saviour passed three days, and by the lion and its frisking cubs (fig. 21). Honorius of Autun, who himself used these two figurative scenes, explained especially the second with great clarity in his sermon for the day of Easter, devoted to the Resurrection.[51] Following the bestiaries, he said: "It is told that the lioness gives birth to stillborn cubs, but three days later, a roar from the lion brings

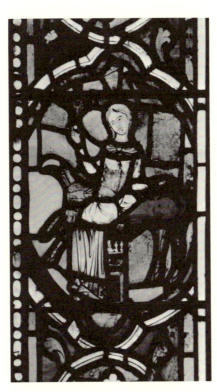

20. The maiden and the unicorn. Lyon (Rhône), Cathedral of St.-Jean. Apse, central window, stained glass (detail of border).

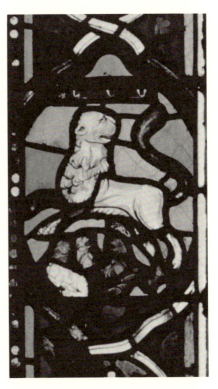

21. The lion and cubs. Lyon (Rhône), Cathedral of St.-Jean. Apse, central window, stained glass (detail of border).

19. Symbolic window, Redemption. Lyon (Rhône), Cathedral of St.-Jean. Apse, central window, stained glass.

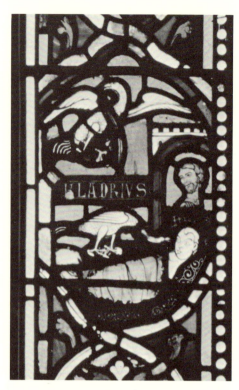

22. The charadrius. Lyon (Rhône),
Cathedral of St.-Jean. Apse, central
window, stained glass (detail of border).

23. The eagle and eagles. Lyon (Rhône),
Cathedral of St.-Jean, Apse, central
window, stained glass (detail of border).

them to life.[52] In like manner, Christ lay in the tomb as one dead, but on the third day he arose, wakened by the voice of his Father." He adds that the phoenix and the pelican are also symbols of the Resurrection, "for from the beginning, God so wished to express by means of these birds what would one day come to pass." For lack of space, the glass painter of Lyon could not include the phoenix and the pelican in his window, but we shall find them elsewhere, and even at Lyon.

Lastly, the medallion of the Ascension is annotated by the legend of the eagle and its young, and by that of a bird called *kladrius* (corruption of *charadrius*) (figs. 22 and 23). These are precisely the only two legends used by Honorius in the sermon written for the day of Ascension.[53] He interpreted them as follows: "Of all the animals, the eagle flies the highest, and it alone dares to look directly into the sun. When it teaches its young to fly, it first flies above them and then takes them on its outspread wings. Thus, Christ is raised higher in heaven than all the saints, and his Father placed him at his right. He spread the wings of his cross over us and carried us on his shoulders, like lost sheep." The legend of the *charadrius* is a strange one. Honorius of Autun said, "There is a bird

called charadrius, which is able to divine whether a sick person will escape death. It is placed near the sick person; if he is to die, the bird turns its head away; if he will live, the bird fixes its gaze on him and absorbs the malady into its open beak. It flies away at once into the rays of the sun, and the sickness it has absorbed oozes from it like sweat. And the sick man is healed. The white charadrius is Christ born of a virgin. He came to the sick, when his Father sent him to save mankind. He turned his head away from the Jews and left them in death, but he looked toward us and carried our sickness onto the cross. A sweat of blood flowed from him, then he arose again to his Father with our flesh, and brought salvation to all of us."[54]

These parallels would seem to leave no doubt that the Lyon window was inspired by the *Speculum ecclesiae* of Honorius of Autun.

Another symbolic work derives, in our opinion, from the same source. We refer to the frieze of animals carved in the early fourteenth century on the tower of Strasbourg Cathedral. This was published by Father Cahier, on the basis of the somewhat sketchy drawings of Father Martin.[55] A cast has now been taken of the frieze, which can be studied at leisure in the Musée de l'Oeuvre Notre-Dame at Strasbourg. After studying the Lyon window, we can guess the intention of the Strasbourg artist simply by naming the subjects he represented. They are: the sacrifice of Abraham, the eagle and its young, the unicorn pursued by hunters, the unicorn taking refuge in the lap of the virgin, the lion resurrecting its cubs, Jonah vomited up by the whale, the brazen serpent, the pelican reviving its young with its own blood, the phoenix in the flames. Are these not all symbols of the Nativity, the Passion, the Resurrection, and the Ascension? Do we not recognize the same symbols used in the sermons of Honorius of Autun? It is true that this artist did not represent the historical events of which these animals are the symbols, as was done at Lyon; at Strasbourg there is no Nativity, Crucifixion, Christ rising from the tomb, or Ascension of Christ, but is there any reason to hesitate over the sculptor's intention? We will notice that when he wished to recall the Resurrection, he was not content, as the Lyon artist had been, to represent only the lion resurrecting its young, but that he also borrowed from Honorius of Autun the legends of the phoenix who burns itself on a pyre and after three days resumes its old form, and of the pelican, who after killing its young, brings them back to life at the end of three days by opening its breast and sprinkling them with its own blood, as God resurrected his Son on the third day.[56]

I find the influence of the *Speculum ecclesiae* of Honorius of Autun again in the four symbolic windows at Bourges, Chartres, Le Mans, and Tours.[57] These windows, which we shall study in detail later on, skillfully correlate the principal events in the life of Christ with the events in the

Old Testament that prefigured them. Now, near Christ issuing from the tomb, we see, alongside the symbolic scenes taken from the Bible, the lion resurrecting its cubs and the pelican opening its breast to restore life to its young.[58] Thus, in the thirteenth century it was accepted on the authority of Honorius of Autun that the lion and the pelican symbolized the Resurrection as truly as did Jonah, for example. It will be said that all the bestiaries teach the same doctrine. That is true, but none the less, Honorius of Autun was the first to use as commentary on the Gospels both events chosen from the Old Testament and legends borrowed from the history of animals. For him, these two orders of symbols had the same value. In his work, this kind of demonstration forms a perfectly coherent doctrine which appealed both to the mind and to the memory. The preachers, well nourished on his book, popularized the legends of the lion, the pelican, and the unicorn. We might almost say that the teachings of the bestiaries reached the medieval clergy solely through Honorius' book. It is remarkable, in any case, that the symbolic animals carved or painted in our cathedrals are precisely those named by Honorius, and no others. On the portal at Lyon, for instance, there are innumerable small medallions, carved in the early fourteenth century, showing, among scenes of pure fantasy and monsters created by the imagination of the artist, several animals borrowed from the bestiaries. These are the pelican,[59] the unicorn,[60] the phoenix, and the siren musicians,[61] which Honorius mentions in his sermon for the Sunday of Septuagesima[62] as the symbol, or even better, as the very voice of worldly pleasure. The trumeau of the west portal of Noyon, now so badly mutilated, still gives a glimpse of the pelican, the phoenix, and a half-destroyed animal which seems to be a lion leaning over its cubs.

Let us give one more typical example of the influence exerted on art by Honorius of Autun's book. For Palm Sunday the *Speculum ecclesiae* contains a sermon on a verse from Psalm 90: "Thou shalt walk upon the asp and the basilisk: and thou shalt trample under foot the lion and the dragon."[63] Following Catholic tradition, Honorius applies this text to Christ, and describes the Lord triumphing over all his enemies. He explains at length the meaning of each monster named by the prophet: the lion is the antichrist, the dragon is the devil, the basilisk is death, and the asp is sin; he dwells on the asp especially and explains its symbolism in these terms: "The asp is a kind of dragon that can be charmed by song. But it is on guard against these charms, and when it hears them, it glues one ear to the ground and stops the other with its tail so that it can hear nothing; thus it escapes the incantation. The asp is the image of the sinner who stops his ears against the words of life." The admirable Christ, called "le beau Dieu" (fig. 24), standing on the trumeau of the

24. Christ, the lion, dragon, asp and basilisk beneath his feet. Amiens (Somme), Cathedral. West façade, central portal, trumeau.

25. The basilisk. Amiens (Somme), Cathedral. West façade, central portal, trumeau (detail of base).

26. The asp. Amiens (Somme), Cathedral. West façade, central portal, trumeau (detail of base).

central portal of Amiens Cathedral, has the lion and the dragon beneath his feet. Lower, to the right and left of the socle, are carved two strange animals (figs. 25 and 26). One, a cock with a serpent's tail, we easily recognize as the basilisk, which the natural history of the time represented as a composite bird and reptile.[64] The other animal is a kind of dragon which has one ear against the ground and the other stopped with the end of its tail. Clearly this is the asp, as the text we have just cited proves. The Christ of Amiens, generally called the Teaching Christ, is thus something more: he is the Triumphant Christ. Through his word, he triumphs over the devil, sin, and death. A beautiful idea, and one magnificently realized by the artist, but let us not forget that this great work was inspired in part by the *Speculum ecclesiae*.[65]

To sum up, we believe that the bestiaries, so often mentioned by archeologists, had no real influence on art until they were utilized by Honorius of Autun. From his book they passed into sermons. I have searched our French cathedrals in vain for images of the beaver, the peacock, and the tiger, for example, and of other animals that figure in the bestiaries but are not mentioned by Honorius. It was only in rare instances that artists went directly to the bestiaries for inspiration. In fact, I know of only two certain examples of deviation from the rule I have just stated. One is a capital in the cathedral of Le Mans, which represents an owl surrounded by various birds.[66] There can be no doubt about the meaning of this representation. Indeed, the bestiaries tell us that the eyes of the owl are so made that it does not see clearly during the day: consequently, when it ventures out into full daylight, the birds chase it. Thus, the owl be-

comes an image of the blindness of the Jewish people who closed their eyes to the sun and became the butt of the Christians.[67] It is clear that the subject of the Le Mans capital was taken directly from the bestiaries, for the symbolism of the owl does not appear in the *Speculum ecclesiae*.

On a capital from Troyes, now in the Louvre,[68] I have found another instance of legendary natural history not mentioned by Honorius of Autun. Birds perch on a tree while two dragons at the right and left observe the birds, apparently awaiting the opportunity to seize them. The tree is the *peridexion* mentioned in the bestiary.[69] Its fruit is so sweet that it attracts the doves who come to nest in its branches. But the birds are in great danger if they are imprudent enough to leave the tree, for a dragon hides nearby, lying in wait to devour them. Fortunately, the dragon fears the shade of the *peridexion* tree, and when its shadow falls on one side, the dragon must move to the other.[70] Since the birds always know where their enemy is, they can avoid him. The *peridexion* is the image of the Tree of Life whose shade thrusts back the devil. The birds are the souls who feed on the fruit of truth.[71]

These are two examples of the direct influence of the bestiaries on art. To be sure, it is possible that others can be found. Nevertheless, I do not believe them to be very numerous. The religious art of the thirteenth century generally accepted only the lion, the eagle, the phoenix, the pelican, and the unicorn, popular symbols of Christ which the *Speculum ecclesiae* and the sermons of preachers had made widely known.

III

The animals so far discussed function as symbols in the cathedrals. Their meaning which has been endlessly clarified by the texts, cannot be doubted. But what of the rich flora and fauna of Reims, Amiens, Rouen, and Paris, and what of the mysterious world of gargoyles? Are we to look for symbols there, too? What book will explain their meaning? What text will guide us?

Let us admit that here books will no longer teach us anything, the texts and the monuments no longer coincide. Placing them side by side no longer leads to certain conclusions, to nothing like the exact results obtained above.

I know that some ingenious archeologists have sought to leave nothing in the cathedral unexplained. According to them, the smallest flower and the most insignificant grimacing monster have a meaning that the medieval theologians could reveal to us. One of them has said, "There is not one detail, not a carved head nor the leaf of a capital in these majestic basilicas that does not represent a thought and speak a language that was understood by everyone."[72]

Exaggerations of the Symbolic School. Symbols are not to be found everywhere. Fauna and flora in thirteenth-century art. Gargoyles; monsters.

Abbé Auber was one of the first and most notable champions of this school. In 1847, at the scientific congress in Tours, he set forth his doctrine,[73] which he strove to apply in his *Histoire de la cathédrale de Poitiers*, and which he developed in his confused *Histoire du symbolisme*.[74] In this latter work, he upheld, among other paradoxes, that the carved brackets decorated with heads of men and animals to be found everywhere on medieval churches conceal the most profound of moral teachings. "These beasts are placed there," he said, "as so many sentinels to proclaim a lesson in virtue to the passersby."[75] In reality, Abbé Auber proved nothing; all that we find in his book is vague and arbitrary; the parallels between monuments and texts are forced.

Félicie d'Ayzac was more ingenious. In her *Mémoire sur trente-deux statues symboliques observées dans les parties hautes des tourelles de Saint-Denis*,[76] she makes skillful use of texts. The St.-Denis statues are hybrid monsters; she separates their parts: lion, goat, he-goat, horse; then, armed with the mystical dictionaries of St. Eucherius and of Rabanus Maurus, she discovers their moral meaning. Thus, each of these monsters is made to express a curious psychological case. They are various states of the soul, as many felicitous combinations of the passions as can live together in one consciousness.

Félicie d'Ayzac thought she had found a method and had created the science of symbolism. In truth, she demonstrated only one thing: our artists of old were never as subtle as their modern interpreters. Is it likely that they would have tried to say so much, and so subtly, by means of figures that can be seen from the ground only with good binoculars?

Madame d'Ayzac, who was nourished on the theological literature of the twelfth century which she knew thoroughly, searched all her life, on the authority of the theologians, for the most complicated symbols in the simplest works of art. She contributed countless ingenious and sterile articles to the *Revue de l'Art chrétien*,[77] and she died before she had completed the *Traité de symbolique* on which she had been working for many years.[78] This final work would no doubt have proved nothing of what she contended, but it would have given further proof of her ingenuity.

Father Cahier, who usually applied a most systematic mind to archeological studies, was unable, even he, to resist the temptation to explain the inexplicable. In a volume of his *Nouveaux mélanges d'archéologie* devoted to "mysterious curiosities," he tried to explain, with the aid of the bestiaries and theological texts, works that are nothing but the products of artists' fantasies.

The Comte de Bastard followed the same path in writing his *Etudes de symbolique chrétienne*.[79]

Thus, even the most learned and judicious archeologists did not escape

the mania for symbolism. What is to be said of those venturesome spirits who conceived of archeology as a work of the imagination?[80] By their articles and memoires, they helped to discredit this kind of study. Didron and Caumont made an exact science of archeology; these people made it a work of fiction.

Nevertheless, their point of departure was correct. They clearly saw that for the great minds of the Middle Ages the world was only a symbol. But they were mistaken to believe that the artists enclosed a symbolic conception of the world within their slightest work. No doubt they sometimes did so, following docilely the instruction they received, as the examples we have cited above prove. But for the most part, they were satisfied to be simple artists, that is to say, to reproduce reality for their own pleasure. Sometimes they lovingly imitated living forms, and sometimes they played with them, shaping and deforming them according to their fancy.

It is surprising that the famous passage from St. Bernard on the luxury of Cluniac churches did not make the overly subtle interpreters of medieval art stop to reflect.

St. Bernard himself had contemplated the animals and monsters decorating the capitals as he walked in the magnificent cloisters of the Cluniac order, and long before our time he had asked what they might mean. He said, "In the cloisters, before the very eyes of the brothers reading, what are those ridiculous monsters doing . . . ? What is the meaning of those disgusting monkeys, of those ferocious lions, or those monstrous centaurs? What are these half-beast half-human creatures or those spotted tigers doing here . . . ? You may see there one head with many bodies, or one body with many heads. Here is a quadruped with a serpent's head; there is a fish with an animal's head; there a creature is a horse in front, a goat in back. . . . For goodness' sake, if we are not ashamed of these absurdities, we should at least bemoan what they cost."[81]

What becomes of Madame d'Ayzac's subtle analyses? As we see, St. Bernard was less acute than our ingenious contemporary; he was unable to discover the subtlest nuances of passion in this mélange of hybrid forms. The great mystic, the interpreter of the Song of Songs, the sermon writer who spoke only through symbols admitted that he did not understand the fantastic creations of the artists of his own time. And not only does he call them incomprehensible. He says outright that they are dangerous, because they draw the soul away from itself, they prevent it "from meditating on the law of God." Such testimony settles the question. It is clear that the fauna and flora of the Middle Ages, whether real or fantastic, have for the most part only a decorative function.[82]

How could it have been otherwise? During St. Bernard's time, that is, at the height of the Romanesque period, the flowers and animals decorat-

ing the cloisters and churches were for the most part copies of originals from antiquity, from Byzantium, from the East, reproduced by artists who did not understand their meaning. In the beginning, the decorative art of the Middle Ages was imitative. The so-called symbols were often copied from a design in a Persian fabric or an Arabian rug.

The more we study the decorative art of the eleventh and twelfth centuries, the more it appears to be a composite art made up of borrowings. We begin to glimpse the many elements it is made of. For example, Romanesque capitals often show two lions placed symmetrically at each side of a tree or a flower. Shall we go with Abbé Auber to eleventh-century theological texts to find what this means? We would be wasting our time, for as Lenormant has proved, these two lions are copied from cloth made at Constantinople after old Persian models. They are the two animals who watch over the *hom*, the sacred tree of Iran.[83] Byzantine weavers no longer knew their meaning and saw in them only a well-composed commercial design. Our twelfth-century sculptors were imitating the figures from Byzantine tapestries brought into France by Venetian merchants, without having any notion that they might mean anything whatever.

Capitals are sometimes decorated with two confronting griffins who drink from one cup. Would there not be some eucharistic symbolism in this? Does not the griffin, a double being who participates in the natures of both the lion and the eagle, hide some mysterious allusion to Christ? No. The griffins drinking from the cup are simply a decorative motif transmitted from antiquity to the Middle Ages.

Elsewhere, the frame of a door or a decorative frieze is made up of birds, monsters, and men who pursue, attack, and devour each other. What truth did the artist claim to be revealing in this? Did he wish to say that struggle is the law of the world? Or that for him these monsters represented the army of vices that every man must combat until death? No doubt the sculptor of old was not so literary, but simply had before him, in a manuscript, one of the drawings that came from a miniaturist's imagination.[84] Charmed by the beauty of the lines, he copied the lively arabesque without attaching any meaning to it.

These are examples given to show how useless it is to interpret symbolically every animal and flower created in the Romanesque period. Let us acknowledge that St. Bernard was right, and try not to be more subtle than he. True symbolism occupies a great enough place in medieval art without our looking for it where it is not.

Some might object that St. Bernard was speaking only of the art of his own time, and that what is true of Romanesque art is not necessarily true of Gothic. For if the decorative art of the twelfth century is a composite art in which elements from everywhere were combined, the decorative

art of the thirteenth century is, on the contrary, a completely original art. Completely new flora and fauna appear in cathedrals. Unknown creations spring forth that cannot be connected with the past. We seem to be looking at another epoch in nature. Out of their own genius, and without models, the Gothic sculptors created this world. Why would they not have infused into each of their creations a thought and a symbol?

These are plausible arguments, but they will not hold up under examination. Whoever studies the decorative fauna and flora of the thirteenth century objectively will see there only the work of pure art. No idea lies behind this charming art except a tender and profound love of nature. When left to themselves, the medieval sculptors did not encumber themselves with symbols: they became one of the people again, and looked at the world with the wonderstruck eyes of a child.

We can imagine them creating the magnificent flora of the thirteenth century. In the first flowers of April they do not look for the mystery of the Fall and of Redemption. In the early spring they go to the woods of the Ile-de-France where lowly plants begin to push through the earth. Bracken, curled back on itself like a strong spring, still has its downy covering, but along the streams the arum lily is almost ready to bloom. They gather budding branches on which leaves will soon appear, and look at them with the tender and impassioned curiosity that we experience in early childhood and that true artists retain all their lives. The powerful lines of these young plants, which strain and aspire to being, seem to them full of grandeur, truly monumental, because of the concentrated energy expressed in them. From the bud about to open they make a fleuron to terminate a pinnacle. From the sprouts pushing through the earth they make designs to decorate the vase of a capital. The capitals of Notre-Dame Cathedral, especially the earliest, are made of these new spring leaves, leaves just broken from the bud and swollen with young sap, which in their thrust seem to try to lift up the abacus and the vaulting.[85]

In a splendid article in his *Dictionnaire*,[86] Viollet-le-Duc was the first to remark that early Gothic art (around 1180) showed a preference for the buds and unfolding leaves of early spring.[87] The impression of youth and restrained power which our earliest cathedrals give—Sens, Laon, the choir of Notre-Dame of Paris—comes partly from this. In the course of the thirteenth century, the buds burst, the leaves develop. At the end of the thirteenth century, and during the entire fourteenth, whole branches, abundant rose and grapevines trail around portals in a way that makes the stone flora of the Middle Ages seem subject to the laws of nature. The cathedrals have their spring and their summer, and when the melancholy thistle appears in the fifteenth century, their autumn.

Throughout these three centuries, we can uncover not one symbolic

intention.[88] The leaves and the flowers were chosen for their beauty. Twelfth-century art loved the buds, thirteenth-century art preferred the leaves. They are simplified leaves, but they are not deformed; their inner structure and general habits of growth were respected (figs. 27, 28). We can easily recognize most of them. Scholars who were both archeologists and botanists have pointed out plantain, arum, ranunculus, bracken, clover, celandine, hepatica, columbine, watercress, parsley, strawberry, ivy, the flowers of the snapdragon and broom, the leaves of the oak.[89] A completely French flora, as we see, the flowers beloved since childhood. Our great sculptors scorned nothing; at the foundation of their art, as of all great art, we find sympathy and love. They thought that the plants of the woods and meadows of Champagne and the Ile-de-France were noble enough to decorate the house of God. The Ste.-Chapelle is full of ranunculi.[90] The broom of the Berry heaths appears on the capitals of Bourges Cathedral. The plantain, watercress, and celandine garland Notre-Dame of Paris.[91] The thirteenth-century sculptors also sang their "May Song." Through them, all the springtime joys of the Middle Ages—the intoxication of Palm Sunday, the hats made of flowers, the bouquets fastened to doors, the fresh boughs strewn in the chapels, the magical flowers cut on midsummer morning—all the ephemeral grace of ancient springtimes and summers will live forever. Thus, the Middle Ages which has been accused of not liking nature, contemplated with adoration the least blade of grass. Who will ever know all the reasons why thirteenth-century artists chose certain flowers? One charmed them with its beauty and proud

27. Watercress branch. Paris, Cathedral of Notre-Dame. West façade, left portal, archivolt (detail).

28. Fantastic animals. Paris, Cathedral of Notre-Dame. West façade, left portal, archivolt (detail).

form, another recalled the happy days of carefree youth, and another was the native flower of a countryside, the emblem of a whole province. At Semur and Auxerre, the Burgundians carved climbing grapevines around their portals. Each put a bit of his own heart into his work. I am also willing to believe that more than one flower flourishing on a capital was carved there because of pagan superstition. Is it by chance that the arum (*le gouet*) displays its large leaves in so many churches? Dr. Woillez was the first to suspect that this flower, so dear to the earliest Gothic sculptors, had been chosen for its mysterious properties.[92] Even today it is an emblem of fecundity for the peasants of the Oise valley; formerly it was used for incantations and sorcery. We must resign ourselves to ignorance of the strange associations of ideas that took place in the heads of the people. Time has left few clues to them. Let us be content to say that the learned symbolism of the theologians counted for nothing in the choice of flora during the Middle Ages. Artists, who were carefully supervised when they were expressing the religious thought of their time, were left free to decorate the cathedral in their own way with innocent flowers. A happy freedom; their naïve love of nature touches us more deeply than the no doubt noble but sterile symbolism of the clergy.

These simple artists carved animals as they carved flowers, with no other thought than to express one of the aspects of the world. Aside from the examples cited above, in which the influence of Honorius of Autun and the bestiaries is beyond question, we can say that the animals of Gothic churches had no more symbolic value than those of Romanesque churches.

In the cathedral of Lyon, small panels covering the plinth of the portal have a large number of animals of the fields and woods. Two hens scratch themselves, one foot deep in the feathers;[93] a squirrel leaps among the branches of a tree from which hazel nuts hang;[94] farther along, a crow perches on a dead rabbit;[95] a crane brings up an eel in its beak;[96] a snail crawls along a leaf;[97] the head of a pig appears among oak branches.[98] All of these animals had been observed attentively, and caught in their most typical gesture. In our medieval artists we recognize observers of great subtlety and amiability, closely related to the trouvères who created with such sure strokes the silhouettes of Renart and Isengrin. They are animal carvers in the manner of La Fontaine.

The *Album* of Villard de Honnecourt proves that they loved to observe animals and took pleasure in drawing them from nature. We know that through luck the notebook was preserved in which an architect of the thirteenth century—a famous one, for he was called to places as far away as Hungary—noted down everything remarkable that had crossed his path.[99] The excellent soul of the old master is revealed in the very first lines. "Villard de Honnecourt," he said in his rude Picard dialect

29. Two parrots. *Album* of Villard d'Honnecourt, Paris, Bibl. Nat., ms. fr. 19093, fol. 26r (detail).

that must be translated, "greets you and begs all who will use the devices found in this book to pray for his soul and remember him." This busy man, who built the collegiate church of St.-Quentin, who traveled over all of France and Switzerland, and in his *Album* sketched the towers of Laon, the windows of Reims, the labyrinth of Chartres, the rose window of Lausanne, and went to the very ends of the Christian world to build churches, found time to study the spirals of a snail's shell.[100] On another page he draws from nature a bear and a beautiful swan whose neck curves gracefully.[101] Elsewhere, he carefully studies a grasshopper, a cat, a fly, a dragonfly, and a crayfish.[102] Permitted by some great lord to visit his menagerie one day, he took the occasion to *contrefaire*, as he says, a chained lion and two parrots on their perch (fig. 29). He wanted us to know that the lion was drawn from life: "Et bien saciés que cil lion fut contrefais al vif."[103]

The habit of observation is to be found among all our great anonymous sculptors of the thirteenth century. They carved an entire world of birds and animals for the pleasure of reproducing living nature.

Perhaps they sometimes wished to glorify some of their good companions. At Laon, almost at the summit of the towers, sixteen great oxen display their colossal silhouettes. Tradition has it that these formidable statues were intended to eternalize the memory of the tireless beasts who,

throughout so many years, transported the stones for the cathedral from the plain to the top of the acropolis of Laon. A legend told by Guibert of Nogent seems to fortify the local tradition.[104] He tells us that one day an ox, who was dragging a cart full of material destined for the church up the slope of the hill, fell down exhausted in the road. The driver could not continue on his way until another ox appeared suddenly and took the place of the fallen beast. In this way, the cart could go on to the top. Once this task was accomplished, the mysterious ox vanished. Such a legend shows that the people had great feeling for those valiant creatures who had worked like good Christians for the house of God. After watching them toil for so long a time, they wanted to honor them.

The oxen of Laon are an exception. Everywhere else, the artists carved animals in profusion with no other thought than to make the cathedral more alive. They felt deeply that the immense church was the epitome of the world. They would have liked to put into it everything that breathes. At Notre-Dame of Paris,[105] two reliefs testify to the desire to include the entire universe. One represents the earth in the figure of a fertile mother whose open robe reveals inexhaustible breasts. A young woman, kneeling before her, comes to her breast to drink of life. Another relief symbolizes the sea. A kind of divinity from antiquity, now much mutilated, rides an enormous fish and controls it with bridle and bit. The spirit of the sea carries a ship in her hand (fig. 30).

30. The sea. Paris, Cathedral of Notre-Dame. West façade, portal of the Virgin, socle (detail).

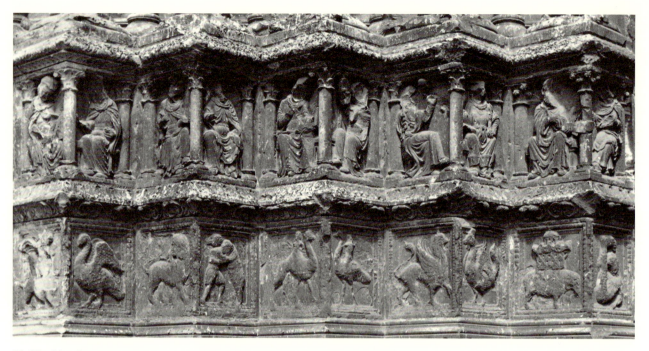

31. The liberal arts; animal series. Sens (Yonne), Cathedral of St.-Etienne. West façade, central portal, left side, socle.

The same idea sometimes took different form. At Sens, the sculptor expressed in another way the immensity of lands and seas (fig. 31). In the socle reliefs of the façade, he sculpted the elephant of India with a castle on its back, the griffin, ancient guardian of the treasures of Asia, the ostrich and the camel ridden by African horsemen. A siren symbolizes the mystery of the ocean.[106] A naked man lying on his back, the legendary sciapod, raises his single foot as a sort of parasol to protect himself from the sun: he alone expresses all of the unknown East where no traveler had set foot since Alexander.[107] Here we recognize the various chapters of a universal geography as it was then conceived. Honorius of Autun, in his *Imago mundi*,[108] Gervase of Tilbury in his *Otia imperialia*,[109] and Vincent of Beauvais in his *Speculum naturale*,[110] to cite only known names, also mentioned monsters when they described the countries of the East. They collected all the fables scattered throughout Pliny, Solinus, in the *De monstriis*, and in the apocryphal *Epistola Alexandri ad Aristotelum*.[111] There can be no doubt that the Sens portal is a kind of geography of the world, illustrated in the manner of an old portolano. The Catalan atlas of 1375, one of the earliest documents of this kind to come down to us, has elephants, camels, sirens, and the kings Gog and Magog drawn alongside the rivers and seas.[112]

I believe that the famous portal of Vézelay, which represents all of the peoples of the world grouped around Christ as he bestowed the Holy Spirit upon the apostles, should also be interpreted as a map of the world. The men with dog's heads, the men with ears as large as winnowing fans (*vannosas aures*),[113] recall that Jesus came to bring the Gospel to all human races and that the Church must carry his word to the ends of the earth.[114]

Thus, the work of our medieval artists betrays a desire to express all of life. But to attempt to explain this work simply by means of the bestiaries would be to belittle it, to reduce it to the meanest proportions.

True, the unnamed creatures perched like a colony of fantastic birds on the buttresses and tops of towers still remain to be accounted for. What do they mean, those long-necked gargoyles who howl in the heights? Were they not held back by their heavy stone wings, they would take off and fly, making terrifying silhouettes against the sky. No time and no people have ever conceived more terrible specters; they are part wolf, part caterpillar, part bat. They are realistic in a way that makes them even more frightening. In the garden behind Notre-Dame of Paris we may still see a few of them, abandoned to the ravages of time. They resemble unevolved monsters of the tertiary age, crumbling bit by bit and preparing to disappear.

What is the meaning of this world of monsters that has been created side by side with the real world? What do they signify—the prodigious heads that emerge from the façade of Notre-Dame of Reims, and those funereal birds veiled by shrouds?[115] As we have seen, Félicie d'Ayzac's interpretations must be cast aside. No symbolism can explain these monstrous creatures of the cathedrals. The bestiaries are silent. Such creations came from the imaginations of the people. These gargoyles, resembling the vampires of cemeteries and the dragons vanquished by ancient bishops, survived in the depths of people's consciousness; they came from ancient fireside tales. They are souvenirs of distant ancestors, the last image of a lost world: here the somber and powerful genius of the Middle Ages bursts into full expression.[116]

But all the monsters created by the thirteenth century are not so terrifying. Most of them bear the mark of joyous fantasy and good spirits. There are innumerable amusing little reliefs of this kind carved in quatrefoils on the Portail des Libraires and the Portail de la Calende of the cathedral of Rouen (figs. 32, 33, and 34). There are so many analogies between these and the figures of Lyon Cathedral that they seem to be the work of the same colony of wandering artists.[117] The monsters swarm everywhere, but they are ingenious and witty monsters. We surmise that the sculptors were young and full of life, competing with and trying to outdo each other. A centaur wearing the cowl and

32. Grotesques. Rouen (Seine-Maritime), Cathedral. North transept, Portail des Libraires (left side).

33. Grotesques. Rouen (Seine-Maritime), Cathedral. North transept, Portail des Libraires (left side).

beard of a prophet rears and reveals horse's feet in front and human feet in boots behind.[118] The physician, wearing the doctor's cap and, like Gérard Dou's physician, gravely examining a phial of urine, is a physician only to his waist: he suddenly terminates in a goose. A philosopher with the head of a pig rests his chin in his hand and meditates. A young music master, half man and half cock, gives an organ lesson to a centaur. A woman with a calf's head half opens her dress. A man, changed into a dog by the spell of a witch, wears a pair of boots on his feet, as if in memory of his former condition. A bird-woman throws off her veil and raises a mysterious finger.

If work was ever free of thought, these surely are. When left to themselves, our thirteenth-century artists were like the artists of all times. Nothing seemed worthier of their effort than the invention of new combinations of lines. At Rouen and Lyon, their problem was simply to inscribe harmoniously one form or another within a quatrefoil. From this came the wealth of hybrid monsters whose supple limbs could be

34. Grotesques. Rouen (Seine-Maritime), Cathedral. North transept, Portail des Libraires (left side).

bent in any direction to fill all parts of the space. It is clear that they were trying to resolve a purely artistic problem. Thus, there is no point in asking ourselves what meaning the Rouen figures may have, and whether they symbolize vices or virtues.[119] Champfleury, in his *Histoire de la caricature*, and after him, Jules Adeline, were well aware that symbolism had nothing to do with these workshop caricatures.[120] Any attempt at explanation is doomed from the start.

The objection that the clergy would certainly not have allowed such subjects to be carved on the very doors of their cathedrals unless they contained some profound meaning only shows lack of familiarity with the medieval spirit. Whoever has looked through a number of thirteenth-century liturgical manuscripts knows that often the high spirits of the illuminator were expressed by extremely secular images in the margins of the most solemn of offices. In a thirteenth-century missal, now in the Bibliothèque Sainte-Geneviève, thousands of grotesques are mingled with the sacred text.[121] The initial letters harbor dragons with bishops'

heads; the stem of a letter is prolonged into a mouse, a bird, or a devil sticking out his tongue. No one would have been shocked to see such a book open on the lectern. And there are many examples of this kind. In the Bibliothèque Nationale there are prayer books decorated on every page with small figures that are neither more serious nor more instructive than those on the portals of Lyon or Rouen. A thirteenth-century Psalter is enlivened with two-headed monsters that would have delighted Callot.[122] In one book, a monk plays at backgammon with a monkey; in another, a child chases a butterfly, cocks fight, an astonishing figure emerges from a snail shell. Of this genre, the masterpiece is perhaps a Book of Hours from the late thirteenth century[123] (figs. 35, 36, 37 and 38). Inexhaustible fantasy and great sureness of line make a very unusual book of this manuscript. Some of the silhouettes seem to have come from the deft brush of a Japanese artist. Human and animal nature mingle ingeniously. Gaiety erupts everywhere: a musician makes music by scraping together the jawbones of an ass; a monkey disguised as a monk walks on stilts, or with the gravity of a physician, studies a phial of urine.

But why give more examples?[124] It is obvious that such figures have nothing to do with the Hours of the Virgin or the Psalms of Penance they illustrate. They have no more meaning than the reliefs of the Rouen portal, which they resemble so closely. The clergy tolerated them in the cathedral just as they tolerated them in their choir books. Medieval Christianity had accepted human nature in its entirety. Laughter and flights of exuberant imagination were never condemned: the Feast of Fools and the Feast of the Ass prove it. When the good canons of Rouen and Lyon saw what figures their sculptors had imagined to decorate the portal on which the Lord and his saints were shown in all their glory, they were no doubt the first to smile. Deep faith gave to these times the gaiety and serenity of childhood. Let us not forget that Dante reserved a circle of hell "for those who wept when they should have been joyous."[125]

35. Marginal drollery. Book of Hours. Paris, Bibl. Nat., ms. latin 14284, fol. 5r (detail).

36. Marginal drollery. Book of Hours. Paris, Bibl. Nat., ms. latin 14284, fol. 10r (detail).

Indecency and irony had no part in the artists' fun. The monstrous obscenities that have been pointed out in our cathedrals existed only in the minds of certain biased archeologists. Thirteenth-century art is extremely chaste, astonishingly pure. The artist who was commissioned to tell of the origins of the world on the cathedral of Lyon left a blank panel when he came to the story of Lot's daughters.

It was only in the fifteenth century that a somewhat low realism, which on occasion did not stop at obscenity, appeared in art. Careful distinction must be made between epochs.[126]

Neither is there any trace of irony in matters relating to worship. Mention is always made of the famous capital of the cathedral of Strasbourg, on which was carved the burlesque burial of a hedgehog, carried to his grave by other animals while a stag says the Mass and an ass chants at the lectern. But this relief has disappeared and we know it only through a drawing published at the beginning of the seventeenth century by the Protestant Johann Fischart, who, in his search for the forerunners of the Reformation, believed this to be a satire of the Mass.[127] We know neither what century it came from, nor if it really existed as Fischart's mediocre reproduction shows it. Even granting that his copy was exact, it is hardly necessary to see more in it than a fantasy of the kind found in *Le Roman de Renart*.

37. Marginal drollery. Book of Hours. Paris, Bibl. Nat., ms. latin 14284, fol. 10r (detail).

38. Marginal drollery. Book of Hours. Paris, Bibl. Nat., ms. latin 14284, fol. 10r (detail).

Let us summarize this chapter briefly.

For the theologians of the Middle Ages, nature was a symbol, and living beings were expressions of God's thoughts. Theologians sometimes imposed their conception of the world on the artists, who, under their supervision, made a few dogmatic works in which each animal had symbolic meaning. But such works are rare. For the most part, the sculptors filled the churches with plants and animals of their own liking. They chose these forms as pure artists, but with the vague notion that a cathedral is an epitome of the world and all God's creatures may enter.[128]

Book Two

SPECULUM DOCTRINALE: THE
MIRROR OF LEARNING

The world has been created. God's work is finished and perfect; but man, by misusing his freedom, has disturbed its harmony. His sin has made him the most miserable of creatures. Adam and Eve, an abject pair shivering in the rain and fog high up on the façade of Notre-Dame of Paris —this is what mankind has come to.[1]

How can fallen humanity redeem itself? Through the sacrifice of the Saviour and through grace: this the Church cries out to us in every one of its statues. But it also teaches that man must merit grace and must himself labor at the work of redemption. In the preface to his *Speculum doctrinale*, Vincent of Beauvais makes this forceful pronouncement: *Ipsa restitutio sive restauratio per doctrinam efficitur*. "Man may redeem himself through learning."[2] And by what follows, he shows that learning includes work of all kinds, even the humblest. Thus, the Middle Ages was not solely an age of contemplation, it was also an age of work—work heroically conceived and accepted as liberation, not servitude. Vincent of Beauvais says in substance that manual work liberates us from the necessities to which our bodies have been subjected since the Fall; learning liberates us from the ignorance that has weighed upon our spirits since man first sinned.[3] Now it so happens that the cathedral, where all the thoughts of the Middle Ages were given visible form, glorified both manual work and learning.

In the medieval church, where kings, barons, and bishops occupy so modest a place,[4] almost all the trades are represented. At Chartres and at Bourges, in the lower parts of windows donated by the trade guilds, the donors had themselves shown with their trowel, hammer, teasel, baker's peel, butcher's knife (fig. 39).[5] No one at the time thought it inappropriate to place these scenes from daily life beside heroic scenes from saints' legends. Work had its own dignity and sanctity. We find this desire to glorify work particularly in evidence at Notre-Dame of Semur. In one of the chapels of the aisles, a window given by the confraternity of drapers represents in a series of scenes all the details of cloth making.[6] This is the sole subject of the window; no saint and no religious scene is shown. Is this a sign of bumptiousness or of simplicity? Neither one. Such a subject had its own justification. If work is a divine law and one of the ways leading to redemption, why should it need a mediator when introduced into God's house? Why can it not be shown by itself in all its nobility? That is what the drapers of Semur thought when they paid homage to Our Lady by showing the simple image of one of their workdays.

But it was the work of tilling the soil, imposed on Adam by God Himself, that the Church seemed to place above all others. Several cathe-

Labor and learning have their role in the work of redemption. Manual labor. Representation of the labors of the months; illustrated calendars.

39. The furriers. Chartres (Eure-et-Loir), Cathedral of Notre-Dame. Ambulatory, stained glass panel.

40. Summer. Paris, Cathedral of Notre-Dame. West façade, left portal, trumeau (detail).

drals have the cycle of a peasant's work carved on the archivolts or the jambs of their portals (fig. 40).[7] Each scene of harvesting, tilling, or grape gathering is accompanied by a sign of the zodiac. These are truly the Works and the Days (*les Travaux et les Jours*).

The practice of decorating churches with stone calendars had been common since the beginnings of Christianity. We know that the paving of early basilicas was sometimes decorated with the symbolic image of the seasons. The mosaics of the church at Tyre, brought back to the Louvre by the Renan mission, represent hunting and vintage scenes, accompanied by symbols of the months.[8] This work belongs to antiquity and seems to have come from a room of a Roman bath or from a villa.

The Church had no scruples against borrowing these consecrated images from the pagan world, but it sanctified them by giving them a Christian interpretation. Consequently, the months of the year recalled not only a cycle of work, but a cycle of prayers and liturgical feasts.

Our ancient Romanesque churches, where the paving is so often decorated with the signs of the zodiac, prove that the traditions of the early Christian centuries were faithfully preserved.[9]

Thus, the great calendars carved on the portals of Gothic churches have a long history. The thirteenth-century Christian who paused on the threshold to look at them found many subjects there for meditation,

according to the degree of his culture. The laboring man saw the immutable circle of labors to which he was condemned until death; but the statue of Jesus or the Virgin soaring above the things of this world reminded him that he did not work without hope.[10] The man of the church, instructed in the liturgy and in computation, might muse that each of these months corresponded to a moment in the terrestrial life of Christ or of the great saints, that each month was marked not by humble work but by a series of heroic acts. To him, the year would be like a crown of virtues. And the mystic might think of the flood of days that issue from God and return to be lost in him. He told himself that time is the shadow of eternity.[11] He reflected that the year, with its four seasons and its twelve months is a symbol of Christ, whose members are the four evangelists and the twelve apostles.[12]

The most beautiful carved calendars are at Chartres, Paris, Amiens, and Reims.[13] They are works of true poetry. In these small scenes, man appears in eternal attitudes. The artist probably intended to represent the peasant of France, but it is also a man of all times, bent toward the earth, the immortal Adam. In their universality, these thirteenth-century reliefs avoid banality. The artists, who themselves did not live far from nature, had experienced this life in all its detail, for just beyond the walls of small medieval towns lay the real country with its tilled fields, its meadows, the beautiful rhythm of its Virgilian labors. The two towers of Chartres rise above the wheatfields of the Beauce, and the cathedral of Reims dominates the vineyards of Champagne. From the apse of Notre-Dame of Paris meadows and woods could be seen. When sculptors were imagining scenes of rustic life, they had only to look around them for models.

This beautiful poem of the months, these Georgics of old France, so filled with kindliness and grandeur, are worth analysis.

It is hard to believe that the obvious meaning of these scenes escaped early nineteenth-century archeologists. In 1806, Lenoir interpreted the twelve scenes illustrating the calendar of the cathedral of Cambrai as the twelve labors of Hercules.[14] Dupuis, author of *L'Origine de tous les cultes*, did identify the signs of the zodiac on the façade of Notre-Dame of Paris, but from this he concluded that the cult of the sun or of Mithra had survived into the thirteenth century.[15]

The zodiac and the accompanying rustic scenes at Chartres[16] and Paris[17] are placed in such a way as to recall the movement of the sun itself. That is to say, the signs of the months rise with the sun from January to June, and descend with it from June to December.

It is to be noted that all these calendars do not begin with the same sign. At St.-Savin, in Poitou, the sign of the Ram (March) is the first sign of the zodiac.[18] On the façade of Amiens, the year begins with the

41. December, January, February. Amiens (Somme), Cathedral. West façade, left portal, socle reliefs.

month of December and the sign of Capricorn (fig. 41). At Chartres, on two portals, the year begins with the month of January, accompanied strangely enough by the sign of Capricorn instead of Aquarius.

This is not due, as has been thought, to the carelessness of the workmen whose job it was to put into place the pieces that had been carved in the workshop. In the Middle Ages, the date at which the year began varied from region to region. Gervase of Canterbury, at the beginning of the thirteenth century, wrote: *Quidam enim annos incipiunt computare ab Annuntiatione, alii a Nativitate, quidam a Circumcisione, quidam vero a Passione* (For certain people count the years beginning with the Annunciation, others with the Nativity, others with the Circumcision, and some with the Passion). Thus, the year sometimes began in March or April (Annunciation, Passion), sometimes on 25 December (Nativity), sometimes on the first of January (Circumcision). Even in two towns as near as Reims and Soissons, the year began at Reims on the Day of the Annunciation (25 March), and at Soissons on Christmas Day.[19] This explains why at St.-Savin the zodiac begins with the sign of the Ram, that is, with the month of March.[20] It is likely, therefore, that at Amiens the intention in beginning the calendar with the month of December was to indicate that the year began there at Christmas.[21] As for the unusual concordance of the month of January and the sign of Capricorn that we noted at Chartres, it also can be explained. The fact is that in the Middle Ages the signs of the zodiac did not correspond exactly with the length of the months but impinged upon the month following. For the month of January, we find proof of this in a verse by the

monk Wandalbert, who in the ninth century wrote a poem of the
Months:

Huic gemino praesunt Capricorni sidera monstro.[22]

(The sign of Capricorn reigns over the monster with two heads
[Janus]—or the sign of Capricorn reigns over the month of
January.)

Nevertheless, it must be admitted that these irregularities are rare. Al-
most all the painted or carved zodiacs begin the year with January, and
the signs, by beginning with Aquarius, correspond exactly with each
month. I know of no exceptions to this rule in illuminated manuscripts,
and they are very rare in cathedral reliefs. Didron was mistaken when he
wrote that on the portal of Notre-Dame of Paris the year begins with
the month of December. Janus and the sign of Aquarius begin the year.[23]

Even at Reims, where, as we have said, the first month of the year was
March,[24] the calendar of the cathedral begins with the month of January.
Thus, long before the edict of Charles IX (1564) fixed the first of Jan-
uary as the beginning of the year throughout France, the Church had
already accepted that date. This explains why Gervase of Canterbury, at
the beginning of the thirteenth century, after citing several local excep-
tions, could write: "The solar year, following the custom of the Romans
and of the Church of God, begins with the Calends of January (the first
of January) and ends after the Nativity of the Lord, that is, at the end of
December."[25]

Let us now examine the reliefs devoted to the labors of each month.
Here we find almost no trace of literary influence. We are in the presence
of an ancient artistic tradition perpetuated throughout the centuries, but
which artists continually refreshed by their observation of the nature
around them. In this way, they infused new life into the old formulas.
We come upon variations that are sometimes interesting in themselves;
manuscripts with miniatures furnish several examples. Thirteenth-cen-
tury prayer books decorated with illustrated calendars are fairly numer-
ous. Even if a study of them teaches us nothing new, at least we see how
strong the tradition was.

For the medieval peasant, January was the month of festivals and of
rest. From Christmas until Epiphany, there was more than one occasion
for banqueting. Pagan instinct, always alive, reasserted itself in favor of
the free enjoyment of the Christmas festivals. Certain old calendars illus-
trate the first days of January with two drinking horns.[26] In the thir-
teenth century, sculptors showed a man seated in kingly majesty before a
well-laden table. Sometimes this figure has two heads, and often, one is
the head of a young man, the other of an aged man (fig. 41).[27] There is
no doubt that this is the two-faced Janus of antiquity, the memory of

which had been perpetuated by the schools. The symbolism of these two faces was well liked: one face looked toward the past, the other toward the future; one belonged to the old year, the other to the new.[28] Sometimes, for greater clarity, Janus was even represented closing a door behind which an aged man vanished, and opening another to a young man.[29] And then, reflecting that Janus with his two faces symbolizes only two moments of time, the past and the future, the artists imagined a third face to symbolize the present—a clumsy invention that had no great success, since we can find no more than two or three examples of it.[30] Thus, Janus in person, seated at the family table, joyously opened the new year.

The work of the fields was not yet begun in February. In Italy, the sun was already shining and the peasant began to prune the grapevines, as can be seen in an Italian manuscript of the Bibliothèque Nationale.[31] But in northern France—the Ile-de-France, Picardy, and Champagne, the France of cathedrals—February is a harsh winter month. The peasant stays at home when he is not obliged to go out, and warms himself beside a roaring wood fire (figs. 42, 43). At Paris and Amiens, these small interior scenes are charmingly intimate (fig. 41). The poor peasant would seem to have walked a long way in the snow, against a bitter wind. He has scarcely sat down, and without even taking off his coat, he pulls off his shoes to warm himself in comfort. We feel that the house is secure against the winter winds. A gentle warmth and security reign there; a ham hangs from the ceiling, and links of sausage still hang from the sideboard.

42. February; Pisces, man warming his feet. Psalter, northern France. Paris, Bibl. Nat., ms. latin 238, fol. lv (detail).

When March comes he can no longer stay by the fire. At Paris, the Ram of the Notre-Dame zodiac is surrounded by the first flowers of spring.[32] The peasant goes to his vineyard. At Chartres, Semur, and Rampillon (fig. 43), he prunes; elsewhere, he cultivates the vines, even at Amiens (fig. 44) which today is outside the wine-growing district, but which had vineyards in the Middle Ages, as the names still attached to several properties prove. Since the wind is cold and the sky changeable, the vine grower keeps on his coat and winter hood, as at Chartres.[33]

For medieval man, April was the most beautiful month of the year; he preferred it to May. A manuscript shows April as a king on his throne, a budding branch in one hand, a scepter in the other.[34] April is the month of which the trouveres sang. Our poets of old seem to have responded to the charm of nature only in springtime, just as later seventeenth-century painters admired only autumnal splendor. The first touch of spring, the clear sun of Eastertime, the flowering orchards beneath the threat of a changeable sky, brought more joy to the thirteenth-century peasant's heart than the most beautiful days of summer. The month of April, so charmingly indecisive in its changing humors, was thought of as an adolescent crowned with flowers, and was thus represented by our thirteenth-century sculptors. At Chartres, which stands at the threshold of La Beauce, April carries spikes of wheat to recall that this is the time of year when it forms. The same emblem is found on the portal of Notre-Dame of Paris. It would seem that during this gentle month the peasants of the Beauce and the Ile-de-France were content to watch their wheat grow.

43. February, March, April, May. Rampillon (Seine-et-Marne), Church of St.-Eliphe. West façade, portal, socle reliefs.

44. March, April, May. Amiens (Somme),
Cathedral. West façade, left portal, socle
reliefs.

45. May. Paris, Cathedral of Notre-Dame.
West façade, left portal, jamb (detail).

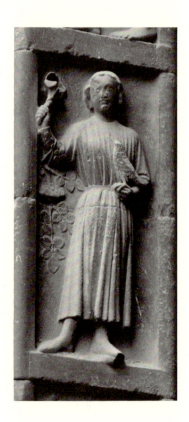

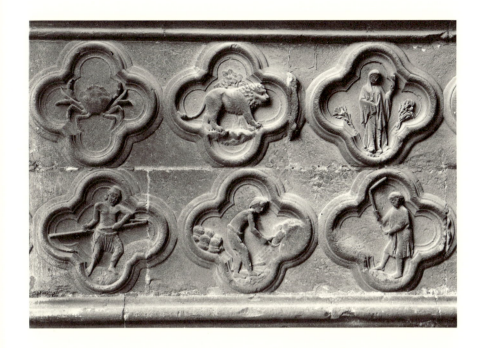

46. June, July, August. Amiens (Somme), Cathedral. West façade, left portal, socle reliefs.

But the vine grower of Champagne does not rest: grapevines are more demanding than wheat; they must be spaded in March, and pruned in April.[35]

May comes in wearing knightly garb. May is the month of gentlemen. With the coming of fine weather, the baron again takes up his horseback rides and his hunting. In painted or carved calendars, we see him sometimes on foot, sometimes on horseback.[36] Occasionally, as in the Chartres window, he carries a lance, but usually he carries a peaceful branch or a flower. Sometimes his falcon sits on his wrist (fig. 45).[37] What is the peasant doing meanwhile? He also is enjoying the season and the last repose before the long hard work of summer; at Amiens, he rests in the shade (fig. 44).

In June, he mows the meadows. At Chartres,[38] the work is not yet begun. No doubt it is St. Barnabas' day, the traditional day to begin. The reaper sets out for the fields, a round hat on his head, his scythe on his shoulder, a whetstone at his side. At Amiens, the reaper is in action; he swings his scythe at the thickest of the hay (fig. 46). At Paris, the hay is already dry; the peasant carries it to the barn, bent under the load. Manuscripts contain insignificant variants. The Italian manuscript already cited,[39] which was no doubt illuminated by an artist from the warm region of the Campania, shows the harvest beginning in June. The motif so frequently used in the fifteenth and sixteenth centuries—sheep-shearing—began to appear in thirteenth-century illuminated manuscripts.[40]

In July comes the harvest. At Chartres, as almost everywhere, the peasant reaps the wheat with a scythe. But on the portal of Notre-Dame of

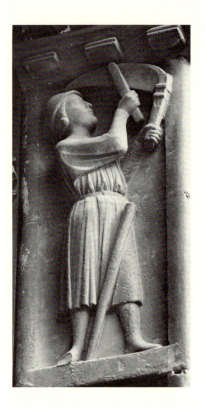

47. July. Paris, Cathedral of Notre-Dame.
West façade, left portal, jamb (detail).

Paris, the reaper, with a completely realistic gesture, whets the great scythe (fig. 47).[41]

In August, the harvest is not yet over: it continues on the north portal of Chartres, at Paris, and at Reims. But elsewhere, at Senlis, Semur, and Amiens (fig. 46), the peasant has begun to thresh the wheat. It is hard work; he is stripped to the waist[42] and works alone, with no companion to complement the rhythm of his flail.

September. The peasant has scarcely had time to catch his breath before the vintage comes. In the France of old, which seems to have had a warmer climate than now,[43] grapes were gathered everywhere at the end of September, and the vintner danced joyously as he pressed the grapes in the vats. Champagne was the sole exception. At the cathedral of Reims, wheat is still being threshed in September, and it is not until October that the vat and barrel appear. At Amiens, fruit is gathered (fig. 48).

In our provinces famous for grapes, October sees the end of work in the vineyard. In Burgundy (Semur) and in Champagne (Reims), the wine which has fermented in the vat is racked into barrels. Elsewhere, at Paris and Chartres, this is the time for sowing. The peasant, who has again put on his winter coat,[44] seems to walk heavily under the already cold sky of October. His apron is filled with the seed which he broadcasts with a wide swing of the arm. The beauty of this *geste auguste* was perfectly captured by the artists of the thirteenth century (fig. 49).[45]

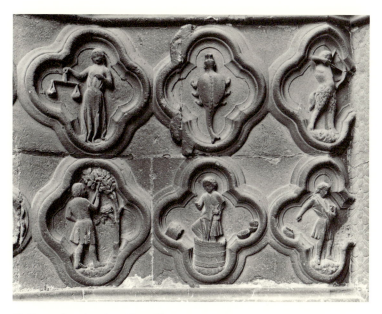

48. September, October, November. Amiens (Somme), Cathedral. West façade, left portal, socle reliefs.

49. October. Paris, Cathedral of Notre-Dame. West façade, left portal, jamb (detail).

In November, preparations must be made for winter (fig. 50). At Reims, the peasant brings in wood. At Paris and Chartres, we see the swineherd with his pigs at the edge of the forest. These are the oak forests, the great Druid forests of Gaul, still vast in the thirteenth century. The autumn winds have knocked down the acorns, and the pigs are fattened on them for the feasts of December. In more than one region, even at Chartres and Semur,[46] pork was killed and salted in November. But at Paris, Reims, and Senlis this was done in the following month. At Amiens, where the calendar is somewhat retarded, the peasant is sowing (fig. 48).

The end of December, like the first of January, was a time for merrymaking and for rest. It would seem that the sole preoccupation was the preparation of the joyous feasts of the Christmas season. Reliefs and manuscripts show peasants killing pigs, slaughtering beef,[47] and baking cakes.[48] Like January, December is sometimes represented by the figure of a merry fellow seated before a ham, with glass and knife in hand.[49] The year begins and ends joyfully.[50]

All of these scenes are simple, serious, and close to man's daily life. There is none of the insipid grace of antique frescoes, no cupids gathering grapes, no winged putti participating in the harvest. Nor are there the charming Florentine goddesses of Botticelli, who dance at the festival of Primavera. Here, man is alone in his struggle with nature. These works are so full of life that even after five centuries they retain all of their moving power.

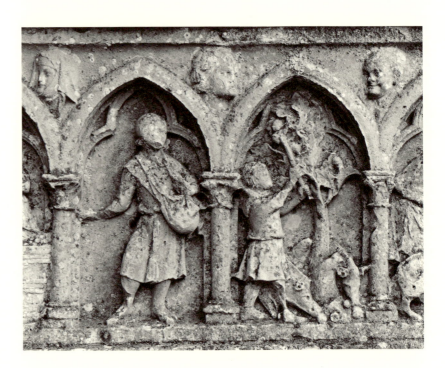

50. October, November. Rampillon (Seine-et-Marne), Church of St.-Eliphe. West façade, portal, right socle.

From manual labor, man rises to knowledge. By dispelling error, learning partially raises us from our original Fall. The seven arts open seven ways (trivium and quadrivium) to human activity. In grammar, rhetoric, and dialectic, on the one hand, and in arithmetic, geometry, astronomy, and music, on the other, are contained almost all the knowledge, outside of revelation, that man can acquire.[51]

Above the seven arts rises Philosophy, who is their mother. Philosophy and the seven arts are the supreme achievement of human intelligence: beyond them begins God's work.

Thirteenth-century artists, eager to embrace the whole domain of human activity, carved these eight medieval muses on the façades of the cathedrals. They are usually represented as grave young women, majestic as queens. At first glance, we see that they are not a part of human life, but reign above the world, like the Ideas of which Goethe wrote. The attributes they hold were no doubt meaningful to the people of the time, but they are not clear to us and must be explained. That can easily be done if we go back to the origins of these personifications of the branches of learning.

The division of learning into the trivium and the quadrivium had been made during antiquity. But it was only at the end of antiquity, when the barbarians threatened to destroy the last remnants of civilization, that several cultivated men did their utmost to save learning by reducing its bulk to the smallest possible volume. St. Augustine was no doubt the first who thought of writing a manual of the seven arts; but his encyclopedia, of which only a fragment remains, was never completed.[52] Boethius wrote several chapters of the quadrivium: his *De institutione arithmetica*, in two books, his *De musica*, in five books, and his *Ars geometrica*[53] transmitted a few poor fragments of Greek learning to the Middle Ages. About the same time, Cassiodorus in his *De artibus ac disciplinis liberalium litterarum* provided a complete manual of the seven arts.[54] With Cassiodorus, the meaning of the body of thought transmitted from antiquity was completely obscured. His book was intended for the monks of Vivarium, and he did his utmost to convince them that the seven arts were indispensable to the meaning of the Scriptures. For, he said, Moses possessed the knowledge of the seven arts in all their plenitude, and the pagans had merely stolen a few scraps of his learning.

Early in the Middle Ages, Isidore of Seville's *Etymologiae* definitively consecrated the division of the branches of learning into the trivium and the quadrivium.[55]

Learning: the trivium and the quadrivium. Martianus Capella's book and the seven liberal arts. Its influence on the literature and art of the Middle Ages.

Thus, the divisions into which the Middle Ages separated its learning had been made at the end of antiquity. The books just cited were all classics in the twelfth and thirteenth centuries; but there is one that was more famous in the Schools than the others: the famous treatise that Martianus Capella published under the misleading title of *De nuptiis Philologiae et Mercurii* (The Marriage of Mercury and Philology). Martianus Capella, an African grammarian of the fifth century, attempted to enliven the rigors of learning with the charm of his imagination. His manual begins like a novel. He imagined that Mercury, finally deciding to take a wife, asked for the hand of Philology. On her wedding day, the young woman appears with her cortège composed of the seven liberal arts, the trivium and the quadrivium. In turn, each of these paranymphs comes forward, and in the presence of the god makes a long discourse that is a complete treatise on the branch of learning she represents. Here, for the first time, we come upon the trivium and quadrivium personified. The strange figures imagined by Martianus Capella took firmer root in the medieval imagination than the purer creations of the masters. Until the Renaissance, they lived on through the power of art.[56] An obscure African rhetorician had done what even few men of genius are able to do: he created types. It is true, however, that medieval artists had to work to simplify these figures that are as overloaded with ornaments as the women of Carthage.

Grammar, the first to be introduced by Martianus Capella, comes forward dressed in a paenula. In her hand she carries an ivory case resembling a physician's kit, for grammar is a true therapeutic which cures us of all the vices of language. In her kit we see, among other things, ink, pens, candleholder, tablets, and a file divided by golden lines into eight sections, symbolizing the eight parts of speech. We also see a kind of scalpel (*scalprum*), with which in various ways Grammar operates on the tongue and teeth so that pronunciation becomes easier.[57]

Dialectic, the next to come forward, is a thin woman clothed in a black mantle; her sparkling eyes shine in her pale face; her hair falls in artful coils to her shoulders. In her left hand she holds a serpent, half hidden beneath her cloak; in the right hand she holds a wax tablet and a fishhook.[58] Remi of Auxerre, who wrote a commentary on Martianus Capella in the tenth century, had no trouble at all in explaining the attributes of Dialectic; medieval subtlety was equal to that of the rhetoricians of antiquity. According to him, the coiled hair symbolizes syllogisms, the serpent the tricks of sophistry, the fishhook specious arguments.[59]

Rhetoric is an armed virgin who advances to the sound of trumpets. She is beautiful, tall, slender; a helmet covers her hair, she brandishes weapons. Stones sparkle on her breast, and a mantle embroidered with thousands of figures covers her.[60]

Geometry wears a splendid robe: it is embroidered with the movement of the stars, the shadow made by the earth in the sky, and the signs of the gnomon. In her right hand she holds a compass (*radius*), and in her left, a sphere. Before her is a table sprinkled with greenish dust on which she traces her figures.[61]

Arithmetic has the awe-inspiring beauty of a primitive goddess; we have only to look at her to understand that she was created at the same time as the world. From her forehead shines a ray that divides and becomes double, then triple, then quadruple, and, after multiplying infinitely, unites again. Her fingers are deft and move with an incomprehensible quickness. Their movement resembles the activity of worms (*vermiculati*) and, according to Remi of Auxerre, symbolizes the rapidity of her calculations.[62]

Astronomy springs from an aureole of flame wearing a crown of stars on her sparkling hair. She opens two great golden wings plumed with crystal. For observing the stars, she carries a quadrant (*cubitalem fulgentemque mensuram*) which shines in her hand. She also carries a book made of various metals which, according to Remi of Auxerre, symbolizes the diversity of the zones and climates she studies.[63]

The last to advance is Music, beautiful Harmonia, with her cortège of goddesses, poets, and musicians. Orpheus, Amphion, Arion, Pleasure, and the Graces sing softly around her as she draws ineffable music from a golden shield strung with resonant chords. From head to foot she is harmonious; each of her movements causes the golden spangles of her costume to quiver melodiously.[64]

Such are the attributes and aspect of the seven handmaidens of Philology, insofar as we can tell from Martianus Capella's obscure Latin.

These seven great and shining female figures, as supernatural as Byzantine mosaics, dazzled the Middle Ages. As early as the time of Gregory of Tours, knowledge of Martianus Capella's book was considered indispensable to every man of the Church.[65] It was part of almost every monastic and chapter library in the eleventh, twelfth, and thirteenth centuries, as the ancient catalogues published by Léopold Delisle indicate.[66]

Henceforth, whenever poets set out to personify the liberal arts, they would no longer be free to use their imaginations, they would be unable to forget the descriptions of the African rhetorician.

This is easily substantiated. Theodulf, bishop of Orléans in the time of Charlemagne, left a little Latin poem on the seven arts.[67] He claimed to have been inspired by a painting he had before him. Here is his description of Grammar:

> . . . *laeva tenet flagrum, seu dextra machaeram.*

(Her left hand holds a whip, her right a sword—or better, a scalpel.)

Here we recognize two of the attributes imagined by the African rhetorician. Dialectic is characterized by a serpent hidden under her cloak:

> *. . . corpus tamen occulit anguis.*

Geometry carries a compass in her right hand, and a globe in her left:

> *Dextra manus radium laeva vehit rotulam.*

Imitation of Martianus Capella is obvious.

Four hundred years later, Alain de Lille, the greatest poet writing in Latin in the Middle Ages, also described the seven arts; he added and retouched, but he also kept many of the details imagined by Martianus Capella.

Alain de Lille was a forerunner of Dante,[68] and like him, tried to summarize in one symbolic poem all the knowledge of his time. He made the first sketch of the colossal monument later constructed by Dante. His book, *Anticlaudianus,* is the noblest effort of monastic art. His verse is charmingly harmonious, his thought is lofty and pure, but what does his poem lack? It is hard to say—life, perhaps, and air.

He imagined that pure human wisdom, Philosophy (*Prudentia*) desires to rise (as in Dante) in search of God.[69] She needs a chariot such as has never been seen before, one capable of carrying her into the infinite. At her request, the seven arts themselves set to work on this miraculous chariot, which as we see symbolizes learning.

Grammar comes first: she is a majestic matron whose full breasts are always ready to give forth knowledge. But if she is as gentle as a mother, when necessary she can also be as stern as a father. In one hand she holds a ferule (*scuticam*), and in the other, a scalpel for scraping rust from the teeth and loosening tongues that are tied.

> *. . . linguasque ligatas Solvit.*[70]

She makes the shafts of the chariot and carves on it the portrait of the great grammarians, Donatus and Aristarchus.

Dialectic is presented next. Wakefulness has made her thin, but has not dimmed the brilliance of her eyes. Her hair is not held with combs. In her left hand she carries not a serpent but a threatening scorpion.[71] She makes the axletree for the chariot.

Rhetoric has an inflamed face, a changeable physiognomy. Her robe shines with a thousand colors, and she carries a trumpet in her hand. She decorates the chariot with a coating of gold and silver, and carves flowers on the axletree.[72]

Arithmetic comes forward, dazzling in her beauty. She carries the Table of Pythagoras, and points to the "combinations of numbers" (*des batailles de chiffres*). She makes the first wheel of the chariot.[73]

Music plays the zither, and makes the second wheel.[74]

Geometry holds a measuring rod with which she measures the world:

Virgam virgo gerit, qua totum circuit orbem.[75]

She makes the third wheel.

Astronomy, who comes last, looks toward the sky. She is dressed in a tunic sparkling with diamonds, and she carries a sphere. She makes the fourth wheel.

When the chariot is finished, Philosophy hitches to it five spirited horses symbolizing the five senses; she gives them rein and they leap into the sky.

It is scarcely necessary to point out what Alain de Lille borrowed from Martianus Capella; it is only too evident. Nevertheless, his imitation is discreet and he strips from his model many of its superfluities.[76]

Must we insist further? Is it necessary to recall that Henri d'Andeli, in the thirteenth century, wrote in the vulgar tongue a "Battle of the Seven Arts," and Jean le Teinturier a "Marriage of the Seven Arts," in both of which we find the usual personifications?[77] And must we also recall that these somewhat pedantic images of the branches of learning are found even in the poetry of chivalry? And that in the romance of *Erec and Enide*, by Chrestien de Troyes, the fairies embroider on a robe the muses of the quadrivium?[78]

Given all these examples, it will no doubt seem well established that the figures created by Martianus Capella were accepted by all the writers of the thirteenth century.

The artists followed along as submissively as the writers. The earliest representations of the Liberal Arts are found on the façades of the cathedrals of Chartres[79] and Laon (figs. 51, 52).[80] And that is as it should be, for few schools in the Middle Ages were more famous than those of Chartres and Laon.

From the end of the tenth century on, the schools of the cathedral of Chartres, whose history has recently been written, had a brilliant reputation.[81] Fulbert, "this venerable Socrates" as his disciples called him, taught all the branches of human learning relating to man. Pupils were already coming there from the remotest provinces, and even from England. Later on, the great bishop St. Ivo, and then Gilbert de la Porrée and John of Salisbury in turn directed the famous school. These masters, among the greatest of the Middle Ages, were distinguished for their encyclopedic knowledge, their respect for the ancients, their scorn for new methods of teaching, which claimed to make the acquisition of knowledge faster and easier. Gilbert de la Porrée and John of Salisbury struggled throughout their lives against the Cornificiens, dangerous innovators who wished to outlaw antiquity and reduce the number of years

51. The Liberal Arts. Laon (Aisne),
Cathedral of Notre-Dame. West façade,
left window, archivolts (detail).

of study. During the entire twelfth century, the schools of Chartres were
the sanctuary of tradition, the refuge of antiquity. No pagan of the
Renaissance, drunk on Latin and Greek, had spoken more eloquently of
antiquity than Bernard, master (*écolâtre*) of Chartres in the twelfth cen-
tury: "If we see farther than they," he said, "it is not because of the
strength of our view. It is because we have been raised by them and car-
ried to a prodigious height. We are dwarfs mounted on the shoulders of
giants."[82]

Thus, we are not surprised to see the series of the seven arts carved on
the portals of Chartres. Nowhere, in the Middle Ages, were the seven
virgins of Martianus Capella more highly honored.

The school of Laon was almost as famous as that of Chartres. For more
than half a century, two of its masters, Raoul, and even more, Anselm of
Laon made it the first school of Christendom.[83] Anselm of Laon, "the
light of France and of the world,"[84] as Guibert of Nogent called him,
was the teacher of William of Champeaux and of Abelard. People came
to study at Laon from Italy and Germany. Masters who were already
famous resigned their posts and went to sit again on school benches to

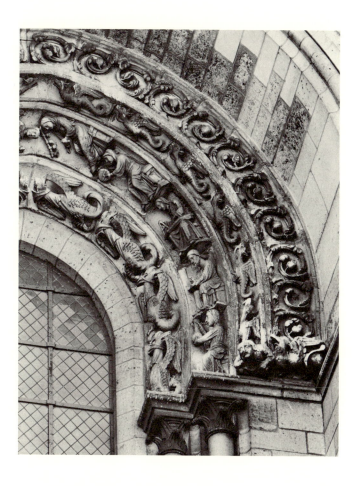

52. The Liberal Arts. Laon (Aisne),
Cathedral of Notre-Dame. West façade,
left window, archivolts (detail).

hear Anselm's lectures.[85] Nothing discouraged the students, neither the
distance, nor the tragic events that took place at Laon before their eyes:
the burning of the cathedral, the murder of the bishop, and the exile of
its citizens.[86]

It would truly seem that the Liberal Arts were carved on the façade
of the new cathedral and painted on one of the rose windows, almost a
century later, in memory of Anselme, "the doctor of doctors."

At Auxerre, the Liberal Arts were also twice represented.[87] That was
because the school of the cathedral of Auxerre had a far-reaching reputa-
tion in the twelfth century. Thomas, later Archbishop of Canterbury, on
returning from Bologna, thought of completing his studies at Auxerre.[88]
It can be said that, in general, all the churches where there are representa-
tions of the trivium and the quadrivium had a flourishing school. This
would explain the presence of the Liberal Arts at Sens, Rouen, and
Clermont.[89]

It would be surprising not to find some representation of the seven arts
at Notre-Dame of Paris, the town called by Gregory IX *parens scientia-
rum* and *Cariath Sepher* (the town of books),[90] for the young University

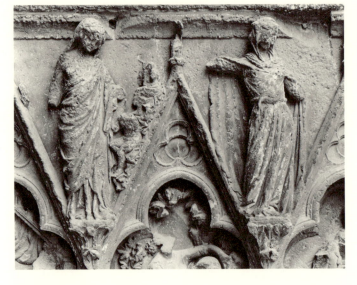

53. Grammar and Dialectic. Auxerre (Yonne), Cathedral of St.-Etienne. West façade, right portal, socle (detail).

of Paris had grown up in the shadow of the cathedral. And in fact they were there before the eighteenth-century mutilations dishonored the façade; they decorated the trumeau of the central portal, against which the statue of Christ was placed.[91]

Let us now examine each of the representations of the Seven Liberal Arts as we find them in our cathedrals, and see to what point the artists had been inspired by Martianus Capella's text. Some miniatures in manuscripts, and even some monuments outside France, occasionally furnish us with valuable details.

Grammar is indeed the venerable woman wearing a long cloak, just as Martianus described her, but of all the attributes given her by the ancient rhetorician, the medieval artists retained only one: the ferule. In this, they acted wisely. It is apparent that the physician's kit, the scalpel, and the file with its eight divisions, evoked nothing very clear. Using good common sense, sculptors and painters, even more resolutely than poets, stripped the branches of learning of Capella's cumbersome ornaments, and kept only the essentials. Wishing to emphasize only the elementary nature of the teaching performed by Grammar, the sculptors and painters represented two children at her feet, their heads bent over their books.[92]

Dialectic kept the serpent, and can be recognized at first glance by this attribute (fig. 53).[93] Of the rare exceptions, only one is worth mention: on the old portal of Chartres, Dialectic carries a scorpion. Alain de Lille also, for unknown reasons, substituted the scorpion for the serpent. Both traditions persisted in art, for in the fifteenth century an unknown artist who painted the Liberal Arts for the chapter hall of Le Puy, and Sandro Botticelli, in the fresco of the Villa Lemmi, both placed the scorpion in Dialectic's hands.

Rhetoric is simply conceived. Except in a thirteenth-century manuscript, she is never given the helmet, lance, and shield as attributes.[94] The figure of Rhetoric at Laon, whose right arm is broken off, possibly held a sword. It is more probable, however, that her arm was raised in an oratorical gesture. That was her usual attitude unless, as in the rose window at Laon, she is shown writing on her tablets.

Arithmetic could not be represented with the cluster of light rays shining from her forehead, multiplying and projecting to infinity. But another detail in Martianus Capella's description caught the artists' attention—the prodigious agility of her fingers which is listed among her other attributes. That is why Arithmetic is represented with extended arms and the fingers of her open hands as if in movement, in the rose window of Auxerre and on the portal of the cathedral of Fribourg.[95] Such a gesture no doubt seemed obscure to the artist of Laon, and he placed the balls of the abacus in Arithmetic's fingers. In this way he clearly expressed that Arithmetic makes the most complicated of calculations with her fingers. At Laon, Arithmetic is represented twice in this same way: on the west portal and in the north rose window. Few artists were as ingenious in translating the texts as the sculptor and glass painter of Laon. Elsewhere, they merely represented a figure seated before a rod strung with moveable balls,[96] or before a table covered with numbers.[97]

In Martianus Capella's text, Geometry's attributes are very clear: a table on which she traces figures, a compass or a graduated rule, according to the meaning given the word *radius*, and a sphere. These attributes, with the exception of the sphere, which might have caused Geometry to be confused with Astronomy, are found in almost all of our cathedrals. At Sens and at Chartres, the compass has been broken and only the tablet on which Geometry traces its diagrams remains. But on the façade of Laon Cathedral, the figure of Geometry is intact. Everywhere, the word *radius* was interpreted as *compass*. However, sometimes a compass was placed in one of Geometry's hands and a rule in the other, to express the two meanings of the word. This is the case in the Auxerre window and on the Fribourg portal, and in certain manuscripts.[98]

Astronomy no longer has the splendor in which Martianus clothed her: she has no aureole of light, no golden wings and diamonds. She simply carries a quadrant (*cubitalem mensuram*), with which she measures the height of the stars, and sometimes she also carries the book made of various metals, the symbol of the climates. At Sens,[99] Laon, Rouen, and Fribourg, Astronomy is shown raising toward the sky a disk (astrolabe), usually grooved with a broken line. On the Auxerre window, she carries a book.[100]

Of all the personifications imagined by Martianus Capella, Music alone kept none of the attributes which distinguished the original. Pagan

Harmonia, whom he imagined leading a retinue of poets and gods as she plays an unknown instrument, was replaced by a seated woman who strikes three or four bells with a hammer (fig. 54).[101] In the Middle Ages, Music almost never had other attributes. In thirteenth-century Psalters, to recall that David was the greatest of all musicians and the living incarnation of music itself, miniaturists represented him striking two hammers on some bells hanging before him.[102] Here we find the trace of a legend widespread in the Middle Ages concerning the origins of music. Using Peter Comestor as his authority, Vincent of Beauvais recounts that Tubalcain, the descendent of Cain, invented music by striking resonant metals with hammers of different weights. He added, "In a fable, the Greeks attributed this invention to Pythagoras."[103] There can be no doubt that the hammers medieval artists put in the hands of Music were intended to recall its origin.

We see that great possibilities for the plastic arts were to be found in Martianus Capella's book, since artists used it constantly for two or even three centuries. The Middle Ages could not represent the seven arts except as seven majestic virgins. The exceptions are unimportant.[104]

On the old portal of Chartres, the artist conformed even more closely to Martianus Capella's text, and borrowed another idea from him. In his book, the branches of learning are almost all accompanied by a retinue of the great men who had distinguished themselves by cultivating them. That is why at Chartres, placed below each personification of the Liberal Arts, there is a seated figure of a man writing or meditating.

It is not easy to name these figures, since Martianus Capella included not one but many in the retinue of each Art. However, with the help of the most widely read books of the time and by examining monuments which are analogous, even though carved later, we can suggest some probabilities.

The figure seated below Grammar can be only Donatus or Priscian (fig. 55). In the Middle Ages, sometimes one was preferred, sometimes the other; usually both were shown. Isidore of Seville, who named the inventor of each branch of learning in his *Etymologiae*, chose Donatus for grammar.[105] But at Chartres itself, Master Thierry, whose *Heptateuch* or *Manual of the Seven Arts* has been preserved, mentioned Donatus and Priscian in the same sentence; he used the books of both for teaching grammar.[106] In the fourteenth-century frescoes of the Spanish Chapel of Sta. Maria Novella at Florence, as at Chartres, beneath each of the seven arts is placed its most distinguished exponent. According to Vasari, the grammarian Donatus is the man below Grammar.[107] But the fifteenth-century frescoes in the chapter hall of Le Puy, which are conceived in exactly the same manner as those at Florence, show Priscian at

the feet of Grammar, and his name is written out in full.[108] Thus, it is hard to assert, as Abbé Bulteau did, that Priscian was represented at Chartres to the exclusion of Donatus.

Beneath Rhetoric, we have little hesitation in identifying Cicero. Although he was known at Chartres in the twelfth century only by his most scholastic treatises, *De inventione, De partitione oratoria*, and the *Perihermenias* attributed to him,[109] all the same, for the men of that time, he was the master of the art of rhetoric. Alain de Lille wrote, "Rhetoric can be called Cicero's daughter."[110] He sits at the feet of Rhetoric in the Le Puy fresco. And although Vasari does not name him, no doubt it is he who is represented in the Florentine fresco.

At Chartres, Dialectic is accompanied by a man who dips his pen in an inkwell and prepares to write. We can say, without fear of error, that this is Aristotle, the great master of the Schools. At the end of antiquity, Isidore of Seville proclaimed that Aristotle was the father of Dialectic,[111] and throughout the Middle Ages this was repeated. But at Chartres there were perhaps special reasons for representing Aristotle in relation to Dialectic, for it is quite likely that Master Thierry of Chartres was the first to make the complete *Organon* known in France. In 1136, Abelard knew only the first two treatises of the *Organon*, the *Categories* and the *De interpretatione*.[112] It was around 1142 that Thierry inserted the others (*Analytics, Topics* and *The Sophistical Elenchi*) into the *Heptateuch*.[113] However, it was Thierry's pupils, John of Salisbury and Gilbert de la

54. Music. Laon (Aisne), Cathedral of Notre-Dame. North transept, stained glass panel, rose window.

55. Grammar with Donatus or Priscian; Music with Pythagoras. Chartres (Eure-et-Loir), Cathedral of Notre-Dame. West façade, south door, archivolts (detail).

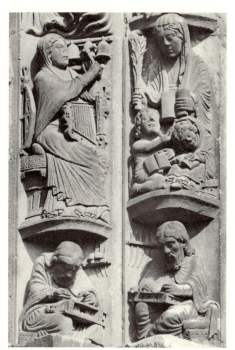

Porrée, later the directors of the schools of Chartres, who first spoke of these still unknown works of Aristotle. Thus, in all likelihood, it was at Chartres that the famous work of Aristotle was studied in its entirety for the first time. In this sense, Chartres was the real cradle of scholasticism. Thus we have no doubt that Aristotle figures on the old portal of the cathedral, which was decorated with reliefs at the very time Thierry finished his book.[114]

Who is the personage seated below Music and writing so diligently (fig. 55)? It is difficult to imagine that this is Tubalcain, whom Vincent of Beauvais names as the inventor of music, for at Florence and Le Puy he is shown striking the anvil with a hammer. At Chartres, this serious man with pen in hand, composing a didactic treatise, resembles a scholar rather than an antediluvian patriarch. Very likely it is Pythagoras. The Chartres sculptor followed the tradition recounted by Cassiodorus[115] and Isidore of Seville,[116] who attributed to Pythagoras the discovery of the laws of music.

Ptolemy is shown below Astronomy. No doubt is possible. Isidore of Seville[117] and Alain de Lille[118] both designated him as the greatest of astronomers. Moreover, in about 1140, no other books than his were known at Chartres. Astronomy was studied from the Tables and in the Canons which the Arabs had transmitted in his name to the Christians.[119]

Is Geometry accompanied by Euclid, as has been thought? We may suppose so, although no book of Euclid appears in Thierry of Chartres' *Heptateuch*. But Euclid was a great name. In Alain de Lille's poem, it is he who represents Geometry;[120] it is also he who is represented in the Spanish Chapel at Florence.[121]

Beneath the feet of Arithmetic is a scholar in the attitude of teaching, but his name is not easy to guess. The encyclopedias of Isidore of Seville[122] and of Vincent of Beauvais,[123] to which medieval men turned for knowledge, both name Pythagoras as the inventor of arithmetic. In Martianus Capella, Arithmetic is accompanied only by Pythagoras, who carries a torch.[124] Thus, Pythagoras was thought to have invented both music and arithmetic; this double glory was usually conferred upon him.[125] Consequently, it is possible that Pythagoras was twice represented at Chartres, once writing at the feet of Music, and again, teaching at the feet of Arithmetic. However, there is one name that might possibly be substituted for his, that of Boethius. For Isidore of Seville named him among the learned men most illustrious in the science of numbers,[126] and he especially was studied at Chartres, where Thierry, in two volumes, had elucidated his treatise on arithmetic.[127] Moreover, it was Boethius, as Chasles has proved by referring to Thierry's *Heptateuch*, who made known to the Middle Ages both the numerals improperly called "Arabic" and positional notation. Thus, Boethius has almost as much right as

Pythagoras to be shown at the feet of Arithmetic; it is impossible to choose between them.

As we see, the order imagined by Martianus Capella was fairly scrupulously respected at Chartres. As in *De nuptiis Philologiae et Mercurii,* each of the branches of learning is accompanied by its inventor, or by the man who gained the most glory by cultivating it.

At the cathedral of Clermont, Martianus Capella's idea is present in a rather original and shortened form: each Art and the scholar are combined in one figure. Aristotle, Cicero, and Pythagoras sit on the cathedra of the Doctors and carry the attributes that we have seen in the hands of the Seven Liberal Arts. But to indicate that these venerable men are beyond life, that they have become symbols and henceforth are to be clothed in the same majesty as learning itself, crowns are placed on their heads.[128]

III

So far, we have discussed only the seven arts of the trivium and the quadrivium, but there was an eighth that dominated all the others: Philosophy. Its image, carved both at Sens and at Laon,[129] has very strange attributes, especially at Laon. Its head is in the clouds and a ladder leans against its chest (fig. 56). Viollet-le-Duc tried to explain the strange figure as follows: "This is either Philosophy or Theology. The figure holds a scepter in its left hand; in its right it holds an open book, behind which is a closed book. We presume that the closed book represents the Old Testament, and the open book, the New Testament. Its head is not crowned, as at Sens, but is lost in the clouds; a ladder, resting on the ground, reaches to its neck, and represents the successive degrees that have to be passed through to arrive at a perfect understanding of the queen of the arts."[130] The description is exact, but the explanation is wrong. Viollet-le-Duc did not know the book from which medieval artists took this singular portrait of Philosophy. For it is indeed Philosophy, and not Theology; and it is Philosophy with the attributes given it by Boethius.

In his *De consolatione Philosophiae,* Boethius tells us that while he was in prison and musing over his sad fate, a woman suddenly appeared before him. He describes her in this way: "The features of her face inspired the most profound respect; light shone from her eyes, and one could feel that her vision penetrated farther into the future than that of mortals; her coloring was that of life and youth, although it was apparent that she was full of days and that her age could not be measured as ours is. As for her height, it was hard to gain any exact idea of it, for sometimes she curbed her stature to human proportions, and sometimes she grew in height, penetrating the sky itself and disappearing from the prying eyes of

Personifications of Philosophy. The influence of Boethius.

56. Philosophy. Laon (Aisne), Cathedral of Notre-Dame. West façade, west portal. After Viollet-le-Duc.

57. Philosophy. Sens (Yonne), Cathedral of St.-Etienne. West façade, central door (detail).

man. Her garments, woven with skillful art, were made of most fine and forever durable threads. She later told me that she had woven them with her own hands. But time, which tarnishes all works of art, had diminished their color and beauty. Along the hem was embroidered the Greek letter Π, and on the border at the top, the letter Θ. To go from one to the other, a series of degrees resembling a ladder was represented, leading from the inferior to the superior elements. It was obvious that these garments had been rent by violent hands which had ripped off everything they could. In her right hand she carried some books; in her left, a scepter."[131]

This strange woman, described so ingeniously by Boethius, is none other than Philosophy who came to console him in prison. Commentators agree that the mysterious letters Π and Θ are a summary way of designating practical and theoretical Philosophy.

The Laon statue corresponds precisely to this description. The sculptor rejected only the features that were not compatible with his art. He represented Philosophy as Boethius had seen her, with her head in the clouds, a scepter in her left hand and books in her right. He even placed the ladder against her breast in order to translate into visual terms the symbolism of the philosopher (fig. 56). Sculpture could hardly go farther in this direction. It may be surprising that the artist did not engrave the Greek letters Π and Θ on the borders of the robe. I believe it quite possible that the letters were painted on the robe and that time has effaced them. Like the architecture of antiquity, medieval architecture was polychrome. Almost all the statues were painted, no doubt discreetly and with

that true feeling for effect that medieval artists possessed to so high a degree; and to judge by their stained glass windows, medieval artists were exquisite colorists. At Notre-Dame of Paris, the painted statues of the portal were set against a gold background. Their effect was so sumptuous that a fifteenth-century Armenian bishop, although accustomed to the magnificence of Near Eastern art,[132] was filled with admiration for them. It is thus quite likely that the Laon artist, who had followed Boethius' text so carefully, had not forgotten the Π and the Θ.

Moreover, these two Greek letters are to be found elsewhere. At Sens, there is a figure carved in relief on the socle of the central portal among the series devoted to the Liberal Arts. Viollet-le-Duc reproduced this figure, asking whether it represented Philosophy or Theology (fig. 57).[133] A careful examination of the relief dispels any doubt, and sufficiently shows that here is again Philosophy. She is represented as a seated woman; conforming to the description of Boethius, she holds a book in her right hand and a scepter in her left; the head, badly mutilated, seems to have been crowned; her head is not lost in the clouds, as at Laon; however, we must remember that even in Boethius, Philosophy did not always assume colossal stature, but is sometimes normal size. With great tact, the artist chose a Philosophy of human proportions and so more accessible to art. He again showed taste in omitting the ladder. He no doubt thought that such a detail would be inappropriate in a composition carved in low relief, and would oddly detract from its strength and nobility. Nevertheless, he was faithful to the thought of Boethius and was anxious to preserve its essentials; he carved a series of Θs on the upper border of the robe, and a series of Πs on the lower one. We can easily make out the Greek letters in Viollet-le-Duc's drawing which reproduces them with scrupulous exactitude, but he did not understand their meaning and took them for decoration. It is clear that he thought the series of Θs to be a sort of Greek border design.

The evidence seems clear to me that the figures at Sens and Laon represent Philosophy, and closely follow Boethius' text.

Boethius' persistent influence will surprise no one who knows something about the transmission of ideas in the Middle Ages. He was venerated as the repository of the wisdom of antiquity and the educator of the contemporary world. He was both the last of the Romans and the first of the clerics. He appeared at the limits of the two worlds, clothed in something of the mystery surrounding Virgil. His faults contributed as much as his virtues to his fame. His universal knowledge was no doubt admired, but what was admired most of all were the diffused melancholy and poetic outbursts so strangely mingled with his dialectic, his subtle symbolism, and in fact everything that was somewhat murky in this philosopher of the end of antiquity. We have only to glance at the cata-

logues of medieval monastic and episcopal libraries to see that Boethius was almost always included (fig. 58).[134] It all goes to prove that his *De consolatione Philosophiae* was a classic. So it is not surprising that Boethius established the features and attributes of Philosophy once and for all. He had seen Philosophy and had talked with her; the Middle Ages took him at his word and could not imagine representing her otherwise.[135]

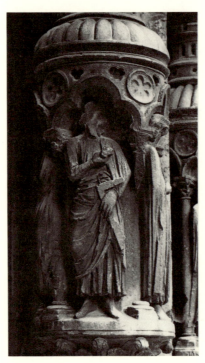

58. Boethius, Philosophy; Plato and Socrates. Montpellier, Bibl. de la Faculté de Médecine, ms. 43, fol. 2r.

59. Architecture. Chartres (Eure-et-Loir), Cathedral of Notre-Dame. North porch, right door.

In the course of the thirteenth century, new figures were added to the Seven Arts and Philosophy. There was a profound desire to understand and embrace everything. The Universities gathered into one bundle all human knowledge. The great books of the thirteenth century naturally took on the form of encyclopedias. The Middle Ages believed that it had reached the limits of knowledge and that its only work was to coordinate it. That is why the new sciences were placed beside the seven virgins of the trivium and quadrivium in our thirteenth-century cathedrals. Medicine appears at Sens,[136] Laon,[137] and Auxerre.[138] At Reims,[139] she studies a patient's urine through a transparent phial held at eye level.

Even the occult sciences, astrology and alchemy, which hovered between true science and imagination, had their place in the cathedral. On the north porch of Chartres, a figure named "Magus" symbolizes the hermetic studies. In his hand he holds a streamer which perhaps was once covered with cabalistic signs; the winged dragon, whose name so often occurs in alchemical formulas, cringes at his feet.

The arts, which developed so magnificently during this time, were not forgotten. Architecture is represented on the north porch of Chartres by the figure of a man holding a rule and compass.[140] A painter holding a palette stands at his side (fig. 59).

On the same porch at Chartres, the mechanical arts and the trades accompany the sciences, as in the Mirror of Knowledge of Vincent of Beauvais. Metallurgy is represented by Tubalcain striking his anvil; agriculture by Adam who digs and Cain who pushes the plow; sheep-raising by Abel guarding his flocks.[141]

Here we sense the effort to widen the somewhat narrow limits of the trivium and quadrivium, and the desire to include all knowledge, all science, and all art.

IV

Work in all its forms is to be respected: such is the lesson taught by the cathedral. But it also teaches still another, that the object of our work is not riches, nor is glory the object of learning. Labor and knowledge are the instruments of our inner perfection, and that is all. The worldly goods our activity here below may bestow upon us are too ephemeral for us to attach ourselves to them.

At the cathedral of Amiens, an odd figure makes this moral truth visible. In the upper part of the south door, we see a kind of half-wheel, around which seventeen small figures are placed. Eight of them seem to rise with the wheel as it turns, eight others descend with it; at the top, a seated man with a crown on his head and scepter in his hand remains

Conclusion. Human destiny. The Wheel of Fortune.

60. The Wheel of Fortune, Amiens (Somme), Cathedral. South façade, rose window (detail).

immobile while everything around him is in movement (fig. 60). What is the meaning of this allegory? Is it, as Didron tried to establish, an image of the different ages of life?[142] I think not. It is enough to note that the figures descending so suddenly with the revolution of the wheel are dressed in rags, and either have bare feet or toes protruding from their shoes, to indicate, along with Jourdain and Duval,[143] that this symbolic half-circle represents the wheel of fortune, not the wheel of life. A miniature from a fourteenth-century Italian manuscript completes the proof.[144] Beside the figure which seems to mount with the wheel is written *regnabo* (I will reign); beside the seated figure at the summit is written *regno* (I reign); and beside those who descend the other side is written *regnavi* (I have reigned) and *sum sine regno* (I am without a kingdom). Thus, this has to do with power, riches, glory, and all the successes of life on earth. The wheel expresses the instability of all things.

The Amiens example is not unique. On the north portal of St.-Etienne at Beauvais, of S. Zeno at Verona, and of the cathedral of Basel, similar figures mount and descend the periphery of a circle. It is likely that other monuments which have disappeared, such as rose windows, had the same motif. A sketch in Villard de Honnecourt's *Album* shows how widespread such a motif was in the Middle Ages.[145] Moreover, there are these significant lines in *La Somme le Roi*: "These cathedral churches, these royal abbeys, where Dame Fortune turns things upside down quicker than a windmill."[146]

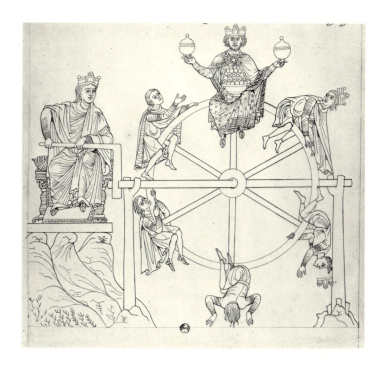

61. The Wheel of Fortune. *Hortus deliciarum* of Herrad of Landsberg, Paris, Bibl. Nat., Fonds Bastard, Cab. des Estampes, A d 144 a, fol. 215r.

Where did this profound and simple idea come from? We might at first be tempted to think it a creation of the people's imagination, but on further reflection, we recognize it as a metaphor from antiquity that had been twisted. The Middle Ages had heard of the Wheel of Fortune, but imagined a goddess not carried on a winged wheel, as in antiquity, but placed within the wheel and moving with it. Honorius of Autun described it in this way: "Philosophers[147] tell us of a woman attached to a continually moving wheel, and they say that her head is sometimes up, sometimes down. What is this wheel? It is worldly glory which is eternally in motion. The woman attached to the wheel is Fortune: her head alternately rises and falls, because those who have been elevated by power and riches often fall into poverty and misery."[148]

It is in approximately this way that the Italian miniaturist mentioned above represented Fortune. He placed her among the spokes of the wheel (*rotae innexa*, Honorius said), which she seems to set in motion.

So new and strange a way of representing Fortune and her wheel derives from various passages of Boethius' *De consolatione Philosophiae*. In fact, the entire second book is devoted to the fickleness of Fortune. In a *prosopopoeia*[149] recalling that of Death in Lucretius, Fortune herself explains to Boethius that he has no right to complain of her changeable nature. Philosophy, who is present at their meeting, speaks in her turn and, armed with all the commonplaces of Stoicism, completes the argument. But what interests us here is the frequent mention of the Wheel

of Fortune in this second book. Now Boethius, curiously enough, already represents man hanging from the Wheel of Fortune, and forced to rise or descend with it. Here is the important passage: "I make a wheel turn rapidly; I love to raise what is down, and lower what is up. So, mount if you will, but on the condition that you will not be indignant to fall when the laws of my game demand it."[150]

This and other passages of the same genre lead to the idea whose origins we are looking for. The Middle Ages, which took everything literally and loved to clothe abstract ideas in concrete form, gave artistic reality to Boethius' metaphor. From the twelfth to the fifteenth century, whenever the rapid changes of Fortune were to be recalled, this was represented by the symbolic wheel with which mankind rose or fell (fig. 61).[151]

Thus, the Wheel of Fortune at Amiens provided a new subject for the meditation of Christians. Royalty, which confers riches, glory, and power, lasts but a moment. The king whom we envy is seated on a wheel: tomorrow, another king may replace him. Our work, our learning, all of our efforts must not be directed toward the possession of such fragile goods. We must have a more solid foundation: this world will not give it to us, and we shall find it only in God.

The object of all work, of all learning, is virtue.

Book Three

SPECULUM MORALE: THE MIRROR

OF MORALS

Nature, knowledge, virtue: this is the order of the *Speculum majus*. These, it is to be noted, are also the three worlds of Pascal: the world of bodies, of minds, and of charity. Christian thought is so perfect a unity that it is identical in all ages. The Middle Ages taught that virtue is superior to knowledge and art: it is the final purpose of the world.

But strangely enough the artists of our cathedrals often placed what is highest in the humblest place. At Paris and Amiens, the twelve pensive virgins who symbolize the Virtues do not reign from above the portal, alongside the angels and the blessed. They are placed at eye level so that passers by may get to know them well. The hands of generations have worn them away; the dust stirred up by feet settles on them. They are truly engaged in life. It would be difficult to convey more clearly that the perfection demanded of us by the Scriptures can be, and must be, attained.

When did the virtues take on concrete and living form in the Christian imagination? When were they first conceived as chaste young women, beautiful, simple, and heroic? At the very beginning of Christianity. Already in the *Shepherd* of Hermas they appeared as virgins.[1] A little later, they were conceived as armed virgins. Tertullian seems to have been the first to represent the virtues as warriors struggling in the arena against the vices. "We see lust overcome by chastity," he said, "perfidy killed by sincerity, cruelty felled by pity, pride vanquished by humility: these are the games in which we Christians receive crowns."[2] Born in Africa, like Martianus Capella who was later to make the branches of learning live, walk, and talk, Tertullian could not help personifying his thoughts. He was the first to express in a simple way a profound idea: that Christianity had not brought peace to the world; it had brought war, and the soul had become a battlefield. The harmony that the ancient sages, in their ignorance of the true nature of man, had wished to impose on us, is not of this world. As long as we are alive, the two natures within us will fight. The drama, conceived by antiquity as a struggle between man and a fate exterior to him, takes place only within ourselves.

The idea of an inner battle, a psychomachy, certainly did not originate with Tertullian, since it is one of the fundamental ideas of Christianity. His contribution was, as the imaginative man that he was, to give it concrete form.

The passage from Tertullian, quoted above, could serve as the argument for Prudentius' poem. His *Psychomachia* recounts the battle of the Virtues and the Vices in Virgilian verse[3]—it is often a patchwork from the *Aeneid*. So novel an idea deserved a newer form; it is surprising to find that Prudentius was at once so young and so old. But it should not be

Representations of the Vices and Virtues in medieval art. The *Psychomachia* of Prudentius and its influence.

forgotten that the Catacomb painters, in order to express all their thought, were also obliged to borrow some traditional figures from classical art.

But even so, Prudentius' poem was very popular with the following age, which thought that he had presented a definitive picture of the struggles within man's soul. The art of the Middle Ages was inspired by it, and from it the Romanesque and even the early Gothic sculptors borrowed their representations of the Vices and Virtues.[4] Consequently, it is important for our work to summarize the characteristic episodes of Prudentius' poem.

He shows us the army of Vices and the army of Virtues drawn up for battle. Champions come forward from the ranks and challenge each other according to the rules of epic poetry, and fight in single combat.

Faith (*Fides*), the first, advances with noble imprudence into the field.[5] She refuses to cover herself with cuirass and shield, but goes with bare breast to meet her enemy, aged Idolatry (*vetus Cultura deorum*). The battle is short. Even though wounded, Faith overthrows Idolatry and proudly places her foot on the vanquished head.

Chastity (*Pudicitia*), a young virgin in shining armor, withstands the onslaught of Debauchery (*Libido*),[6] a courtesan brandishing a smoking torch. Chastity knocks down the torch by throwing a stone,[7] draws a sword and slaughters Debauchery, who vomits forth blood as thick as mud, soiling the purity of the air as she breathes out her soul. Pitiless as a Homeric warrior, Chastity apostrophizes the corpse of her enemy, praising Judith in whom chastity triumphed for the first time, and then washes her defiled sword in the holy waters of the Jordan.

Patience (*Patientia*), grave and modest, stands firm against Wrath's (*Ira*) attack.[8] She impassively receives the countless blows which ring against her cuirass. Finally, Wrath rushes forward, sword in hand, and strikes her enemy on the head; but the helmet resists the blow and the sword flies into pieces. Beside herself, Wrath seizes a spear lying at her feet and plunges it into her own breast. Thus, Patience triumphs over her enemy without even drawing her sword.

Pride (*Superbia*), meanwhile, has mounted a spirited steed which prances before the enemy line (fig. 62).[9] Her hair rises from her forehead like a tower; the wind billows her cloak. This fiery warrior insolently berates the enemy army and accuses the impassive Virtues of cowardice. All at once, both horse and rider disappear into a pit which Fraud (*Fraus*) has dug in the battlefield. Humility (*Mens humilis*) then comes forward, takes the sword offered her by Hope (*Spes*), and cuts off Pride's head. This done, the beautiful virgin spreads her golden wings and rises to heaven.

Lust (*Luxuria*), with perfumed hair, graceful and languishing, appears mounted on a splendid chariot.[10] The axletree is of gold, the wheels

are plated with electrum, and shining with precious stones. The beautiful enemy fights in a new way: instead of shooting arrows, she throws violets, and plucks rose petals. When they see her, the Virtues falter, but Sobriety (*Sobrietas*), armed with the standard of the cross, marches before the chariot. The horses bolt, the chariot turns over, and Lust rolls in the dust. All her retinue abandon her: Wantonness (*Petulantia*) throws away her cymbals as she flees, Desire (*Amor*) drops his bow. With the blow of a stone, Sobriety overcomes her feeble enemy.

While this battle is taking place, Avarice (*Avaritia*), always vigilant, rapaciously gathers up the gold and jewels that have fallen into the dirt in Lust's flight.[11] She hides them in her bosom, and then fills purses and sacks which she conceals beneath her left arm.[12] Reason (*Ratio*) dares to attack her, but cannot conquer her alone; Charity (*Operatio*)[13] must come to her aid. She kills Avarice and distributes her gold among the poor.

The battle seems to be over. Concord (*Concordia*), crowned with an olive branch, gives the order to take the victorious standards back to camp,[14] but even while she is talking, an arrow is shot from the enemy ranks and strikes her in the side. It was shot by Discord (*Discordia* or *Haeresis*) who refuses to lay down her arms. A new battle begins, and Discord, vanquished by Faith, has her tongue pierced by a lance.

The Virtues, victorious at last, raise a temple resembling the New Jerusalem of the Apocalypse, to celebrate their triumph.

Such is Prudentius' poem, to which both writers and artists went so often for inspiration. The Carolingian poets, Theodulf and Walafrid Strabo, both imitated Prudentius in retelling the battle of the Vices and Virtues.[15] Later, Alain de Lille used the same subject: the ninth book of the *Anticlaudianus* is completely taken up with a psychomachy.[16] Poets such as Rutebeuf, writing in the vulgar tongue, also sometimes worked over this old theme.[17] The writings of theologians themselves are full of Prudentius' poem: the struggle of the Virtues and Vices seemed to them a drama. Isidore of Seville has them come to grips in a chapter of his *Sententiae*.[18] Gregory the Great, if he is indeed the author of the treatise *De conflictu vitiorum et virtutum* attributed to him, has the Vices and Virtues confront each other two by two, and challenge each other like Homeric warriors.[19] Vincent of Beauvais reproduces a part of this treatise, no doubt because he admired its life and movement.[20] Even such serious Church Doctors as Hugh of St. Victor[21] and William of Auvergne[22] felt obliged when they dealt with the Virtues to show them in action and to make them speak. The impetus, everywhere, stems from Prudentius.

Quite early, artists began to struggle with his text. The first illustrated manuscript of Prudentius goes back perhaps to the very century in which

he lived, for the tenth-century manuscript belonging to the Bibliothèque Nationale is decorated with drawings still in the style of antiquity and obviously copied from a very ancient original.[23] The old drawings, slightly retouched and adapted to the taste of the time, reappear again in a thirteenth-century Prudentius.[24] Of all the illustrations of Prudentius, those of the *Hortus deliciarum*[25] are certainly the most interesting. The drawings of this rude manuscript, which has no connection with those of the preceding group, represent the Virtues as twelfth-century knights (fig. 63); the virgin-warriors, who in Prudentius wear the cuirass of Aeneas and Turnus, have become French barons. They wear coats of mail and the helmets with nosepieces of the First Crusade, and carry the large triangular shield, and broad sword. The battle is fierce: it would seem to be a feudal tourney, or trial by combat (*Jugement de Dieu*). The artist followed the text very closely and illustrated it episode by episode.

It is in this knightly form, with the same battle equipment, that the Virtues appear on the capitals and portals of Romanesque churches. Armed with lances, they trample their enemies, who sometimes have the form of monsters. The Virtues are so conceived on one of the capitals of the church of Notre-Dame-du-Port, at Clermont,[26] at the cathedral of Tournai,[27] and on the portals of many churches in the west of France: Notre-Dame-de-la-Coudre at Parthenay; St.-Hilaire at Melle; St.-Nicolas at Civray;[28] at Aulnay,[29] at Fenioux in Charente-Maritime; St.-Pompain in Deux-Sèvres.[30] At Aulnay (fig. 64), the Virtues and Vices are designated by their names: *Ira* and *Patientia*, *Luxuria* and *Castitas*, *Superbia* and *Humilitas*, *Largitas* and *Avaritia*, *Fides* and *Idolatria*, *Concordia* and *Discordia*. These are the pairs who confront each other in Prudentius. Only *Pudor* and *Libido* are missing; but for reasons of symmetry, the artist at Aulnay, as everywhere else moreover, restricted himself to six

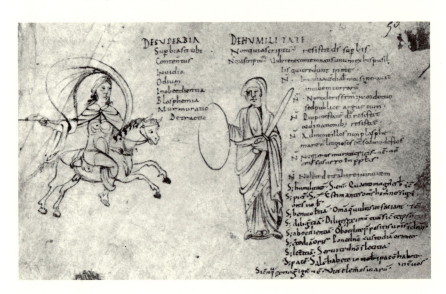

62. Pride and Humility. Prudentius, *Psychomachia*. Paris, Bibl. Nat., ms. latin 8318, fol. 53r.

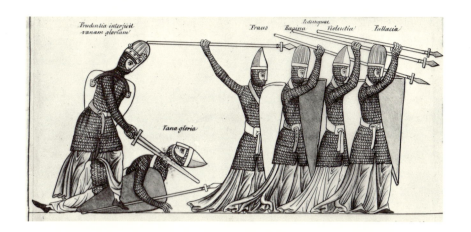

63. Prudence slays Vainglory. *Hortus deliciarum* of Herrad of Landsberg. Paris, Bibl. Nat., Fonds Bastard, Cab. des Estampes, cote A d 144a, fol. 201v.

64. Psychomachia. Aulnay (Charente-Inférieure), Church of St.-Pierre. West façade, central portal, archivolts.

pairs. The action, which is so varied in Prudentius, is uniformly represented. Each Virtue triumphs over her enemy in the same way; all distinguishing details have disappeared.[31] The movement of battle is replaced by the calm of victory. What the poet imagined as dynamic, so to speak, the artist realized as static. Such are the requirements of monumental statuary, which were so well understood in the twelfth century. Thus the somewhat vulgar turbulence of Prudentius' heroines becomes majestic immobility.

Gothic artists had by no means the same fondness for Prudentius' poem as the Romanesque artists. As we shall see, they found new images to represent the Virtues. However, they did not altogether abandon the old theme of the Psychomachia. One of the portals of Laon Cathedral, a work still somewhat archaic, shows the battle of the Vices and Virtues in the archivolts (fig. 65).[32] The artist took liberties with Prudentius' text: symmetry required him to add another to the seven pairs of warriors delineated by Prudentius. And sometimes he replaced one Vice or Virtue with another; however, he never strays far from his model, from whom he borrowed small picturesque details. Debauchery, for example, holds a flaming torch in her hand, and with it threatens Chastity; Avarice clutches a purse against her breast. The inscriptions, several of which are mutilated,[33] give the names of the combatants: [*Sobriet*]*as* and *Hebeta-*[*tio*]; *Luxuria* and *Castitas*; *Pati*[*entia*] and *Ira*; *Caritas* and *Paup*[*er*];[34] *Fides* and *Idolatria*; *Superbia* and [*Humilitas*]; *Violentia* and [*Mansue-tudo*(?)]; *Largitas* and *Avaritia*. These figures at Laon no doubt date from the first years of the thirteenth century.

During the course of the thirteenth century, Prudentius' poem gradually lost its creative power. The artists still retained some memory of it, since episodes imagined by the poet appeared in their work, but it is apparent that the central idea of Prudentius, the idea of a battle between the Vices and the Virtues, was gradually losing its force. The north porch of Chartres[35] shows the old artistic tradition in the process of transformation. The Virtues still triumph over the Vices, but they seem to win without combat; the Virtues trample them under foot, no longer deigning to look at them. In fact, the battle is over; the Virtues have taken off their armor and hold only the attributes of peace in their hands.[36] The artist intended to represent not the battle but the victory—a noble spectacle, certainly, but a much less moving one. The triumphant Virtues no longer seem to belong to this world.[37] Even the choice of Virtues and Vices is no longer that of the poet. At Chartres, Prudence is paired with Folly, Justice with Injustice, Fortitude with Cowardice, Temperance with Intemperance, Faith with Infidelity (shown as the Synagogue), Hope with Despair, Charity with Avarice, Humility with Pride. This is no

longer the somewhat helter-skelter battalion that Prudentius seems to have chosen at random and in which the Virtues have no fixed rank. At Chartres, we recognize the four cardinal Virtues and the three theological Virtues. The necessity of filling the empty space and of placing four Virtues in each archivolt explains the presence of Humility and Pride; a felicitous choice, moreover, since contemporary theologians regarded pride as the root of all the vices. However, several details show that Prudentius was not completely absent from this composition. Pride, for example, tumbles head first into the pit beneath his feet (fig. 68). Avarice, not content with filling her purse and coffers, conceals her riches in her bosom. Despair (in Prudentius, Wrath) stabs herself with her own sword.

This is one of the last, and already enfeebled, images of the *Psychomachia*. The artists had already imagined an entirely new way of representing the Vices and Virtues. However, toward the east, in Alsace, so faithful to the past, and still bound to the Romanesque tradition, the old theme was preserved for a long time to come. On the portal of the cathedral of Strasbourg, the Virtues, charming virginal figures from the early fourteenth century, finish off the Vices with lances, as they lie at their feet.[38] A fourteenth-century window in the interior is devoted to the symbolic combat of the twelve Vices and twelve Virtues.[39] There is a richer and more systematic choice than Prudentius gives; the cardinal Virtues and theological Virtues are accompanied by a certain number of accessory Virtues.[40] It was not in vain that the genius of the Church Doctors of the Middle Ages had been exerted to distinguish, define, and classify the Virtues.

Once more in the fourteenth century, and almost at the end of the Middle Ages, the church of Niederhaslach in Alsace shows, as a final instance, carved on its portal and painted on its windows, the battle of the Vices and Virtues.[41]

II

As early as the twelfth century, the theologians, and following their lead, the artists began to see the opposition of the Vices and Virtues in a new way. Honorius of Autun, one of the sources of medieval art, represented Virtue as a tall ladder uniting heaven and earth.[42] He interpreted the vision of Jacob in a moral sense; each rung of Jacob's ladder is a virtue, to which he gives a name. There are fifteen: *patientia, benignitas, pietas, simplicitas, humilitas, contemptus mundi, paupertas voluntaria, pax, bonitas, spirituale gaudium, sufferentia, fides, spes, longanimitas,* and *perseverantia.*[43]

New forms in the representation of Vices and Virtues in the thirteenth century. The twelve Virtues and twelve Vices at Notre-Dame of Paris, Chartres, and Amiens.

It was not easy to realize in images a metaphor with so little plastic possibility. The miniaturist who illustrated the *Hortus deliciarum* made the attempt. Moreover he took his inspiration from a Byzantine original. He faithfully represented the mystic ladder, with its base resting upon the earth and its top lost in the clouds. On this ladder he placed humanity (fig. 66).[44] Men, clerical and lay, painfully ascend, rung by rung, while the Vices call to them from the earth below. A bed symbolizing Sloth invites them to come and rest from their efforts; Lust smiles at them. Baskets of gold, viands on plates, horses and shields, arouse all their covetousness. Some cannot resist and fall to earth with a rude jolt from the heights they have attained. But a woman, no doubt a nun, sees and hears nothing, and rises toward the crown awaiting her at the summit. Is it possible to conceive a more dramatic allegory? How it must have moved the childlike souls of the nuns for whom it was destined. And even today, are we not moved by the sincerity we sense there?

Another metaphor came into being at about this same time. The theologians of the twelfth and thirteenth centuries, who studied the relations of the vices and virtues so closely, often compared them with two vigorous trees.[45] Hugh of St. Victor, one of the first to present this new idea in fully developed form, gives a name to each branch of the two trees.[46] One is the tree of the old Adam and has pride (*superbia*) as its root and trunk. Seven large limbs grow from the trunk: envy, vainglory, wrath, sorrow, avarice, intemperance, and lust. Each of these limbs in turn has secondary branches: for example, fear and despair sprout from sorrow. The second tree is the tree of the new Adam. Its trunk is humility, and the seven main branches are the three theological and the four cardinal virtues. Each virtue is subdivided in turn. For example, chastity and obedience grow like shoots from faith; patience and joy grow out of hope; and from charity grow concord, liberality, peace, and mercy. Adam planted the first of these trees, and Christ planted the second. We must choose between them.[47]

One of the most famous books of the thirteenth century, *La Somme le Roi*, written in French by the Dominican Friar Laurent for Philippe III, the Bold, for whom he was confessor,[48] presents Hugh of St. Victor's thought in new forms.

The author begins by presenting the two trees of good and of evil; but with a profound knowledge of human nature, he makes of love, that is, charity, the root of the first, and cupidity, that is, egotism, the root of the second.[49] Thus, all the vices grow out of love of self, just as all the virtues come from self-forgetfulness. He could very well have stopped with that beautiful comparison, so simple and so true, but Friar Laurent was a son of his time and worked out a much subtler symbolism in the course of his book. The seven virtues are no longer the seven branches of a single tree,

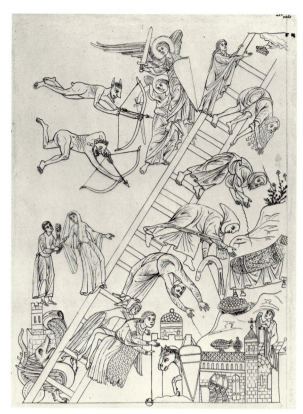

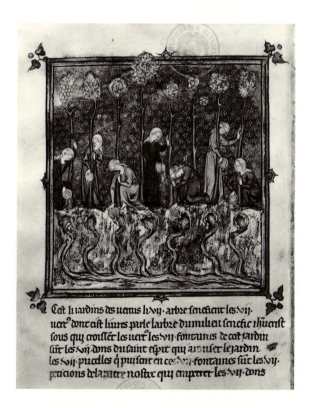

Ceft li iardins des uertus li vij . arbze fenefient les vij. uert° dont aft liures parle larbze dumilirt fenefie ihucrift fous qui croiffet les uert les vij fontaines de ceft iardin fur les vij dons dufaint efpt qui aioufet lejardin les vij puceles q puifent en ce vij fontaines fur les vij pracions delamere noftre qui empetret les vij. dons

65. Psychomachia. Laon (Aisne), Cathedral of Notre-Dame. West façade, left portal, archivolts (detail).

66. The Ladder of Virtue. *Hortus deliciarum* of Herrad of Landsberg. Paris, Bibl. Nat., Fonds Bastard, Cab. des Estampes, cote A d 144a, fol. 215r.

67. The Seven Virtues, as trees, maidens, and streams. *La Somme le Roi*, Paris, Bibl. Mazarine, ms. 870, fol. 61v.

but are seven different trees planted in the beautiful orchard, which is the Eden of the soul (fig. 67). Seven clear springs (the seven gifts of the Holy Spirit) spring forth at the foot of the seven trees, and seven maidens draw water from these seven springs with seven pitchers, which are the seven petitions of the *Pater Noster*.[50] The vices are also represented by a new symbol. Friar Laurent believed that the seven arrogant heads of the beast of the Apocalypse were the perfect image of the seven deadly sins, and above each of the heads he inscribed the name of a vice.

Such conceptions were not without influence on art. They explain certain enigmatic drawings in thirteenth-century manuscripts. To cite one example, the *Miroir de vie et de mort*, in the Bibliothèque Sainte-Geneviève, contains a strange miniature representing a tall tree with wide-spreading roots.[51] The peculiarity of these roots is that they terminate in serpents, and these serpents terminate in figures of women. Most of these women carry an emblem or make a gesture that identifies them, even when their names are not inscribed beside them. The first (*Radix luxuriae*) looks at herself in a mirror, the second (*Radix gulae*) holds a glass in her hand, the third (*Radix avaritiae*) closes a strongbox, the fourth (*Radix acidiae*) turns away from the altar, the fifth (*Radix iracundiae*) tears her hair, the sixth (*Radix invidiae*) carries a beast in her bosom, the seventh (*Radix superbiae*)[52] has no characteristic attribute. The tree, whose roots are sins, flourishes magnificently. At its top a queen is seated with a crown on her head, scepter in hand, and surrounded by black birds. This insolent figure is a kind of Anti-Virgin, a Virgin of Evil; the white doves that rest on Mary are here replaced by the black crows of hell. A ladder leans against the tree, and while musicians tune their instruments, a woman clothed in white, as a dead person would be clothed, slowly mounts it, carrying under her arm the lid of her coffin.

In this are to be recognized a learned blend of several metaphors dear to the twelfth- and thirteenth-century theologians. The tree is clearly the Tree of Evil of the Church Doctors, but conceived somewhat differently. The vices are at its roots, and these roots are, at the same time, the seven heads of the beast of the Apocalypse. The ladder reminds us of the one that Honorius of Autun placed between heaven and earth, but the one leads to life, the other to death. Those who climb it imagine that they go toward life, and they are already wrapped in their shrouds. All the ideas having to do with vice and virtue held by educated people of the time, and all the comparisons current in the Schools, are expressed here.

Great monumental art never utilized so subtle a symbolism, but left such refinements to the miniaturists. The thirteenth-century sculptors represented neither the tree of vices nor the mystic ladder of virtues. Nor did they return to the *Psychomachia*, which, however, left more than one mark on their work, as we shall see.[53] They opposed the virtues to the

vices, it is true, but in a completely new way. The Virtues carved in relief are seated women; they are grave, immobile, and majestic; they carry on their shields an heraldic animal testifying to their nobility. The vices are no longer personified, but are represented as actions in medallions beneath each Virtue: a man beating his wife represents Discord; Inconstancy is a monk fleeing his monastery as he casts off his cowl. Thus, virtue is represented in its essence; vice in its effects. On the one side, all is repose; on the other, all is movement and struggle. This contrast arouses an awareness of the idea the artists wanted to express: the calm figures teach us that only virtue can unify the soul and give it peace; outside virtue there is only turmoil. Thus, thirteenth-century artists, by abandoning the Psychomachia so cherished by the preceding age, seemed to wish to go farther and express a deeper thought. The Romanesque sculptors tell us: "The life of the Christian is a struggle." But Gothic sculptors add: "The life of the Christian who can make all the virtues reign in his soul is peace itself, and he already reposes in God."

The earliest example of this type of representation is on the façade of Notre-Dame of Paris.[54] There is no doubt that it was an artist from Paris who conceived this new program with the counsel of a theologian in the early years of the thirteenth century.

Restored as they are, these reliefs, which in the eighteenth century underwent the clumsy restorations of Soufflot's workmen,[55] are the starting point of our study. The great rose window of the west façade of Notre-Dame of Paris has the same subject, treated in an almost identical way.[56] The reliefs at Amiens[57] were carved several years after those at Paris, and reproduce very nearly all their details. Those at Chartres,[58] carved before the middle of the thirteenth century, are faithful to the prototype (fig. 68). A window at Auxerre,[59] almost contemporary with the porch of Chartres, is less complete but clearly derives from the same original. Lastly, at Reims, a series of reliefs of the Vices and Virtues were carved at approximately the same time. In spite of mutilations and losses, we still can find traces of the original idea.[60]

Let us study these different series, completing them and letting them clarify each other.

The reliefs of Paris, Amiens, and Chartres, where the thought was fully developed, show in exactly the same order twelve Virtues and twelve Vices: Faith and Idolatry, Hope and Despair, Charity and Avarice, Chastity and Lust, Prudence and Folly, Humility and Pride, Fortitude and Cowardice, Patience and Wrath, Gentleness and Harshness, Concord and Discord, Obedience and Rebellion, Perseverance and Inconstancy.

The foremost question is: what general idea is behind the choice of Virtues? For not all of them are shown, and even some of the principal ones are missing.[61]

We readily see that the series begins with the three theological Virtues: Faith, Hope, and Charity, whose nature was first defined by St. Paul.[62] They are placed in the same order assigned them by theologians; for as they said, "Faith lays the foundations of the spiritual edifice, Hope builds it, and Charity crowns it." And again, "It is because we believe that we hope, and it is because we hope that we love."[63]

After the three theological Virtues, we expect to find the four cardinal Virtues, Temperance, Fortitude, Prudence, Justice. They were taken by St. Ambrose from Plato's *Republic*, but were shaped to fit Christian thought[64] and introduced into the theological literature of the West in the fourth century. St. Augustine sanctified this division with his own authority;[65] Isidore of Seville and, after him, Rabanus Maurus transmitted it to the Middle Ages.[66] The theologians who had studied the virtues most profoundly, Peter Lombard[67] in the twelfth century and St. Thomas in the thirteenth, adopted the established classification. Each of the three theological virtues and four cardinal virtues mark a division of the *Summa.* St. Thomas strove to show precisely how these seven principal virtues engender all the others.[68] The *Speculum morale*, added to the *Speculum majus* after the death of Vincent of Beauvais, adopted St. Thomas' method and although part of the scholastic apparatus was omitted, it presents his conclusions.

Thus, in the sculpted series of Virtues it would seem only natural to expect to find the cardinal Virtues following the theological Virtues. Consequently, the canons Jourdain and Duval, who made the first attempt to explain the reliefs of the cathedral of Amiens, were determined to find that Temperance, Fortitude, Prudence, and Justice follow Faith, Hope, and Charity.[69] Their reasoning was based on their familiarity with medieval art and their conviction that the relief sculptures of the cathedrals are infallible catechisms in stone that always conformed to the teaching of the Schools. But this time they were mistaken, and their bias kept them from understanding the true meaning of the figures they wished to explain.

In the series of works of art under discussion, there is not, it must be admitted, the scrupulous dogmatic exactness the medieval artists have led us to expect. The nine Virtues accompanying the three theological Virtues seem to have been chosen and arranged haphazardly. A derivative Virtue takes precedence over the mother Virtue, or even replaces her. Justice, for example, does not appear at all; the Virtue of Obedience, which derives from her, has been substituted for her.

I asked myself whether some deeper order might not be hidden behind this apparent disorder. Proceeding from the fact that the earliest series of twelve Virtues and twelve Vices was carved at Notre-Dame of Paris,[70] I looked for justification of the choice in the works of the theologians

who belonged to the clergy of that cathedral in the late twelfth and early thirteenth century. In the relations between some of the figures there are certain details that point to the collaboration of a cleric. Unfortunately, neither the *Sententiae* of Peter Lombard, bishop of Paris at the end of the twelfth century, nor the *Verbum abbreviatum* of Peter the Chanter who taught theology at the cathedral school at the very time the new church was begun,[71] nor the treatise *De moribus et de virtutibus* of William of Auvergne, who ascended the episcopal throne of Paris at the beginning of the thirteenth century,[72] tells us what we want to know. There is no trace in any of these books of a classification of Vices and Virtues that conforms to the works of art we are trying to explain. All the numerous works devoted to the vices and virtues in the thirteenth century—dogmatic *Summas* like those of Friar Laurent or Guillaume Péraud,[73] poems in the vulgar tongue such as the short treatises on the vices and virtues[74] and the *Roman de Fauvel*,[75] lastly simple lists of the virtues and vices in opposing pairs, as they are found in the manuscripts,[76]—all these works are conceived differently, and have different classifications.

Thus, our research has produced no results. Perhaps others will be more fortunate.[77] We can scarcely believe that a work as important as the series of Vices and Virtues of Notre-Dame of Paris, which was thought worthy of copying at Amiens and Chartres, had not been carefully thought out. We recall the tabernacle of Or San Michele at Florence, where Orcagna represented the Virtues by following St. Thomas' method. In this splendid monument, where Scholasticism is crystallized in marble, just as it is transfigured into light by Dante, each of the cardinal Virtues is accompanied by an accessory Virtue taken from the list drawn up by St. Thomas, which reveals his profound knowledge of the workings of the soul.[78] For example, Fortitude is flanked by Patience and Perseverance, Prudence by Docility and Ability. If so scrupulous a method of classifying the Virtues prevailed at Florence in the fourteenth century, we can scarcely believe that in thirteenth-century Paris, at the height of the age of theologians, their order was left to chance.[79]

However that may be, here we must study these images of the Virtues and Vices, one after the other, and with the aid of theological literature, try to explain all their details.

Faith, carved at the right of Christ, has the place of honor. Seated on a bench, she holds a shield on which, at Paris, a cross is represented,[80] at Chartres a chalice,[81] and at Amiens a cross in a chalice (fig. 69).[82] On the north porch of Chartres, Faith fills the chalice with the blood of the lamb sacrificed upon the altar. Thus, faith, to the Middle Ages, is faith in the virtue of the sacrifice of Christ who died on the cross, but it is also (as the chalice proves) faith in the perpetuity of the sacrifice miraculously renewed every day on the altar. Thus, Faith was represented by our artists

68. Folly, Humility, Pride. Chartres (Eure-et-Loir), Cathedral of Notre-Dame. South transept, porch.

in conformance with the definition of St. Augustine, which was taken up by Peter Lombard and accepted by all of Christianity: "Faith is the virtue by which we believe in what we do not see."[83] The sacrament of the Eucharist is its most perfect symbol.

Below Faith, at Paris, Amiens (fig. 69), and Chartres, a man makes the gesture of adoring a hairy idol resembling a monkey.[84] This is Idolatry, for such is the naïve figure given to the gods of the pagans by the Middle Ages.[85] According to the thought of the time, the statues of the ancient gods were inhabited by dangerous demons who sometimes manifested themselves in hideous forms; whoever worshiped them worshiped Satan himself.

On the north portal of Chartres, another thought is expressed. Beneath the feet of Faith is the Synagogue, with a blindfold over her eyes. In this we must recognize one of the episodes in the dramatic struggle between the two religions which, as we shall see, so often inspired the artists of the thirteenth century.

When Dante, accompanied by Beatrice, arrives in the eighth circle of paradise, a voice issues from a shaft of light and questions him on Hope.

69. Faith and Idolatry. Amiens (Somme),
Cathedral. West façade, central portal,
socle reliefs.

70. Hope and Despair. Amiens (Somme),
Cathedral. West façade, central porch,
socle reliefs.

The poet recognizes St. James who, in a famous Epistle, had been the
first to speak of this virtue. And Dante, "as quickly as a scholar respond-
ing to his teacher," and without changing a word, gives the definition he
had read in the *Sententiae* of Peter Lombard: "Hope is an assured wait-
ing for the future glory produced by divine grace and previous merit."[86]
That is why, at Paris, Amiens (fig. 70), and Chartres, Hope looks with
assurance to heaven and extends her hand toward a crown, symbol of the
future glory awaiting her.[87] Beside her, we see a shield on which a stand-
ard surmounted by a cross is drawn. It seems to me that the meaning of
this emblem has not been completely understood. Archeologists see it as
a sign of victory when in reality it is a symbol of resurrection. In fact, the
cross to which a standard is attached is, as we know, the attribute of
Christ issuing from the tomb. The Middle Ages had the sublime idea of
transforming the instrument of ignominy in the hands of the Saviour into
an instrument of triumph. Now the confidence shining from the face of
Hope and from her whole person is founded precisely on the certitude
of the resurrection of the body. In a classic book, Peter the Chanter, in
speaking of hope, characterized her by this passage from *Job*: "For I

71. Wrath. Lyon (Rhône), Cathedral of St.-Jean. Choir. Stained glass, Infancy window (border detail).

know that my Redeemer liveth, and in the last day I shall rise out of the earth. And I shall be clothed again with my skin: and with my eyes I shall see my God."[88] Thus, the medieval relief, by means of the crown and the cross, conveys to us, in its hieroglyphic language, the idea that we shall receive our recompense on the day of Resurrection.

Opposite Hope we see Despair (fig. 70). This figure is sometimes a man, sometimes a woman,[89] who commits suicide by plunging a sword in his chest. Such a figure is without doubt traditional and derives directly from Prudentius' poem. As we have seen, in Prudentius it is Wrath (*Ira*) who, despairing of triumphing over Patience, kills herself. In the thirteenth century, artists usually attributed to Despair what the poet had said of Wrath. There are works which mark the transition. A window at Lyon, in which the spirit of those remote centuries still lives (fig. 71), shows *Ira* stabbing herself with her own sword in the presence of *Patientia*.[90] But at Auxerre, it is *Desperatio* who kills herself in the presence of *Patientia*.[91] At Paris, the sculptor, more logical than the painter of Auxerre, opposes *Desperatio* to *Spes*, while representing *Desperatio* as *Ira* had been represented in the past.[92]

Now we come to the highest of the theological virtues, Charity.

St. Paul said, "And now there remain faith, hope, and charity, these three: but the greatest of these is charity."[93] And he defined charity in these magnificent terms: "If I speak with the tongues of men and of angels, and have not charity, I am become as sounding brass, or a tinkling cymbal. And if I should have prophecy and should know all mysteries and all knowledge, and I should have all faith, so that I could remove

mountains, and have not charity, I am nothing. And if I should distribute all my goods to feed the poor, and if I should deliver my body to be burned, and have not charity, it profiteth me nothing."[94]

What, then, is this sublime virtue? It is love of God and of our neighbor, for the sake of God and in God.[95] The greatness of charity, which places it above the two other theological virtues, is this: it alone partakes of eternal life. Faith and hope are virtues given to us for our pilgrimage here below (*in via*); at the end of the journey (*in patria*), they will fade into charity.[96] Thus, charity is not only the highest of the virtues; it is the unique virtue, and the words of St. Paul become clear.

How did the Middle Ages represent the queen of the virtues? It must be admitted that in this, the artists of the thirteenth century were not up to their task. The Charity they show us is simple Almsgiving, which is only an effect, and an exterior effect of Charity.[97] At Chartres[98] and Amiens (fig. 72), and in windows at Auxerre and Lyon (fig. 73), Charity is a woman taking off her cloak to give it to a poor man. At Paris,[99] she simply holds a shield decorated with a lamb.[100] True, the lamb is a touching symbol of self-forgetfulness. "The sheep," said Rupert de Tuy,

72. Charity and Avarice. Amiens (Somme), Cathedral. West façade, central portal, socle reliefs.

73. Charity. Lyon (Rhône), Cathedral of St.-Jean. Choir, stained glass, Infancy window (border detail).

"gives its flesh to eat to those who are strong, its milk to those who are weak, and covers with its fleece those who are naked, and takes off its skin to warm those who are cold."[101] Nevertheless, the essential characteristic of Charity—love of God—was not expressed by our French artists. The Italians of the fourteenth century were better able to convey the double nature of Charity. In the Arena Chapel at Padua, Giotto places in one hand a heart which she presents to God, while her other hand is poised above a basket containing offerings to be given to the poor.[102] Orcagna's Charity on the tabernacle of Or San Michele is even better conceived: she gives suck to an infant and offers to God her flaming heart.[103] These beautiful figures fully explain the words: "Love God with all thy heart and thy neighbor as thyself."[104] French art is closer to the earth. Is this a French characteristic? When we think of it, our greatest saints were less mystics than men of action. The Charity who offers her flaming heart to God is from the country of St. Francis of Assisi; the Charity who gives her cloak to the poor is from the country of St. Vincent de Paul.

On our cathedrals, Avarice is opposed to Charity, or more correctly, Beneficence (fig. 74).[105] Avarice is a woman who fills her strongbox (figs. 72 and 73), or with an energetic gesture, shuts its lid. Sometimes she puts her hand to her bosom to conceal the gold hidden there.[106] Here we find the influence of Prudentius:[107] certain details from the *Psycho-machia* (we shall see other examples) remained deeply graven on men's minds.

The two reliefs that follow have often been misinterpreted (fig. 75). Jourdain and Duval, convinced that the cardinal virtues must always follow the theological virtues, thought they represented Justice and Injustice. Guilhermy adopted this interpretation and applied it to the two

74. Magnanimity. Sens (Yonne), Cathedral of St.-Etienne. West façade, left portal, socle reliefs.

reliefs (almost completely restored, moreover) of Notre-Dame of Paris. Saint-Laurent repeated the mistake in his *Guide de l'art chrétien.* However, doubt was cast on this interpretation very early. Comte de Bastard advanced the idea that the two Amiens medallions represent Chastity and Lust.[108] Duchalais, in an article in *La Bibliothèque de l'Ecole des Chartes,* provided the proof.[109]

Let us, in our turn, study these two reliefs. At Paris, Amiens, and Chartres, Chastity is a young virgin, "whose mouth has never been kissed," as Alain de Lille said.[110] On her head she wears the virginal veil. In one hand she carries a palm branch, and in the other, a shield on which we see an animal among flames. Is this a salamander? Duchalais thought so, and with the bestiaries as authority, he had no trouble proving that the salamander, who was said to live in the flames and could even extinguish them, was the symbol of chastity. He might also have added that, according to thirteenth-century naturalists, the salamander was a sexless animal.[111] But when we look more closely at the heraldic animal of Chartres, Amiens, and the rose window of Notre-Dame of Paris (figs. 75 and 76), it is easy to see that this is a bird, and not a salamander. A bird surrounded by flames can only be the phoenix, which

75. Chastity and Lust. Amiens (Somme), Cathedral. West façade, central portal, socle reliefs.

76. Chastity. Paris, Cathedral of Notre-Dame. West façade, stained glass, rose window (detail).

had been the symbol of immortality since early Christian antiquity. If such is the case, the attributes of Chastity are extremely vague. The palm and the phoenix mean that she will find her reward in another life. I admit that this explanation is not wholly satisfactory. The animal emblem, so precise everywhere else, is too general in this case. I am willing to believe that the Parisian artist had inadvertently carved a bird instead of a salamander, and that his mistake was repeated at Amiens and Chartres.[112]

But without insisting further, let us study the group placed below Chastity. At Chartres, and at Amiens (fig. 75),[113] a young man embraces a young woman who holds a scepter in one hand and a mirror in the other; on the rose window of Notre-Dame of Paris, there is only the figure of a woman looking into a mirror (fig. 77). She is Lust, shown as a courtesan. The scepter and mirror are clearly symbolic. The scepter expresses the omnipotence of woman and her carnal rule. By means of the scepter, the medieval sculptors conveyed the same meaning as the Italian storytellers of the Renaissance when they gave the beautiful names of "Violante" and "Imperia" to their courtesans. As for the mirror, it is the emblem of woman's coquetry and her powers of seduction (fig. 78).[114] The delicately carved ivory mirror cases that have come down to us from the thirteenth century all celebrate the invincible power of woman: women victoriously defend the Castle of Love, or receive the vanquished and submissive lover whom they crown with roses.[115] A number of these graceful mirrors no doubt belonged to thirteenth-century courtesans. The group carved at Chartres is charming and exceedingly chaste. They came from the age of chivalry par excellence, an age that deified woman; artists, whose task it was to warn against her, could not bring themselves to demean her. We have come a long way from the

77. Lust. Paris, Cathedral of Notre-Dame. West façade, stained glass, rose window (detail).

terrible figures of Lust carved on the portals of Romanesque churches. At Moissac and Toulouse, toads devour a woman's genitals and hang from her breasts.[116] The thirteenth-century sensibility was more refined; it could not endure the brutal images carved for the purpose of affecting souls that were still simple and rude.[117] Our artists well understood that by representing vice in so hideous a fashion, they took from virtue all its nobility.

Prudence comes next, after Chastity (fig. 79). We recognize her at first glance by the attribute given her both at Chartres and at Paris. Her shield is decorated with a serpent which sometimes is coiled around a staff (fig. 80). No blazon is nobler, since it had been given to Prudence by Jesus himself when he said: "Be ye therefore wise as serpents and innocent as doves."[118]

78. Chastity and Lust. *La Somme le Roi*, Paris, Bibl. Mazarine, ms. 870, fol. 147.

79. Prudence and Folly. Amiens (Somme), Cathedral. West façade, central portal, socle reliefs.

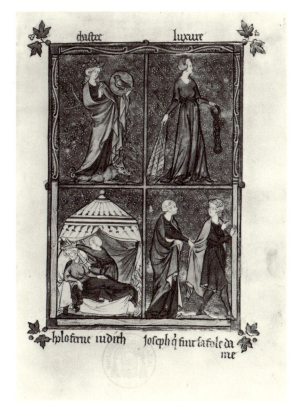

Folly, who is opposed to Prudence, requires fuller explanation. He is shown at Paris,[119] at Amiens (fig. 79), and in the rose windows of Auxerre and of Notre-Dame of Paris (fig. 81), as a scantily dressed man armed with a club, who walks among stones and sometimes is hit on the head with one. He almost always holds a shapeless object to his mouth. This is clearly the image of the fool pursued by unseen children who throw stones at him. This lifelike figure, seemingly borrowed from daily life, has in fact a popular origin.[120] There was an old tradition in the Middle Ages of representing the fool with a club (later the fools' bauble) in his hand and eating a piece of cheese. Many poems in the vulgar tongue, especially *La Folie Tristan*, describe fools in this way.[121] We can scarcely doubt that artists, in imagining this figure, were conforming to this tradition.[122]

Humility and Pride[123] follow Prudence and Folly. Humility carries a bird in her arms. Sculpted reliefs[124] (figs. 82 and 68), windows,[125] and even miniatures[126] faithfully reproduce this emblem. We can say with certainty that the bird is a dove. Jesus said to his disciples, "Be as innocent as doves." According to the commentators, simplicity must be understood

80. Prudence. Paris, Cathedral of Notre-Dame. West façade, stained glass, rose window (detail).

81. Folly. Paris, Cathedral of Notre-Dame. West façade, stained glass (restored), rose window (detail).

as simplicity of heart, which is the opposite of pride. That is why St. Bernard could say that the dove is the true symbol of Humility.

Pride appears in a form familiar to us: a horseman thrown by his mount and rolling with it into a pit[127] (figs. 82, 83, and 68). We easily recognize an episode from the *Psychomachia*. It is clear that thirteenth-century artists, even when they wanted to introduce changes, were never entirely free of the influence of Prudentius. This figure of Pride seemed consecrated. Villard de Honnecourt reproduced it in his *Album* as an established model from which no one could deviate (fig. 85).[128] He wrote in the margin: "Orgueil, si cume il trébuche." (This is the way Pride falls.) By which he meant: when one is required to represent the figure of Pride, this is the way it should be shown.

Then begins the second series of Virtues, which are placed at the left of Christ on the portals of Paris and Amiens.

First, we see Fortitude, dressed as a warrior in a coat of mail and helmet, with sword in hand (fig. 86). This warrior is a woman, as indicated by the long robe falling to her feet. Fortitude is not in the least threatening: she is seated in a noble attitude, calm and poised;[129] she

82. Humility and Pride. Amiens (Somme), Cathedral. West façade, central portal, socle reliefs.

83. Pride. Paris, Cathedral of Notre-Dame. West façade, stained glass (restored), rose window (detail).

challenges no one. With clear mind and straightforward gaze, she waits, ready for whatever may come. A lion or a bull is stamped on her shield. No image of Fortitude was ever conceived with truer nobility, and none conforms more closely to the definition of the theologians: "Strength of soul, always guided by reason."[130] It was only natural that such a figure should occur spontaneously to the artists of the age of chivalry. The Christian soldier, who disciplined his strength and put it to the service of the Church, then seemed the highest human ideal. Still, could not this image of Fortitude have emerged from some lines from St. Paul? For him, the truly strong Christian was a warrior clothed in the principal virtues as if in armor: "Fortify yourselves," he said, "in the Lord. . . . Put on the armor of God, that you may resist. . . . Take up the breastplate of Justice and the shield of Faith, . . . the helmet of salvation and the sword of the Spirit which is the word of God."[131] Taken in itself, this passage might not seem especially significant since Fortitude is not named expressly; but it is noteworthy that in the Middle Ages it was singled out and applied specifically to the virtue under discussion. In *De anima,* where each virtue is discussed in turn, Hugh of St. Victor puts Paul's words into the mouth of Fortitude.[132] Thus, it can be that the idea of arming Fortitude as a knight does come from St. Paul. The meaning of the lion represented on the shield is clear. Do all the texts have to be cited in order to prove that, to the symbolists of the Middle Ages, the lion was one of the types of courage?[133] Rabanus Maurus said, "By his courage, the lion is the king of animals." The Book of Proverbs says: "The lion is the most courageous of beasts; it fears no encounter."[134] In the twelfth century, the *De bestiis* repeated verbatim Rabanus Maurus' words.[135]

Cowardice is paired with Fortitude. At Paris[136] (figs. 84 and 90), Amiens (fig. 86), Chartres, and Reims, the artists represented a scene of folkloric geniality. A panic-stricken knight, pursued by a rabbit, throws

84. Cowardice. Paris, Cathedral of Notre-Dame. West façade, stained glass, rose window (detail).

85. Pride and Humility. Paris, Bibl. Nat., ms. fr. 19093, fol. 3v. Album of Villard de Honnecourt.

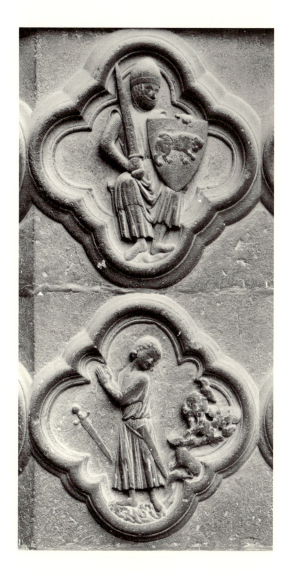

86. Fortitude and Cowardice. Amiens (Somme), Cathedral. West façade, central portal, socle reliefs.

down his sword and runs away;[137] no doubt the scene takes place at night since an owl cries lugubriously from its perch in a tree. Couldn't this be from an old proverb or fabliau? I could easily believe that the anecdote of the soldier pursued by a hare was one of the little stories that preachers liked to tell. Etienne of Bourbon, it is true, has nothing similar, but in Friar Laurent there is something very like our relief. In speaking of the coward, in *La Somme le Roi*, he says: "This one resembles the one who dares not take the path of righteousness, for fear the snail will show its horns."[138] Such a comparison, no doubt repeated many a time from the pulpit, must have inspired our sculptors (fig. 87).[139]

87. Knight frightened by a hare. Book of Hours. Paris, Bibl. Nat., ms. latin 14284, fol. iv (detail).

The meaning of the Virtue and Vice which follow is not very clear. The Virtue's only attribute is an ox on her shield (fig. 88). The Vice is represented by a man[140] advancing, sword in hand, against an impassive monk (fig. 88).[141] The usually accepted explanation is that the Virtue is Patience, symbolized by an ox, and the Vice is Impatience[142] or Wrath; the layman threatening the cleric with his sword might be an unruly penitent who cannot endure a reprimand. This is a credible explanation, but it is not supported by any text. Here something remains to be discovered, but I admit to having fared no better in my search than my predecessors.

The two reliefs that follow have given rise to controversy. Let us first describe them. The Virtue carries a shield emblazoned with a lamb (fig. 89). The Vice is engaged in a lively scene: a richly clad lady, who seems to be of the nobility, is seated on a carved chair; she kicks a very humble person in the stomach when he presents her with a cup (figs. 89 and 91). Jourdain and Duval thought that the scenes represent Violence opposed

88. Patience and Anger. Amiens (Somme), Cathedral. West façade, central portal, socle reliefs.

89. Gentleness and Harshness. Amiens (Somme), Cathedral. West façade, central portal, socle reliefs.

to Gentleness. This interpretation was accepted by others,[143] but was contested by Duchalais.[144] According to him, the two reliefs represent Nobleness and Meanness. In the course of studying an illustrated manuscript of *Fauvel*, a singular symbolic work in which a horse (the base appetites of human nature) reigns over a court of Vices, he discovered a fourteenth-century miniature that exactly reproduces the violent scene represented at Paris,[145] Amiens, and Chartres. Also, this miniature is placed near a passage on Nobleness and Meanness. His argument seems fairly strong. On examining ourselves the manuscript of *Fauvel*,[146] we were able to attest to the perfect likeness between this miniature and the reliefs under discussion: the same noble lady kicks her servant with the same brutality, and the cup is also shown. The analogy is complete. But on reading the poem, we recognized that there is no reason to claim that the miniature exactly illustrates the verses devoted to Meanness. The poet's image of this vice is as vague as it can possibly be; it contains no detail and no word that relate it to this picture.[147] On the other hand,

90. Cowardice. Paris, Cathedral of Notre-Dame. West façade, central portal, socle relief.

91. Harshness. Paris, Cathedral of Notre-Dame. West façade, central portal, socle relief.

the verses immediately preceding the miniature concern Ingratitude, and although they are also vague, they suggest an idea similar to that expressed by the painter:

> Amprès li sist Ingratitude
> Qui est très mauvaise et très rude
> Car el ne veust nul recognoistre.

> (Beside him sits Ingratitude
> Who is very wicked and harsh
> Because she refuses to be grateful to anyone.)

The lady who rewards the servant with a kick when he offers her a drinking cup deserves the epithets of the poet, and it is accurate to say of her that she "ne veust nul recognoistre," that is, she has no gratitude for anyone. It seems clear to me that the miniature was placed as it is to illustrate the verses on Ingratitude, and not the passage on Meanness. Moreover, the miniaturist availed himself of a conventional subject that had passed from workshop to workshop for at least a hundred years, and the old motif seemed to him to fit, more or less, the text of *Fauvel*.

Thus, it is probable that for a hundred years the little scene of unknown origin, depicting the mistress and her vassal, was used to express Ingratitude, or more exactly, Hardness of Heart, for the lamb carved on the shield of the opposite Virtue symbolizes Gentleness rather than Gratitude. For the theologians, the lamb was the perfect symbol of Gentleness, because it does not resist when what is most precious to it—its wool and its milk—is taken from it.[148] Following Isidore of Seville, *ovis* was always linked with *oblatio* in the Middle Ages.[149] Consequently, in spite of Duchalais' theory, there is no reason to change the names suggested by Jourdain and Duval, nor to add Nobleness and Meanness to the list of Virtues and Vices.

Concord or Peace, clearly recognizable by its attribute, comes next, paired with Discord. The olive branch is shown on Concord's shield (fig. 92).[150] In Prudentius, it is recalled, Concord wears a crown of olive leaves; Alain de Lille, shortly before the time these reliefs were carved, described her with holding a flowering branch of olive.[151]

A domestic scene symbolizes Discord: a husband and wife pull each other's hair, while a pot or pitcher rolls to one side and a distaff to the other (fig. 92).[152] Is it possible that Friar Laurent had this relief in front of him when, in *La Somme le Roi*, he wrote concerning anger:[153] "Li tierce guerre que li irous ha, cest a cels qui sont dessous lui, c'est a sa fame et a sa meignie, car li homs est aucune foiz si forcenez que il bat et fiert et fame et meignie et enfanz et brise pous et hanaps." (The third quarrel he has is with those under his authority, his wife and his house-

hold, for this man is sometimes so furious that he beats and slaps his wife, servants and children, and breaks the bowls and goblets.) The fact is that both the theologian and the artists drew on the rich treasure of popular sermons which were filled with vivid scenes from life.

The first of the two following reliefs represents a woman whose shield is decorated with a kneeling camel (figs. 93 and 95); and the second, a man who raises his hand against a bishop (fig. 93). The camel kneeling to receive its load is the symbol of humility, or submission.[154] The Virtue on whose shield the camel figures is certainly Obedience.[155] The opposing Vice can only be Rebellion. Friar Laurent explains Rebellion in this way: "C'est quant li homs est rebelle à ceus qui son bien li veulent; si on le reprent il se défend, si on le chastie, il se courrouche."[156] (It is when a man rebels against those who are concerned for his welfare; if he is criticized, he protests, if he is chastised, he is enraged.) Who are they who "have the man's welfare at heart," who are able to reprimand him and have the right to punish him, if not the bishops, the true spiritual leaders? Thus, to the Middle Ages, Rebellion was shown only in one form: disobedience to the Church. The man who raises his hand against

92. Harmony and Discord. Amiens (Somme), Cathedral. West façade, central portal, socle reliefs.

93. Obedience and Rebellion. Amiens (Somme), Cathedral. West façade, central portal, socle reliefs.

his bishop is not only guilty of violence; he is in conflict with reason and the law. The rose window of Notre-Dame of Paris contains one curious detail: the man who rebels against the bishop wears the cone-shaped hat of the Jews. There is no doubt here about the interpretation of an idea so common in the Middle Ages. The Jew, who for so many centuries had refused to listen to the word of the Church, seemed the very symbol of rebellion and obstinacy.[157]

The last two reliefs show Perseverance and Inconstancy. The idea of placing Perseverance at the end of the series of Virtues, not as the humblest, but as the most indispensable and the one to be practiced to the end, has a kind of beauty. Honorius of Autun, as we have seen, also made Perseverance the last rung of the mystical ladder leading to heaven. Perseverance has a crown on her shield (figs. 94 and 95). In the Apocalypse, John said: "Be thou faithful unto death; and I will give thee the crown of life."[158] Perseverance has two other attributes, which are less clear at first glance: a lion's head, looking like a severed head, appears in the upper part of the composition, and on the Virtue's shield there is a lion's tail.[159] This is a naïve hieroglyph: the head and the tail simply

94. Perseverance and Inconstancy. Amiens (Somme), Cathedral. West façade, central portal, socle reliefs.

95. Obedience and Perseverance. Paris, Cathedral of Notre-Dame. West façade, central socle (detail).

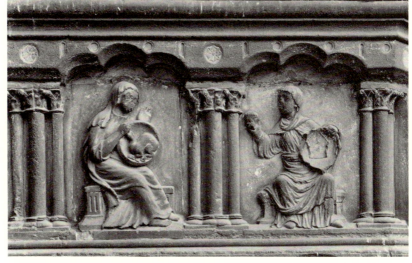

signify the beginning and the end. The artist meant to convey that perseverance is necessary from our first to our last day.

Inconstancy is represented by a monk who glances back as he flees his monastery (fig. 94). He looks for the last time at the monastery church, or perhaps at the empty cell where he has left his cowl.

We can see how complex these little compositions are. In them are traces of Prudentius, emblems borrowed from the Old Testament, the Gospels, the bestiaries; there are numerous traces of the theological teaching of the Schools, and of popular scenes which perhaps served as examples in sermons. A host of ideas common in the thirteenth century are organized and grouped around these figures of Virtues and Vices. Unquestionably, an experienced cleric guided the artists' hands.

All together, the scenes constitute a fairly profound work on moral life. The figures of the Virtues are touching in their chastity and modesty. In the terrible feudal world where blazons bristled with claws and talons, the animals chosen to decorate the shields of the Virtues (except for Fortitude's lion) were the humblest and gentlest: the lamb, the sheep, the dove, the ox, the camel—the beasts of the Gospel parables, sanctified, as it were, by Christianity. We find here again the charming pastoral art of the Catacombs, which had delighted Christian artists' imaginations for so many centuries.

We have said that the choice of these Virtues does not conform to the classifications of the theologians, but none the less, it is an interesting choice. The man who drew up the list, whoever he was, shows that he was a true Christian, for he gave top place to the humblest, most inward and hidden virtues: humility, patience, gentleness, obedience, and perseverance. Since he was preoccupied with the deep recesses of the soul, it had not occurred to him to include a social virtue such as Justice. A soul adorned with the virtues he names would be a very beautiful soul indeed and would belong to some of the greatest saints of the Middle Ages. The ideal of the humble, patient, and gentle life, the Christian life in a word, conceived by these centuries of faith is inscribed even today on the façades of our cathedrals. Our unknown theologian was very close to the author of the *Imitation*.

We have only to compare our own modern glacial allegorical figures of Courage and Justice with these meditative little figures from whom an aura of sanctity emanates to feel the vitality coursing through the art of the Middle Ages. Through their chastity and gentleness, they truly act upon the souls of those who look at them sympathetically. To the men of the Middle Ages they seemed to say: "Your days are passing, you feel old age and death coming on. Look at us: we neither grow old nor die; our purity preserves our eternal youth. Receive us into your souls if you do not wish to grow old and die."

But does man not have to withdraw from the world if he is to acquire these beautiful virtues? Can they be acquired in our day-to-day life? The cathedral replied to this crucial question also. The cathedral of Chartres tells us that the active life and the contemplative life are equally holy. In fact, on the north porch, very near the representations of the Virtues, there are twelve charming little figures symbolizing the two kinds of human activity.[160] At the left, six smiling women work: one washes wool, another cards it (fig. 96a), another flails flax, another combs it, another spins it, and the last winds it into skeins. A large seated figure, which unfortunately disappeared during the Revolution,[161] completed and summarized the series. She was shown in the act of sewing, and symbolized the Active Life.

At the right, six statuettes represent veiled young women who read, meditate, and pray (fig. 96b). One raises her eyes to heaven in ecstasy. A large statue of a woman reading, also destroyed during the Revolution, stood above the carved cordon. She was the Contemplative Life. Perhaps the two large statues specifically represented Martha and Mary, or Leah and Rachel, who, for the Church Doctors, were the usual symbols of the Active and the Contemplative Life.[162]

At Chartres the Active Life, it is true, is given the place of honor, but we sense that both were thought to be equal in the eyes of God.

Thus—and this is the final teaching provided by the cathedral—let no one seek pretext or excuse. Virtue is obligatory, and it is obligatory and binding on all men and in all circumstances, for all paths can lead to God.

The Active and the Contemplative Life: the statues at Chartres.

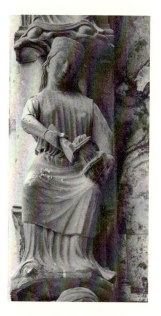

96. (a) The Active Life; (b) The Contemplative Life. Chartres (Eure-et-Loir), Cathedral of Notre-Dame. North porch, east portal, archivolts (detail).

Book Four

SPECULUM HISTORIALE: THE
MIRROR OF HISTORY

I

The Old Testament

Until now, we have been studying man in the abstract, with his vices and his virtues, his inventive mind that created the sciences and the arts. Now we shall see man in action, living: we come to history.

The history of the world told by the cathedrals conforms exactly to the plan used by Vincent of Beauvais. At Chartres, as in the *Mirror of History*, the history of mankind comes close to being the history of God's elect. Its material was furnished by the Old Testament, the New Testament, and the Lives of the Saints. These three books contain all that a man needed to know about those who had lived before him. They are the three acts in universal history, and there can be only three. God himself had decreed the plan of the drama. The Old Testament shows us mankind waiting in the expectation of the Law; in the New Testament the Law is incarnate and living; in the Lives of the Saints we participate in men's efforts to conform to the Law. Each of these great books marks one of the stages of history, and we shall devote a chapter of our study to each of them.

I

Ever since mosaicists decorated the nave of Sta. Maria Maggiore with a series of biblical scenes, the Old Testament had been a source of inspiration for medieval art. But until the thirteenth century, there were no great narrative compositions embracing the entire history of God's people. The windows of the Ste.-Chapelle, for example, illustrate completely the various books of which the Bible is composed, from Genesis to the Prophets (fig. 97).[1] Eleven immense windows, several of which have as many as a hundred panels, display in a supernatural light the entire history of the heroes of the Old Law. These countless compositions, treated in the manner of miniatures, make the Ste.-Chapelle the most admirable of historical Bibles. On the south portal of Rouen Cathedral, an extensive series of small reliefs have the same narrative character: in them, as at the

The Old Testament considered as prefiguring the New. Origins of the symbolic interpretation of the Bible. The Alexandrian Fathers, St. Hilary. St. Ambrose. St. Augustine. The Middle Ages. *Glossa ordinaria.*

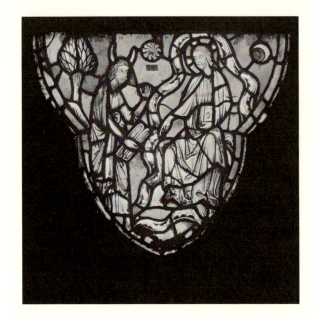

97. God speaking to Moses. Paris, Ste.-Chapelle. Stained glass panel.

Ste.-Chapelle, the artist followed the story of the first books of the Old Testament step by step, and he stopped only when he ran out of space.

It would be long and completely useless to review all the thirteenth-century compositions—the windows and the reliefs—that tell the story of some part or other of the Bible. It will suffice to note that certain touching and truly popular subjects such as the story of Joseph appear more often than others.[2] All the compositions dealing with the Old Testament are simple and restrained, taking the form of a clear and impersonal story (fig. 98).

Had the Middle Ages been content simply to create these great historical cycles, there would be no point in discussing them further. It would be enough merely to mention them. But the thirteenth century had another and much stranger way of understanding the Old Testament: instead of taking it literally, the artists for the most part interpreted its spirit. For them, the Old Testament was a vast prefiguration of the New.[3] With the Church Doctors as their guides, they chose a certain number of Old Testament scenes and placed them in correspondence with scenes from the Gospels, in order to make clear the perfect concordance of the two. The windows of the Ste.-Chapelle present a story; those of Chartres and Bourges present a mystery.

Such a system of interpretation is completely orthodox, but since the Council of Trent, the Church has allowed the symbolic method to fall into disuse and has preferred to cling to the literal meaning of the Old Testament. As a result, the exegesis based on symbolism which the

Church Fathers used constantly, if not solely, is generally unknown to-day. Thus, it would seem useful for us to outline briefly a doctrine which was so often expressed in art.

God, who sees all things under the aspect of eternity, created a profound harmony between the Old and the New Testaments: one prefigures the other. What the Gospels present in the light of the sun, to speak the language of the Middle Ages, the Old Testament presents in the dim light of the moon and stars. In the Old Testament, truth wears a veil; but the death of Christ rent this mystic veil. That is why it is said in the Gospels that "the veil of the temple was rent in two from the top

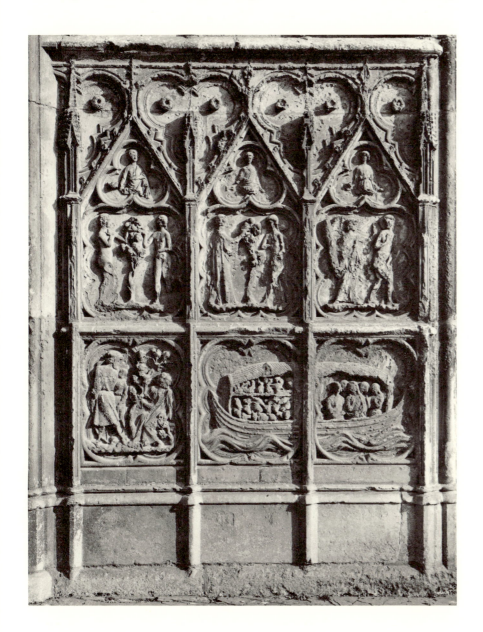

98. Genesis. Auxerre (Yonne), Cathedral of St.-Etienne. West façade, left portal, right socle.

even to the bottom" when Jesus gave up the ghost.[4] Thus, the Old Testament has meaning only in relation to the New, and the Synagogue, by insisting on the self-contained meaning of the Old Testament, wears a band over its eyes.[5]

This doctrine, which has always been the doctrine of the Church, is taught by Christ himself in the Gospels: "And as Moses lifted up the serpent in the desert, so must the Son of God be lifted up."[6] And also, "For as Jonah was in the whale's belly for three days and three nights: so shall the Son of Man be in the heart of the earth three days and three nights."[7]

As we see by their Epistles, the apostles taught the new Christians the mysterious concordance of the two Laws. St. Paul, especially, insists on it in his Epistle to the Hebrews. He told the recently converted Jews, who were still too firmly attached to the literal meaning of the Old Testament, that the ceremonies of the Old Covenant were only symbols foretokening the New.[8] He explained that Melchizedek, the priest-king, is no more than a symbol of the Son of God, pontiff and king. Several passages from the first Epistle to the Corinthians, the Epistle to the Galatians, and several verses from the first Epistle of St. Peter, are proof that the practice of allegorical interpretation was familiar to the apostles.[9]

But it was at Alexandria in the third century that this method of explaining the Bible was systematized. There is nothing surprising about this if we remember that as early as the first century the Jews of Alexandria, imbued with the Hellenic spirit, already regarded their sacred book as symbol only. Philo, in order to accommodate his system to the Bible, omitted from his commentary the literal meaning of the Old Testament.[10] He explained Genesis in somewhat the same way as the Stoics explained Homer: for them, the *Iliad* and the *Odyssey* were profound allegories concealing the highest philosophy. Thus, in that extraordinary city of Alexandria, the genius of the Greeks combined with the genius of the Near East. In some respects, Philo can be called the earliest of the Church Fathers; there is no doubt that St. Clement of Alexandria and Origen were his pupils.

It is in Origen that the allegorical interpretation of the Old Testament first appeared as a fixed system. He begins by stating the axiom that the Scripture has a three-fold meaning: for the Holy Writ, like man, is composed harmoniously in the image of God. Just as man is made of three constituents, body, soul, and spirit, the Scripture has three meanings: literal, moral, and mystical.[11] However, he adds, all passages from the Scripture cannot be interpreted in three ways; in some we must hold to the literal, and in others, to the moral or the mystical meaning. Origen especially distrusted the literal meaning, because it seemed to him to contain absurdities and contradictions from which all the heresies arose.

"Who is stupid enough to believe that God, like a gardener, had planted Eden and had really put a tree there called the Tree of Life that could be sensually perceived?"[12] In his Commentary on Genesis, he explains that Eden is nothing more than an allegory of the future Church.[13] Always in his Commentaries on the Scripture, he ignores the literal meaning. When he explains the passage from Genesis where it is said that God made for Adam and Eve garments of skins, he says, "What man of limited intelligence, what old woman would want to believe that God had slaughtered animals to make clothing from them in the manner of leather workers?" According to Origen, if such absurdities are to be avoided, the garments made of skins must be understood to mean the mortality that followed the Fall. "In this way," he adds, "we learn to find the treasure hidden behind the letter."[14]

He tried to justify such a bold method. The kind of interpretation he adopted had come, he said, from the apostles and had been transmitted to his own time by oral tradition. But it is clear that Origen was carried away by his own powerful imagination. In the flame of his genius, which has been compared to a furnace for molten metal, the literal meaning of the Scripture vanished. Celsus, and all the mediocre minds, who, by holding to the letter of the Scriptures, saw nothing there but contradictions, were confounded; but Origen himself sometimes went beyond the bounds of orthodoxy, and in turn, risked being considered a heretic.[15]

The Western Church learned the allegorical method from the Fathers of the Greek Church, and particularly from Origen. St. Jerome declared that St. Hilary of Poitiers had done the most to make it known to the Latin world.[16] For four years, when he was exiled to Asia Minor by the Emperor Constantius, St. Hilary studied Greek and read the works of the doctors of the Eastern Church. When he returned to Gaul, he wrote a *Commentarii in Psalmos* filled with the spirit of Origen.

Although it was brought from the Near East by St. Hilary, the method of allegorical interpretation really became popular only through St. Ambrose. He spread St. Clement's and Origen's doctrine through preaching, for there can be no doubt that in their original form his *Treatises* on Cain and Abel, Noah's Ark, Abraham and Isaac, were familiar sermons. In his homilies, he was determined to make known the spiritual meaning of the Scriptures, and he explained to the people all the mysteries of their allegory. We have St. Augustine's testimony to this. In his *Confessions*, he says: "Often I have joyously heard St. Ambrose tell the people in his talks with them: 'The letter killeth, the spirit giveth life.' And he interpreted in a spiritual sense the passages which, if taken literally, would seem to be incitations to vice."[17] In this way, St. Augustine, who was still struggling with the difficulties of biblical interpretation, was at last won over by St. Ambrose.

In turn, St. Augustine took over his master's method and made it known to the whole Christian world. But at the same time, he laid down for the centuries to come the fundamental principle of symbolic exegesis: the literal meaning, so often scorned by Origen, is sacred. "Brethren," he said, "above all things, I warn you in the name of God to believe when you listen to the Scripture being read that things really happened as it says in the book. Do not take from the Scripture its historical foundation, for without that you build on air. Abraham really existed, and he truly had a son by his wife Sarah. . . . But God made of these people heralds of his Son who was to come. That is why we may look for Christ and find Christ in all that they said and all that they did. All that the Scripture said of Abraham really happened, but at the same time he is a prophetic figure. The apostle teaches us this himself. He said (Galatians 4: 22-24), 'For it is written that Abraham had two sons: the one by a bondwoman and the other by a free woman; which is an allegory: one of the women is the Old Testament; the other is the New.' "[18] Thus, St. Augustine would not grant that the literal meaning of the Scriptures should be obliterated. On the contrary, he insisted that the historical fact be the solid base of allegory. He wrote his long commentary *De genesi ad litteram* to establish that the facts, even though they can be interpreted in many mystical ways, none the less took place as the Holy Writ tells. Once his principles are set forth, he makes constant use of the allegorical method. *The City of God* is filled with mystical explanations. Noah's Ark becomes the figure of Christ on the cross, because man's body is six times longer than it is wide, and these are precisely the dimensions of the ark;[19] even Noah's nakedness symbolizes the Passion of the Saviour;[20] Abraham sacrificed Isaac to prefigure the sacrifice of the Son of God;[21] Saul was rejected by God in favor of David to symbolize the replacement of the Old Law by the New.[22] One sentence from *The City of God* might serve as an epigraph to all of St. Augustine's exegetical work: "The New Testament lies hid in the Old, and the Old Testament is manifested in the New."[23]

The same kind of exegesis can be found in those of his sermons which are based on passages from the Old Testament. For example, this is his explanation to the people of Hippo of the story of David and Goliath: "Brethren, here we see pitted against each other the devil figured by Goliath, on one side, and Jesus Christ figured by David, on the other. David chose five stones out of the torrent and put them in the vessel into which he milked the sheep, and thus armed, marched against his enemy. David's five stones represent the five books of the Law of Moses. The Law, in turn, contains ten beneficent commandments from which all the others are derived. Thus, the Law is symbolized by both the number five and the number ten. That is why David fought with five stones,

and sang, as he said, with a ten-stringed instrument. And note that he does not hurl the five stones, but one only: this single stone is the unity brought about by the Law, that is, by Charity. Note also that he took the five stones from the bed of a river. What does the river represent if not a flighty and inconstant people whose violent passions plunge them into the sea of the world? Now such were the Jewish people. They had received the Law, but it passed over them as a river flows over stones. The Lord took the Law so that he might bring it to Grace, just as David chose the stones from the bed of the river and placed them in the milk-vessel. And what is a truer symbol of Grace than the abundant sweetness of milk?"[24]

Such ingenious and surprising similes often occur in St. Augustine's writing, but he was careful to present them as possible interpretations, not as dogma: "We plumb the secrets of the Old Testament as best we can. Others may have more success; but one thing is certain, that all of this was not written without mystery."[25]

After St. Augustine, St. Gregory the Great, the last of the Church Fathers, added to the already rich store of mystical exegesis. In his Commentary on the Book of Job, so famous in the Middle Ages, he constantly used the allegorical method.[26]

The enormous work in symbolism done during the early Christian centuries was respectfully accepted by the Middle Ages. They made no changes in it and added very little.

It was Isidore of Seville who summarized all the commentaries of the Church Fathers for the barbaric centuries to come. His *Quaestiones in Vetus Testamentum* is one of the essential links in the immense chain of Catholic tradition.[27] In his preface he says that in order to write his Commentary he drew largely on Origen, St. Ambrose, St. Jerome, St. Augustine, Fulgentius, Cassian, and St. Gregory. In his manual he condensed all the learning of the ancient Church Doctors; but he was most taken with their allegorical explanations. He compares the Scriptures with a lyre whose chords resound infinitely.

To make the mystical character of the Bible even more perceptible, he wrote a tract called *Allegoriae quaedam sacrae scripturae*, which is a kind of key to the Holy Scriptures. He names the principal figures of the Scriptures, and basing himself on the Church Fathers, briefly indicates in what sense they prefigured the Messiah. Adam, Abraham, and Moses are sacred signs. All the patriarchs, heroes, and prophets become the letters of a mysterious alphabet used by God to write the name of Jesus Christ in history.

The books of Isidore of Seville gave definitive form to the mystical commentaries on the Old Testament. For centuries, medieval writers repeated the allegorical interpretations made and consecrated by the

Church Fathers. In the language of the thirteenth century, the "torrent of the Doctors" endlessly flows with the same doctrine. When we read through the Commentaries on the Scriptures by the Venerable Bede or Rabanus Maurus, we are surprised to find so little originality in their books. They copied the Church Fathers, if they did not simply copy Isidore of Seville. Moreover, it is clear that their works were written as textbooks and that they made no pretensions to originality. On the contrary, they were very careful to keep scrupulously to tradition.

The book most valued for its exactness during the Middle Ages, and that remained famous until the Renaissance, was a product of the school of Rabanus Maurus, written in the ninth century: the *Glossa ordinaria.*[28] Walafrid Strabo, its author, made no pretense to be anything more than a skillful compiler. The allegorical explanations he gives for each verse of the Bible conform perfectly to tradition; for the most part he merely quotes the Church Fathers, or Isidore of Seville, Bede, and Rabanus. The popularity of the *Glossa ordinaria*[29] in the Middle Ages makes it an extremely valuable book for us; it alone can take the place of almost all the other medieval commentaries. Similar works written in the eleventh and twelfth centuries added little to it. The same doctrine, somewhat expanded, is found in the *Allegoriae in Vetus Testamentum*, an anonymous work of the school of St. Victor.[30] We find it again at the end of the twelfth century, this time condensed into mnemonic verse, in the *Aurora* of Peter of Riga, canon of Reims.[31] Many other names could be cited.

It would obviously be foolish to say that the clerics directing the artists consulted one commentary rather than another for interpretations of the Bible. However, we may conjecture that the *Glossa ordinaria*, a convenient teaching manual used in all the monastic and episcopal schools, was used most often. In any case, this is one of the most useful books to come down to us from the Middle Ages, since it gives the answers to most of the questions raised by allegorical interpretations of the Bible.

Thus, at the beginning of the thirteenth century, when artists were decorating the cathedrals, the Church Doctors placed all their authority behind the doctrine that the Scriptures were both history and symbol. It was granted that the Bible could be interpreted in four different ways: historically, allegorically, tropologically, and anagogically. The historical interpretation dealt with the events as they had happened, the allegorical interpretation showed the Old Testament as a prefiguration of the New, the tropological meaning unveiled the moral truth concealed behind the letter of the Scriptures, and the anagogical interpretation—as the term indicates—gave a glimpse of the mysteries of future life and eternal bliss. To give an example, the name of Jerusalem, which occurs so often in the Scriptures, might be interpreted in one of four ways. William Durandus

said, "In the historic sense, Jerusalem is the town in Palestine where pilgrims now go; in the allegorical sense, it is the Church Militant; in the tropological sense, it is the Christian soul; and in the anagogical sense, it is the Heavenly Jerusalem, the heavenly home."[32] All passages from the Bible do not permit a four-fold interpretation; some can be understood only in three ways. The story of Job's suffering, for instance, is first of all an historical account; it is an allegory of Christ's Passion; and lastly, in the tropological sense, it symbolizes the trials of the Christian soul.[33] Other passages can be interpreted in only two ways, and many must simply be taken literally.

Such was the method adopted by the Schools.[34] In this, as we have seen, the Middle Ages conformed to the tradition of the Early Christian era, being neither bolder nor subtler than the Church Fathers. The allegorical interpretation of the Bible, then, is a fundamental part of Christian tradition.

This brief sketch of the relation of ideas was necessary if we are to understand the influences at work on the curious works of art we are to study.

II

The most imposing works in Gothic art devoted to the concordance of the two Testaments are stained glass windows.[35] The famous windows of Bourges (fig. 99),[36] Chartres, Le Mans, Tours, Lyon, and Rouen all treated the same doctrine in almost the same manner. The great symbolic pages we are about to study are almost always arranged in the same way: a central medallion shows the factual scene, while nearby medallions show the symbolic scenes.[37]

The mystical representations taken from the Old Testament are generally grouped around the great drama of the Passion. Around Christ Carrying the Cross, our thirteenth-century windows grouped Isaac carrying the wood for the sacrifice, the Jews marking the doors of their houses with the mysterious *tau*, the widow of Sarepta gathering up the two sticks of wood in the presence of the prophet Elijah, and the patriarch Jacob blessing the two sons of Joseph, Ephraim and Manasses.

These, the scenes from the Old Testament are, in fact, figures in which the commentators make us perceive the cross of Jesus Christ. The *Glossa ordinaria* tells us first of all that Isaac is a symbol of the Son of God, just as Abraham symbolizes the Father. God, who was to give his son for mankind, desired that the people of the Old Law be given an intimation of the great sacrifice. The entire passage of the Bible in which the sacrifice of Abraham is told is filled with mystery, and each word must be

The figures of the Old Testament in medieval art. Figures relating to Christ. The symbolic windows of Bourges, Chartres, Le Mans, and Tours.

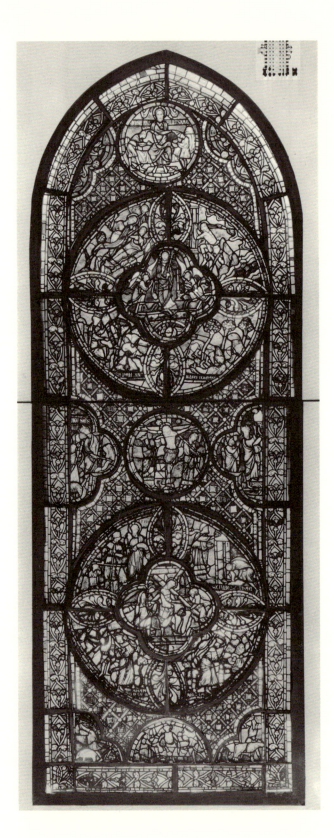

99. Symbolic window. Bourges (Cher),
Cathedral of St.-Etienne. Ambulatory,
stained glass panel.

weighed. For example, the three days' walk separating Abraham's house from the land of Moriah signifies the three ages of the Jewish people, from Abraham to Moses, from Moses to John the Baptist, and from John the Baptist to the Lord. The two servants who went with Abraham are the two halves of the Jewish people, Israel and Judah. The ass that unknowingly carried the instruments of the sacrifice is the uncomprehending Synagogue. Lastly, the wood carried by Isaac on his shoulder is the cross of Christ itself.[38]

The sign drawn with the blood of the lamb on the doors of their houses by the Jews was also taken to be a figure of the cross. The commentators were accustomed to bring together this passage from Exodus and one from Ezekiel in which the prophet tells that he saw the angel of the Lord mark the letter *tau* on the foreheads of the just. It was thought that the *tau* of Ezekiel must be the same sign that the Jews in Egypt had drawn on their doors. And also, since the letter *tau* (T) resembles the form of the cross, the conclusion was that the two passages alluded to the cross of Jesus Christ.[39]

The medallion of the prophet Elijah and the widow of Sarepta again prefigures the same mystery. Elijah, driven out by the Jews, is sent by God to the country of the Gentiles, to the house of a widow of Sarepta in the land of Zidon. When he arrives there, the widow has just drawn water and she now picks up two sticks of wood. In this story, there is nothing that is not symbolic. Elijah, driven out by the Jews and later taken up to heaven in a chariot of fire, is a prefiguration of Christ. The widow of Sarepta is the Church of the Gentiles receiving the Saviour whom the Synagogue had rejected. She has drawn water to indicate that she will believe thereafter in the virtue of baptism, and she gathers two sticks as a way of saying that she awaits salvation through the cross.[40] That is why both the Bourges artist (fig. 99) and the Le Mans artist placed in the widow of Sarepta's hands not two sticks of wood but an actual cross.

At Le Mans and Tours, the Carrying of the Cross is accompanied by a fourth symbolic scene: the patriarch Jacob blessing Ephraim and Manasses, the sons of Joseph. According to the interpreters, this is also a prefiguration of the cross, for in fact, Jacob blessed his grandsons "by crossing one hand over the other," as the biblical text says—a gesture that seemed full of mystery to all the commentators.[41] The glass painter of Bourges reproduced the same scene, but he placed it at the very top of the window, in the place of honor (fig. 99). By doing so, he apparently wanted to express a more general and deeper thought than the artists of Le Mans and Tours had done. The Church Fathers had remarked that Jacob, when he blessed his grandsons with one hand crossed over the

other, had shown that he preferred the younger son to the older, for he placed his right hand upon Ephraim, the younger son. Jacob's blessing thus became an image of the New Covenant: Manasses represented the Jewish people, and Ephraim the Gentiles. By preferring Ephraim to Manasses, Jacob, the symbol of Christ, foretold that through the mystery of the cross, the Messiah would supplant the ancient peoples with the new.[42] By placing the scene of Jacob's blessing at the highest point of his window, the Bourges artist no doubt wished to express the thought that Jesus died on the cross not for the chosen people but for all mankind.[43]

After the Carrying of the Cross, the richest symbolism in our stained glass windows was centered around the Crucifixion. In the medallions surrounding the crucified Christ, we see the image of Moses smiting the rock and causing water to flow abundantly,[44] the brazen serpent,[45] the death of Abel,[46] and lastly, the miraculous branch with its cluster of grapes brought from the Promised Land (figs. 99 and 100).[47]

Since St. Paul, the Church had considered the rock smitten by Moses to be the image of Christ.[48] This connection, briefly mentioned by the apostle, had been dwelt on at length by the commentators of Exodus. According to the *Glossa ordinaria*, which summarizes all of them, the water that sprang forth abundantly when Moses smote the rock is the water and the blood that flowed from Christ's side when he was pierced by the lance of the centurion. The multitude crying out against Moses as they await the miracle symbolizes the new peoples who no longer wish to submit to the Judaic law and who will one day slake their thirst with the living waters of the New Testament.[49] We understand how such a scene, seemingly so far removed from the Crucifixion, can have been related to it.

The brazen serpent, set up for a sign by Moses for the healing of the people, had already been given in the Gospels as a figure of the Crucifixion. Consequently, the commentators explained this passage from the Old Testament more briefly than was their usual custom. No doubt they assumed that it was well known. Isidore of Seville, citing the *Glossa ordinaria*, simply states that Jesus is the new serpent that had vanquished the ancient serpent, and he adds that brass, the hardest and most durable of all metals, was chosen by Moses to express the divinity of Christ and the eternity of his reign.[50]

The death of Abel, the first of the just and the prototype of the future Messiah, was taken by the interpreters as a transparent symbol of the death of Christ. They merely said that Cain, the eldest of Adam's children, was a clear symbol of the ancient people of God. Abel, killed by Cain, was Jesus killed by the Jews.[51]

On the other hand, the cluster of grapes brought from the Promised Land was not so easy to interpret, and the commentators dwelt at length

on this famous passage from Numbers. The twelve spies sent by Moses into the land of Canaan, and who declared when they returned that the Promised Land could not be conquered, are the scribes and Pharisees who persuaded the Jews not to believe in Christ. Jesus, moreover, was among them in the figure of the miraculous cluster of grapes. These grapes, carried on a pole by two of the spies, are the symbol of Christ on the cross. For Christ is the mystical cluster of grapes whose blood filled the chalice of the Church.[52] The two bearers also express a mystery. The one who walked in front, turning his back on the grapes, symbolizes the blind and uncomprehending Jewish people who turned their backs on the truth. The one who walked behind with his eyes fixed on the grapes is the image of the Gentiles who go forward with their eyes on the cross of Jesus Christ.[53] This mystical explanation, which is that given by the *Glossa ordinaria,* was followed to the letter by the artist who designed

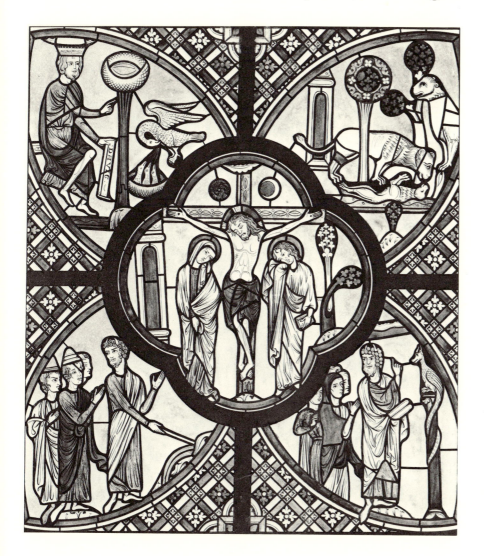

100. Symbolic window. Le Mans (Sarthe), Cathedral of St.-Julien. Chapel of the Virgin, central window, stained glass panel.

the symbolic subjects for the reliquary of the True Cross at Tongres.[54] On the head of the first bearer, who does not see the grapes, he placed the conical hat worn by the Jews to make clear that the figure symbolizes the Old Law. By this example we see how faithfully the artists of the Middle Ages translated the thought of the Church.

Like the Passion, the Resurrection had been foretold by biblical symbols, which are also found in our windows. The most famous of all was taken from the story of Jonah. By issuing alive from the belly of the whale, the prophet foretold the victory of the Son of Man over death. As we have seen, the Gospels had already indicated this connection. The commentators observed that Jonah had lived for three days in the whale's belly, just as Jesus had remained for three days in the tomb.[55] In the windows of Bourges, Le Mans, and Lyon, the scene showing Jonah vomited up by the monster is placed close beside that of Jesus rising from the tomb (fig. 99).

Another biblical image sometimes[56] accompanying the Resurrection is of a somewhat more refined interpretation: the story of Elisha resurrecting the widow's son (fig. 101).[57] This has to do not with the Resurrection of Christ but of humankind itself, which rose from the tomb along with the Saviour. The *Glossa* interpretation is the following:[58] Elisha is a symbol of Jesus Christ. When he heard that the widow's son was dead, he gave his staff to his servant and told him to bring the child back to life. But the servant had not the divine strength to perform the miracle. This, said the *Glossa*, is an image of Moses, the servant whom God had armed with a rod to save his people and who was unable to do so. Like Elisha, Jesus came to accomplish the work of salvation. Elisha lay upon the dead

101. Elisha resurrects the son of the Sunamite. Le Mans (Sarthe), Cathedral of St.-Julien. Chapel of the Virgin, stained glass panel from Passion window.

child, put his mouth upon its mouth, his hands upon its hands, which is to say that Christ united himself with mankind by taking on a mortal body. Seven times Elisha breathed the breath of life into the dead mouth, which signifies that Christ brought to mankind the seven gifts of the Holy Spirit, and he arose with the live child as humanity rose from the tomb at the same time as Christ.

The window at Chartres shows us a new symbol of the Resurrection: Samson carrying off the gates of Gaza (fig. 102). Samson was led in chains to Gaza, and the Philistines shut the gates on him, thinking they could hold him prisoner. But during the night, the hero tore the doors from their hinges, placed them on his shoulders, and deposited them on the summit of the mountain. Samson is the symbol of Christ, and Gaza of the tomb in which the Jews thought to have imprisoned the Saviour for all time. But before dawn, he, like Samson, broke open the doors of the tomb and carried them with him to the mountain, that is, to heaven, thereby indicating that he had conquered death forever.[59]

These are examples of the way in which artists interpreted the Old Testament by placing it in correspondence with the New, and we see to what degree they participated in the thought of the commentators.[60]

102. Samson carries off the gates of Gaza. Chartres (Eure-et-Loir), Cathedral of Notre-Dame. North side aisle, stained glass panel from Redemption window.

III

The scenes taken from the Old Testament were not always grouped around Christ, however; they were sometimes around the Virgin.

Fairly early, the Church Doctors had said that certain details from the Old Testament should be considered as allusions to the virginity of Mary. It was only natural that the thirteenth century, which so lovingly honored the Virgin, should give artistic expression to some of these symbolic scenes. Two in particular inspired the artists: the passage from Exodus in which Moses saw God in the burning bush,[61] and from Judges in which Gideon called down the dew from heaven upon the fleece he had spread on the floor.[62] The Church Doctors had said that the burning bush is a symbol of the Virgin. This bush, which burned without being consumed and in which the Lord appeared in a flame of fire out of its midst, is an image "of her who, without being consumed, had received the divine fire in her womb."[63] Although the *Glossa ordinaria* gives another, this interpretation was accepted and was adopted by the Church in the Office of the Virgin. Although the mysterious fleece of Gideon was first thought to be a symbol of the Church,[64] later, especially toward the thirteenth century, it was taken to be an image of Mary. St. Bernard, who must always be consulted on questions of the cult of the Virgin in the Middle Ages, developed the allegorical meaning of the fleece of Gideon in one of his sermons: the dew that fell from heaven upon the fleece is a clear symbol of the Immaculate Conception.[65]

The thirteenth-century windows at Laon (fig. 9) and at Lyon show both of these symbols of the Virgin's virginity beside the scenes from her life.

But without question, the most remarkable symbolic work devoted to the glorification of the Virgin through biblical symbols is the portal of Laon Cathedral, at the left as you enter. Allow me to dwell on this important ensemble of sculpture, which has not yet been correctly described[66] nor properly understood.

The scenes from the life of the Virgin (Annunciation, Adoration of the Magi, Birth of Christ) carved on the lintel and tympanum of the door alert us that the entire doorway is devoted to the Mother of God. The presence of angels in the first band of the archivolts, and in the second band, the Christian Virtues usually attributed to the Virgin by the Church Doctors, confirm our first impression.[67] But the subject of the third band suddenly throws us off. We see the fleece of Gideon[68] and Moses before the burning bush, to be sure, but what is Daniel doing there,[69] crushing the dragon beneath his feet and then receiving the basket brought to him by Habakkuk in the lions' den (fig. 103)?[70] And what is the meaning of the Ark of the Covenant, shown above and designated

by its name *ARCHA DEI*, and lastly, a closed door near which a prophet is standing (fig. 104)? In the fourth band of the archivolts, there are scenes almost as disparate and as difficult to relate to a single idea. A young girl takes an animal (a unicorn, as we shall see) onto her lap, and the inscription reads *CAPITUR*.[71] We also see Balaam, who is identified by the inscription *B[ALAA]M: ORIETUR STELLA EX JACOB*; and King Nebuchadnezzar asleep on his bed and seeing in his dream the statue of gold, silver, brass, iron, and clay, which is shown above him with the inscription *STATUA*; then a personage crowning a king; a woman carrying a tablet for whom there is an enigmatic inscription: *ET: P: SECLA: FUTURUS*; and lastly, the three young Hebrews in the fiery furnace, with the inscription which has been preserved in its entirety: *TRES: PUERI: IN: FORNACE*.

103. Daniel trampling the dragon; Daniel and Habakkuk. Laon (Aisne), Notre-Dame. West façade, left portal, archivolts.

104. Ark of the Covenant; prophet. Laon (Aisne), Cathedral of Notre-Dame. West façade, left portal, archivolts.

What could be the meaning of such diverse subjects, and what idea was responsible for such an arrangement? We find the clearest possible answer to this question in the *Speculum ecclesiae* of Honorius of Autun. We have already mentioned the popularity of his book in the Middle Ages, and here is another instance of it. The sermon given in the *Speculum ecclesiae* for the day of the Feast of the Annunciation explains and unifies the figures on the Laon portal.[72] Honorius of Autun sought to prove that the mystery of the virginity of Mary had been foretold by the prophets and revealed symbolically in the Old Testament. This is his explanation:[73] "Moses saw a burning bush that the flames could not consume and in the midst of which God appeared. That is a figure of the Holy Virgin, for she carried within herself the flame of the Holy Spirit, without burning with the fire of lust. . . . Aaron, following God's command, placed a dry rod in the Ark of the Covenant,[74] and the following day the rod flowered and produced fruit. The sterile rod which bore fruit is the Virgin Mary who gave birth to Christ, both God and man. . . . Gideon, a judge of Israel, spread a fleece on the threshing floor and the dew of heaven fell upon it without wetting the floor. The fleece on which the dew fell is the Holy Virgin who became fruitful; the floor that remained dry is her virginity which remained untainted. . . . Ezekiel saw a gate that was always shut, through which only the King of Kings had passed, and after he passed, he left it closed. Holy Mary is the gate of heaven who remained inviolate before, during, and after Christ's birth.[75] King Nebuchadnezzar saw a statue with a head of gold, breast and arms of silver, belly and thighs of brass, legs of iron, and feet of clay. A stone, cut out of the mountain without the help of hands, struck the statue, reducing it to powder. But the stone that struck the statue became a great mountain and filled the whole earth. The various materials of the statue are the different kingdoms. The stone cut out of the mountain without the help of hands is Jesus Christ born of a Virgin whom no one had touched with his hands. Christ will subjugate all peoples and reign forever.[76] The same King Nebuchadnezzar had a golden statue made that was sixty cubits high and six cubits broad, and commanded all the people to worship it. But Shadrach, Meshach, and Abednego refused to bow before it. The angered king had them bound in chains and commanded that they be thrown into a fiery furnace heated seven times hotter than was usual. Now by the will of God, the flame of fire coming from the furnace burned those who were outside, but did not singe even a hair of the heads of those within. Meanwhile, they sang in the midst of the flames, and the king saw that the Son of God was with them. It was thus that the Holy Spirit fecundated the Virgin with his inner fire, while protecting her without from the lusts of the flesh. . . . Authorized by the king, Daniel destroyed the idol of the Babylonians, and killed a dragon

they worshiped.[77] That is why the angry Babylonians threw him into the lions' den, and a large stone was laid upon the mouth of the den for seven days; the king sealed it with his own ring. Then the angel of the Lord brought out of Judea the prophet Habakkuk with a basket of food, and set him down on the lions' den. Habakkuk passed the food to Daniel without breaking the seal of the cave. When the king came on the seventh day, he found the seal unbroken, and Daniel alive. He praised God, and commanded that Daniel be taken out of the den and his enemies thrown to the lions. It is thus that Christ entered into the womb of his mother without breaking the seal of virginity, and issued forth from the virginal place without touching the seal."

We cannot but be struck by the close similarity between the written work and the sculpture. Both use the same examples, and in the story of Daniel especially, the artist followed the text so closely that he even represented episodes (such as the death of the serpent) which do not contribute directly to the proof of Mary's virginity. We can say with certainty that Honorius of Autun's sermon was the program given the artist to follow. But there were still empty spaces to fill in the archivolts, and two symbolic scenes taken from two other sermons devoted to the Virgin by Honorius were used. The first relief represents a young girl holding a unicorn on her lap.[78] We have already seen what meaning Honorius of Autun gave to this scene: he saw in it an image of the Incarnation. The second relief represents the prophet Balaam foretelling, as the inscription says, that a star would be born of Jacob. This was well known, and Honorius of Autun had no trouble in demonstrating that this prophecy again concerns the birth of Christ.[79]

I have dwelt at length on the Laon portal because no one had yet understood the true meaning of the great ensemble of sculpture, which, as we see, is devoted entirely to the virginity of Mary, and because it so clearly reveals the close relation between written works and works of art.[80]

Several other thirteenth-century works can be cited in which the person of Mary is symbolized in scenes from the Old Testament.[81] Of the first rank are the reliefs of the west portal of Amiens Cathedral, all of which are devoted to the Mother of God.[82] Above the two large statues of the right wall representing the Virgin and the Angel of the Annunciation, there are four reliefs with scenes familiar to us (fig. 105): the stone which Daniel sees cut out of the mountain, Moses and the burning bush, the fleece of Gideon, Aaron's rod. Since they are the same scenes as those on the cathedral of Laon, we must suppose that both the Amiens and the Laon artist took them from Honorius of Autun's sermon on the Annunciation. The scene of the Annunciation accompanying the reliefs at Amiens makes my hypothesis very likely.

105. Symbolic reliefs relating to the Virgin. Amiens
(Somme), Cathedral. West façade, right portal, right socle.

106. Life of the Virgin. St.-Quentin (Aisne), Collegiate
Church. Apsidal chapel, stained glass window.

A window of the collegiate church of St.-Quentin[83] seems to derive from the same text (fig. 106). Scenes from the life of the Virgin are placed in correspondence with these same symbolic figures from the Old Testament. The Annunciation is accompanied by Nebuchadnezzar seeing the statue in his dream, and Aaron wearing priestly ornaments.[84] The birth of Christ is accompanied by the fleece of Gideon and the burning bush of Moses. The Adoration of the Magi is placed beside the prophecy of Balaam, who rides an ass. The similarity of the St.-Quentin window and the portals of Laon and Amiens is close enough for us to suppose that all three works derived from the same sermons of Honorius of Autun.

Each of the three great symbolic works of art just discussed is new proof of the cult devoted to the Mother of God in the Middle Ages. The artists wished us to think of the Virgin when they painted or carved the scenes from the Old Testament that are ostensibly so far removed from her.

IV

As we see, the Middle Ages was fond of foreshadowing the New Testament with scenes taken from the Old. But as early as the twelfth century, artists had imagined an even simpler way of representing Christ in the Old Law. At the entrance to the cathedral, they simply placed the patriarchs or the kings designated by the Church Fathers as figures of the Saviour. Thus, on the very threshold, the saints of the Old Testament foretold Christ, and so became "the heralds of God," as St. Augustine said. On the north porch of Chartres, Melchizedek, Abraham, Moses, Samuel, and David stand at the entrance to the sanctuary.[85] These great statues are among the most extraordinary carved in the Middle Ages (figs. 107 and 108). They are so superhuman, they seem to belong to another race of men. It is as if they were moulded of primeval clay, and belong to the first days of the world. The art of the early thirteenth century, unskilled in rendering individual character, powerfully expressed what is universal and eternal in all human forms. The patriarchs and prophets of Chartres appear to be the fathers of peoples, the pillars of humanity. But what adds infinitely to their grandeur and mystery is that they recall someone greater than they, and form a symbolic way leading to Christ. At Reims, in the south bay of the west portal, there are the same symbolic figures, arranged almost in the same order as at Chartres and astonishingly like them (fig. 109). They are to be found again at Senlis, but because of clumsy restorations, all of them cannot be identified.[86] Before the Revolution, they appeared also on the portal of the col-

The patriarchs and the kings. Their symbolic role.

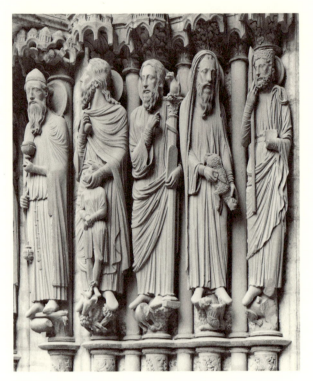 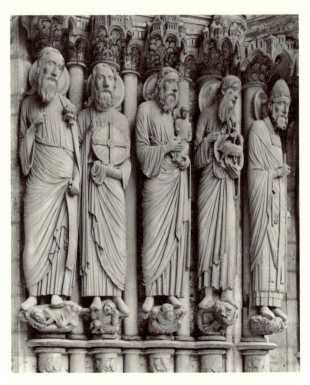

107. Melchizedek, Abraham, Moses, Samuel, David. Chartres (Eure-et-Loir), Cathedral of Notre-Dame. North transept, central portal, left jambs.

108. Isaiah, Jeremiah, Simeon, St. John the Baptist, St. Peter. Chartres (Eure-et-Loir), Cathedral of Notre-Dame. North transept, central portal, right jambs.

legiate church of St.-Nicolas, at Amiens.[87] An incomplete series still exists on the portal of St. Benoît-sur-Loire, and among the mutilated statues we easily recognize Abraham placing his hand on the head of his son, and King David.[88] In the last century, a series quite similar to the preceding decorated the portal of the collegiate church of St.-Madeleine, at Besançon.[89] All these ensembles derive from one prototype and express the same thought.

Different series devoted to the figures of the Old Law are found in other cathedrals: the statues of the upper parts of the cathedral of Lyon,[90] and the figurines in the archivolts of the portal of St.-Honoré, at Amiens.

The clearest commentary known to me on all these works of art is the manual that Isidore of Seville called *Allegoriae quaedam sacrae scripturae*.[91] In this little book, he enumerated the principal figures of the Old Testament and explained their mystical meaning. The few lines he devoted to each are sometimes so brief and concise that they could be carved on phylacteries and placed in the hands of the statues. Isidore of Seville's manual answers all the problems raised by the presence of an Old Testament character in a thirteenth-century work. We shall borrow from him the explanation of the symbolic statues of Chartres, Reims, Amiens, Senlis, and Lyon.

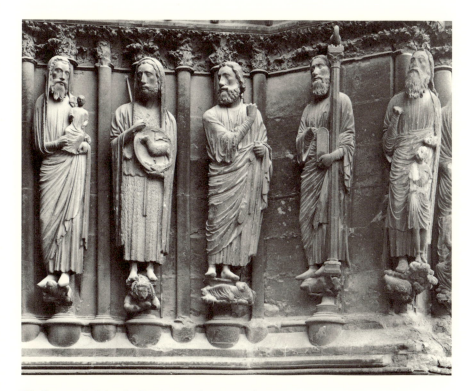

109. Simeon, St. John the Baptist, Isaiah, Moses, Abraham.
Reims (Marne), Cathedral of Notre-Dame. West façade,
right portal, right jambs.

Adam is the first prototype of Christ, and also the most meaningful
(fig. 110).[92] Christ is the new Adam. The first Adam was created on the
sixth day, and the second was incarnated in the sixth age of the world.
Through the sin of the first, we were lost; the other saved us by his death,
and by dying, remade man in the image of God.[93] We understand why
in the Middle Ages Adam was so often placed at the foot of Christ's
cross, and why it was thought that the tree of the earthly paradise, mi-
raculously preserved throughout the ages, served to make the cross of
Christ. The legend was beautiful and thrilling, and gave popular form
to the dogma of the Fall and of Redemption.

Abel is the second prototype of Christ.[94] It was not only by his death
that he symbolized the Saviour, but also by his life. He was a shepherd
and in the beginning of time he foreshadowed the other shepherd who
said of himself, "I am the good shepherd who gives his life for his
sheep."[95] Consequently, in medieval art the distinctive mark of Abel is a
lamb.

Noah prefigured Christ, and Noah's Ark symbolizes the Church of
Jesus Christ (fig. 110).[96] The ark was made of wood, as was the cross.
By means of mystical numbers, the dimensions of the ark prefigured the
dimensions of the cross. The ark had been built by Noah, the only just

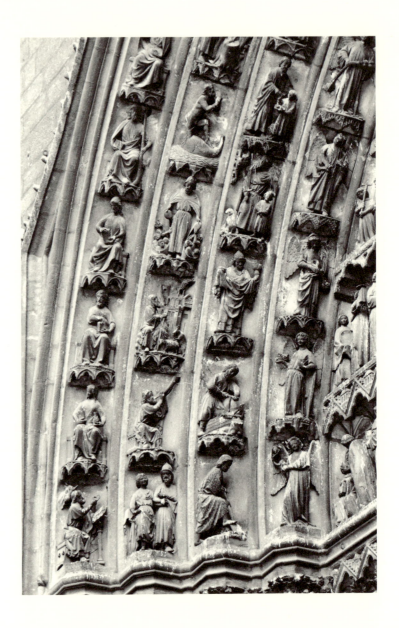

110. Patriarchs and prophets. Amiens
(Somme), Cathedral. Portal of St. Honoré,
south façade, archivolts to left of
tympanum.

man of the ancient world, as the Church had been erected by Jesus Christ, the Just par excellence. Lastly, the ark had floated upon the waters of the flood to teach mankind that the Church finds its salvation in the waters of baptism: a truth signified in another way by the eight persons shut up within the ark, for eight is the number of regeneration and eternal life.[97]

Melchizedek became the most famous of all the prototypes of Christ because of the Canon of the Mass in which his name figures.[98] The Bible, which speaks of him so mysteriously, says that he was both pontiff and king, two titles appropriate only to Christ. In the first days of the world, by offering the bread and wine to Abraham, Melchizedek foretold the

divine sacrifice that Christ was later to institute.[99] The mystical idea evoked by the name of Melchizedek was felicitously expressed by the artist at Chartres: he placed a tiara encompassed with a crown on the brow of the ancient king of Salem and a chalice in his hand. The Reims artist was even bolder. He represented Melchizedek presenting the bread in the form of the Eucharistic host to Abraham (fig. 111).[100]

111. Melchizedek and Abraham. Reims (Marne), Cathedral of Notre-Dame. West façade.

Abraham, who at Chartres, Reims, Amiens, and Senlis is represented raising a knife against his son Isaac,[101] is too clear a figure to require further explanation. It is enough to remark that here it is Isaac, not Abraham, who symbolizes Christ. At Chartres, a ram is carved on the socle of the statue of Abraham and Isaac (fig. 107). According to the biblical story, the patriarch found a ram caught by its horns in briars, and he sacrificed it instead of Isaac. The episode of the ram constituted a mystery for the commentators, who saw in it a new symbol of Christ's sacrifice. The ram's horns, which held him fast in the briars, became a symbol of the two arms of the cross, and the briars in which his head stuck fast were considered to be an allusion to the crown of thorns.[102]

112. Joseph's dream. Bourges (Cher),
Cathedral of St.-Etienne. Ambulatory,
stained glass panel.

The patriarch Joseph prefigures Christ, not because of any single act, but by his entire life. Isidore of Seville merely says in general that like Jesus, Joseph had been betrayed by his family, and also like him, had been received into a foreign nation.[103] This would be enough to explain the presence of Joseph's statue on the portal of Chartres.[104] But Isidore of Seville's somewhat vague parallel did not satisfy the thirteenth century; the comparison between Joseph and Jesus was worked out in detail. A window at Bourges, for example, represents several symbolic scenes from the life of Joseph. It would be possible to see in them merely a simple story if the seven stars which dominate the whole composition, and which were considered to be Christ's emblem, did not warn us that, in the artist's mind, the life of Joseph is only a prefiguration of that of Christ.[105] The chapters on Joseph in the *Glossa ordinaria*[106] leave little doubt about the intention of the artist who designed the Bourges window, and we may assume that Joseph's dream, represented first in the window (fig. 112), conforms to the exegesis of the time and alludes to the reign of Christ. And in fact, Joseph dreamed that the sun and the moon worshiped him because it was said to the Saviour: "The moon and the sun shall adore Thee and all the stars." His brothers rose up against him when he told them his dream, just as the Jews, among whom Jesus was born and whom he called his brothers, rose up against the Saviour. Joseph, shown in other sections of the window stripped of his coat, thrown into the pit (fig. 113), and sold for twenty pieces of silver to the Ishmaelite merchants, successively symbolizes the betrayal, the Passion, and the death of Christ. The coat stripped from him is the humanity that

113. Joseph cast into the well. Bourges (Cher), Cathedral of St.-Etienne. Ambulatory, stained glass panel.

clothed Christ until it was taken from him by his death on the cross. The pit into which Joseph was thrown after he was stripped of his coat is Limbo, into which Jesus descended after his death. Lastly, the twenty pieces of silver paid for Joseph by the Ishmaelite merchants recall the thirty pieces of silver of Christ's betrayal. The story of Joseph and Potiphar's wife, shown in successive medallions, is another allusion to Christ's Passion. Potiphar's wife symbolizes the Synagogue, given to committing adultery with foreign gods. The Synagogue tried to seduce Jesus who repulsed its doctrine and finally left his garment in its hands, that is to say, he left his body which he cast off upon the cross. Joseph's triumph, the crowning scene of the window, symbolizes the victory of Christ over death and his eternal reign.

Such is the veiled meaning of the Bourges window. Where the people had seen only a touching story, theologians recognized a symbol.

After Joseph, Moses is one of the characteristic prototypes of Christ.[107] He brought the first Law to the Jews, just as Jesus brought the second. Consequently, at Chartres, Reims, and Amiens, he is represented with the Tables of the Law in his hand. According to the Church Fathers, many details in the story of his life foreshadowed Christ.[108] The sculptors rarely used any but one: Moses raising the brazen serpent. They all put in his hand a column surmounted by a winged dragon.[109]

David and Solomon were also popular prefigurations of Christ. As always, the reasons for this are many. However, several seemed conclusive to thirteenth-century artists. At Chartres and Amiens, they wished above all to recall that the anointing of David by Samuel was a symbol of an-

other more majestic anointing—the anointing of him who was called *"l'oint du Seigneur"* (Anointed of the Lord). At Amiens, we see Samuel pouring oil on David's head,[110] while at Chartres, the statue of Samuel is simply placed beside that of David.

It was not without reason that Solomon's statue was placed beside that of the Queen of Sheba at Chartres, Amiens, and Reims.[111] This was meant to signify that, in conformance with ecclesiastical doctrine, Solomon symbolized Christ, and the Queen of Sheba symbolized the Church that hastened from the ends of the earth to hear the word of God.[112]

The foregoing are the most famous prototypes of Christ, and those the Middle Ages represented with the most grandeur. But many others could also be cited. There are grounds for supposing, for example, that the scenes from the lives of Job, Tobias, Samson, and Gideon filling the archivolts and tympanum of the right bay in the north portal of Chartres were placed there with the intention of honoring Christ, of whom these Old Testament figures were symbols. Because of his suffering and his victory, Job is the prototype of the Passion and triumph of Christ.[113] Gideon is also a prototype, but for more mystical reasons. The victory he won with his three hundred companions prefigured the Saviour's victory won by dying on the cross, because the number 300 (T), as we have seen, is the hieroglyph of the cross.[114]

Tobias, who restored his old father's sight, is Christ who brought light to the people of God, become blind.[115] We have already said that Samson was usually considered the prototype of Christ as the conqueror of death.

From these examples, it appears that the souls of medieval Christians were filled with the love of Christ: they sought him everywhere, and everywhere they saw him. They read his name on every page of the Old Testament. This kind of symbolism is the key to many medieval works which otherwise would be unintelligible. We speak not only of art, but also of literary compositions. The symbolic bent of the Middle Ages alone can explain the structure of so apparently disconnected a work as the *Mistère du Viel Testament.*[116] Why had the anonymous fifteenth-century poets who composed this vast sacred drama not thought it necessary to give the same importance to all the parts of the Old Testament, and why did they choose one character rather than another? Why did they dwell particularly upon Adam, Noah, Abraham, Joseph, Moses, Samson, David, Solomon, Job, Tobias, Susanna, Judith, and Esther? Clearly because these biblical heroes and heroines were the most popular prototypes of Christ and Mary. The authors, moreover, did not intend to leave their readers in doubt of their meaning, and at the beginning of the story of Joseph, they have God the Father himself say that all the sufferings of the patriarchs are only prefigurations of the sufferings that his son would undergo.[117] Thus, the entire Mystery play is composed like a ca-

thedral portal. The characters in the drama are the same as those represented, for analogous reasons, at Chartres and Amiens.[118]

Thus, in the Middle Ages, all the arts were united in giving the same religious instruction to the people.

V

After the patriarchs and the kings who by their lives prefigured Christ, the Middle Ages represented the prophets who foretold Christ by their words (fig. 114). And these are the most extraordinary figures of the Old Testament. These visionaries torn by God from their flocks and their sycamores, who wrestled with the spirit, who felt themselves snatched by the hair, who cried: "Lord, Lord, I am not eloquent!"; who, overcome by an unknown force, stood at the gates of towns to foretell frightful calamities; who prophesied from the bottoms of wells; who shaved off their hair and eyebrows, rent their cloaks, walked barefoot in the desert —these superhuman visionaries were the very subjects to arouse the imaginations of the great thirteenth-century artists. It must be admitted, however, that only Michelangelo was able to create a profoundly moving image of them. His truly biblical spirit alone was able to express the hopes and fears of the ancient world; he alone could render the infinite sadness of Jeremiah whose head rests on his hand, or the rapture of the young Daniel as he feels the breath of the spirit raise his hair. The Middle Ages never tried to equal this.[119]

In their representations of prophets, the sober artists of the thirteenth century were again performing dogmatic work. Their sole preoccupation was to express the theological truth that the prophets were the apostles of the Old Law, and that their prophecies differed very little. With this intent, in the windows of the apse at Bourges, for example, they placed the four great evangelists and the twelve apostles in correspondence with the four great and the twelve minor prophets (fig. 115).[120] They clothed the latter in the same tunic as the apostles and gave them the same book and nimbus. The only distinction they made is the cone-shaped Jew's hat worn by some of the prophets.[121] It is as if they were urging the faithful to draw the parallel themselves. However lacking in individuality, these images are nevertheless profoundly impressive. The prophets of the Bourges window, monotonous in aspect and crudely primitive in execution, but awe-inspiring at such a height, appear as a solemn assembly of witnesses. Their names are inscribed beneath their feet: Amos, Joel, Nahum, Zephaniah. . . . And the names themselves, coming from such antiquity, seem to add to their mystery.

This conception of the prophets' role explains why the Middle Ages did not bother to individualize them: they were thought of only as shad-

The prophets. Attempts in medieval art to represent their prophecies.

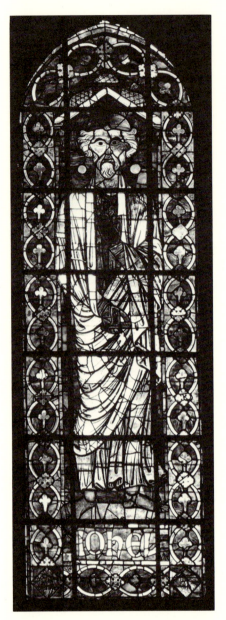

114. The prophet Amos. Le Mans (Sarthe),
Cathedral of St.-Julien. Chapel of the
Virgin, stained glass (detail).

115. The prophet Joel. Bourges (Cher),
Cathedral of St.-Etienne, stained glass.

ows of the apostles.[122] The astonishing poetry of the prophetic books moved the men of the times less than the commentaries on them made by St. Jerome, Walafrid Strabo, and Rupert. Unless the name of Christ was read into every line, they found the lamentations of Jeremiah and the maledictions of Ezekiel vapid and meaningless. Thus, they treated the prophets as symbols that were of value only when placed in relation to Jesus and his apostles.

The St.-Honoré portal at Amiens is one of the few thirteenth-century works in which the prophets are treated as individuals (fig. 110).[123] Yet even here their distinguishing features are taken less from their works

than from their legendary history. We see Isaiah with cleft skull, martyrized by his executioners, Jeremiah stoned as he lies on the ground, Daniel defending Susanna when the elders accuse her, and Hosea giving his hand to the symbolic prostitute he married.[124] For these, the artist used the little historical manuals in current use, in which all the legends dating from the earliest times were summarized. I have no doubt that the short treatise *De ortu et obitu Patrum*, attributed to Isidore of Seville, was the principal source of all that the Middle Ages told of the prophets.[125] This kind of biographical dictionary, a mixture of history and legend, is a very brief summary of the lives and deaths of biblical heroes. The apocryphal legends of the Jews, which St. Jerome had done so much to make known in the West, especially by his letters to Pope Damasus, were placed in the same category as the most solidly established historical facts. There we read that Isaiah was sawed in two during the reign of Manasses, and that Jeremiah, a captive in Egypt, was stoned to death by men and women near the town of Taphnas. These legends, summarized in Isidore's work, were extremely popular in the Middle Ages. In the twelfth century, they were repeated in Peter Comestor's famous *Historia scholastica*[126] in which almost all the traditions are collected, and in the thirteenth century, in Vincent of Beauvais' *Speculum historiale* which only expanded Comestor's work. All the same, iconography owes little to these legendary stories. The apocryphal history of the prophets is far less important in medieval art than the apocryphal history of the apostles.

However, there was another way of characterizing the prophets in the thirteenth century. Phylacteries inscribed with verses from their books were placed in their hands (fig. 116).[127] Thus, the prophetic words were given more importance than the prophets themselves, and in this way, the artists expressed the thought that all the great visionaries of the Old Testament were but mouthpieces through which God spoke. The prophecies that were once painted on stone banderoles have not survived the ravages of time, but it is likely that they corresponded to the place assigned to the prophets in the great monumental compositions. The prophet Isaiah on the north porch of Chartres, near the statue of the Virgin, probably foretold by the inscription on his phylactery that a flower would come forth from the root of Jesse. Long before, the Church Fathers had classified the passages from the prophets that related to the birth, life, Passion, and death of Christ, and the artist had only to choose the one suitable to his subject.[128] But the book most often referred to by artists would seem to be the famous discourse *Contra Judaeos, Paganos et Arianos*, attributed to St. Augustine.[129] The anonymous orator had one prophet after another pass in procession and pronounce a verse from his work relating to the divinity of Christ. The sermon of the Pseudo-Augus-

tine, read at matins on Christmas day, was famous throughout Christendom. Marius Sepet has shown, as we know, that liturgical drama grew out of it.[130] Julien Durand also demonstrated that many great medieval artistic cycles are related to it. The prophets of Notre-Dame-la-Grande, at Poitiers, and those on the façade of the cathedrals of Ferrara and Cremona carry phylacteries carved with the very words they pronounced in the sermon of the Pseudo-Augustine.[131]

At Amiens, where the prophets are placed on the west façade, the prophetic verses, usually inscribed on banderoles, were ingeniously replaced by small reliefs carved below the statues (fig. 117) in an effort to give plastic form to some of the most famous prophecies of the Old Testament. Beneath Zephaniah, for example, we see the Lord visiting Jerusalem with lamp in hand, and beneath Haggai, the dry earth and the temple in ruins.[132] These small scenes placed in quatrefoils are naïve and pure. They have the same charm as the simple little woodcuts in late fifteenth-century French Books of Hours. But it must be admitted that they retain nothing of the grandeur of the originals they claim to translate. The shadowless poetry of the Bible, illuminated by the light of the East and blazing with metaphor, and the magnificent visions that ap-

116. A prophet. Reims (Marne), Cathedral at Notre-Dame. West façade, interior.

117. Prophets. Amiens (Somme), Cathedral. West façade, buttress, between central and right portals.

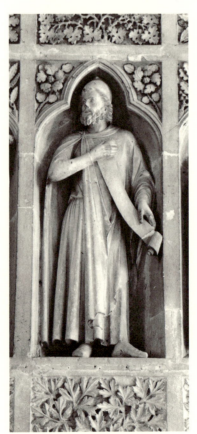

peared with the frightening clarity of reality before the eyes of the prophets would seem to be proper inspirations for art. But they are not. The visions of the prophets, however precise and detailed, cannot be limited by form. The artists of the thirteenth century learned this from experience. Today we are struck as much by the faults of their works as by their good qualities. For example, it is hard to imagine that the Amiens sculptor, who carved Ezekiel with his head resting on his hand as he contemplates a paltry little wheel (fig. 118), could possibly be illustrating this passage from the prophet: "Now as I beheld the living creatures, behold one wheel upon the earth by the living creatures, with his four faces. The appearance of the wheels and their work was like unto the color of a beryl: and they four had one likeness: and their appearance and their work was as it were a wheel in the middle of a wheel. . . . As for their rings, they were so high that they were dreadful: and their rings were full of eyes round about them four. And when the living creatures went, the wheels went with them. . . . And the likeness of the firmament upon the heads of the living creature was as the color of the terrible crystal. . . ."[133] All the religious awe of such a vision disappears the moment an attempt is made to represent it.

Farther along, we see a medallion representing a small Gothic monument; a bird is perched on the lintel and a hedgehog stands in the open doorway (fig. 119). This would seem to refer to one of Aesop's fables and not to the terrifying passage from Zephaniah, which the artist claims to represent: "And he will stretch out his hand against the north, and destroy Assyria; and will make Nineveh a desolation, and dry like a wilderness. And flocks shall lie down in the midst of her, all the beasts of the nations: both the cormorant and the bittern shall lodge in the upper lintels of it: their voice shall sing in the windows: desolation shall be in the thresholds; for he shall uncover the cedar work."[134]

118. The vision of Ezekiel. Amiens (Somme), Cathedral. West façade, central portal, socle relief.

119. The prophecy of Zephaniah. Amiens (Somme), Cathedral. West façade, left portal, socle relief.

120. The vision of Zechariah. Amiens (Somme), Cathedral. West façade, socle reliefs.

In another medallion, below the feet of Zechariah, two winged women hold aloft another woman seated on a vessel. It is an elegant and well-balanced composition (fig. 120), but what has happened to the strangeness of the sacred text? "Then the angel that talked with me went forth, and said unto me, Lift up now thine eyes, and see what is this that goeth forth. And I said, What is it? And he said, This is an ephah that goeth forth. He said moreover, This is their resemblance through all the earth. And, behold, there was lifted up a talent of lead: and this is a woman that sitteth in the midst of the ephah. And he said, This is wickedness. . . . And, behold, there came out two women, and the wind was in their wings; for they had wings like the wings of a stork: and they lifted up the ephah between the earth and the heaven. Then said I to the angel that talked with me, Whither do these bear the ephah? And he said unto me, To build it an house in the land of Shinar. . . ."[135]

The precision of the sculpture destroys all the mystery of the prophetic dream.

However, our medieval artists rarely tried to express the too powerful poetry of the East. Who knows whether the Amiens sculptors had read the originals and had taken their subjects from the prophetic books themselves? It is doubtful. It is possible that they knew the prophets only

through treatises such as Isidore of Seville's *De ortu et obitu Patrum*, in which brief summaries of the most vivid parts of their prophecies were placed alongside the account of their lives.[136] In this way, the choice of the small scenes represented at Amiens would be explained, and their inadequacy as well.

VI

Of all the prophecies, there is really only one of any lasting inspiration to art, and that is Isaiah's prophecy of the Tree of Jesse: "And there shall come forth a rod out of the root of Jesse: and a flower shall rise up out of his root. And the spirit of the Lord shall rest upon him: the spirit of wisdom and of understanding, the spirit of counsel and of fortitude, the spirit of knowledge and of godliness. And he shall be filled with the spirit of the fear of the Lord. . . . In that day, the root of Jesse, will be displayed before all as an ensign."[137]

The Tree of Jesse. The kings of Judah on the façades of Notre-Dame of Paris, Amiens, and Chartres.

We may consult any commentator of Isaiah and find for this passage a symbolic explanation that had not varied since St. Jerome. In the twelfth century, the monk Herveus wrote: "The patriarch Jesse belonged to the royal family, and that is why the root of Jesse signifies the line of kings. The rod symbolizes Mary, just as the flower symbolizes Christ."[138]

The artists of the Middle Ages were not afraid of so abstract a motif.[139] They found a way that was both simple and magnificent to translate the text of Isaiah. With childlike candor, they interpreted the prophet's words literally. In the cathedral they set up a genealogical tree somewhat like those seen above feudal fireplaces, but much more imposing. Combining the verses from Isaiah with the genealogy of Christ as it is given in the Gospel of St. Matthew and recited on Christmas and the day of Epiphany,[140] they represented a great tree issuing from the belly of the sleeping Jesse;[141] along the branches they placed the kings of Judah; above the kings they placed the Virgin, and above her, Christ; lastly, for Jesus they made an aureole of seven doves to recall that upon him reposed the seven gifts of the Holy Spirit (fig. 122). This was in reality the heraldic tree of Christ: it made his nobility manifest. But to give to the composition its complete meaning, they placed alongside his ancestors according to the flesh, his ancestors according to the spirit. Beside the kings of Judah in the windows of St. Denis, Chartres (fig. 121), and the Ste.-Chapelle, we see the prophets, with finger raised, foretelling the Messiah who was to come. In this, art equaled, if not surpassed, the poetry of the text.[142]

The ancestors of Jesus were sometimes represented in a simpler way. On the façades of many of our great thirteenth-century cathedrals, there is a gallery of colossal statues, called the gallery of kings.

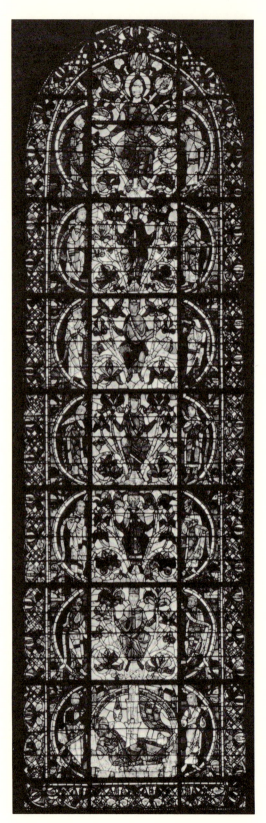

121. The Tree of Jesse. Chartres (Eure-et-Loir), Cathedral of Notre-Dame. Stained glass (detail).

122. The gifts of the Holy Spirit. Le Mans (Sarthe), Cathedral of St.-Julien. Ambulatory, stained glass.

What is the meaning of these statues? It was long thought that they represented the kings of France, but Didron, and after him, Viollet-le-Duc, stated unequivocally, but without furnishing decisive proof, that they represented the kings of Judah, the ancestors of Christ. Their opinion seemed to prevail, but in recent years scholars have gone back to the former tradition and claimed that the statues were in reality those of the kings of France.[143] I must say that although I have found nothing conclusive in their arguments, they have brought to light the difficulties of the problem. If it is impossible to demonstrate that the kings of Notre-Dame of Paris are the kings of France, it is not easier to prove that they are the kings of Judah. However, it is possible to say the following: first of all, it is clear that this new theme was first used at Notre-Dame of Paris. The gallery of kings of Notre-Dame must have been finished before 1220. It was from Paris that the idea spread. So, if we could learn who the kings of Notre-Dame represent, we would have the key to the enigma. Unfortunately, all the kings of Notre-Dame were mutilated during the Revolution and have been restored, so that a study of them can tell us nothing. We may remark, nevertheless, that there were twenty-eight, the number of Christ's ancestors from Jesse to Joseph as enumerated by St. Matthew. Of these twenty-eight ancestors, only fifteen, it is true, were kings, but they were all of royal blood, and it is precisely Christ's royal birth that the Middle Ages wished to bring to light. I am inclined to think that at Paris, where the earliest gallery of kings is to be found, the number twenty-eight was not chosen at random.[144] I recognize that no proof can be drawn from the number of kings elsewhere. In the Trees of Jesse, the number of the kings of Judah was never established: sometimes there are more than fifteen, sometimes less. The artists took the liberty of augmenting or diminishing the number of kings according to the space at their disposal.[145]

The gallery of kings of Notre-Dame was already finished in 1224 when the project of building the great porches before the transepts of Chartres Cathedral was conceived. There is no doubt that the master of works of Chartres was profoundly influenced by the façade of Notre-Dame of Paris. The Vices and Virtues on one of the pillars of the south porch are copies of those that decorate the lower part of the central portal of Notre-Dame of Paris. But this was not all: he also wanted to have a gallery of kings, and skillfully placed it beneath the arcades rising above the south porch. These arcades, it is true, are not continuous, but the intention of copying Notre-Dame of Paris is none the less evident. Now at Chartres, the eighteen kings of the gallery are intact, and they closely resemble the kings of France: they wear the long mantles of the thirteenth century, they wear crowns, and in their gloved hands they carry scepters (fig.

123). We might think that these are the Capets; however, they are the kings of Judah. The first king of the series, in fact, holds a long branch which grows out of a small figure asleep at his feet. This is King David, the son of Jesse, the ancestor of Christ, and, dispelling all doubt, in his left hand he carries the harp that designates him as the author of the Psalms. Thus, the eighteen kings of Chartres are eighteen kings of Judah. Consequently, one thing is certain: one gallery of kings, that of the south transept of Chartres, is a gallery of the kings of Judah. And since we know that the master of Chartres did not invent this motif, we may suppose that his model, the gallery of Notre-Dame of Paris, was also decorated with statues of the kings of Judah, and not of the kings of France.

But at Chartres, another gallery of kings complicates the problem. At a date difficult to determine but which could not have been long after the first quarter of the thirteenth century, sixteen statues of kings were arranged beneath the arcades above the rose window of the west façade. It is strange, to be sure, that the master of Chartres should have wished to erect a second gallery of kings of Judah. But here again we sense the desire to imitate an arrangement that had given so monumental a character to the façade of Notre-Dame of Paris. There is a curious likeness between the two series, at Paris and at Chartres: both are dominated by a statue of the Virgin carrying the Child and standing between two angels.[146] In the Trees of Jesse, the Virgin and Child, who were descended from the kings of Judah, are placed above them. On the façade of Chartres, as on the

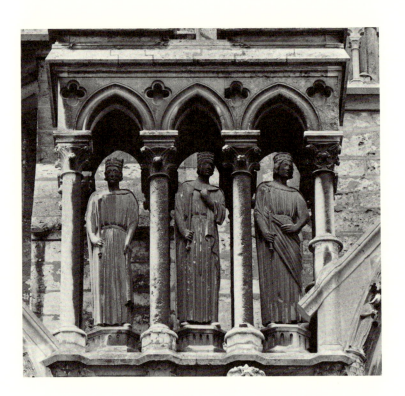

123. Kings of Judah. Chartres (Eure-et-Loir), Cathedral of Notre-Dame. South porch, detail of gallery.

façade of Notre-Dame of Paris, the close relationship established between the Virgin, the Child, and the kings placed below them, would seem to designate the kings as kings of Judah. However, we search in vain for any meaningful attributes in their hands: they hold only scepters. Nevertheless, at the very center of the gallery, we see a king mounted on a lion. Is this Pépin the Short and his lion? I do not think so. On the south tower of the cathedral of Soissons, beside the prophets, apostles, and saints, there is a king mounted on a lion, who is similar to the king at Chartres. This isolated king, surrounded by figures from the Old and New Testaments, cannot be Pépin the Short. He can only be a biblical king. No doubt he is David mounted on the lion of Judah.[147] And this must be the name of the figure at Chartres. The king mounted on a lion was also found at Notre-Dame of Paris, and this detail, reproduced at Chartres, establishes yet another link between the two series.

What was imitated at Chartres was also imitated at Amiens. The façade of Amiens Cathedral, begun after 1220, owes too much to Notre-Dame of Paris for us to doubt that its gallery of twenty-two kings was imitated from Paris. But at Amiens we find more than one detail that was borrowed from Chartres also;[148] consequently, the galleries of kings at Paris, Chartres, and Amiens appear to be closely connected. Since we are certain that one of these galleries, that of the south porch of Chartres, is devoted to the kings of Judah, we have reason to think, in the absence of positive proof, that the others are also (fig. 124).[149]

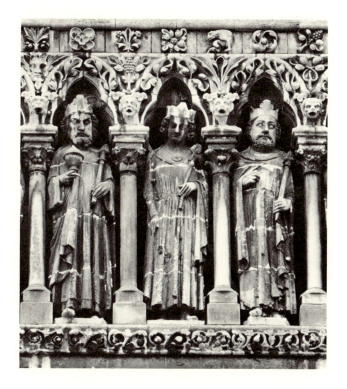

124. Kings of Judah. Amiens (Somme), Cathedral. West façade, central portal, from gallery of Kings below rose window.

But what of the cathedral of Reims? Is it possible to believe that the statues of the kings decorating the cathedral where kings were crowned did not represent the kings of France?

At Reims, a distinction must be made between two series of kings, those of the buttresses and those of the façade.

The buttresses of the north and south transepts are each decorated with eight statues of kings placed beneath magnificent architectural canopies. These sixteen statues are in the noblest style and must have been carved about 1240. In them we again find the influence of Paris, Chartres, and Amiens. Chartres, in particular, which the artists of Reims had imitated several times,[150] seems to have inspired the two galleries of kings decorating each of the transepts. The idea behind the kings of Paris, Chartres, and Amiens was still alive toward 1240, and we may believe that the lion carved at Reims under the feet of one of the kings no more represented the lion of Pépin the Short than it had at Chartres, but is the lion of Judah.

But at Reims there is a second series of kings—decorating the top of the façade and continuing around the bell towers. These kings are fifty-six in number, and we see them lined up at each side of the baptism of Clovis, as if they were the royal line of the first Christian king. Are these not the kings of France?

We must first remark that these statues, often mediocre, date from sometime late in the fourteenth century. At least a hundred and fifty years had passed since the kings of Notre-Dame of Paris had been carved. The great ideas embodied in the statues of the cathedrals were beginning by that time to be imperfectly understood. It seems probable that illiterate people by the end of the thirteenth century imagined the kings of Notre-Dame of Paris to be the kings of France. In a frequently cited fabliau, a wretch standing on the parvis before Notre-Dame points his finger at Pépin and Charlemagne on the façade of the church, while a thief snatches his purse from behind.[151]

Furthermore, in the fourteenth century, royal pride had markedly increased. Charles V and his queen had themselves represented on the portal of the church of the Celestines, standing in the place where saints were formerly placed. The same Charles V did not find it shocking to be represented, with his sons and his household, on the buttresses of Amiens Cathedral.[152] The spirit of the fourteenth century is not that of the thirteenth.

Thus, it would not be impossible—although no proof can be provided —that on the façade of Reims, the fourteenth-century artists, ignorant of the meaning of what had been done before, had in fact meant to represent the kings of France and to give a national character to the cathedral

where they were crowned. For my part, I see no objection to this hypothesis, and even feel disposed to accept it.

But I still believe that nothing like this took place in the thirteenth century. I recognize the desirability of stronger proof; nevertheless, there is another argument that seems to me to carry great weight. How can we believe that at Notre-Dame of Paris—where Louis VII and St. Louis are shown in two tympanums kneeling humbly at the feet of the Virgin— the kings of France were represented in triumph on the façade? The church would then seem to be dedicated to them, and not to the Virgin. In 1220, at the height of the theological age, nothing would have seemed more shocking than this deification of royalty. Such an idea is opposed to the very spirit of thirteenth-century iconography.[153]

These kings at Notre-Dame of Paris, on whom our attention first falls, are thus in all likelihood the ancestors of Christ. They are also, be it noted, the ancestors of the Virgin, although St. Matthew's genealogy ends with Joseph, and not with Mary. But the Middle Ages believed that this was the genealogy both of Joseph and of the Virgin. William Durandus explains. The men of the family of David, he says, were not permitted to marry outside this royal family, so that both man and wife had the same ancestors.[154] It seems clear that the kings of Judah were particularly chosen to decorate the façade of four cathedrals dedicated to the Virgin because they were the ancestors of the Virgin. In the feudal world, where nobility of soul was presumed to go along with nobility of blood, the Church thought it necessary to remind people that both Christ and his mother had been born of kings.

Such is the general devlopment that Isaiah's prophecy underwent in thirteenth-century art. The kings of Judah on the façades of cathedrals mark, so to speak, the epochs of the history of the world and symbolize the waiting of the generations for the Messiah.

VII

It is clear how important a place the prophets and their prophecies held in the imaginations of medieval men. For them, the visionaries of Israel were the most serious of witnesses. They liked to line them up on the façades and porches of their churches, and to place in their hands, inscribed on phylacteries, the proof of Christ's divine mission. The people of the Middle Ages knew the prophets well. Each year at Christmas and Epiphany, they saw them pass by in the guise of old white-bearded men dressed in long robes. The procession entered the cathedral and when each prophet's name was called, he testified to the truth and recited a biblical verse.[155] Isaiah spoke of the branch that was to grow from the root of

The Play of the Prophets.

Jesse. Habakkuk foretold that the Child would be recognized between the two animals, David prophesied the universal reign of the Messiah, the aged Simeon thanked God for having seen the Saviour before he died.[156] The Gentiles were also called to bear witness: Virgil spoke a verse from his mysterious eclogue,[157] the Sibyl chanted her acrostic song on the end of time, Nebuchadnezzar proclaimed that he had seen the Son of God amidst the flames of the fiery furnace,[158] and Balaam, riding the ass, foretold that a star would rise above Jacob. The ass itself had a role; by its presence, it attested that the spirit of God sometimes spoke through the mouths of the humble, and that the eye of a beast might see the angel that was invisible to the eyes of man.

In the figures of the porch, the faithful recognized the prophets who had passed before them in procession. This procession, from which religious drama grew and which was a drama in itself, was not without influence on art. The artists attended it, mingling with the crowd; like the others, they were filled with admiration, and probably would have had difficulty imagining the prophets in any form other than that in which they had seen them on such days. It is believable that the beautiful statues of Reims and Amiens reproduce something of the costume and appearance of the sacred actors. Evidence in manuscripts is unfortunately sketchy.[159] Information on the costumes and attributes of characters in the Mystery plays became precise only at a much later period than the one we are concerned with. However, I have no doubt that the magnificent costumes of the prophets at Auch[160] and Albi[161]—splendid cloaks strewn with great flowers, Oriental turbans, sumptuous hats from which clusters of diamonds and ropes of pearls hang—derive from representations of a Mystery play.[162]

In the Middle Ages, cult, drama, and art were unified; they all taught the same lesson, all made manifest the same thought.

VIII

Summary. The symbolic medallions of Suger's windows at St.-Denis. The statues of the north portal of Chartres.

The conclusion from all the foregoing is that the Middle Ages were less responsive to the narrative and pictorial qualities of the Bible than to its dogmatic meaning. The thirteenth century was far too Christian to look only for interesting motifs in the stories of Genesis. The heroic episodes in the Book of Judges and the Maccabees, so well suited to appeal to the knights of the Crusades, were not represented at all. The serious artists of the Middle Ages would no doubt have been shocked by Benozzo Gozzoli's charming frescoes at the Campo Santo of Pisa, with their beautiful Italian vineyards where Noah gathers grapes with the Tower of Babel rising in the Florentine countryside among cypresses and orange trees—a biblical world as agreeable and attractive as the stories told by a

nursemaid. In representing such a subject, they would have had no thought of giving pleasure; their aim was to teach. Even though their work is sometimes clumsy, it is always strong and full of meaning; it was infused with the full spirit of the Church Fathers.

Several medallions of a window at St.-Denis, for which Suger himself furnished the inscriptions, summarize in a striking way the theological doctrine regarding the Old Testament as it had been formulated in the great centuries of the Middle Ages. Not all the St.-Denis medallions have survived, but we know those that are missing by Suger's own description.[163] Three especially seem to contain the controlling idea behind the work.

In the first (fig. 125), there is a kind of aureole radiating from Christ's breast that is formed of seven doves symbolizing the seven gifts of the Holy Spirit. With his right hand, Christ crowns the Church, and with his left raises the veil covering the face of the Synagogue. What does such an allegory mean if not that Christ, by coming into the world and promulgating the New Law, had suddenly made intelligible all the mystery of the Old Law that had seemed to be hidden under a veil? A verse, mutilated in the window but given in full by Suger, explains succinctly the meaning of the composition:

Quod Moyses velat Christi doctrina revelat.

(What Moses had covered with a veil, the doctrine of Christ revealed.)[164]

The second medallion shows the ark of the Covenant carried on four wheels; it resembles a triumphal chariot (fig. 126). In it we see the tables of

125. Jesus between the Old and the New Law. Saint-Denis (Seine-Saint-Denis), Abbey Church. Stained glass, "anagogical" window (detail).

126. Symbolic Quadriga of Aminadab. Saint-Denis (Seine-Saint-Denis), Abbey Church. Stained glass, "anagogical" window (detail).

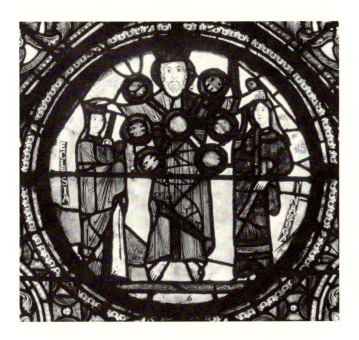

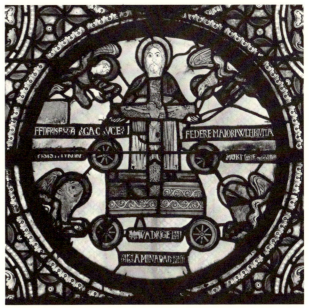

the Law and Aaron's rod. But from the depths of the ark, dominating the tables and the priestly rod, a tall green cross on which Christ is crucified rises like a standard. God the Father supports the cross, and near each of the four wheels are the four animals of the evangelists, seemingly the team to draw the symbolic chariot. Here, the same idea is presented in subtler form. The ark, the tables of the Law, and Aaron's rod, which marked the first covenant of man with God, are only symbols of another covenant that was definitive. The ark appears as the pedestal of the cross. As the inscription says, the ark surmounted by the cross is in reality the Quadriga of Aminadab, the triumphal chariot of the Song of Songs, which the evangelists had to draw to the ends of the earth.[165]

We know the third medallion, now destroyed, only through Suger's description. It also expressed this same idea, but in a less theological and more popular form. It showed the prophets pouring wheat into a mill while St. Paul turns the millstone and collects the flour. This is a way of saying that the Old Testament, interpreted by St. Paul's method, dissolves entirely into the New.[166] And in being transformed, it is also purified, for as Suger's Latin verses say, the bran has disappeared and only the flour remains:

Tollis agendo molam de furfure, Paule, farinam.
Mosaicae legis intima nota facis.
Fit de tot granis verus sine furfure panis,
Perpetuusque cibus noster et angelicus.

(By working the mill, thou, Paul, takest the flour out of the bran.
Thou makest known the inmost meaning of the Law of Moses.
From so many grains is made the true bread without bran,
Our and the angels' perpetual food.)[167]

Nothing expresses better than these medallions the thoughts of the medieval Church Doctors. We see that, in their eyes, the commentaries of the Bible were of as much value as the Bible itself. Although the complete Old Testament had been translated by the University of Paris as early as the beginning of the thirteenth century, we know that the Church had never especially recommended that the faithful read it. At that time, the Bible was not thought to be an edifying work that the father of a family might explain to his children in the evening. People had greater respect for this enigmatic book; they thought they needed the help of the Church Fathers to understand it.[168] The clergy was content to transmit to the people through words or works of art what was essential for them to know.

Inspired by the theologians, the artists also, in their way, were commentators of the Bible. The system of interpretation is the same, whether in reliefs, windows, or the miniatures in manuscripts.[169]

Later, the first printers, in their editions of the famous *Biblia paupe-rum*, tried to make the mysteries of the Old Testament intelligible to even the most ignorant. The woodcuts used in the *Biblia pauperum* were designed like the medallions of stained glass windows. Two figures from the Old Testament were placed in correspondence with one impor-tant event from the New. For example, the Nativity of Christ is accom-panied by the burning bush and the flowering rod of Aaron. Christ's Descent into Limbo is symbolized by the victory of Samson over the lion and David's victory over Goliath. Doubting Thomas is ingeniously sym-bolized by Jacob wrestling with the angel, and by Gideon's incredulity in hesitating to recognize the messenger of God. If it weren't that it would take us outside our subject, we could cite many works from the same period infused with the same spirit: Kerver's Book of Hours, the *Specu-lum humanae salvationis*, the tapestries of the life of the Virgin at Reims Cathedral. Until their decline, the Middle Ages remained faithful to the old exegesis.[170]

To summarize, the medieval interpretation of the Bible relied far more on symbol than on history.

As we have seen, historical representations are far more rare than sym-bolic representations. There are cases, however, in which symbol and history were combined. Of all these works of double meaning, the most profound is certainly that in the central bay of the north porch at Char-tres (figs. 107 and 108). Here there are ten statues of patriarchs and prophets arranged in chronological order, all of whom symbolize or fore-tell Christ, but all of whom, at the same time, tell the history of the world. Melchizedek, Abraham, and Isaac represent an age of mankind. They recall the time, to speak the language of the Church Doctors, when men lived under the law of circumcision. Moses, Samuel, and David rep-resent the generations who lived under written law and worshiped God in the Temple. Isaiah and Jeremiah, Simeon and John the Baptist repre-sent the prophetic times that lasted until the coming of Christ. And the last, St. Peter, dressed in the dalmatic, crowned with a tiara and carrying the cross and chalice, tells that Jesus abolished the law and the prophecies and by creating the Church, he established the reign of the Gospels for all time.[171] At the same time, each of the great figures of Chartres carries a symbol that foretells Christ, that is Christ himself. Melchizedek carries the chalice, Abraham places his hand on Isaac's head, Moses holds the brazen serpent, Samuel has the lamb of sacrifice, David the crown of thorns,[172] Isaiah the rod of Jesse,[173] Jeremiah the cross, Simeon the Holy Child, John the Baptist the lamb, and Peter the chalice. The mysterious chalice that first appeared at the beginning of history in the hands of Melchizedek reappears in the hands of Peter.[174] By this, the cycle is joined. Each of these figures is a kind of Christ-bearer who transmits from generation to generation the mysterious sign.

These are the great periods of a universal history in which everything speaks of Christ. These are the very chapters of Vincent of Beauvais' *Speculum historiale*. Here the Bible appears as it appeared to the Middle Ages: a series of prefigurations of Christ, whose meaning becomes increasingly clear. The patriarchs, symbols of the Messiah, and the prophets who foretold his coming, form a long chain reaching from the first Adam to the second.

II

The Gospels

I

After the age of prefigurations, we now come to the time of the real events. This is the crucial point in the history of the world. All things led to Christ, and all things proceed from him.

Never was this philosophy of history more clearly expressed than on the portal of Amiens. Jesus is truly the central point of the immense façade. Clothed in divine beauty, trampling underfoot the lion and the dragon, he blesses with his right hand and in his left holds the book of the Gospels (fig. 24). Around him, the Old Testament is represented by the prophets, the New Testament by the apostles, the history of Christianity by the martyrs, confessors, and Church Doctors. We see at once that Christ is the center of history. Bossuet's *Discours sur l'histoire universelle* is magnificently realized at Amiens.[1] Both the south portal of Chartres (fig. 127), and the windows and great nave of Bourges, where Christ also occupies the central place, teach the same lesson.

The teaching Christ on the cathedral trumeaux so forcefully sums up all of the New Testament, he is so clearly its soul, that the Middle Ages did not think it necessary to retrace in detail for the eyes of the faithful the Gospel scenes.

No one has yet pointed out that the lives of the saints occupy a far greater place in thirteenth-century churches and are treated with more sympathy than the life of Christ, even though this is quite striking. One or two windows and a few sculptures represent a small number of Gospel scenes, and that is all, even in such rich cathedrals as Chartres, Bourges, and Amiens. Surprise increases when these sculptures and windows are compared and it becomes clear that the scenes from the Gospels are always the same, and that the artists seem to have obstinately avoided many others. For example, none or almost none of the miracles that figured so often in the art of the Catacombs appear in thirteenth-century art:[2] the healing of the paralytic and the woman with an issue of blood, the man born blind restored to sight, the raising of the widow's son, and the cen-

Not all the scenes from the life of Christ were represented in the Middle Ages. Why? The artists represented only the cycle of feasts of the Church calendar. The influence of the liturgy. The Christmas and Easter cycles.

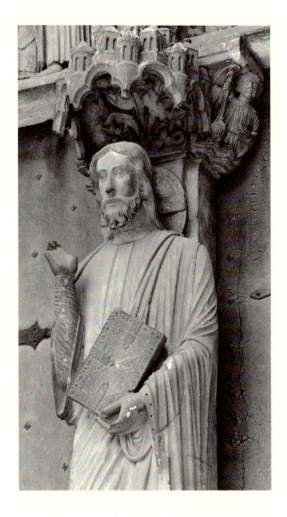

127. Christ. Chartres (Eure-et-Loir),
Cathedral of Notre-Dame. South transept,
central portal, trumeau.

turion's servant. Christ's preaching, his daily teaching in the temple, his meeting with his apostles beside the Sea of Galilee, his repast in the Pharisee's house—all these well-known scenes, so appropriate as inspiration for great artists, are seldom seen. What is human, tender, or simply pictorial in the Gospels seemed to leave medieval artists unmoved. They clearly did not see the same things in the New Testament that a Veronese or a Rembrandt saw.

Here, as everywhere, thirteenth-century artists were the docile interpreters of the theologians.

If the life of Christ is divided into three parts—the infancy, the public life, and the Passion—it is apparent that only the first and last were represented in full. Four scenes summarized his public life: the Baptism, the Marriage at Cana, the Temptation, and the Transfiguration. And it is extremely rare to find all four scenes together.[3] There is almost no exception to this rule. If we do happen to find some other episode from Christ's public life, such as the calling of the apostles, for example, it appears incidentally in a window dedicated to St. Peter.[4]

This is true even of illuminated manuscripts. The artists who illustrated books might seemed to be freer than the sculptors who carved reliefs, but they were not. I have looked through a sufficient number of manuscripts illuminated from the twelfth to the fifteenth centuries to confirm the rarity of detailed illustration of all parts of the Gospels.[5] The miniatures of the famous Gospel Book of the Ste.-Chapelle perhaps provides the only example of a complete series.[6] For the most part, the artist merely represented scenes from Christ's infancy and Passion, sometimes adding the few scenes from his public life that were usually represented at that time.

To give a characteristic example, French manuscript 1765 of the Bibliothèque Nationale contains a collection of texts from the Gospels for each Sunday of the year, with numerous miniatures accompanying the text.[7] The book begins with the Gospel texts for Christmas that tell the circumstances of Christ's infancy. Faithful to the text, the artist illustrates in turn the Adoration of the Magi, the Flight into Egypt, the Presentation in the Temple. For the Gospels referring to Christ's public life, the artist again represents the Baptism of Christ, the Marriage at Cana, the Temptation, and the Transfiguration. Then the miniatures stop; half the book has no illustrations. The artist does not resume the cycle until Holy Week, where he shows us the Passion, the Resurrection, Christ's appearances after the Resurrection. Is it not apparent that our artist was drawing after earlier models that were strictly limited in number? When there was no tradition to follow, it did not occur to him to invent. He simply did what others had done before him, and no more. In most of the illustrated Psalters, Breviaries, Missals, and Gospel Books, there are no scenes at all illustrating Christ's public life. Only the cycles of the Infancy and the Passion are treated with their customary fullness.[8] And sometimes, in certain sparsely illustrated manuscripts, Christ's entire life was summarized by two great scenes: the Nativity stood for the Infancy cycle, and the Resurrection for the Passion cycle.

Whence this strict discipline? The problem is easily resolved, for where would it have come from in the Middle Ages if not from the Church? And in fact, as we shall see, it was the liturgy that determined the choice of one scene from Christ's life to the exclusion of another.

The Church no more intended to present Christ's complete life to the congregation than to give the four Gospels to it to read. Instead, it chose certain events that were profoundly meaningful to everyone and presented them to the faithful for meditation. These events are the same that the Church celebrates each year in the cycle of its feasts. Sculptors, glass painters, and miniaturists were simply illustrating the liturgical calendar. We shall find proof of this in the works of twelfth- and thirteenth-century liturgists.

The cycles of Christ's Infancy, Public Life, and Passion, as they are represented in sculpture and stained glass windows, consist of the following scenes: the Nativity, the Annunciation to the Shepherds, the Massacre of the Innocents, the Flight into Egypt, the Presentation in the Temple, the Adoration of the Magi, the Baptism of Christ, the Marriage at Cana, the Temptation, the Transfiguration, Christ's Entry into Jerusalem, the Last Supper, the Washing of the Disciples' Feet, the Passion in all its detail—the Crucifixion, the Entombment, the Resurrection, his appearances after death, and the Ascension. Rupert, Honorius of Autun, and William Durandus all tell us that these are precisely the mysteries celebrated by the Church at Christmas time, Epiphany, Lent, Holy Week and the weeks that follow. For Christians, these are the great days of the year. The painters of Mount Athos, who even today preserve some of the medieval traditions, still paint on the walls of their monasteries "the fifteen great feasts of the Church," in an unchanging sequence.[9]

To give one instance, the representations of the Nativity and the Annunciation to the Shepherds correspond so exactly to the two high moments of the Christmas feast—the midnight Mass and the Mass at dawn —that further discussion is unnecessary.

The Massacre of the Innocents, which might seem to be an episode of secondary importance, is closely linked with the Christmas feast. In fact, during the three days following Christmas, the Church celebrates the Massacre of the Innocents along with the feasts of St. Stephen and St. John the Apostle. The liturgists tell us that the Church desired to gather around Christ's cradle the innocent children and the proto-martyr deacon who were the first to shed their blood for the faith; it included St. John the Apostle because he was the well-beloved disciple of the Saviour, and he alone of all men had rested his head against Christ's heart.[10] The refined and tender feeling that brought these subjects together was responsible for artistic compositions that have not been noticed before. In the apse of the cathedrals of Lyon and Troyes, there are thirteenth-century windows representing, along with the Christmas scenes and the Massacre of the Innocents, the lives of St. John and St. Stephen.[11] The windows of Lyon and Troyes sing out like old Christmas carols. All of Christmas week is celebrated in them. The people who joyously celebrated the last days of December and loved to see the deacons playing ball in the cathedral on St. Stephen's day,[12] understood easily these works of art which to us say little. I have no doubt that other works of art inspired by the same idea could be found.[13]

The Presentation in the Temple, celebrated at the beginning of February under the popular name of Candlemas, occupied as important a place in art as in the liturgy. The feast was meant to recall that the Son

of God, who came to bring the New Law, had nevertheless wished first to submit to the Old Law.[14]

The Adoration of the Magi, the Baptism of Christ, and the Marriage at Cana, which came next in works of art, correspond to three very different moments in Christ's life; yet the men of the Middle Ages, with their poetic sense of mysterious relations, attached them to a common idea. All three were celebrated on the same day, and the feast was called Theophany until it later came to be called Epiphany. These were the first three manifestations of God. In worshiping Christ, the magi had been the first among the Gentiles to recognize his divinity. On the day of his baptism, the voice from on high had proclaimed his divinity a second time. And lastly, at the Marriage in Cana, Jesus himself had performed a miracle, his first, to manifest his divinity. And so that the parallel would be perfect, the Middle Ages would have it that the three events had taken place on the same day. The liturgists said that the Baptism had taken place thirty years, and the Marriage at Cana thirty-one years to the day, after the Adoration of the Magi.[15] From this comes the uncommon importance in art of these three subjects.[16] The special predilection of thirteenth-century artists for the Marriage at Cana has no other explanation. If they had not been so submissive to liturgical rules and had followed their own feelings, they would no doubt have chosen a more moving miracle and one that appealed to the heart. But once again, thirteenth-century art did not allow for individual whim; art was nothing more than the tangible form of Church doctrine.

In art, the Temptation and the Transfiguration are at the center of Christ's life; these two scenes, along with the Baptism and the Marriage at Cana, summarize all Christ's public life. Why was this singular privilege conferred upon these events? Again the reason is in the liturgy. The Temptation and the Transfiguration were intended to recall another moment of the Christian year. Between Christmas and Easter, no time is more meaningful to the Christian than the weeks of Lent. Struggle against temptation and victory over the flesh are perfectly symbolized by the two scenes from Christ's life chosen by the Church itself as examples for us. Every Christian is a Christ; he must participate in the trials of his Divine Master if he is to participate in his triumph. The forty days' abstinence of Lent are the image of Christ's forty days of fasting and struggle in the wilderness. Consequently, on the first Sunday of Lent, the Gospel of the Temptation is read, and thus it became the symbol of the battles a Christian must wage.[17] But so that the Christian will not falter, the text of the Transfiguration is read twice at the end of the first week, both on Saturday and Sunday. In the minds of medieval liturgists, the Transfiguration was a kind of exaltation of fasting. Among other things, they said

that Jesus had appeared to the apostles between Moses and Elijah because both Moses and Elijah had fasted for forty days in the wilderness. They had instituted fasting in the Old Law, just as Jesus had done in the New Law.[18] Thus, for the struggling Christian, Christ's Transfiguration was a promise of victory. In certain churches—those of Paris, for example—the gospel of the Transfiguration was read after the story of Jacob wrestling with the angel.[19] Such symbolism, better understood in the thirteenth century than today, accounts for the presence of the Temptation and the Transfiguration in a certain number of works of art from that period.

The representations of Christ's public life stop there. One proof that the artists had not intended to follow the chronological order of events, but the order of the liturgical feasts, is the immediate succession in their work of scenes from the Passion after the Temptation and the Transfiguration.

The Easter cycle almost always begins with Christ's triumphal entry into Jerusalem (fig. 128),[20] which corresponds to Palm Sunday. The Last Supper follows, and then the Passion itself, treated with a fullness that can be explained by the importance of the ceremonies of Holy Week. Lastly, the Resurrection makes visible the Mystery of Easter and terminates the cycle. There is nothing in this that is not easily explained and perfectly clear to us.

Most of the Gospel series end with the Resurrection, but a few go beyond. In the famous reliefs of the choir of Notre-Dame of Paris, the appearances of Christ after his resurrection are represented in detail such as we find nowhere else: his appearance to the holy women, to the disciples at Emmaus, to St. Thomas, to the apostles in the Cenacle, and to St. Peter and his companions on the shores of the sea of Tiberias. This was not due to a caprice of Maître Le Bouteiller, "carver of images," for such representations are closely linked with the feast of Easter. In the thirteenth century, the entire week following Easter was a week of Church feasts whose offices were followed with devotion by the faithful. A strange and symbolic ceremony, the procession of the serpent carried triumphantly on the end of a pole to the baptismal fonts, excited the people's interest.[21] Now on each day of this week, one of the appearances of Christ was read from the Gospels.[22] Thus, the feast of Easter was prolonged until the following Sunday, and it is just precisely this liturgical week that the artist was commissioned to represent on the choir screen of Notre-Dame of Paris.

Finally the Ascension, quite naturally, completed the Gospel story in many works of art.

To sum up, it is clearly apparent that artistic representations of the life of Christ were grouped around the Nativity and the Resurrection. In

128. Entry into Jerusalem; Last Supper. Bourges (Cher), Cathedral of St.-Etienne. Stained glass detail of Passion window.

thirteenth-century cathedrals, we are almost sure to find two windows devoted to Christ, one of which might be called the Christmas window, and the other, the Easter window. The series of sculptures, which are far more rare, could be called by the same names. But one point must be made: there are many more painted or carved representations of the Christmas cycle than of the Easter cycle. We can easily understand why. In relating Christ's infancy, the story of a part of his mother's life was also told, and both were celebrated in the same work. Most of the windows that we call the Infancy windows could as well be called windows of the Virgin. There are some examples where there is no doubt about this, and where the artist himself took pains to make known what he had in mind. At Strasbourg, in the lower part of a window devoted to the infancy of Christ, an inscription, *Ave, Maria, gracia plena,* leaves no doubt about the artist's intention. In the north rose window of the transept of Soissons Cathedral, all the scenes of the infancy are shown, but the presence of the Virgin in the central medallion indicates that the work is dedicated to her. Books of Hours supply similar evidence up to the fifteenth century, and demonstrate the persistence of a tradition. At the beginning of all these works, in fact, we find a series of prayers collected under the title,

"Hours of Our Lady"; this section of the book, dedicated solely to the Virgin, is always illustrated with scenes from the infancy of Christ, which at first glance could be misleading concerning the purpose of the work.[23]

Moreover, in thirteenth-century windows in which the story of Christ's infancy is told, frequently one or another scene introduced into the series alerts us to the fact that the Virgin is being celebrated as well as her son. For example, it is rare not to find the Annunciation and the Visitation there. The Middle Ages infused into such works all its great love for the Virgin. To tell the story of Christ's early years, was that not also a celebration of the devotion and tenderness of Mary, whose protection and gentle influence were spread over the entire infancy of the Son of God? How could they better glorify her than to show that she was essential to the work of salvation, and that because of her, the frail Child in whom the hope of the world lay, lived and grew to manhood?

The stained glass windows and the sculpture devoted to the infancy of Christ are, in reality, testimony to the ardent cult devoted to the Mother of God in the thirteenth century.[24]

This is the spirit behind the choice of scenes from the life of Christ. Nowhere does the profoundly dogmatic character of medieval art appear more clearly—an art that is a visual rendition of liturgy itself and of theology.

II

Symbolic interpretations of the New Testament: the Birth of Christ; the Crucifixion; the two Adams; the Resurrection; the Marriage at Cana.

But if we study them closely, the scenes from the Gospels as they are represented in art hold still other surprises for us: a detail, an attitude, a figure that we may not even notice today, revealed a whole world of symbols to the people of that time. Thirteenth-century artists, enlightened by the theologians, saw in the Gospels not a collection of pictorial or moving pictures, but a series of mysteries.

Unfamiliar as we are with the books of the Middle Ages, we might think that the Gospels are void of symbolism. If the whole of the Old Testament is a prefiguration, must not the New Testament be taken for reality itself? What is there to look for behind the events it tells? What is the Christian to do but read it as a simple narrative? But this was not the opinion of the medieval Church Doctors. For them, the New Testament is doubtless the supreme reality, but the inspired words of the evangelists are so profound in meaning that they resound infinitely. Each of Christ's acts and each of the words he pronounces contain the present, the past, and the future. The Church Fathers reveal some of these mysteries to us; they show us that the New Testament is as symbolic as the Old, and that we must search out in one and the other the historical,

allegorical, tropological, and anagogical meanings. Walafrid Strabo's *Glossa ordinaria* uses the same system for interpreting the New Testament as the Old. We shall continue to follow this famous guide, being sure that in doing so we are following the true Christian tradition.

Among the scenes from Christ's life that we have enumerated, the symbolism of four or five of them is most strange.

First, the Nativity. Faithful to the tradition of the preceding century, thirteenth-century artists represented Christ's birth in a way that will seem strange to us if we take the trouble to look at it closely. In this scene that was represented many times in stained glass windows, there is no tenderness, and one might say there is no humanity. The mother does not kneel before the Infant, contemplating him with clasped hands and enveloping him in an infinite love, as in the paintings of the Quattrocento Italians. In the thirteenth-century scene, Mary reposes on a bed and seems to turn her head away so as not to see her son; she gazes vaguely at something invisible before her. The Infant lies not in a crèche but, strangely enough, on a raised altar that occupies the entire central part of the composition; above his head, a lamp hangs between open curtains. The scene seems to take place not in a stable but in a church (fig. 129).

129. Nativity. Paris, Bibl. Nat., ms. latin 17326, fol. 10r.

130. Nativity. Laon (Aisne), Cathedral of
Notre-Dame. West façade, detail of north
portal.

And, in fact, the medieval artist-theologians intended to evoke a church.
From the very moment that Christ is born, he must be given the aspect
of a victim. The crèche in which he lies, the *Glossa* says, is the very altar
of the sacrifice.[25] A thirteenth-century French manuscript shows Christ
crucified above the Infant Jesus lying on the altar. The shaft of the cross
rises from the same altar on which the Infant lies. Here, the symbol
speaks for all to see.[26]

In the presence of such a mystery, human feelings are silenced, even
maternal love. Mary keeps a religious silence; through her mind, the
commentators say, pass the words of the prophets and of the angel, words
that have just been realized. St. Joseph likewise is silent. Both are im-
mobile; their eyes are fixed, as if they are listening to their souls. Such a
grand and theological conception is indeed far from the picturesque
"crèches" which appeared in the fifteenth century and marked the end
of great religious art (fig. 130).[27]

Next to the birth of Christ, it was natural that in art the greatest sym-
bolic significance should be given to his death. In representing the Cruci-
fixion, the purpose of thirteenth-century artists was not so much to move
us by the sufferings of the Man-God as to bring to mind two great dog-
matic ideas: that Jesus Christ was the new Adam brought into the world
to efface the sin of the first Adam, and that on the very day of his birth,

the Church was born and all the powers of the ancient Synagogue were abrogated.

The idea of Christ as the new Adam was so familiar to the people of the Middle Ages that it was presented in all possible forms. In such a subject, they pushed their love of symmetry, one of their passions, to its utmost limits. They were convinced that the angel's announcement to Mary of the birth of a Saviour had taken place exactly where God had made Adam of the primeval clay,[28] and in spite of some scrupulous Church Doctors,[29] they continued to believe that Christ had been crucified on the exact spot where Adam was buried, so that his blood had flowed over the bones of our first ancestor.[30] The cross had not been made of just any wood; it was made of the Tree of Good and of Evil, whose trunk, after serving as a bridge for the Queen of Sheba when she entered Jerusalem, had been miraculously preserved by God's will at the bottom of the *piscina probatica*, so that by God's will, the instrument of the Fall had become the instrument of Redemption.[31] And also, the hour and the day of Christ's death had mystical meaning, for Jesus was put to death on Friday, the same day that Adam had been created, and he gave up the ghost at the third hour, the very hour when Adam committed the original sin that caused the fall of the human race.[32]

It must certainly not have been easy to condense all the poetry surrounding the cross, but the artists succeeded in doing so. They translated into visual form one of the Church Doctors' most astonishing ideas about the New Adam. They maintained that just as Eve had been brought forth from the sleeping Adam's side to bring about man's downfall, the Church, to save mankind, had issued from the open wound in Christ's side when he was dead, or rather sleeping, on the cross. The New Adam had produced a New Eve. The blood and water that flowed from Christ's wound are symbols of the two principal sacraments of the Church: Baptism and the Eucharist.[33] The theologians' idea was translated literally into works of art that are not without a certain grandeur. The artists first imagined that Christ's heart had been pierced by a lance entering from the right side, and not from the left, as would seem natural. Thus, they placed Christ's wound in his right side to convey that the wound is first of all symbolic. It symbolizes the wound in Adam's right side, and also the mystical door that opened in the side of the ark.[34] Near the wound they placed the New Eve, the Church in the guise of a queen receiving the blood and water in her chalice. Lastly, they sometimes made the idea even clearer as in a window at Sens (fig. 134, bottom medallion) and a window at Rouen, by placing beside the cross the seraphim who drove our first ancestors from the earthly paradise; but in this case, the angel is no longer the minister of God's vengeance. By placing his flaming sword

back in its scabbard, he proclaims that a New Adam has requited the Old Adam's sin and divine wrath is satisfied.[35]

In their representations of Christ dying on the cross, the thirteenth-century artists' concern was not to affect our emotions but to recall the dogma of the Fall and Redemption, the central idea of Christianity.

And it seemed to them that an equally important idea should be expressed at the same time. By his death, Jesus not only brought about the birth of the Church; he abolished the authority of the Synagogue. At the very instant that Jesus gave up the ghost on Calvary, the Synagogue, with its bloody sacrifices, which were but symbols, and its Bible whose meaning it did not understand, fell down before the Church. Henceforth, the Church alone would have the authority to celebrate the Sacrifice, it alone would be able to explain the mysteries of the Bible.[36]

The defeat of the Synagogue and the victory of the Church at the foot of the cross occupied far too important a place in theology for the artists not to represent it in this solemn moment. The thirteenth-century artists were simply conforming to a long tradition.[37] They placed the Church at the right of the crucified Christ and the Synagogue at his left: the Church, with crown and nimbus and triumphal standard in its hand, receives the blood flowing from the Saviour's side into the chalice; the Synagogue, its eyes covered with a band, holds in one hand the broken staff of its banner, while the tables of the Law fall from the other hand, and the crown falls from its head (fig. 131). The attributes of the Synagogue were taken from a passage of the Lamentations of Jeremiah, which the Middle Ages applied to the Synagogue: "*The crown is fallen from our head*. Woe unto us, because we have sinned! Therefore is our heart sorrowful: *therefore are our eyes become dim*."[38] Sometimes, as in the fragments from a window of Le Mans, St. Peter was placed beside the Church and Aaron beside the Synagogue which he sustains in its downfall,[39] in order to emphasize the opposition of the two ministries (fig. 132).

It would be difficult to find a clearer and more pictorial form for an abstract idea. But the artists were not always so explicit in their representations of the triumph of the Church over the Synagogue at the foot of the cross. They sometimes used so veiled a symbolism that we would be unable to uncover it without the help of the commentators of the Gospel. At times, the centurion was substituted for the Church and the sponge bearer for the Synagogue.[40] These two figures, symmetrically opposed, appeared in very early Christian art, and we would know little about the ideas of the Middle Ages if we imagined their role to be simply historical. The minor characters in the drama of the Passion were never so honored, and above all, they would not have been placed invariably at the right

131. Crucifixion with the Church and the Synagogue. Bourges (Cher), Cathedral of St.-Etienne. Ambulatory, stained glass (detail).

132. The Church crowned by St. Peter. Le Mans (Sarthe), Cathedral of St.-Julien. Stained glass detail of Christ in Limbo window.

and left of the cross. Both are symbolic figures. The Roman centurion who, after plunging his lance into Christ's right side, recognized that he was truly the Son of God and proclaimed his belief for all to hear, is the new Church. He is there to teach us that on this day the faith passed from the blinded Jews to the Gentiles who had recovered their sight.[41] The sponge bearer, traditionally a Jew, is the Synagogue itself. The vinegar in which he soaks his sponge is the old doctrine that has become corrupted: for henceforth, the Church alone will pour the generous wine of divine knowledge.[42]

But there was an even better solution. In the place of the two symbolic figures we have just mentioned, the artists sometimes represented only the Virgin and John at the foot of the cross. The presence of the mother of God and the beloved disciple in this scene is not in the least surprising, for they are in the place assigned to them by the Gospels. But even in this, the subtle spirit of the Middle Ages would discover a mystery. To the theologians, Mary was not only the mother of Jesus; she was also the Church personified. And strange as it may seem to us, John represented the Synagogue. Anyone who knows the patristic literature of the Middle Ages will have no doubt that Mary, in certain cases, symbolizes the Church. In his *Allegoriae,* Isidore of Seville summarized in one sentence the doctrine of the early Christian era: "Mary is the symbol of the Church."[43] And the Middle Ages repeated it after him. Mary symbolizes the Church in almost all the circumstances of her life, but above all when she stands at the foot of the cross. When Jesus gave up the ghost, no one, not even Peter, believed; Mary alone did not doubt. As Jacob of Voragine said, the entire Church took refuge in her bosom.[44] Thus, Mary is the Church, and for this reason she is entitled to the place at the right of the dying Christ. And she is entitled to it even more because she is the New Eve, worthy of standing at the right side of the New Adam. The Middle Ages so often compared Mary with Eve that it is superfluous to insist on this point. It is enough to recall that the name *Eva,* reversed by the angel of the Annunciation and changed into *Ave,* seemed to be one of the many proofs of their identification.[45]

Thus, there is no doubt about the mystical meaning of Mary at the foot of the cross, but John as a symbol of the Synagogue is less understandable. The Church Fathers, however, explain it. In the Gospels, it is true, John symbolized the Synagogue only once, but that gave the artists sufficient authority to place him at the left of the cross. In his Gospel, John tells that on the morning of the Resurrection both he and Peter ran to the tomb. John was first to arrive; he did not enter, but allowed Peter to precede him. What is the meaning of John's act, said Gregory the Great, if not that the Synagogue, which had been first, would forever

after give way before Peter, that is, before the Church?[46] John symbolized the Synagogue once in his life, and therefore it was legitimate to place him in correspondence with Mary, the symbol of the Church.

Consequently, the presence of the Virgin and John at the foot of the cross had a suprahistorical meaning for the thirteenth century. If there are any doubts about this, we have only to glance at the Crucifixion scene in the Rouen window, in which the Church is placed beside Mary and the Synagogue beside John. And if we examine the windows of Tours and Le Mans, both published by Father Cahier, we see that in both windows all the scenes grouped around the cross express one idea: by his death, Christ replaced the Synagogue with the Church. Thus, we have grounds for supposing that the Virgin and John are also intended to recall the Church and the Synagogue, the true subjects of these works.

The idea of a new covenant, a transmission of authority taking place at the foot of the cross, was so familiar to the men of the Middle Ages that all the circumstances of the Passion were a reminder of it. Even the two crucified thieves, one at the right and one at the left of Christ, were thought to be symbols of the new Church and the ancient Synagogue.[47]

In the symbolic Crucifixion, as it was conceived at this time, we find the exact symmetry and mathematical perfection that pleased the Middle Ages above everything else.

A twelfth-century work illustrates so felicitously what we have just said that we will mention it, even though it does not belong to the period under discussion. A miniature in the *Hortus deliciarum* represents the Crucifixion in all its symbolic detail[48] (fig. 133). At the right of the cross, there are the centurion, the Virgin, the good thief, and the Church seated on a mount with four heads, each head easily recognizable as an evangelistic animal. At the left are the sponge bearer, John, the bad thief, and the Synagogue mounted on an ass, the obstinate beast who goes backward when he should advance. In the upper part of the composition, the veil torn from the temple clearly reveals the meaning of the picture, which is the substitution of the New Law for the Old. This miniature is of interest because it brings together elements that are usually found in isolation. With the evidence furnished by such a grouping, there can be no doubt about the symbolic meaning of any particular figure in the composition.

Why had the Middle Ages been so partial to this symbolic Crucifixion, meaning of which was lost in the course of time? Perhaps the reason has to do with the desire to convince the Jews of the futility of their faith, or rather to strengthen the faithful against the pride of an obstinate people who had always claimed that they alone could explain the Bible. The two great figures on the façade of Notre-Dame of Paris,[49] the Syna-

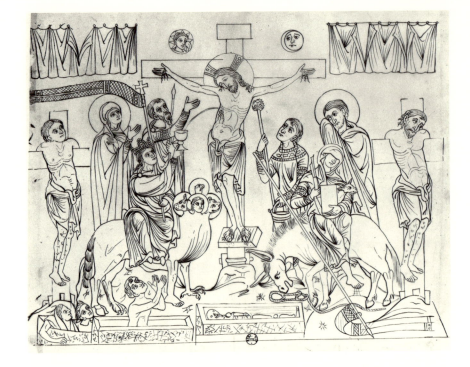

133. Symbolic Crucifixion. *Hortus deliciarum* of Herrad of Landsberg. Paris, Bibl. Nat., Fonds Bastard, Cab. des Estampes, cote A d, 144a, fol. 150r.

gogue with veiled eyes and the Church, eloquently proclaim to the Jews that the Bible no longer has any meaning for the Synagogue, and to the Christians that it no longer holds mystery for the Church. In any case, this is the basis of argument used by an Isidore of Seville or a Petrus Alfonsi in their apologetic books written to convert the Jews.[50] A popular legend in the Middle Ages summarized this cluster of ideas. It was said that Christ's cross had been oriented so that Jerusalem was behind him and Rome before him. Thus, at the hour of his death, he turned away from the city that killed prophets so that he might gaze toward the Holy City of the new era.[51]

As we have seen, the birth and death of Christ contain the richest material for symbolic interpretation, but other scenes from his life lend themselves equally well. The representation of Christ's resurrection, which the early Christians shrank from,[52] was conceived by thirteenth-century artists in a singular way. Contrary to the Gospel story which tells that an angel rolled back the stone from the door on Sabbath morning after the resurrection,[53] they almost always showed Christ rising out of a tomb from which the stone had already been rolled back. When the theologian contemplated this image, he thought of the lofty meaning the Church Fathers had attached to the rolling back of the stone. For them, the stone over the tomb was a symbol. According to the *Glossa*, it was the stone tablet on which the Old Law was written, and was itself the Old Law.

Christ was hidden beneath it, just as the letter hid the spirit in the Old Testament. Christ's resurrection meant that the Old Law had no further meaning.[54]

It is possible to discover symbolism in other representations of the Gospels, but to do so, some striking detail must alert us. Such is the case, for example, in a window of Canterbury Cathedral devoted to the Marriage at Cana. All the commentators of the Gospel of St. John tell us that the miracle at Cana contains a mystical lesson. The six stone water jars, filled with water that was made into wine, are the six ages of the world. The water, in which an invisible wine is hidden without anyone knowing it, is the Old Law that hid Jesus beneath the letter. For according to the letter, the Scripture is an insipid water, but according to the spirit it is a generous wine. Throughout six ages marked by Adam, Noah, Abraham, David, Jeconiah, and the John the Baptist, Jesus was hidden to the world, as was the wine in the water. He appeared in the seventh age, and his reign will endure until the Last Judgment, that is, until the eighth age which will be without end.[55] If we examine the scenes surrounding the Marriage at Cana, there can be no doubt that this was the symbolism accepted by the glass painter of Canterbury. First we see the six ages of human life: *infantia, pueritia, adolescentia, juventus, virilitas, senectus*; then, the six ages of the world marked as by milestones with the figures of Adam, Noah, Abraham, David, Jeconiah, and Christ.[56]

Hydria metretas capiens est quaelibet aetas:
Lympha dat historiam, vinum notat allegoriam.

(The water jars containing measures of water symbolize the ages. The water is the historical meaning, the wine the allegorical meaning.)

Here, the symbolic intention is manifest.

III

After discussing the acts of Christ, let us turn to his words. The forty parables sometimes represented by the painters of Mt. Athos were seldom illustrated in our medieval art. Why did these beautiful stories, illuminated by so clear a light, fail to inspire our artists? Why was the story of the Good Shepherd no longer used in the thirteenth century—a story that had been cherished by the painters of the Catacombs and that gave to Early Christian art so sweet and idyllic an atmosphere? It is difficult to say.

Only four parables are represented in our cathedrals: the stories of the Good Samaritan, the Wise and Foolish Virgins, the Prodigal Son, and

The parables. Parables of the Wise Virgins and of the Good Samaritan. Their symbolic meaning. The parables of Dives and Lazarus and of the Prodigal Son.

134. Parable of the Good Samaritan. Sens
(Yonne), Cathedral of St.-Etienne.
Ambulatory, stained glass.

Dives and Lazarus. These four parables, it must be said, are among the most dramatic, the most moving, and the most truly popular of all those in the Gospels.

It may at first be surprising that symbolism could be found in such straightforward stories. What is the point of seeing a mystery in such simple tales? Does the true meaning of the parable of the Good Samaritan not appear of itself? Must we look for something other than a lesson in charity? We have only to glance at the windows of Sens (fig. 134) and Bourges[57] to see that medieval artists did understand it in another way. They expanded the story of the poor traveler on his way from Jerusalem to Jericho and made of it the story of all mankind. The traveler is man, and so that there might be no doubt of this, the glass painter of Sens wrote his symbolic name: *Homo*. Needless to say, the artist invented nothing; he only repeated the lessons of the Schools. The traveler who went from Jerusalem to Jericho, the *Glossa* tells us, is the symbol of fallen man who was driven from paradise after the Fall. In holy books, Jerusalem is often the symbolic name of Eden; Jericho, which in Hebrew signifies "the moon," recalls the shortcomings of mankind who, like the moon, has its phases.

Man is attacked by thieves who strip him of his raiment, that is, all the sins sent by the devil beset him and deprive him of his cloak of immortality. While he lies naked and wounded on the road, a priest and a Levite pass by; both turn away their eyes and continue on their way. The priest and the Levite are the image of the Old Law, the Law of Moses, which was powerless to heal mankind's sickness. At last, the Good Samaritan comes along, binds the wounds of the dying man, sets him upon his horse, and takes him to the inn. The Good Samaritan is Christ himself: *samaritan*, in Hebrew, means "guardian," and no name is better suited to Christ. He binds the wounds of mankind that Moses was not able to heal, and takes him to an inn, that is, to the Church.

This is the theological meaning that the Church Doctors, beginning with St. Augustine, gave to the parable of the Good Samaritan.[58] The Sens window, composed with perfect clarity, reproduces the Church's teaching and makes it visible.

Three lozenge-shaped medallions, which stand out very clearly in the center of the composition, contain the Gospel story (fig. 134). Circular medallions surrounding these central scenes clearly explain them and give their symbolic meaning. They are the gloss accompanying the text. Thus, around the first lozenge-shaped medallion showing the traveler stripped by the thieves, we see the creation of man and woman,[59] their fall, and their expulsion from the earthly paradise.[60] Around the second central medallion, which represents the traveler prostrate between the

indifferent priest and Levite, we see Moses and Aaron before Pharaoh, Moses receiving God's Law, the brazen serpent—a dim prefiguration of another victim, and lastly, the golden calf, which proclaims the inadequacy of the Old Law. Around the third and last medallion, which represents the Good Samaritan taking the wounded man to the inn, we see the condemnation, the Passion, the Death, and Resurrection of Christ.[61] Could clearer expression be found for these abstract ideas? At a glance we seize the meaning of the parable: in actuality, the work of art is better organized than the written work.

The composition of the windows at Bourges and Chartres,[62] where the same subject is treated in almost identical fashion, is somewhat less felicitous. The Rouen window has been badly damaged, but nevertheless, we are able to recognize some of the scenes just pointed out. Since it is found in four of our great cathedrals, we see how popular the parable of the Good Samaritan was in the Middle Ages, and we see that it was always interpreted in the same way.

But of all the Gospel parables, the parable of the Wise and Foolish Virgins was the most popular in the thirteenth century. They are represented on the western portals, to the right and left of the sovereign judge, at Amiens, Bourges,[63] Notre-Dame of Paris,[64] Reims,[65] Sens, Auxerre, and Laon (figs. 135a, b). They are present at the Last Judgment in which they seem to play a role. And in fact, according to the theologians, they are the symbolic figures of the saved and the damned. Their mysterious and terrible history is the history of mankind's final moment.

When we refer to the *Glossa ordinaria,* we first learn what the five Virgins symbolize and why they are five in number, for a number never occurs by chance in the Scriptures. The Wise Virgins are five in number because they symbolize the five forms of inner contemplation, which are, as it were, the five senses of the soul. Thus, they are the perfect image of the Christian soul striving toward God. The oil burning in their lamps is the supreme virtue, Charity. The five Foolish Virgins symbolize the five forms of worldly concupiscence, the joys of the five senses, which cause the soul to forget all divine thought so that it allows the flame of love to die within itself. The bridegroom they all await at the door of the bridal chamber is Christ. They wait so long that they fall asleep; and their sleep itself is symbolic: it symbolizes the waiting of the generations of man who sleep the sleep of death, and who will awake after long centuries at the hour of the second coming of Christ. The parable says, "And at midnight a cry was made." The frightening nocturnal cry is the voice of the archangel, the trumpet of God that will resound in the silence of the night when no one expects it, for "the Lord will come as a thief in the night." The Virgins awaken and arise as the dead will waken

135. (a) The wise virgin; (b) The foolish virgin. Amiens (Somme), Cathedral. West façade, central portal, jambs.

and rise from their tombs. Those who come with the lamp in which the love of God burns will enter with the bridegroom; the others will remain outside the closed door, and the bridegroom will say to them, "I know you not."[66]

We now understand why the parable of the Wise and Foolish Virgins was always associated with the Last Judgment in the thirteenth century. Their presence gives to that terrible scene the sanction of the divine word; it reminds the Christian that Christ himself foretold it in all its detail under the transparent veil of symbol.[67]

Following the medieval habit of arranging all things in proper hierarchy, the Wise Virgins were placed at Christ's right and the Foolish Virgins at his left. The first have nimbuses, the others do not. A door opens before the Wise; it closes before the Foolish.

In the parables of the Good Samaritan and the Wise and Foolish Virgins, the symbolism is evident, and there can be no doubt about the intentions of the artists who represented them. But this is not exactly the case with the other two parables, the Prodigal Son and Dives and Lazarus.

136. The Prodigal Son. Bourges (Cher),
Cathedral of St.-Etienne. Ambulatory,
stained glass (detail).

The story of the Prodigal Son was very dear to medieval artists. They painted it on the windows of Bourges (fig. 136), Chartres, Sens, Poitiers, Auxerre; they carved it on the portal of the same cathedral of Auxerre in charming medallions somewhat eroded by time. But nowhere, and notwithstanding what Father Cahier said,[68] can we discover the symbolic intention of these compositions.

It is true that the commentators of Luke explain the mystical meaning of the Prodigal Son. According to them, the son who leaves his father to wander over the world and live with courtesans while his elder brother stays at home, is the symbol of the Gentiles who wandered away from God while the Jewish people faithfully kept his law. But the father was so indulgent that he pardoned his lost son and seated him in the place of honor in the banqueting hall in spite of his brother's protests.[69]

Such symbolism could have been expressed in plastic form, just as the symbolism of the Good Samaritan had been, but I have found no attempts to do so. Father Cahier's theory, that the eight small figures scattered over the background of the Bourges window (fig. 136) are meant to recall the eight princes spoken of by the prophet Micah (III, 12) as being chosen by God to subdue the infidels and convert the Gentiles, is far too problematical. Such an allusion is so obscure and farfetched that no one would have understood it. The truth is that this fine story is sufficient unto itself. People saw in it nothing but a father's forgiveness of his son. It is quite remarkable that the artists' imagination, usually so

137. Lazarus and Dives. Bourges (Cher),
Cathedral of St.-Etienne. Ambulatory,
stained glass (detail).

constrained, was here given free play. They took as many liberties with the sacred text as with the *Golden Legend*. They show the Prodigal Son playing at dice in a tavern, bathing before sitting down at table,[70] being beckoned by the courtesans standing before their doors, crowned with flowers, and then driven away when he had nothing left to give them but his coat. These are little genre paintings enlivened by fancy. It would appear that the theologians gave over this touching story to the people.

The same might be said of the parable of Lazarus and Dives. Although the commentators said that Lazarus symbolizes the Gentiles, and Dives symbolizes the Jewish people,[71] even they recognized that this interpretation was secondary and that the literal meaning of such a subject was more forceful than its symbolism. The story of Lazarus, they said, is a narrative rather than a parable.[72]

Belief in the historical reality of the Gospel stories was so strong that the poor leper of the parable was sanctified: he was called St. Lazarus or St. Ladre, and became the patron saint of beggars, lepers, and all those called *lazzaroni* by the Italians—a name given them in the beginning out of Christian pity. It is truly difficult to see in this realistic little story anything but exaltation of the poor and condemnation of the rich. No commentary ever stood between the artist and the sacred text. The Bourges window, where Lazarus appears in the guise of a thirteenth-century leper carrying a clapper to warn passers-by, is a pure narrative (fig. 137).[73] That the Church's sole intention was to provide the faithful with a lesson

in charity is proved by the location of the parable of the Dives in certain early medieval churches. At Moissac and La Grolière (Corrèze), it was placed on the porch, and at St.-Sernin in Toulouse, on the capitals of the south transept door—that is, in the place where the poor sat. The beggars standing at the church door with outstretched hands would grow in stature and be transfigured in the eyes of the faithful who saw the triumph of Lazarus in the carving above their heads.

These are the parables represented in thirteenth-century art.

The artists of those centuries of profound faith strove above all to express the profound dogmatic meaning of the New Testament. They made little effort to bring the Gospels down to man. The purely human tenderness sought after by less believing centuries barely emerges in their work. This was the time when the Virgin stood at the foot of the cross and bore her grief without faltering.[74] To be sure, the old Italian masters created profoundly moving works of the fainting—the *spasimo*—of the Virgin, but these spoke to the heart. The thirteenth century sought to speak to the mind. It must not be forgotten that the cathedral artists were St. Thomas' contemporaries. Their art is as austere as the *Summa*, the commentaries, and the sermons of the time—works in which there is almost nothing but pure doctrine.[75]

Thirteenth-century works of art give the same impression of greatness as certain pages of Bossuet's *Elévations sur les mystères*.[76] Their beauty is of the same order. Later, there is nothing like them; for from the fourteenth century on, tenderness begins to appear in art: the Virgin lovingly clasps her Child to her breast, smiles at him, offers him flowers or a bird. The symbolic apple placed in the grave thirteenth-century Virgin's hand to recall that she is the New Eve, becomes in the fourteenth century a plaything to keep the Child from crying. Such art is more human in scale, but far less serious. Even Fra Angelico, the most deeply affected of all the artists who painted the Gospel scenes, would not always have appeared grave enough to our old masters.

III

The Traditional Legends Based on the
Old and the New Testaments

We have not yet said everything about the works of art inspired by the Bible, for they contain other mysteries. We have seen the artists give form to the thought of theologians; now we shall see them give form to popular legend. These complex works, whose elements must necessarily be analyzed separately, are a harmonious fusion of the Bible text, the commentary of the Church, and the simple legends of the people. What we speak of separately is in fact united; neither the symbolism nor the legend can be detached from the sacred text. Their vigorous growth tenaciously twines about the tree of the cross.

To give an example, the scene of the Nativity as it was conceived in the thirteenth century is represented first of all as the historical event in all its simplicity. But by substituting an altar for the crèche, the artist interpreted the thought of the commentators and gave plastic form to the doctrine of Redemption. And by placing the ox and the ass—which are not mentioned in the Gospels—near the Infant, he showed that he did not wish to separate the charming legend from the historical fact.

Such works are charged with thought and imagination. And how superior they are to the poor creations of modern artists who claim to be renewing Christian art!

But let us proceed with our analysis. Having shown how symbolism contributed to the grandeur of the Gospel scenes, let us now see what legend added in the way of naïveté and sometimes tenderness.

I

A large body of popular literature based on the Bible was created in the Near East. These legends are quite different in character, depending on whether they relate to the Old or the New Testament.

The traditions based on the Old Testament, which we shall discuss first, have to do with marvels. They lead us into the world of fairyland,

Apocryphal traditions based on the Old Testament. The death of Cain.

as strange as the world of the *Thousand and One Nights*. A new Bible, both fantastical and dreamlike, was created from the commentaries of the rabbis and the stories of the Arabs.[1] Each line of the sacred text was amended and completed. For example, the rabbis taught that once God had created Adam, he made a woman named Lilith out of the same clay so that Adam would have a companion.[2] But Lilith refused to obey Adam; she claimed that she was his equal since she was formed of the same clay. Consequently, God was obliged to create another woman, Eve. He made her from Adam's rib so that she would have no cause to pride herself on her origins.

These curious legends abound in rabbinical books. But even the great Biblical figures—Moses, David, and Solomon—are barely recognizable. The kings and prophets were transformed into skillful magicians who understood the language of birds and knew the properties of precious stones. The full range of the imagination of the East played around Solomon. He was not only cherished by the Jews; he appealed to the Arab imagination also. In Arab legends, Solomon ruled over angels and devils, imprisoned djinns in brass vases, caused the twelve golden lions on the steps of his throne to roar. He talked with the ants and the birds. His ring gave him power over all creatures. The whole universe, subject to his will, seems to be a work of magic.

Such stories bear the mark of their origin. The imagination of the desert peoples of the East seems to partake of the light that creates the chimerical world of the mirage.

Not all of these tales of marvels were known in the Middle Ages. However, a few of them did spread to the West and were accepted by the compilers. Peter Comestor included some of them in his *Historia scholastica*, as did Vincent of Beauvais in his *Speculum historiale*.[3]

Artists sometimes used them as subjects. They favored one legend in particular and painted or carved it in many of our cathedrals. This is the story of the death of Cain as told in the apocryphal books. According to the rabbis, Cain was killed by Lamech who, without intending to do so, punished Abel's murderer. Lamech, grown blind in his old age, nevertheless continued to hunt under the guidance of a child named Tubalcain. One day while Lamech was hunting in the forest, the child aimed Lamech's arrow at a thickly wooded spot where he thought he had glimpsed a wild beast. Lamech shot the arrow and killed Cain who was hiding in the thicket. When he learned of his crime, he flew into a violent rage and killed the child who had given him such bad counsel.

This legend, to which St. Jerome merely alluded,[4] first appeared in full in Walafrid Strabo's *Glossa ordinaria*.[5] He had found it in a book written by his master, Rabanus Maurus, which has been lost. The legend of the

death of Cain, unknown in detail to the early Church Fathers, came into literature only in the ninth century. It is likely that Rabanus Maurus took it from a rabbi. In the Middle Ages, relations between Jews and Christians were closer and more peaceful than we might think. The Church Doctors knew certain traditions of the Synagogue long before the time when the converted Jew, Nicolas of Lyra, revealed them in his works on the Old Testament.[6] The story of the death of Cain was accepted by the Schools on the authority of the *Glossa ordinaria.* In the twelfth century, Peter Comestor included it in his story of the creation of the world.[7]

The artists followed suit. They rarely painted or carved the story of the first men without including the death of Cain. In the thirteenth century, they were fond of representing the first chapters of Genesis. The tradition of that time, even in miniatures, was to show the Creation, the Fall of Adam, and the Flood. But they rarely went beyond the story of Noah. It seemed sufficient to show the people the earliest stage of the world. But the legend of Cain was given a place, even in so brief an account. It was carved on the façade of Auxerre Cathedral (fig. 138) in the lower section of the left portal, and on the portal of the cathedral of Bourges (fig. 139).[8] We find it among the numerous medallions decorating the façade of Lyon Cathedral. We see it in windows; it is represented on two panels in the window at Tours devoted to the creation of the world.[9] It is also shown in the Genesis window of the Ste.-Chapelle.

138. Lamech killing Cain. Auxerre (Yonne), Cathedral of St.-Etienne. West façade, left portal, socle relief.

139. Lamech killing Cain. Bourges (Cher), Cathedral of St.-Etienne. West façade, spandrels of socle.

140. Tower of Babel; Creation of Eve. Lyon (Rhône), Cathedral of St.-Jean. West façade, central portal, jambs.

These examples, which could no doubt be multiplied, demonstrate that the legend was already popular in the thirteenth century. It became even more popular later: the Mystery plays made it known to everyone, and artists frequently used it as a subject until the sixteenth century.[10]

Of all the rabbinical legends, it was the only one to endure in art; however, it is not impossible that others can be found in our medieval monuments. Among the numerous medallions devoted to Genesis on the façade of the cathedral of Lyon, there is one that might well derive from a Jewish legend (fig. 140). A workman standing on a tower lets something that seems to be a brick fall on the head of his helper. This has to do with the Tower of Babel and the legend of the confusion of tongues, as

told in the Synagogue. It is found in *Yashar*, a book filled with strange traditions: "After that day, one man no longer understood the speech of another; and when a mason was given material he had not asked for by his apprentice, he threw it at his head and killed him: and many of them died in that way."[11]

Nevertheless, the apocryphal traditions based on the Old Testament never occupied a large place in art. For the Middle Ages the text of the Bible was almost always enough and fully satisfied interest.

II

However, this was not quite the case with the New Testament. The apocryphal stories of the life of the Saviour, always tolerated by the Church, spread freely throughout art.

Apocryphal traditions based on the New Testament. The Gospel of the Infancy. The Gospel of Nicodemus.

These legends go back to the Early Christian era. They grew out of the love of Christ and the desire to know him and those who had been with him. The people found the Gospel stories too brief and remained curious about what was not related there. They took literally the words of St. John at the end of his Gospel: "But there are also many other things which Jesus did, the which, if they should be written every one, I suppose that even the world itself could not contain the books that should be written."[12]

The desire to find out about the hidden life of Christ is always present. The *Meditations* of the Pseudo-Bonaventura, the revelations of St. Brigid and of Maria d'Agreda, and the astonishing stories of Sister Catherine Emmerich show that the tender curiosity out of which the apocryphal Gospels grew has not disappeared, even in our time.

The small Christian communities of the Near East could never hear enough about Jesus. His infancy, spoken of so briefly in canonical books, was especially moving to the popular imagination. Stories of marvels were created both by the Christians of Syria and by the fellahin and sailors of the Nile. The caravans carried them into the depths of Arabia.[13] At resting places in the desert, stories were told of Jesus creating birds out of damp earth and making them fly by clapping his hands; of Jesus reading the letters of the alphabet in the schoolroom without having learned them beforehand; of Jesus helping his adopted father to make ploughs with all the expertness of a master carpenter.

But not all is engaging in these stories of the Saviour's Infancy. Some of the miracles attributed to him are childish, and some are barbarous. In Egypt, Jesus restored to his original form a man who had been changed into a mule by a sorcerer. But in Judea, on the other hand, he changed children into rams to manifest his powers. Another story tells

that he dried up the hand of a schoolmaster who attempted to slap him, and he caused a child who had run against him while playing to drop dead before him. Several chapters of the apocryphal Gospels resemble the *Life of Apollonius of Tyana*, or even the *Golden Ass*. Belief in witchcraft and magic is evident throughout. The credulous people of the East made these legends in their own image. The stories are ingenuous and childlike, although from time to time we find evidence of the desire to sanction a Gnostic theory.

The anonymous authors of the apocryphal Gospels sometimes attained true grandeur. There are many admirable pages, especially in the Gospel of Nicodemus, whose author was certainly a Jew and very familiar with the Bible. The triumphal descent of Jesus into hell bears comparison with the most beautiful passages from the Scriptures themselves.

All of the legends, which in collected form are called the apocryphal Gospels, were no doubt first written in Greek as it was spoken in Egypt and Syria. Those that have come down to us are written in various languages—Greek, Coptic, Arabic, and Latin. We do not have to search out the origins of these legends and study the relation between them. This has already been done in part by the editors of the apocryphal Gospels, Fabricius, Thilo, and Tischendorf.[14] Our sole interest in them is what the Middle Ages knew of these old traditions.

Among the stories of the Saviour, there are two in particular that seem to have been used by twelfth- and thirteenth-century writers, in spite of Pope Gelasius' decree that they are apocryphal. The first is the Gospel entitled *Evangelium de nativitate Mariae et infantis Salvatoris*, the first part of which deals with the youth of Mary, and the second with the Infancy of the Saviour.[15] This book, which has come down to us in a Latin translation, was attributed to St. Matthew. It seems to have been highly valued in the Middle Ages, for it was mentioned with honor by Fulbert of Chartres,[16] and Vincent of Beauvais borrowed from it some of the legends that he included in his *Speculum historiale*.[17]

The second of the apocryphal Gospels known to the Middle Ages is the Acts of Pilate or Gospel of Nicodemus, which deals with Christ's Passion and his descent into hell. This book, preserved only in Greek, must have been known quite early in the Near East in a Latin translation, for it had already been cited by Gregory of Tours, who knew no Greek.[18] In the thirteenth century, Vincent of Beauvais transcribed it almost entirely in his *Speculum historiale*, as did Jacob of Voragine in his *Golden Legend*.[19]

Most of the apocryphal traditions found in thirteenth-century literature and art came from these two Gospels. However, not everything can be explained by them. There are several stories, particularly in the *Golden*

Legend, that do not derive from them. For example, Jacob of Voragine tells that on the night of Christ's birth, the vines flowered throughout all of Palestine. And he tells several interesting details about the journey of the magi: how they were guided by a star in the shape of a child, which in fact was an angel, and how they departed in a boat of Tarsus to escape the anger of Herod.

Where did such legends come from? Are they of Eastern origin like the others? We cannot say, for we have found nothing like them in any of the Apocrypha of the New Testament thus far published. However, it matters little to us where they came from, since this is not our concern. It is enough for us to study the fully developed cycle of legends as found in medieval historical encyclopedias, and to show what artists borrowed. We shall refer constantly not only to the apocryphal Gospels themselves, but to the *Historia scholastica* of Peter Comestor, the *Speculum historiale* of Vincent of Beauvais, and the *Legenda aurea* of Jacob of Voragine, in all of which later traditions were mingled with the ancient traditions of the East. It is also useful to add the great *Vita Christi* by Ludolf of Saxony to these famous books, even though it dates from the middle of the fourteenth century.[20] For in it, almost all of the earlier legends are to be found. It is the most complete *Summa* left to us by the Middle Ages.

III

In scenes of the infancy of Christ as they were represented by thirteenth-century artists, there are several apocryphal details. The Gospel story and the legend are so closely interwoven that they are not easily separated. We are too accustomed to the ox and the ass in the Nativity scene for it to occur to us that these animals are not mentioned in any of the Gospels. They are mentioned, in fact, only in the apocryphal *Evangelium de nativitate Mariae et infantis Salvatoris*.[21] The legend, which no doubt grew out of a prophecy of Isaiah and a misunderstood passage from Habakkuk,[22] was accepted in the time of the origins of the Church, and it remained alive throughout the ages because it touched the hearts of the people to see their God unrecognized by men but welcomed by the humblest of beasts. The liturgy definitively consecrated the tradition by mentioning the animals in a response of the Christmas Mass.[23] Thirteenth-century artists, like the authors of our old *Noëls*, always included the ox and the ass.

Another, very naïve, tradition connected with the birth of Christ also appears occasionally in our cathedrals. Near the Virgin reclining on a bed, two women hover over the Infant Jesus and often wash him in a tub. Sometimes one of the women carries her arm in a sling.[24] These are the

Apocryphal stories of the infancy of Christ. The ox and the ass. The midwives. The magi and their journey. Miracles of the Infant Jesus in Egypt.

midwives spoken of in the *Evangelium de nativitate Mariae et infantis Salvatoris.* "Joseph went to find a midwife, and when he returned, Mary had already been delivered of her child. And Joseph said to Mary, 'I have brought two midwives, Zelemie and Salome, who are waiting at the entrance to the cave.' When Mary heard this, she smiled. And Joseph said to her, 'Do not smile, but take care for fear that you may need help.' And he asked one of the midwives to come in. And when Zelemie came to Mary, she said, 'Allow me to touch you.' And when Mary had granted her leave, the midwife cried aloud, 'Lord, Lord, have pity on me, I never dreamed of such a thing; her breasts are full of milk, and she has a male child, even though she is a virgin. No defilement was at the birth, and no pain in childbirth. Virgin she has conceived, virgin she has given birth, and virgin she remains.' The other midwife, Salome, heard Zelemie's words and said, 'I will not believe a word until I see for myself.' Salome came to Mary and said, 'Allow me to touch you and to see if what Zelemie said is true.' And Mary gave her leave. Salome touched her, and her hand immediately withered. In great pain, she began to weep bitterly and to cry and say, 'Lord, you know that I have always held you in awe. . . . And now I am become wretched because of my incredulity, because I dared to doubt thy virgin.' When she had spoken thus, a young man of great beauty appeared to her and said, 'Approach the infant and worship him, then touch him with your hand and he will heal you; for he is the Saviour of the world and of all who place their hope in him.' Forthwith, Salome approached the infant, and in worshiping him, touched the hem of the swaddling-clothes in which he was wrapped, and her hand was immediately healed."[25]

These midwives called in to certify the virginity of Mary, this childish miracle—the whole naïve story—had very early aroused the indignation of the Church Fathers.[26] But St. Jerome's anger at the foolishness of the Apocrypha, *deliramenta Apocryphorum*, did not diminish the legend's popularity. In the Middle Ages, Jacob of Voragine accepted it, changing only the name of one midwife. The Zelemie of the apocryphal Gospel became Zebel in the *Golden Legend.*[27] As the old theme was worked over, several new embellishments were added. In several poems of the twelfth and thirteenth centuries, and particularly in a Provençal Mystery play, the midwives were replaced by a crippled woman named Anastasie or Honestase. Anastasie was born without arms, but when she verified the virginity of Mary, her arms grew at once.[28]

The medieval Church, being most indulgent toward popular legends and in this at one with the people, many times allowed artists to represent the story of the midwives. We find it in the interior of the cathedral of Lyon on a capital in the apse; on the west façade of Chartres on one of

the capitals forming the long frieze which tells the life of Christ;[29] on one of the windows of the chevet at Laon (fig. 141); and on a window devoted to the Infancy of Christ in the chapel of the Virgin at Le Mans (fig. 142). Many others examples could be added to these, but they would date from an earlier period. The capitals at Chartres and Lyon are from the twelfth century, the windows of Laon and Le Mans are from the early thirteenth. After this, the legend of the midwives no longer appears in our cathedrals. Neither have I found it in the thirteenth- and fourteenth-century illustrated manuscripts I have looked through. Apparently the extreme naïveté of the old legend had finally shocked the Church, and if for some time to come the midwives continued to be allowed to appear in Mystery plays, they were at least excluded from the sanctuary. In the thirteenth century, the old motif of the midwives and the child, which went back to the beginning of Christian art, was forgotten.

None of the scenes from Christ's infancy furnished richer material for the popular imagination than the Adoration of the Magi. These mysterious and vaguely defined figures from the Gospels excited such lively interest that legend supplied what St. Matthew had omitted. From the legend we learn the names of the magi and what happened to them on their journey; it tells us the entire story of their lives and their deaths. According to it, they died true Christians, baptized by St. Thomas on his journey to India, and the cathedral of Cologne piously received their relics. Great medieval families claimed the magi as ancestors. In the ruins of the château of Les Baux near Arles, we may still see the shield with

the star which attests to the noble origins of that illustrious house. The people, in their way, also honored the magi. Their names were used in incantations and in witchcraft. The three names written on a ribbon and worn around the wrist were believed to cure epilepsy.[30]

In the Middle Ages, traditions relating to the magi were many and picturesque. The Far East, from which they came, was a magical land. The medieval imagination knew no bounds when it was carried away to the land of the Queen of Sheba, the land of gold and spices. Among other things, it was told that the magi were descended from Balaam and that they had inherited the ancient secrets of divination;[31] that the gold pieces they had brought as gifts to the Child had been beaten out by Terah, the father of Abraham, and that they had been given to the people of Sheba by Joseph, son of Jacob, when he went to their country to buy aromatic herbs to embalm the body of his father.[32]

The strange thing is that the apocryphal Gospels contain none of these legends and add almost nothing to the canonical Gospel. The conciseness of this chapter of the *Evangelium de nativitate Mariae et infantis Salvatoris* is evidence that it goes back to Early Christian antiquity.[33] The traditions concerning the magi came from elsewhere; the cycle of legends developed slowly. In the thirteenth century, Jacob of Voragine collected into two chapters of the *Legenda aurea* a part of the legends of the magi.[34]

He tells us that the magi were three in number, and that their names were Caspar,[35] Balthazar, and Melchior. The magi were also kings. In their own countries, they climbed to the tops of mountains and observed the stars. The star that guided them had the shape of a child and was an angel—in fact, the same angel that appeared to the shepherds.[36]

Most of the details noted by Jacob of Voragine were represented in thirteenth-century art. In our cathedrals, the number of magi, which had not yet been established in earlier centuries, is never more than three. They always wear crowns on their heads as a sign of their royalty. And sometimes the star has the form of an angel. Guigue and Bégule, in their *Monographie de la cathédrale de Lyon*, published a fourteenth-century miniature taken from a French Missal belonging to the treasury of St.-Jean, in which the head of an angel appears in the center of the star in the scene of the Adoration of the Magi.[37] For the choir screen of Notre-Dame of Paris, the artist found a more graceful means of translating the same legend. He placed the star in the hands of an angel who seems to guide its course (fig. 143).[38]

Of all these legends, none was more scrupulously followed by artists than that which assigned a different age to each of the magi. In stained glass windows, reliefs, and manuscripts, the first king is always shown as an aged man, the second as middle-aged, and the third as a beardless

youth. There are so many examples of this that we need cite only one of the most famous: the Adoration of the Magi on the choir screen of Notre-Dame of Paris. The tradition is very old; it was already followed by miniaturists in the eleventh century,[39] and goes back even farther in time.[40] The first mention appears in a strange passage attributed to Bede, and can be found in the *Collectanea* accompanying his works:[41] "The first Magus was Melchior," said the Pseudo-Bede, "an old man with long white hair and a long beard. . . . It was he who presented gold, symbol of divine royalty. The second, named Caspar, was young, beardless, and ruddy; he honored Jesus by giving incense, an offering that manifested his divinity. The third, named Balthazar, of dark complexion (*fuscus*), wearing a full beard . . . , bore witness, by offering myrrh, that the Son of Man would die."[42]

Medieval compilers seem to have paid little attention to the portraits drawn by the Pseudo-Bede; they omitted them from their books. But the artists did not ignore them. For centuries, the tradition of assigning a different age to each of the magi was perpetuated in the workshops.[43]

It must further be noted that, in the thirteenth century, the descriptive word *fuscus* applied by the Pseudo-Bede to Balthazar was never taken literally. It was only in the fifteenth century that one of the magi kings appeared with negroid features.[44] The artists were led to this new interpretation by the commentaries of theologians. Sermons of the time taught

143. Adoration of the Magi. Paris, Cathedral of Notre-Dame. Choir screen, detail.

218

144. The story of Herod and the magi.
Amiens (Somme), Cathedral. West façade,
right portal, left socle.

that the three magi, prefigured in the Old Testament by the three sons of
Noah—Shem, Ham, and Japheth—symbolize the three human races, the
three parts of the world that came to pay homage to Christ.[45]

There are certain strange scenes from the lives of the magi in our
cathedrals that have often puzzled their interpreters. On the right portal
of the façade of the cathedral of Amiens, several small medallions placed
below the large statues of the magi kings represent their history (fig. 144).
In one, all three have embarked and seem to be sailing toward their own
countries; and in others, a figure gives the order to set fire to a ship.[46]
In the Middle Ages, the legend was well known; everyone recognized in
the reliefs of Amiens the episode of the return of the magi, which Jacob
of Voragine relates as follows: "When Herod had ordered the slaying
of the Innocents, Caesar sent to him a citation to appear before him and
answer to the accusation of his son. And as he was passing through Tar-
sus, he learned that the three kings had embarked from the port in a boat,
and in anger, he had all the boats burned, in fulfillment of the words of
David: 'He shall burn all the ships of Tarsus in his wrath.' "[47] Like many

others, this legend grew out of a verse of the Old Testament.[48] It was clearly quite popular in the thirteenth century,[49] for it was represented several times in art. We see the magi in their boat in one of the panels of the rose window at Soissons,[50] and at the cathedral of Tours in a window of the chapel of the apse devoted to the Infancy of Christ.[51]

Herod himself was a part of the legends of the magi. Not all of the stories by Peter Comestor, Vincent of Beauvais, and Jacob of Voragine which told of the horrors of Herod's old age passed into art. Only one episode was retained. On the right portal of the façade of Amiens Cathedral, under the statue of Herod before whom the magi appear as summoned, there is a naked figure being plunged into a tub by two servants (fig. 145). This is Herod in his old age, trying to fend off death by taking baths in oil. "And Herod was already seventy-five years old when he fell sick of a terrible malady: violent fever, rotting and swelling of the feet, continual torment, bad cough and worms eating at him causing a foul stink, and he was in great torment; and then, following the advice of the doctors, he was placed in an oil bath from which he was taken out half dead."[52] Herod lived on long enough to learn that his son Antipater had not concealed his glee when he heard of his father's agony. Divine wrath burst forth in this Death of Herod, which Comestor had made famous by including it in his *Historia scholastica*.[53] Thus, it was ingenious of the Amiens sculptor to place beneath the feet of the triumphant Herod, the old and vanquished Herod. In this way he foretold the future and God's vengeance to come.

The Flight into Egypt, told in a word in the Gospels, was one of the subjects that most excited people's imaginations. In the legendary stories, Jesus performs countless miracles. He subdues dragons and wild beasts,

145. The servants plunge Herod into the bath. Amiens (Somme), Cathedral. West façade, right portal, socle under figure of Herod.

and disarms brigands. The water in which his swaddling clothes were washed resurrects the dead. Local traditions preserved by the Copts and stories created even by the Arabs[54] were added to the apocryphal Gospels.

Use of the rich treasure of legends was discreet in the Middle Ages. Vincent of Beauvais did no more than transcribe the *Evangelium de nativitate Mariae et infantis Salvatoris*, the least burdened with fabulous events.[55] Jacob of Voragine, contrary to habit, was restrained,[56] and the artists were even more so. Of all these legends, they scarcely used any other than the Fall of Idols.

The *Evangelium de nativitate Mariae et infantis Salvatoris*,[57] and following it, many medieval writers told that when Jesus entered the temple of Sotinen, called Hermopolis by others, he caused the idols to fall, in fulfillment of Isaiah's words: "Behold the Lord will ascend upon a swift cloud and will enter into Egypt. And the idols of Egypt shall be moved at his presence. . . ."[58] When the governor of the town, Affrodosius, heard of the miracle, he went to the temple; when he saw that all the statues were broken, he worshiped Jesus. The tradition adds that Affrodosius afterward journeyed to Gaul and preached the Gospel in the Narbonnaise; it was said that he was the first bishop of Béziers.

The Church adopted the story of the Fall of the Idols, which like many apocryphal legends, grew out of the desire to justify a prophetic text, and it authorized the artists to represent it. It appears in all the painted or

146. Fall of the Idols. Le Mans (Yonne), Cathedral of St.-Julien. Chapel of the Virgin, stained glass (detail).

147. Flight into Egypt. Paris, Cathedral of Notre-Dame. Choir screen (detail).

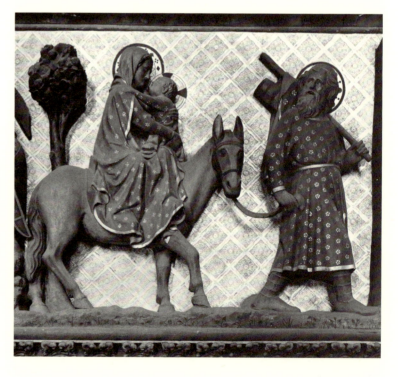

carved series of scenes devoted to the Infancy. The thirteenth century gave an abridged, almost hieroglyphic form to the legend. There are neither town, temple, nor priests, as in some works of art from earlier centuries; two statues falling from their pedestals and breaking in two suffice to recall the miracle. A window at Le Mans contains a curious detail: the Egyptian idols are multicolored. Their heads are golden, their breasts silver, their bellies copper, their legs, painted blue, seem to be of iron, and their feet are the color of clay (fig. 146).[59] It is clear that the painter had in mind the statue of Nebuchadnezzar's dream, which for him was the idol par excellence.

This is all the legend supplied to the artists. It is possible, however, that one apparently insignificant detail often seen in representations of the Flight into Egypt was taken from another legendary tradition. A tree is often placed near the Holy Family on its journey. Is this meant simply to indicate that they are traveling through the country? Is it not rather the miraculous tree spoken of in the apocryphal Gospels? In fact, we read in the *Evangelium de nativitate Mariae et infantis Salvatoris* that on the third day of the journey, the weary Virgin sat beneath a palm tree and wished for one of its fruits. St. Joseph pointed out to her the height of the tree. "Then the Child Jesus, who was in the arms of the Virgin Mary, his mother, said to the palm tree: 'Tree, bow down your branches and nourish my mother with your fruit.' At his voice, the palm tree lowered its topmost branches to Mary's feet. They picked the fruit it bore and all were nourished. The next day, when they were departing, Jesus said to the tree: 'Palm tree, it is my will that one of your branches be carried by my angels and planted in the paradise of my Father. For recompense, I will that it be said to all those who conquer in the battle for the faith: 'You have deserved the palm of victory.' As he spoke these words, an angel of the Lord appeared in the palm tree, took one of its branches, and flew to heaven with it in his hand."[60]

This story, which Vincent of Beauvais transcribed,[61] is found with variations in the works of several medieval writers. But on the authority of a passage from Cassiodorus, they all substituted a peach tree for the palm.[62] Even Vincent of Beauvais, who followed the *Evangelium de nativitate Mariae et infantis Salvatoris* very closely, this time followed Cassiodorus. This is an important detail. On the choir screen of Notre-Dame of Paris, near the Virgin mounted on an ass we see a tree laden with fruit. It seems to be a peach tree (fig. 147). If our conjecture is correct, the artist wished to recall the legend of the desert tree. The presence of the tree in many works of art of the same period makes this hypothesis very likely. It appears in representations of the Flight into

Egypt in a window of the cathedral of Lyon,[63] and in a window of the cathedral of Tours.[64]

These are the apocryphal details that the thirteenth-century artists usually placed in representations of the Flight into Egypt. However, we also see the beginnings of certain legends that were to become popular later, and which artists, especially miniaturists, often drew on.[65] We refer particularly to the legends of the thieves and of the field of wheat.

An incunabulum of the fifteenth century tells the two stories as follows: "Mary and Joseph had no money, and they had to carry their child and flee to a strange country through wild deserts and over terrible paths where they came upon robbers, one of whom gave them good cheer and most sweetly showed them their way, and it is said that this was the good thief who was saved at the Passion of Our Lord. In this way, after Our Lady had journeyed on, they found a laborer sowing wheat. The Infant Jesus put his hand into the sack and scattered a handful of wheat on the road; at once the wheat was as large and ripe as if it had grown for a year, and when Herod's soldiers, in search of the child to kill him, came to the laborer who harvested the wheat, they asked if he had seen a woman carrying a child. He said, 'Yes, when I was sowing this wheat.' Whereupon, the murderers thought he did not know what he was saying, for surely the wheat had been sown almost a year before, and they turned back."[66]

These two episodes, the first of which is taken from the apocryphal Gospels,[67] and the second from an unknown source, were not accepted by thirteenth-century compilers. Neither Vincent of Beauvais nor Jacob of Voragine included them. However, the two legends cannot have been unknown at that time, for they appeared in art. The episode of the wheat field is carved on the portal of the thirteenth-century church at Rougemont in the Côte d'Or. It is found again in a thirteenth-century panel of the cathedral of Châlons-sur-Marne, and in the late thirteenth-century murals discovered under the plaster at St. Maurice-sur-Loire (Loire).

The legend of the thief decorates a thirteenth-century Limoges enamel, now in the Cluny museum. The good thief, who can be identified by his sword and lance, himself carries the Infant on his shoulders.[68]

IV

Apocryphal stories of the public life of Christ. The Marriage at Cana.

Thus, only a few of the apocryphal legends of the Infancy of Christ appeared in thirteenth-century art, and fewer still were used in scenes of his public life. Who, indeed, would dare to tamper with the sacred text, in its most solemn passages? Who would dare to challenge the majesty of the Gospel? Moreover, here the apocryphal Gospels are silent.

However, love of the miraculous and the extraordinary was very strong in the Middle Ages. Even if no word, no gesture of the Son of God might be changed, a thousand conjectures could be made about the sick he had cured, the disciples who had come to him, the anonymous people he had spoken to. Here, at least, the silence of the Gospels could be filled without sacrilege.

It was very hard for the people of the Middle Ages to believe that those who had seen and heard Christ had remained obscure men, and had not, later on, become illustrious Christians and great saints. The churches of France were especially rich in such traditions; almost every one of them claimed to have been founded by one of those, however humble, who had walked in the shadow of the divine master. From them came the titles of nobility conferred on our metropolitan churches. St. Martial, for example, who founded the see of Limoges, had been the child of whom Jesus said: "Whosoever shall not receive the kingdom of God as a little child shall not enter into it."[69] St. Martial had later served at table at the Last Supper, and had brought the water for Christ to wash the apostle's feet.[70] St. Sernin of Toulouse had held Christ's robe while St. John the Baptist baptized him in the Jordan. St. Restitutus, the first bishop of St.-Paul-Trois-Châteaux, was the man born blind and restored to sight by the Saviour. Zacchaeus, the publican who had climbed a sycamore tree to watch Jesus pass, had come to Gaul in search of solitude and had lived for long years in the wilderness where the church of Notre-Dame of Rocamadour was later built.[71] And as we know, it was the glory of Provence that it had received the Gospel from the mouth of Lazarus, who had come there with Mary Magdalene and Martha.

There are some traces of these traditions in art. On a Romanesque capital representing the Last Supper, in the museum of Toulouse, the servant with a nimbus above his head and carrying a platter is certainly St. Martial.[72] A window at Tours devoted to St. Martial shows the young saint pouring the water on Christ's hands and serving the Lord and the apostles at table.[73] A window at Laon also shows St. Martial serving at the Last Supper.[74]

The most unusual of these legends is unquestionably that which concerns the bride and groom of the Marriage at Cana. A very ancient tradition, as it is found already in Bede, gives the names of the betrothed pair of whom the Gospels say so little. They were said to be St. John and Mary Magdalene. In this way, the presence of Christ and his mother at the wedding was ingeniously explained. The Virgin and her son were said to have been invited by Salome, the sister of Mary and mother of St. John; they were there as members of the bridegroom's family. It was added, however, that St. John abandoned his wife on the very day of the

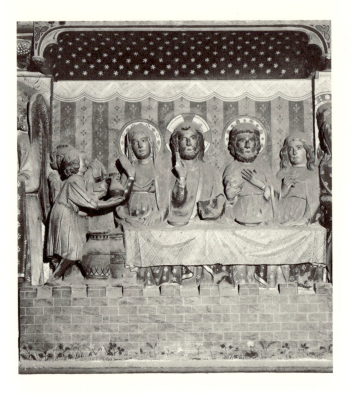

148. Marriage at Cana. Paris, Cathedral of
Notre-Dame. Choir screen (detail).

marriage. After the wedding feast, the Lord had said to him: "Leave your bride here and follow me." And John chose a life of virginity and followed the Master.[75]

This strange tradition was not unknown to artists, as the scene on the choir screen of Notre-Dame of Paris proves (fig. 148). We see that the fiancé has a nimbus. Since the nimbus was given only to saints in medieval iconography, the artist was probably designating St. John by this attribute.[76]

A careful study of works of art from this period, principally in manuscripts, would certainly uncover other examples.[77]

V

Apocryphal stories of the Passion and Resurrection of Christ. Legends of the cross. The Descent into Hell. The Appearances.

Legend is absent from the other great Gospel scenes. Awe curbed the imagination.

We come upon legend again only in Christ's Passion. How could it be otherwise? The mystical twelfth and thirteenth centuries constantly pondered this unparalleled drama. The death of a God, mystery of mysteries, is the foundation and very soul of medieval art. The cross was to be found everywhere, even in the symbolic plan of the cathedral. As a Church Doctor magnificently said: "Life is merely the shadow cast by the cross of Jesus Christ; beyond this shadow, there is only death."[78]

Masterpieces were created out of the endless meditation on the Passion: the *Stabat Mater*, the *Meditations* attributed to St. Bonaventura, the liturgy of Holy Week, the poems of the Holy Grail cycle, the great Christ of the Poitiers window who dies on the cross soaked in the royal purple.[79]

All these miraculous flowers were created from one drop of holy blood, like the roses painted by the old masters on Calvary.

The Passion was in fact the sole study of the Middle Ages. St. Francis of Assisi, in whom the Middle Ages were incarnated, went so far in his love that he endured the Passion himself and became one with Christ, even to suffering his wounds. St. Bernard cried: "O Lord, who will console me for having seen thee hanging from the cross?"[80]

How could so many ardent souls fail to ponder the sacred text! And in fact, legends flourished in the margin of the book. We do not know where many of the details concerning the Passion came from—moving details, no longer childish, that one senses came from the very heart of the Christian peoples. The Virgin tears the veil from her own head to cover Christ's nakedness on the cross;[81] the disciples gather Christ's blood into the same cup that was used at the Last Supper, the holy chalice whose miraculous story was told by poets; the centurion Longinus recovers his sight when drops of the holy blood fall upon his eyes;[82] the devil, perched on the cross like a sinister bird, waits for Christ's soul to pass from him, in the hope of finding some blemish there, and flees defeated.[83]

The cross itself aroused great interest. People wished to know its shape and dimensions. It was said to have been made of four kinds of wood: cedar, cypress, palm, and olive—a miraculous secret that was guarded in mystery and awesomely transmitted by craft guilds to new members.[84] And it was also claimed that the eclipse of the sun produced by the death of Christ had been seen at Athens by Dionysius the Areopagite. Dionysius, still a pagan, was so awe-struck by this inexplicable phenomenon, that he erected an altar "to the unknown God."[85]

Some of these legends, which had penetrated deep into the Christian consciousness, were used in art.

The Holy Grail, the chalice of the Last Supper, was from the twelfth century sometimes to be seen below the feet of the crucified Christ.[86] At a somewhat later time, the angels themselves were shown receiving the holy blood. And again, as in the window at Angers, the blood of Christ flows in a stream directly onto the earth. The holy blood would seem to water the world, and according to Origen, flow even to the stars. These two modes of representation are interesting. In the first example, the chalice into which the blood of the Saviour flows recalls that the Sacrifice is eternal, unlimited by time and renewed each day. In the second example, the stream descending from the cross reminds us that the Sacrifice was made for the entire universe and is not limited in space.[87]

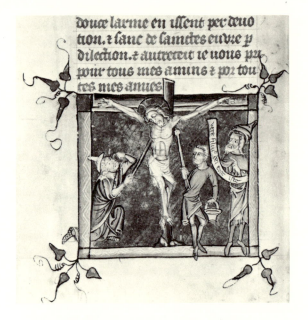

149. Crucifixion. Paris, Bibl. de l'Arsenal,
ms. 570, fol. 31v (detail).

The legend of the centurion Longinus healed at the foot of the cross was sometimes represented in art. To express the miracle, the artist showed Longinus covering his eyes with his hand, like a man dazzled by light (fig. 149).[88]

The legend of the four trees used in making the cross was not easy to express in artistic form. The glass painters tried it, however. I believe that I have identified it in a window devoted to the Passion at the cathedral of Bourges: the artist has, precisely, painted the wood of the cross in four different colors.[89] This is probably more than pure coincidence.

The legend of St. Dionysius the Areopagite watching the eclipse was most often represented in the fourteenth (fig. 150),[90] and fifteenth centuries;[91] however, it was used in the thirteenth century in a famous manuscript of the Bibliothèque Nationale, illuminated in 1250.[92]

But of all the legends that grew up around the Passion of Christ, that of the Descent into Hell was unquestionably the most popular as well as the most imposing. Its origins are well known. It is first found in its fully developed form in the Gospel of Nicodemus, which was merely transcribed by Vincent of Beauvais, Jacob of Voragine, and other compilers of the thirteenth century.[93] The Gospel of Nicodemus, especially its second part, has a grandeur that makes it one of the finest works of Early Christian literature.[94]

This miraculous story was said to have been written by two silent shades—two dead men whose tombs opened and who were resurrected on the day that Christ died. They were named Carinus and Leucius and were the sons of the aged Simeon who had taken Christ in his arms in the temple. After their resurrection, they lived in the town of Arimathaea

U rbs heliopolishec est: caligine solis.....
h te amittat dyo nisint hanc speculat.

150. St. Paul and St. Denis at Heliopolis.
Paris, Bibl. Nat., ms. nouv. acq. fr. 1098,
fol. 30r (detail).

and prayed night and day. "Sometimes their cries could be heard, but
they spoke to no one and remained as silent as the dead." When the
priests learned that they had been brought back to life, they were sum-
moned to the temple and beseeched to tell of this miracle. Carinus and
Leucius asked for parchment and wrote down what they had seen in the
other world.

Their story begins as follows: "When we were with all our forebears
in death's darkness, we were suddenly enveloped in a light as golden as
the sun's, and a shaft of royal light illuminated us. Suddenly, Adam, the
father of the human race, and all the patriarchs and prophets, trembled
with joy and said: 'This light is the creator of eternal light, who has
promised to transmit to us a light that will never dim or end.' And all
the just of the Old Law rejoiced in the expectancy of fulfillment of the
promise. Meanwhile, Hell grew troubled; the Prince of Tartarus feared
the coming of him who had already defied his power by bringing Laza-
rus back from the dead. He said: 'When I heard the power of his word,
I trembled. We could not keep Lazarus back; he went from us with the
swiftness of an eagle.'

"As he was speaking thus, there came a voice as the voice of thunder,
the roar of a storm: 'Princes, open your doors, and open, eternal gates,
that the King of Glory may enter....' And the Prince of Hell said to his
ungodly ministers: 'Close the brazen doors and pull the iron bolts, and
resist valiantly.'

"Again there came a voice as of thunder, saying: 'Princes, open your
doors, and open, eternal gates, that the King of Glory may enter....'
And the Lord of Majesty came in the form of a man, and illuminated

the eternal darkness, and broke the chains, and his invisible virtue was conferred on us who sat in the depths of sin's darkness and in the shadow of sinful death.

"The Prince of Tartarus, Death, and all the infernal legions were in terror. They cried to Jesus: 'Who are you? Where did you come from?' But Jesus did not deign to reply.

"Then the King of Glory, taking from Hell all its power by crushing Death beneath his feet and seizing Satan, led Adam into the light. And the Lord said: 'Come with me, all my Saints who were made in my image and resemble me.'

"And all the saints gathered into the hand of God sang his praises. David, Habakkuk, all the prophets, recited passages from their ancient songs in which they had foretold in mysterious words what had come to pass on this day. And all, guided by the Archangel St. Michael, entered Paradise where the two just men who had not endured death, Enoch and Elijah, awaited them, along with the good thief who still had the sign of the cross on his shoulders."

This was the story written on parchment by Carinus and Leucius. When their work was finished, they placed it in the hands of Nicodemus and Joseph. "And suddenly they were transfigured and covered with vestments of a dazzling white. Then they were seen no more."[95]

This old Christian epic, worthy of Dante and Milton, would seem to be a magnificent paraphrase of the verse from Isaiah: "O death, where is thy victory? O death, where is thy sting?"[96] Although the work was patently apocryphal, it contained such beautiful passages that the Church Fathers and Doctors did not condemn it, and in fact were often inspired by it.[97]

Artists followed suit. The Descent into Limbo, as it was conceived in thirteenth-century art, is almost a literal translation of the Gospel of Nicodemus. Jesus advances in triumph; he carries the cross of victory, to which a white oriflamme was attached in the fourteenth century, as if it were the banner fastened to a knight's lance. He walks over the gates torn from their hinges, which in falling have crushed Death and Satan. Hell opens before him. Hell is the yawning mouth of the biblical Leviathan, which seems ready to devour him.[98] But Jesus plants the foot of the cross in the threatening maw and holds out his hand to Adam.[99] The Italians of the Trecento sometimes placed the patriarchs and all the saints of the Ancient Law behind Adam.[100] Our glass painters showed only Adam and Eve, both naked, as if clothed in a new innocence.[101]

But this was not all that the artists of the thirteenth century borrowed from the apocryphal Gospels. They also knew some of the legends of Christ's appearances after his death. The famous appearance of Christ to

151. Christ appears to St. Peter. Paris,
Cathedral of Notre-Dame. Choir screen
(detail).

his mother on Easter morning, so often seen in Renaissance windows and
miniatures, was not, it is true, represented in the thirteenth century. It
might perhaps have been used at Notre-Dame of Paris in the part of the
choir screen that has been destroyed, for we can see that the artist had
undertaken to represent all of Christ's appearances, either authentic or
legendary, by following step by step the *Golden Legend*, which included
Christ's appearance to his mother.[102] Moreover, on the same choir screen
we see the apocryphal appearance of Christ to St. Peter (fig. 151). It was
told that after the death of his Master, St. Peter took refuge in a moun-
tain cave. There, while he was weeping over the death of the Lord and
over his own cowardice, the Lord appeared to him and comforted him.
A rock in the form of a grotto is shown at Notre-Dame of Paris, and this
recalls the legend.[103]

These are most of the apocryphal details added by artists to the stories
of the infancy, the public life, the Passion, and the resurrection of Christ.

VI

Up to this point, we have discussed only the written legends that passed
from book to book throughout the centuries and were transmitted with
the same fidelity by artists.

But were there not other legends? Was there an oral tradition based
on the principal events of Christ's life, which left no trace in books? We

Do certain traditional details found in
works of art come from apocryphal
books? Workshop traditions. Was there
a thirteenth-century guide for painters?

are tempted to think so when we study closely certain medieval works of art. For example, let us examine the principal twelfth- and thirteenth-century representations of the Last Supper. Almost always, Christ and all the disciples are seated at one side of the table, and Judas is alone at the other side. In front of the Master there is a plate with a fish on it.[104] This theme was so scrupulously followed by three or four generations and was so faithfully reproduced in various works of art that we can only wonder if it was not based on a popular tradition now lost to memory.

The same question occurs to us constantly when we observe closely medieval works of art. Why, for at least two centuries, were all three of the magi represented asleep in one bed, under one coverlet, when the angel appeared to warn them not to return home by way of Herod? The old capital of the cloister of St.-Trophime at Arles, the window at Lyon,[105] the window at Le Mans,[106] the tympanum of the north portal of Chartres (fig. 152), and the beautiful relief of the former chancel screen (fig. 153) of Chartres, follow this motif exactly. And why was Christ nailed to the cross with four nails until the end of the twelfth, and with only three after the thirteenth century?[107] The texts are silent. If these details are based on legend, the legends have completely disappeared.

The fact is that it is a question here not of popular legend, but of workshop traditions.

Some of these formulas go back to a very early period, many of them having been created during the Early Christian era by Eastern artists.[108] But others are far more recent. In studying the art of the twelfth and thirteenth centuries, we can watch some of them develop before our eyes.

Let us give an example. In the late twelfth century, there was still un-

152. Adoration of the Magi. The magi asleep in the same bed. Chartres (Eure-et-Loir), Cathedral of Notre-Dame. North portal, tympanum.

certainty in representations of the scene of the Adoration of the Magi, but a formula was soon created for artists to follow. The first of the magi, the aged king, kneels (fig. 154); he has taken off his crown and presents his gifts to Jesus. The second, the middle-aged king, stands beside him; his crown is on his head and he holds a vase in one hand. But instead of looking at the Child, he turns his head in the direction of the magus following him, and with his other hand points to the star that has stopped in its course above the stable. The last king, the young beardless man, also stands and wears a crown; in his right hand he holds a vase of offerings and seems to listen to the words of his companion. This picturesque formula is most felicitous, since it introduces movement and drama into a hieratic scene.[109]

The type of the Adoration of the Magi, created before 1200, was henceforth established.[110] Artists remained faithful to it for a long time: reliefs, windows, and miniatures show it in unvarying form not only throughout the thirteenth century, but during the greater part of the fourteenth.[111] From France, the new formula spread with our Gothic art over almost all of Europe.

We owe several such innovations to thirteenth-century artists. While remaining deeply respectful of tradition, they strove to introduce life into the still immobile art of the twelfth century. A single expressive gesture was sufficient for them. In the twelfth century, for example, in scenes of the Flight into Egypt, Joseph holds the donkey by its bridle and walks ahead, carrying his belongings in a bundle tied to the end of a stick resting on his shoulder. Nothing was changed in the thirteenth century, except that Joseph turns his head and looks back solicitously at the mother

153. The magi asleep in the same bed. Chartres (Eure-et-Loir), Cathedral of Notre-Dame. Fragment of choir screen.

154. Adoration of the Magi. Paris, Bibl. Nat., ms. latin 17326, fol. 16r (detail).

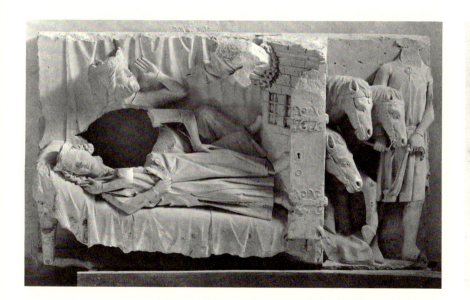

and Child (fig. 109).[112] In the scene of the Visitation, Elizabeth and Mary no longer stand facing each other immobile. In the thirteenth century, Elizabeth is shown placing her hand tenderly on Mary's breast and marveling to feel it swollen with milk (fig. 155).[113]

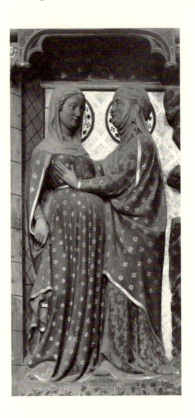

155. Visitation. Paris, Cathedral of Notre-Dame. Choir screen (detail).

These discreet and touching innovations were willingly accepted by all the artists, and gave a new character to thirteenth-century art.

Thus, certain ingenious and moving details that appeared in the art of the time came neither from written legends nor oral tradition. They were created by anonymous artists and transmitted in workshops for more than a century.

We might wonder if all these rules were not put down in writing to form a kind of *Summa* which artists had to know. The extraordinary resemblance between works of art created for cathedrals often at a great distance from each other might make us think so. In the cathedral workshops, the permanent ateliers called *opere del duomo* by the Italians, a manual of iconography—a guide for painters and sculptors—was no doubt handed down from generation to generation. Such a manual must have resembled the book by the monk Dionysius, discovered by Didron at Mount Athos. This famous Guide to Painting, written by a Greek monk, dates of course only from the eighteenth century, but it perpetuates the

most ancient traditions. Nothing changes in the immobile East. Even today, the painters of Mount Athos, who follow the rules transmitted to them by the monk Dionysius when they decorate new chapels, paint exactly as their predecessors painted in the Middle Ages. In France, there must have been a book of this kind that contained the rules of iconography and maintained the unity of religious art during the long period here under study.[114]

This book has not been preserved, but we could almost reconstruct it from our study of thirteenth-century works of art. After comparing a certain number of reliefs, windows, and miniatures, it would not be difficult to block out the main chapters. To take an example, we can imagine that the Guide described the scene of the Resurrection as follows: "The tomb is open, Jesus is standing and places his right foot out of the tomb.[115] He blesses with his right hand and holds the triumphal cross with long staff in the other. Two angels stand at his right and his left, one carrying a torch, the other a censer.[116] Above the tomb, in the trilobed arcature, three small-sized soldiers are represented asleep."[117] This was how the Resurrection was represented for almost a hundred and fifty years.

If we possessed a *corpus* of thirteenth-century windows and miniatures, we could point out a thousand curious examples of the same kind. We could rediscover all the canons of medieval art and reconstruct with assurance the chapters of the thirteenth-century Guide to Painting.

As we see, written tradition does not explain all of medieval art; we must take into account what may be called artistic tradition. We must guard against attributing to apocryphal legends what were simply workshop formulas. However, these liberties amount to very little. In so respectful a century as the thirteenth, artists did not stray far from the Bible or from legends accepted by the Church. Our sober artists restricted their inventions to a gesture, an expression, an attitude. By faithfully following the rules and ancient traditions, they expressed with restraint the emotions they felt when they read the Gospels.

VII

The Virgin owes more to legend than any other New Testament figure. Very early, the Gospels, which give only a glimpse of her and record few of her words, came to seem inadequate. People wanted to know about her family, her childhood, the circumstances of her marriage, her old age, and her death. In the Early Christian era, apocryphal stories were created that charmed the Middle Ages. The figure of the Virgin was set against a background of legend, just as she was placed against a background of roses in paintings by the old masters.

Apocryphal traditions concerning the Virgin. The cult of the Virgin in the thirteenth century. The Birth of the Virgin. St. Anne and St. Joachim. The Marriage of the Virgin. Apocryphal details in the scene of the Annunciation. Death, Burial, and Coronation of the Virgin.

156. Virgin and Child Enthroned. Bourges
(Cher), Cathedral of St.-Etienne. North
porch, portal of the Virgin, tympanum.

The apocryphal stories of the life and death of the Virgin are to be seen
everywhere in our churches. It is a curious fact that the legend and his-
tory of the Virgin was carved on the portals of all our cathedrals in the
thirteenth century. That she was given this place of honor in the cathe-
drals dedicated to her—Notre-Dame of Paris, Reims, Amiens, Chartres,
Laon, and Senlis—is not surprising; but it is surprising that a portal was
dedicated to her at St.-Etienne of Bourges, St.-Etienne of Sens and of
Meaux, and St.-Jean of Lyon (fig. 156).[118] She rarely appeared in early
Romanesque churches. Her son and his apostles occupied the portals of
Arles, Vézelay, and Autun, but in the thirteenth century she was to be
seen everywhere. A beautiful and spacious chapel close to the altar on
the axis of the cathedral was always dedicated to her. We sense that she
held the same place of honor in people's hearts.

The cult of the Virgin that grew up in the twelfth century spread during
the thirteenth. The bells of Christendom began to ring the Angelus.[119] The
Office of the Virgin was recited daily.[120] Our most beautiful cathedrals
were dedicated to her. The idea of the Immaculate Conception began to
take form in the minds of Christians who for centuries had meditated
on the mystery of a Virgin chosen by God. The mystical church of Lyon
celebrated the feast as early as the twelfth century. In their solitude,

monks had always meditated on the Virgin, and they exalted her perfections. More than one of them would have deserved the title of *Doctor Marianus* given to the solitary Scot, Duns Scotus. New religious Orders —the Franciscans and the Dominicans—were true knights of the Virgin and spread her cult among the people.

We must read the Sermons of St. Bernard—*De Laudibus beatae Mariae*[121] and *Speculum beatae Mariae*[122]—for a true idea of the feeling professed for the Virgin in the twelfth and thirteenth centuries. In his extensive commentary on the Song of Songs, St. Bernard applied all of its metaphors to Mary.[123] He clothed her in all the gracious and mystical names he found in the Bible. She was the bush, the ark, the star, the flowering branch, the fleece, the bridal chamber, the door, the garden, the dawn, Jacob's ladder.[124] He shows us that she appeared in the Old Testament, foretold there on every page.[125]

St. Bernard's commentary on the *Ave Maria* filled one volume of the *Speculum beatae Mariae*. Each word is a profound mystery which he unveils. In this extraordinary book neither scholasticism nor false etymologies[126] can smother the poetry. The theologian often rises to lyricism and develops beautiful metaphors. Mary, he said, is the dawn that in this world preceded and foretold the sun of justice; she appeared at the end of the long night of ancient days. Just as dawn brings us from deep night to full light, Mary leads us from sin to grace. She is the intermediary between man and God. "Mary is our dawn," he exclaimed. "Let us follow the example of our workmen who set out at dawn, and work when our dawn appears."[127]

The *De Laudibus beatae Mariae* is considerably imprinted with scholasticism.[128] In this long *Summa* of twelve books, the author reviews all the virtues of Mary and all her symbolic names. Tripartite and quadripartite divisions abound. But often the sober doctor shows feeling: Mary's humility moves him to tenderness. It was her humility, he said, that caused God to violate his decree, and that drew the Lord of Heaven down to earth.[129]

In all the books written to glorify the Virgin, perhaps the idea that recurs most often is that Mary is *Queen*. In the *Speculum beatae Mariae*, St. Bernard said that Mary is not only Queen of Heaven enthroned among the angels, but Queen of Earth where she often manifests her power, and Queen of Hell where she has complete power over the devils.[130] Elsewhere, he compares her to a queen who enters her palace with a king.[131]

Among the many ideas and feelings that clustered around the Virgin in this period, the idea of royalty was the one best understood and most strongly expressed by artists.[132] The Virgin of the twelfth and early thir-

teenth centuries is a queen. On the west portal of Chartres and the Ste.-Anne portal of Notre-Dame of Paris (fig. 157),[133] she is seated on her throne in solemn majesty. She wears a crown, holds the flowering scepter in her hand[134] and the Child on her knees. This is also the way she is represented in the window of Chartres called "La Belle Verrière" (fig. 158), and in a beautiful window at Laon[135] (fig. 159). It would seem that our artists of old wanted to express the words of the Church Doctors: "Mary is the throne of Solomon."[136] In fact, the Child Jesus is seated on her lap as on a throne.[137] Mary is a queen who holds the King of the world. At no other period were artists able to confer such majesty upon the image of the mother of God.

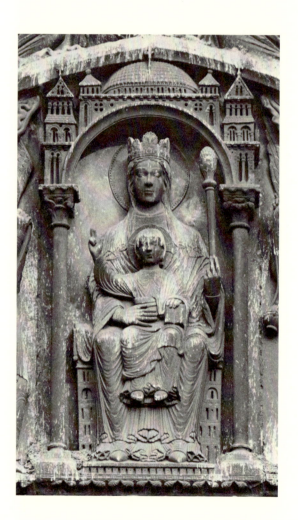

157. Virgin and Child Enthroned. Paris, Cathedral of Notre-Dame. West façade, portal of St. Anne, tympanum (detail).

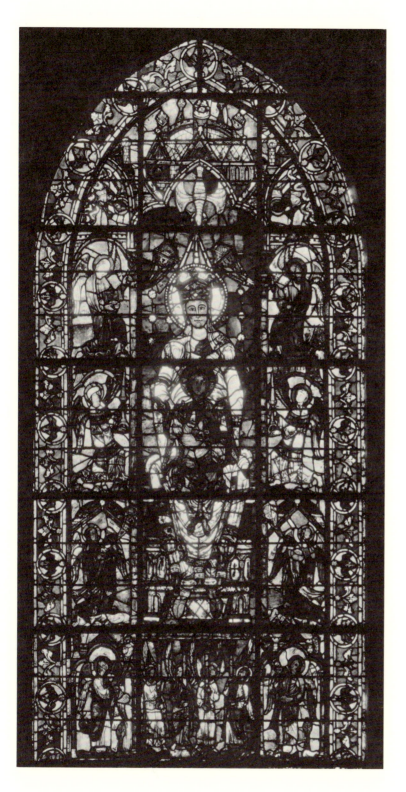

158. Virgin and Child. Chartres (Eure-et-Loir), Cathedral of Notre-Dame. Stained glass ("Notre-Dame de la Belle-Verrière").

159. Virgin and Child. Laon (Aisne),
Cathedral of Notre-Dame. Stained glass,
detail of rose window, choir.

160. The Virgin. Paris, Cathedral of
Notre-Dame. North transept, trumeau.

161. "La Vierge Dorée." Amiens (Somme),
Cathedral. South transept, trumeau.

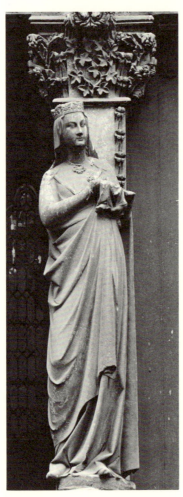

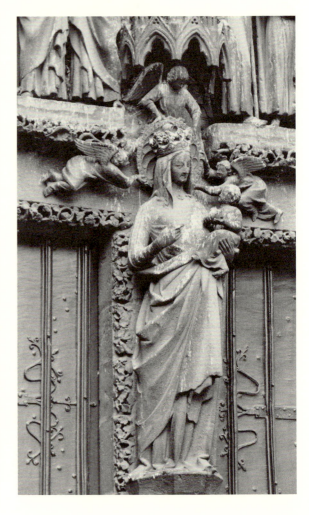

Toward the end of the thirteenth century, this Virgin of the theologians, as majestic as pure idea, seemed too remote from man. All the miracles attributed to her in the thirteenth century, all the times she appeared to sinners, merciful and smiling, had brought her closer to mankind. It was then that the artists, faithfully interpreting the feelings of the people, conceived the Virgin of the north portal of Notre-Dame of Paris (fig. 160) as a mother radiating maternal pride, and a little later, the golden Virgin of Amiens as a slender girl who lightly carries the Infant and contemplates him with a charming smile (fig. 161). Angels support her nimbus, and her high crown seems too heavy for her young head. The Virgin had grown to womanhood; she is a mother.

In the fourteenth century, the Virgin and Child group, represented with such solemnity a century before, has only intimacy left. The theological ideas represented by the Virgin became less and less accessible to artists. They did not comprehend, as in the past, when they heard the recitation of the Office of the Virgin, "that it was the desire of the Infinite God to unite with a Virgin, and that she had carried in her womb him that the world could not contain"; they could no longer recreate the superhuman Virgins of the past. They were satisfied to represent a mother smiling at her child.[138]

Soon they would bring the Virgin even closer to humanity through her grief. But the *Mater dolorosa* that inspired so many masterpieces in fifteenth-century art, the Virgin old before her time who wept over the bleeding forehead of her son, does not belong to the century under study. In this, art was somewhat behind literature. The *Stabat mater* and the Seven Sorrows of the Virgin had long been celebrated, and it was repeated after the Church Doctors that she was the "martyr of martyrs,"[139] but artists did not yet dare to express her grief. It is only occasionally that we see, here and there, in a window, a symbolic sword plunged into the heart of Mary at the foot of the cross,[140] or again, in ivories, a lance reaching from Christ's side to the heart of his mother.[141]

If the artists liberated themselves fairly early from the ideas of theologians, they remained on the contrary faithful to the legends. They borrowed almost all the episodes in the life of Mary from the apocryphal Gospels. It is important for us to know what books and what traditions inspired them.

It did not occur to thirteenth-century artists, as it would to those of the late Middle Ages, to represent the Virgin before her birth. The thirteenth century left this to the sixteenth. It was shortly after 1500 that the young girl with long hair, surrounded by the rose, the star, the mirror, the fountain, and the closed garden appeared in stained glass windows, tapestries, and Books of Hours. This Virgin—a pure concept, anterior to

time, an eternal thought of God—did not yet exist.[142] Such a lofty idea, and one imminently suited to serve as inspiration to artists contemporary with St. Bonaventura and Dante, was however unknown to them. Yet the biblical verse, "Before all ages, in the beginning, he created me, and through all ages I shall not cease to be,"[143] was already being included in the Office of the Virgin.

Neither did thirteenth-century artists go back to the father and mother of St. Anne in the genealogy of the Virgin. They did not represent the strange story of St. Fanuel, nor of the mother of St. Anne who conceived her daughter by breathing in the fragrance of a rose.[144] They went back only as far as St. Anne, and following the legend, sometimes represented her with her three husbands and three daughters.[145] But even so, such representations, so frequent in the fifteenth century, were rare in the thirteenth:[146] the artists dealt only with the story of St. Anne and St. Joachim, her first husband.

This famous legend has come down to us in three apocryphal Gospels: the *Protevangelium Jacobi,* the *Evangelium de nativitate Mariae,* the text of which was attributed to St. Matthew and the Latin translation to St. Jerome, and the *Evangelium de nativitate Mariae et infantis Salvatoris.* Although all three books were known in the Middle Ages,[147] the last was the most often cited,[148] and from it, Vincent of Beauvais[149] and Jacob of Voragine took most of the apocryphal events they added to the life of Mary. It was the source to which most artists turned;[150] so it is from it that we will take the story of the miraculous conception of the Virgin.

"In Israel there was a man named Joachim, of the tribe of Judah, who tended his sheep and feared God in the simplicity and uprightness of his heart."[151] The story begins in a biblical tone. Joachim had been married to Anna for twenty years and had no offspring. One day when he went to the temple to make an offering to the Lord, a scribe sent him away, saying: "It is not seemly for you to take part in the sacrifices offered to God, for God has not blessed you; he has not bestowed offspring on you in Israel." Joachim went away weeping, and dared not return home. He went to the mountains to be with his sheep among shepherds. For five months Anna grieved as she waited for his return, not knowing if he was dead or alive. One day as she was praying, she saw a sparrow's nest on a laurel branch. "She sighed deeply, and said: 'Lord, All-powerful God, who has given offspring to all creatures, to the beasts and serpents, the fish and birds, and who has caused them to rejoice in their little ones, I offer thee thanks, for thou hast willed that I alone am excluded from the favors of thy goodness; for thou knowest, Lord, the secret of my heart; on the very day of my marriage, I made a vow that if I be given a son or a daughter, I would dedicate my child to thee in thy holy temple.' And when she

had said this, an angel of the Lord appeared before her eyes, saying: 'Fear not, Anna, for your offspring is in the plan of God, and the child born of you will be the admiration of all the ages until the end.' And when the angel had spoken thus, he disappeared from before her eyes."[152]

The same angel appeared to Joachim among his flocks and told him to return to Jerusalem. "Be it known," the angel said, "that your wife will conceive a daughter who will be in the Temple of God, and the Holy Spirit will descend upon her." And he ordered Joachim to sacrifice to God. Now, it so happened that when Joachim offered the sacrifice, the angel of the Lord rose to heaven with the smoke and the smell of the sacrifice. Then Joachim fell down and remained there with his face against the earth from the sixth hour until evening.[153]

Then he set off with the shepherds and walked for thirty days. When he came near to Jerusalem, the angel appeared to Anna, and said: "Go to the gate called the Golden Gate, and present yourself to your husband, for he is coming to you today." She arose at once and walked forth with her servants, and stood near the gate, weeping. When she had stood for a long time and was about to fall from so long a wait, she saw Joachim approaching with his flock. Anna ran to him and fell on his breast, offering thanks to God.[154]

Then Anna conceived, and when nine months had passed, she gave birth to a daughter and named her Mary.

This story, although apocryphal, was not rejected by the medieval Church. It was customary to read it on the day of the feast of the Nativity of the Virgin. From time to time a bishop might voice certain scruples. Fulbert of Chartres said: "I would read this book to you today if it had not been condemned by the Church Fathers."[155] However, this did not

162. St. Joachim and St. Anne. Paris, Cathedral of Notre-Dame. West façade, south portal, portal of St.-Anne, lintel (detail).

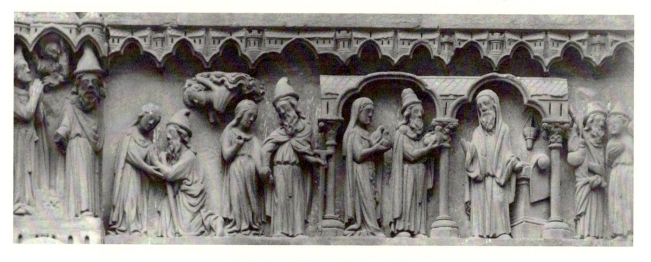

prevent him from telling the entire story of Anna and Joachim in another sermon for the feast of the Nativity.[156] Certain churches were so indulgent toward the legend that they included it in their lectionaries. It was read especially in Norman churches on the day of the Nativity, as a lectionary of Coutances and a breviary of Caen prove.[157]

Thus, it is not surprising to find the story of St. Anne and St. Joachim represented in our cathedrals. At Chartres, the successors of Fulbert did not share his scruples, for they allowed the complete story to be carved on the capitals of the west portal.[158] It appeared again on the north portal, but in a less fully developed form: Joachim and his flock are placed below the large statue of Anna.[159] At Notre-Dame of Paris, the first lintel of the St.-Anne Portal shows the same legend (fig. 162); it is continued in the archivolts to the right where we see Joachim among the shepherds, and the meeting at the Golden Gate. A window at Le Mans in the chapel of the Virgin represents a part of the legend of St. Anne and St. Joachim (fig. 163).[160]

163. St. Joachim and St. Anne. Le Mans (Sarthe), Cathedral of St.-Julien. Stained glass.

The meeting at the Golden Gate is the subject most frequently depicted.[161] The artists of the late Middle Ages had a marked predilection for it. In fact, it was the only way that had been devised to represent the Immaculate Conception.[162] Although the error had been condemned by the Church Doctors,[163] it was repeated that Mary had been conceived at the moment when Anna and Joachim kissed. That is why a fourteenth-century Italian artist, in an exquisite fresco, represented an angel bringing the heads of the couple together for the kiss.[164]

In works of art, the story of the Virgin's childhood and marriage almost always accompanied the story of her conception. At Chartres, as at Paris and Le Mans, the journey to Jerusalem and the presentation of Mary in the temple immediately follow the legend of Anna and Joachim. Except at Le Mans, I have found no attempts to represent the life of the Virgin in the temple, as it was so pleasantly told in the *Evangelium de nativitate Mariae*.[165] These pages have the sweetness of certain paintings by Fra Angelico. The Virgin was so beautiful that the radiance of her face could hardly be endured; she was so serious that her young companions dared not laugh in her presence nor speak in loud voices; she was so pure that the angels descended from heaven to talk with her and bring her food. The window at Le Mans represents the Virgin talking with an angel in the temple (fig. 163).

The episodes of the marriage of the Virgin can be easily recognized at Chartres, Paris,[166] and in the window of the chapel of the Virgin at Le Mans.[167] The legend is well known. When the Virgin was fourteen years old, the high priest informed her that it was proper that she be married, but she refused. He then resolved to give her into the protection of a man of the tribe of Judah. He sent word to all the unmarried men of that tribe to come on the next day to the temple, each with a rod in his hand. The rods would be placed in the holy of holies, and when they were returned to the suitors, the one whom God had chosen would see a dove issue from the end of the rod. The rods were returned, and the dove did not come forth. Then the angel appeared to tell the high priest that he had left Joseph's rod in the sanctuary. As soon as it was returned to him, a pure white dove flew forth in the temple.[168]

The anger of the rejected suitors was not mentioned in the text, and appeared in works of art only much later.[169]

After this moment, Mary comes out of the half-light of legend to enter the full light of the Gospels. The Annunciation, the Visitation, all the scenes of which she is a part are so clearly described in the New Testament that artists had no reason to look elsewhere for material. In the thirteenth century, in fact, they would not have dared to depart from the sacred text. However, in certain regions where ancient traditions were

164. Annunciation. Lyon (Rhône),
Cathedral of St.-Jean. Choir, stained glass,
detail of central window.

very strong, apocryphal details were inserted even into the most solemn of scenes. At the cathedral of Lyon, whose windows contain reminiscences of a much earlier art even though they date from the thirteenth century, we see a spindle in the hands of the Virgin in the Annunciation scene[170] (fig. 164). This detail was taken from the apocryphal Gospels. According to the *Evangelium de nativitate Mariae*, Mary continued to spin for the temple after her betrothal to Joseph. The high priest had assigned several companions to work with her, but to her alone was given the honor of weaving the purple veil for the holy of holies. She was at work on it when the angel appeared to her for the second time.[171] "On the third day, as she was weaving the purple with her [own] fingers, a young man of indescribable beauty appeared to her. When Mary saw him, she was seized with fright and began to tremble; and he said to her, 'Be not afraid, Mary, you have found grace with God. Behold, you will conceive and give birth to a King whose empire will spread over all the earth.' "[172] The Virgin winding the purple thread on her spindle at the moment of the Annunciation was represented for the last time in the thirteenth century at Lyon; but if we go farther back in time, we shall see that she was frequently represented in this way, especially in the Near East.[173] The people, moreover, never forgot this ancient tradition: the cobwebs that float so lightly in the fields in autumn are even today called the threads of the Virgin (*les fils de la Vierge*).

Another detail from the legend is shown in a twelfth-century window of the cathedral of Angers: contrary to all likelihood, a young girl is represented beside Mary at the moment of the Annunciation. Her presence can be explained only by the apocryphal Gospels. The *Evangelium*

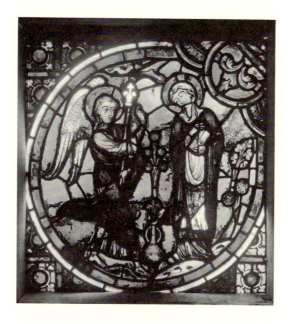

165. Annunciation. Laon (Aisne),
Cathedral of Notre-Dame. Choir,
stained glass, detail of window of the
Life of the Virgin.

de nativitate Mariae tells us, in fact, that the high priest gave five girls as companions to Mary in the house of Joseph. They were Rebecca, Sephora, Susanna, Abigail, and Zahel.[174] The Angers painter supposed that one of them had been present at the Annunciation.[175]

In the thirteenth century, the simplicity of the Gospels returned to the Annunciation scene. The Virgin and the angel are alone; they stand facing each other; the Virgin betrays her emotion only by a slight movement of her hand. The scene is as solemn as the mystery it represents. There is no scenery. Thirteenth-century artists represented neither the light portico where the Italian Virgin prayed, nor the chaste little chamber like a Beguine's cell, where the Virgin of Flanders meditated. They included nothing that would divert our attention from the two actors of the mystery.

However, in the course of the thirteenth century, one symbolic detail appeared which seems to me not to have been properly understood: a long-stemmed flower stands in a vase between the Virgin and the angel. This flower is not the lily it was later to become; it does not symbolize the purity of Mary, as we might think. It refers to another mystery. Medieval Church Doctors, among whom St. Bernard must be cited first, claimed that the Annunciation had taken place in springtime, "flower-time," and they believed they found proof of this in the name of Nazareth itself, which means "flower." Consequently, St. Bernard could say: "The flower desired to be born of a flower, in a flower, in the season of flowers."[176] The flower appeared in many thirteenth-century windows; it will suffice to cite those of Laon (fig. 165), Sens, and Bourges.[177] We almost always find it in miniatures of the same period. When it is miss-

ing, we can be sure that it was due to the artist's carelessness, for the composition of the scene was rigidly established and nothing in it was changed for nearly a century. The standing angel with his two wings falling in parallel lines raises his right hand; in his left hand he holds a phylactery on which *Ave Maria* is written. The Virgin also stands; she holds a book in her left hand, and with her right hand gestures in astonishment. Between them stands the vase and the flower.[178] This is the origin of the beautiful flowers which the Italian primitives place between the Virgin and the angel of the Annunciation, against a gold background.

Our thirteenth-century artists tactfully rejected certain apocryphal events in the life of the Virgin that were often used in the Near East. For example, they did not make the mistake of representing the trial by bitter water, as had been done in the eleventh century at S. Marco in Venice under Byzantine influence. It was unseemly to suppose that the Virgin, in order to prove her virginity, had been obliged to drink the bitter water of the ordeal, and after walking around the altar seven times, show the high priest that no sign appeared on her face.[179]

I have found only one legendary detail in the life of the Virgin as it was represented at this time. It was supposed that she prolonged her visit to Elizabeth so that she might be present at the birth of John the Baptist,[180] and that she received the Precursor when he came into the world and held him in her arms. In works of art of this period, beside the bed of Elizabeth we sometimes see a woman with a nimbus, who can only be the Virgin.[181] It was in this way that the Saviour, still in the womb of his mother, and the Precursor, at the moment of his birth, were brought together. The Middle Ages clung to this tradition and never represented the two children playing while the Virgin and angels watch over them, as Leonardo da Vinci, Raphael, and Renaissance artists were later to do.

It is only in representations of the Virgin's last moments that we come upon legend again. The account of her death, ascension, and coronation is entirely apocryphal, but these stories were so popular that there is perhaps not one of our great cathedrals that does not have at least one episode from them. Churches dedicated to the Virgin almost always have her coronation represented on the tympanum, a roof gable, or a gable of the façade.[182] The Coronation of the Virgin was carved three times in the cathedral of Paris alone,[183] and five reliefs are devoted to her death, funeral ceremonies, and assumption.[184]

Thus, no subject was more popular. However, even though the Church allowed these legends to be carved on all its cathedrals, it did not accept them in its liturgical books. I have looked in vain for them in late twelfth-century lectionaries, usually so hospitable to apocryphal stories, and in thirteenth-century breviaries. A letter on the death of the Virgin,

supposedly written by St. Jerome to Paula and Eustochia, was read at the feast of the Assumption.[185] The letter is solemn and somewhat cold; the author speaks with great reserve about legendary traditions current in his time. He said, "Nothing is impossible for God, but for my part, I prefer to affirm nothing."[186] The ardent piety of the people required certainty; to them, doubt seemed impious. Moreover, the tomb from which the Virgin came forth when summoned by her son had been seen by the crusaders in the Valley of Josaphat; they had beautified it and decorated it with lamps of gold. They cherished it as a place sanctified by the most beautiful of Christ's miracles.

Consequently, the Church did not wish to take from the people the joy of belief in the miraculous story of the Death and Assumption of Mary. It was attributed to Melito, the disciple of St. John, and sometimes to St. John himself. The text, as it has been preserved, dates from a very early period. The fame of the legend spread far; Arab and Coptic versions, more or less altered, have been found.[187] It was Gregory of Tours who made it known in abridged form to the Gallican Church.[188] In the thirteenth century, Vincent of Beauvais and Jacob of Voragine reproduced the Latin version with very few changes.[189]

We must study this story very closely if we wish to understand the works of art, difficult to interpret, that illustrate it. It is a kind of drama that is extremely animated and terminates in a magnificent epilogue. In analyzing it, artists discovered as many as seven motifs appropriate to art.

The first is the appearance of the angel to Mary. Mary was sixty years old,[190] and for a long time had desired to be reunited with her son. One day, in the midst of brilliant light, an angel appeared to her carrying a palm branch in his hand. He said, "Hail, Mary. I bring you a branch cut from the palm tree of paradise. Have it brought to your tomb on the third day after your death, for your son awaits you."[191] The angel rose to heaven, and the branch of the palm tree he had brought shone "like the morning star." This final angelic salutation, which must not be confused with the first, was represented in windows at St.-Quentin[192] and at Soissons (fig. 166).[193]

But that was only the prelude to the great event to come. The apostles, by then dispersed throughout the world to preach the Gospel, suddenly felt themselves carried by a mysterious force and put down together in the chamber of Mary. Mary, reposing on her bed, awaited death. In the third hour of the night, Jesus appeared, and with him, a multitude of angels, martyrs, confessors, and virgins. And while they sang angelic choruses, a dialogue began between the mother and the son. Jesus said, "Come, my chosen one, and I will place thee on my throne, for I desire

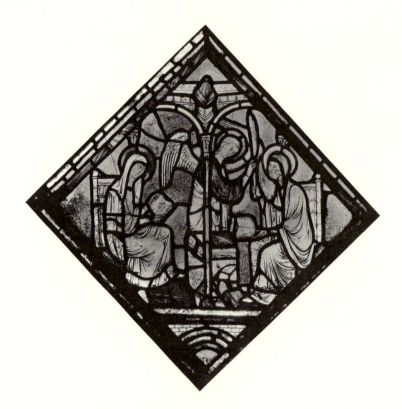

166. Annunciation of the Death of the Virgin. St.-Quentin (Aisne), Collegiate Church. Chapel of the Virgin, stained glass panel.

thy beauty." And Mary replied, "I come, for it is written of me that I shall do thy will." And Mary's soul left her body and flew into the arms of her son. All the choirs of the blessed mounted to heaven, carrying in their arms the soul of her who had borne their king, and they sang, "Who is she that rises out of the desert? She is the fairest of all Jerusalem's daughters. . . ."

This is the great scene. It is of Eastern origin, and as the beautiful mosaic at Daphni proves, the Byzantines had already represented it in the eleventh century. The apostles are placed around the bed on which the body of the Virgin lies, and in his arms Jesus holds the soul of his mother in the form of a child. The composition has the grandeur of antiquity.

The Death of the Virgin did not appear in our monumental art until the end of the twelfth century. We see it for the first time carved about 1185 on the lintel of the portal of Senlis, but the relief is so badly mutilated that we can scarcely make it out.[194] On the north portal of Chartres, which dates from the early thirteenth century, the scene is better preserved. We have no trouble in recognizing on the lintel the imposing composition created in the Near East (fig. 167): Christ stands among the apostles and holds his mother's soul. But strangely enough, the monumental art of the thirteenth century did not keep to this early formula, and Christ rarely figures in this scene of the Death of the Virgin. At Sens (fig. 168), St. Thibault (Côte-d'Or), Mouzon (Ardennes), and in the

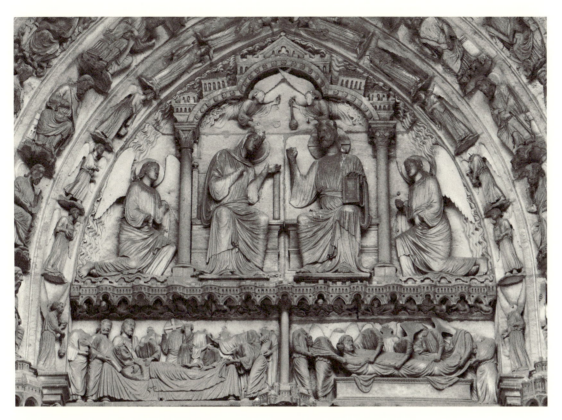

167. Coronation of the Virgin. Chartres (Eure-et-Loir), Cathedral of Notre-Dame. North transept, central portal, tympanum and lintel.

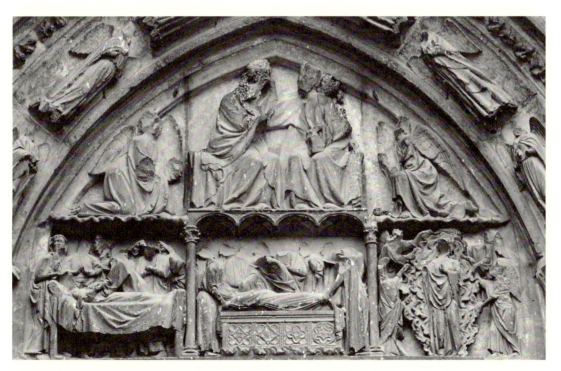

168. Death, Entombment, Assumption and Coronation of the Virgin. Sens (Yonne), Cathedral of St.-Etienne. West façade, right portal, tympanum.

reliefs of the north wall of Notre-Dame of Paris, only the apostles are lined up around the deathbed. In this, we regret that the artists forgot their ancient model; but if they ceded a point here to the Orientals, what follows will show them displaying a richness of invention never attained by Eastern art.

The funeral ceremonies of the Virgin follow. Her body, radiating dazzling light, was placed in the coffin; the apostles took their places in the funeral procession. St. John was first, holding in his hand the celestial palm branch given to him by the Virgin; St. Peter and St. Paul carried the coffin on their shoulders, St. Peter at the head and St. Paul at the foot, because he himself had said that he was the humblest of the apostles. They advanced singing *In exitu Israel*, and angels from the heights of heaven accompanied them. The Jews assembled when they heard the celestial melody. When they learned that Mary the mother of Jesus was being interred, they wanted to stop the procession, take the body and burn it. The chief high priest was bold enough to try to seize the coffin, but his two hands suddenly dried up and stuck to the bier. In vain he beseeched St. Peter, who replied: "You can be healed only by believing in Jesus Christ and in her who bore him." The chief high priest then cried, "I believe that Jesus was the true Son of God and that Mary was his mother." Immediately his hands were freed, but his arms remained withered. Then Peter said to him, "Kiss the coffin and say, 'I believe in Jesus Christ and in Mary who carried him in her womb and remained a virgin after bearing him.' The priest repeated the words and was immediately healed."[195]

We rarely find all the details of this scene in a single work, but we find them one after the other in windows, reliefs, and miniatures. Thus, in the window at Angers, John carries the palm; in thirteenth-century miniatures, Peter is placed at one side of the deathbed and Paul at the other.[196] At St.-Ouen, in Rouen, and at Notre-Dame of Paris (fig. 169),[197] a relief represents the miracle of the withered hands. In the Paris relief, two figures seem to try to seize the coffin: one rushes forward and seizes it, the other falls to the ground while his hands remain stuck to the shroud covering the bier. In reality, both figures represent the same person, but in different moments of time. Duplication of the same figure was infrequent in medieval art; like the contemporary theater art was often synoptic. In works of art, as on the stage where the Mystery plays were performed, one took in at a glance a whole series of events.[198]

Meanwhile, the apostles themselves placed the body of Mary in the tomb. This is the scene that is usually confused with the Death of the Virgin. However, it is easy to see that the Virgin is not lying on a bed, but is suspended for an instant above the tomb into which she will disap-

169. Funeral of the Virgin. Paris,
Cathedral of Notre-Dame. Choir, north
side.

pear, while the apostles, holding the shroud, contemplate the mother of
their God. This is the scene represented at St.-Yved-de-Braîne,[199] Long-
pont (fig. 170), Sens (fig. 168), Longpré-les-Corps-Saints (Somme), and
Amiens (fig. 171). At Amiens, to make even clearer the meaning of the
scene, one of the apostles holds the kind of cross carried in funeral
ceremonies.

By God's decree, the apostles watched over the sepulcher for three days.
On the third day, Jesus appeared with a multitude of angels to resurrect
the body of his mother. The Archangel Michael carried the soul of Mary.
And the Lord said, "Arise, my dove, tabernacle of glory, vase of life,
celestial temple; as in conceiving you knew no blemish, so in the sepul-
cher, your body will not know corruption." And at that instant Mary's
soul reentered her body.[200]

This scene of the resurrection of the body has also often been confused
with the scene of the Death of the Virgin, and at first glance this is a
possible mistake. The admirable tympanum of Notre-Dame of Paris (fig.
172) does not represent the death of Mary as is usually said,[201] but her
resurrection. Two angels, tremulous with respect, lift the Virgin from the
tomb. They carry her gently on a long veil, for they dare not touch the
sacred body. Jesus raises his hand to bless his mother, and the apostles

170. Entombment, Resurrection and Coronation of the Virgin. Longpont-sur-Orges (Essonne), Priory. West portal, tympanum.

171. Entombment, Resurrection and Coronation of the Virgin. Amiens (Somme), Cathedral. West façade, right portal, tympanum and lintel.

172. Resurrection and Coronation of the Virgin. Paris, Cathedral of Notre-Dame. West façade, left portal, tympanum.

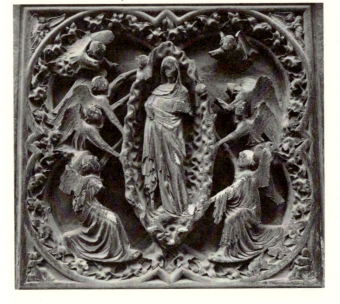

173. Assumption of the Virgin. Paris,
Cathedral of Notre-Dame. Choir, north
side.

thoughtfully meditate on this mystery. Mary is beautiful, clothed in eternal youth; age dares not approach her. On this point alone, the artists did not want to follow the tradition of the *Golden Legend.*[202] At Chartres, the text was followed even more exactly than at Paris, for two archangels, soaring above the tomb, respectfully carry on a cloth the soul of the Virgin, which would soon reunite with her body. At Senlis,[203] the artist represented the multitude of angels referred to in the legend: they swoop down beside the tomb and with a love scarcely tempered by respect, dart forward together to accomplish God's work.

The Assumption follows the Resurrection. The body of Mary, reunited with her soul, rises to heaven accompanied by angels. At Sens, in the window of the choir, and at Troyes, in a window of the apse, Mary triumphantly carries a palm branch.[204] This is the sign of victory spoken of in the hymn of the Assumption: *palmam praefert singularem.*[205] Reliefs sometimes show the Virgin ascending in an aureole resembling a scalloped seashell (figs. 173, 168). The effect is strange, but in trying to translate into stone the luminous image of windows, the sculptor had no other way to render the radiance of the glorified body of Mary than to make solid rays of light. The angels, not daring to touch the body of the mother of God, support the aureole and ascend with her.[206]

Then comes the episode of the Virgin's belt. St. Thomas had been absent, arriving only after the resurrection. When he saw the empty tomb, he characteristically refused to believe the miracle. From the heights of heaven, Mary threw down her belt to convince him. The Italians were particularly fond of this legend, and prided themselves on possessing the belt of the Virgin at Prato. Consequently, in the beginning it is rarely

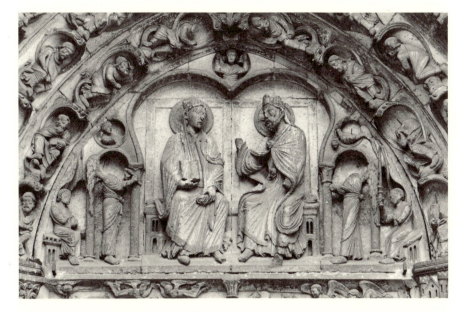

174. Coronation of the Virgin. Senlis (Oise), Cathedral of Notre-Dame. West façade, central portal, tympanum.

found except in Italian art. A thirteenth-century Italian miniature, traced by the Comte de Bastard, provides one of the earliest examples.[207] It is clear that the sculptor of the tympanum of Notre-Dame of Paris was unfamiliar with the legend, or perhaps did not wish to represent it, for he shows all twelve apostles present at the resurrection of the Virgin.

When Mary was borne to heaven by the angels, Jesus seated her at his right on the throne, and placed a crown on her head. This is the Coronation of the Virgin, which the *Golden Legend* does not describe but merely indicates by the following words: "Come with me from Lebanon, my spouse," Christ said to Mary, "come and *be crowned*." And Jacob of Voragine added that the joyous choirs of the blessed accompanied her to heaven, where *she was seated on the throne of glory*, at the right hand of her son. The text of the Office of the Assumption, however, gives precise indications by applying the words of the Psalmist to Mary: "The Queen was seated at his right in golden vestments,"[208] and, "He placed on her head a crown of precious stones."[209] However, it was only in the twelfth century that the liturgical words were expressed in art. As is fitting, the scene of the Coronation of the Virgin first appeared in St. Bernard's time, and the earliest example I know is on the portal of the cathedral of Senlis.[210] The following century, the thirteenth, proclaimed the royalty of Mary and inscribed it on the façades of all its cathedrals.

In the course of the thirteenth century, the scene of the Coronation of the Virgin was composed in three different ways. The relief of Senlis follows the earliest formula (fig. 174). The Virgin is seated at the right of her son, and angels cense her or carry torches. But what is remarkable here is that the Virgin already wears the crown on her head and her son

merely raises his hand to bless her. The coronation has taken place, and the Virgin has taken possession of the throne for all eternity. Such is the Coronation of the Virgin at Laon, which imitates that of Senlis. Such also is the Coronation of the Virgin at Chartres, a work still archaic in character which dates from the early thirteenth century (fig. 167).

At Notre-Dame of Paris, the Coronation of the Virgin assumed a new form. This time it is indeed a coronation, but it is not Christ who crowns his mother; an angel comes from above and places the crown on her head (fig. 172). Everything is remarkable in this tympanum. There is no more chaste and sober work in all medieval art.[211] The Virgin, seated beside her son, turns her pure face to him and contemplates him with clasped hands while the angel places the crown on her head. Jesus, radiant with divine beauty, blesses her and presents her with the flowering scepter. This scepter is the symbol of his power, and he desires that henceforth his mother shall share it with him. The gesture of the Virgin expresses both gratitude and modesty. In the past, this group was gilded; Mary was dressed in a golden mantle, like the queen of the Psalmist. The setting sun of summer evenings restores her ancient finery. Around her in the archivolts are grouped the angels, kings, prophets, and saints, who form the court of the Queen of Heaven. Of course we admire the exquisite painting in the Louvre, by Fra Angelico, in which Mary is crowned by her son among the choirs of virgins, saints, and martyrs, all dressed in celestial colors. But let us not do our old masters an injustice, for they had treated the same subject two centuries before Fra Angelico, and with even more grandeur.[212] They placed all of paradise in concentric circles around the Virgin; like Dante, they opened heaven to man's eyes and showed Mary at the center of divine things, surrounded by "more than a thousand angels with outspread wings, who celebrated her, each having its own splendor."[213]

The tympanum of Notre-Dame of Paris was set in place about 1220. The new formula for the Coronation of the Virgin, which it inaugurated, was to hold sway for more than a quarter of a century. It is even found again at Notre-Dame of Paris on the "Porte rouge" (fig. 175). It was used again at Longpont (fig. 170), and at Amiens (fig. 171), where the imitation of Paris is evident.[214] Nevertheless, at Amiens, the details of the composition are less felicitous: the scepter presented in the Paris composition by Christ to his mother is already in her hands. The artist had thought to honor the Virgin even more, but he took away from his group the delicacy of feeling that the Paris artist expressed. At Amiens, the touching dialogue between the mother and son is over.

At a date difficult to determine precisely, but which must have been near 1250, a third formula for the Coronation of the Virgin appeared.[215]

This time, respect for the Virgin had become so great that Christ himself, not the angels, places the crown on her head. Such are the Coronations at Sens (fig. 168), Auxerre (fig. 176), and Reims. The beautiful group of the mother crowned by her son, made popular abroad by our ivories (fig. 177), charmed all of Europe. We find it in Italy, Spain, and Germany. It marks the high point of the cult of the Virgin in the thirteenth century.[216]

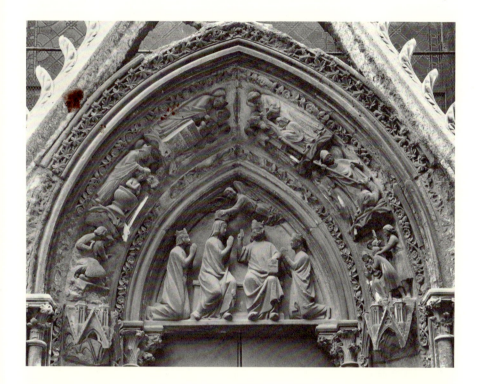

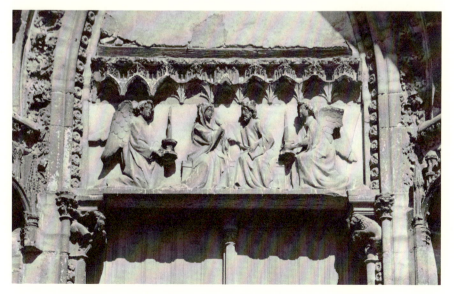

175. Coronation of the Virgin. Paris, Cathedral of Notre-Dame. North façade, "Porte Rouge," tympanum.

176. Coronation of the Virgin. Auxerre (Yonne), Cathedral of St.-Etienne. West façade, right portal, lintel.

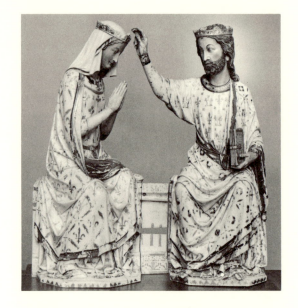

177. Coronation of the Virgin. Paris, Louvre. French ivory, thirteenth century.

The miracles of the Virgin. The story of Theophilus. Gregory of Tours' *De gloria martyrum*. Study of several windows at Le Mans.

Thus, the legends surrounding the Virgin were extremely fruitful for artists. These simple stories, no longer read, enchanted people for four hundred years and are responsible for at least half our ancient works of art. It is enough to remark here that of the three great portals of Notre-Dame of Paris, two—the St.-Anne Portal and the Virgin Portal—are decorated almost solely with subjects taken from the apocryphal Gospels.

VIII

In the thirteenth century, the miracles of the Virgin were almost as famous as her legend. At the time, Mary represented the grace that was more powerful than the law. On the tympanum of cathedrals, we see her kneeling before her son who prepares to judge the world; she heartens the sinner who dares not look his judge in the face when he comes into his presence.

She was the "advocate" of hopeless causes.[217] All the treasures of God's mercy were in her hands.[218] Dante said: "Lady, you are so great, and you have so much power, that whoever wishes a grace and does not appeal to you, would have his desire fly without wings."[219]

Moreover, the Virgin of the Middle Ages remained a woman. She paid no regard to good and evil, but pardoned out of love. To be saved, it was enough to have recited half of her *Ave Maria* every day. That Satan was king of logicians amounted to nothing, for at the last moment she could put him to rout with charming grace and Gallic subtlety. She appeared in disguise where the devil did not expect her. She was present at the weighing of souls and could tip the scales on the right side.

Les Miracles de Notre Dame, which Gautier de Coincy, canon of Soissons, put into rhyme, is the book of divine grace: Mary saves all who have been condemned by human and divine justice. It is also the most diversified of stories. The poet transports us to a world as full of marvels as the world of the Breton *lais*: lighted candles appear on the mainmast of the ship during a tempest, or descend upon the *vielle* of the jongleur of Rocamadour; the shipwrecked float on the waves, sustained by the mantle of the Virgin; holy images keep back lions and save pilgrims in the desert.

All of these stories were well known when Gautier de Coincy put them into verse. Some had already been famous for a century.[220] Many great churches had their collections of miracles. Hugues Farsit, a canon of St.-Jean-des-Vignes, wrote a book about the cures wrought by the Virgin of Soissons to manifest her powers during a plague in the beginning of the twelfth century.[221] The monk Hermann told of all the miracles that had come to pass both in France and in England during the processions of the reliquary of Notre Dame of Laon.[222] Later, Jean le Marchand celebrated the all-powerful intercession of Notre Dame of Chartres, sometimes borrowing stories from Gautier de Coincy for the greater glory of his venerated patron.[223]

These books did not have as much influence on art as we might imagine. At Chartres, Laon, and Soissons, there is no trace in sculpture and stained glass of the celebrated miracles of these Virgins. However, it may be that some of the many destroyed windows were devoted to these local legends.[224]

It is a remarkable fact that, except at Le Mans, only one miracle of the Virgin was represented in our cathedrals, and it is always the same: the miracle of Theophilus (figs. 178, 179). It appears twice at Notre-Dame of Paris.[225] It is represented in a mutilated window at Chartres, and in fully developed form in windows at Laon, Beauvais, Troyes, and in two windows at Le Mans. A relief on the west portal of the cathedral of Lyon treats the legend briefly.

The miracle is truly dramatic. The clerk Theophilus was *vidame* to the bishop of Adana in Cilicia, and was so pious and virtuous that, at the death of the bishop, the people unanimously chose Theophilus to succeed him. But the modesty of Theophilus was such that he refused, wishing to remain simple *vidame* to the new bishop. The devil, however, did not despair of possessing so saintly a man: he tempted his humility and soon made him wish for the power he had refused. Theophilus searched out a Jew learned in the magical arts and promised to give over his soul to hell if in exchange Satan would give him worldly glory. The pact was drawn up in good form, written on parchment, and signed by Theophi-

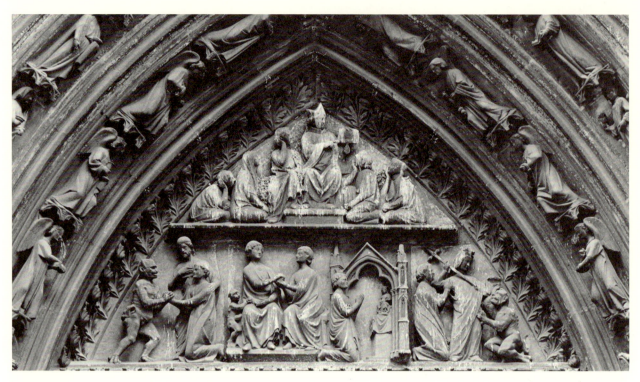

178. Miracle of Theophilus. Paris, Cathedral of Notre-Dame. North transept, portal, tympanum.

lus. Summoned by a necromancer, Satan appeared and carried away the parchment. From that day onward, everything succeeded for the *vidame*. He soon supplanted the bishop in the favor of the people, and to him went all the honors and gifts.[226]

However, in the midst of the joys of power, remorse began to assail him. His sin haunted him, tortured him, cast him into despair. One night, after praying long before the statue of the Virgin, he fell asleep in the church. He dreamed that Mary appeared to him in dazzling light, pardoned his sin, and gave back to him the parchment she had taken from the devil. Now when he awoke, he found that this was not a dream for he held the parchment in his hand.

The pardoned Theophilus gave thanks to Mary and confessed his sin to his bishop; he went even farther and told the people the story of his sin and pardon. A few days after his public confession, he died a saintly death.

This story, so like a first sketch of the Faust legend, was of Eastern origin, but it had come to the West at an early date.[227] Paul, bishop of Naples, translated it from the Greek; the abbess Hrotswitha and the bishop Marbodius put it into verse; and in the thirteenth century, Rutebeuf made a Mystery play of it.[228]

Such a drama, whose action is at the borders of two worlds, was well designed to stir the people, and this explains its success. But it was so popular only because from among many others it had been chosen and adopted by the Church. In the eleventh and twelfth centuries, the story of Theophilus had become an exemplum used in sermons honoring the Virgin. Honorius of Autun, who in the *Speculum Ecclesiae* summarized all the religious teaching that the clergy dispensed to the people of his day, did not omit the story of Theophilus from the model sermon he composed for use of the clergy in the feast of the Assumption.[229]

In the eleventh century, the miracle of Theophilus was officially consecrated by the liturgy. The following verses were included in the Office of the Virgin:

> *Tu mater es misericordiae*
> *De lacu faecis et miseriae*
> *Theophilum reformans gratiae.*
>
> (Thou art the mother of pity
> From the pit of dregs and misery
> Refashioning Theophilus to a state of grace.)[230]

These are the real reasons for the presence of the miracle of Theophilus in so many churches, and there is no point in looking for others.[231]

It was no doubt thought that this one famous miracle was sufficient manifestation of the Virgin's powers, for in general, artists refrained from representing others.

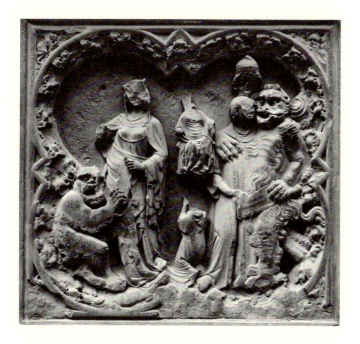

179. Miracle of Theophilus. Paris, Cathedral of Notre-Dame. Choir, north side.

Only the cathedral of Le Mans, where the legend of Theophilus occurs three times, displays along with it representations of other legends. In the chapel of the Virgin and the triforium of the choir, there are two windows that merit description.

First we see workmen, and then children, raising the columns of a basilica; next there is a burning house, and lastly, monks seem to receive gifts from the hands of the Virgin (figs. 180 and 181).

What is the meaning of these disparate scenes? No one has yet given a satisfactory answer. Hucher, deceived by the presence of a bishop called S. Gregori[us] by an inscription, no doubt thought that this was St. Gregory the Great, and tried to see in the windows of Le Mans some of the mystical symbols of Mary's virginity.[232]

In the course of studying twelfth-century lectionaries, I found the answer. In the Office of the Assumption, following the famous letter attributed to St. Jerome, it was customary in medieval churches to read the story of four or five miracles of the Virgin taken from the *De gloria*

180. Miracles of the Virgin (lower section). Le Mans (Sarthe), Cathedral of St.-Julien. Chapel of the Virgin, stained glass.

181. Miracles of the Virgin (upper section). Le Mans (Sarthe), Cathedral of St.-Julien. Chapel of the Virgin, stained glass.

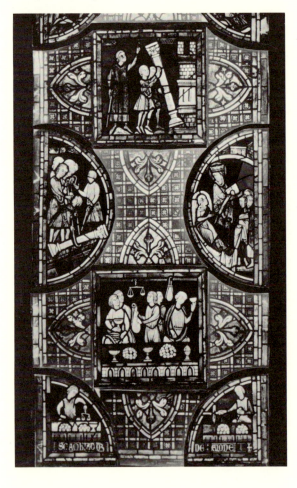

martyrum by Gregory of Tours.[233] This, in fact, was the oldest collection of the miracles of the Virgin known to the Gallican Church. As we see, it long remained in use.

The following are the legends, in the same order as told by Gregory of Tours.

—The Emperor Constantine had a magnificent church built and dedicated to the Virgin, but when the columns were to be put in place, no one could lift them. The Virgin appeared to the architect in a dream and told him to take three children to help him when they came out of school. The architect did as he was told, and without effort the three children raised the columns of the basilica.

—At Marciacum in the Auvergne, there was an oratory of the Virgin containing her relics. One night, Gregory of Tours went there to keep vigil. When he arrived, the windows were so brightly lighted that he thought thousands of lamps were burning in the church. The door opened before him as he approached, and once he was inside, he was in total darkness except for the light of his torch.

—In a town of the Near East,[234] a Jewish glassmaker had a son who often went to church with the young Christians. One day, the child took communion with them. When his father learned of this, he fell into such a fury that he threw his son into the furnace he had just lighted. All the town came running when the mother's cries were heard. They thought the child would be consumed, but he was seen to be lying in the flames "as sweetly as if he were on a featherbed." He told that the lady whose image was in the church had covered him with her mantle, and the miracle was attributed to the Holy Virgin.

—In a rich monastery of Jerusalem, there was no food one day. The monks went to the abbot to complain. He replied, "Brothers, let us pray." They passed the night in prayer, and the next morning their granary was so full they could not close the door. A few years later, there was another famine. The abbot and his monks again passed the night in prayer until the hour of matins. When they had gone away, an angel came and placed a great quantity of gold pieces on the altar. The sacristan guarding the door had seen no one enter, and the miracle was again attributed to the intervention of the Virgin.[235]

—While walking through the fields, Gregory of Tours saw a farmhouse on fire. The peasants tried in vain to put out the fire. The bishop wore on his breast a cross containing relics of the Virgin. When he held it toward the flames, they suddenly died out.

These five miracles, found in certain lectionaries,[236] were certainly included in the liturgical books of the church of Le Mans,[237] for the two windows mentioned above are exact translations of them.[238] In the first,[239]

182. Legend of the Foundation of the
 Abbey of Evron. Le Mans (Sarthe),
 Cathedral of St.-Julien. Chapel of the
 Virgin, stained glass.

we see all the miracles told by Gregory of Tours, except for the story of the Jewish child. In the second,[240] we see the miracles of the columns and of the monastery in Jerusalem, to which was added the famous miracle of the painter who was caused by the devil to fall from the scaffold, and whom the Virgin caught by the arm because he had just painted her image on the wall.

In a nearby lancet, enough remains of several mutilated medallions for us to make out another legend whose heroine is the Virgin. We see a warrior and a bishop talking at a church door, then a knight, armed from head to foot, plunging his sword into the breast of a crowned figure seated at a table. Hucher, who described these medallions, thought they had to do with an episode from the life of St. Bernard.[241] In reality, they represent another miracle of the Virgin, and one often represented with the preceding. It was told that the Emperor Julian, when passing through Caesarea, had been received by the bishop St. Basil who offered him three loaves of barley bread as a gift of hospitality. Julian, scorning so modest a present, had hay sent to the bishop out of mockery. Basil said to him, "We gave you what men live on, and you sent us what beasts feed on." Annoyed, Julian replied, "I shall destroy this city; I will raze it so that it will produce wheat instead of sheltering men." But that very same night, the Virgin resurrected a knight named Mercurius who had been put to death by Julian because of his faith in Christ. Fully armed, Mercurius appeared before Julian and pierced him with his lance. As he was dying, Julian the Apostate cried, "Galilaean, You have conquered!" This legend, found for the first time in the life of St. Basil, passed into the *Speculum historiale* of Vincent of Beauvais,[242] and the *Golden Legend*;[243] two poems in the vulgar tongue made it popular.[244]

The story of the Jewish child is found twice at Le Mans in adjoining windows, both of which are dedicated to the Virgin.[245] It must be noted that in both windows, the miracle of the Jewish child accompanies the miracle of Theophilus. The first legend was almost as famous as the second; each had become an exemplum used in sermons. Honorius of Autun told it for use in the feast of the Purification.[246]

In the church of Le Mans, where windows dedicated to the Virgin are so numerous, there is one—the only one I have found—that tells of a local miracle of the Virgin (fig. 182). The window was certainly donated by the Abbaye d'Evron, for its subject is the miraculous foundation of that abbey. A pilgrim returning from the Holy Land brought back a relic of the Virgin in his scrip. Between Le Mans and Laval, he stopped at the foot of a tree, tied his scrip to one of the branches, lay down in its shade and fell asleep. When he awoke, the tree had grown so tall he could not reach his scrip. The whole countryside was aroused. Woodcutters tried to

cut down the tree, but their axes grew blunt when they struck it. The bishop came: he had hardly made the sign of the cross when the tree bent down before him and presented him with the holy relic. By this, it was understood that the Virgin wished to be honored on that spot, and they built an abbey in her honor.

The miracles of the Virgin we have just reviewed are the only ones that figure in our medieval churches. Everywhere, except at Le Mans, only the miracle of Theophilus was carved or painted. In spite of the fame of the miracles, artists preferred to tell the story of the Virgin's life and death.

Thus, in the Middle Ages the apocrypha were a live source of poetry and art. The life of the Virgin and parts of the life of Christ, as told by medieval artists, would be unintelligible to us without the help of these books. In ending this chapter, we can affirm once again that without the apocryphal Gospels, at least half the works of medieval art would be a closed book.

IV

The Saints and the *Golden Legend*

I

The cathedrals and Vincent of Beauvais' *Speculum historiale* present the history of the Christian world in the same way. The centuries are marked off, not by emperors and kings but by saints. By its windows and statues, the cathedral proclaims that since the coming of Christ the only great men were Church Doctors, confessors, and martyrs. In the sanctuary, the conquerors and the victorious, all those whose glory was of this world, are reduced to the humblest attitudes: windows show them kneeling at the feet of saints and smaller than children.

The *Speculum historiale* of Vincent of Beauvais is our evidence that such was the medieval conception of history. The organization of this great work from which so many generations, and even our kings themselves, learned history is nothing less than astonishing. At the beginning of each book, Vincent of Beauvais enumerates the emperors of the East, the emperors of Germany, and the kings of France. He devotes a few lines to their battles and their treaties, and then he arrives at his real subject, the history of the saints contemporary with these emperors and kings. His heroes are abbots, hermit monks, young shepherdesses, beggars. To him, the most important events in the history of the world are the transfer of relics, the foundation of monasteries, the healing of those possessed by devils, the withdrawal of a hermit into the desert.

In his history, Vincent of Beauvais registers neither surprise nor emotion that the civilization of antiquity has come to an end, and that Symmachus and Boethius appear among the barbarians as "the last of the Romans." He turns his eyes from Rome and serenely arranges in their order the only events of the time that seem worthy of record: the miracles of St. Leonard in the Limousin, of the abbot St. Mexent (Maxentius) in Poitou, and the journeys of St. Malo.[1] The hermit St. Dié (Deodatus) in the forest of the Vosges occupies the historian longer than the Emperor Heraclius.

The saints. Their place in the lives of medieval men.

Thus, the history of the Middle Ages is reduced to the history of a few pure souls who lived far removed from men. It would seem that in the ninth and tenth centuries, the earth was inhabited only by saints and that the world resembled the landscape of the Campo Santo at Pisa, peopled only by anchorites in prayer. Except for the crusades, great contemporary events were never given first place in Vincent of Beauvais' history. The battle of Bouvines goes almost unnoticed, placed as it is between the histories of St. Marie d'Oignies and St. Francis of Assisi. The saints form a celestial chain linking St. Louis with the apostles, and continuing back through the patriarchs and the prophets, linking the apostles with Abel, the first of the just.

To the men of the thirteenth century, this was the true history of the world, and this was the true City of God. We must keep this conception of history in mind if we are to interpret the innumerable saints' legends painted or carved in the cathedral of Chartres. It is as if each window and each relief were a chapter from the *Speculum majus*. This way of understanding history explains in a certain measure the prodigious number of saints' images decorating our cathedrals, but it does not explain everything.

For medieval Christians, the saints were not only the heroes of the history of the world, they were above all intercessors and patrons. There was more than a remnant of pagan antiquity in the honors paid to them. They mingled in the lives of men and cities just as the local gods had done in pagan Rome. When the Christian was born, he was given at baptism the name of a saint who would be his patron and model. These names were not bestowed by chance: preferably, they were those of ancient bishops or ancient monks whose relics worked miracles in their province. Many Christian names, now become family names, reveal even today the locality from which the family originally came.[2] When the child grew to manhood, he chose a trade and joined a guild: there another saint welcomed him. If he was a stonecutter, he kept the day of St. Thomas the Apostle; if a woolcarder, he kept the day of St. Blaise; tanners kept the day of St. Bartholomew. On their saint's day, they forgot the hard work and the long days: proud as knights, they marched behind the banner of their patron saint, went to Mass with masters and fellow workmen, and then sat at the same table with them. The name of a saint was associated with the happiest memories of youth. The great feasts with splendid processions, sparkling reliquaries, and Mystery plays were the feasts of the patron saints of towns, when the entire city gave itself over to the spectacle. Even in the remotest villages of old France, there was at least one celebration a year. People danced beneath the elm near the cemetery on the feast day of the saint whose relics were kept in

the church. In the central provinces of France, the feast day of the village is still called the *apport*, a name recalling the offering that every good Christian had to present on that day to the altar of the patron saint of the parish.

The saints lifted medieval man out of his monotonous life, they obliged him to take his staff and wander over the world. Almost all the travelers of the time were pilgrims. The poorest went from abbey to abbey, from hospice to hospice, until they arrived at Santiago de Compostela. Those who were not able to undertake the long journey had to be content with offering a wax candle to St. Mathurin of Larchant or to St. Faron of Meaux. The roads of France were crowded with travelers who wore on their hats the leaden image of St. Michael in Peril of the Sea or of St. Gilles of Languedoc.[3] These small medals were equal to a king's safe conduct; enemy armies allowed these peaceful men to continue their journey "for the cure of their souls." Moreover, each province had its holy places that had been sanctified by a bishop, a hermit, or a martyr. Fountains once inhabited by mother-goddesses, and stones on the moors haunted by the fairies, became Christian, for great saints had consecrated them. In the Morvan, the peasants each year went to drink at the spring that St. Martin had caused to flow with a blow of his cross, and to crawl on their knees around the rock on which the mule of the great bishop had left its hoofprint.[4] The saints replaced the spirits of the mountains, valleys, and forests. Hilltops once dedicated to Mercury were now dedicated to St. Michael, the heavenly messenger who showed himself on the peaks. The soil of France became a vast sanctuary, just as in Celtic times; some man of God had left his trace in even the most solitary places.

Sanctuaries, hermitages, and holy fountains—these constituted the geography of the time. The saints constituted all of knowledge for thirteenth-century man, they mingled in all his thoughts and all his acts. In sickness, he turned to them to be healed. He invoked St. Genevieve of Paris against fever, and St. Blaise against diseases of the throat. St. Hubert, the great hunter who had lived so long a time among his hounds, cured hydrophobia: an iron key, blessed in one of his chapels and heated red-hot, had to be applied to the bite. St. Apollonia, whose jaw had been broken by her tortures, cured toothache. St. Sebastian, St. Adrian, and after the fourteenth century, St. Roch, protected towns against the plague. The scourge did not enter those houses bearing the three protecting letters: V.S.R. (Vive St. Roch).[5] A kindly patron saint took pity on man's weak and quivering flesh. Women were eased of the lassitude brought on by pregnancy by wearing the girdle of St. Foy or St. Marguerite. Children who wore around their wrists a ribbon bearing the name of St. Amable of Riom were never afraid at night. St. Servais inured weak souls against

the fear of death. St. Christopher protected against sudden death. It was enough to have seen his huge image at the entrance to the cathedral to be assured of not dying that day:[6]

> *Christophorum videas, postea tutus eas.*

> (If thou see Christopher, thereafter wilt thou go in safety.)

The virtue of the prayers recited in honor of the saints reached animals, plants, and all of nature. St. Corneille protected the cattle, St. Gall the chickens, St. Anthony the pigs, St. Saturnin the sheep,[7] St. Médard protected the vines against frost.

This passionate desire for support, for healing, and health, in profound ignorance of all things, is deeply moving.[8] In difficult hours, when the spirit was troubled and the soul melancholy, the name of a helpful saint always came to the Christian's mind. Travelers who had lost their way in the night prayed to St. Julian the Hospitaler. Hopeless causes were placed before St. Jude. During their vigil of arms, knights who were to fight in judicial combat invoked the aid of St. Drausin, bishop of Soissons; Thomas à Becket, before leaving for England to fight against Henry II as a champion of God, wanted to pass a night beside the tomb of the ancient bishop.[9] Like Bohémond, prisoners shut up in deepest dungeons invoked St. Leonard and promised to hang silver chains in his church on the day of their deliverance.

Our old French proverbs, now forgotten but passed from mouth to mouth for centuries, mingled the names of the saints with popular wisdom. Since the ecclesiastical calendar was well known to everyone, people might say:

> *A la Saint-George (23 avril)*
> *Sème ton orge;*
> *A la Saint-Marc (25 avril)*
> *Il est trop tard.*

> (On St. George's day [23 April]
> Sow your barley;
> On St. Mark's day [25 April]
> It is too late.)

Or:

> *A la Saint-Barnabé (11 juin)*
> *La faux au pré.*
> *A la Saint-Leu (1ᵉʳ septembre)*
> *La lampe au cleu.*[10]

(On St. Barnabas' day [11 June]
The scythe in the field.
On St. Leu's day [first of September]
Hang up the lamp.)

The little popular calendars, which illiterate peasants carved with their knives, marked the principal days of the year by the attributes of saints: an arrow for St. Sebastian's day, a key for St. Peter's, a sword for St. Paul's.[11] Such hieroglyphs were understood by everyone.

The saints gave rhythm to the year. One after the other, they seemed to rise above the horizon like constellations. They retained something of the pagan charm of nature and the seasons. St. John's day in summer, celebrated "when all plants are in flower," was something like a festival of the sun. St. Valentine's day, marking the end of winter, was (especially in England) the festival of early spring not yet fully arrived. It was said that on this day the birds come back in pairs to the woods, and young men should place flowers at the windows of their true loves.

In popular thought, the saints not only marked the return of the seasons, they also regulated their progress. Like ancient Germanic gods, they distributed good and bad days to mankind, according to their whim. In Provence, St. Césaire of Arles had complete power over storms: his glove, taken full of air into the valley of Vaison, had unleashed the winds there.[12] St. Servais kept three days of snow in reserve for the middle of May. St. Barbara kept lightning away: that is why the bells that were tolled during storms bore her image.[13] St. Médard was the master of rain. Several other saints shared this privilege with him; during long periods of drought, the people, angry that their prayers were unavailing, repeatedly immersed the statue of the saint they had invoked in vain.[14]

Nature and all the universe proclaimed the glory of the saints. The Milky Way was called the *chemin de saint Jacques* (the way of St. James); the phosphorescence of the sea was called *le feu de saint Elme* (St. Elmo's fire). The little hedge berries that ripen in winter were called in Flanders *lampes de sainte Gudule* (lamps of St. Gudule); the plantain that cured scrofulus was known in the north of France by the name of *herbe de saint Marcoul*.[15]

Thus, pagan antiquity was artlessly perpetuated under the cover of the saints. As Brittany is today with its chapels, its fountains, and its *pardons*, such was all of France in the Middle Ages.

The *Legenda aurea* (the *Golden Legend*). Its character. Its charm.

It is understandable that so much space in cathedrals was given to the saints, and that so many windows were dedicated to them. The people never tired of seeing their protectors and friends—those who were closer to them than God. Neither did they tire of hearing about them. Poems in the vulgar tongue, popular dramas, and sermons constantly kept before Christians the memory of famous miracles and illustrious exempla taken from the lives of the saints. The Church faithfully guarded the storehouse of this almost infinite history and transmitted it to the people. In each cathedral and monastery, the Acts of the saints of the diocese were preserved and read from the pulpit on their feast day. The lives of the saints famous in all of Christendom were contained in more or less abridged form in the lectionary, the book of readings for the divine service. The lectionary, whose lessons were later to be included in the breviary when in the course of the thirteenth century it replaced all the old liturgical books,[16] had for centuries kept the saints alive in the memory of the Church. It was composed of excerpts from the most famous of the legends. The *Historia apostolicae* of the Pseudo-Abdias, the *Historia eremitica* translated by Rufinus of Aquileia, the Dialogues of St. Gregory the Great, the *Martyrologium* of Bede, and many anonymous stories were drawn on with the greatest of naïveté and complete lack of critical spirit. It was a *Summa* of the lives of the saints, precious in a time when books were rare.

Thus, Jacob of Voragine was doing nothing new when he wrote his famous *Legenda aurea* at the end of the thirteenth century.[17] His book was simply a popularization of the lectionary, and even followed its plan.[18] His compilation is not in the least original; here and there he merely completed the stories of the lectionary by referring to the original texts and adding new legends. The *Golden Legend* became famous in all of Christendom because it made available to everyone the stories that until then had scarcely ever been found outside liturgical books; barons in their châteaux and merchants in the back of their shops could henceforth savor these fine stories at their leisure.

The criticism heaped upon Jacob of Voragine in the seventeenth century was beside the point. This golden legend, which the critics called "a leaden legend,"[19] was not the work of one man, but of all Christendom. The guilelessness and credulity of the writer were shared by all of his contemporaries. The fabulous stories of St. Thomas' voyage to India and the miraculous mantle of St. James, so sympathetically told in the *Golden Legend*, outraged the stern theologians educated at the school of the Fathers of the Council of Trent, but in the thirteenth century they

were accepted by everyone. They were read publicly in cathedrals and represented in stained glass windows. To condemn Jacob of Voragine is to condemn all of the old lectionaries, and along with them, the canons who read them and the faithful who listened to them.

For us who search for the spirit of the time in medieval books, the *Golden Legend* remains one of the most interesting of the period. The fidelity with which it reproduced earlier stories, and its lack of originality, make it particularly valuable. Such a book admirably represents a whole series of works and, if need be, makes it unnecessary to consult them. When we have read it, we can explain almost all the reliefs and windows representing legends in our cathedrals. In his new edition of the *Golden Legend*, Graesse rendered a great service, if not to religious history, at least to the history of art.[20] The *Golden Legend*, therefore, will be our principal guide in this study, and we shall turn to this popular book for the explanation of works of art made for the people.

Without great effort, we can understand the charm that such a book must have had, and what moral sustenance it provided for the people of the Middle Ages.

First of all, its numerous biographies presented the most varied picture of human existence. To know the lives of the saints was to know all humanity and all life; all ages and all conditions could be found there.[21] Our novels, our *comédies humaines*, are less varied and rich in experience than the vast collection of the *Acta sanctorum*, of which the *Golden Legend* contains the essence. There was no trade and no profession that did not have its saints. There were saints who had been kings, like St. Louis, popes like St. Gregory, knights-errant like St. George, shoemakers like St. Crispin, beggars like St. Alexis. Even a lawyer had been canonized, and the people showed their good-natured astonishment in the hymn they sang in honor of St. Yves:

> *Advocatus et non latro*
> *Res miranda populo.*
>
> (A lawyer yet not a thief—
> A thing to excite people's wonder.)

Shepherds, cowherds, ploughmen, and humble servants had been judged worthy to sit at the right hand of God. The lives of these humble Christians revealed what was most serious and profound in human life. For the medieval reader they were the richest storehouse of wisdom, for in them each person could find a model for his own life.

The *Golden Legend* taught Christians to know life, and it also taught them to know the world, to imagine other climates and other centuries; it gave the people of the Middle Ages a glimpse of history and geography.

To be true, the universe it revealed was vague and unsettled, as deformed as it is in old maps, but it was an image of reality, nevertheless. According to the day of the week, the reader would be transported to the tombs of the desert of the Thebaid, where the men of God lived among jackals, or to the Rome of St. Gregory, a deserted city in ruins, devastated by the plague. Or he would follow the narrator to the banks of German rivers, or fly with him to the "Isle of the Saints." When the end of the Christian world had come, the reader's imagination had taken him to all countries and he had lived through all the centuries; even the humble, whose world was his own street and bell tower, had lived through the entire life of Christendom.

However, it was not so much the truth of the book as its marvels that gave it charm. Many of the lives of the saints are as romantic as novels. The legends of the eastern saints, compiled by Greek or Coptic hagiographers, resemble fairy stories. The stories of St. Eustace, St. George, and St. Christopher are especially exotic.

183. Legend of St. Eustace (lower section). Chartres (Eure-et-Loir), Cathedral of Notre-Dame. Nave, north aisle, stained glass.

Placidas, "master of chivalry" to the emperor Trajan, one day saw the image of Christ between the antlers of a great hart he was hunting. Converted by this miracle, he had himself and his wife baptized, and he took the name of Eustace (figs. 183, 184, 185). To humble him, God brought him to ruin, as he had his servant Job. Despoiled of all his great possessions, he set sail with his family and came to Egypt. Since he had no money to pay their passage, the master of the ship demanded his wife. Sorrowfully, Eustace plunged into the unknown country where he had just landed, and with his two children came to a river, "and for the great abundance of water he dared not pass that river with both his sons at once. He left one of them on the bank of the river, and carried the other to the opposite shore. He went back to get the second one, and was already in the middle of the river when a wolf from one side, and a lion from the other, carried away both his sons (fig. 184). In despair, Eustace went into the neighboring town, and hired himself out as a day laborer." He stayed a number of years, grieving over his sons whom he

184. Legend of St. Eustace (middle section), Chartres (Eure-et-Loir), Cathedral of Notre-Dame. Nave, north aisle, stained glass.

thought dead, although they were growing to manhood with nearby peasants who had saved them. The story ends as classical romances and ancient comedies ended. The dramatic device so often used by Menander and Terence—the recognition scene (ἀναγνώρισις) is skillfully managed by the hagiographer. Two of Trajan's knights passed through the town where Eustace was dwelling and recognized their old general. Eustace, whom the emperor reinstated as head of the legions, recognized his two sons who had enrolled in the army. In turn, the two young men were recognized by their mother who overheard them, in an inn, tell the story of their childhood. Thus, after many trials, Eustace was reunited with his wife and children, but their happiness was short lived. Hadrian, Trajan's successor, when he learned that Eustace had become a Christian, had him, his wife, and children put into a bronze bull and subjected to the torture invented by Phalaris (fig. 185).

For the people of the Middle Ages, such stories had the charm of our adventure stories.[22]

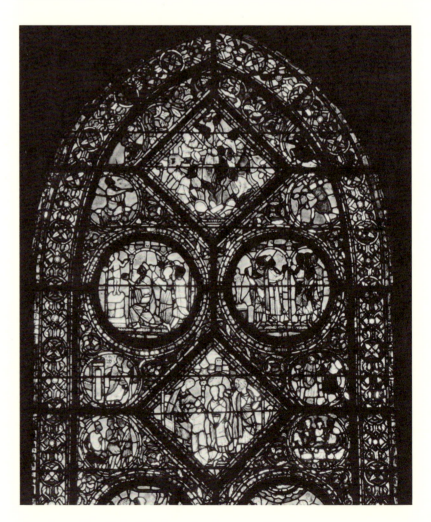

185. Legend of St. Eustace (upper section). Chartres (Eure-et-Loir), Cathedral of Notre-Dame. Nave, north aisle, stained glass.

The legend of St. George, which originated in the Greek world, is a fragment of an epic. In Greece, the epic spring had never run dry. St. George is the Perseus of Eastern Christendom.—Near Silene, in Libya, there was a pool inhabited by a monster. The city regularly sent it a tribute of sheep, and if by chance it failed to do so, the monster advanced to the city walls and envenomed the air with its breath. When there were no more sheep, the monster was offered young boys and girls. Now it happened that the lot fell eventually on the king's daughter. Nothing could save her, and after a delay of eight days, before the eyes of the entire city, she proceeded to the pool, dressed in her royal garments. St. George, who was passing by, saw that she was weeping, and asked where she was going. "Young man," she said, "I believe you are great and noble at heart, but make haste to depart." St. George replied, "I shall not leave until you have told me the cause of your tears." When she had told him all, he said, "Never fear, I shall help you in the name of Jesus Christ." "Brave knight," she replied, "do not seek to die with me; it is enough that I should perish, for you could not help or deliver me, and would die with me." At that moment the monster came out of the water. Then the virgin said, trembling, "Flee, knight, as quickly as you can."—In response, George mounted his horse, made the sign of the cross, advanced toward the monster and calling on Jesus Christ intrepidly charged. He brandished his lance with such force that it struck the monster to the ground. Then, turning to the king's daughter, he told her to tie her girdle around the monster's neck and to fear nothing. This done, the monster followed her like the gentlest of dogs (fig. 186).[23]

This chivalric adventure equals the most splendid undertakings of Lancelot and Gawain. What knight-errant could be compared to St. George?

The story of St. Christopher is even more astonishing. Christopher was a giant from the land of Canaan, twelve cubits tall and terrible in aspect. He entered the service of a king because he had heard that that king was the most powerful in the world. One day the name of the devil was mentioned and the king crossed himself. Christopher realized from this that there was someone in the world more powerful than his master; and so he left, to enter the service of the devil. He met the devil in a desert and went along with him. Arriving at a crossroad, they saw a cross, and suddenly the devil fled. When Christopher caught up with him, he wanted to know the cause of this sudden fear. The devil, pressed with questions, had to admit that there was someone more powerful than he, and that was Jesus Christ; without delay, Christopher went off in search of the master more powerful than the devil. He met a hermit who instructed him in the Christian truths and baptized him. Wanting him to

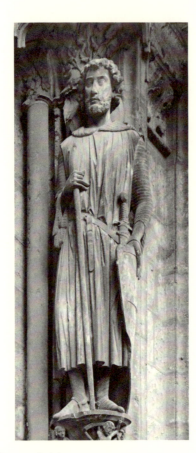

186. St. George. Chartres (Eure-et-Loir),
Cathedral of Notre-Dame. South transept,
left portal, jamb.

187. St. Christopher. Pernes (Vaucluse), La
Tour Ferrande. Fresco.

progress along the path of perfection, the hermit recommended that he
fast; but the good giant could not. Then the hermit urged him to say his
prayers, but Christopher became muddled and could not get on with it.
The hermit, knowing his pupil, set this man of good will up on the
banks of a rapidly flowing river, in which every year many travelers
drowned. Christopher took the passers-by on his back and, with the aid
of a staff, crossed the torrent. One day he heard a child call him. He
came out of his hut, put the young traveler on his shoulder and started
to cross the river. But when he was in the middle of it, the child became
so heavy that the giant, bent double, advanced only with great difficulty.
Arriving finally at the shore, he asked the child who he was. "You put
such a great weight on me," he said, "that if I had been carrying the
whole world on my shoulders, I would not have had a heavier load."—
"Do not be surprised, Christopher," the child replied, "for you had on
your shoulders not only the whole world, but the one who created the
world. Know that I am Jesus Christ." The child disappeared imme-
diately, and Christopher, who had planted his staff in the sand, saw that
it was covered with leaves and flowers (fig. 187). Not long after, Chris-

topher died as a brave martyr, in Lycia, in the town of Samos.[24]—If St. George resembles Perseus, St. Christopher resembles Hercules: like him, he was born to serve. In Christian Greece, old heroes, thought to be dead, were reborn in new forms.

All these stories charmed the childlike people. Almost all the saints' legends of eastern origin have an atmosphere of romance. St. Theodore disguised herself as a man and lived for twenty years among monks;[25] St. Alexis went as a beggar to the palace of his own father, slept below the stairs with the dogs, and was recognized by no one.[26] The legend of the Seven Sleepers of Ephesus is as charming as a story from the *Thousand and One Nights*, and has its own cave and treasures.[27]

Although the history of western saints is less rich in adventure, some biographies of Germanic and Celtic saints appeal to the imagination. The legend of the king St. Gontran of Burgundy, who was guided by rats to an underground passage filled with gold, no doubt came from a popular song of the Burgundian tribes.[28] The lives of St. Patrick and St. Brendan of Ireland would seem to be written by Celtic bards recently converted to Christianity.[29] The poet (and he deserves the name) constantly takes his readers beyond the limits of the known world. The story of St. Brendan's adventures on the sea was the sole travel book of the Middle Ages, until Marco Polo wrote his. The mythical islands, which the Irish saint was thought to have discovered in the Atlantic, still haunted the imaginations of the first navigators of the fifteenth century.

However, if there were fewer adventures in the lives of western saints, there were as many miracles as in the lives of the eastern saints. The Church, even in the Middle Ages, was suspicious of several miracles told in the *Golden Legend*, but the people accepted them all and even attributed new ones to their favorite saints.[30] Reasonable saints—a St. Vincent of Paul or a St. Francis of Sales—would hardly have pleased the Christians of the thirteenth century. A true saint was a man who met demons and angels face to face. Of the history of St. Genevieve, the people of Paris retained only one event: the devil extinguished her candle at one side while an angel relit it at the other.

The constant intervention of the angels gives these legends a delightful charm. The angels came humbly to serve the saints, for these heroic men had become greater than they through struggle and suffering. The angels gently carried the aged St. Peter Nolasco, founder of the Mercedarians, to the choir stalls when his legs would no longer support him. They ploughed the furrow that St. Isidore left unfinished in order to pray. They carried the virginal body of St. Catherine to Sinai after her martyrdom. Heaven and earth mingled: Christ descended to St. Denis in prison and gave him communion with his own hand.

The miracles best loved by the people were those by which the saints manifested their power over nature. The world around these men of God seemed to return to its first innocence. The hermits who lived in the forests of Gaul seem to have been living in Eden. For a companion in the wilderness of Le Perche, St. Calais had the *aurochs*, the wild bull of ancient Gaul. St. Gilles was fed by a doe and his hand was pierced by an arrow when he defended her against the king's huntsmen, for on their hunts these Merovingian kings often met the hermits face to face. St. Blaise cured sick animals, but before they approached him they waited for him to finish his prayers. St. Brigid stroked the swans of northern seas when they set down on the frozen pond of Kildare.

In the *Life of the Saints*, man is reconciled with nature, and even the fiercest animals become gentler. A lion followed St. Gerasimus in the desert;[31] a wolf guided blind St. Hervé across Brittany; when St. Gervase slept in the countryside, an eagle hovered above his head to shield it from the rays of the sun.

One could say that virtue emanated from the saints, and even inanimate nature responded when they passed. On the day of the translation of St. Firmin's relics, the trees stripped bare by winter suddenly grew green again. Where St. Ulphe of Picardy passed on her way to church, the grass was greener than elsewhere. Thus, the saints reestablished around themselves the ancient harmony of the world. Many of these legends, creations of the people, testify to great gentleness and a profound feeling for nature; they speak highly for the people who created them and of those who adopted them.

Such is the charm of the *Golden Legend*. Thirteenth-century Christians found in it what they loved most: a picture of human life, a summary of the world's history, strange adventures, and miracles.

Since the Council of Trent, the Church has dealt sternly with these simple stories, judging, no doubt, that such marvels conceal the true greatness of the saints. The seventeenth-century Church Doctors knew their own times; they did not wish the lives of the saints to offend those whose minds had been influenced by Protestant criticism. Launoi deserved his nickname *dénicheur de saints*. When the curate of St.-Eustache met this formidable man, he bowed low, trembling for the patron saint of his church. Such scruples would never have occurred to the medieval Church. Moreover, beneath the trappings of the legends, the people almost always sensed the truly sublime. The endless stories told of St. Martin's miracles did not keep artists from preferring the most human incident of his life, and eternalizing the heroic gesture of the young Roman soldier who, with his own sword, cut his soldier's coat in half to clothe a poor and naked man (fig. 188).

188. St. Martin. Chartres (Eure-et-Loir), Cathedral of Notre-Dame. South transept, right portal.

III

Thus, for all the reasons given above, the *Golden Legend* was the favorite book of the Middle Ages. We must now see how the artists interpreted it.[32]

In the thirteenth-century cathedrals, the great saints were glorified in two ways: sometimes their entire lives were told in a series of scenes, and sometimes their image, clearly characterized, was represented alone.

The first method was preferred by the glass painters. During the thirteenth century, windows were above all narrative. The windows of the aisles of Chartres Cathedral, so well preserved, are the brilliant pages of a *Golden Legend*. They form one of the most beautiful books of miniatures that ever a prince bought for its weight in gold. With Jacob of Voragine's text in hand, we can easily decipher all the scenes.[33] Beginning at the bottom of the window and working toward the top, the artist followed the legend step by step. The story of St. Eustace, for instance, is told in its entirety in twenty-odd medallions, from the appearance to Placidas of the miraculous stag to the martyrdom of the saint and his family in the bronze bull. From each episode our artists took only the essential. Only a few figures appear in a medallion, and what they mime is extremely clear. When studied at close range, their gestures seem exaggerated to the point of caricature, but seen from farther away they are very expressive. The scenery is reduced to the essentials: a tree, a city gate, undulating lines indicating rivers or the sea. These are the signs intended to suggest

How artists interpreted the *Golden Legend*: their effort to express saintliness.

the scene's locale. There is no local color: Roman soldiers wear the coats of mail and shields of the thirteenth century, emperors bear the scepter and crown of the kings of France and sit on thrones similar to the famous bronze throne of St. Denis. One king is so like another, one soldier so like another, that they seem almost to be symbols. There is no effort to go beyond the subject and develop a brilliant episode; there are none of the irrelevant scenery, architecture, and domestic scenes that were so pleasing to Renaissance glass painters. In these small paintings, the genius for clarity and abstraction is remarkable; it reminds us of our classical theater. The legends of the saints are often long and diffuse, but in interpreting them, artists almost always avoided this defect.

The second manner of honoring the saints was to present them, not engaged in action but immobilized in a solemn attitude. The stained glass in high windows and the statues of portals represent the saints under an almost superhuman aspect. The thousands of compartments in the lower windows tell of their struggles and sufferings in this life, while the large images show them beatified and transfigured by the light of another world, radiating eternal serenity. The former were dedicated to the Church militant, the latter to the Church triumphant.

Artists, and above all sculptors, who were commissioned to represent the large figures, found themselves at grips with one of the most difficult problems in art. The face of each saint must express a different virtue. There is nothing monotonous about the great saints. In the *Golden Legend*, each has his individual character: St. Paul was a man of action and St. John a contemplative; St. Jerome was a scholar whose eyesight had grown dim from poring over books, and St. Ambrose was the bishop par excellence, the guardian of his flock. There is no sentiment or nuance of a sentiment that a saint might not incarnate. St. George represents the courage that throws itself in the face of death, and St. Stephen the resignation that awaits death. St. Agnes, St. Catherine, and St. Cecilia represent virginity, but St. Agnes is the guileless virgin, ignorant and defenseless, whose emblem is the lamb. St. Catherine is the wise virgin who knows the science of good and evil and disputes with Church Doctors, while St. Cecilia is the virginal wife who voluntarily embraces chastity in the nuptial chamber. The lives of the saints offered the artists all of these delicate shadings. As a result, the art of the Middle Ages, which represented little but saints, is the idealistic art par excellence, for it was required only to reveal the soul. Fortitude, charity, justice, temperance—these must be read on the saints' faces. But these faces are not cold abstractions; the saints were living realities. To use the words of the Church Doctors, there was more real life in them than in all other men combined. They alone had lived.

At the same time, each had his physical type and character. Instead of having to represent "Eloquence" in the figure of an indeterminate orator, the artist had to create the portrait of St. Paul, a small bald man with a long beard, transfigured by his genius.[34] As a result, this art, although basically idealistic, was strongly attached to truth and to life. The true grandeur of medieval art lies in this.[35] It does not treat academic ideals, or beauty filtered by the canons of the Schools until it has no more savor than pure water. It seized on the most wretched reality and made it radiant. The artist proceeded as the saints themselves had done in shaping their own lives with painful effort, and made chastity, strength of soul, and charity—in sum, a reflection of God—shine forth from repellent, vulgar, or simply humanly beautiful faces. As the theologians of the Middle Ages would have said, the artist did what God himself will do on Judgment Day; he gave to each of the elect the features he had had in this life, but these faces, imbued with the light of a pure soul, participate in eternal beauty.

These were the principles that guided the artists' hands in the thirteenth century, but they were sensed and felt, not reduced to pedantic formulas. All the statues of medieval saints are not masterpieces, but in all of them we sense the same effort. Some are admirable. The St. Martin of the south portal of Chartres (fig. 191), with pastoral staff in his hand, at once active and stern, truly has command over all creatures. St. Modeste, on the north porch (fig. 3), is the personification of Chastity. St. Theodore is the image of the true knight (fig. 189). At Reims, St. Nicaise,[36] although the top of his head is missing, walks serenely between two angels who smile at him. On the portal of Amiens Cathedral, St. Firmin (fig. 190), clothed in celestial light, makes a gesture in which there is something of the eternal. Perhaps the essential being has never been better expressed: the St. Firmin of Amiens *is* a soul. The apostles of Chartres and Amiens were conceived by men of genius; almost all of them resemble Christ, as if the spirit of the Master in passing into them had formed them.

During three hundred years, the obligation of artists was to represent men who were superior to man, and this gave to medieval art its inimitable character.

We now understand the influence the *Golden Legend* had on the history of French art.

If this were the proper place, we could also show how the study of the lives of the saints refined the sensibility of Italian artists also, and taught them the knowledge of moral man. At the end of the fourteenth century, they tried in their painting—that subtle instrument of analysis—to express on faces the most varied states of soul. In the fifteenth century, Fra

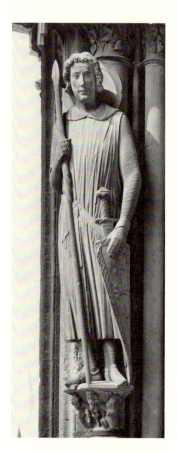

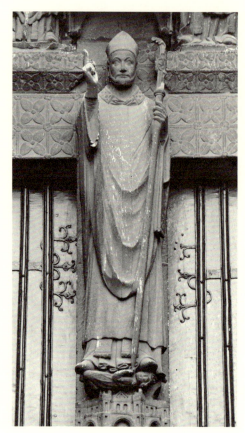

189. St. Theodore. Chartres (Eure-et-Loir),
Cathedral of Notre-Dame. South transept,
left portal, jamb.

190. St. Firmin. Amiens (Somme),
Cathedral. West façade, left portal,
trumeau.

Angelico found the sweetest of nuances in the lives of the saints. Even the pagans of the sixteenth century still painted the saints. For them also, a Mary Magdalene or a John the Baptist in the Desert radiated thought and dream, and into their faces the artists put all their knowledge of life.

IV

Characteristics of the saints. Their emblems and attributes. The effect of art on legend.

However, in spite of their efforts and their fervent desire to bring out individual character, the thirteenth-century artists were not able to create figures that the people could unhesitatingly identify. How to prevent confusion between St. George and St. Theodore, both of whom were knights and saints? Or between the two virgins, St. Barbara and St. Agnes? The solution to this problem was still being sought in the thirteenth century.

At Chartres, it was solved in an ingenious way. Beneath the feet of each saint, a small scene was placed recalling some famous circumstance of his life or death (figs. 191, 192).[37] For example, one of the lions to which St. Denis was thrown is carved on the socle of his statue, and on the socle of St. George's statue there is a wheel that refers to his death.

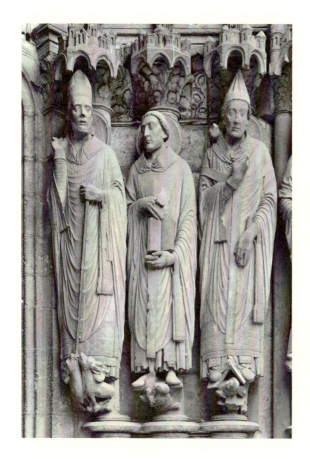

191. St. Martin, St. Jerome, St. Gregory. Chartres (Eure-et-Loir), Cathedral of Notre-Dame. South transept, right portal.

192. Detail of St. Gregory, his secretary beneath his feet. Chartres (Eure-et-Loir), Cathedral of Notre-Dame. South transept, right portal.

The saints stand on the instruments of their torture and on their torturers, in triumph over them.

But artists sought an even more striking solution; they were soon to place in the hands of the saints themselves the instrument of their martyrdom. The apostles were the first to appear on the portals of our cathedrals, some carrying the cross to which they had been nailed, and others the lance or sword that had been plunged into them or the knife that had cut them to pieces.[38] By the fourteenth century, almost all of the saints are represented with an attribute in their hands. On the "Portail des Libraires" of the cathedral of Rouen, St. Apollonia holds the pincers that were used to pull out her teeth, St. Barbara holds the tower pierced with three windows (symbol of the Trinity) in which her father imprisoned her. Proudly, triumphantly, the saints bear the instruments of martyrdom that opened heaven to them.

Sometimes a famous episode in the life of the saint provided the artist with an emblem. The chalice surmounted by a serpent identified St. John and recalled that the apostle had drunk a cup of poison unharmed after he had made the sign of the cross.[39] St. Gregory the Great was distin-

guished from other popes by the dove resting on his shoulder. The dove had come to dictate into his ear the books he wrote; his secretary, hidden behind a curtain, had once seen this (figs. 191 and 192). St. Mary of Egypt could not be confused with any other penitent because she carried in her hand the three loaves of bread she had bought before going into the desert, her nourishment for forty years. In this way, the entire life of the saint was concentrated into one detail. The people never made a mistake, so familiar were these emblems to them. This shows how popular the *Golden Legend* was, for all these characteristic signs were borrowed from it. We must keep it constantly before us if we are to identify by their attributes the saints of portals and windows.

But even the *Golden Legend* does not account for everything. The saints played a great part in the lives of the people and were given the strangest of attributes in popular art. For example, St. Martin is sometimes accompanied by a wild goose. There is nothing in his legend to account for it; the goose does not figure in any of his miracles. In truth, it was intended to remind the people that St. Martin's feast occurs at the beginning of winter, at the time when birds migrate.[40] In this case, art gave form to an old popular saying.

The power of art over the people was so great that the emblems imagined by artists sometimes gave rise to new legends. In this case, art did not borrow from the *Golden Legend*, but just the reverse. We sense this obscure alchemy better than we can explain it. All that goes on in the depths of the popular soul remains half shrouded in mystery. St. Denis, we know, is always represented carrying his head in his hands. Many of the twelfth-century lectionaries[41] show him thus, but this type of representation is surely older. In turning back to it, artists had simply intended to recall the manner of his death: to show him holding his head in his hands was a hieroglyphic sign signifying that St. Denis had been beheaded. This somewhat barbaric idea, however, is not without grandeur, for the saint seems to offer his head to God with his own two hands. The people never completely understood the artists' intention, and in their own way explained what they saw. They imagined that St. Denis, after his beheading, had actually carried his own head. Here we come upon the medieval genius for myth-making. This embellishment was soon added to the written life of the saint, and without knowing it, the artists had contributed to the *Golden Legend*.[42]

In the same way, the legend of St. Nicholas was enriched by another miracle. From the twelfth century on, none was more famous than the story of the three children murdered by an innkeeper, cut into pieces, placed in a salting tub, and finally brought back to life through the intervention of St. Nicholas. Ancient lives of the saint do not mention this

miracle. Strangest of all, Jacob of Voragine, no doubt considering it somewhat doubtful, did not include it in the *Golden Legend*. In the fourteenth century, it had not yet been included in the lessons of the breviaries.[43] However, artists throughout the thirteenth century represented the miracles of the three resurrected children. We see it at Bourges in a window dedicated to St. Nicholas, in two windows at Le Mans,[44] in a window at Troyes, and in another at Chartres (fig. 193). The same story is included in the innumerable reliefs of the St. John Portal, at Lyon.

193. St. Nicholas and the three children. Bourges (Cher), Cathedral of St.-Etienne. Chapelle Ste.-Croix, stained glass (detail).

Here we are in the presence of a tradition transmitted orally long before it was written down. What is its origin? Father Cahier's conjecture seems so likely, and so in conformity with medieval habits of mind, that we accept it as the correct explanation.[45] The *Golden Legend* tells that St. Nicholas freed three unjustly imprisoned officers of the emperor Constantine; the saint snatched them from the hands of the executioners in the prison, just before they were to be put to death. No doubt this subject was adopted by artists at an early period, especially in the East where the cult of St. Nicholas originated. According to the practices of medieval art, in the East as well as the West, deference was paid to the saints by giving them superhuman size. Consequently, St. Nicholas was shown as very tall, while the three officers at his feet were as small as children. In the simple fashion of the time, the three heads protruded above a tower to

indicate that the prisoners had been freed. The legend became known in the Occident only in the eleventh century.[46] Western Christians were not yet familiar with the legend, and invented one to explain the images they saw. The three officers became three children, and the tower a salting-tub. The innkeeper-murderer and his wife were easy to imagine, since they were so much a part of the popular imagination. We find them in many stories; they are the ogre and ogress of Perrault. This children's story was added to the legend of St. Nicholas; it passed from mouth to mouth, and although the artists did not find it in writing, they had no scruples against representing it.[47] However, the story of the three officers was revived and it appeared in windows (at Bourges, for example) along with the story of the three children.

Something quite similar happened to the legend of St. George. The beautiful episode of the king's daughter saved from a dragon by the knight probably developed from the misunderstanding of a painting. It was a practice in the East, and one adopted in the West, to symbolize idolatry by the figure of a monster. In his *Historia ecclesiastica*, Eusebius had already related that Constantine had himself represented piercing the dragon of paganism with his lance. The dragon became a symbol, and accompanied the image of valiant martyrs who had carried the faith to new countries. Consequently, St. George was represented in this way. And also, when the eastern artists painted the holy warrior for the first time, in the fifth or sixth century, the traditions of the art of antiquity still prevailed: the allegory and personificaions of pagan times had not died out. We see them in the mosaics of Ravenna, where an aged man crowned with rushes symbolizes the Jordan. Thus, it is probable that the figure of a young girl placed beside St. George and the dragon personified in ancient pictures the province of Cappadocia evangelized by the martyr. When this symbolism was no longer understood, the Greek people created the epic story that accounts for all the details of the scene. A monk wrote it down, and it spread throughout Europe.[48]

The legend of St. George helps us to understand all those in which a dragon figures. Although symbolic in the beginning, and presented as symbol by artists, the monsters were soon taken literally. If we are to believe the ancient Acts of the saints, almost all of our early bishops of France, and especially the founders of episcopal sees, had to fight with monsters. According to legend, St. Romain of Rouen chained up the "gargoyle" which was devastating Normandy, St. Marcel of Paris put to rout a terrible serpent inhabiting a cemetery, St. Julien of Le Mans and one of his successors, St. Pavace, killed the monsters guarding a fountain. The same was told of St. Front of Périgueux, St. Lô, bishop of Coutances, St. Loup, third bishop of Bayeux, and St. Germain, bishop of Auxerre.

In Brittany, as many as ten saints and notably the great bishops, St. Brieuc and St. Pol de Léon, were said to have had the same adventure. All these victories over monsters expressed victories over idolatry. Legends of dragons were not created after the sixth century—that is, after France became Christian.[49] Thus, a simple metaphor was turned into a lively story by the creative imagination of the people.[50]

When a subject passes into popular art, it comes to life, takes on concrete form. Where did the candle carried by St. Genevieve come from if not a metaphor? The saint holds in her hand the torch of the wise virgins, the symbolic lamp spoken of by the Gospels: the merest breath of the evil spirit can extinguish the tenuous light, and this would come about were it not watched over by an angel. This figure of speech from a sermon was translated by the artists into the genial scene shown on the portal of Notre-Dame of Paris: on one side, the devil blows out the saint's candle; on the other side an angel relights it.[51] The mystical comparison of the lamp of the wise virgins was applied to St. Gudule and represented by Flemish artists in the same fashion as by Paris artists. On the chapter seal of Brussels, St. Gudule carries her lamp and is placed between the devil and an angel.[52]

It is a delicate matter to trace the beginnings of such legends, for they do not always derive from metaphor, but sometimes from misinterpretation of facts. After the late fourteenth century, why was St. Anthony the hermit always represented accompanied by a pig wearing a bell around its neck? Very early, the people had imagined that the holy hermit had lived in the wilderness with this faithful companion. But we find no mention of it in the *Historia eremitica.* A misunderstood image of a confraternity was probably responsible for the legend. In Dauphiné, there was a religious order founded in 1095 by two barons, under the patronage of St. Anthony. The Antonines were hospitalers dedicated to the care of the sick and of pilgrims.[53] Protected by private persons and the king, the order had houses in many towns in France. Police regulations forbidding pigs to run loose in the streets made an exception for pigs belonging to the Antonines. The hospice pigs wore bells around their necks and tranquilly foraged for food in the town gutters. Drawings, and probably seals, commemorated this privilege: St. Anthony, patron saint of the order, was shown accompanied by a pig wearing a bell. This image was graven on people's minds and transmitted through the centuries until the original meaning was forgotten.[54] Proof of the attribute's origin is that St. Anthony was almost always shown at the time with a T-shaped crutch drawn on his mantle. The crutch was something like a coat-of-arms for the Antonines, and recalled that the brothers had taken the vow to devote their lives to the crippled.

The medieval faculty for creating legends is astounding. St. Erasmus, or St. Elmo, was the favorite saint of Mediterranean sailors: his image was to be seen on the bows of the feluccas of the Latin seas. As patron saint of mariners, he carried in his hand a capstan wound with a cable. Such an emblem would not have been understood by people living inland. The population of the eastern part of France, who held St. Erasmus in great honor, imagined that he, like other saints, held the instrument of his torture. Thus, it was supposed that the torturers had slit open his stomach and with refined barbarity had wound his intestines on a windlass. The Acts of the Saints accepted this popular story, and henceforth, St. Erasmus was invoked against colic. In the small church of L'Huys, near Braîne in the Soissonais, mothers came to hang skeins of yarn on the neck of the saint and pray for the cure of their babies.[55]

Thus, artists often contributed unknowingly to the *Golden Legend*. Many times, lives of saints were written around ancient symbolic images whose meaning had been forgotten. When we are told that St. Ronan beat the devil with his stick, this means that in some old chapel a Breton artist had carved the image of the holy bishop symbolically resting his crozier on a demon lying at his feet.[56] Childlike peasant souls took the scene as literal fact. It is clear how much critical spirit and learning are necessary in order to understand the real meaning of all the emblems placed in the hands of saints by artists. Fortunately, Father Cahier has made this task easy for archeologists. In the great dictionary he published under the title *Caractéristiques des saints dans l'art populaire*,[57] there is scarcely an attribute that he has not fully explained. Learning will not add much to a book in which all earlier work has been utilized and brought up to date. With pen in hand, Cahier had read not only all the collection of the Bollandists, but also everything that had been written since the seventeenth century on the cult of the saints.[58] The only fault we find is that he did not give enough place to works of art. He knew the texts better than the monuments. To make his work perfect, he needed his usual collaborator, Father Martin. But such as it is, his book enables us to recognize almost without hesitation all the saints who figure in works of art, especially those from the late Middle Ages up to our own time.

V

Characteristics of the saints and the craft guilds. Patron saints.

It was in the late Middle Ages, in fact at the very end of the period we are studying, that emblems multiplied. Each saint had his own, consecrated by custom.

The craft guilds contributed most to the preservation and distribution of these emblems. As we have seen, each body of workmen had its patron

saint. In the thirteenth century, did the guilds have the same patron saints they were to have later? It is probable, although documents are rare, and Etienne Boileau's book says very little on this point.[59] However, there is abundant information for the fourteenth, and especially the fifteenth and sixteenth centuries.[60] If we are to judge by the permanence of the corporations' cult of the saints throughout two centuries, it is probable that their patrons remained the same in a given region. Thus, fifteenth- and sixteenth-century texts and documents allow us to draw some conclusions about the thirteenth century. The reasons that determined the corporations' choice of patron are often quite simple: it is altogether natural that St. Eligius should have become the patron saint of goldsmiths and St. Crispin of shoemakers. But reasons for other choices are not always easy to find. The cabinet makers, for example, who were sometimes commissioned by churches to make the tabernacle which held the holy pyx, chose St. Anne for their patron because she had made the first tabernacle—the Virgin who carried God in her womb.[61] The sawyers celebrated the feast of the Visitation because the Virgin and St. Elizabeth had bowed to each other on that day, just as two workmen incline toward each other when using a long two-handed saw.[62]

Some of the ideas behind these choices are not without beauty and touching ingenuity. Porters chose St. Christopher as patron because he had carried Christ on his shoulders.[63] The pin makers' corporation chose the feast of the Nativity because it was thought that on Christmas night the Virgin had fastened the Infant Jesus' swaddling clothes with pins, in the way that nurses did.[64] Servants invoked the humble and active St. Martha; the perfume merchants celebrated Mary Magdalene who had anointed Christ's feet with precious ointments; the innkeepers celebrated St. Julian who received even lepers.

Several choices are not in very good taste. St. Bartholomew, who was flayed alive, was the patron saint of tanners; St. John, who was plunged into boiling oil, was the patron of candle makers.[65] Many of these analogies are childish, and some are even founded on poor puns. A play on words had caused St. Claire to become the patron saint of glass makers. There is nothing in the life of the deacon St. Vincent to account for his being chosen by vineyard workers. He was chosen because of the first syllable of his name.[66]

Childish and touching as it is, the cult of saints had deep roots in the popular imagination. By multiplying the images of their protectors, the corporations were not without influence on art. Some of the attributes placed in the saints' hands were derived not from an episode in their lives but from patronage. St. Honoré carries an oven peel only because the bakers had chosen him as patron.[67] A similar reason explains the bunch of grapes St. Vincent holds in his hand on several medals from the

late Middle Ages,[68] struck for the vine dressers' guild. We would look in vain for explanations of such emblems in the *Golden Legend*.

The guilds did not always suggest new attributes to artists, but they always obliged them to represent the established attributes with the greatest clarity. The carders, whose patron was St. Blaise, insisted that the iron comb, the instrument of his torture, be clearly shown in the hands of the martyr. An image of St. Eligius without the pincers would not have satisfied the goldsmiths. The workers' guilds, therefore, helped to accustom the artists to represent the saints with attributes that were always the same.[69]

We find proof of this in looking through the strange collection of figured lead medals in the Cluny museum.

These small monuments of popular art were found in the Seine when the quais were rebuilt in the time of Napoleon III. Forgeais, an antiquarian, piously collected and published them. He made the likely supposition that these medals, which date from the thirteenth through the sixteenth centuries, had come from the shops that once stood on the wooden bridges of the Cité. In the Middle Ages, the bridges of Paris quite frequently collapsed or burned, and each time a large number of these small objects fell onto the river bed where they were perfectly preserved. Of all the coins, medals, and tokens that have come down to us in this way, the medals struck for the craft guilds are the most interesting. Each carries the image of the patron saint on one side, and on the other, the name or emblem of the guild. Some of them date from the thirteenth century, although most are from the fourteenth and fifteenth. But on all of them we find the same saint's image—crude, childish, and reduced to its essential traits. What we notice first of all, and what reveals the name of the saint immediately, is the attribute in his hand. Thus, the attribute was the prime preoccupation both of the one who struck the medal and of those for whom it was intended.

By the fourteenth century, the patron saint and his emblem had become hieroglyphic signs in which nothing could be changed. At the end of the Middle Ages, attributes of the saints were to be seen everywhere. Coins issued by towns, and coats-of-arms of certain religious orders kept them in constant view. On the shield of the Dominicans, for example, a dog carrying a flaming torch in its mouth recalls the prophetic dream of St. Dominic's mother before his birth. The shield of the Carthusians has the seven stars that appeared in a dream to the bishop of Grenoble and foretold the arrival of St. Bruno and his six companions. Saints' attributes passed into proverbs. It was said of two friends: they are as inseparable as St. Roch and his dog.[70]

Which of the saints venerated in the Middle Ages were most often represented in art?

Anyone who has seen the cathedrals of Chartres, Amiens, and Notre-Dame of Paris[71] knows that the apostles were given first place among the saints. Placed on each side of the principal portal, they surround Christ. They held so honored a place in the church (they were carved or painted two or three times in each of our cathedrals) that we also must accord them a place of honor.

Artists sometimes represented the lives of the apostles and sometimes the apostles alone. A fair sized number of windows are devoted to the lives of the apostles at Chartres, Bourges, Tours, and Poitiers. Among the medieval works dealing with legendary subjects, these perhaps are the most extraordinary. If we know only the Acts of the Apostles, we will understand nothing of St. John's miracles or St. Thomas' voyage to India represented on our windows, for it has been three hundred years since anything of the sort has been related about them.

These stories, definitively abandoned after the Council of Trent, were once very famous. They came from apocryphal books which, although condemned by Pope Gelasius, were tolerated and remained in current use. In the East, people could not resign themselves to the scant mention in holy books of most of the apostles. No doubt some oral traditions, worthy of belief, had already existed in the first Christian communities, but legend soon smothered history. There were the Acts of Sts. John, Peter, Paul, and Thomas, attributed to a certain Leucius, where truth was mingled with fiction.[72]

Several heretical sects contributed to the composition of these romances, and used the authority of the apostles to cloak their errors.[73] An anonymous compiler, probably in the fifth century, assembled all that had been written on the subject in a book which he called *Historia certaminis apostolici* and attributed to Pseudo-Abdias, bishop of Babylonia and contemporary and companion of St. Jude and St. Simon. The book of the Pseudo-Abdias was said to have been first written in Hebrew, then translated into Greek, and finally put into Latin by a certain Julius Africanus. Julius Africanus' translation was widely used in the Middle Ages. Vincent of Beauvais drew on it to write his *Speculum historiale*, and Jacob of Voragine often used it in the *Golden Legend*, abridging its long speeches.[74]

Great authority was conferred on the Pseudo-Abdias' book by the medieval Church. It was not only tolerated, but portions of it were read in the choir on the feast day of each apostle. Proof of this is found in

Which saints were most often represented in the Middle Ages? The apostles. Their apocryphal history: the Pseudo-Abdias. Attributes of the apostles.

twelfth-century lectionaries.[75] The legends of the apostles were included in the first breviaries of the thirteenth and fourteenth centuries. Thus, there was no reason why the clergy should have forbidden artists to represent scenes from these apocryphal lives; they read in choir books the same stories that the master glass painters used in their windows.

Thanks to works of art in particular, the faithful knew every event in the lives of the principal apostles. It was accepted that each of them had evangelized a different country. Peter brought the faith to Rome, Paul had spread the faith from Jerusalem to Illyria, Andrew had taken it to Achaia, James the Greater to Spain, John to Asia, Thomas to India, James the Less to Jerusalem, Matthew to Macedonia, Philip to Galatia, Bartholomew to Lycaonia, Simon to Egypt, and Jude to Mesopotamia.[76]

The travels and miracles of the apostles were not all equally famous. Artists usually represented in detail only the lives of Sts. Peter, Paul, John, Thomas, James, Jude, and Simon. The master glass painters so often painted the apocryphal history of these apostles that it will be useful for us to know the principal details.

The legends of Peter and Paul were always placed together; a single window united the two saints whose feasts fell on the same day (figs. 194, 195).[77] It was thought that they should be kept together because they had undergone the same struggles and, it was said, had embraced just before going to their deaths.[78] Consequently, windows usually show episodes from their sojourn in Rome, and the scenes in which they prayed together to overcome Simon Magus.

The *Golden Legend* completed the distortion of the apocryphal acts of Peter and Paul. Jacob of Voragine's Rome was the fabulous city beloved by the Middle Ages, the Rome embellished by Virgil, the magician. Nero reigned over it, surrounded by sorcerers. He married one of his followers, and wanted above all that his physicians deliver him of a child. And in fact, by means of a potion, he gave birth to a frog, which he had raised in the palace. The sage Seneca dared not oppose his pupil's mad schemes. Nero amused himself by brandishing his sword above Seneca's head. He even said to him one day, pointing to a tree: "From which branch do you want to be hanged?" He kept on until the wretched Seneca finally killed himself, and through his death justified his name (*Se necans*).[79]

It was before this Nero, transformed by legend into a completely fabulous character, that Peter and Paul were brought. The emperor had heard of their miracles, and had even learned that Paul had brought Patroclus, his butler,[80] back to life, but he was unconvinced. They had a formidable rival in the person of Simon Magus, who held high favor with Nero because of his sorcery. Simon boasted that he had made serpents of brass move, and made images of iron and of stone laugh, and dogs sing. He

194. (a) Simon Magus and Emperor Nero,
(b) Simon Magus tries to restore the dead
youth. Bourges (Cher), Cathedral of St.-
Etienne. Apsidal chapel, stained glass
(details).

195. St. Peter resurrects the dead youth.
Bourges (Cher), Cathedral of St.-Etienne.
Apsidal chapel, stained glass (detail).

commanded the sickle to reap, and it did more work than ten men. He
could change his visage suddenly, so that sometimes he seemed young
and sometimes old. One day he was to have himself beheaded by the
executioner but by artful magic was able to substitute a ram in his place,
and on the third day reappeared before Nero. "That is why the Romans
raised a statue to him with the inscription: *Simoni deo sancto* (To Simon
the holy God).[81]

The emperor wished to pit the apostles against his magician. When they
were brought before him, Peter said to Nero: "If divinity be in him let
him tell what I think, and I will first whisper in your ear what is on my
mind." And secretly, Peter said to Nero: "Command some man to bring

to me a barley loaf, and deliver it to me privately." When Peter received the bread, he blessed it, and hid it under his sleeve, and then said: "Now Simon say what I think, and have said and done." Simon answered: "Let Peter say what I think." Peter answered: "What Simon thinks, I will show that I know." Then Simon, full of anger, cried aloud: "Let dogs come and devour him." And suddenly great dogs appeared and attacked Peter. He gave them of the bread that he had blessed, and right away made them flee.[82]

But Simon would not admit defeat, and did his utmost to bring back to life a young man who had just died. But even when he pronounced the most efficacious formulas, he could do no more than cause the young man to move his head. Then the apostles approached the bed, and Peter said: "Young man, in the name of Jesus Christ of Nazareth, who was crucified, arise and walk." And the dead man arose and walked (fig. 195).[83]

The people began to murmur against Simon. The discontented magician declared he wanted to leave a city no longer worthy to be his home, and announced that he would ascend to heaven. On the appointed day, he climbed to the Capitol, crowned with laurel, and in the presence of all the townspeople he threw himself from a high tower and started to fly. Nero, full of admiration, said to the apostles: "This man spoke the truth; as for you, you are only imposters." Then the apostles started to pray, and suddenly the devils who were supporting Simon abandoned him. He fell and cracked open his head.[84]

Nero was inconsolable over the death of his magician and had the apostles shut up in the Mamertine prison, but they converted their guards, who freed them. Peter, fearing the death that threatened him, decided to flee. He was already outside the walls, and had arrived at a place where the church of Sancta Maria ad passus now stands, when he suddenly saw Christ coming toward him. "Lord, whither goest thou?" said Peter. And Christ replied, "I go to Rome to be crucified again." St. Peter understood the lesson his master had given him, and weeping for his weakness, returned to Rome to die.[85]

The governor, Agrippa, seized the apostles at once, and after having them brought before him, he condemned them to death. Before going to their martyrdom, they embraced. Peter, a Jew, was nailed to a cross, and out of humility, he asked that he be crucified head downward. At the moment of his death, the eyes of the executioners were opened and they saw angels with crowns of roses and of lilies surrounding Peter on the cross (fig. 196).[86] As a Roman citizen, St. Paul was condemned to have his head cut off. On the road he encountered a Christian woman named Plautilla; he asked her to lend him her veil so that he might blindfold

his eyes, and he promised to return it after his death. The soldiers began to laugh, called him a false magician, and out of mockery, allowed Plautilla to do as he had asked. Paul was beheaded near the road to Ostia, pronouncing the name of Jesus Christ. On the same day, he appeared to Plautilla, clothed in incomparable splendor, and returned to her the veil stained with blood.[87]

196. Crucifixion of St. Peter. Rouen (Seine-Maritime), Cathedral. North transept, Portail des Libraires, gable.

In the stories just summarized, there are traces of the miracles of Apollonius of Tyana mixed with childish fables of a later time. One beautiful and sublimely simple episode, that of the *Domine, quo vadis,* alone recalls the great literature of the Early Christian era.

These legends appealed too strongly to the dominant passion of the Middle Ages, its love of marvels, for them not to be preferred to the solemn stories of the Acts of the Apostles. In fact, the remarkable thing is that the Acts inspired so very few works of art in the thirteenth and fourteenth centuries. Artists always preferred the troubled source of the apocryphal.[88]

The story of St. John, also, is taken almost entirely from the *Golden Legend.* There is probably no apostle's biography that has given rise to more fables than that of John. Jacob of Voragine by no means included all the stories. For example, he did not know the curious one that was said to have been written down by John's disciple Prochorus.[89] This life of the apostle charmed the Greeks because of its air of sincerity and the

extreme precision of its details;[90] but it does not seem to have reached the West before the sixteenth century.[91] Jacob of Voragine did not even set down all the events told by the Pseudo-Abdias. The dramatic story of Callimacus' love for Drusiana, about which the abbess Hrotswitha had written a tragedy in the tenth century, does not appear in the *Golden Legend*. Nevertheless, even though it is abridged, the story told by Jacob of Voragine is sufficient to explain all the thirteenth-century works of art.

St. John, after being plunged into a vat of boiling oil near the Porta Latina at Rome, was exiled to Patmos where he wrote the Apocalypse. At the death of Domitian, John was brought out of exile to Ephesus. As he entered the city, a Christian woman named Drusiana was being buried. Drusiana had passionately desired John's return, but had died without seeing him again. Moved by pity, he stopped the procession and brought her back to life.[92]

The next day, John saw Crato, a philosopher, in the forum of Ephesus, who was giving the crowd a lesson in abnegation. Two young men, his disciples, followed his counsel by selling all their possessions and with the proceeds bought precious stones. Crato ordered them to take hammers and reduce the diamonds to powder. John censured this manner of despising the world because he saw that it came from pride. "It is written," he said, "that to be perfect, you must sell your goods and give the proceeds to the poor." Crato then said to him: "If your master is the true God, make these broken stones whole again so that the money they cost can be given to the poor." Then John began to pray, and the stones became whole as before. And the young men and the philosopher then believed in God.[93]

Two other young men, moved by this example, sold all their patrimony and gave it to the poor, and followed the apostle. But soon they grew sad and regretted their former riches. John was aware of this. One day by the shores of the sea, the apostle had them gather sticks and stones, and changed them before their eyes into gold and precious jewels. And he said to them: "Go and buy again your lands, for you have lost the grace of God; clothe yourselves sumptuously so as to be beggars perpetually." The young men were ashamed, and when they had done penance, the gold and diamonds became stick and stones again.[94]

The miracles performed by John caused the priests of the great goddess Diana of Ephesus to move against him. They drove him into the temple and wanted to force him to do sacrifice. But John started to pray and suddenly the temple fell down. Aristodemus, "bishop of the idols," unconvinced even by so great a prodigy, said: "I will believe in your God if you will drink the poison I give you." "Do as you will," replied John. The strength of the poison was first tried on two condemned men, who

fell dead after drinking it. Then John, without emotion and in the presence of everyone, took the cup, blessed it with the sign of the cross, and drank it and sufferd no harm. Aristodemus remained incredulous: "I shall believe," he said, "if you will bring these dead men back to life." John did not deign to go near the corpses. He merely said to Aristodemus: "Cover them with my coat." Aristodemus did so, and the men were resuscitated by the virtue that was in John's coat. The apostle baptized Aristodemus along with the governor of the city and all his family, and founded a church.[95]

Time passed, and St. John arrived at a very old age. He could no longer walk and was carried to church by his disciples. For instruction, he was limited to repeating the words: "My children, love one another." And when his disciples asked why he repeated so often the same words, he answered, "Because it is the commandment of our Lord, and if that alone is accomplished it will suffice." John was ninety-nine years old; he had just written his Gospels, and while he was writing them, all of nature rested in deep calm, and out of respect, no winds blew. Then Christ appeared to him and said: "Come to me, my well-beloved, for it is time for you to be seated at my table with your brothers." And on the following Sunday, when the fatihful were assembled in church, after exhorting them to observe the commandments, John had a pit dug at the foot of the altar (figs. 197 and 198). He descended into it, clasped his hands, and prayed. Then he was enveloped in such brightness that none could stand to look. When the splendor was gone, there was no sign of the apostle, and those who leaned over the pit found it full of scented manna.[96]

197. St. John in the tomb. Lyon (Rhône), Cathedral of St.-Jean. Apse, stained glass (detail).

198. St. John the Evangelist in the tomb, Feast of Herod, Beheading of St. John the Baptist. Rouen (Seine-Maritime), Cathedral. West façade, left portal, tympanum.

The life and death of John as told in the apocryphal Gospels is not without beauty. In the minds of the first to tell it, the story of the precious stones was no doubt a kind of fable in which Christian charity was contrasted with Stoic pride. As for the legend of the death, or rather the mysterious disappearance of John, it was born of the widespread faith of the first generation of Christians that the beloved disciple would never die.

In the Middle Ages, the legendary story of John was so sincerely believed to be true that certain windows dedicated to him, as at Chartres and Bourges, contain not a single detail that is not taken from the apocryphal Gospels.

The legend of St. Thomas' adventures in India is pure fiction. Although St. Augustine severely condemned it,[97] it was no less cherished by the faithful and by artists (fig. 199), who were charmed to follow Thomas to the ends of the known world and the realm of the mysterious Gundoferus. It was told that this faraway king had sent his provost for Thomas to come as architect so that he might build for him "a palace after the work of Rome." The apostle set out and arrived in a city where

199. Legend of St. Thomas. Semur-en-Auxois (Côte-d'Or), Priory of Notre-Dame. North transept portal, tympanum.

a wedding was being celebrated. He was invited and sat with the cele-
brants at the feast table. There was a young girl from Judea there, playing
the flute and singing. She guessed that Thomas was a Jew and began to
sing in Hebrew: "It is the God of the Hebrews who created all things
and founded the seas." The apostle listened, his eyes raised to heaven.
The butler, seeing that Thomas neither ate nor drank, became angry and
slapped him. God did not allow the insult to go unpunished. When the
butler went out to draw water from the fountain, a lion killed him, tore
his body into pieces and carried the hand into the festival hall. The
company understood that there was a secret force in the stranger, and the
flute player fell down at his feet. Then Thomas spoke, and his words were
so persuasive that the newly married pair asked to be baptized and took
the vow to live in continence.—After this, the apostle went to the capital
of Gundoferus. The king gave him the plan of the palace he wanted to
have built, opened his treasury to him and went off to another province.
Thomas began at once to preach the Gospel, and converted part of the
city. When the king returned and learned what the apostle had been
doing during his absence, he had him thrown into prison and con-

demned to be flayed. But on the eve of the execution, the brother of the king, who had just died, came back to life and said to his brother: "Brother, I have seen the palace of gold, silver and jewels built by this man: it is in paradise, and if you wish, it is yours." Gundoferus was moved and sent for the apostle, who said to the king and his brother: "Believe in Jesus Christ, and be baptized, for in heaven there are many palaces that have been prepared since the beginning of the world."[98] Here we glimpse the origins of this kind of legend: it was born of a metaphor. The apostles built the edifice of the faith, they "edified" a temple made of living stones, which is the Church. Even today, the word *édifier* has this mystical meaning in our language. Some writer with a lively imagination began there and made an architect of St. Thomas.[99] The story was taken literally in the Middle Ages, without commentary or exegesis. Nothing astonished those naïve souls.

Certain legends in which the apostles appeared as skillful magicians seem to have been particularly pleasing. The glass makers often reproduced the story of St. James the Greater, which could have been taken from a book of sorcery.

When James was preaching in Judea, a magician named Hermogenes sent his disciple Philetus to him to convince him of his errors. The master had not bothered to go himself. But it so happened that by his preaching and his miracles, James converted Philetus. When Hermogenes learned what had happened he was so angry he tied Philetus up by means of his magic and held him so that he could not move. Philetus sent a messenger to inform James. James put his coat on him saying: "Let him take this coat and say, 'The Lord raises those who have fallen and delivers those who are captives'" (fig. 200). As soon as Philetus touched the coat he was released from the captivity of Hermogenes' magic, and he made haste to go find James. Then Hermogenes was angry, and called many devils, and commanded them to bring him James and Philetus, both bound so that he could avenge himself on them. Then, flying through the skies, the devils came to James, saying: "James, apostle of God, have pity on us for we burn before our time is come." To them James said: "Why have you come to me?" And they replied: "Hermogenes sent us to bring you and Philetus to him; but on our way, the angel of God bound us with chains of fire and rudely tormented us." And James said: "Go back to him who ordered you to come, and bring him to me bound, but do not hurt him." Then they went and took Hermogenes and bound his hands and feet behind his back, and brought him to James. James spoke to him gently, explaining to him that Christians must return good for evil, and then released him. But Hermogenes dared not leave. He said: "I know well the fury of the devils, but if you do not give me something that

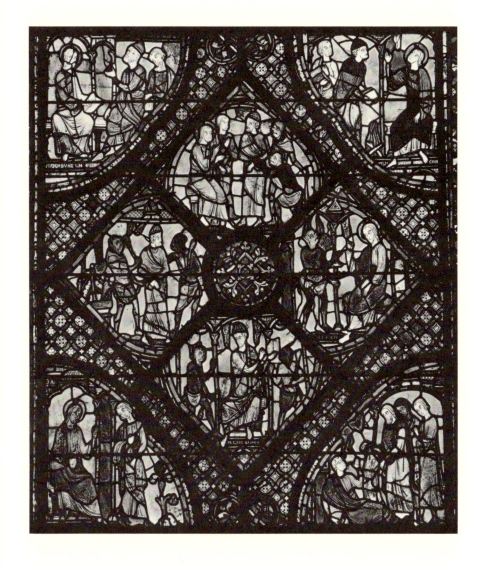

200. Legend of St. James. Chartres (Eure-et-Loir), Cathedral of Notre-Dame. Ambulatory, stained glass (detail).

belongs to you, they will kill me." Then James gave him his staff. Shortly after, Hermogenes threw all his books of magic into the sea and received baptism.[100]

In the *Golden Legend*, almost all of the apostles struggled against sorcerers. But it was St. Jude and St. Simon who had to combat the most formidable thaumaturges. They confronted them even in the sanctuary of the magic arts, the temple of the sun at Sannir, near Babylon. The art of Zaroes and Arphaxat did not frighten them: they foretold the future, caused a newborn baby to speak, subdued tigers and serpents, caused a demon in the form of a black and naked Ethiopian to issue from a statue and to flee screeching hoarsely.[101]

St. Andrew was able to convert Asia and Greece only when he had overcome the magic of the enchanters by chasing away from Nicaea seven

demons who ravaged the town in the form of seven huge dogs, and by exorcizing a spirit that inhabited the baths and strangled the bathers.[102]

These legends, as tedious as they may seem to us today, are not without historic value. They testify to a spiritual state; they are valuable documents from the world of Christian antiquity and the time in which they were created. They remind us that the pagan world really wished to combat the Christian Church by magic, that Apollonius of Tyana was set up as a rival to Christ, and that Julian and the philosophers tried to answer miracles with miracles.

On the other hand, the people of the Middle Ages loved these works which seemed to have been written expressly for them: they recognized in them their own concept of the marvelous. Whence so many stained glass windows with subjects supplied by the Pseudo-Abdias.

These windows are probably the most curious works that the Middle Ages devoted to the apostles, but they are not the most beautiful. The figures are too small and do not have the majesty of the large isolated figures of the apostles in the high windows and statues of the porches.

At Chartres, and especially on the main portal of Amiens, we are struck by the beauty of the noble figures and their luminous faces. As we have said, the artists, by happy inspiration, had given almost all of them a certain Christlike air. They radiate intelligence. They gaze straight ahead with profound serenity. The best way to describe them is to take the description of St. Bartholomew from the *Golden Legend*: "His skin is white, his eyes large, his nose even and straight, his beard full and with a few white hairs. He is clad in a purple robe covered with a white mantle, which is decorated with precious stones. For twenty years his garments have never become worn or soiled. The angels go with him on his travels. His countenance is always affable and serene. He sees and knows all things, he understands and speaks the languages of all peoples and knows well what I am now saying."[103]

Only Sts. Peter, Paul, and John are recognizable by traditional details of physiognomy: Peter has short curly hair; Paul is represented bald or at least with a very high forehead. The type of the two heads of the Apostolic College had not varied since the first centuries of the Church.[104] And St. John, the youngest of the apostles, was represented as beardless, even in his extreme old age.[105] The other apostles can be recognized only by the attributes they hold in their hands. But at first, even these attributes were given only to certain apostles, and were assigned to the others only gradually.

When we review the principal series of apostles found in our churches, it is possible to see what procedure the artists followed.

In the Romanesque period, the only attribute the apostles had was a book. Peter alone carried the keys, in memory of the power given him

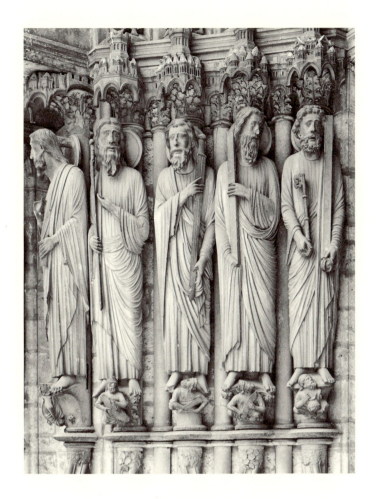

201. Apostles. Chartres (Eure-et-Loir),
Cathedral of Notre-Dame. South transept,
left of central portal.

by the Lord to bind and to loose. In the thirteenth century, when the
apostles were lined up at each side of the portal, the instruments of their
martyrdom began to be placed in their hands. But there was as yet no
agreement about the way in which each had met his death. At the end
of the thirteenth century, we find evidence of this uncertainty in Jacob of
Voragine's text.[106] There was agreement first about Paul, Andrew, James
the Less, and Bartholomew. Paul was given a sword, because there could
be no doubt about his having been decapitated; Andrew carried a cross,
because his Acts said that he had been crucified;[107] James the Less held a
club, because he had been struck down at the foot of the temple of Jerusa-
lem by a fuller armed with a club. From the first half of the thirteenth
century, in spite of disagreement among compilers of legends, it was
accepted that St. Bartholomew had been flayed, and consequently a knife
was put into his hand.[108]

On the south portal of Chartres (fig. 201),[109] the apostles just named

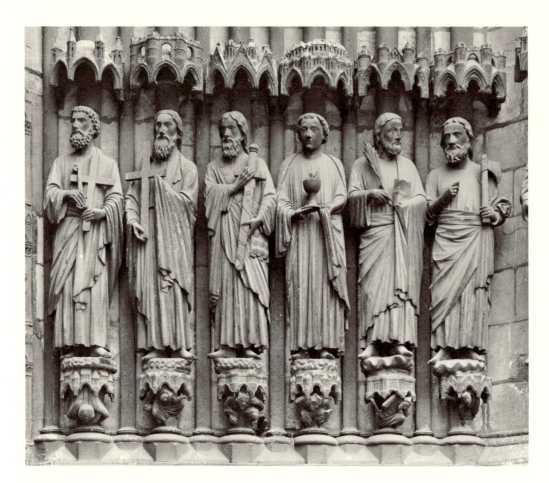

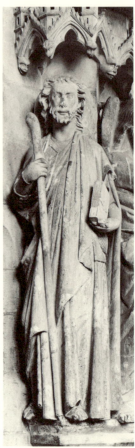

202. Apostles to the left of Christ. Amiens (Somme), Cathedral. West façade, central portal.

203. St. James. Bayonne (Basses-Pyrénées), Cathedral of Notre-Dame. Cloister portal, jamb.

are the only ones that can be recognized by their emblems; the others either carry books, as in the Romanesque period, or swords which recall somewhat vaguely their violent deaths.

Soon, three other apostles received distinctive attributes: as on the portal of Amiens (fig. 202),[110] John sometimes carried the chalice from which Aristodemus made him drink the poison. James, who at first had been given only the sword of his martyrdom,[111] a little later received the pilgrim's staff similar to that carried by pilgrims to Santiago.[112] The cockleshells that were brought back from the shores of Galicia, the famous "combs of St. James" (*pecten Jacobaeus*), were represented on his robe or on his scrip (fig. 203). The apostle seemed to have just returned from his church at Compostela. By the late fourteenth century, James had become the very image of the medieval pilgrim with his staff, broad hat, and cloak decorated with cockleshells. And Thomas, in memory of the palace he was to build for King Gundoferus in India, was shown carrying in his hand the architect's square. The first representation of this attribute

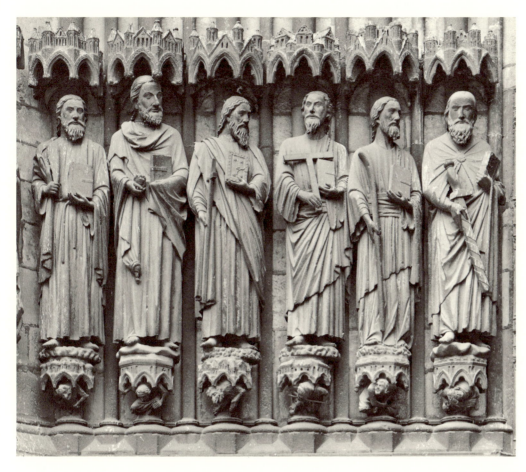

204. Apostles to the right of Christ. Amiens (Somme), Cathedral. West façade, central portal.

is perhaps that of the west façade of Amiens Cathedral (fig. 204).[113] However, John's chalice, Thomas' square, James the Greater's staff, and even the club of James the Less were not fixed emblems, as we may see by glancing at the chart on page 308, where the works are classified in a roughly chronological order. Actually, only Peter, Paul, Andrew, and Bartholomew had attributes that remained more or less the same through-out the Middle Ages. Philip, Matthew, Simon, Jude, and Mathias, whose characteristics were less distinct and whose legends were less well known, never had absolutely fixed attributes. It was only in the course of the fifteenth century that by pragmatic sanction Philip and Jude were repre-sented with a cross, Matthew with an axe, Simon with a saw, and Mathias with a halberd,[114] to indicate the kind of death attributed to each.

There are not many series of apostles left on the portals of our churches today: many were destroyed during the Wars of Religion or the Revolu-tion—in 1562 or in 1793. But it is probably safe to say that almost all our cathedrals once had apostles ranged on each side of their great portals.

ORDER Canon of the Mass	CHARTRES South portal	AMIENS West portal	CHARTRES Windows	REIMS North portal	LE MANS La-Couture Statues of porch	BORDEAUX St. Seurin statues
St. Peter	Keys and cross	Keys and cross	Keys	Keys (broken)	—	Keys
St. Paul	Sword	Sword (restored)	Sword	Sword and book	Sword	Book
St. Andrew	Latin cross (broken)	Latin cross	—	Latin cross	Cross (broken)	Latin cross
St. James the Greater	Sword and shell	Sword and shell	Shell	Sword and shells	Sword staff scrip	Staff and shell
St. John	Book	Chalice (restored)	Book	Book	—	—
St. Thomas	Sword	Square or broken cross	—	—	—	Graduated rule?
St. James the Less	Club	Club	Palm		Club	—
St. Philip	Sword	—	—	—		—
St. Bartholo-mew	Knife	Knife (modern axe)	Knife	Knife	—	—
St. Matthew	Sword (broken)	—	—	—	—	—
St. Simon	Book	—	—	—	—	—
St. Thaddeus or Jude	Book	—	—			
St. Mathias	—	—	—			

BOURGES Windows	REIMS Windows	TOURS Windows	CHARTRES South porch (archivolts)	REIMS South portal	REIMS Buttresses	CHARTRES St. Père windows	ORDER Canon of the Mass
Keys and cross	Keys book	Keys	Keys	Keys	Keys	—	St. Peter
Sword	Sword	Sword	Sword book	Sword	—	Book	St. Paul
—	Latin cross	Latin cross in-X	Latin cross	—	Cross	Axe	St. Andrew
Staff	Bird of passage	—	Staff	Staff, hat		Book	St. James the Greater
—	Book	Palm	Priestly vestments	Palm, book		Book	St. John
Sword book	Sword	—	Square	—		Square and book	St. Thomas
Book	—	—	Bishop's robe	—	Club	Club	St. James the Less
Book	—	Sword	—	—	—	Pike and book	St. Philip
Knife	Knife	Knife	Knife	Knife		Knife	St. Bartholo-mew
Book	—	—	Sword	—		Book	St. Matthew
Book	—	—	—	—		—	St. Simon
—	Listel	—	—	—		—	St. Thaddeus or Jude
		—	Axe	—		Sword	St. Mathias

After the apostles, who were the favorite saints of the Middle Ages? Is it possible to tell why one saint was represented instead of another? What idea was responsible for the choice of the countless legends painted on the windows of Chartres, Bourges, Tours, and Le Mans? Why, for example, was the story of St. Nicholas represented so often?

It is not easy to answer all these questions. Despite the research of scholars, aspects of the medieval cathedral will always remain obscure. Nevertheless, one can glimpse some solutions.

Thirteenth-century works of art devoted to saints can be grouped under four or five headings.

One is first struck by the pious zeal with which each diocese honored its own saints. After the apostles, local saints were given first place in the cathedrals; an entire portal was often given over to their lives, their miracles, their deaths.

At Amiens, the whole religious history of Picardy is summarized on the left portal of the great façade of the cathedral. The apostle St. Firmin, who brought the faith to the ancient Samarobriva of the Ambiani, is placed with his back to the lintel, and surrounding him are his guard of honor, the first martyrs: St. Gentien, St. Fuscian, St. Victoric; the first bishops: St. Honoré, St. Salve; and the most celebrated saints of the diocese: St. Domice, St. Geoffrey, and the virgin St. Ulphe.[115] The story of the relics of St. Firmin, along with the miraculous procession of his reliquary, is represented on the tympanum. On the south portal, the principal events in the life of St. Honoré, the greatest bishop of Amiens, are shown in detail.

At Reims, the great saints of that province, those who established the faith in Champagne, are shown on one of the north portals. St. Sixtus at Reims, as St. Firmin at Amiens, has the most honored place, as was fitting for the saint who had brought the Gospel. His successors, martyrs, and illustrious bishops are at his sides: St. Nicaise, murdered by the Vandals on the threshold of his own church where he left a trace of his blood on the stones;[116] St. Eutropie, his sister, who was killed while trying to defend him (fig. 205);[117] and St. Remi receiving the holy ampulla brought by the dove.[118] The memory of St. Remi was too deeply rooted in the consecration church for his story not to be told to the people of Reims. His legend and his principal miracles are carved in the charming reliefs of the north portal.[119]

Of the five portals of the cathedral of Bourges, two are devoted to local saints. St. Ursin, the apostle of the Berry and the Bourbonnais, is the subject of the right portal; the bishop St. Guillaume, renowned, for his miracles and his victories over the devil, is the subject of the left portal.[120]

The statues of these two portals, broken by the Protestants, no doubt represented the sainted bishops of the church of Bourges: St. Outrille, St. Sulpice, and, in a word, all those whose images were placed with those of the apostles in the windows of the nave.

At Notre-Dame of Paris, even though an entire portal is not devoted to the saints of the Ile-de-France, several large statues and several prominently placed reliefs kept fresh the Parisians' memory of St. Denis, St. Genevieve,[121] and above all, St. Marcel. On the trumeau of the still archaic St. Anne Portal, the famous bishop of Paris is shown piercing the dragon with his cross.[122] But on the archivolts of the "Portail Rouge," later in date by at least a century, a part of the saint's legend (fig. 206), especially his struggle with the vampire of the cemetery, are carved with exquisite delicacy.

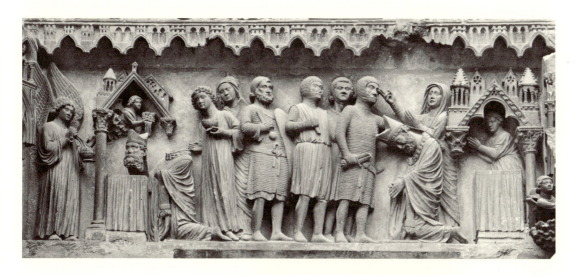

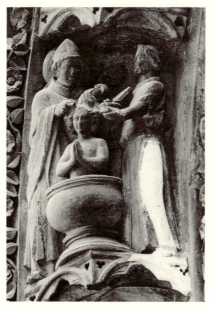

205. Martyrdom of St. Nicaise and St. Eutropia. Reims (Marne), Cathedral of Notre-Dame. North transept, tympanum (detail).

206. St. Marcel baptizing. Paris, Cathedral of Notre-Dame. North façade, "Porte Rouge," archivolt.

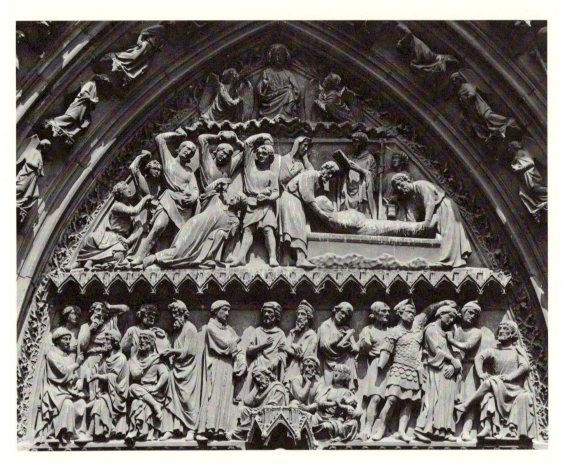

207. Story of St. Stephen. Paris, Cathedral of Notre-Dame. South transept, "Portail St.-Etienne," tympanum.

At Chartres, windows and statues vie in celebrating the first confessors of the faith in the country of the Carnutes: St. Potentien, who built his church above a grotto that for centuries had been dedicated, it was said, to the virgin who would give birth, *virgini pariturae*; St. Modeste, daughter of the Roman governor Quirinus, thrown by her father into a well along with other martyrs; [123] St. Chéron, who carried his own head as St. Denis had done;[124] the herdsman St. Lubin, who became bishop of Chartres;[125] and the abbot St. Laumer, monk from the forest of Le Perche.[126]

This practice was true of all our cathedrals. Many churches, now mutilated and deprived of most of their statues and windows, nevertheless still have commemorative monuments to their first bishops and martyrs.

The cathedral of Le Mans has preserved an immense twelfth-century window dedicated to St. Julian, the apostle to the Cenomani. Windows at Soissons tell the life of St. Crispin and St. Crispinian; at Tours, the life of St. Martin; at Lyon, the lives of St. Pothin, St. Irénée, and St. Polycarp. At St.-Quentin, in the choir ambulatory, reliefs (now restored) recount

the lives of the first apostles to the Vermandois. At Rouen, on the "Portail de la Calende," reliefs that for a long time were unintelligible, tell the legend of two great Norman saints, Romain and Ouen.[127]

Thus, a bit of a province's own past was to be found in its cathedral. All that was considered worthy of escaping oblivion in the annals of a town was carved for eternity on the cathedral. These great monuments gave to humble people a vague idea of their own history and a sense that they were not without roots in the earth, that they too had ancestors. Each of our cathedrals truly grew out of the earth like indigenous plants whose perfume and color come from the soil around them.

The thirteenth century seems to have had a highly developed cult of the past and a love of history. The artists demonstrated their respect for the past when they adapted a twelfth-century door to the thirteenth-century façade of Notre-Dame of Paris.[128] And they went even further. When the new cathedral was built, they were obliged to tear down the old church of St.-Etienne, which stood next to the ancient basilica of the Virgin and was almost as old.[129] But since they did not wish its memory to be lost, they devoted to St. Etienne and his martyrdom the admirable relief on the tympanum of the south portal which rises exactly above the place where the church had stood (fig. 207).

VIII

After the local saints, the saints who were illustrous in all of Christendom held the most important place in cathedrals.

Saints adopted by all of Christendom.

I had begun to draw up a list of all the saints' images still to be found in our thirteenth-century cathedrals, but I soon realized that such a work is impossible because too much uncertainty remains, and always will, about the identity of a great many statues without names and attributes. Moreover, even if such a catalogue were possible, firm conclusions could not be drawn from it because there are too many lacunae in the series of statues and windows of our churches. We must be content with approximate conclusions.

From our incomplete list, the somewhat too general but nevertheless valuable deduction may be made that the thirteenth century preferred to represent the saints who were famous enough to occupy a place in the liturgical books of all Christianity. Canon Ulysse Chevalier drew up an interesting calendar in which only those saints figured who were honored in all or almost all medieval churches: numerous antiphonaries and breviaries from all sources furnished the elements (fig. 208).[130] Now the greater number of these saints, if we except certain martyrs and confessors of the Church of Rome who had been adopted by the Christian world

208. St. Vincent (left); St. Gregory (right);
"Breviary of Philippe le Bel." Paris, Bibl.
Nat., ms. latin 1023, fols. 294v, 444v
(details).

out of respect for the holy city, are found painted on the windows or carved on the porches of churches. The deacons Sts. Vincent, Stephen, and Lawrence; the martyrs Sts. Sebastian, Blaise, George, Gervase, Protase, Hippolytus, Denis, Christopher, Thomas à Becket; the confessors Sts. Marcel, Gregory, Jerome, Nicholas, Martin; the virgins Sts. Agnes and Cecilia—these saints were honored in all churches. These are precisely the saints whose images are most often seen, even today.

On the south portal of Chartres, we come upon this precise purpose of honoring the saints in conformance with the prescriptions of the liturgy: the central door, in fact, is devoted to the apostles, the right door[131] to the martyrs, and the left door to the confessors. In numerous reliefs, scenes of martyrdom and miracles (not always easy to identify) decorate the pillars of the porch. The litanies in use in the diocese of Chartres very probably were the basis for the artists' general plan and even for the details of this imposing ensemble.[132]

But so splendid an arrangement is not found everywhere. Even at Chartres, it seems that chance played a part in the choice of the saints whose lives are represented in the windows. Why does the same saint appear in as many as three windows? Why is one legend shown alongside another in the chapels? What reasons determined these choices and groupings?

It is possible to indicate some of them.

IX

Influence of relics on the choice of saints.

First of all, it is certain that the relics in the possession of the churches contributed, more than anything else, to the multiplication of saints' images.

A full study of relics would provide one of the strangest chapters in the history of the Middle Ages, and would be instructive to historians of both civilization and art. Such a subject would require greater learning and knowledge of the past than is found in the *Dictionnaire des reliques* of Collin de Plancy—a weighty document written by a belated disciple of Voltaire, but one who had neither the wit nor the style of his master.[133] To study the Middle Ages for the purpose of poking fun, and not to enter into its spirit, is a mockery of another time.

The interesting study that the Comte Riant made of the religious spoils taken from Constantinople in the thirteenth century is the first reliable, and already productive, work that has been undertaken on this important subject.[134]

The relics in which so many generations took such impassioned interest are, in fact, objects of serious study. The announcement of the jubilee of Aix-la-Chapelle, and the assurance of seeing from a distance the holy veil worn by Christ on the cross, drew forty million pilgrims from all parts of Europe.[135] Relics really possessed creative virtues. Wherever there was the arm of an apostle or the blood of a martyr, a rich abbey was founded and a town grew up. The reliquary of St. Foy created Conques in the mountains of Aveyron. A holy body placed on an altar dictated the form of the church containing it, forcing the architect to find new forms, to enlarge the choir and widen the transepts.[136] The most ingenious inventions of medieval goldsmiths came from their having to enclose a piece of a bone in crystal or to encase it in gold.[137] A world of hopes and desires hovered about these frail reliquaries; they move us even today, as does everything on which the thought of man has dwelled for an extended period of time.[138]

The history of art has no right to scorn these relics. Let us not forget that the most perfect monument of the thirteenth century, the Ste.-Chapelle, is only a reliquary designed to shelter the crown of thorns (fig. 209).[139] And what is the temple of the Holy Grail itself—the highest mystical dream of the Middle Ages—if not a reliquary?

Calvin, in a breath, dissipated all this poetry. With his coarse energy and logical mind, he demonstrated to the "poor world" that God is everywhere, and that it was not necessary to go so far like pagans to worship these dubious relics. In his *Traité des reliques*, he said: "I ask you, has the world not gone mad when people travel five or six score leagues, at great cost and great hardship, to see a piece of cloth (the holy shroud at Cadouin) about which they cannot be certain but rather are constrained to doubt?"[140] Nothing found grace in the eyes of this terrible destroyer, none of the remains that should have been handled with great delicacy—not the urn of the Marriage at Cana exhibited at Angers, nor

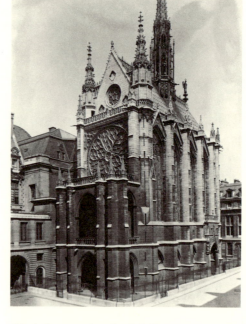

209. Paris, Ste.-Chapelle from southwest.

Christ's tear that had fallen on Lazarus and was enshrined at Vendôme, nor the pictures painted by angels, "for we know full well," Calvin said, "that painting is not the angels' business."

Mankind had decidedly emerged from the age of poetry.[141] The enthusiasm of the crusades in defending an empty tomb and bringing back as their total treasure a pinch of holy ground would henceforth be seen as inexplicable folly. "And in fact," Calvin said, "they consumed their bodies and their wealth and a good part of the substance of their country in order to bring back a heap of worthless little trifles with which they had been duped, thinking them to be the most precious jewels in the world."

This was in fact what the crusaders of the thirteenth century felt, sending back as inestimable treasures from Constantinople to the churches of Champagne, the Ile-de-France, and Picardy, a mass of relics enclosed in precious receptacles[142] that were not without influence on art.[143]

One of the most illustrious relics of Christendom arrived at Amiens in 1206: the forepart of John the Baptist's head, found in the ruins of an old palace at Constantinople.[144] In the new cathedral, whose foundation stone was laid a few years later, in 1220, two works of art recalled the remarkable relic: a thirteenth-century window retraced the life of the Precursor;[145] and later, at the end of the fifteenth century, beautiful scenes from the life of John were carved on the choir screen.[146]

In the reign of St. Louis, the Ste.-Chapelle acquired the back part of John the Baptist's head, which had remained at Constantinople.[147] After the relics of the Passion, this was the most precious object in the treasury.

Two windows given a place of honor at the back of the apse were a constant reminder of the presence of these venerated objects, which were only rarely exposed to the public view: one was dedicated to the Passion of the Saviour, and the other to the life of John the Baptist.

Chartres had its share of the relics from Constantinople. In 1205, the Count of Blois brought back the head of St. Anne to the cathedral of Notre-Dame. As an entry in the Chartulary says: "The head of the mother was received with great joy in the church of the daughter."[148] One of the statues of the north portal of the cathedral, begun in the early thirteenth century,[149] would seem to commemorate the recent acquisition of the precious relic. In fact, on the trumeau of the central portal, it is not the Virgin carrying the Child that we see, as was customary, but St. Anne carrying the Virgin (fig. 210). This unusual feature is reproduced in the interior where one of the clerestory windows beneath the north rose window also shows St. Anne holding the Virgin in her arms (fig. 211). In

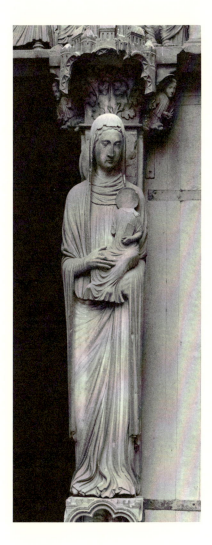

210. St. Anne holding the Virgin. Chartres (Eure-et-Loir), Cathedral of Notre-Dame. North transept, central portal, trumeau.

211. St. Anne and the Virgin. Chartres (Eure-et-Loir), Cathedral of Notre-Dame. North transept, stained glass, lancet below rose window.

this, there is a clear desire to honor the mother of Mary in a very special way, and only the presence of her head in the church can explain the unusual place she occupies.

Many problems of this sort would be resolved if we had a list of all the relics the cathedral of Chartres had in the thirteenth century. For example, the large statue of St. Theodore on the south portal was long taken to be a statue of St. Victor. Didron thought that the Roman legionary was better known in French churches than the Greek soldier of Heraclea. It was not then known that the head of St. Theodore had been brought from Rome to Chartres in 1120, as the Chartulary published in 1862 tells us.[150] Since then, it has been possible to identify conclusively this beautiful statue that makes a pair with that of St. George.[151]

At the cathedral of Sens, in the ambulatory of the choir, there is a fine window devoted to the history of Thomas à Becket (fig. 212). This is because the church treasury preserved the cope and mitre of the illustrious archbishop who had lived for a time at the monastery of Ste.-Colombe, near Sens. These sacerdotal ornaments became precious relics when the martyr was canonized by the pope in 1173.

212. St. Thomas preaching. Sens (Yonne), Cathedral of St.-Etienne. Ambulatory, stained glass (detail).

It is understandable how important an exact knowledge of the relics preserved in each of our ancient churches, even the smallest, can be for the history of art. The little church of Valcabrère,[152] one of the oldest and most unusual religious edifices of the Pyrenees, furnished proof of this several years ago. As was known, the church was dedicated to St. Just and St. Pasteur whose martyrdom was carved on the capitals of the portal; but it had never been explained why the life of St. Stephen was also included. In 1886, relics were discovered by happy chance in a hollow within the altar. A parchment accompanying them said that they were the relics of the three saints, Just, Pasteur, and Stephen, patrons of the church.[153] Thus, the problem that archeologists had not been able to solve was answered.

The portal of St. Thibault, in the Côte-d'Or, also presents a puzzle. The church possessed a venerated relic of St. Thibault, who was born at Provins at the beginning of the eleventh century. There was no doubt that the statue standing with its back against the trumeau, as if welcoming the visitor, was his. But what was the meaning of the four accompanying statues at each side of the entrance? They were believed to be contemporary figures, princes and princesses of the House of Burgundy who had enriched the church with two donations in the thirteenth century. But we have only to read the life of St. Thibault to discover their true names. At the left of the spectator, the mitred prelate is the great uncle of Thibault, the bishop of Vienne who was raised to sainthood; beside him is his niece, the mother of Thibault; he foretells to her that she will have a great servant of the Lord as a son. At the right, the two young men in thirteenth-century costumes are Thibault and his friend, Gaultier, as they quit the world to live in solitude near Vicenza. Thus, we have here the sketch of a story familiar to pilgrims; the saints' names could once be read on the banderoles they hold, but these are now effaced.

In my opinion the relics preserved in our great cathedrals often explain their windows. There can be no doubt about the chapels of the apse of Notre-Dame of Chartres. By rare good fortune, a lawyer named Rouillard, who published a description of the cathedral in the early seventeenth century under the title *Parthénie*, named the saints to whom the chapels were dedicated.[154] The windows correspond to them exactly. Beginning at the left, the first chapel contained the relics of St. Julian the Hospitaler and was named for him; the name has since been changed, but a section of the central window still tells the story of his life and death. The second chapel was called the Chapel of St. Stephen or of the Martyrs and indeed a window in a place of honor displays the story of St. Stephen; three other windows are devoted to Sts. Savinien, Potentien, Modeste, Chéron, and Quentin, all martyrs. The third chapel was known as the Chapel of the

Apostles: consequently, scenes in the central window represent the vocation of the apostles and Christ addressing himself to the entire Apostolic College,[155] and in neighboring windows there are the stories of Sts. Simon and Jude, and of Sts. Peter and Paul at Rome. The fourth chapel was called the Chapel of St. Nicholas or of the Confessors: St. Nicholas occupies one window, as does St. Remi. It is surprising, it is true, to find beside them St. Catherine, St. Marguerite, and St. Thomas à Becket, who were not confessors, but martyrs.[156] Rouillard called the fifth chapel the Chapel of St. Loup and St. Gilles, but the only windows there now are in grisaille, and seem to be of a fairly late period.

The exact correspondence at Chartres between the subjects of the windows and the patron saints of the chapels was probably a feature of all our cathedrals. Unhappily, the proof is not easy to find today, for sometimes the names of the chapels have disappeared, and sometimes the windows.

From the few windows at Amiens that have survived the vandalism of recent centuries, we can suppose an arrangement as regular as at Chartres. A chapel of the apse, now dedicated to the Sacred Heart but once dedicated to St. James the Greater,[157] has a window in which the story of the apostle is told. Another chapel of the apse, dedicated to St. Theodosia, is decorated with a thirteenth-century window which tells the story of St. Augustine. In the Middle Ages, St. Augustine was the titular saint of the chapel.[158]

There is no need for further examples.[159] Those we have given suffice to prove that stained glass windows were not placed in chapels haphazardly; the relics of the saint to whom the chapel was dedicated determined the choice of the pious donors.

X

Saints chosen by donors. The guilds.

But relics do not explain everything, for the stained glass windows are not all in chapels. Large figures of saints are to be seen in the clerestory windows, stories from the *Golden Legend* occupy the windows of the aisles. What prompted the choice of these saints? There surely were reasons, for the medieval church left nothing to chance; and in fact some of them can be found.

These windows were given to our cathedrals by guilds or by private persons who wished to perpetuate the memory of their generosity. The lower panels of thirteenth-century windows[160] usually contain the image and sometimes the names of the donors: praying monks, bishops holding a model of the window in their hands, fully armed knights recognizable by their coats-of-arms, money-changers weighing coin to test its content

(fig. 180), furriers selling furs (fig. 39), butchers slaughtering cattle, sculptors carving capitals. These scenes from the life of the times, besides being valuable in themselves, enable us to resolve in part the problem we are concerned with here.

In fact, it is often easy to guess why such and such a donor chose a certain saint. St. Louis gave to Chartres a window representing St. Denis thrown to the lions: the king of France wanted to honor the protector of the French monarchy.[161] St. Ferdinand of Castile gave to the same cathedral of Chartres a window dedicated to St. James. In this way, the illustrious conqueror of the Moors expressed his devotion to the apostle-knight, the *Matamoro* as he was called, who was seen fighting in the front rank of the Christian army.[162]

Again, we can easily understand why a bishop of Nantes gave a window dedicated to Peter and Paul to the cathedral of Tours: the two apostles were, and had been since earliest times, the patron saints of the cathedral of Nantes. Nor is it difficult to guess why an abbot of Cormery paid homage to the same cathedral by presenting a window dedicated to St. Martin, for the Abbaye de Cormery was, in fact, a dependency of St.-Martin of Tours and with special devotion venerated the great apostle to the Gauls.[163] And we may accept as quite probable Hucher's conjecture that the three great abbeys of St.-Vincent, St.-Calais, and Evron gave to the cathedral of Le Mans the three windows dedicated to St. Vincent, St. Calais, and the miracle of the Virgin of Evron.

Sometimes a donor simply presented the image of the saint whose name he bore. Jeanne de Dammartin, second wife of Ferdinand of Castile, gave the great window at Chartres dedicated to the life of John the Baptist, her patron saint.[164]

The guilds presented the story of their protector, the saint whose image decorated their banners and seals. At Bourges, the window of St. Thomas the Apostle, patron of architects and those who worked for them, was given by the stonecutters. At Chartres, the grocers paid for a window dedicated to St. Nicholas, their patron, and the basket makers gave a window dedicated to St. Anthony.[165]

When donors don't present the images of their patron saints, we can sometimes guess their reasons for choosing some other saintly person. It is not very surprising that three knights, Pierre of Courtenay, Raoul of Courtenay, and Julien de Castillon, gave three windows representing St. Eustace, St. George, and St. Martin to the cathedral of Chartres.[166] These three saints were soldiers, and the models of true chivalry.[167] Simon de Montfort, recognizable by his shield bearing a lion rampant, argent on a field of gules, appeared at Chartres in the rose of a window dedicated to St. Paul. Was this not because St. Paul, the apostle who carried a sword,

was also, in the Middle Ages, one of the patron saints of men of arms? William Durandus, in his *Rationale divinorum officiorum*, tells us that knights rose to their feet when the epistle read by the priest was taken from St. Paul.[168]

The same feelings guided the corporations' choice of saints. The barrel makers of Chartres, instead of giving a window dedicated to their patron saint who was no doubt St. Catherine, gave a window of Noah, apparently because the holy patriarch had planted the first vines. At Tours, the ploughmen gave the Adam window, because Adam in the sweat of his brow first tilled the soil.

But the explanations suggested by the names of donors are by no means always so satisfactory. We must frequently admit that we do not understand. Why, at Chartres, did the armorers choose the story of St. John, the tanners St. Thomas à Becket, the weavers St. Stephen, the porters St. Gilles? Nothing that we know of the ancient guilds explains these bizarre choices.

In many cases it is clear that the chapter of the cathedral proposed to the donors the subject of the window they wished to offer. To be convinced, we may note that at Bourges the window of the Good Samaritan was given by the weavers, and at Chartres, by the shoemakers. Now, it seems unlikely that the idea of offering this parable with its accompanying theological commentary could have occurred to the artisans. The canons must have asked donors to give windows either with the story of

213. Cloth merchants, from St. James window. Chartres (Eure-et-Loir), Cathedral of Notre-Dame. Nave, stained glass (detail).

a famous saint such as Thomas à Becket,[169] or with theological subjects like those that had been given to other cathedrals and whose fame had spread.

We may perhaps also suppose that artisans' guilds of this time venerrated certain saints with a special cult that was not perpetuated in the following centuries. We know very little about the organization of medieval guilds; we know especially little about the workmen of Chartres. De Lépinois, who sketched out the history, found few documents relating to the period before the late thirteenth century;[170] those found in the *Ordonnances des rois de France* date only from the fifteenth.[171] And they say almost nothing about the guilds' patron saints. It would seem, however, that certain guilds were divided into confraternities, each having its own particular saint. At Chartres, for example, the weavers gave three windows dedicated to St. Stephen, the saints Savinien and Potentien, and St. Vincent respectively (fig. 213). Now below the St. Vincent window, near the medallions representing the weavers, there is this inscription:

TERA : A CEST : AVTEL : TES : LES : MESSES :
QEN : CHARE : SONT : ACOILLI : EN : TO
ERET : CESTE : VERRIE : CENT : CIL : QVIDO
LI : CONFRERE : SAINT : VIN

An extremely obscure inscription, whose meaning we can only dimly make out, and for which de Lasteyrie proposed the following reading: "A cet autel toutes les messes qui en charge sont accueillies . . . et donnèrent cette verrière . . . ceux qui sont les confrères de saint Vincent."[172] From this confused text we may assume that the weavers had formed a confraternity of St. Vincent, and that they had Masses said (probably for deceased members) in the chapel of the saint. Nowhere is St. Vincent named as the weavers' patron saint; they usually placed themselves under the patronage of St. Blaise. Perhaps the same was true at Chartres, but the large guild was divided into small religious confraternities that honored other saints. This could be the explanation for the fact that certain windows donated by artisans are not dedicated to the usual patron saints of the guild.[173]

If we know little about the devotions of the guilds, we know even less about those of private persons. Why, for example, should William of Ferté-Hernaud, a knight, have given to Chartres Cathedral a window dedicated to St. Bartholomew? Was it because of a hereditary devotion in his family, a holy image preserved in a private oratory, a relic kept as a talisman in the hilt of a sword, a vow made during a battle? There are thousands of small facts, if we knew them, that would no doubt explain the donors' choice of saints.

Influence of pilgrimages on the choice of saints. St. James, St. Nicholas, and St. Martin.

Out of the countless mysterious reasons the faithful may have had for choosing the image of a certain saint, one is in evidence more than once. It is the gratitude of the pilgrim who had returned from the famous sanctuaries of Compostela, Bari, or St.-Martin of Tours.

It is a remarkable fact that of all the saints venerated in the Middle Ages, those who appeared most often in our churches were St. James, St. Nicholas, and St. Martin.

At Chartres, where the series of windows is almost complete, there are as many as four windows dedicated to St. James.[174]

The thirteenth century was, in fact, the high point of the pilgrimage to Compostela. The *Liber Sancti Jacobi*, which appeared in the course of the twelfth century, excited all of Christendom. It told of the countless miracles performed by the apostle as reward for the pilgrims' faith. The author of the *Liber Sancti Jacobi* was neither Pope Calixtus II, as was thought in the Middle Ages, nor Aimeri Picaud, as modern scholars have long believed.[175] The author remains anonymous, but we sense that the work came from the Abbey of Cluny, for the monks of Cluny were the great organizers of the pilgrimage to Compostela.[176] The book is of the greatest interest, for following the story of the miracles of St. James, there is a guide intended for pilgrims[177] which mentions all the famous sanctuaries that a traveler would pass on his journey. Four different routes to Compostela are indicated. If the pilgrim went through Provence, he would visit the cemetery of the Aliscamps, the reliquary of St. Gilles, and St.-Sernin at Toulouse. If he followed the mountain route, he would stop at Notre-Dame du Puy, the monastery of Aubrac, Ste.-Foy at Conques, and Moissac. If he crossed the Limousin, he would stop at St.-Léonard, St.-Front at Périgueux, and La Réole. Should he set off from Paris, he would perform his devotions at the tomb of St. Martin at Tours, the tomb of St. Hilary at Poitiers, the tomb of the paladin Roland (*beatus Rolandus*) at Blaye. These famous churches were milestones along the road to Santiago.[178]

By the end of the twelfth century, the journey had become easier and safer. Hospices were set up at every stopping place to receive the travelers.[179] When they were crossing the Pyrenees and found themselves in the depths of mountain gorges where everything terrified the men from the plains—the mountains that "seemed to touch the sky," the foaming water of the torrents thought to be poisonous, the men from Aragon with long knives, the Basques "who could imitate the cry of the wolf or the owl"[180]—suddenly they came to the Hospice de Ste.-Christine. The ancient Roman road to Galicia had been repaired. In the twelfth century, Sto. Domingo de la Calzada (St. Dominic of the Causeway) had spent his life

rebuilding the bridges between Logroño and Compostela that had been washed away by the torrents, and the Church had canonized him for his holy work. Since 1175, the knights of St. Jacques de l'Epée-Rouge[181] had patrolled the roads and protected the travelers. The greatest personages undertook the pious journey. Charlemagne, according to the Pseudo-Turpin, was the first of the pilgrims to Galicia, and when he left France, he was guided by the Milky Way, called thereafter "the Way of St. James." Following the example of the great emperor, Louis VII paid a visit to the sanctuary of Compostela.[182] St. Louis had not been able to go, but he was especially devoted to the apostle. Joinville tells that on his deathbed, he pronounced the name "Monseigneur Saint Jacques." The people, in whom the spirit of the crusades was still strong, did not hesitate to undertake the long journey. The pilgrims set off with staff in hand, and along the way they sang the song of St. James, all joining in the old refrain: *Ultreia!* (Forward!).[183] Confraternities of St. James were organized in many of the towns. At first, only pilgrims who had made the journey to Galicia could belong; later, toward the end of the Middle Ages, it was enough to pay a sum of money to be admitted to the confraternity.[184] Of these, the Paris confraternity is best known. Its history, sketched out by Abbé Lebeuf,[185] has been written by Bordier.[186] The association of Parisian pilgrims goes back to the thirteenth century, but all we know about it comes from documents dating from the fourteenth. However, the confreres were still very numerous in the fourteenth century; at a banquet given on 25 July 1327, in honor of the patron saint, 1,536 members of the brotherhood were present. Etienne Marcel was one of the confreres of St. James.

Were there confraternities of this kind at Chartres, Tours, and Bourges? Although there are no documents, the stained glass windows give us reason to think so. There is one window at Chartres (not to mention three others dedicated to St. James—an indication of a special veneration) that represents nothing less than six pilgrims accompanied by a chancellor of the church of Chartres, Robert de Berou, whose name is written out in full in an inscription (fig. 214).[187] Now one of the pilgrims carries the "coquille de St. Jacques." Is this not the window of a confraternity like that of Paris, of which Robert de Berou was the dean?

At Bourges, the window dedicated to St. James and his struggle against Hermogenes has been damaged and has no donor's name.[188] But because of the large cockleshells so valued by pilgrims, the "comb of Saint James," repeated on the background, we may attribute the window to a confraternity.

At Tours, of the two windows dedicated to St. James, one is particularly interesting.[189] In fact, after the legend of the contest between St. James and Hermogenes, it represents a miracle taken from the *Liber Sancti*

214. Pilgrims of St. James. Chartres (Eure-
et-Loir), Cathedral of Notre-Dame.
Clerestory of choir, stained glass window
of Robert de Berou.

Jacobi. This is the story of the innkeeper of Toulouse who had a young pilgrim to Compostela condemned to death because he accused him of stealing a golden cup which the innkeeper himself had placed in the pilgrim's scrip. Happily, St. James rectified men's injustice. For several weeks, and with his own hands, he supported the young man hanging on the gallows, and returned him alive to the father who came to proclaim his innocence.[190] The use of such an episode in the window at Tours indicates a desire to honor St. James of Compostela in a very special way. That is why it is perhaps not too audacious to attribute the gift of this window to a confraternity of pilgrims.[191] And lastly, it was certainly due to the influence of the confraternities of St. James that thirteenth-century artists took up the practice of representing the apostle with the staff, scrip, and cloak decorated with cockleshells.

We know much less about the confraternities of St. Martin and St. Nicholas. All we can say is that these confraternities did exist in the thirteenth century.[192]

St. Martin and St. Nicholas were venerated as the greatest miracle workers that had ever been. One was the thaumaturge of the West, the other of the East. On the south portal of Chartres, one was placed facing the other. The intention of drawing a parallel between the two great saints is apparent.

There is a profusion of images of St. Nicholas in our medieval churches. At Chartres, where almost no work of art has disappeared, there are as many as seven paintings or carvings of St. Nicholas (fig. 215). Although the windows at Auxerre are incomplete, two are devoted to St. Nicholas' legend, and two also at Le Mans. We find him in the cathedrals of Rouen, Bourges, Tours, St.-Julien-du-Sault in Burgundy, and at St.-Remi at Reims. There was once a window at Troyes dedicated to him.[193] In sum, he is to be found almost everywhere that thirteenth-century windows still exist. Although he was venerated here in France as early as the eleventh, and perhaps even the tenth century,[194] his cult became really popular only after the translation of his relics from Myra to Bari in 1087. The miracles that took place in the famous Italian sanctuary, spread his fame abroad. In the eleventh century, Pietro Damiani, in one of his sermons, urged that St. Nicholas be invoked immediately after the Virgin, because he regarded the saint as the most efficacious protector a Christian might have in heaven.[195]

People turned to St. Nicholas when in gravest peril. Joinville tells that, in 1254, the queen promised a silver ship to St. Nicholas if he would bring her safely through a furious tempest in the Mediterranean.

The pilgrimage to Bari, less famous no doubt than that to Santiago, also appealed to the medieval imagination. The marvel that people went

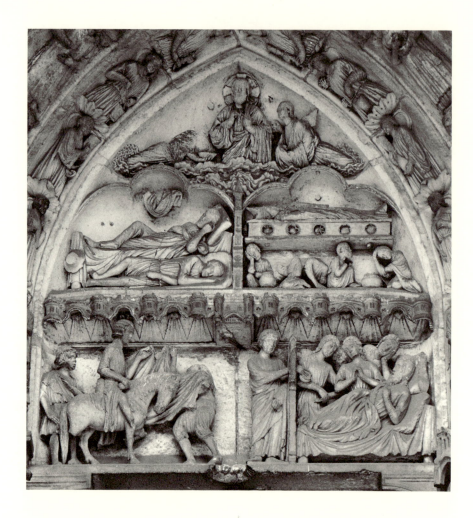

215. St. Nicholas and St. Martin. Chartres (Eure-et-Loir), Cathedral of Notre-Dame. South transept, right portal, tympanum.

to see was the fountain of aromatic oil flowing from the tomb of the saint, and they filled lead phials with this inexhaustible liquid which they used as a remedy. A fragment of one of St. Nicholas' bones brought to Varangeville in Lorraine was said to produce this miraculous oil also.[196] A church named St.-Nicolas-du-Port was built there and soon became famous; to it flocked the French pilgrims who were frightened of the long journey to Bari.

The two famous pilgrimages to Bari and Varangeville no doubt had some influence on the many works of art devoted to St. Nicholas in the Middle Ages. But here we can only conjecture, since written documents are lacking. However, it is not unlikely that more than one window in honor of St. Nicholas was commissioned by pilgrims.

At Chartres, moreover, a relief of a tympanum[197] of the south portal is devoted to the famous miracle of Bari (fig. 215). It shows the sarcophagus on which the bishop lies; from it trickles the oil which the sick gather into phials or rub on themselves. This subject might very well

have been carved at the request of a confraternity of St. Nicholas, and in any case, it reveals the preoccupations of the people of the thirteenth century.

St. Martin was as famous St. Nicholas, at least in France. In Merovingian times, the sanctuary of St.-Martin at Tours had been the real center of religious life in Gaul. Barbarian pilgrims of the sixth century came to press their foreheads against the bronze railing surrounding his tomb, or to drink the water in which the dust from the lid of his sarcophagus had been dissolved. In the thirteenth century, the ancient devotion was still very much alive if we can judge by the works of art inspired by the great apostle to the Gauls. At Chartres, he is represented as many as seven times; at Tours, two windows are dedicated to him; at Bourges and Le Mans, two also. There is one at Angers, and it has been discovered that a window at Beauvais, not before identified, contains the entire history of St. Martin.[198] When all the decoration of our cathedrals was intact, every one of them no doubt had a window dedicated to St. Martin.

Here again, the influence of the confraternities can be seen. At Tours, the windows in the cathedral dedicated to the saint could very well have been given by the confraternity of St. Martin that existed as early as the late twelfth century.[199] The generosity of the confraternity of Tours seems to have extended to neighboring churches, for on a window of Chartres dedicated to St. Martin there is this inscription: *VIRI : TVRONV̄ : DEDERV̄T : HAS : III.*

It is likely that many of the windows dedicated to St. Martin were given by confraternities and by pilgrims. The knight who had nailed a horseshoe to the door of the church in honor of St. Martin[200] before setting out on a long journey, would, on his return, do homage to the saint who had protected him by giving a window. All of this can be seen indistinctly; unhappily, the lack of written documents makes it impossible to arrive at certainty.

Such are the saints most often honored in our medieval churches. Relics, pilgrimages, confraternities, private devotions—a thousand reasons, many of them unknown to us today, determined the choice of saints.

Thus, for more than three hundred years, saints' lives provided inexhaustible subject matter for artists. Next to the Gospels, the collection of the lives of the saints is the book that had the most profound influence on the art of the West.

V

Antiquity. Secular History

The cathedral is the city of God. The righteous, and all those who had worked since the beginning of the world to build the holy city have their places there. But those of the other lineage who, as St. Augustine said, were descended not from Abel, but from Cain, were excluded, no matter what role they had played in the world. There was no place for Alexander or for Caesar.

Even Christian kings rarely appear there. The honor of being represented in the church was not bestowed upon everyone; it was reserved for those who had truly worked for the reign of Christ—Clovis, Charlemagne, and St. Louis. Thus, secular history, where it appeared in thirteenth-century windows, was sacred history all the same.

I

At first we are somewhat surprised to find so few traces of antiquity in the cathedrals. To us, the thirteenth century seems ungrateful toward its teachers. Nourished on Aristotle and Virgil, and although ignorant, it is true, of Greek it had a profound knowledge of Latin—in short, it was almost as classical as the sixteenth century. We have only to look through Vincent of Beauvais to realize that, in spite of errors of detail, the main outlines of Greek and Roman history were known, and that the principal Latin writers, Virgil, Horace, Ovid, Lucan, Cicero, and Seneca, were read and appreciated.[1] Vincent of Beauvais extracted passages from their work that he thought worthy of being graven on man's memory.

Nevertheless, only at the cathedral of Chartres do we find images of some of the great men of antiquity. We have seen that Cicero was sculpted beneath the feet of Rhetoric, Aristotle beneath Logic, Pythagoras beneath Arithmetic, and Ptolemy beneath Astronomy.

Byzantine art was far more open than ours to the great men of the ancient world. It was a tradition in the Near East to depict in churches the pagans who had spoken well of God, and whose books could be con-

sidered an "evangelical preparation." The *Manual* of Mount Athos, whose formulas certainly date from the Middle Ages, urged painters to place Solon, Plato, Aristotle, Thucydides, Plutarch, and Sophocles beside the prophets.[2] Each one should hold a phylactery on which a sentence having to do with an unknown God was inscribed. Plato had said: "The old is the new, and the new is the old. The father is in the son and the son in the father: unity is divided into three and the trinity is reunited in unity." Aristotle had said: "By his nature, the generative power of God is unceasing, for the Word itself receives its essence from him." And Sophocles had said: "There exists an eternal God; single in nature, he created the heaven and the earth." Didron had seen some of the pagan sages painted on the exterior porch (as if it was they who granted access to the temple) of the church of the *Panagia Portaïtissa,* at the monastery of Iviron on Mt. Athos.[3] Like St. Justin, the Greek church contended that the old sages had had their own revelation, and that the beauty found in their works is Christian. This presaged the great and humane spirit of the Renaissance. Raphael himself was to reconcile ancient philosophy with Christianity, for opposite the *Dispute of the Holy Sacrament* he painted the *School of Athens.*

At first glance, our French artists seem to have far less breadth of spirit than the Byzantine painters and the artists of the Renaissance. A superficial observer would consider them to be inferior, but let us not make hasty judgments.

In thirteenth-century cathedrals, it is true, any memory of antiquity would seem to be lost.[4] Except at Chartres, the pagan sages were never represented. Only Aristotle and Virgil are sometimes represented, but in very strange poses. Aristotle walks on all fours carrying the courtesan Campaspe on his back (fig. 216), and Virgil sits in a hanging basket.[5]

The legends these are based on are so well known that it hardly seems necessary to repeat them.

Aristotle wanted to tear Alexander away from his love for Campaspe. The young woman swore vengeance on the philosopher. One morning when Aristotle was working in his chamber, Campaspe, clothed only in a lavender shift, passed beneath his window as she gathered the flowering mint. The sight of her aroused the sage; he went down into the garden and declared his love. But as proof, the beautiful Indian girl demanded that he allow her to saddle and bridle him and that he carry her on his back. Alexander, who had seen it all, arrived meanwhile to find his teacher in this awkward position. Showing no surprise, the old logician himself drew the moral of the episode: how much must a young prince be on his guard against love, since an old philosopher like himself can be taken in by it.

216. Aristotle and Campaspe. Lyon (Rhône), Cathedral of St.-Jean. Relief from west façade.

217. Legend of Virgil. Caen (Calvados), St.-Pierre. Nave capital, north side.

This charming fable has no pretentions to history. It was never taken very seriously since it was not included either in the Latin biographies of Aristotle or in the legend of Alexander.[6] In fact, it was represented in our cathedrals only because preachers sometimes embellished their sermons with it.[7] The fable of Aristotle is an exemplum that was used to illustrate a moral truth. It appeared on church portals and capitals in the same category as the Aesop's fables which were frequently represented there,[8] and which were also popular with the preachers.[9] Thus, they were in no way intended to recall to the faithful the historical Aristotle, the great master of the Schools.

The same can be said of the Virgil legend, the subject of a fourteenth-century capital in the church of St.-Pierre at Caen (fig. 217).[10] The ridiculous adventure the Middle Ages associated with the poet is well known.

Virgil had made an assignation with a fickle Roman lady who lived at the top of a tower. She pulled the poet up in a basket, but left him dangling there, halfway between heaven and earth. The next day, all the town came to see the famous magician who knew everything, except what women are capable of.[11] Such a story, never mentioned by serious writers, is only an amusing fable.[12] It was a corollary to the Aristotle legend, and both were excellent exempla for sermons on women's mischief-making. In truth, the names of Virgil and Aristotle are there only to embellish the story and make it efficacious. What is woman if she could place the two most learned men in the world in such a ridiculous position?

There is no point in discussing such representations further for they have little to do with our subject. It is only too clear that the artists who carved these little stories had nothing profound in mind and were not attempting, like the Byzantines, to bring the great men of antiquity into the house of God to bear witness.[13]

However, antiquity is nobly represented in thirteenth-century cathedrals. The pagan sages, it is true, do not appear there, but in many of our churches the pagan sibyl does.

In fact, to the Middle Ages, the sibyl was a profound symbol, the voice of the ancient world. All of antiquity spoke through her mouth; she attested that the Gentiles themselves had foreseen Jesus Christ. While the prophets announced the Messiah to the Jews, the sibyl foretold the Saviour to the pagans; the two peoples and the two cities had been tormented by the same desire. Thus, the word of the sibyl was worth all the wisdom of the philosophers; she alone deserved to represent paganism, for she alone had clearly foretold the coming of the Saviour and had called him by name.

The prophetess of antiquity is still to be seen at Laon and Auxerre (fig. 218). Perhaps she was carved on the portals of all our cathedrals, but if so, time has effaced her name on the phylacteries so that we no longer recognize her.

What name should be given to the sibyls of Auxerre and Laon?

As many as ten sibyls were known in the thirteenth century. Vincent of Beauvais repeated Lactantius,[14] St. Augustine,[15] Isidore of Seville,[16] and the Venerable Bede,[17] and gave to these pagan prophetesses the following names: Persica, Libyca, Delphica, Cymeria, Erythraea, Samia, Cumana, Hellespontia, Phrygia, and Tiburtina.[18] But of these ten, only one was famous, the Erythraean Sibyl. Vincent of Beauvais said: "The Erythraean Sibyl was the most famous and illustrious of all. She prophesied at the time of the founding of Rome, when Achaz, or according to others, Ezechias was king of Judah."[19] The fame of the Erythraean Sibyl came from a passage of the *City of God*, in which St. Augustine attrib-

218. A sibyl. Auxerre (Yonne), Cathedral of St.-Etienne. Choir arcade (detail).

219. The Erythraean Sibyl. Laon (Aisne), Cathedral of Notre-Dame. West façade, left portal, archivolt.

uted to her the famous acrostic verses on the Last Judgment.[20] In this poem dealing with the end of the world, the first letters of each verse form the name of God the Saviour.

The Erythraean Sibyl was for that reason thought to be the greatest of all the sibyls and the most divinely inspired. It was no doubt of her that the *Dies irae* speaks, for her name was associated with the final catastrophe:

> *Dies irae, dies illa*
> *Solvet saeclum in favilla,*
> *Teste David cum sibylla.*[21]

(Day of wrath, that day
will dissolve the age in ash,
with David being a witness along with the Sibyl.)

It remains to be shown that the sibyl of Auxerre and the mutilated figure at Laon really represent the Erythraean Sibyl. We may only con-

jecture that this is true of the Auxerre Sibyl, for the name inscribed beside her is simply "Sibylla."[22] However, the absence of a qualifying adjective may indicate that the artist was thinking of the sibyl par excellence, the sibyl of the *Dies irae*. What gives considerable probability to this hypothesis is the presence beside the sibyl of the crowned head of a king which is more than likely that of King David. In this way, the sculptor would have been attempting to translate a verse of the *Dies irae*.

But at Laon, there is no question. The figure, placed in an archivolt of the left portal of the façade (fig. 219), has never before been designated by its right name.[23] Abbé Bouxin, in his description of the cathedral of Laon, called it "Divine Law."[24] He misread the inscription, reconstructing it in this way: *Aeterna per saecla futura*, and translating it as "she (Divine Law) will live throughout the eternal centuries." It should be read: [*adveni*] *et per saecla futurus*. This is the end of the second line of the acrostic poem attributed by St. Augustine to the Erythraean Sibyl. It begins as follows:

Judicii signum: tellus sudore madescet,
E coelo rex adveniet per saecla futurus,
Scilicet in carne praesens ut judicet orbem.

([A] sign of judgment: the earth will grow wet with sweat,
from the heaven the king will arrive who will
 remain through the ages,
Obviously present in flesh in order that he may judge the world.)

There can be no doubt. The figure on the portal of Laon Cathedral represents the sibyl par excellence, the Erythraean Sibyl.

The frescoes in the Papal Palace at Avignon, which date from the fourteenth century, show a sibyl opposite the prophets.[25] She holds a streamer, on which is written: *Judicii signum tellus sudore madescet / e coelo rex adveniet per saecla futurus / scilicet in carne* [*prae*] *sens / sibilla.* Here we recognize the Erythraean Sibyl who, in the fourteenth as well as the thirteenth century, continued to represent all the sibyls.

How can this privilege be explained? It can be stated without risk of error that the fame enjoyed by the Erythraean Sibyl in the Middle Ages derived from the role given her by the Pseudo-Augustine in his famous sermon. She follows the procession of prophets, wearing a crown on her head and pronouncing the acrostic verses on the end of the world cited above: *Judicii signum.* . . . Artists, who had already borrowed from this sermon the idea of representing the procession of prophets carrying messianic verses on phylacteries,[26] also took from the Pseudo-Augustine the figure of the sibyl, and through her symbolized the waiting of the Gentiles for the Messiah.

One curious detail worth pointing out is that the Guide to Painting of Mt. Athos also named only one sibyl. The prophetess is called by the vague name of "the wise sibyl,"[27] but when we read the words attributed to her by the Guide, we recognize that it is a question again of the Erythraean Sibyl. She is described as holding a streamer on which is written: "An eternal king will come from heaven to judge all flesh and all the universe"—a prophecy that is only a rather free translation of the acrostic verses given above: *A coelo rex adveniet . . .* etc., and which would seem to prove that the Orient had taken from the West both the sibyl and the words she uttered.

Thus, in thirteenth-century France, only one sibyl was represented, the Erythraean Sibyl; the others appeared only later.[28]

II

Ancient myths interpreted symbolically. Ovid moralized.

Thus, antiquity was symbolized in the cathedrals only by the mysterious figure of the sibyl.

However, something particular was at work in thirteenth-century minds. To the scholars, the books of the ancient world came to be considered as obscure revelation through which the truth could sometimes be glimpsed. Ovid's *Metamorphoses*, especially, was interpreted by the same symbolic method that was applied to the Bible, and was found to contain the same teaching. The idea, so frequently upheld, that the whole of pagan mythology was nothing more than a corruption of biblical tradition was not exactly the view of thirteenth-century scholars. They went much farther. To them, pagan fable was a kind of special revelation that God had made to the Gentiles, in which he had sketched out, as in the Old Testament, the history of the Fall and Redemption. In the criss-crossing threads of Ovid's vast tapestry, Christians could make out the figures of Christ and the Virgin, woven in by the poet without his knowing it.

Most remarkable, in this connection, is the manuscript of the *Metamorphoses*, now in the Bibliothèque de l'Arsenal.[29] Among miniatures devoted to the stories of Medea, Aesculapius, and Achilles, suddenly we see a Crucifixion, an Annunciation, and a Descent into Hell. The rhymed commentary accompanying each of Ovid's stories explains and justifies the presence of the Christian subjects. They tell us that Aesculapius, who died because he had brought the dead back to life, is a symbol of Christ.[30] Jupiter, changed into a bull and carrying Europa on his back, is again a symbol of Christ, the sacrificial ox who took upon himself the sins of the world.[31] Theseus, who abandoned Ariadne for Phaedra, prefigured the choice that Jesus made between the Synagogue and the Church.[32] Thetis,

who gave to her son Achilles the weapons with which he would triumph over Hector, was none other than the Virgin Mary who gave to the Son of God a body, or as theologians would have said, the humanity in which he had to be clothed to vanquish the enemy.[33]

These few examples will give an idea of this kind of book. The whole of mythology was taken to be prophetic and sibylline. Medieval artists (except for the miniaturists) seem not to have known this kind of interpretation: they never put a scene from fable in correspondence with a scene from sacred history. But Renaissance artists had no scruples against pairing Hercules with Samson;[34] or Adam, condemned to die because of woman's sin, with Hercules, burning on a pyre on Mt. Oeta because of his excessive love of Deianira;[35] or Eve with Pandora.[36]

In the beginning, this was the result of childlike simplicity. But humanists and scholars began to laugh at such naïveté, and Rabelais said: "Do you believe, upon your word, that Homer, when he was writing the *Iliad* and *Odyssey*, ever thought of the allegories which Plutarch, Heraclides, Ponticus, Eustathius, and Phornutus have sifted out of those words, and which Politian has pilfered from these others? If you think so, you do not come within either hand or foot of my opinion, which is that all those things were as little dreamed of by Homer as the sacraments of the Gospel were by Ovid, in the latter's *Metamorphoses*, though a certain Friar Wolf, a true bacon-cruncher, will take it upon himself to prove the latter case, whenever he happens to meet anyone as foolish as himself and, as the proverb says, a lid worthy of such a kettle."[37]

The great art of the thirteenth century was wiser and followed better counsel when it admitted only the Erythraean Sibyl into the cathedral as a symbol of the pagan world.

III

Nevertheless Christ is born, and the history of the Christian era begins. Now we are on other side of the cross. Henceforth, the true heroes are the saints: they alone are represented in cathedrals. The Christian kings, however great, are rarely considered worthy of such an honor.

Nevertheless, in the coronation church of Reims, there is no doubt that the clerestory windows of the nave represent the kings of France. The name of one, "Karolus," is even given in an inscription (fig. 220).[38] Each king is accompanied by the bishop who had anointed him. However, not one of the solemn figures of the twenty kings can be distinguished from another. They are there to remind people that royalty is a divine right, and that a king anointed with holy oil is more than an ordinary man. The strange statues carved on the exterior of the church around the great

The history of France. The kings of France. Their images appear less frequently than we might imagine. Montfaucon's error.

rose window of the façade, complete this instruction. David is anointed by Samuel, and Solomon by Nathan. The following scenes were intended to recall that God, in raising kings above all other men, exacts greater virtue of them; he demands that they be courageous (David presents the head of Goliath to Saul) (fig. 221), that they be just (Solomon returns the child to its mother), and that they be pious (Solomon builds the temple). The figure of God blessing the kings appears at the top.[39] This might be called a kind of *Politique tirée de l'Ecriture Sainte* (Polity taken from the Holy Scriptures). Such subjects were perfectly in place in the coronation church, and it even seems that the artist had been inspired by the prayers recited at royal coronations.[40]

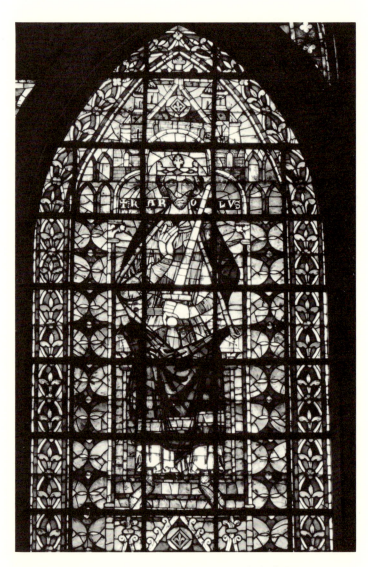

220. Charlemagne window. Reims (Marne), Cathedral of Notre-Dame. Clerestory of nave, south side, stained glass (upper half).

221. David brings Goliath's head to Saul. Reims (Marne), Cathedral of Notre-Dame. West façade, archivolt of rose window.

Images of the kings of France seldom occur in other cathedrals.[41] We have already said that the statues alighted on the façades of Notre-Dame of Paris, Notre-Dame of Chartres, and Notre-Dame of Amiens, once thought to be statues of kings, are in all likelihood the kings of Judah, ancestors of the Virgin.[42]

Eighteenth-century archeologists, unfamiliar with the true spirit of the Middle Ages, lent weight to the opinion that the images of our ancient kings were placed on the portals of churches in the twelfth and thirteenth centuries. Montfaucon, in his *Monumens de la monarchie françoise*, had no doubts that the eight large statues of the portal of St.-Germain-des-Prés (now destroyed) represented seven princes and princesses of Mero-vingian times, accompanied by the bishop St. Remi. He even named them. According to him, they represented Clovis, Clotilde, Clodomir, Théodoric, Childebert, Queen Ultrogothe, and Clotaire.[43]

At Notre-Dame of Paris, on the old St. Anne Portal, Montfaucon also identified the statues as our first line of kings, and suspected that the figure holding a violin[44] was Chilperic, because "he had composed hymns for the Church."

Montfaucon thought that the statues of the Royal Portal of Chartres Cathedral, and of the portal and cloister of St.-Denis, were also of Mero-vingian kings. We know that he had drawings made of these figures to illustrate his history of the first kings of France.[45]

It is astonishing that this learned Benedictine, who was so skillful in interpreting the monuments of antiquity, should have known so little about the religious art of his own country. The kings and queens of France he thought he recognized on the portals of our churches are in reality biblical figures. The grave kings and the queen with beautiful tresses of the portal of Chartres are the heroes and heroines of the Old Testament, those who awaited the Messiah.[46]

This mistake of the Benedictine School had the most disastrous consequences. On Montfaucon's authority it had often been repeated that the statues of St.-Germain-des-Prés and Notre-Dame of Paris were images of the kings of France; consequently, in 1793, the revolutionaries felt obliged to destroy them. A false interpretation caused the loss of our most precious monuments; their disappearance has made it very difficult to trace the history of the origins of French sculpture.[47] Montfaucon's error has been perpetuated even in our time. Some archeologists still persist in looking for images of the kings of France on the portals of churches. Abbé Bulteau made this mistake more than once in his *Monographie de la cathédrale de Chartres*. On the Royal Portal, he thought he recognized Charlemagne, Berthe aux Grands Pieds, King Canute, William the Conqueror, and Queen Mathilde.[48] Without a shadow of proof, he stated

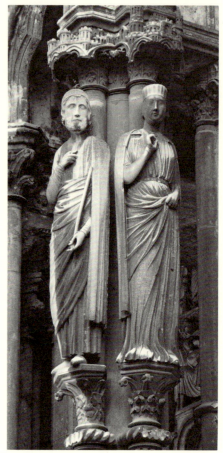

222. Biblical personages incorrectly identified as Louis VIII and Isabelle of France. Chartres (Eure-et-Loir), Cathedral of Notre-Dame. North transept, central portal, porch.

223. Biblical personages incorrectly identified as Philippe and Mahaut of Boulogne. Chartres (Eure-et-Loir), Cathedral of Notre-Dame. North transept, central portal, porch.

that the two large statues of the north porch represented Louis VIII and Isabelle of France, daughter of Louis VIII and Blanche of Castille (fig. 222).[49] Among the statues of this same porch, some of which have disappeared, he found Philippe, Count of Boulogne, and his wife, Mahaut (fig. 223); Philip Augustus, king of France, and Richard the Lion Hearted.[50] According to him, they were placed there because they had been benefactors of the cathedral. It did not occur to him that these statues might represent the prophets of Israel and illustrious kings and queens of the Bible, prefigurations of Christ. The scenes carved beneath the statues should have enlightened him. Below the statues (now destroyed) of the supposed Philip Augustus and Richard the Lion Hearted, we can make out episodes from the story of Saul and David. Where Bulteau saw a king of France and a king of England, he should simply have seen two kings of Israel.[51] Also, beneath the statues of the supposed Louis VIII, his daughter and the two men accompanying them, we recognize six scenes from the story of Samuel. One of these small reliefs

represents Samuel brought by his father and mother before the high priest Eli; all of them are named: Anna, Eloana, Samuel, Hély. Thus, it is most likely that the large statue represented Samuel with his mantle drawn up over his head, his mother Hannah, and the high priest Eli holding a censer. The king is doubtless Saul, who was anointed by Samuel (fig. 222). We notice that in the large statue, Hannah holds a book, just as the figure does in the small relief designated by the name of Anna.

Works of art that can be said with certainty to represent figures from French history are very infrequent in our cathedrals. The piety and respect of kings for the house of God no doubt explain the rarity of their effigies. They did not wish to be placed above the heads of the faithful, alongside the prophets, the apostles, and the martyrs. On the gold altarpiece of St. Henri (eleventh century, in the Cluny museum), the emperor and his wife, so small that at first we do not notice them, are prostrated before Christ, scarcely daring to kiss his feet. Such feelings were powerful in the eleventh century, and they had lost none of their force in the thirteenth. In stained glass windows, kings, barons, and bishops occupy the very modest place of donors. Usually they kneel humbly at the feet of Christ, the Virgin, or the saints.

Louis VII was carved in this attitude on the tympanum of the St. Anne Portal of Notre-Dame of Paris. On the "Porte Rouge" of the same church, St. Louis and his wife, Marguerite of Provence, kneel before the Virgin who is seated at the right hand of her son (fig. 175).[52]

In the course of the following century, if piety did not diminish, royal pride increased. About 1375, Charles V, the Dauphin Charles VI, Jean Bureau, Sire de la Rivière and counselor to the king, Duke Louis d'Orléans, and Cardinal La Grange were represented on the buttresses of the north tower of Amiens Cathedral, beside the Virgin and John the Baptist and by statues equal in size to the sacred figures.[53] Such familiarity would no doubt have shocked a St. Louis; but in 1375, the end of the true Middle Ages was approaching.

From the preceding, we may conclude that in the thirteenth century—the greatest period of religious art—kings, barons, and bishops were usually represented in cathedrals only as donors, and were almost always shown in attitudes that would distinguish them from the blessed.[54]

IV

If images of the kings of France appear rarely in the cathedral, were their victories, which had sometimes saved the Church, not represented there? Are chapters from the history of France not to be found in this most national of monuments?

The great scenes in the history of France. The baptism of Clovis. The history of Charlemagne (the window at Chartres). The crusades. The life of St. Louis.

I have discovered up to three: the baptism of Clovis, the feats of Charlemagne, and the victories of the first crusaders. In thinking about it, one realizes that for a Frenchman of the thirteenth century this constituted the entire history of France. These great names and great associations were almost all that survived in the popular memory. The Church accepted them and made them its own. In fact, Clovis, Charlemagne, and Godfrey of Bouillon mark three epochs in the history of French Christianity. The royal line and all of France seem to have been baptized on the day that Clovis was baptized; the Christian era in France can almost be said to have begun then. Three hundred years later, Charlemagne had given to Gaul its first perfect model of the Christian king. By placing his sword at the service of the faith, he had fulfilled the hopes of the Church. Then, it would seem, nothing happened for three hundred years, until Godfrey of Bouillon and the first crusaders continued the great emperor's work. Changes of dynasty, movements of peoples, and feudal wars meant nothing to the Church, which searched only for God in history. For three hundred years God had seemed to abandon the world, but suddenly he had reappeared: the crusades, the "Gesta Dei per Francos," were his work.

224. Baptism of Clovis. Reims (Marne),
Cathedral of Notre-Dame. West façade,
Gallery of Kings (detail).

Vincent of Beauvais understood history in somewhat this way. With evident pleasure, he recounts the exploits of Clovis, Charlemagne, and the first crusaders.[55]

As faithful interpreters of the Church's thought, artists carved the baptism of Clovis on the façade of Reims Cathedral (fig. 224). Above the rose window, seven great statues sheltered in seven niches represent Clovis, St. Remi, Queen Clotilde, and four lay or ecclesiastical dignitaries. The nude barbarian king is immersed to the waist in the baptismal font; St. Remi holds out his hand to receive the holy oil brought to him by a dove. The statues of the king and the bishop occupy the very center of the façade, drawing our attention the moment we raise our eyes. It is obvious that they were meant to remind future generations that France had become Christian in the person of its king through a miracle of God.

The history, or rather the legend of Charlemagne is told at Chartres in a window given by the furriers. This famous window, so often reproduced and described, has never been entirely understood. Consequently, it is worth studying in detail.[56]

The mistake of interpreters arose from their not being able to untangle the various sources from which the authors of the window took the story. It drew, in fact, upon three works: *L'Histoire du voyage de Charlemagne en Orient*, the *Chronique* of the Pseudo-Turpin, and *La Vie de St. Gilles*.

L'Histoire du voyage de Charlemagne en Orient is the work of a monk of St.-Denis, who wrote it in the early twelfth century, about 1124.[57] To prove the authenticity of certain relics of the Passion preserved in the church of St.-Denis, he tells of Charlemagne's expedition to the Holy Land. As a reward to the emperor of the Franks for freeing the Holy Sepulcher, the emperor of Constantinople gave him the crown of thorns.

The *Chronique* of the Pseudo-Turpin was written between 1140 and 1150. In the beginning, it was one of the chapters of the famous *Liber Sancti Jacobi*, which had been written by the monks of Cluny to draw pilgrims to Galicia. It tells of the battles of Charlemagne against the infidels of Spain, and includes the great emperor among the first pilgrims to Compostela. The *Chronique* was well received by the Church, and accepted as an authentic work of the old archbishop of Reims.[58]

La Vie de St. Gilles added only one detail to the legend of Charlemagne: the story of a terrible sin that the emperor did not wish to reveal, and that God, by a miracle, made known to the holy hermit.

The Chartres window was composed from the three works just mentioned. We may suppose that they had been collected into a single work, which was in the possession of the canons of Chartres. A compilation of this kind does in fact exist. It was undertaken in the twelfth century by a

monk of Aix-la-Chapelle, by order of Frederick Barbarossa who wished to spread the history of the recently canonized emperor throughout Christendom.[59] The book, entitled *De la Sainteté, des mérites et de la gloire des miracles du bienheureux Charlemagne*, includes the *Voyage en Orient*, the *Chronique* of the Pseudo-Turpin, and several biographical details taken from other sources. It is true that the story of the encounter between St. Gilles and Charlemagne does not appear in the manuscripts we have been able to look at.[60] But we can scarcely doubt that this episode had been added in some thirteenth-century manuscripts, for the famous reliquary of Charlemagne at Aix-la-Chapelle represents—besides the episodes of the journey to Constantinople and to Spain—the story of Charlemagne and St. Gilles.[61] So close an analogy between works of art from two regions so remote from each other proves that they both derived from a common written source.

Let me now describe the different scenes in the Chartres window, beginning (as is the rule) from the bottom. The first six panels (fig. 225) are taken from the *Voyage en Orient.*[62]

1. Charlemagne, with nimbus, receives two bishops who bring a letter from Constantine, emperor of the Orient. This letter contains the story of Constantine's vision.

2. Vision of Constantine. "While I was asleep," the text says, "an angel said to me: 'Behold Charlemagne, the king of France, your defender, who stands before you,' and he showed me an armed warrior wearing a coat of mail, holding a red shield, and girt with a sword whose sheath was the color of purple. He had a long lance from whose tip flames spurted; in his hand he held a golden helmet, and his face was that of an aged man with long beard, majestic and beautiful. His hair was white, and his eyes shone like stars."[63] The artist did not follow this fine description very closely, for he hid the face of his hero behind the closed helmet worn in the thirteenth century; nevertheless, the tall silhouette of Charlemagne, immobile on his horse and mysterious as an apparition, has epic grandeur.

3. A battle. Charlemagne delivers Jerusalem.

4. Charlemagne, victorious and still wearing his spurs, is received by Constantine at the gates of Constantinople.

5. Charlemagne receives three reliquaries from the emperor: one contains the crown of thorns, which at this very instant blossomed and with its perfume cured three hundred sick people; the others contained a fragment of the cross, Christ's winding sheet, the Virgin's shift, and the arm of the aged Simeon who had held the Child in the temple.

6. Charlemagne offering these holy relics to the church of Aix-la-Chapelle.

225. Charlemagne window (lower section).
Chartres (Eure-et-Loir), Cathedral of
Notre-Dame. Ambulatory, stained glass.

226. Charlemagne window (upper section). Chartres (Eure-et-Loir), Cathedral of Notre-Dame. Ambulatory, stained glass.

From this point, the author borrowed his subjects from the *Chronique* of the Pseudo-Turpin.

7. Charlemagne and two of his followers gaze at the sky in which they see the Milky Way. The emperor marvels and asks where this great way leads.[64]

8. St. James appears to Charlemagne. He commands him to follow the Milky Way as far as Galicia and to free his tomb, then in possession of the infidels.

9. Charlemagne departs with his warriors, among whom we recognize the archbishop Turpin.

10. The emperor falls on his knees in the presence of his army and prays God to deliver Pamplona to him.

11. The Christians enter Pamplona. The artist of Chartres, unlike the Aix-la-Chapelle artist, did not represent the walls of Pamplona crumbling under God's hand.

12. Charlemagne gives orders to the workmen who build a church in honor of St. James (fig. 226).

13. Charlemagne has returned to Spain. His army prepares to engage that of the pagan king Aygoland. During the night, the lances of the Christian soldiers who will die on the morrow flower.

14. The battle. The infidels can be distinguished by conical helmets and round shields.

15. Here, the artist inserts in the midst of stories from the Pseudo-Turpin an episode taken from *La Vie de St. Gilles*. Charlemagne had committed a sin so grave that he dared not confess it. Now while St. Gilles was celebrating the Mass in the emperor's presence, an angel brought to the holy hermit a banderole on which the sin was written. Charlemagne repented and God pardoned him.[65] This is the subject represented in the panel, which Abbé Bulteau and P. Durand took for the archbishop Turpin celebrating the Mass. But they did not notice that the celebrant is a monk, not an archbishop, that he has the nimbus of a saint, and that an angel issuing from heaven hands him a banderole, while the emperor sits apart holding his chin anxiously. The subject is represented in the same fashion on the reliquary of Aix-la-Chapelle; four poor Latin verses accompanying the scene leave no doubt about its meaning.[66] The Mass of St. Gilles appears a second time at Chartres, carved on the south porch in one of the archivolts of the right portal.

16. The story told in the *Chronique de Turpin*, interrupted briefly, continues. Roland, engaged in single combat with the giant Ferragut (Ferracutus), kills him with a thrust of his sword. We notice that Roland plunged Durandal into the giant's stomach because, according to the Pseudo-Turpin, he was vulnerable only in the navel.

17. Charlemagne crosses the mountains on his return to France. He seems to be in conversation with a personage, who is probably Ganelon.

18. Roland, with the rear guard, is taken by surprise. He remains alone among the dead. The artist, following the medieval practice of presenting simultaneously two different episodes of a story, represented the hero twice in the same panel. First, Roland strikes the rock with his sword; then he sounds his horn. This is an exact graphic translation of a passage from the chronicle: "He raised his sword and wept on it. Then, wishing to break it, he struck a rock, but he split it from top to bottom and drew out his sword intact. Then he blew his horn with such force that it broke in the middle, and the veins and nerves of his neck burst. The sound of the horn, carried by an angel, was heard by Charlemagne. . . ." Roland is represented with a nimbus, because in the thirteenth century he was honored as a saint. Ancient passionals called him "sanctus Rolandus comes et martyr in Roncevalla."[67] Pilgrims to Compostela, who went by way of Blaye, made their devotions at his tomb.[68] At that time, canonization was the highest form of popular admiration.

19. Baudoin (Balduinus) takes his helmet to look for water to give Roland to drink.

20. Baudoin, finding no water and being unable to do anything further for Roland, mounts the hero's horse and goes to Charlemagne to tell him of the death of his nephew.

21. The joust between Roland and Ferragut. The glass painter inadvertently misplaced this panel; it should precede the one representing the death of the giant.

Such is the most remarkable of medieval works of art devoted to Charlemagne.[69] It is based completely on legend, it is true, but the Charlemagne it presents is the pious hero who lived in the Church's memory—the king beloved by God and favored with the concourse of saints and angels.

The history of the crusades provided the subject for an interesting stained glass window, formerly at St.-Denis, which disappeared during the Revolution. We know it only from Montfaucon's book. It was only natural that the monks of St.-Denis, guardians of our national antiquities and chroniclers of the history of France, should have devoted a window to the most splendid victories of the holy war. In this way, were they not at the same time performing an act of devotion and honoring the memory of true martyrs?

The St.-Denis window, only a few panels of which are known, was conceived by an artist filled with the epic spirit of the great twelfth century. He used episodes that are quite minor in the eyes of historians, but are truly heroic and beautiful in themselves, such as the duel between

a Saracen and Robert, Count of Flanders (Duellum Parthi et Roberti flandrensis comitis), and the curious combat between an infidel and the Duke of Normandy (R[obertus] du[x] Normannorum Parthum prosternit).[70] Nevertheless, the three great victories of the First Crusade—the capture of Nicaea, Antioch, and Jerusalem by Godfrey of Bouillon—were not forgotten, and apparently occupied the center of the composition.[71] The Christian knights can be distinguished from the infidels by the cross on their helmets. Such a monument, so valuable for our history, unfortunately exists only in Montfaucon's work, in which the mediocre plates were drawn and engraved by artists who knew nothing of the spirit of our old masters.[72]

227. So-called scenes of student life. Paris, Cathedral of Notre-Dame. South transept portal, right buttress, reliefs.

The life of St. Louis concludes the series of historical representations admitted into the cathedrals of the Middle Ages. But this king is also a saint, and it was especially because of this that he was represented in churches. Nevertheless, the window of the Ste.-Chapelle (extensively restored, unfortunately),[73] which represents several episodes from the life of St. Louis, and notably the translation of the crown of thorns, was put in place before the king's canonization (1297). And in fact, St. Louis is shown without a nimbus.

The window devoted to the life, death, and miracles of St. Louis, dating from the early fourteenth century and once in the sacristy of St.-Denis, was clearly intended to honor the saint.[74] The same is true of the window

of Poissy (late fourteenth century),[75] and of the fourteen frescoes which decorated the convent of the Cordelières de Lourcine.[76] Such works derive from hagiography, not from history.

Our conclusion is that works of art of a purely historical character are rare in our cathedrals (cf. fig. 227).[77] Great events were not represented for their own sake. Only those symbolizing a great victory of the Church were accepted. Clovis, Charlemagne, Roland, Godfrey of Bouillon are represented in churches only because they were champions of Christ.

VI

The End of History. The Apocalypse
The Last Judgment

When Vincent of Beauvais' history of the world was completed up to the year in which he wrote, even then he did not believe that his work was finished. Christians knew the future; they knew that the world would end and they knew how it would end: Jesus himself in the Gospels, and St. John in the Book of Revelation had set a limit to history. That is why Vincent of Beauvais added the account of the Last Judgment as an epilogue to his book.

Artists did the same; they carved the solemn drama of the final day on the tympanums of the great portals of churches, on the side lit by the setting sun.

Thus history was brought to a close.

In the thirteenth century, the thought of the Last Judgment was ever present to all minds. It would no doubt have seemed impious to try to set the date when it would come about, for the Lord had said: "But of that day and hour no one knoweth"; nevertheless, people were receptive to the prophecies then current. The abbot Joachim, to whom Dante attributed the power of prophecy, had said in his commentary on Jerome that the world would end after 1200.[1] The clairvoyant St. Hildegarde foretold that the Last Judgment would come soon after 1180.[2] The fulfillment of these prophecies still seemed imminent to Vincent of Beauvais half a century later.

It was agreed that certain signs would herald the end of time: an excess of crime, the propagation of heresies, and the spread of knowledge.[3] Thirteenth-century mystics, who took a stern view of their own time, must have thought more than once that the "day of wrath" was at hand.[4]

The scenes of the Last Judgment carved on the portals of cathedrals stirred people more deeply than we can now imagine, and they regarded them not without anxiety. As they passed beneath the porch, they imagined that even on the morrow they might hear the blast of the angels' trumpets carved on the tympanum above their heads.

The Apocalypse. How artists were in-
spired by it. The Spanish Apocalypse and
the Anglo-Norman Apocalypse. The in-
fluence of the latter.

How did artists express the terror of the final day? And where did they go for inspiration?[5]

Their first thought was to interpret in their fashion one of the terrible pages of the Apocalypse. They chose the second vision in which God, seated on his throne and radiating dazzling light, is present at the loosing of the seals and the appearance of the prodigies announcing the end of time. "And he who sat there," as the apostle mysteriously called him, "appeared like jasper and carnelian, and round the throne was a rainbow that looked like an emerald. Round the throne were twenty-four thrones, and seated on the thrones were twenty-four elders, clad in white garments, with golden crowns upon their heads. From the throne issue flashes of lightning, and voices and peals of thunder, and before the throne burn seven torches of fire, which are the seven spirits of God; and before the throne there is as it were a sea of glass, like crystal. And round the throne, on each side of the throne, are four living creatures, full of eyes in front and behind."[6]

The passage was well chosen, for God appears both as glorious as a sovereign and as threatening as a judge. This apocalyptic figure, surrounded by the elders and the beasts, was placed above the triumphal arches of basilicas, and later, on the portals of Romanesque churches. No work surpasses the beauty of the Moissac tympanum, which is almost equal to the text. The Sovereign Judge, wearing the polygonal crown of ancient emperors, is placed against a background of stars. The angels, elders, and beasts surround his throne and lift their heads toward him, both attracted and dazzled by his splendor. Bright colors, now faded, added something supernatural to the great composition, making of it "an emerald-like vision."

The formidable God of Judgment Day was first given this form in medieval art, but as we shall see, in the twelfth century a new conception of the scene of the Last Judgment replaced the old. Magnificent compositions appeared that were not derived from the Apocalypse but from the Gospel of St. Matthew.

Nevertheless, artists did not altogether abandon the vision of St. John as a source for their scenes of the end of the world (fig. 228). There are works of art from the thirteenth and fourteenth centuries to prove that the Apocalypse continued to furnish themes for art. However, representations inspired by the Book of Revelation are relatively rare: a window at Bourges, a window at Auxerre (the fragments of which have been dispersed), tapestries of the cathedral of Angers, and above all, the interior and exterior sculptures of one of the portals of the west façade of Reims

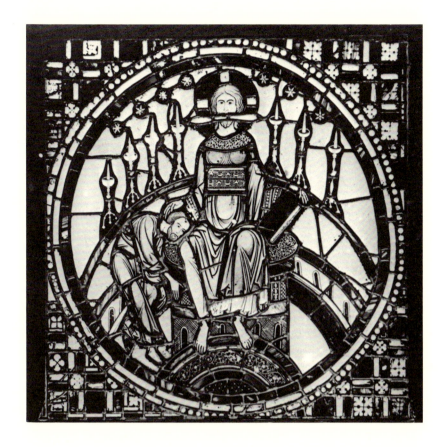

228. The vision of St. John. Lyon (Rhône),
Cathedral of St.-Jean. Choir, stained glass.

are almost the only compositions of any importance that can be cited for
this long span of years.

Most of the time the artists probably recoiled before the difficulty.
There is no common measure between the poetry of such a text and
human capacity in art. What sculptor would dare attempt such a scene
in which "the heaven departed as a book folded up," or the beast whose
"tail drew the third part of the stars of heaven and cast them to the
earth"? And what painter could reproduce the resplendent colors of the
Heavenly Jerusalem—sapphire, emerald, chrysoprase? The genius of the
prophets of Israel did not express itself in plastic terms; like certain mir-
rors, their visionary eyes deformed reality. Westerners, Latins, passion-
ately committed to pure line, preferred to incarnate ideas in concrete
forms, and they were never able to render the supernatural, monstrous,
and discordant forms imagined by the visionaries of the Near East. That
is why the Apocalypse was the source of strange works that have charac-
ter and are sometimes imposing, but that never have the humanity, the
profundity, the eternal character of works inspired by the Gospels.

With childlike simplicity, the miniaturists of the West soon dared to try to reproduce literally the visions of the Apocalypse. Two great schools of artists seem to have applied themselves particularly to the task.[7]

The first was a Spanish school which, from the ninth to the twelfth century, illuminated in vivid colors the fierce drawings accompanying the Commentary on the Apocalypse by Beatus, abbot of Liebana. Léopold Delisle has listed the principal manuscripts belonging to this family (manuscripts of Silos, Gerona, Urgel, La Cogolla, etc.).[8] The most beautiful of these is the Apocalypse of St.-Sever, in the Bibliothèque Nationale.[9] All of these manuscripts seem to derive from a single original manuscript of the eighth or ninth century. Thus, the Spanish monks of the ancient monasteries of the Asturias, Aragon, and Navarre, were perhaps the first in the West to illustrate the text of the Apocalypse. And perhaps there was some deep sympathy between the somber poem and the genius of these people. Their work may be sometimes barbaric, but it is never vulgar. In the Apocalypse of St.-Sever, the figures sometimes stand out against backgrounds of yellow or red, like a sky at sunset, and at other times against bands of dark violet, like a beautiful nocturnal sky. Some pages are very powerful. We have only to cite the eagle that flies

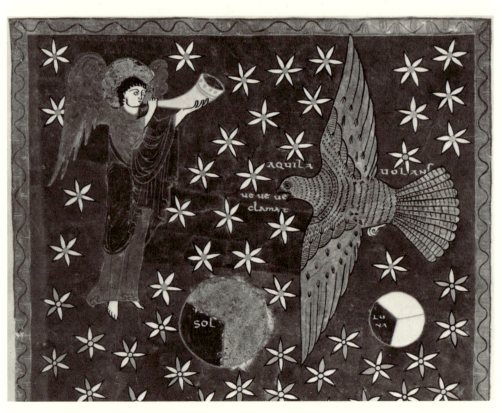

229. The fourth trumpet. Apocalypse of St.-Sever. Paris, Bibl. Nat., ms. latin 8878, fol. 141r (detail).

among the stars crying "*Ve! Ve!*" (Woe! Woe!) (fig. 229),[10] or the colossal serpent covered with scales, thrown into the bottomless pit by the angel.[11] By sheer force of candor, the naïve artist equaled the sublimity of St. John's text: "When the Lamb had opened one of the seals, I heard one of the four beasts crying with a voice of thunder: 'Come.' I looked, and I saw a horse. . . ."[12] The Spanish monk imagined a winged lion flying toward St. John, taking his hand in its claws, and showing him a rider mounted on a black horse (fig. 230).[13]

Another school, whose origins remain somewhat obscure but which seem to be English,[14] also attempted to illustrate the Apocalypse. A typical work of this school is a manuscript written in a French mixed with various Anglo-Norman expressions.[15] The miniatures, the work of artists whose color sense was not very lively, are far from the polychrome Apocalypses created by the Spanish. The backgrounds are white, and the drawing is set off by the palest of colors. However, no miniaturist was ever more faithful to the letter: the literal meaning of each verse is reproduced. The mystery evaporates, it is true; the limitless is given precise limits, the vast is reduced to human proportions. The work is estimable in many ways, but something is lacking—harshness, shock, the unexpected.

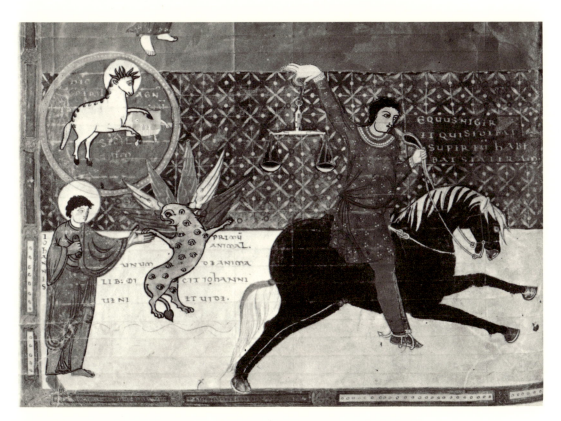

230. Rider of the Apocalypse. Apocalypse of St.-Sever. Paris, Bibl. Nat., ms. latin 8878, fol. 108r (detail).

The drawings of the beautiful manuscript in the Bibliothèque Nationale (latin 403) were made in the early thirteenth century, but they reproduce much earlier originals. The notation on the fourth page, *Apocalypsis in pictura facta Carolo Magno*, leads us to believe that the original manuscript was from the Carolingian period. Is it true, as Didot believed, that the original came from the workshops of York, in the time of Alcuin? Whatever this hypothesis is worth, and without going more deeply into the still insoluble problem, it is sufficient to say that few works were more productive than the Anglo-Norman Apocalypse (if we may give it this name). Almost all the thirteenth- and fourteenth-century works of art devoted to the Apocalypse—miniatures,[16] windows, and reliefs—owe something to it. The artist who first imagined so many forceful scenes and drew them with vigorous lines was working for the future. In fact, the Anglo-Norman Apocalypse inspired not only the painters and sculptors of the Middle Ages, but the woodcutters of the fifteenth century.[17]

Certain verses, which the Spaniards had been unable to render, here found definitive form. The magnificent beast who raises his haughty heads,[18] the woman with a halo of stars who shields her child from the attack of the monster by giving him into the hands of an angel (fig. 231),[19]

231. The woman and child, and the beast. Paris, Bibl. Nat., ms. latin 403, fol. 19v (detail).

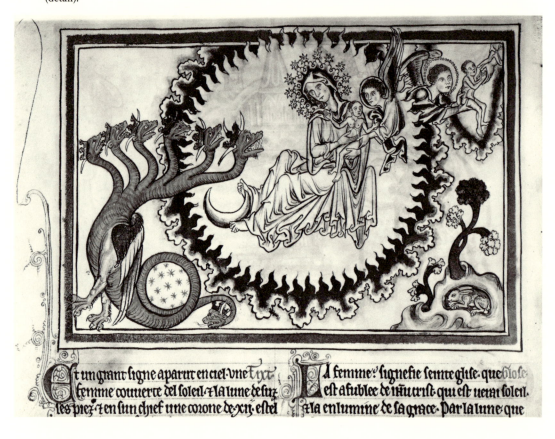

Et un grant signe aparut en ciel · une fem-
me couuerte del soleil · et la lune desuz
les piez · et en sun chief une corone de xij · estel

La femme · signefie sente glise · que close
est afublee de ihu crist · qui est uerai soleil.
et la enlumine de sa grace · Par la lune que

the divine apparition who carries a sword in his mouth[20]—all these figures were constantly repeated in the Middle Ages. The imitation was far from servile and the artists took all kinds of liberties with their model, but it is nevertheless true that their creative fantasy was confined within the limits of the old Anglo-Norman work.

One of the earliest monuments of medieval painting, the famous frescoes of St.-Savin, reveal this influence quite clearly. Fragments of an illustration of the Apocalypse still exist on the walls of the porch; we see a woman who turns away from the beast and gives her child to an angel.[21] This is the same motif, less richly expressed, that is found in folio 19 of manuscript 403 (fig. 231). Since the frescoes of St.-Savin are, it would seem, from the early twelfth century, we may conclude that the English archetype from which manuscript 403 derived was already known in France.[22]

But it was in the fourteenth century that the imitation is most evident. Unquestionably one of the most beautiful works of art ever inspired by the Apocalypse in the Middle Ages is the series of tapestries now in the cathedral of Angers (fig. 232). They were begun in 1375 by order of Louis I of Anjou, brother of Charles V.[23] We know that Hennequin of Bruges, who designed them, asked the king of France for a manuscript

232. The woman and child, and the beast. Angers (Maine-et-Loir), Cathedral. Tapestry (detail).

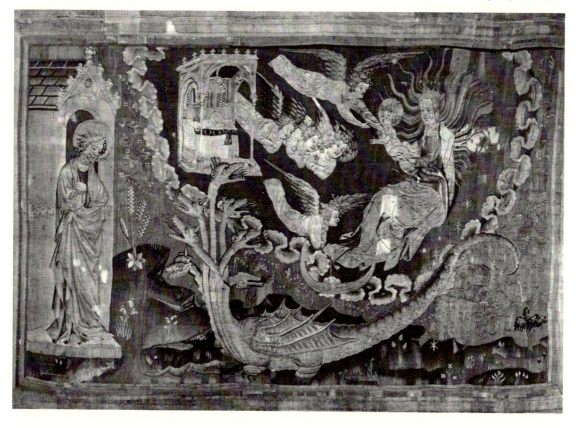

of the Apocalypse to use as a model. What manuscript was this? Giry believed that it was precisely this same Anglo-Norman Apocalypse (ms. fr. 403), which had in fact belonged to Charles V.[24] Maxence Petit took up Giry's thesis and tried to substantiate it further.[25] The resemblances are indeed striking. Meanwhile, Léopold Delisle, after closer examination, concluded that it could not have been manuscript 403 that Hennequin of Bruges had seen.[26] The manuscript he used differed only in a few details from manuscript 403, but it belonged to a second family that is well represented by the Apocalypse now in the library of Cambrai. Hennequin of Bruges invented nothing: the few scenes that do not appear in manuscript 403, and which he was thought to have created, are found in the Cambrai manuscript.

Thus, one of the most important medieval works of art devoted to the Apocalypse derived from a manuscript of the Anglo-Norman family.

The sculptures of the portal of Reims are also related to it, although less closely. These statuettes, of such highly refined artistry, were put in place toward the middle of the thirteenth century. Beginning with the reliefs of the buttresses,[27] they tell the story of the apostle's vision, and continue without strict order in the figures of the archivolts (fig. 233) and the interior and exterior niches of the portal.[28] The story ends on the south wall with the life and death of St. John.[29]

The resemblance between the statues and the miniatures is not apparent at first glance. The isolated figures in the niches scarcely recall the complicated and dramatic scenes of the manuscript. And never was the Apocalypse less terrible. The angels of Reims, clothed in long robes, carry cups, swords, and stars, and smile with sensual charm. The exquisite masters of Reims, uniquely enamored of beauty, were no longer able to express the somber poetry of the book. Their work is charming in detail, but artistically it is a mistake.

The claim that so personal a composition was inspired by this manuscript may seem farfetched, but nevertheless it is quite likely that the Reims artists did make use of an illustrated book derived from an Apocalypse belonging to one of the two groups of Anglo-Norman manuscripts. Certain details furnish proof: the woman fleeing before the beast,[30] the rider with a sword in his mouth,[31] the four angels confining the four winds by means of four antique masks,[32] and the crows pecking out the eyes of the dead.[33] These figures are derived through intermediaries, if not directly, from the original manuscript. But there is one even stronger proof. One of the characteristic details of the Anglo-Norman manuscript is the illustrated life of St. John which accompanies the Apocalypse. The biography on which the artist based his work was that of the Pseudo-Abdias, later reproduced in the *Golden Legend*. That is why the manu-

233. The angel casts the millstone into the sea. Reims (Marne), Cathedral of Notre-Dame. West façade, archivolt of south portal.

scripts deriving from this archetype, and the later incunabulae illustrated with woodcuts,[34] almost always begin or end with several episodes from the life of the apostle. Albrecht Dürer himself followed this tradition. As we have already said, the Apocalypse of Reims is completed on the south wall by scenes from the life of St. John. As in the manuscript, we see the torture of St. John at the Porta Latina, the miracle of the poison at Ephesus, and lastly, the mysterious death of the apostle.[35] And this final scene, at least in certain details, was conceived in the same way by both the sculptor and the miniaturist. The apostle lies in his tomb, covered by his chasuble; he is tonsured; above, angels carry his soul to heaven. It is hard to believe that so many resemblances can be laid to chance. The sculptors of Reims often used their imaginations, or they took so many liberties with their model that for the most part it can scarcely be recognized, but nevertheless, there is enough evidence of imitation in their work to enable us to guess which model they worked from.

We see what vitality there was in the work of the Anglo-Norman miniaturist. Were it not that it would take us outside our subject, it would be interesting to show how artists perpetuated the old forms until the end of the fifteenth century.[36] They continued to imitate the formula until Albrecht Dürer created a new one.[37]

In the thirteenth century, the Apocalypse inspired one curious and isolated work that does not derive from tradition because it was based on another idea. In fact, the window at Bourges is not an illustration of the Apocalypse but a commentary on it. The theologian who conceived the plan of the composition attempted to express in visual terms St. John's doctrine as interpreted by commentators. The institution of the Church, the real presence of Christ in the Church whose soul he is, and the eternal glory of the Church after the end of time—these are the verities the artist expressed.[38]

In the lower part of the window (fig. 234), Christ is represented as he appeared in John's vision: the sword is in his mouth and the book with seven seals in his hand; before him, Peter baptizes the throng. This is the symbolic translation of the following passage from the Apocalypse: "And before the throne there was a sea of glass like unto crystal."[39] All of the medieval interpreters of the Apocalypse, and especially Anselm of Laon, understood "the sea of glass" to mean baptism. "The sea of glass like unto crystal," said Anselm of Laon with all the subtlety of an eleventh-century Church Doctor, "is baptism. For, just as crystal is hardened water, baptism transforms wavering and irresolute men into firm and resolute Christians."[40] Thus, the first vision of John has to do with the institution of baptism, or, if you will, of the Church.

In a higher section of the window, we see Christ in glory surrounded by twelve figures from the Old Testament, one of whom is Moses, and by the twelve apostles of the New Testament. It was in this way that the Church Doctors interpreted the vision of the Apocalypse in which God was seen seated on his throne and surrounded by the four-and-twenty elders. The four-and-twenty elders, according to their interpretation, are the twelve apostles and the twelve heroes of the Old Law.[41] So that the artist would leave nothing in John's text unexplained, he replaced the four symbolic animals with figures of the four evangelists. Thus, Christ seated at the center of the prophets, apostles, and evangelists, is Christ seated at the center of his Church, where, as he had said, he would ever be.[42]

In the third panel of the window, Jesus and the Lamb carry the triumphal cross. St. Peter speaks to the throng while two men drink from the breasts of the Church, symbolized by a crowned queen. In this we recognize the Church Doctors' interpretation of the final visions of the Apocalypse. Peter is the Church Militant; he calls the faithful to the marriage of the Church Triumphant with the Lamb. In the fullness of time, the Church that nourishes men with the milk of the two Testaments will enter eternal glory and become one with God.[43] Seven stars and seven clouds, the signs of temporality (which henceforth will be abolished), dominate the entire composition.

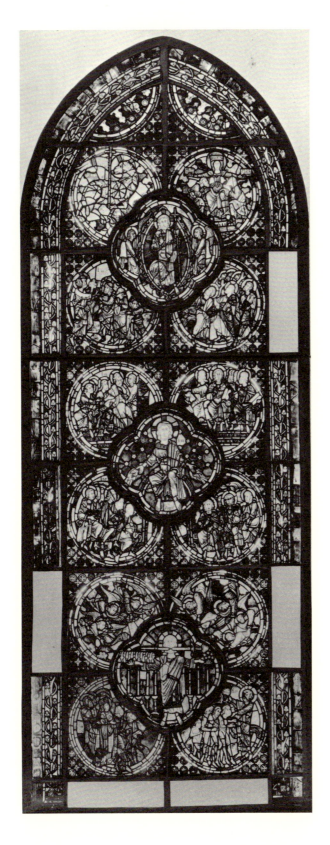

234. Apocalypse window. Bourges (Cher),
Cathedral of St.-Etienne. Ambulatory,
stained glass.

Such is this great theological composition, the most profound and subtle work ever inspired by the Apocalypse in the Middle Ages. It is entirely doctrinal, and owes nothing to traditional types.

II

The Last Judgment. The sources. Importance of the *Elucidarium* of Honorius of Autun. The premonitory signs. The appearance of Jesus Christ. The resurrection of the dead. The Judgment. St. Michael and his scales. Hell. The mouth of Leviathan. The elect.

In spite of the examples cited, it cannot be said that the Apocalypse was a very fertile book in the thirteenth century. In fact, already in the twelfth century, artists had preferred Matthew's account of the world's end.[44] The evangelist's text is no doubt less striking, but it is within the reach of art. In the Gospel of St. Matthew, God is no longer a vast precious stone whose brilliance is unbearable. He is the Son of Man; he sits on his throne as if he were on earth; mankind can recognize his face.

A chapter from Paul's First Epistle to the Corinthians on the resurrection of the dead[45] furnished some details for the composition, and the Apocalypse furnished one or two minor ones.

These diverse passages, interpreted by theologians and enriched by the imagination of the people, were the basis of the beautiful scenes of the Last Judgment which decorated almost all the thirteenth-century cathedrals.

In France, in the twelfth century, the two ways of representing the Last Judgment coexisted (according to the Apocalypse, and according to St. Matthew). At St.-Trophime of Arles they were even combined. The tympanum has the traditional king surrounded by the four animals as described in the Apocalypse, but the reliefs of the frieze represent the separation of the saved from the damned, in conformance with the Gospel of St. Matthew.

It was the great school of sculpture of the southwest of France that developed the new disposition of the Last Judgment scene in the early twelfth century. It appeared on the old capitals of La Daurade, now in the museum of Toulouse.[46] On the portal of Beaulieu, in the Corrèze, it had been developed with all the amplitude of monumental sculpture, and soon after, enriched with new details, it appeared on the portal of Conques, in Aveyron. At Conques, some of the scenes are grouped together that were henceforth to form the scene of the Last Judgment: Christ displaying his wounds, angels carrying the instruments of the Passion, the weighing of souls, the separation of the saved from the damned, paradise, and hell. From Languedoc the new formula for the Last Judgment seems to have spread both north and south. In the south, we find it with certain variations on the "Pórtico de la Gloria" at Santiago de Compostela, inscribed with the date 1183. In the north, it was carved shortly

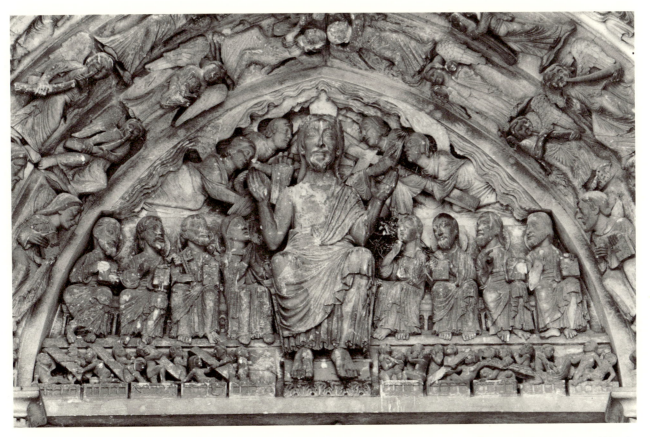

235. Last Judgment. Laon (Aisne),
Cathedral of Notre-Dame. West façade,
south portal, tympanum.

after 1135 on the portal of St.-Denis, and about 1180 at Notre-Dame of
Corbeil.[47] The northern artists further embellished the southern composi-
tion: at each side of the Judge they placed the Virgin and John. The Last
Judgment of Laon, overcrowded and confused, is quite archaic (fig.
235). But at Chartres, the scene is clarified and well composed (fig. 236).
At Paris, a somewhat different formula appeared (fig. 237).

It is this complex and rich Last Judgment of our thirteenth-century
cathedrals that we propose to study at the very moment it reached its
full development. Such a study, many times attempted, has never pro-
duced satisfactory results because the archeologists who undertook it were
too unfamiliar with the literature of the Middle Ages. In such a subject
there is no place for personal interpretation. Only in the books of the
twelfth- and thirteenth-century theologians can we hope to find the
meaning of the vast compositions.

The most valuable of these books was written in the early twelfth cen-
tury by Honorius of Autun: the *Elucidarium*.[48] The third book of this
kind of catechism in dialogue is devoted almost entirely to the end of the

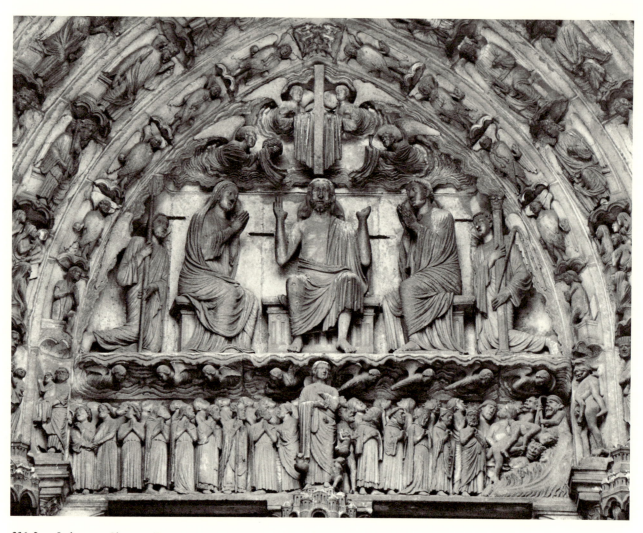

236. Last Judgment. Chartres (Eure-et-Loir), Cathedral of Notre-Dame. South transept, central portal, tympanum.

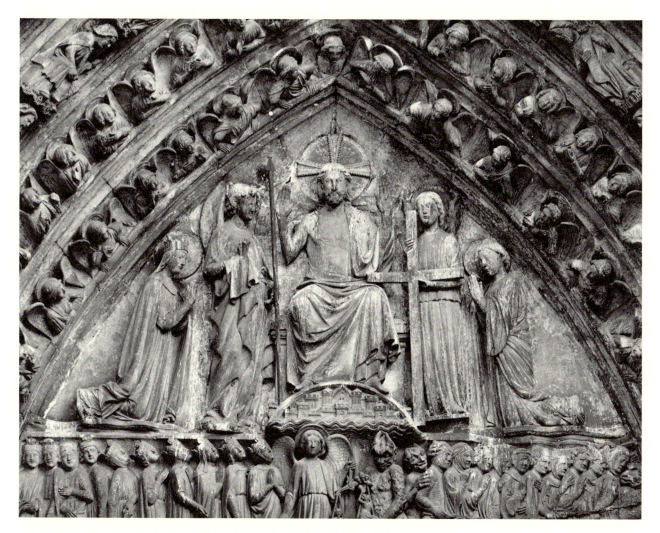

237. Last Judgment. Paris, Cathedral of Notre-Dame. West façade, central portal, tympanum.

world and the Judgment of God. Since the *Elucidarium* was written before the artistic formula for the scene of the Last Judgment had been found,[49] it may have provided certain features to painters and sculptors. The great fame of Honorius' manual, which was soon adopted by the Schools and placed within reach of laymen by a French translation,[50] makes such an hypothesis quite likely. A century later, Vincent of Beauvais summarized in the Epilogue to his *Speculum historiale* all that the Middle Ages thought they knew about the second coming of Christ.[51] As a contemporary of the artists who carved the tympanums of Amiens and Reims, he provides the best commentary on their work.

In the *Summa*, St. Thomas Aquinas treated the same subject with his usual method. The concrete details that emerge from the ground of his

238. Horseman of the Apocalypse: Death.
Paris, Cathedral of Notre-Dame. Portal of
the Last Judgment. West façade, archivolt.

closely woven syllogisms are in perfect conformity with received doctrine.[52] Lastly, Jacob of Voragine, in the first chapter of the *Golden Legend* furnishes proof that the Church's sentiment about the Last Judgment had not changed at the end of the thirteenth century.[53]

Thus, during the Middle Ages there was a strong current of opinion on the circumstances that would accompany the second coming of Christ.

With such books to guide us, we will not risk being mistaken about the intentions of the artists.

The Last Judgment, as it was understood in the thirteenth century, is a great drama divided into exactly five acts. Out of necessity, the sculptors presented successive scenes simultaneously. It is for us to separate them and find their temporal order.

239. Horsemen of the Apocalypse, and
Hell. Amiens (Somme), Cathedral. West
façade, central portal, archivolts.

First, premonitory signs announce the end of the world and form the prelude to the Judgment. The threats of the Apocalypse have come to pass, and the Antichrist is born at Babylon of the tribe of Dan. Theologians dwelt at length on the scourges that will precede the final catastrophe: Vincent of Beauvais enumerates the fifteen cosmic catastrophes which, according to Jerome, will signify to mankind that the end of time is at hand.[54] Thirteenth-century sculptors were more restrained. At Paris and Amiens (figs. 238 and 239), the horsemen of the Apocalypse, placed in the archivolts of the portal of the Last Judgment, alone recall the days of terror that will precede the coming of the Son of Man. Certain of these figures are worthy of their subject. At Paris, the figure of Death, blindfolded, bent forward over his horse and carrying a corpse on its rump, is a terrifying figure that expresses magnificently the cycle of terror that is to come.[55]

Suddenly, at the given time, at the very same instant in the middle of the night when Christ had been resurrected, the Judge will appear in the clouds.[56] The evangelist said: "And then shall appear the sign of the Son of Man in heaven: and then shall all the tribes of the earth mourn, and they shall see the Son of Man coming in the clouds of heaven with power and great glory."[57] This brief passage from Matthew, on which all of Christendom had meditated, was enriched by commentary and was given its perfect form in the thirteenth century.

At the top of the tympanum, where the Judgment will take place, Christ appears seated on his throne. Contrary to the figure described in the Apocalypse, he wears neither crown nor golden belt. He reveals himself to mankind as he was when among us, clothed in his humanity. With an admirable gesture, he raises his two hands to display his wounds, and his tunic is drawn back to reveal the wound in his side (fig. 236). We sense that he has not yet opened his mouth to speak to the world, and his silence is terrible.

What was his intention in showing us these wounds? This is what the Church Doctors said: "He shows his wounds," said one of them, "to testify to the truth of the Gospels, and to prove that he was truly crucified for us."[58] But that is not all. According to another, "His wounds prove his mercy, for they recall his voluntary sacrifice; they also justify his wrath, for they cause us to remember that all men were not willing to profit by his sacrifice."[59] And Thomas Aquinas added: "His wounds prove his power, for they attest that he triumphed over death."[60] The gesture of Christ designates him as redeemer, as judge, and as the living God.

The angels appear at each side of Christ. Some carry the cross and the crown of thorns, others, the lance and the nails. Their hands, almost

always covered with a veil, touch the sacred objects respectfully. According to all the Church Fathers, the "signs of the Son of Man" spoken of by the evangelist are the instruments of his Passion, especially the cross. Just as an emperor's standard, scepter and crown are carried before him when he makes solemn entries, so will angels carry in triumph the cross, the lance, and the crown of thorns on the glorious day when the Son of God reveals himself to the world for the second time.[61] So brilliant a light will shine forth from these instruments of ignominy become emblems of glory that the sun and the moon will be eclipsed. The cross will project a light seven times as bright as the light of the stars.[62] That is why, as at Bordeaux,[63] angels are sometimes shown taking away the sun and the moon above the head of Christ, as lamps are extinguished when they are no longer needed (fig. 240).

Lastly, to further enrich the scene already so full of movement, artists placed the Virgin and St. John in prayer at the right and left of the Judge. The Gospel makes no mention of this, but theologians could justify the presence of these two figures new to the scene. Honorius of Autun remarked that the Virgin and John had scarcely known death, for they had been carried to heaven by Christ himself. Thus, it was as if they were the first fruits of the resurrection.[64]

But I would be more inclined to believe that in introducing the Virgin and St. John into the scene of the Last Judgment, the artists were guided by popular piety. Would not the mother and the well-beloved disciple deserve to be with the triumpher on the day of glory, when it was they who had stood beside the cross on the day of suffering? But in this case, why should they be represented as kneeling with clasped hands, like supplicants? Here we touch on one of the most delicate sentiments of the Christian soul. Theologians had stated that no prayer would sway the Judge at the supreme moment, but the humble throng of Christians could not believe it. They continued to hope that even on that day the Virgin and John would still be powerful intercessors and would save more than one soul by their prayers. The artists were inspired by a belief they shared: they opposed grace to law, and made a ray of hope shine from the midst of the awesome machinery of justice.[65]

The scene of the appearance of the Son of Man was thus complete.

The problem was to group these figures artistically. Artists found two solutions.

At Chartres (fig. 236), the Virgin and St. John, seated at the right and left of Christ, implore him with clasped hands while kneeling angels hold the instruments of the Passion. By bringing together the Judge, the Virgin, and John, and placing them at his sides, the artist seemed to want to give their prayers greater efficacy, to make their supplication irresistible.

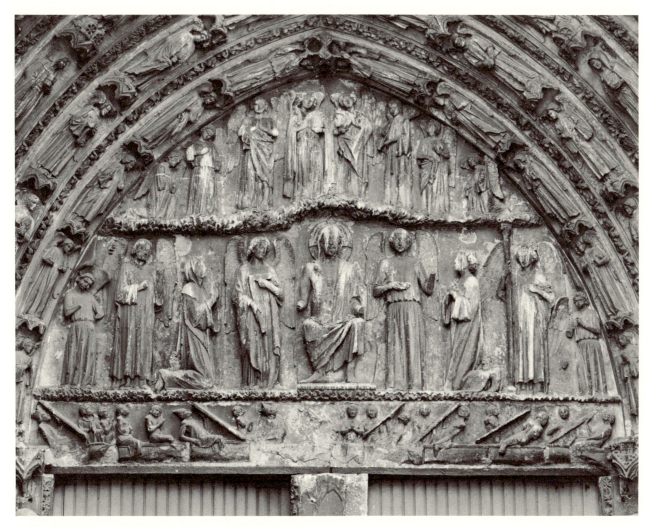

240. Last Judgment. Bordeaux (Gironde), Cathedral of St.-André. West façade, north portal, tympanum.

This moving disposition of figures was used also at Amiens (fig. 244), but with a variation: the Virgin and John, humbler than at Chartres, dared not seat themselves beside Christ, but in order to pray more fervently, they are on their knees.

The touching scene of supplication at Amiens was repeated several times in France: at Notre-Dame-de-la-Couture in Le Mans, at Bayeux, south of the Loire at Levroux (Indre), Bazas (Gironde), Le Mas d'Aire (Les Landes), and even as far as the cathedral of Burgos, in Spain.[66]

Meanwhile, in the first years of the thirteenth century, a new formula appeared at Notre-Dame of Paris. It is perhaps less moving, but it is better composed (fig. 237). In the center, the seated Christ is larger than all that surrounds him; at his sides, two angels stand and hold the instruments of the Passion; the kneeling figures of St. John and the Virgin fill the spaces at the sides of the composition. Here, the artist had skillfully triumphed over the problems raised by the triangular form of the tympanum. It is obvious that figures must diminish in height if they are to fit harmoniously into a triangle, and of necessity, the kneeling figures occupy the angles. The two supplicants are farther from the Judge, it is true; two angels stand between them and him, but what arrangement could be more harmonious?

The Paris formula had much greater influence than the formula of Chartres and Amiens. As would be natural, it was first used in the region near Paris, at Larchant, Rampillon (Seine-et-Marne), and St.-Sulpice-de-Favières (Hauts-de-Seine) (fig. 243).[67] Then, farther from Paris, it was used in the west at Sillé-le-Guillaume (Sarthe), and in the south and southwest at Bourges,[68] Poitiers (fig. 241), Bordeaux (fig. 242),[69] St.-Macaire and St.-Emilion in the Gironde, and Dax in Les Landes. It also crossed th Pyrenees and appeared in Spain at the cathedral of León. Beyond the Alps, it was used at Ferrara.[70]

Such was the beautiful artistic development of the scene of the appearance of the Judge.

When Christ shows himself in the clouds, the trumpet sounds[71] and the third act of the drama begins. Summoned by angels, the dead raise the lids of their tombs and prepare to come before the Judge. In almost all our cathedrals, one band of the tympanum is devoted to the Resurrection. The artists, docile pupils of the theologians, expressed delicate nuances in this scene which would escape us entirely, could we not refer to our usual guides.

While the angels are sounding their long ivory oliphants, the dead rise up in their tombs, dazzled "by the great day of eternity." They all turn their eyes toward the light, and certain pure souls awaken with hands clasped in an attitude of prayer.[72] The resurrection takes place in the wink

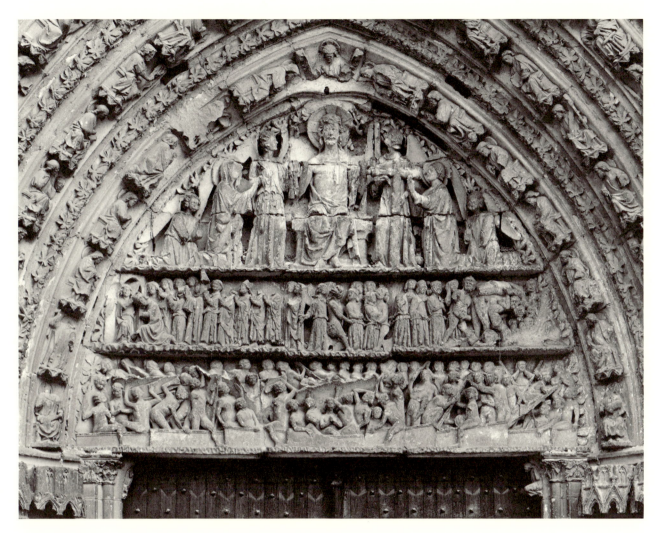

241. Last Judgment. Poitiers (Vienne), Cathedral of St.-Pierre. West façade, central
portal, tympanum.

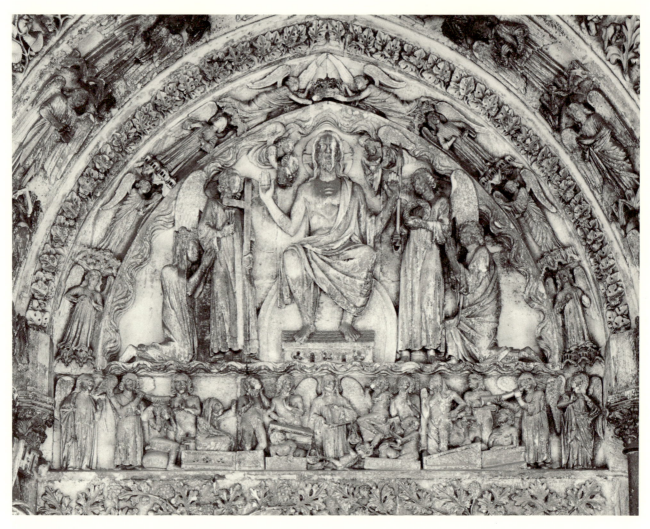

242. Last Judgment. Bordeaux (Gironde), St.-Seurin. West façade, south portal, tympanum.

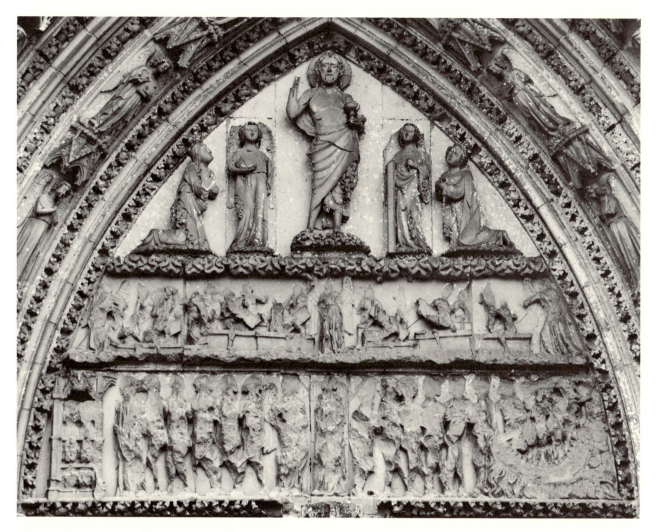

243. Last Judgment. St. Sulpice-de-Favières (Hauts-de-Seine), Church of St.-Sulpice.
West façade, portal, tympanum.

of an eye (*in ictu oculi*);[73] the human dust has taken on its fleshy form
at the very first sound of the trumpet. Consequently, the thirteenth-cen-
tury artists did not represent the dead as fleshless or only half-fleshed skel-
etons, as Luca Signorelli did at Orvieto.[74]

The dead are naked or partly veiled by their shrouds (fig. 245). A royal
crown, a papal tiara, or a bishop's mitre appear on some of the anxious
heads, and makes manifest the equality of all men before the judgment
seat of God. Medieval art tried to avoid the nude figure, but at this point
it had to follow the teaching of the Church. Man must come out of the
earth as God had brought him forth at the beginning of the world. On
the final day, each man will fulfill his type and according to the law of
his own being, attain perfect beauty.[75] The sexes will remain, although

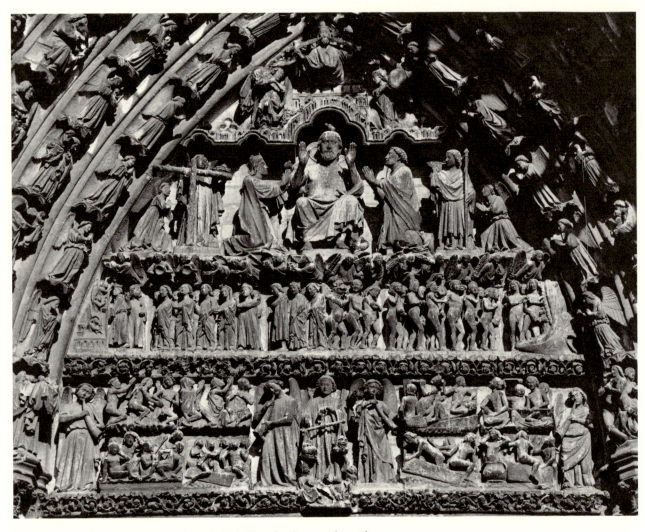

244. Last Judgment. Amiens (Somme), Cathedral. West façade, central portal, tympanum.

sex has no further purpose; nevertheless, they will serve to manifest the omnipotence of God and will embellish the eternal city with their diversity.[76] Moreover, at the moment of resurrection, men will not have the same age as they had at death. If they had, they would not fulfill the beauty that is the supreme law of all creatures—they would either fall short of their type or go beyond it. Consequently, everyone, whether he died as an infant or an old person, will be reborn at the perfect age of thirty. All of mankind will thus resemble Jesus Christ, the divine example who triumphed over death at precisely that age.[77]

Artists took this strange doctrine literally. In thirteenth-century scenes of the Last Judgment, there are no children or old people. The bodies are young, beautiful, and full of vitality when they arise from the tombs. At Bourges (one of our most beautiful carvings of the Last Judgment) the dead are naked,[78] no drapery conceals the sex of the figures, and insofar as the artist was capable, he gave them the perfection of youth and beauty. The delightful relief at Rampillon (fig. 246) is conceived in the same manner.

After the resurrection of the dead comes the Judgment. Jesus judges, but not alone. The apostles are his assessors, for Jesus himself had said to them: "You shall sit upon twelve thrones, judging the twelve tribes of Israel."[79] From this came the custom of representing the twelve apostles either at the sides of the Judge or below his feet, as at the cathedral of Laon, the portal of St.-Urbain at Troyes, and in the rose window of St.-Radegonde at Poitiers;[80] or standing in the embrasure of the portal, as at Chartres, Paris, Amiens, and Reims.

But the principal actor in the scene of the Last Judgment is neither Christ nor the apostolic college. It is the Archangel Michael. He stands, clothed in a long robe with vertical pleats (in the thirteenth century he was not shown in knightly armor), and holds the scales in his hand. Beside him, a trembling soul awaits the verdict of the scales, for in one pan his good acts have been placed, and in the other, his sins. The devil is present, because he fills the role of prosecutor before the tribunal.[81] The wily prosecutor is a marvel of dialectic. He dares pit his wits against God. Thinking that the noble archangel, who looks straight ahead with such honesty, will not suspect his trick, he tips the scale with his finger.[82] St. Michael is unmoved by this contemptible trick worthy of a grocer; he does not deign to notice it. But in his hand, the scale fulfills its function and tips to the side it should. Satan is vanquished; the archangel gently caresses the little soul.

Where had the artists found the idea for a scene of such profound pathos? No scene from the Gospels authorized it, but it came of a metaphor as old as humanity itself. Ancient Egypt and early India had already

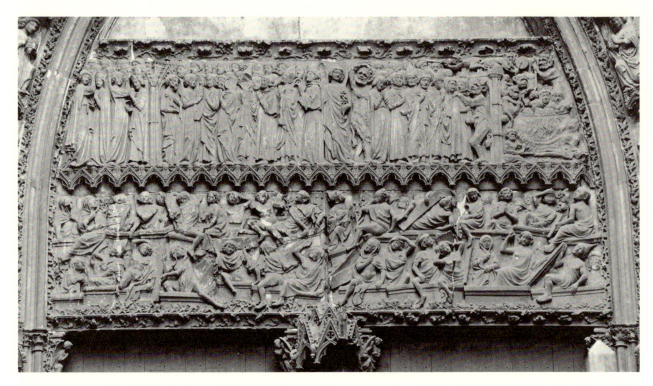

245. Resurrection of the dead. The Elect and the Damned. Rouen (Seine-Maritime),
Cathedral, Portail des Libraires. North transept portal, tympanum (detail).

246. Resurrection of the dead. Abraham receiving souls. Rampillon (Seine-et-Marne),
Church of St.-Eliphe. West façade, portal, lintel.

imagined that the vices and virtues would be weighed in the two pans of a scale on the day that the dead were judged.[83] The Church Fathers often used the same figure of speech: "Good and bad acts will be weighed in the balance," said St. Augustine, ". . . and if the bad outweigh the good, the sinner will be sent to hell."[84] St. John Chrysostom said: "On that day, our acts, our words, and our thoughts will be placed in two pans, and the scale, by dipping on one side or the other, will bring about the irrevocable sentence."[85]

The scales first appeared in scenes of the Last Judgment in the Near East; it was from the Near East that we borrowed them.[86]

But there are enough variations in the scene of the weighing of souls, as it was conceived in the thirteenth century, to indicate that it had not been the product of official Church teaching. Great liberty of imagination was left to the artists. At Chartres, for example, one of the pans holds a small figure with clasped hands, symbolizing good acts, and the other pan holds a hideous head and toads representing the vices. Nothing could be clearer. On the portals of Notre-Dame-de-la-Couture at Le Mans, the same small figure with clasped hands appears in both pans of the scale, as if to say that even from the depths of our sinfulness, a prayer can still rise to God. At Amiens, the Lamb of God rests in one pan, and the ignoble head of a damned soul in the other.[87] Here, the artist meant to convey that even though we are saved, it is only through the merits of Jesus Christ; that what we call our virtues are only gifts of his grace. At Bourges, the same idea is expressed. In one of the pans of the scales we see a chalice, and in the other, a hideous figure; which is to say that it is by the blood of Christ that we are saved.

The role played by St. Michael in the scene of the Last Judgment requires explanation. During the entire Middle Ages, St. Michael was believed to induct souls into the future life. He was the holy psychopomp. In the Early Christian era, the Church, wishing to divert the still pagan Gallo-Romans' worship of Mercury to St. Michael, seemingly transferred to the archangel some of the attributes of the pagan god. Chapels dedicated to St. Michael were built on the ruins of temples of Mercury which usually occupied high places. A hill in La Vendée still bears the significant name of St.-Michel-Mont-Mercure.[88] St. Michael who was already the messenger of heaven, became, like Mercury, the guide of the dead. Ancient customs confirm the funerary role played by St. Michael. The chapels of cemeteries were dedicated to him, and confraternities organized to bury the dead had him as patron saint.[89] His image was sometimes carved on tombstones or on the tombs themselves.[90] And in the Middle Ages, the offertory of the Mass for the Dead said expressly: *Signifer sanctus Michael repraesentet eas (animas) in lucem sanctam* (May

St. Michael, bearer of the standard, lead them [the souls] into the sacred light). Thus, St. Michael is the angel of death, and this is why he presides over the judgment of the dead.

When the judgment has been accomplished, the final scene begins. The sheep are separated from the goats,[91] the good from the wicked. The saved go to the right of the Judge and the damned to his left, toward reward or toward eternal damnation. Demons first seize on the damned, binding them together in single file with a chain and pulling them toward the gaping mouth of hell. We find few traces of doctrinal teaching in this scene. Popular fantasy is responsible for all its details—the bestial ugliness of Satan and his acolytes, their cynical gaiety, the liberties they take with noble ladies, the despair of the damned. The vices are not systematically differentiated. Among the throng of unnamed sins, we scarcely notice avarice with a purse hung around its neck (figs. 247, 248).[92] And popular feeling was also responsible for the artists including kings and bishops among the number of the damned.[93] In the manner of Dante, the sculptor set himself up as judge.

All of these creations, born of artists' lively imaginations, owe nothing to the books of theologians. However, we do find a trace of doctrinal teaching on the portal at Bourges. Demons are represented with a human head sketched on their bellies or the lower part of their abdomens. What does this mean if not that the damned have displaced the seat of their intelligence, and have put their souls to the service of their lowest appetites? An ingenious way of conveying that the fallen angel descended to the level of the beasts.

The image of hell as it was represented in the Middle Ages also derived from the commentaries of Schoolmen. Almost all of the thirteenth-century scenes of the Last Judgment show an enormous open mouth belching flames into which the damned are hurled. The devils issued from just such a mouth, jointed and made movable, in late fifteenth-century Mystery plays.

How is it that such an image should have been transmitted so faithfully throughout the entire Middle Ages? The real reason is that its source was not a caprice of the imagination but a text. The mouth of hell is the mouth of Leviathan referred to in the Book of Job. It was God himself who described the monster he had created, and sternly asked of the patriarch: "Can you draw out Leviathan with a hook? . . . Who can go into his mouth? Who can open the doors of his face? Round about his teeth is terror. . . . Out of his mouth go flames, giving off sparks. Out of his nostrils comes smoke, as from a boiling pot. . . . He makes the deep sea boil like a pot. . . ."[94]

247. Separation of the elect and the damned. Laon (Aisne), Cathedral of Notre-Dame.
West portal, tympanum (detail).

248. The damned. Reims (Marne), Cathedral of Notre-Dame. North transept, west
façade, tympanum (detail).

Very early, the commentators of the Book of Job (Gregory the Great was one of the first) recognized in Leviathan a symbol of Satan and his works. Certain passages, interpreted with amazing subtlety, were of great influence in the Middle Ages. For example, Gregory the Great contended that the passage concerning the hook that will snare the monster relates to the victory of Christ over Satan.[95] The most famous interpreters of the Book of Job, Odon of Cluny[96] and Bruno of Asti,[97] transmitted this doctrine to Honorius of Autun, who outdid them both in his interpretation: "Leviathan, the monster who swims in the sea of the world, is Satan. God cast a line into that sea. The cord of the line is Christ's ancestral line; the iron hook is Christ's divinity; the bait is his humanity. Lured by the smell of flesh, Leviathan seized it, but the hook caught in his jaw."[98] The *Hortus deliciarum*, Herrad of Landsberg's famous manuscript, contains a miniature which translates into visual terms the thought of the commentators of the Book of Job: the ancestors of Christ composed the cord of the line, and Christ tears the monster's mouth with the hook (fig. 249).[99]

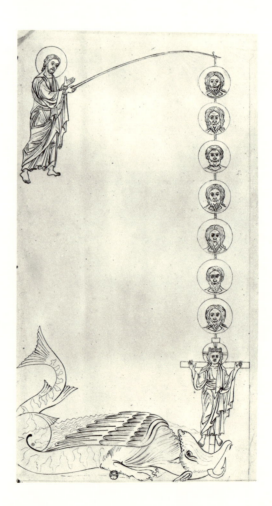

249. The Fisher of the Leviathan. *Hortus deliciarum* of Herrad of Landsberg. Paris, Bibl. Nat., Fonds Bastard, Cab. des Estampes, A d 144, fol. 84r.

It was also said that the passage concerning "the one who will open the doors of Leviathan's face" referred to Christ's descent into hell and his victory over Satan. "In breaking down the gates of hell," said Bruno of Asti "Christ broke down the gates behind which Leviathan hid his face."[100] This is the source of the well-known tradition in art of representing in the scene of the Descent into Hell the open mouth of Leviathan beside the broken gates that Christ tramples upon.

Lastly, the verses that say that "flames shoot out of his mouth, that smoke comes from his nostrils as from a boiling pot, and that he makes the deep sea boil like a pot" were taken as an exact description of hell. Indeed, thirteenth-century artists translated these images literally, even going so far as to represent a boiling pot in the monster's open mouth. There is an example of this on the tympanum of Bourges Cathedral (fig. 250) and on an archivolt of Notre-Dame of Paris.

But such exact conformity with a theological commentary is no longer present in the various scenes representing the suffering of the damned. Artists did not accept the doctrine of St. Thomas and the majority of theologians who interpreted the torments of hell in a symbolic sense. Thomas said, "The worms devouring the damned must be understood in a moral sense, and to signify the remorse of the conscience."[101] Artists were faithful to the letter. At Bourges, serpents and toads devour the damned, while devils stir them in the cauldron. Medieval sculptors rejected all symbolism. They seem to have based their work on the famous verses describing the torments of hell, then current in the Schools—atrocious verses which resemble instruments of torture:

> *Nix, nox, vox, lachrymae, sulphur, sitis, aestus,*
> *Malleus et stridor, spes perdita, vincula, vermes.*[102]

> (Snow, night, cries, tears, sulfur, thirst, heat,
> the hammer and clamor, lost hope, chains, worms.)

While terror reigns at the left of the Judge, joy bursts forth at his right. The artists chose to represent the moment when the decree opening eternal glory to the saved has just been pronounced. We are on the threshold of paradise. Contrary to the doctrine of Honorius of Autun, who strove to prove that the just will be clothed only in their innocence and the splendor of their beauty, the saved wear long robes, or even the costumes of their earthly rank and condition.[103] Because they wanted either to follow the Apocalypse which refers to "those who are clothed in white robes,"[104] or rather to recall earthly struggles in the very bosom of beatitude, medieval artists chose to clothe the blessed in the costumes of their former condition. Kings, bishops, and abbots march with the throng of holy souls toward heaven. At Bourges, a king walks with a flower in his hand. This

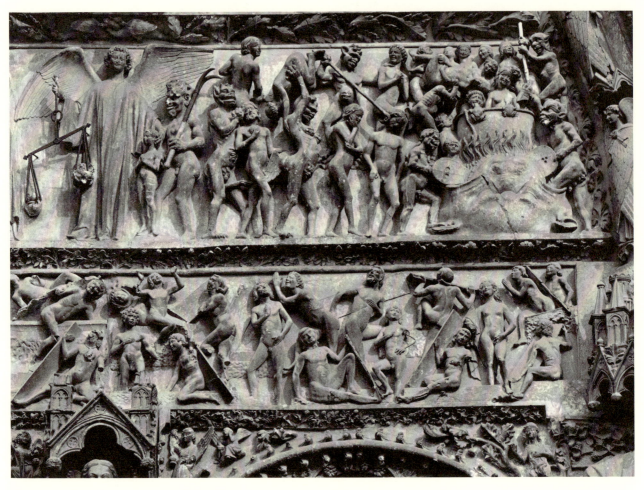

250. Last Judgment. The damned. Bourges (Cher), Cathedral of St.-Etienne. West façade, central portal, tympanum (detail).

charming figure expresses the union of royalty and sainthood. The memory of St. Louis, who was not long dead, had perhaps inspired the artist. It is not a portrait but the idealized image of a Christian king, of which St. Louis was the archetype. At Bourges, he is represented as a slender knight, and "beautiful as an angel," to borrow the words of Fra Salimbene, the charming painter of the sainted king.[105] It is interesting that at Bourges, Notre-Dame-de-la-Couture of Le Mans, and Amiens, a Franciscan wearing the rope belt with three knots walks beside the king at the head of the saved (fig. 251). It is possible that the Bourges artist, whose work must be later than the death of St. Louis, wished to associate in the same homage the two purest souls of his century, St. Francis of Assisi and St. Louis. In any case, it is certain that the recently founded Franciscan Order, the new path to salvation, was glorified at Bourges, at Amiens, and at Le Mans.[106]

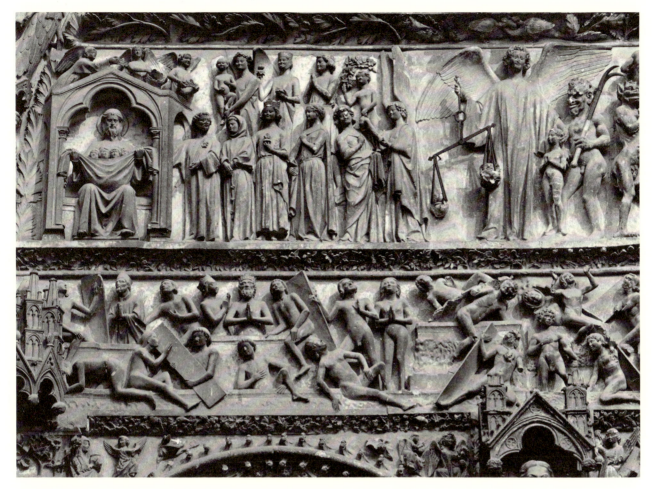

251. Last Judgment. The elect. Bourges (Cher), Cathedral of St.-Etienne. West façade, central portal, tympanum (detail).

Thus, the elect advance, clad in the costumes they wore on earth; but the angels who stand at the gates of heaven prepare to decorate them with the royal emblem. They hold crowns that they place on the heads of those crossing the threshold. This episode occurs in almost all the representations of the Last Judgment.[107] At Notre-Dame of Paris, the saints have already received their crowns, and even before they enter paradise, they all resemble kings. At Amiens, the angels, holding crowns, form a graceful frieze above the heads of the elect. So well established a tradition can only be explained by a text. And in fact, we read in the Apocalypse: "Be faithful unto death: and I will give you the crown of life."[108]

At the threshold of paradise, designated by a doorway, a grave figure among the smiling angels attracts attention. This is St. Peter who with key in hand receives the new arrivals.[109] The people imagined thousands of charming stories on this subject, and transformed Peter into the keeper

of the gates of heaven. The artists' idea was more profound. Peter is only a symbol: he stands for the power to bind and to loose that Christ conferred on the Church in the person of the first pope. By representing St. Peter at the gates of paradise, artists intended to convey that it is through the Catholic Church alone, and through its sacraments, that we may enter into eternal life.[110] The glass painter who composed the window of the Last Judgment at Bourges had more space to work in, and consequently developed this controlling idea at greater length. In the lower section of the composition, he represented the sacrament of penance in a figure kneeling before a priest.[111]

III

However, we have not yet entered paradise. If the sculptor was to complete his "divine comedy," he must take us there. He tried, but it cannot be said that he altogether succeeded. Perhaps he took St. Paul's words literally: "No eye has seen, nor ear heard; nor the heart of man conceived, what God has prepared for those that love him."[112] Art admitted defeat at the outset.

An archaic and naïve figure conceived by Eastern artists continued to be used as the image of paradise, even at the height of the thirteenth century. The patriarch Abraham, seated on his throne, carries the souls of the just in his bosom.[113] Such a representation, which moreover conforms closely to theological teaching,[114] is only a kind of hieroglyph. At Reims, it is true, the artist made an heroic effort to make the metaphor expressive. With exquisite delicacy, angels carry the souls of the blessed on sacred cloths toward Abraham's bosom (fig. 252). Never has respect for

Eternal bliss. The beatitudes of the soul. The beatitudes of the north portal at Chartres represented according to St. Anselm. The end of history.

252. Angel delivering souls to the bosom of Abraham. Reims (Marne), Cathedral of Notre-Dame. North transept portal, tympanum (detail).

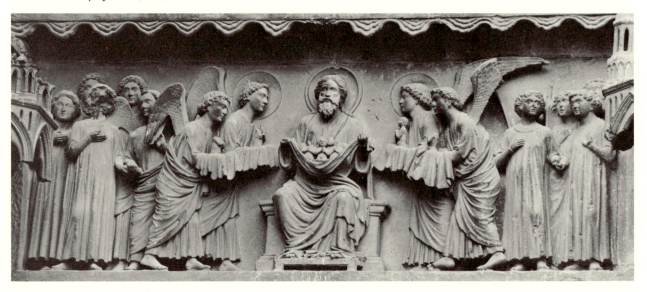

the human soul and faith in immortality been better expressed. But where are the joys of paradise? Where are the divine fields of Fra Angelico, the circle of the saved among tall flowers, and the light of the day that has no end?

Enslaved by obdurate matter and prisoners of the inflexible laws of their art, the sculptors did not try to express the infinite and the eternal. The only one to make a noble effort was the remarkable unknown artist of Bourges. True, the saved are not yet in heaven, but the lines of their beatified bodies are so chaste, and such pure joy radiates from their faces that, all the same, there is a reflection of paradise in his work. Elsewhere, only a few details are worth mention. At Notre-Dame of Paris, a married pair are reunited and walk hand in hand, united forever. At St.-Urbain of Troyes, souls emerge from foliage and appear among the "holy flowers of paradise."

Dante well understood that sculpture is incapable of expressing eternal beatitude. His paradise is music and light. The souls are rays of light that sing. Form disappears, absorbed by a light a hundred times brighter than the sun. The holy of holies is a vast rose with petals of fire, and in the background, the Trinity can be glimpsed in the mysterious form of a triple circle of flames.

Only the clear colors of a Fra Angelico could give any reality to so dazzling a vision. Color can transport us to the heights almost as well as music. But what was the poor sculptor to do, with his half-pagan art and his heavy figures that seem burdened with the weight of original sin?

However, medieval sculpture was too idealistic not to try to express the inexpressible. Once at least, on the portal of Chartres, art attempted to express the infinite beatitude of the elect.

If we are to understand these figures, we must have some notion of the theological doctrine of eternal life.

When the world has been judged, it will be renewed. All that was undisciplined and unruly in nature—heat, cold, storms, all the disorder born of original sin—will disappear. The ancient harmony will be re-established. The elements will be purified. Water, sanctified by Christ when he immersed his body in the Jordan, will become more sparkling than crystal. The earth, which martyrs soaked with their blood, will be covered with everlasting flowers.[115] The bodies of the just will participate in the universal renewal and be glorified. The soul itself will be enriched with immortal gifts. There will be seven gifts of the body and seven gifts of the spirit. The gifts of the body will be beauty, agility, strength, liberty, health, pleasure, longevity; the gifts of the spirit will be wisdom, friendship, concord, honor, power, security, and joy. All that we so sadly lack in this world we shall then have. The body will participate in the

nature of the spirit: it will be agile, strong, and as free as thought. The soul will be completely harmonious: it will be reconciled with the body and with itself.

In the eleventh century, St. Anselm first classified the fourteen beatitudes, as we have just listed them.[116] The system he adopted was either faithfully followed, or modified only slightly by all the great theologians of the Middle Ages: Honorius of Autun,[117] St. Bernard,[118] St. Thomas Aquinas,[119] St. Bonaventura,[120] and Vincent of Beauvais.[121] Contemplation of the promised joys filled all these Church Doctors with saintly happiness. A great wave of enthusiasm elevated Honorius of Autun; his *Elucidarium* became a lyric poem. The master speaks, the pupil listens in ecstasy: "*Master*: 'What would your joy not be if you were as strong as Samson?' *Pupil*: 'O glory!' *Master*: 'What would you say if you found yourself as free as Augustus who possessed all the world?' *Pupil*: 'O splendor!' *Master*: 'If you were as wise as Solomon who knew all the secrets of nature?' *Pupil*: 'O wisdom!' *Master*: 'If you were united to all of mankind with a friendship like David's for Jonathan?' *Pupil*: 'O beatitude!' *Master*: 'If your joy equaled that of a man condemned to death who, from the rack on which he was stretched, was suddenly called to the throne?' *Pupil*: 'O majesty! . . .'"[122]

The fourteen sublime gifts to the soul and body appeared to the artists of the thirteenth century as a choir of fourteen beautiful virgins, and they represented them on the north porch of the cathedral of Chartres (fig. 253).[123]

Even though nine of the figures at Chartres are named, they have caused the archeologists a great deal of trouble. In 1847, Didron wrote a brilliant article to prove that they were meant to represent the civic virtues.[124] His admiration was unbounded for the thirteenth-century sculptors who dared erect a statue to Liberty. The naïve old masters became for him, as only too often for Viollet-le-Duc, the precursors of the French Revolution.

Two years later, Félicie d'Ayzac published an erudite and sensible brochure on the same subject.[125] She demonstrated definitively that the fourteen statues of Chartres do not represent the civic virtues, but the fourteen beatitudes of the soul in eternal bliss, as classified by St. Anselm. Thus, our image makers of old were dispossessed of the certificate for good citizenship bestowed upon them by Didron.

Nine of the fourteen statues at Chartres are named: Liberty, Honor, Agility, Strength, Concord, Friendship, Majesty, Health, and Security. Five have no inscription, but by ingeniously interpreting their attributes, Mme. d'Ayzac recognized them to be Beauty, Joy, Pleasure, Longevity, and Knowledge.

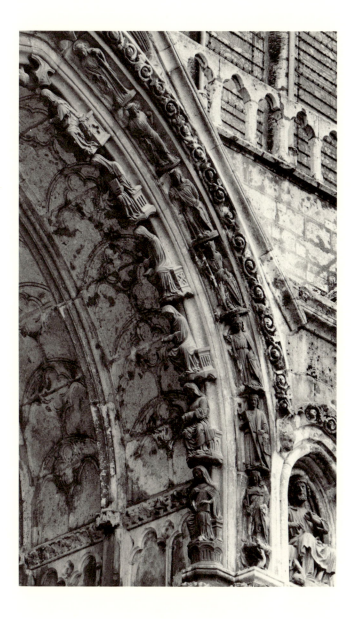

253. Beatitudes of the soul. Chartres
(Eure-et-Loir), Cathedral of Notre-Dame.
North porch, left portal, archivolts.

These fourteen beatitudes are fourteen queens with crowns and haloes.
They have an air of nobility and freedom. Their unbound hair flows to
their shoulders; their full robes fall in straight folds and mold the pure
lines of their noble bodies. In one hand they hold a scepter, the other
rests lightly on a large shield decorated with an emblem. Each has her
own blazon. Liberty wears two crowns to recall that sovereigns are freer
than other men. Honor has a double miter on her shield, because the
miter is the highest symbol of honor. The Psalmist said of the bishop
wearing the miter on his head: "Thou madest him to have dominion over

the works of thy hands; thou hast put all things under his feet."[126] On her shield, Longevity has the eagle, which in old age grows young again in the heat of the sun; for emblem Wisdom has the griffin which knows where hidden treasures lie. Certain attributes of the beatitudes are less erudite: Agility carries three arrows, Strength has a lion, Concord (fig. 254) and Friendship have doves, Health has fish, Security a fortified castle, and Beauty has roses.

All of these virgins are images of beatified souls. Their beauty and serenity caused the Christian who contemplated them to forget this imperfect world, and they opened heaven to him. Through them, paradise became visible; and it cannot be said of the artists who created these noble figures that they had been defeated by the grandeur of the subject and were incapable of expressing eternal beatitude.

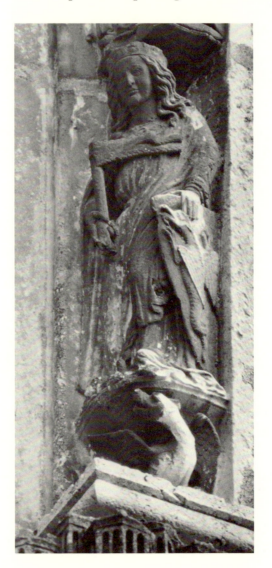

254. A beatitude of the soul in the eternal life. Chartres (Eure-et-Loir), Cathedral of Notre-Dame. North transept, east door, archivolt.

We now have some idea of the richness of invention displayed by medieval artists in the composition of the scene of the Last Judgment. But even so, many details have gone unmentioned. We have not spoken of the legions of angels and saints who, from the heights of the archivolts, contemplate the work of divine justice. At Notre-Dame of Paris, charming angels lean from the archivolts as from a balcony of heaven. And we have said nothing of the symbolic figures often accompanying the principal theme. The most frequently represented are the wise and foolish virgins. The former stand at the right of the Judge and proudly hold their lamps filled with oil; the latter are placed at his left, their empty lamps dangling sadly from their hands (fig. 255). A clear image of the saved and the damned. The wise virgins walk toward an open door; the foolish virgins toward a closed door.[127]

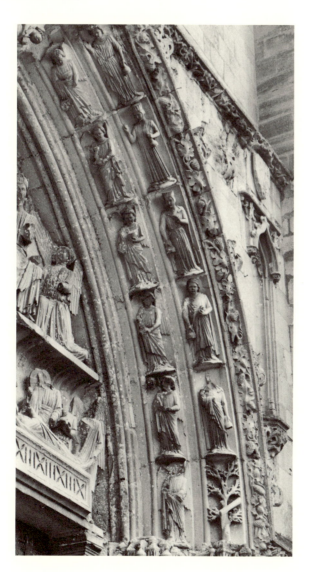

255. The foolish virgins; the tree and the axe. Longpont-sur-Orges (Essonne), Notre-Dame Priory. West façade portal, archivolts.

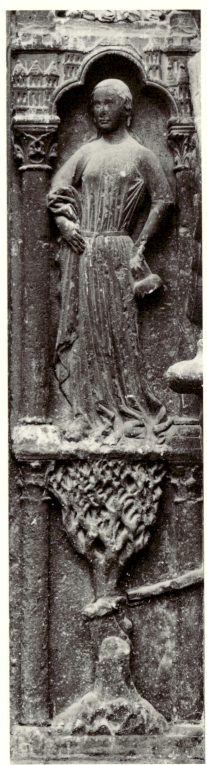

256. (a) The wise virgin, (b) the foolish virgin; the trees and the axe. Amiens (Somme), Cathedral. West façade, central portal, jamb (details).

Sometimes also, as at Amiens, a tree laden with fruit is shown at the right of the Judge, and a withered tree, cut into by an axe, is shown at his left (figs. 256a, b). There is no doubt as to the meaning: the allusion to punishment and recompense is clear. But we would perhaps not completely understand the thought of the artist had not Vincent of Beauvais explained it. "The damned," he said, "will undergo double punishment, separation from the kingdom, and fire. This," he added "is the axe and the fire spoken of in the Gospels where it says: 'Every tree which brings not forth good fruit is hewn down, and cast into the fire.' "[128] The axe symbolizes, as we see, the separation of the damned, who on the final day will be cut off from the Church Triumphant.

We notice that there is no trace of purgatory in any of the representations of the Last Judgment. Nothing could be more logical, for purgatory exists in time and is subject to the laws of time. Now after the Last Judgment, the world will be conceived only under the aspect of eternity. Only paradise and hell will exist, for paradise and hell alone are eternal.

Thus the history of the world comes to an end. Like Vincent of Beauvais, the artist has magnificently unfolded it before us, in its entirety. He has served as our guide through time, from the awakening of the first man under the hand of the Creator until his final rest in the bosom of God.

Conclusion

In a chapter of *Notre-Dame de Paris*, where the light mingles with so much shadow, Victor Hugo said: "In the Middle Ages, mankind had not a single important thought that it did not write in stone." In this volume, I have laboriously demonstrated what the poet had sensed by intuition.

Victor Hugo was right; the cathedral is a book. The encyclopedic character of medieval art is best recorded at Chartres; each mirror of Vincent of Beauvais found its place there. The cathedral of Chartres is medieval thought expressed in visual terms; nothing essential is lacking. Its ten thousand figures, carved or painted, form an ensemble unique in Europe.

Perhaps several other of our great cathedrals were once as complete as Chartres, but time has treated them with less respect. However, so sustained an effort to encompass the universe appears nowhere else. One facet is developed at Amiens, another at Bourges. Such diversity is not without charm; whether it was intended or whether some of the works of art have been destroyed, it would seem that the purpose of each of our cathedrals was to stress in particular one truth, one doctrine.

In this sense, Amiens is a messianic, a prophetic cathedral. The prophets of the façade, leaning forward like sentinels on the buttresses, look into the future. Everything in this solemn work speaks of the approaching advent of the Saviour.

Notre-Dame of Paris is the church of the Virgin. Four out of six portals are dedicated to her. She occupies the center of the two great rose windows: in one, the saints of the Old Testament, and in the other, the cycle of the works and the months and the figures of the Virtues are arranged in relation to her. She is at the center of things. Nowhere was she more loved; the twelfth century (St. Anne Portal), the thirteenth century (Virgin Portal), and the fourteenth century (reliefs of the north side)—all celebrated her with untiring devotion.

The cathedral of Laon is erudite. It seems to place knowledge in the foremost rank. The Liberal Arts accompanied by Philosophy are carved on the façade and painted on one of the rose windows. There, the Scriptures were presented in all their mystery; the truths of the New Testament were concealed behind Old Testament symbols. We sense that famous Church Doctors had lived in the shadow of the cathedral, which itself has the stern countenance of a doctor of the Church.

Reims is our national cathedral. The others are catholic, universal; Reims alone is French. The baptism of Clovis fills the upper section of the gable; the kings of France are painted on the windows of the nave. Its façade is so rich that it needs no further decoration on coronation days;

The character of each of our great cathedrals.

stone hangings are carved on the portal; it holds itself in readiness to receive kings.

Bourges celebrates the virtues of the saints. Its windows illustrate the *Golden Legend*. The life and death of the apostles, confessors, and martyrs form a dazzling crown around the altar.

The portal of the cathedral of Lyon tells of the marvels of creation. Sens gives us a glimpse of the immensity of the world and the variety of God's work. Rouen is like a rich Book of Hours in which God, the Virgin, and the saints occupy the center of the pages, while fantasy is allowed free play in the margins.

However, we must not exaggerate. In each cathedral, we sense the desire to present a summary of all knowledge. One particular chapter of the *Speculum* was no doubt developed in each one, but it is rare not to find the other chapters at least indicated.

Through the statues and stained glass windows of churches, the clergy attempted to teach medieval man as many truths as possible. They well knew the power of art over childlike and humble souls. For the great mass of illiterate Christians, who had neither psalters nor missals and of their religion knew only what they saw, ideas had to be materialized, clothed in visual form. In the twelfth and thirteenth centuries, both the statues of church portals and the characters of liturgical dramas incarnated Church doctrine. Christian thought had created its own powerful spokesmen. There again, Victor Hugo was right: the cathedral was the book in stone for the uneducated, a book little by little made useless by the invention of printing. "The Gothic sun set behind the gigantic printing press of Mainz."

II

The disposition of subjects was regulated by the clergy. Artists were submissive interpreters of Christian thought. Viollet-le-Duc's error. Lay artists did not rebel.

There is no doubt that the plan of these great theological, moral, and scientific pages in stone was regulated by the clergy. The artists were only the interpreters of Church thought. In 787, the Fathers of the second Council of Nicaea said: "The composition of religious images is not to be left to the initiative of artists; it must come from the principles laid down by the Catholic Church and religious tradition." And further on: "The talent alone belongs to the painter; the plan and disposition belong to the Fathers of the Church."[1]

In the East as well as the West, this was indeed the doctrine of the Church in the thirteenth century, just as it had been in the eighth. The study of the works of art, often so profound in meaning, that we have made in the preceding chapters, leaves no doubt on this point. Is it likely that medieval artists were capable of imagining such learned works? I

am willing to grant that they had some literary culture. Villard de Honnecourt knew Latin.² But that is far from saying that they could have composed such theological windows as those in the cathedrals of Bourges and Chartres devoted to the Passion. The Good Samaritan windows (at Bourges and at Sens), in which each episode is accompanied by its symbolic interpretation, presupposes the most thorough doctrinal instruction. Ensembles such as the north portal of Chartres (central portal), where each of the great *christophoros* statues personifies an epoch of the world's history and symbolizes the waiting of the nations, could only have been conceived by clergymen. It was these clerics who followed the *Speculum ecclesiae* of Honorius of Autun, and planned the left portal of the west façade of Laon Cathedral, where the heroes of the Old Testament are presented as symbols of the Virgin. Clerics also planned the window at Lyon, in which each event of the life of the Saviour is placed in correspondence with an animal of the bestiary again in conformance with the doctrine of Honorius of Autun.

Everywhere, we find the work of the Schoolmen, the Church Doctors. Would it have occurred to humble artists, who at that time were scarcely differentiated from artisans,³ to go to Boethius for the image of Philosophy and carve Greek letters on the hem of its robe, or to look for a description of the Seven Arts in a work as obscure as that of Martianus Capella? Even in popular works and works having to do with legends, where we might think the artist had spontaneously reproduced what he knew by heart, we find evidence of direction by the Church. Have we not shown that the windows of Le Mans, in which some of the most famous of the Virgin's miracles are represented, are no more than a translation of a passage of the lectionary?

In all the works we have studied, we have found evidence of minds familiar with ecclesiastical doctrine. It must not be forgotten that the cathedral was a school. The most learned men and the most eminent masters of the Middle Ages mingled in its chapters. Bishops were often former professors and doctors emeritus. There can be no doubt that they supervised the decoration of their cathedrals, and that they themselves drew up the programs for the artists. In many cases, they must have provided the artists with actual manuals of instruction.

The only document of this kind that has come down to us from the Middle Ages is the book Suger devoted to the church of St.-Denis.⁴ The pages in which he described the windows of the basilica are of capital importance. There we see that the abbot himself chose the subjects, skillfully arranged them, and wanted to compose himself the inscriptions that make the symbolic works somewhat less obscure. We would have many such probative pages if the bishops of the thirteenth century had taken

the trouble to write down the history of the construction and decoration of their churches. Unfortunately, no documents of this kind have been found. The few we have date from the fifteenth century. In 1425, the church of the Madeleine, at Troyes, had a series of tapestries woven representing the history of its patron saint. Care was taken to leave nothing to the artist's imagination. "Friar Didier, Jacobin, having extracted and written down the history of St. Madeleine, Jacquet, the painter, drew a small pattern on paper. Then Poinsète, the seamstress, and her helper assembled large bed sheets to be used for executing the patterns that were painted by Jacquet the painter and Symon the illuminator." The Jacobin friar returned many times while the work was going on, to make sure that the painter followed his instructions. He gave advice, while drinking wine with the artists.[5]

We do not have Friar Didier's memorandum, but we do have one that an unknown person wrote several years later in similar circumstances. The church of St.-Urbain, at Troyes, wished to have a series of tapestries woven illustrating the lives of Pope Urban, and of St. Valerian and his wife, St. Cecilia. A cleric (as his erudition indicates) drew on various sources[6] and made an outline so detailed and precise that nothing was left to the artist's imagination. The following is a passage from this curious manuscript:

> Make and portray a place and tabernacle in the manner of a beautiful chamber, within which will be the said St. Cecilia, humbly prostrated on her two knees, with hands clasped, in the attitude of prayer. And near her will be the said Valerian gazing with great admiration at an angel who is above their heads holding two crowns made of and portraying lilies and roses, and who seems about to light and to place one crown on the head of St. Cecilia and the other on the head of Valerian, her husband; and from the mouth of this angel will come a scroll, on which will be written, if it is possible, or at least in part: *Istas coronas mundo corde et corpore custodite, quia de paradiso Dei ad vos marcescent, nec odorem amittent* (Guard these garlands with pure heart and body, for I have brought them to you from God's paradise, nor will they ever wither or lose their aroma).[7]

We may conjecture that the use of such manuals goes back to the beginning of the Middle Ages. From the twelfth century until the Renaissance, the Church never relaxed the surveillance it thought it must exercise over works of art.

On the other hand, we have seen that the artists themselves had their traditions. In representations of the Gospels, certain immutable rules were followed. In the scene of the Nativity, the Infant had to be lying on an altar. The three magi had to represent the three ages of man: youth,

middle age, and old age. Christ on the cross had to have his mother at his right and St. John at his left. The centurion pierced his right side. In the scene of the Resurrection, the Saviour had to rise from an open tomb with the triumphal cross in his hand. We discussed these details as we came to them, and there is no need to amplify examples. As I have said, these traditions were probably codified: a written manual, or at least sketches of models, transmitted them from workshop to workshop, from generation to generation. Now these traditions themselves came from the Church; the artistic formulas had been gradually elaborated in the East and in the West. Manuscripts with miniatures make it possible, if not to trace their origins, at least to follow their development. And everywhere we find Christian thought and dogma.

Thus, we must give up thinking that our old masters were independent, restless spirits who were ever ready to throw off the yoke of the Church. In *Notre-Dame de Paris*, Victor Hugo was the first to state this completely erroneous idea: "The architectural book no longer belonged to the priesthood, to religion, to Rome: it belonged to the imagination, to poetry, to the people. . . . At that time, a privilege comparable to our freedom of the press existed for thought written in stone: architecture had freedom and this freedom was far reaching. Sometimes a portal, a façade, or an entire church presented a symbolic meaning that was absolutely foreign to the cult, or was even opposed to the Church. . . . Under the pretext of building churches, art was developing in magnificent proportions."

In 1832, when Victor Hugo wrote these lines, notions about medieval iconography were dim and confused; but thirty years later there was less excuse for Viollet-le-Duc to uphold the same paradox. In the article on sculpture in his *Dictionnaire*, he repeated Victor Hugo's idea. "In the life of the towns," he said, "where the state of the body politic was far from perfect, art became, if I may use the expression, *a kind of freedom of the press*,[8] an outlet for minds always ready to react against abuses of the feudal state. Civil society saw art as an open register in which it might boldly record all its thoughts under the cloak of religion. We do not claim that this was deliberate; it was instinctive. . . . If we closely examine the lay sculpture of the thirteenth century, studying even its smallest details, we will discover something quite other than religious feeling. What we will find there is, first of all, the artists' pronounced democratic feeling in their manner of treating the given programs (?), a hatred of the oppression that was everywhere around them, and what was nobler and created an art worthy of the name, the disengagement of their minds from theological and feudal fetters. Observe the heads decorating the portals of Notre-Dame. What do we see? The imprint of the mind, and of moral prudence in all its forms. The expression on one

face is pensive and stern; on another, we see a trace of irony in the tightly closed lips. And the meditative expressions of the prophets on the Portal of the Virgin present a puzzling problem. Several faces, animated by unquestioning faith, have the features of illuminati; but many more express a doubt, pose a question and meditate upon it."[9]

After the long preceding study, we think we have the right to call Viollet-le-Duc's theory false, for it is not supported by a single fact.

No. The artists of the Middle Ages were neither rebels nor "thinkers," nor precursors of the Revolution.[10] Nor is it necessary any longer to present them as such in order to interest the public in their work. It is enough to show them as they really were: simple, modest, sincere. To us, they are more pleasing that way. They were docile interpreters of a great body of thought; they put all of their genius into understanding it. They were rarely permitted to invent; the Church gave over to their fancy only purely decorative work. But there, it was possible for their creative powers to have free play; to decorate the house of God, they wove for it a crown of all living things. Plants, animals, all the beautiful creatures that arouse curiosity and tenderness in children and in the people came to life under their hands. Through them, the cathedral became a living being, a gigantic tree sheltering birds and flowers. It is more like a work of nature than of man.

III

The cathedral as a work of faith and love.

The entire cathedral expresses certitude and faith, not doubt. Even today, cathedrals emanate serenity, however little we may expose ourselves to it.

Let us forget for an hour our concerns and our theories and approach the cathedral. From afar, its transepts, its spires, and its towers make it seem a great ship ready to set sail. The whole city could safely embark in its mighty hull.

Let us go closer. On the porch, we meet first Christ, as every man meets him when he comes into this world. He is the key to the enigma of life. Around him are written the answers to all of our questions. We learn how the world began and how it will end; the statues, each a symbol of an epoch of the world, measure its duration. All the men whose history we should know are placed before our eyes; there are those who were prototypes of Christ under both the Old and the New Law, for existence as men depends on the degree of participation in the nature of the Saviour; others—emperors, kings, conquerors, philosophers—are names only, unreal shadows. Thus are the world and the history of the world made clear to us.

But our own history is written alongside that of this vast universe. We learn from it that our life is a struggle—a struggle against nature during every month of the year, a struggle against ourselves at every instant, an eternal psychomachy. From the depths of the heavens, angels proffer crowns to those who have fought the battle well.

Is there room here for doubt, or only for some spiritual anxiety?

Let us enter the cathedral. The sublimity of the great vertical lines have an effect first upon the spirit. It is impossible to enter the great nave of Amiens Cathedral without feeling purified. By its beauty alone, the church functions as a sacrament. There also we find an image of the world. Like plains and forests, the cathedral has its own atmosphere, its own fragrance, its light, chiaroscuro and shadows. During the evening hours, the great rose window on the side of the setting sun seems to be the sun itself, about to disappear at the edge of a miraculous forest. But this is a transfigured world in which the light is more brilliant than the light of reality and the shadows more mysterious. Already we feel that we are at the center of the Heavenly Jerusalem,[11] the eternal city. Profound peace descends on us; the clamor of life falls back from the walls of the sanctuary and becomes a far-off murmur: this is indeed the indestructible ark against which no winds prevail. No other place in the world has ever filled man with a greater sense of security.

How much more keenly must the men of the Middle Ages have felt what we feel, even today. For them, the cathedral was a total revelation. Speech, music, the living drama of the Mystery plays, the immobile drama of the statues, all of the arts were combined there. It was something more than art; it was pure light, light before it had been refracted into multiple rays. Man, closed within a social class or within a métier, distracted, worn down by work and life, could there regain a feeling of unity with nature, again find equilibrium and harmony. The throng that assembled on great feast days felt that it was itself the living unity; it became the mystical body of Christ whose soul merged with his soul. The faithful were humanity, the cathedral was the world, and the spirit of God filled both man and all creation. The words of St. Paul became reality: man moved and had his being in God. This is what the men of the Middle Ages dimly felt as they stood shoulder to shoulder on the fine day of Christmas or of Easter, when the entire city filled the immense church.

A symbol of faith, the cathedral was also a symbol of love. Everyone worked to build it. The people offered what they had: their strong arms. They pulled the carts or carried the stones on their shoulders. They had all the good will of the giant St. Christopher.[12] The bourgeois gave his money, the baron his land, the artist his talent. During more than two

centuries, all the vital forces of France collaborated; from this comes the living power radiating from these eternal works. Even the dead joined with the living; the cathedral was paved with tomb slabs; former generations, with hands clasped on their tombstones, continued to pray in the ancient church. The past and the present were united in the same feeling of love. The cathedral was the conscience of the city.

We have only to compare the art of the Middle Ages with the art of following centuries, the sixteenth and the seventeenth, to feel its true grandeur. On the one hand, we have a national art born of the collective thought and will; on the other, an imported art with no deep roots. Of what interest to the people were Jupiter, Mars, Hercules, the heroes of Greece and Rome, the twelve Caesars who had taken the places of the twelve apostles? The simple people wanted to see St. James with his pilgrim staff, and St. Anne with her keys hung from her waist like a good housewife, teaching the child Mary to read. And what were they shown? Mercury with his caduceus, Ceres and Proserpine. Moreover, these refined works were not made for the people, but for a rich financier or for the terrace of a royal château. Maecenases and art-fanciers appeared; art was put to the service of individual caprice.

In the thirteenth century, rich and poor enjoyed the same art. The people were not on one side, and a class of so-called connoisseurs on the other. The church was everyone's house; art translated the thoughts of all. If our sixteenth- and seventeenth-century art tells us little about the most serious concerns of the France of that time, our art of the thirteenth century, on the contrary, fully expresses a civilization and an age of history. The cathedral can take the place of all the books of the time.

And it is not only the genius of Christianity, but the genius of France that bursts forth here. The ideas embodied in our cathedrals did not belong to us alone, it is true. They were the common patrimony of Catholic Europe. But France can be recognized in them by her passion for the universal. She alone was able to make of the cathedral an image of the world, a summary of history, and a mirror of moral life. What was germane to France was the admirable order imposed upon a multitude of ideas, as if by a higher law. The other cathedrals of the Christian world, all erected later than ours, were incapable of saying so many things and saying them in so beautifully ordered a way. There is nothing in Italy, Spain, Germany, or England that can be compared with Chartres Cathedral. Nowhere do we find such richness of thought. If we think of all that religious wars, bad taste, and revolutions have destroyed in our cathedrals, even rich Italy will seem poor.[13]

When shall we understand that, in the domain of art, France has never created anything greater?

APPENDIX

List of Principal Work Illustrating the
Life of Christ (End of the Twelfth Century,
Thirteenth and Fourteenth Centuries)

NOTRE-DAME OF PARIS

—North portal. There we see the sculptured cycle of the Infancy from the Nativity to the Flight into Egypt (thirteenth century).

—Sculptures of the choir enclosure. Very typical Gospel series. Lacks part of the Passion, which has been destroyed. We see: the Visitation, the Annunciation to the Shepherds, the Adoration of the Magi, the Massacre of the Innocents, the Flight into Egypt, the Presentation in the Temple, Christ among the Doctors, the Baptism of Christ, the Marriage at Cana, the Entry into Jerusalem, the Last Supper, the Washing of Feet, the Garden of Olives (lacuna), the *Noli me tangere*, Christ and the Three Marys, Christ Appearing to Saint Peter, the Disciples at Emmaus, [Christ] Appearing on Easter evening, the Doubting Thomas, the Miraculous Draught of the Fish, Christ Appearing Twice to the Apostles (end of thirteenth and fourteenth century).

SAINTE-CHAPELLE

—In the Sainte-Chapelle, where all of the Old Testament is recounted, there are only two windows devoted to Christ. These are, as usual, the window of the Infancy (the story of Saint John the Evangelist completes the window) and the window of the Passion (on the axis: thirteenth century).

CHARTRES

—On the old portal, historiated capitals show us the life of Christ represented according to the formula which we have indicated: the Infancy (Nativity, Annunciation to the Shepherds, Adoration of the Magi, Flight into Egypt, Massacre of the Innocents, Circumcision, Christ and the Doctors).—The Public Life (Baptism, Temptation).—The Passion (Entry into Jerusalem, Last Supper, Washing of Feet, Christ in the Garden of Olives, Entombment, the Holy Women at the Tomb, the Pilgrims at Emmaüs, Christ Appearing to the Apostles). Some capitals have been transposed (twelfth century).

—Windows devoted to the life of Christ over the west portal. There we see the usual scenes. In the first: the Annunciation, the Visitation, the Nativity, the Annunciation to the Shepherds, the Adoration of the Magi, the Massacre of the Innocents, the Presentation, the Flight into Egypt, the Baptism, the Entry into Jerusalem.

In the second: the Transfiguration, the Last Supper, the Washing of Feet, the Betrayal, the Flagellation, the Crucifixion, the Entombment, the Resurrection, [Christ] Appearing to the Magdalene, to the disciples at Emmaus (twelfth century).

—A window of the ambulatory of the choir devoted to the Virgin shows, further, the Miracle at Cana and the Transfiguration (thirteenth century).

BOURGES

—The window of the Passion, from the Entry into Jerusalem to the Descent into Limbo and the Resurrection (thirteenth century).

—Sculptures of the choir screen. These were devoted to the Passion, to the Resurrection, to the Descent into Hell, as is proven by the beautiful fragments preserved at the Louvre and in the Museum in Bourges (thirteenth century).

TOURS

—Infancy window, representing both the Tree of Jesse and scenes of the infancy of Christ (Annunciation, Visitation, Nativity, Annunciation to the Shepherds, Adoration of the Magi, Massacre of the Innocents, Flight into Egypt; thirteenth century).

—Passion window (Entry into Jerusalem, the Last Supper, the Kiss of Judas, the Flagellation, the Carrying of the Cross, Christ on the Cross, Entombment, Limbo, Holy Women at the Tomb, *Noli me tangere*; thirteenth century).

These two windows were published by Marchand and Bourassé: *Verrières du choeur de Tours*, VII and VIII. The two following, which are found in the apsidal chapel on the axis of the church, have not been published:

—Infancy window (Annunciation, Visitation, Nativity, the Angel and the Shepherds, the Journey of the Magi, Presentation in the Temple, Departure of the Magi, Massacre of the Innocents, Flight into Egypt; thirteenth century).

—Passion window (Last Supper, Washing of Feet, Garden of Olives, Flagellation, Christ before Pilate, [Christ] Bearing the Cross, the Crucifixion, Christ Rising from the Tomb, *Noli me tangere*, Pilgrims at Emmaus, the Doubting Thomas, *Pasce oves* ["Feed my sheep," John 21:17], thirteenth century).

SENS

—Infancy window (Nativity, Annunciation to the Shepherds, Flight into Egypt; thirteenth century).

—Passion window (from the Entry into Egypt to the Ascension; thirteenth century).

LAON

—Infancy window (in the chevet: all of the Infancy of Christ to the Flight into Egypt, with several Old Testament figures relating to the Virgin; thirteenth century).

—Passion window (in the chevet: from the Entry into Jerusalem to the Ascension; thirteenth century).

ROUEN (CATHEDRAL)

—Passion window (from the Last Supper). Published by Cahier, *Vitraux de Bourges*, plan XII (thirteenth century).

CHALONS-SUR-MARNE

—In the Cathedral. Window (since displaced) containing both the Infancy (three scenes) and the Passion (a single scene) (thirteenth century). Published by Cahier, *Vitraux de Bourges*, plan XII.

—At Notre-Dame (choir, north chapel). A window of the thirteenth century is devoted to the Infancy (Nativity, Flight into Egypt, the Magi).

—In the Cathedral. Infancy window (Annunciation, Magi, Presentation; thirteenth century).

—At Saint-Urbain. Window devoted to the Passion from the Entry into Jerusalem (fourteenth century).

REIMS (CATHEDRAL)

—Passion window (in the apse). Christ on the Cross, and, above, in the seven compartments of a rose [window], seven episodes of the Passion (thirteenth century).

—Sculptures of the façade (archivolts of the left portal, gable and buttress). We see: the Temptation, the Entry into Jerusalem, the Washing of Feet, the Garden of Olives, the Kiss of Judas, the Flagellation, Christ on the Cross (in the gable), Limbo, the Disciples at Emmaus (thirteenth century).

—Interior sculptures (same portal). We have seen that by a unique circumstance of which there is no other instance in the Middle Ages, these sculptures show Christ and the Samaritan, and, in several scenes, Christ healing Saint Peter's mother-in-law. We have put forth the idea that these sculptures might have been copied after an antique sarcophagus. Christ, in fact, is shown beardless (thirteenth century).

BEAUVAIS

—Infancy window (in the Chapel of the Virgin). We see: the Annunciation, the Visitation, the Nativity, the Shepherds, the Magi, the Presentation in the Temple, the Massacre of the Innocents, the Flight into Egypt, the Fall of the Idols (thirteenth century). The panel which shows the Marriage of the Virgin is modern.

AMIENS

—In the chapel of the Virgin, two windows of the thirteenth century were devoted to the Infancy and the Passion of Christ, but these windows have been so very much restored that they have practically no archeological value.

CLERMONT-FERRAND

—In a chapel of the choir (fifth chapel on the right, today called chapel of la Bonne Mort, graced with thirteenth-century windows, we see the Infancy of Christ and the entire Passion beginning with the Last Supper. A panel showing Saint Peter crucified upside-down has been added to this window as a result of restoration.

BAYEUX

—The left portal of the cathedral (western façade) shows, in the tympanum, all of the Passion beginning with the Last Supper and the Washing of Feet (fourteenth century).

DOL

—The great window which fills the chevet has highly varied scenes borrowed from the Old Testament, and from the *Golden Legend*. Two compartments are devoted, one to the Infancy (Annunciation, Nativity, Shepherds, Magi), the other to the Passion (Entry into Jerusalem, Last Supper, all of the Passion from the Flagellation, to the Descent from the Cross, Holy Women at the Tomb, *Noli me tangere*; thirteenth century).

—The façade of Strasbourg shows the Infancy of Christ on the tympanum of the left portal, and on the tympanum of the central portal, the whole Passion from the Entry into Jerusalem to the Ascension. All these figures, mutilated during the time of the Revolution, have been restored but according to old drawings.

—The south aisle preserves a series of large windows illustrating the life of Christ. There we see not only the Infancy and the Passion of Christ, but also his public life and his miracles. To tell the truth, this Life of Christ, which would become so rare in the thirteenth century, no longer belongs to the period with which we are concerned. The Strasbourg windows are of the last years of the fourteenth century. They already begin to be free of the old discipline.

ANGERS

—Infancy window. Passion window (thirteenth century).

LE MANS

—Passion window. Infancy window.

LE BOURGET (SAVOIE)

—Passion of Christ from the Entry into Jerusalem (sculptures of the thirteenth century).

IN THE WORKS of decorative art, the same principles are applied. The life of Christ is summarized in several typical scenes which are precisely those which we have indicated. The famous reliquary of Aix-la-Chapelle, or Reliquary of the Great Relics (thirteenth century), shows: the Annunciation, the Visitation, the Nativity, the Annunciation to the Shepherds, the Magi, the Presentation in the Temple, the Baptism, the Temptation, the Last Supper, the Crucifixion, the Descent from the Cross, the Entombment.

—Several crosses of wood, carved in the twelfth century: cross of Saint-Gibrien, of Saint-Gauthier, of Saint-Aubin, showing the Life of Christ with many details. But there we find nothing but traditional scenes. (See *Congrès Archéologique*, Reims, 1861, p. 160.) These scenes are the following: Annunciation, Visitation, Nativity, Journey of the Magi, Adoration of the Magi, the Angel and the Magi, Presentation in the Temple, Massacre of the Innocents, Flight into Egypt, Baptism of Christ, Temptation, Entry into Jerusalem, Washing of Feet, Last Supper, Garden of Olives, Flagellation, Bearing of the Cross, Crucifixion, Entombment, Resurrection, Limbo, [Christ] appearing to the Holy Women, appearing to the Magdalene, to the disciples at Emmaüs, [and] to Saint Thomas, Ascension, Descent of the Holy Spirit (the Epiphanies are not seen on the staff of Saint Gibrien).

—The miniaturists follow the same precept. We shall first cite a series of thirty paintings in gouache of the end of the twelfth century, preserved at Saint-Martial of Limoges, and published by the Comte de Bastard in 1879 under the title of *Histoire de Jésus-Christ en figures*. This series is very interesting for us. The artist, whom nothing constrained or limited, did not however make this a narrative work. He chose the traditional scenes of the life of Christ: scenes of the Infancy, Baptism, Temptation, Entry into Jerusalem, Last Supper, Passion, Resurrection (the Holy Women at the Tomb), the Epiphanies, the Ascension.

—As for the actual manuscripts, these generally contain, with greater or lesser

elaboration, the two cycles, the Infancy and the Passion. Let us give some examples:

Bibl. Nat., ms. lat. 9428 (ninth century). Sacramentary of Drogo, the cycles of the Infancy and of the Passion and, in addition, the Temptation corresponding to Lent (fol. 41).

Bibl. Nat., ms. lat. 17325 (ninth century). Gospels for various feasts. The two cycles.

Bibl. Nat., ms. lat. 17961 (twelfth century). Psalter. The Infancy. The Public Life (Baptism). The Passion (Kiss of Judas).

Bibl. Nat., ms. lat. 833 (twelfth century). Missal. The two cycles.

Bibl. Nat., ms. lat. 1073 (twelfth century). Psalter. The two cycles.

Bibl. Nat., ms. lat. 1328 (twelfth century). Psalter. Cycle of the Infancy.

Bibl. Nat., ms. lat. 1077 (thirteenth century). Psalter. The two cycles.

Bibl. Nat., ms. lat. 10434 (thirteenth century). Psalter. Infancy. Passion.

Bibl. Nat., ms. fr. 183 (thirteenth century). Légende dorée. The two cycles.

Bibl. Nat., ms. fr. 185 (fourteenth century). Légende dorée. The two cycles.

Bibl. Nat., ms. lat. 10484 (fourteenth century). Belleville Breviary. The two cycles.

Bibl. Nat., ms. lat. 1394 (fourteenth century). Psalter. Cycle of the Infancy.

Bibl. Mazarine, 414 (twelfth century). Missal. Annunciation. Resurrection. Ascension. Descent of the Holy Spirit.

Bibl. Mazarine, 416 (fourteenth century). Missal. Cycle of the Infancy and of the Passion.

Bibl. Mazarine, 419 (fourteenth century). Missal. The two cycles.

Bibl. Mazarine, 412 (fifteenth century). Missal of Paris. The two cycles.

Bibl. Mazarine, 420 (fifteenth century). Missal of Poitiers, one miniature for the Nativity (Christmas), one for the Resurrection (Easter).

IN CONCLUSION *Early Drawing and Illuminations* by Walter de Gray, Birch and Henry Jenner, London, 1879. The miniatures are grouped by subjects; thus, while the catalogue of the scenes from the Infancy and the Passion of Christ fills long pages, we note that the scenes of the Public Life (miracles, preaching), if not entirely lacking, are found only in a small number of manuscripts.

NOTES

PREFACE

1 Johannes Molanus, *De historia sacrarum imaginum et picturarum*. The first edition was published in 1580. Consult the edition of Louvain, 1771 with J. N. Paquot's notes. [See also E. Mâle, *L'Art religieux après le Concile de Trente*, Paris, 1932.]

2 Gobineau de Montluisant, seventeenth-century Hermetist. His treatise has been published: G. de Montluisant, "Notre-Dame de Paris," *Annales archéologiques*, 21 (1861), pp. 137-147, 210-221.

3 [C. F. Dupuis, *Origine de tous les cultes ou religion universelle*, Paris, 1795, III, pp. 48-49, Atlas, p. 13, pl. XVIII. The Virgin of the north transept portal is compared to Isis, goddess of months and the year.]

4 A. Lenoir, *Description historique et chronologique des monumens de sculpture réunis au musée des monumens français*, 6th ed. (Year x), Paris, 1802, p. 120.

5 This is especially Wilhelm Lübke's error in the chapters he devoted to the art of the Middle Ages: W. Lübke, *Geschichte der Plastik*, 2 vols., Leipzig, 1871.

6 I am not speaking of purely decorative work. I shall show (Book 1) that they have no symbolic meaning.

7 [See P. Thoby, *Le Crucifix des origines au Concile de Trente*, Nantes and Paris, 1959 (Supplement, 1963).]

8 A. N. Didron, *Iconographie chrétienne; Histoire de Dieu*, Paris, 1843. [Engl. ed.: Didron, *Christian Iconography*, tr. E. J. Millington, 2 vols., London, 1851 (repr. New York, 1965).]

9 H.L.G. de Saint-Laurent, *Guide de l'art chrétien*, 6 vols., Paris, 1872-1875.

10 However, the following studies have been made: A. Crosnier, *Iconographie chrétienne*, Paris, 1848; J.-B.-E. Pascal, *Institutions de l'art chrétien*, 2 vols., Paris, 1856; X. Barbier de Montault, *Traité d'iconographie chrétienne*, 2 vols., Paris, 1890. Foreign studies: the treatise on iconography by Detzel is worth mention: H. Detzel, *Christliche Ikonographie*, 2 vols., Freiburg-im-Breisgau, 1894-1896. We also cite the good summary by F. X. Kraus, *Geschichte der christliche Kunst*, Freiburg-im-Breisgau, 1908, II, pp. 263ff. In all these works, the works of art are rarely placed in relation to medieval theological and liturgical texts, and to legends.

11 The *Congrès archéologiques de France* should be added to the collection of the *Bulletin monumental*.

12 C. Cahier and A. Martin, *Mélanges d'archéologie, d'histoire et de littérature*, 4 vols., Paris, 1847-1856, and *idem*, *Nouveaux mélanges d'archéologie et d'histoire sur le moyen âge*, 4 vols., Paris, 1874-1877.

13 *Idem, Monographie de la cathédrale de Bourges*, pt. I. *Vitraux du XIIIe siècle*, 2 vols., Paris, 1841-1844.

14 C. Cahier, *Caractéristiques des saints dans l'art populaire*, 2 vols., Paris, 1866-1868.

15 R. de Lasteyrie and E. Lefèvre-Pontalis, *Bibliographie générale des travaux historiques et archéologiques publiés par les sociétés savantes*, 6 vols., Paris, 1888-1918. Included are the tables of contents of the *Bulletin monumental* and of the *Congrès archéologique de France*. [Contents of the publications of local antiquarian societies are now regularly listed in the *Revue d'histoire de l'église de France*. Publication was begun in 1910, suspended 1915-1919; except for July/Sept., 1939, there has since been continuous publication. For the *Bulletin monumental* and *Congrès archéologique*, see the index volumes published in 1926 and 1954.]

16 It should be supplemented by the collection of the Rue de Valois (Commission des monuments historiques).

17 The collection made by Martin-Sabon should be added to these. [See also F. R. de Gaignières, *Les Dessins d'archéologie de Roger de Gaignières*, ed. J. Guibert, 3rd ser., 8 vols., Paris, 1911-1914.]

18 F. de Lasteyrie, *Histoire de la peinture sur verre d'après ses monumens en France*, 2 vols., Paris, 1853-1857. [A comprehensive survey of western European stained glass, *Corpus vitraearum medii aevi*, is now in progress.]

19 J. Marchand and J.-J. Bourrassé, *Verrières du choeur de l'église métropolitaine de Tours*, Paris, 1849.

20 E. Hucher, *Vitraux peints de la cathédrale du Mans*, Paris and Le Mans, 1865.

21 A. de Florival and E. Midoux, *Les Vitraux de la cathédrale de Laon*, 2 vols., Paris, 1882-1891.

22 Y. Delaporte and E. Houvet, *Les Vitraux de la cathédrale de Chartres*, 4 vols., Chartres, 1926.

23 It has not been published; it can be consulted under the title *Nouvelles acquisitions françaises 5813, 5814, 5815*. The very brief catalogue of illuminated manuscripts in the Bibliothèque Nationale made by the Comte de Bastard should be mentioned. It also is unpublished: Paris, Bibl. Nat., *Nouvelles acquisitions françaises 5811-5812*. [See P. Lauer, *Les Enluminures romanes des manuscrits de la Bibliothèque nationale*, Paris, 1927. The catalogue of Latin manuscripts of the Bibliothèque Nationale is in progress: Paris, Bibl., Nat., *Catalogue général des manuscrits latins*, ed. P. Lauer, 4 vols., Paris, 1939-1953.]

24 See the study by Léopold Delisle on illustrated books: L. Delisle, "Livres d'images," *Histoire littéraire de la France*, 31 (1893), pp. 213-285. He attempts to designate groups of manuscripts with miniatures. See also G. Vitzthum, *Die Pariser Miniaturmalerei*, Leipzig, 1907.

25 [Recent restorations have been regularly reported in the periodical, *Les Monuments historiques de la France* (Bulletin trimestriel publié par la Caisse Nationale des Monuments Historiques), Paris, since 1936 (publication suspended 1940-1954).]

INTRODUCTION, CHAPTER I

1 F. Piper wrote a book with this title, but we do not find in it what we are led to expect: F. Piper, *Einleitung in die monumentale Theologie*, Gotha, 1867. Although the author reviewed all the theological writers of the Middle Ages and the Renaissance, he did not deal with his true subject, the probable effect of their books on art. This is also the weakness of another work, otherwise interesting in many ways, by J. Sauer, *Symbolik des Kirchengebäudes und seiner Ausstattung in der Auffassung*

des Mittelalters, Freiburg-im-Breisgau, 1924.

2 As we have said, it is not our intention to write a history of the nimbus, or of the other attributes to be mentioned in this chapter. Most of them go back to Early Christian antiquity, and some, such as the nimbus, even to pagan times. This question has been studied by Didron, *Iconographie chrétienne; Histoire de Dieu*, pp. 25-170. [Cf. M. Collinet-Guérin, *Histoire du nimbe des origines aux temps modernes*, Paris, 1961.]

3 All these signs were used constantly in stained glass. [See also J. Baltrušaitis, "Villes sur arcatures," *Urbanisme et architecture; Etudes écrites et publiées en l'honneur de Pierre Lavedan*, Paris, 1954, pp. 31-40; W. Müller, *Die heilige Stadt*, Stuttgart, 1961, pp. 53-68.]

4 The word hieroglyph will no doubt not seem too strong if we recall that the evangelists were sometimes represented as men with the head of the ox, the eagle, and the lion (capital in the cloister at Moissac). In this, medieval art is linked with the art of ancient Egypt, and perhaps even derives from it through the intermediary of the Christian art of Alexandria. [See R. Crozet, "Les premières représentations anthropozoomorphiques des évangélistes (VIe-IXe siècles)," *Etudes mérovingiennes*, Paris, 1953, pp. 53-63; *idem*, "Les quatre évangélistes et leur symboles, assimilations et adaptations," *Les Cahiers techniques de l'art*, 4 (1962), pp. 5-26; and Z. Ameisenowa, "Animal-Headed Gods, Evangelists, Saints and Righteous Men," *Journal of the Warburg and Courtauld Institutes*, 12 (1949), pp. 21-45.]

5 This was very probably the headdress worn by the Jew in the Middle Ages. [See B. Blumenkranz, *Le Juif médiéval au miroir de l'art chrétien*, Paris, 1966, pp. 44-45, 103; and G. Kisch, "The Yellow Badge in History," *Historia Judaica*, 19 (1957), pp. 95-122, 133, 141.]

6 On the representations of the Last Supper, see J. de Laurière, "Chronique," *Bulletin monumental*, 47 (1881), pp. 312-314. [Cf. K. Möller, "Abendmahl," *Reallexikon zur deutschen Kunstgeschichte*, ed. O. Schmitt, Stuttgart, 1937, I, cols. 28-41; and G. Schiller, *Ikonographie der christlichen Kunst*,

Gütersloh, 1968, II, pp. 35ff. (Engl. ed., Greenwich, Conn., 1971).]

7 [See Thoby, *Le Crucifix des origines au Concile de Trente*, pp. 35, 75, 125, 157; and Schiller, *op. cit.*, II, pp. 98ff.]

8 St. Modeste's statue is on the north porch (exterior); St. Martin's on the south porch (right portal). [See E. Houvet, *Cathédrale de Chartres; Portail sud*, Chelles, 1919, I, pls. 15, 42.]

9 *Summa theologica, supplementum tertiae partis, Quaest.* 96 [Ottawa ed., 473b-491a. References to the *Summa theologica* will be cited from the recent edition published by the Institute of Medieval Studies of Ottawa, Canada, 1941-1953. An English translation, with the Latin text and thorough annotation is in the process of publication under the editorship of Thomas Gilby, O.P., by McGraw-Hill, New York City.] See also: Vincent of Beauvais, *Speculum historiale*, I, xxi, [Graz ed., IV.20. References to the *Speculum maius* of Vincent of Beauvais will be cited from the facsimile edition of the 1624 Douai edition: Vincentius Bellovacensis, *Speculum quadruplex sive Speculum maius*, 4 vols., Graz, 1964.]

10 William Durandus, *Rationale divinorum officiorum*, I, iii, Lyon, 1672. [Cf. ed. V. d'Avino, Naples, 1859, pp. 22-27; and tr. and ed. C. Barthélemy, *Rational ou Manuel des divins offices de Guillaume Durand*, 5 vols., Paris, 1854. The first book of Durandus' *Rationale* has been translated into English: William Durandus, *The Symbolism of Churches and of Church Ornaments*, tr. and ed. by J. M. Neale and B. Webb, Leeds, 1843; and into French: *Du Symbolisme dans les églises du moyen âge*, ed. with introd. by J.-J. Bourassé. Tours, 1847.]

11 "Κατ' ἀνατολὰς τετραμμένος (οἶκος)," *Constitutiones apostolicae*, II, lvii, Migne, *P. G.*, I, col. 724. [See C. Vogel, "Sol Aequinoctialis: Problèmes et technique de l'orientation dans la culte chrétien," *Revue des sciences religieuses*, July-Dec., 1962, pp. 175-211.]

12 William Durandus, *Rationale*, I, i, viii. [Cf. Engl. ed. Neale and Webb, p. 21; Fr. ed. Barthélemy, I, p. 16; ed. d'Avino, p. 13.]

13 This was scrupulously carried out at Chartres. The heroes of the Old Law are carved on the north porch, those of the New Law on the south porch. At Notre-Dame of Paris, the great north rose window is devoted to the Old Testament, and that of the south to the New Testament. At Reims, the north rose (damaged) still contains scenes from the Old Testament (Creation, Adam, Cain, Abel, etc.); the south window (restored in the sixteenth century, but no doubt on the model of the old window) is filled with the story of Christ and his apostles.

This practice was still followed, curiously enough, in the fifteenth century. The north windows of St.-Ouen, at Rouen, and of St.-Serge, at Angers, represent the prophets, and the south windows the apostles. This practice was also followed in the Eastern Church. In the monastery of Salamis, the Old Testament is at the left, that is, the north; the New at the right, the south. See A. N. Didron, *Manuel d'iconographie chrétienne grecque et latine avec une introduction et des notes, traduit du manuscrit byzantin, Le guide de la peinture, par le Dr. Paul Durand*, Paris, 1845, p. xi. On the subject of the symbolism of the north and south, see especially William Durandus, *Rationale*, IV, xxiii-xxiv, [ed. d'Avino, pp. 195-205 and ed. Barthélemy, II, pp. 128-152] and Rabanus Maurus, *De Universo, IX, Prologus*, "Auster sancta Ecclesia est fidei calore accensa," Migne, *P. L.*, 3, col. 261.

14 We would have to cite the west portals of almost all of our great cathedrals, and some west rose windows (rose window of Chartres, for example).

15 *Hortus deliciarum*, by Herrad of Landsberg; see A. Le Noble, "Notice sur le Hortus deliciarum," *Bibliothèque de l'Ecole des Chartes*, I (1839-1840), p. 246. As early as the Carolingian period, the *Carmina Sangallensia* placed the Last Judgment at the west; see J. von Schlosser, *Schriftquellen zur Geschichte der karolingischen Kunst*, Vienna, 1892, p. 328.

16 [Psalm 44:10 (Vulgate); 45:9 (King James Version).]

17 Hermas, *Vision* III, i. Latin text (*Pastor*) in Migne, *P. G.*, 2, cols. 899-900. Greek text given in C. Tischendorf, *Bibliorum Codex Sinaiticus Petropolitanus*, IV. *Novum Testamentum cum Barnaba et Pastore*, St. Petersburg, 1862, fols. 142r-148v. [Presently

in London, Brit. Mus., Add. ms. 43725.] The Middle Ages knew the Latin version of Hermas' *Shepherd* which, until the fifteenth century, was sometimes included in the Bible, at the end of the New Testament. [See *The Apostolic Fathers* (Loeb Classical Library, II), tr. and ed. K. Lake, London and New York, 1913, II, pp. 28-29; and R. Joly, tr. and ed., "Le Pasteur Hermas," *Sources chrétiennes*, 53 (1958), pp. 99-113. For the *Shepherd* in relation to the Gospel apocrypha, see E. Hennecke, *New Testament Apocrypha*, eds. W. Schneemelcher and R. McL. Wilson, Philadelphia, 1965, II, pp. 629-642, with critical bibl.]

18 See especially Peter Damian, *Opuscula varia*, xxxv, Migne, *P. L.*, 154, col. 589.

19 There are several exceptions that confirm the rule. On the principal portal of Amiens Cathedral, for example, it is Paul who is at Christ's right, and Peter at his left; such an arrangement takes us back to Early Christian art. In early times, Paul was sometimes placed at the right and Peter to the left to show that the Gentiles had replaced the synagogue. This is an explanation given by Peter Damian in the eleventh century, in the treatise he wrote on representations of the Princes of the Apostles (Migne, *P. L.*, 154, cols. 589-596). He said that Paul had placed the multitude of Gentiles at God's right. Moreover, he said, Paul belonged to the tribe of Benjamin, and Benjamin means "son of the right." The papal bull which represented Paul at the right and Peter at the left of the cross perpetuated the ancient doctrine. [Cf. F. Cabrol and H. Leclercq, eds., "Pierre," *Dictionnaire d'archéologie chrétienne et de liturgie*, Paris, 1939, XIV, pt. 1, cols. 964-968.]

20 However, at Notre-Dame, the confessors are placed before the martyrs.

21 See M. J. Bulteau, *Monographie de la cathédrale de Chartres*, Chartres, 1891, II, p. 358. This excellent monograph is in three volumes. Bulteau had already published a complete study of the cathedral of Chartres in a single volume: *Description de la cathédrale de Chartres*, Chartres, 1850. [Cf. A. Katzenellenbogen, *The Sculptural Programs of Chartres Cathedral*, Baltimore, 1959, pp. 79ff. and figs. 74-75.]

22 Dante, moreover, placed Dionysius the Areopagite in paradise, Canto X, vv. 115-117. [See *La Divina Commedia or The Vision of Dante in Italian and English*, ed. M. Casella and tr. H. R. Cary, London, 1927, p. 249. The authorship of this and related treatises by Dionysius the Areopagite has been rejected and the treatises identified as the work of an early sixth-century Dionysius, hence surnamed the Pseudo-Areopagite. For the text of the *Celestial Hierarchy*, see Migne, *P. L.*, 122, cols. 1023-1194. Cf. C. E. Rolt, *Dionysius the Areopagite on the Divine Names and the Mystic Theology*, London and New York, 1940.]

23 John the Scot (Erigena), *Sanctus Dionysius Areopagite, De coelesti ierarchia*, Migne, *P. L.*, 122, cols. 1037-1070. Hugh of St. Victor, *Exegeticorum genuinorum, pars secunda, Commentariorum in Hierarchiam coelestem S. Dionysii Areopagite*, x, i-x, Migne, *P. L.*, 175, cols. 923-1151.

24 Bulteau, *Monographie de Chartres*, II, pp. 313ff., adopted a somewhat different order, but it is clear that he was mistaken. For instance, the figure armed with lance and shield and trampling on the dragon obviously represents the order of archangels and not Virtues.

25 Rabanus Maurus, *De universo*, I, v, Migne, *P. L.*, III, col. 29: *Et ideo quantum vicinius (angeli) coram Deo consistunt, tanto magis claritate divini luminis inflammantur.*

26 On the north portal; this is the Virgin of the Visitation.

27 West façade, portal of the Coronation of the Virgin. On the socles of this portal, see Cahier and Martin, *Nouveaux mélanges d'archéologie, d'histoire et de littérature sur le moyen âge*, II, pp. 237-245; A. Duchalais, "Explication de quelques basreliefs de la cathédrale de Paris," *Mémoires de la Société royale des antiquaires de France*, 16 (1842), pp. 190-206. [M. Aubert, *Notre-Dame de Paris; architecture et sculpture*, Paris, 1928, pl. 36.]

28 On this concordance, see the *Commentarii in Genesim*, I, attributed to St. Eucherius, Migne, *P. L.*, 50, col. 923; and Isidore of Seville, *Liber numerorum qui in sanctis scripturis occurrunt*, XIII, Migne, *P. L.*, 83, col. 192. The windows of the cathedral of Lyon place in correspondence the apostles, the prophets, and the patriarchs (two patri-

archs are missing). There is a reproduction of three prophets in L. Bégule and M.-C. Guigue, *Monographie de la cathédrale de Lyon*, Lyon, 1880, p. 142.

29 A fresco of the late tenth century, in the church of S. Sebastiano-in-Pallara, in Rome, shows the twelve prophets carrying on their shoulders the twelve apostles. I have dealt with this subject in *Rome et ses vieilles églises*, Paris, 1942, p. 157. [Cf. Engl. tr. by D. Truxton, *The Early Churches of Rome*, London, 1960, p. 209 and fig. 69.] A similar theme was carved on the portal of the cathedral of Bamberg, under French influence. [See E. Panofsky, *Die deutsche Plastik des elften bis dreizehnten Jahrhunderts*, Munich, 1924, pls. 80-81, 83.]

30 Window in the apse of the cathedral of Auxerre: in equal number the Arts are shown in one rose window and the Virtues in another.

31 St. Augustine, *De libero arbitrio*, II, xvi, Migne, *P. L.*, 32, col. 1263. [See St. Augustine, *On Free Choice of Will*, tr. by A. S. Benjamin and L. H. Hackstaff, Indianapolis, 1964, pp. 63-65 and 72-75; and *De libero arbitrio*, ed. W. M. Green, *Corpus scriptorum ecclesiasticorum latinorum*, Vienna, 1956, LXXIV, p. 41.]

32 St. Augustine, *loc. cit.*

33 St. Augustine, *Quaestionum in Heptateuchum*, I, clii, Migne, *P. L.*, 34, col. 589. See also St. Augustine's treatise, *De musica*, the chapter, *De numeris spiritualibus et aeternis*, VI, xii, Migne, *P. L.*, 32, col. 1181. [See: *Quaestionum in Heptateuchum, Corpus Christianorum, series latina*, Turnholt, 1963, XXXIII, pp. 58-59; and St. Augustine, *Enarrationes in Psalmos*, VI, *ibid.*, 1961, XXXVIII, p. 28; *Expositions on the Book of Psalms*, tr. A. C. Coxe, *A Select Library of Nicene and Post-Nicene Fathers of the Christian Church*, ed. P. Schaff, 1st ser., VIII, Oxford and New York, 1886 (repr. Grand Rapids, Mich., 1956); *On Music*, Engl. ed. and tr. R. C. Taliaferro (Classics of the St. John's Program), Annapolis, 1939.]

34 [See H. Bober, "In Principio. Creation Before Time," *De Artibus Opuscula XL, Essays in Honor of Erwin Panofsky*, New York, 1961, pp. 13-28.]

35 St. Eucherius, Migne, *P. L.*, 50, cols. 727-772; Isidore of Seville, *ibid.*, 83, cols. 179-200; Rabanus Maurus, *ibid.*, 177, cols. 469-899.

36 [See H. Bober, "An Illustrated Medieval School-Book of Bede's 'De Rerum Natura,'" *Journal of the Walters Art Gallery*, 19-20 (1956/1957), pp. 65-97; and cf. V. F. Hopper, *Medieval Number Symbolism*, New York, 1938; E. DeBruyne, *Etudes d'esthétiques médiévales*, 3 vols., Bruges, 1946; M. C. Ghyka, *Philosophie et mystique du nombre*, Paris, 1952; U. Grossmann, "Studien zur Zahlensymbolik des Frühmittelalters," *Zeitschrift für Katholische Theologie*, 76 (1954), pp. 19-54; G. Beaujouan, "Le symbolisme des nombres á l'époque romane," *Cahiers de civilisation médiévale*, 4 (1961), pp. 159-169.]

37 St. Augustine, *Enarrationes in Psalmos*, VI, Migne, *P. L.*, 36, col. 91: *Numerus ternarius ad animun pertinet, quaternarius ad corpus*, and Hugh of St. Victor, *Exegetica*, I, *In scripturam sacram, De scripturis et scriptoribus sacris*, Migne, *P. L.*, 175, col. 22.

38 On the number 12, see Rabanus Maurus, *De universo*, XVIII, iii, Migne, *P. L.*, 111, col. 492: *Item duodecim ad omnium sanctorum pertinent Sacramentum, qui, ex quatuor mundi partibus per fidem Trinitatis electi unam ex se faciunt ecclesiam . . .* (Likewise twelve refers to the sacrament of all the saints, who, chosen from the four corners of the earth through faith in the Trinity, create from among themselves the one church . . .), and Hugh of St.-Victor, *De scripturis*, Migne, *P. L.*, 175, col. 22.

39 On the number 7, see Hugh of St. Victor, *Exegetica*, I, *In scripturam sacram, Expositio moralis in Abdiam*, Migne, *P. L.*, 175, cols. 400ff. [Cf. S. Wenzel, "The Seven Deadly Sins; Some Problems of Research," *Speculum*, 43 (1968), pp. 1-22; and M. Bloomfield, *The Seven Deadly Sins*, East Lansing, Mich., 1952.]

40 Subtle and learned Italy related the planets to the seven ages of man on the capitals of the Ducal Palace at Venice, and in the frescoes in the Eremitani at Padua; W. Burger and A. N. Didron, "Iconographie du palais ducal à Venise," *Annales archéologiques*, 17 (1857), p. 196, and A. N. Didron, "Les planètes," *ibid.*, pp. 300-303.

The frescoes, the work of Guariento, belong to the fourteenth century. After birth the child is under the influence of the Moon, who governs him for four years. Then Mercury adopts him, and influences him for ten years. Venus takes the young man for seven years. The Sun then governs man for nineteen years, Mars for fifteen years, Jupiter for twelve years, and Saturn until death. All of these traditions reach back into antiquity.

41 [See C. de Tolnay, "The Music of the Universe; Notes on a Painting by Bicci di Lorenzo," *Journal of the Walters Art Gallery*, 6 (1943), pp. 83-104.]

42 On the symbolism of the seven days of creation, see Rabanus Maurus, *De universo*, x, ix, Migne, *P. L.*, 111, cols. 296-300.

43 On the symbolism of the seven hours of the office, see William Durandus, *Rationale*, v, i [ed. Barthélemy, III, pp. 1ff., and ed. d'Avino, pp. 323-325].

44 The seven tones (with the octave) are carved on the capitals from the abbey of Cluny (today in the Musée du Farinier of that city). They were probably related to the seven virtues and the seven ages of the world, if compared to some other capitals. See the two-part article by J. Pougnet, "Théorie et symbolisme: Des tons de la musique grégorienne," *Annales archéologiques*, 26 (1869), pp. 380-387 and 27 (1870), pp. 32-50, 151-175 and 287-338. [See also K. J. Conant, *Cluny; les églises et la maison du chef d'ordre*, Mâcon, 1968, pp. 87-92; and E. Mâle, *Religious Art in France: The Twelfth Century*, ed. H. Bober, tr. M. Mathews (Bollingen Series XC:1), Princeton, 1978, pp. 321-322.]

45 [Hugh of St. Victor, *De arca Noe morali* and *De arca Noe mystica*, Migne, *P. L.*, 176, cols. 617-704. Cf. Hugh of St.-Victor, "Noah's Ark," *Selected Spiritual Writings*, tr. by a Religious of C.S.M.V., New York, 1962, pp. 45-182.]

46 Honorius of Autun, *Sacramentarium*, IV, Migne, *P. L.*, 172, col. 741. The four letters of the name Adam represent as well, according to Honorius of Autun, the first four letters of the four cardinal points: *anatole* (east), *dysis* (west), *arktos* (north), *mesembria* (south). It is hardly necessary to say that Honorius of Autun was not the inventor of these combinations of numbers and letters, which go back to very ancient times. [This formulation is already found in the *De ordine creaturarum*, XI, attributed to Isidore of Seville, Migne, *P. L.*, 83, col. 942. Cf. F. Dornseiff, *Das Alphabet in Mystik und Magie*, Berlin, 1925, pp. 137-138.]

47 Walafrid of Strabo, *Glossa ordinaria, Liber Judicum*, VII, vi, Migne, *P. L.*, 113, col. 527. The same doctrine is found in St. Augustine, *Quaestionum in Heptateuchum*, VII, xxxvii, Migne, *P. L.*, 108, col. 1163; and in Rabanus Maurus, *Commentaria in Librum Judicum et Ruth*, LII, Migne, *P. L.*, 108, col. 1163.

48 The *Inferno* has thirty-four cantos, but the first can be considered as introductory. [See C. S. Singleton, *Dante Studies*, 2 vols., Cambridge, Mass., 1954-1958.]

49 Dante, *Vita nuova*: ". . . this lady was accompanied by this number nine in order to signify that she was a nine, that is, a miracle, whose root, that is, of the miracle, is only the marvelous Trinity." [C. S. Singleton, *An Essay on the Vita Nuova*, Cambridge, Mass., 1949, p. 13.]

50 [See J. Gimpel, *Les Bâtisseurs des cathédrales*, Paris, 1958. Engl. tr. by C. F. Barnes, Jr., *The Cathedral Builders*, New York, 1961, p. 134; and cf. E. Panofsky, *Gothic Architecture and Scholasticism*, Latrobe, Pa., 1951, p. 26 and fig. 1.]

51 See ed. Neale and Webb, *Du symbolisme dans les églises du moyen âge*, p. 157. [Cf. Engl. ed. Neale and Webb, pp. 17-193; ed. d'Avino, I, pp. 11-67.]

52 St. Ambrose said: *Quis autem dubitet majus esse octavae munus, quae totum renovavit hominem . . .* (Who therefore can doubt that the gift of the octave, which has renewed the whole of a person greater?) *Epistolae classis*, I, xliv, Migne, *P. L.*, 16, col. 1189. Elsewhere, he remarked that the number 8, which in the Old Law was related to the circumcision, is now related to baptism and resurrection: *In Psalmum David CXVIII, Expositio*, Migne, *P. L.*, 15, col. 1262.

53 Examples: the baptisteries of Ravenna, Novara, Cividale del Friuli, Torcello, Aix-en-Provence, Fréjus, etc. See A. Lenoir, *Architecture monastique*, 2 vols., Paris,

1852-1856. [See also R. Krautheimer, "Introduction to an 'Iconography of Medieval Architecture,'" *Studies in Early Christian, Medieval and Renaissance Art*, New York, 1969, pp. 131-141; Cabrol and Leclercq, "Baptistères," *Dictionnaire d'archéologie chrétienne*, II, 1, cols. 382ff.]

54 This poem, which seems to have been intended as an inscription for the baptistery of Milan, was published by J. Gruter, *Inscriptiones antiquae totiva orbis romani*, Amsterdam, 1707, 1166. This is the essential passage:

Octachorum Sanctos Templum surrexit inusus,
Octagonus fons est munere dignus eo,
Hoc numero decuit sacri baptismatis aulam
Surgere, quo populo vera salus rediit.
(Eight-niched soars this church destined for sacred rites,
eight corners has its font, that which befits its gift.
Meet it was thus to build this fair baptismal hall
about this sacred eight: here is our race reborn.)
[Tr. by F. van der Meer and C. Mohrmann, *Atlas of the Early Christian World*, 2nd ed., London, 1966, p. 129.]

55 See a study of medieval baptismal fonts by P. Saintenoy, "Prolégomènes à l'étude de la filiation des fonts baptismaux depuis les baptistères jusqu'au XVIe siècle," *Annales de la Société d'archéologie de Bruxelles*, 5 (1891), pp. 5-33; 243-281; 6 (1892), pp. 69-158. He studied and classified a great number of baptismal fonts from all parts of Europe, dating from the eleventh to the sixteenth century: thirty-two are round in form, but sixty-seven are octagonal; a small number have other forms. [See also F. Bond, *Fonts and Font Covers*, London, 1908.]

56 We shall return to the texts when we come to the study of all these subjects.

57 *Rationale divinorum officiorum*, VI, lxxx [ed. d'Avino, pp. 543-546; cf. ed. Barthélemy].

58 On the beautiful Exultet of the early Church, see L. Duchesne, *Origine du culte chrétien*, Paris, 1889, p. 242 [Engl. tr. M. L. McClure, *Christian Worship*, 5th ed., London and New York, 1927, pp. 252-257; the service, and subjects, e.g. the bees, etc. are illustrated in contemporary mss.; see M. Avery, *The Exultet Rolls of South Italy*, Princeton, 1936].

59 In this brief resumé of chapter v and the following chapters of book IV of the *Rationale*, we have omitted a great many details. The same doctrine is found in the other liturgists of the Middle Ages. See especially, Sicard of Cremona, *Mitrale, De officiis ecclesiasticis summa*, III, ii, Migne, *P. L.*, 213, cols. 92-102.

60 Each of the articles of the Credo is attributed to an apostle. From the fourteenth century on, the apostles were often represented carrying a scroll on which was written the article of the Credo attributed to each. [Concerning the order in which the apostles are shown, see C. Bühler, "The Apostles and the Creed," *Speculum*, 28 (1935), pp. 335-359; and cf. L. J. Friedman, *Text and Iconography for Joinville's Credo*, Cambridge, Mass. 1958.]

61 The following should be read: Amalarius, *De ecclesiasticis officiis, Libri quatuor*, and *Eclogae de officio missae* (ninth century), Migne, *P. L.*, 105, cols. 985-1242, 1315-1332; Rupert de Tuy (Rupertus of Deutz), *De divinis officiis* (twelfth century), Migne, *P. L.*, 170, cols. 9-332; Honorius of Autun, *Gemma animae* and *Sacramentarium* (twelfth century), Migne, *P. L.*, 172, cols. 541-737, 737-806; Hugh of St. Victor, *Speculum de mysteriis ecclesiae* and *De caeremoniis, sacramentis officiis et observationibus ecclesiasticis* (twelfth century, the attribution to Hugh of St. Victor is doubtful), Migne, *P. L.*, 176, cols. 335-380, 381-456; Sicard of Cremona, *Mitrale* (twelfth century), Migne, *P. L.*, 213, cols. 13-434; Innocent III, *De sacro altaris mysterio* (thirteenth century), Migne, *P. L.*, 217, cols. 773-916. In the late thirteenth century William Durandus summarized and amplified all the works of his predecessors in his *Rationale divinorum officiorum*. It is curious that the oldest liturgiologists, such as Isidore of Seville, *De ecclesiasticis officiis*, Migne, *P. L.*, 83, cols. 737-826, gave no place to symbolism. The symbolic interpretation of the Mass belonged to the Middle Ages, and began only with Amalarius.

62 [See J. Braun, *Die liturgische Gewandung im Occident und Orient nach Ursprung und Entwicklung, Verwendung und Symbolik*, Freiburg-im-Breisgau, 1907, pp. 458-474.]

63 William Durandus, *Rationale*, III, vii [ed. d'Avino, pp. 110-111].

64 *Rationale*, III, v [ed. d'Avino, pp. 107-109].

65 *Ibid.*, III, xiii [ed. d'Avino, pp. 119-121].

66 *Ibid.*, I, iv [ed. d'Avino, pp. 32-35; Engl. ed. Neale and Webb, p. 90].

67 "Honoré, prestre et scholastique de l'église d'Autun, ensuite solitaire," *Histoire littéraire de la France*, 12 (1763), pp. 183-184.

68 From Amalarius to William Durandus, all the liturgists made the stole the symbol of obedience. Amalarius, *De ecclesiasticis officiis*, II, xx, Migne, *P. L.*, 105, col. 1096; Rupert, *De divinis officiis*, I, xxi, Migne, *P. L.*, 170, col. 22; Honorius of Autun, *Gemma animae*, I, cciv, Migne, *P. L.*, 172, col. 605; Hugh of St. Victor, *De officiis ecclesiasticis*, Migne, *P. L.*, 177, col. 404; Sicard, *Mitrale*, II, v, Migne, *P. L.*, 213, cols. 74-75; Innocent III, *De sacro altaris mysterio*, I, xxxviii, Migne, *P. L.*, 217, col. 788.

69 A. N. Didron, "Bronzes et orfèvrerie du moyen âge," *Annales archéologiques*, 19 (1859), pp. 70-73; and Cahier and Martin, *Mélanges d'archéologie, d'histoire et de littérature sur le moyen âge*, III, pp. 1ff. [See also Müller, *Die heilige Stadt*.]

70 Censer at Lille, A. N. Didron, "Encensoirs et parfums," *Annales archéologiques*, 4 (1846), pp. 293, 305-311; and Didron, "Bronzes et orfèvrerie," pp. 112-114. It is a work of Renier of Huy. [See S. Collon-Gevaert *et al.*, *Art roman dans la vallée de la Meuse aux XIe et XIIe siècles*, Brussels, 1962, pp. 80, 218 and pl. 36; H. Swarzenski, *Monuments of Romanesque Art: The Art of Church Treasures in North-Western Europe*, Chicago, 1954, fig. 346 with bibl.; and cf. K. H. Usener, "Renier von Huy und seine künstlerische Nachfolge," *Marburger Jahrbuch für Kunstwissenschaft*, 7 (1933), pp. 116-119.]

71 Cahier and Martin, *Nouveaux Mélanges d'archéologie*, II, *Ivoires*, pp. 26-28. This is the Siegburg Crozier of the late eleventh century. [See also J. Braun, "Bischofsstab,"

Reallexikon zur deutschen Kunstgeschichte, II, cols. 792ff. and fig. 1.]

72 In the Louvre Museum, galerie d'Apollon. [See Cahier, *Caractéristiques des saints dans l'art populaire*, Paris, 1867, II, illus. p. 523.]

73 See Sicard, *Mitrale*, I, ix, Migne, *P. L.*, 213, col. 34 [*Deinde per parietes ecclesiae duodecim cruces cum chrismate facit . . . , quae per apostolos a Judaeis pervenit ad gentes. . . .*]

74 The statues to be seen today, with the exception of four, have been restored (F. de Guilhermy, *Description de la Sainte-Chapelle*, Paris, 1887). The twelve apostles were also placed with their backs to twelve columns in the church of St.-Jacques-des-Pèlerins, at Paris (N. de Launay, "Mélanges: Les artistes parisiens au moyen âge, III," *Revue de l'art chrétien*, 46 (1896), p. 399). [On the Ste.-Chapelle apostles, four of which are now in the Cluny Museum, Paris, see F. Salet, "Les Statues d'apôtres de la Sainte-Chapelle, conservées au musée de Cluny," *Bulletin monumental*, 109 (1951), pp. 135-156 and "Nouvelle note," *ibid.*, 112 (1954), pp. 357-364.]

75 At the Chartreuse of Dijon, the Gospel lectern was a column surmounted by a phoenix. The four surrounding beasts served as reading stands. If the Gospel according to Mark was read, the book was placed on the lion; if it were Luke, it was placed on the ox, etc. (L. de Moléon, pseud. of J.-B. Le Brun des Marettes, *Voyages liturgiques de France*, Paris, 1718, p. 156.) [See J. C. Cox, *Pulpits, Lecterns and Organs in English Churches*, London and New York, 1915.]

76 The figure of the Virgin that opens which was formerly in the collection of ivories in the Louvre is probably a forgery. However, one very much mutilated Virgin that opens is authentic; see A. E. Molinier, *Les Ivoires* (*L'Histoire générale des arts appliqués à l'industrie du Ve à la fin du XVIIIe siècle*, I), Paris, 1896, p. 177. Another has been cited: see A. Lecler and J. de Verneilh, *La Vierge ouvrante de Boubon*, Limoges, 1898. [See also R. Koechlin, *Les Ivoires gothiques français*, Paris, 1924, I, pp. 51-53, II, pp. 3-4, III, pl. IV, no. 9; and L. Grodecki, *Ivoires français*, Paris, 1947, p. 81.]

77 On the chevet of Chartres, before the fire of 1836. Villard de Honnecourt, in his *Album* (Paris, Bibl. Nat., ms. fr. 19093, fol. 22v), explains the mechanism that made the angel turn. [See H. Hahnloser, *Villard de Honnecourt*, Vienna, 1935, pp. 134-135, pl. 44; cf. F. Biebel, "The 'Angelot' of Jean Barbet," *Art Bulletin*, 32 (1950), pp. 340ff.]

78 One of the questions that has long been the subject of controversy in medieval archeology is the frequent deviation from the axis in the choir area of churches. Was such an irregularity due to chance, or to material requirements, or did it have a mystical meaning? Was the intention to recall that Christ, of whom the Church is the image, died on the cross with drooping head? Viollet-le-Duc did not think so, although he recognized that such an idea would be in perfect agreement with what we know of the medieval spirit. See E. E. Viollet-le-Duc, "Axe," *Dictionnaire raisonné de l'architecture française du XIe au XVIe siècle*, Paris, 1861, II, pp. 58-59. As for me, for a long time I was inclined to interpret the deviation from the axis in mystical terms. The remarkable article which Lasteyrie devoted to this question: R. de Lasteyrie, "La Déviation de l'axe des églises, est-elle symbolique?" *Mémoires de l'Institut national de France, Académie des inscriptions et belles-lettres*, 37 (1906), pt. 2, pp. 277-308, convinced me that such deviations could have no symbolic significance. [Also printed in *Bulletin monumental*, 69 (1905), pp. 422-459.] When it did not come about from the nature of the location, it was the result of an error in alignment and always had to do with the resumption of work on the cathedral. The examples Lasteyrie gives are so precise that they leave scarcely any room for doubt. His study was almost immediately supported by A. Saint-Paul, "Les Irrégularités de plan dans les églises," *Bulletin monumental*, 70 (1906), pp. 129-155, who for a long time had been one of the champions of the symbolic interpretation. Once this symbolism had been abandoned, nothing remains of the ingenious theory of F. d'Ayzac, by which she tried to prove that the small door cut in the side of Notre-Dame of Paris, the "Porte Rouge," was the symbol of the wound made by the lance in Christ's right side. F. d'Ayzac, "Symbolisme, III," *Revue de l'art chrétien*, 5 (1861), pp. 85-90. Symbolism played a large enough part in medieval art without our adding the fantasies of modern interpreters.

INTRODUCTION, CHAPTER II

1 [On medieval universities, see H. Rashdall, *The Universities of Europe in the Middle Ages*, rev. ed. F. M. Powicke and A. B. Emden, 3 vols., Oxford, 1936; S. D'Irsay, *Histoire des universités françaises et étrangères*, I. *Moyen Age et Renaissance*, Paris, 1933; N. Schachner, *The Medieval Universities*, New York, 1938.]

2 [See M. Lemoine, "L'oeuvre encyclopédique de Vincent de Beauvais," *La Pensée encyclopédique*, UNESCO, Neuchâtel, 1966, pp. 77-85; H. O. Taylor, *The Medieval Mind*, Cambridge, Mass., 1949, II, pp. 345-352; and cf. A. L. Gabriel, *The Educational Ideas of Vincent of Beauvais*, Notre-Dame, Ind., 1956, and *Vincent de Beauvais; ein mittelalterlicher Erzieher*, Frankfurt, 1967.]

3 *Speculum maius*, 4 vols., Douai, 1624; this is the reprint by the Jesuits. References throughout will be to this edition [repr. Graz, 1964].

4 Vincent of Beauvais did not have time to write the *Speculum morale*, and the work we have by this title dates from the early fourteenth century (see M. Daunou, "Vincent de Beauvais, auteur du *Speculum maius* terminé en 1256," *Histoire littéraire de la France*, 18 [1835], pp. 449-519). But it is evident that the *Speculum morale* was a part of Vincent of Beauvais' original plan, which is all that is important here.

5 [For a more general interpretation of the medieval concept of history, see B. Croce, *History: Its Theory and Practice*, tr. D. Ainslie, New York, 1921, pp. 200-223; C. H. Haskins, *The Renaissance of the Twelfth Century*, Cambridge, Mass., 1927, chap. VIII, Historical Writing; W. Lammers, *Geschichtsdenken und Geschichtsbild im Mittelalter*, Darmstadt, 1961, with bibl., esp. pp. 470-473.]

6 [Didron, *Iconographie chrétienne; Histoire de Dieu*. For Engl. tr., see Bibliography.]

1 St. Ambrose, *Hexaemeron*, Migne, *P. L.*, 14, cols. 123-274. [Scc also Bede, *Opera exegetica, De sex dierum creatione, ibid.*, 93, cols. 207-234, and Peter Abelard, *Expositio in Hexaemeron, ibid.*, 178, cols. 731-784.]

2 Chartres (north porch, central bay, archivolts); Laon (west façade, archivolts of the large right window); Auxerre (west façade, bases of portal); Lyon (reliefs of west portal); Noyon (reliefs of west portal, badly damaged); Bourges (reliefs of west portal); several windows of the Creation can also be cited: Auxerre (thirteenth century); Soissons (window of the chevet).

3 A. N. Didron, "Iconographie des cathédrales. Création de l'homme et de la femme," *Annales archéologiques*, 11 (1851), pp. 148-156; a detailed study of the Creation cycle at Chartres Cathedral. [A new study of this cycle is in preparation by Lech Kalinowski of the University of Cracow.]

4 Gervase of Tilbury, *Otia imperialia*, 1: "Filius ergo principium temporis, principium mundanae creationis." ["The Son therefore is the beginning of time, the beginning of earthly creation." See G. W. von Leibnitz, ed., *Scriptores rerum Brunsvicensium*, Hanover, 1707, 1, p. 884.]

5 This is clearly visible at Chartres: scenes from the Creation, north porch, fig. 15. [See E. Houvet, *Cathédrale de Chartres, Portail nord*, Chelles, 1919, 11, pls. 39-45. The Trinity represented as three identical persons was also associated with the Creation. See A. Heimann, "Trinitas Creator Mundi," *Journal of the Warburg and Courtauld Institutes*, 2 (1938-1939), pp. 42-52.]

6 Didron, *Iconographie chrétienne; Histoire de Dieu*, pp. 171ff. [for Engl. tr., see Bibliography]; J. Michelet in the introduction to *Histoire de France*, Paris, 1855, VII. *Renaissance*, pp. 38-39.

7 Theologians interpreted the passage "In principio Deus creavit coelum et terram" in this way; *principium* was the equivalent of *verbum*. Vincent of Beauvais, *Speculum naturale*, bk. 1, chap. IX [Graz ed., 1, pp. 25-26]; Honorius of Autun, *Hexaemeron*, 1,

Migne, *P. L.*, 172, col. 254. The idea derives from St. Augustine. [See Bober, "In Principio. Creation before Time," *Essays in Honor of Erwin Panofsky*, pp. 13-28.]

8 *. . . in Christo, omnia asserit creata, et postmodo cuncta in eo astruit reparata.* Honorius of Autun, *Hexaemeron*, 1, Migne, *P. L.*, 172, col. 253. [In Christ were all things created and thereafter all things in him restored.]

9 Hugh of St. Victor, *Eruditionis Didascalicae*, VII, iv, Migne, *P. L.*, 176, col. 814. [For translation, see J. Taylor, *Didascalicon, A Medieval Guide to the Arts*, New York, 1961.]

10 Adam of St. Victor, *Sequentiae*, Migne, *P. L.*, 196, cols. 1433-1434.
Contemplemur adhuc nucem . . .
Nux est Christus, cortex nucis.
Circa carnem poena crucis.
Testa, corpus osseum.
Carne tectas deitas,
Et Christi suavitas,
Signatur per nucleum.
[Let us contemplate the nut further . . .
The nut is Christ,
The skin of the nut.
Around his flesh [was] the pain of the cross.
The meat is his body and bones.
His divinity clothed in flesh,
And Christ's sweetness,
Is symbolized by the kernel.]
The same idea had already been developed by St. Augustine. It goes back to Origen and can be found in his *In numeros homiliae*, ix, Migne, *P. G.*, 12, cols. 632-633.

11 Peter of Mora, *E. Rosa alphabetica seu ex arte sermocinandi*, J.-B. Pitra, ed., *Spicilegium Solesmense*, Paris, 1855, III, pp. 489-490.

12 Hugh of St. Victor, *De bestiis et aliis rubus*, 1, i, ii, vii, ix, x, Migne, *P. L.*, 177, cols. 15-20. *De bestiis*, attributed to Hugh of St. Victor, could well have been written by Hugh of Fouilloi. See B. Hauréau, *Les Oeuvres de Hugues de Saint-Victor: essai critique*, Paris, 1886, p. 169. [Repr. Frankfurt-am-Main, 1963.]

13 Marbodius, *Lapidum pretiosorum de quibus in proecedenti prosa, mystica seu morales*

applicatio, Migne, *P. L.*, 171, col. 1774. [On medieval lapidaries, see F. de Mély, *Les Lapidaires de l'antiquité et du moyen âge*, 3 vols., Paris, 1898; J. Evans and M. S. Serjeantson, eds., *English Medieval Lapidaries*, Oxford, 1933; L. Baisier, *The 'Lapidaire Chrétien,' Its Composition, Its Influence, Its Sources*, Washington, 1936.

14 Indicated in St. Augustine, Appendix, cxix (*In natali Domini*, iii), Migne, *P. L.*, 39, col. 1983. See also P. Guéranger, "Advent," *The Liturgical Year* (Engl. ed., Dublin), i (1870). [See also J. A. Jungmann, *The Early Liturgy*, Notre-Dame, Ind., 1959, pp. 266-277.]

15 Rabanus Maurus, *De universo*, x, xi, Migne, *P. L.*, 111, cols. 302-303.

16 Heinrich von Eicken, in his book on the medieval conception of the world, clearly saw that to the Middle Ages nature was a symbol, but he did not understand that the entire interpretation was based on the Bible. See H. von Eicken, *Geschichte und System der mittelalterlichen Weltanschauung*, Stuttgart, 1887, bk. iii, chap. vi. [See also H. de Lubac, *Corpus mysticum; l'eucharistie et l'église au moyen âge. Etude historique*, Paris, 1944.]

17 *De universo* derived from the *Etymologiae* of Isidore of Seville; Rabanus Maurus merely added its mystical meaning to each word.

18 Jean-Baptiste Pitra collected a great deal of other testimony in the commentary accompanying the text of the Pseudo-Melito: *Spicilegium Solesmense*, J.-B. Pitra, ed., ii, pp. iv-vii.

19 The so-called *Clavis* of Melito was published by J.-B. Pitra, ed., *ibid.*, vols. ii and iii. He tried unsuccessfully to prove that the book dates from the second century. Rottmanner, in *Le Bulletin critique*, 1885, p. 47, pointed out the Pseudo-Melito's debt to St. Augustine. A. Harnack (*Geschichte der altchristlichen Literatur bis Eusebius*, i, Leipzig, 1893, p. 254) pointed out that the title of the manuscript, *"Melitus asianus episcopus hunc librum edidit quem et congruo nomine clavem appellavit,"* is written in another hand and was added later. The sentence was clearly borrowed from St. Jerome. [A new edition of the *Clavis Melitonis* is in preparation by Ann Freeman; see *Speculum* xlii, no. 3, 1967, p. 579.]

20 *Spicilegium Solesmense*, ii, p. 414. [Ecclesiastes 39:17.]

21 *Ibid.*, p. 422. [Isaiah 34:13; Proverbs 24:30-31.]

22 *Ibid.*, p. 432. [Job 21:18.]

23 *Ibid.*, p. 406.

24 The *Clavis* of Melito, *ibid.*, p. 484, says expressly that in certain cases the dove symbolizes the Church; the author of *De bestiis* bases his view on this.

25 On this point see J.-B. Pitra, ed., "Prolegomena ad Spicilegii Solesmensis," *Spicilegium Solesmense*, iii, p. lxiii; C. Cahier, "Le Physiologus ou Bestiaire: Avant-Propos," *Mélanges d'archéologie*, 2 (1851), pp. 85-100; C. Cahier and A. Martin, "Du Bestiaire et de quelques questions qui s'y rattachent," *Nouveaux Mélanges d'archéologie*, i. *Curiosités mystérieuses*, Paris, 1874, pp. 106-164; F. Lauchert, *Geschichte des Physiologus*, Strasbourg, 1889. [See also F. McCulloch, *Medieval Latin and French Bestiaries*, Chapel Hill, N.C., 1960, with bibliography.]

26 Greek and Armenian texts in, *Spicilegium Solesmense*, iii, pp. 338-393; Latin text in C. Cahier, "Bestiaires, ii," *Mélanges d'archéologie*, 3 (1853), pp. 203-283. [See also McCulloch, *Medieval Latin and French Bestiaries*, pp. 15-20, and M. L. Gengaro, F. Leoni, G. Villa, eds., *Codici decorati e miniati dell'ambrosiana, Ebraici e Greci*, Milan, 1959, pp. 35, 126ff.]

27 E. Walberg, eds., *Le Bestiaire de Philippe de Thaün*, Paris and Lund, 1900. A twelfth-century English bestiary (Cambridge, Univ. Lib., Ms. ii. 4.26) has been published in translation: *The Bestiary. A Book of Beasts*, tr. and ed. by T. H. White, London, 1954, repr. New York, 1960.]

28 *Le Bestiaire divin* by William the Norman was published by C. Hippeau, "Le Bestiaire divin de Guillaume, clerc de Normandie, trouvère du XIIIe siècle," *Mémoires de la Société des antiquaires de Normandie*, 9 (1851) (2nd ser.), pp. 317-346, and more recently by R. Reinsch, *Le Bestiaire: das Thierbuch des normannischen Dicters Guillaume le Clerc*, Leipzig, 1892. [See also translation by G. C. Druce, *The Bestiary of Guillaume le Clerc*, London, 1936.]

29 [Pope Gelasius I, *Appendix tertia. Concil-
iorum sub Gelasio habitorum relatio*, v,
Migne, *P. L.*, 59, col. 162.]

30 On the *De proprietatibus rerum* by Bar-
tholomaeus Anglicus and *De natura rerum*
of Thomas of Cantimpré, see L. Delisle,
"Traités divers sur les propriétés des
choses," *Histoire littéraire de la France*, 30
(1888), pp. 355-365; 365-388. [See also
K. von Megenberg, *Von der Sel; eine Uber-
tragung aus dem Liber de proprietatibus
rerum des Bartholomäus Anglicus*, ed. G.
Steer, Munich, 1966, and A. Hilka, ed.,
*Eine altfranzösische moralisierende bear-
beitung des Liber de monstruosis homini-
bus Orientis aus Thomas von Cantimpré,
De natura rerum, nach der einzigen Hand-
schrift* (Paris, Bibl. Nat., ms. fr. 15106),
Berlin, 1933.]

31 Richard de Fournival, *Le Bestiaire d'amour
suivi de la réponse de la dame*, ed. C. Hip-
peau, Paris, 1860. [See A. Långfors, ed., *Le
Bestiaire d'amour en vers par Richard de
Fournival*, Helsinki, 1924; C. Segre, ed., *Li
Bestiaires d'Amours di Maistre Richart de
Fornival e li Response du Bestiaire*, Milan,
1957.]

32 *Spicilegium Solesmense*, III, φυσιολόγος, περὶ
ζῴου ἐλέφαντος, p. 364.

33 [*The Opus Majus of Robert Bacon*, ed.
R. B. Burke, Philadelphia and Oxford,
1928, II, p. 577.]

34 The first of the beasts was not an angel, as
is commonly thought, but a man. We shall
see that the man expressly symbolizes hu-
man nature.

35 P. Guéranger, "Carême," *L'Année litur-
gique*, 5 (1899), pp. 398-400. See the en-
tire passage which was borrowed from the
Sacramentarium of Pope Gelasius. [*Sacra-
mentarium Gelasianum*, I, Migne, *P. L.*,
74, cols. 1087-1088.] There we find none
of the subtle explanations familiar to the
twelfth and thirteenth centuries. [See F.
van der Meer, *Maiestas Domini, théopha-
nies de l'apocalypse dans l'art chrétien*,
Rome and Paris, 1938.]

36 Félicie d'Ayzac collected many of these in
her excellent study, *Les Quatre Animaux
mystiques*, appended to F. d'Ayzac, *Les
Statues du porche septentrional de Chartres*,
Paris, 1849. See also Cahier, "Evangélistes,"
*Caractéristiques des saints dans l'art po-
pulaire*, I, pp. 392-399, and A. Darcel, "Le
Benitier de la cathédrale de Milan; sym-
bolisme des evangélistes," *Annales archéo-
logiques*, 17 (1857), pp. 139-150.

37 See especially Lectionary of Crépy (Paris,
Bibl. de l'Arsenal, ms. 162, fols. 222ff.).

38 Rabanus Maurus, *Commentaria in Eze-
chielem*, I, Migne, *P. L.*, 110, col. 515.

39 "*Quand il* (l'aigle) *regarde le soleil, il ne
flecist mie ses ex par la force del rai.*"
(When the eagle looks into the sun, it does
not lower its eyes a whit from the strength
of its rays.) Bestiary of Pierre le Picard
(Paris, Bibl. de l'Arsenal, ms. 3516, fols.
198ff.).

40 *Spicilegium Solesmense*, III, φυσιολόγος.
περὶ τοῦ λέοντος, I, p. 338.

41 *Leo etiam apertis oculis dormire perhi-
betur; quia in ipsa morte, in qua ex hu-
manitate redemptor noster dormire potuit,
ex divinitate sua immortalis permanendo
vigilavit* (The lion is said to sleep even
with its eyes open; because in death itself,
in which by virtue of his humanness our
Redeemer was able to sleep, he was yet
awake, remaining immortal by virtue of his
divinity). Lectionary, Paris, Bibl. de l'Arse-
nal, ms. 162, Lectio II.

42 The miniature painters gave artistic form
to this symbolism. Sometimes they repre-
sented the Nativity beside the man of Mat-
thew, the Crucifixion beside the ox, the
Resurrection beside the lion, the Ascension
beside the eagle. There are examples dating
from the tenth century (Gospel Book of
the Emperor Otto: see X. Barbier de Mon-
tault, "Le Trésor du dôme d'Aix-la-Cha-
pelle," *Bulletin monumental*, 43 (1877),
pp. 209-239, illus. p. 220), through the four-
teenth century: *Postillae* of Nicolas of Lyra
(Paris, Bibl. Mazarine, ms. 167, fol. 1).
[On the Gospel Book of Emperor Otto, see
H. Jantzen, *Ottonische Kunst*, Munich,
1947, pp. 77ff. and *passim*. To the exam-
ples cited by Mâle should be added the rep-
resentations in two important twelfth-cen-
tury manuscripts of the Mosan region: the
Averbode Gospels (Liège, Univ. Lib., ms.
363B) and the Floreffe Bible (London, Brit.
Mus., ms. add. 17738). See J. Stiennon,
"La miniature dans le diocèse de Liège aux
XIe et XIIe siècles," *L'Art mosan*, ed. P.
Francastel, Paris, 1953, pp. 90-101. For two

miniatures from the Averbode Gospels, see A. Grabar and C. Nordenfalk, *Romanesque Painting from the Eleventh to the Thirteenth Century*, New York, 1958, p. 165. On the relation of the Crucifixion with the ox of Luke, see C. R. Dodwell, *The Canterbury School of Illumination, 1066-1200*, Cambridge, 1954, pp. 87-88.]

43 Cahier and Martin, *Monographie de la cathédrale de Bourges*, I, *Vitraux du XIIIe siècle*, pl. VIII. The valuable drawing reproduced by Martin (fig. 11 [in French edition; in this edition figure 19 is from a recent photo]) shows the window as it was before it was restored by Emile Thibaud, glass painter of Clermont-Ferrand. In 1842, Thibaud rearranged the central medallions, so that they no longer correspond exactly to the medallions of the borders. On this restoration, see the interesting article by G. Mougeot, "La Verrière de la rédemption à Saint-Jean: histoire d'une restauration," *La Revue d'histoire de Lyon*, 1 (1902), pp. 207-222.

44 We shall explain in detail the meaning of these figures in our chapter on the Old Testament.

45 Honorius must have written between 1090 and 1120: B. Pez, *Thesaurus anecdotorum novissimus seu veterum monumentorum*, Augsburg, 1721, II, iv. A. H. Springer, in his dissertation, *Uber die Quellen der Kunstdarstellungen im Mittelalter*, Leipzig, 1879, glimpsed the importance of the *Speculum ecclesiae* in the history of art. [For more on Honorius, see F. P. Bliemetzrieder, "L'Oeuvre d'Anselme de Laon et la littérature théologique contemporaine, I. Honorius d'Autun," *Recherches de théologie ancienne et médiévale*, 5 (1933), pp. 275-291; E. Rooth, "Kleine Beiträge zur Kenntnis des sogenannten Honorius Augustodunensis," *Studia neophilologica*, 12 (1939-1940), pp. 120-135; J. de Ghellinck, *L'Essor de la littérature latine au XIIe siècle*, Brussels, 1946, II, pp. 113-118.]

46 We shall show that an entire portal of Laon Cathedral was inspired by the *Speculum ecclesiae* (early thirteenth century).

47 *Speculum ecclesiae*, Migne, *P. L.*, 172, cols. 819 and 904 (*De nativitate Domini* and *In annunciatione Sanctae Mariae*).

48 We shall come back to this symbolism

when we explain the Laon portal, which was conceived according to the sermon on the Annunciation by Honorius of Autun.

49 This medallion has been badly restored; perhaps originally the young girl was not mounted on the unicorn.

50 *Speculum ecclesiae*, Migne, *P. L.*, 172, cols. 911 and 922 (*Dominica de passione Domini* and *Dominica in Palmis*). Further on (chapter on the Old Testament), we shall explain the meaning of these figures.

51 The story of Jonah is found in *Speculum ecclesiae, ibid.*, cols. 925-926 (*In coena Domini*); the story of the lion is in the sermon *De Paschali Die, ibid.*, col. 935.

52 Some bestiaries give another explanation. They say that the lion resurrected the cubs by breathing into their mouths: *Spicilegium Solesmense*, III, φυσιολόγος, I, p. 338, and Cahier, "Bestiaires I," *Mélanges d'archéologie*, 2 (1851), p. 107. The story comes from Pliny, *Historia naturalis*, VIII, 17. [Pliny's chapter on the lion does not include this particular legend: Pliny, *Natural History*, tr. H. Rackham (Loeb Classical Library, III), London and Cambridge, Mass., 1956, pp. 33-34. Evidently Origen, in his Homily on Genesis 17, adapted it from an early Physiologus. See K. Künstle, *Ikonographie der christlichen Kunst*, Freiburg-im-Breisgau, 1926, I, p. 87.]

53 *Speculum ecclesiae*, Migne, *P. L.*, 172, col. 958 (*In ascensione Domini*).

54 Honorius of Autun took the story of the charadrius from the bestiaries. See *Spicilegium Solesmense*, III, φυσιολόγος, περὶ χαραδριοῦ, v, p. 342. The legend comes from Aelianus, *De natura animalium*, XVII, 13. [Aelian, *On the Characteristics of Animals*, tr. A. F. Scholfield (Loeb Classical Library, III), London and Cambridge, Mass., 1959, p. 339. Here the name of the bird is translated as "stone-curlew."]

55 Cahier and Martin, "Du Bestiaire," *Nouveaux Mélanges d'archéologie*, 1: *Curiosités mystérieuses*, p. 153. See F. Chardin, "Notice sur deux bas-reliefs de la cathédrale de Strasbourg," *Revue archéologique*, 10 (1853), pp. 591-602, 648-655. [On the animal frieze of Strasbourg Cathedral, see H. Haug and others, *La Cathédrale de Strasbourg*, Strasbourg, 1957, pls. 90-91.]

56 *Speculum ecclesiae*, Migne, *P. L.*, 172, col.

936 (*De Paschali Die*). We are not referring to the other part of the Strasbourg frieze, which is composed of either purely fantastic scenes (battles between monsters) or popular scenes (men and women pulling hair, chess players exchanging blows, etc.).

57 Published by Cahier and Martin, *Monographie de la cathédrale de Bourges*, pt. I. *Vitraux du XIIIe siècle*, pl. I and study-plate IV.

58 At Chartres, the lions have disappeared; at Tours and Le Mans, they have been relocated as a result of alterations.

59 Reproduced in Bégule and Guigue, *Monographie de la cathédrale de Lyon*, pl. II.

60 *Ibid.*, pl. B.I, p. 202.

61 *Ibid.*, 2nd ser., pl. IV, c.3, and 2nd ser., pl. I, c.1 and 2.

62 *Speculum ecclesiae*, Migne, *P. L.*, 172, cols. 855-856 (*Dominica in septuagesima*).

63 *Speculum ecclesiae, ibid.*, cols. 913-922 (*Dominica in Palmis*).

64 Albertus Magnus, *De animalibus*, XXIII, 24: *Basilicus . . . sicut gallus, sed caudam longam serpentis habet* (The basilisk . . . like a cock, but it has the long tail of a serpent). [Albertus Magnus, *Opera omnia*, ed. A. Borgnet, Paris, 1891, XII, p. 488.]

65 Here, the influence of Honorius cannot be questioned, since we see the asp stopping its ear with the end of its tail. However, it must be said that the image of Christ trampling the lion and the dragon while he blesses with his right hand and holds a book in his left, goes back to Early Christian art: it is found for the first time in the Christian catacomb of Alexandria. Alexandrian ivories reproduce this image exactly, as the ivory in the Vatican shows. This representation of Christ came into Western art through ivories, and the Amiens artist was probably inspired by one of them. But a theologian, who had read Honorius of Autun, had explained to him the necessity of representing the asp and the basilisk as they are shown here. These two animals were not used in this way in Alexandrian ivories. I have explained all this in detail in a study presented to the *Congrès archéologique du Caire* in 1909. [On this representation of Christ, see E. Kantorowicz, "Gods in Uniform," *Proceedings of the American Philosophical Society*, 105 (1961),

pp. 368-393 (repr. in *Selected Studies*, New York, 1965, pp. 7-24.]

66 Cahier and Martin, "Du Bestiaire," *Nouveaux Mélanges d'archéologie*, I, p. 141, fig. A.

67 On the owl, see *Bestiaire latin*, published by Cahier, "Bestiaires I," *Mélanges d'archéologie*, 2 (1851), p. 170.

68 Capital from St.-Urbain at Troyes. [M. Aubert and M. Beaulieu, *Encyclopédie photographique de l'art; sculptures du moyen âge*, Paris, 1948, pls. 81, 82, and p. 24.]

69 *Spicilegium Solesmense*, III, φυσιολόγος, περὶ δενδρου περιδεξίου, p. 356.

70 This, no doubt, is why there are two dragons on the capital.

71 Perhaps this is the interpretation of the large capital of Reims (a cast of which is in the Trocadéro), which represents birds among branches, and dragons. However, the presence of a goat and a lion casts doubt on this interpretation.

72 C. A. Auber, "Histoire et théorie du symbolisme religieux, I. Du symbolisme chez les anciens," *Revue de l'art chrétien*, 10 (1866), p. 133.

73 Discussion by C. A. Auber reported in *Congrès scientifique de France* (Tours, 1847), Paris, 1848, 15th session, I, p. 102 and II, p. 85.

74 C. A. Auber, *Histoire de la cathédrale de Poitiers*, 2 vols., Poitiers, 1848-1849, and *idem, Histoire et théorie du symbolisme religieux avant et depuis le christianisme*, 4 vols., Paris and Poitiers, 1870-1872.

75 *Ibid.*, III, p. 127.

76 F. d'Ayzac, "Mémoire sur trente-deux statues symboliques, observées dans la partie haute des tourelles de Saint-Denys," *Revue générale de l'architecture et des travaux publics*, 7 (1847), pp. 65-81.

77 F. d'Ayzac wrote only two studies of any lasting value: *Les Statues du porche septentrional de Chartres*, and *Les Quatre Animaux mystiques* appended thereto. [For a bibliography which includes her animal studies, see J. Helbig, "Madame Félicie d'Ayzac," *Revue de l'art chrétien*, 4 (1886), pp. 1-12.]

78 See the fragment from an unfinished work by F. d'Ayzac, "De la Zoologie composite (c'est-a-dire imaginaire et complexe) dans

les oeuvres d'art chrétien, avant le XIVe siècle," *Revue de l'art chrétien*, 4 (1886), pp. 13-36.

79 A. Comte de Bastard-d'Estang, *Etudes de symbolique chrétienne*, Paris, 1851, and *idem*, "Crosse de Saint-Amand de Rouen," *Travaux du Comité des travaux historiques et scientifiques*, 1857, pp. 521-539.

80 For example, C. Daux, "La Flore monumentale du cloître abbatial de Moissac," *Revue de l'art chrétien*, 19 (1876), pp. 45-100. Each carved flower is reputed to represent a virtue, or an idea. A capital devoted to Saints James and John is decorated with five-lobed flowers; the author asks himself "if this might not be the representation of the five stages of the journey through which each of the two brothers passed." A method of interpretation almost as venturesome held sway in other countries. See W. Menzel, *Christliche Symbolik*, 2 vols., Regensburg, 1856. [This type of symbolic interpretation still fascinates a number of scholars; more recently, see O. Beigbeder, "Symbolisme des chapiteaux de la nef d'Anzy-le-Duc," *Gazette des beaux-arts*, 60 (1962), pp. 381-399. Cf. below, n. 88.]

81 *Apologia ad Guillelmum Sancti-Theodorici abbatem*, XII, Migne, *P. L.*, 182, cols. 915-916. [The letter from which this excerpt is taken is reprinted in full in G. G. Coulton, *Life in the Middle Ages*, Cambridge, 1930, IV, pp. 72-76. See also E. G. Holt, ed., *A Documentary History of Art*, New York, 1957, I, pp. 18-22. In the same sense, see M. R. James, "Pictor in Carmine," *Archaeologia or Miscellaneous Tracts Relating to Antiquity*, 94 (1951), pp. 139-166.]

82 [On the interpretation of works without specific symbolic illusion, cf. M. Schapiro, "On the Esthetic Attitude in Romanesque Art," *Art and Thought: Issued in Honour of Dr. Ananda Coomaraswamy*, London, 1947, pp. 130-150, and *idem*, "The Bowman and the Bird on the Ruthwell Cross and Other Works: The Interpretation of Secular Themes in Early Medieval Religious Art," *Art Bulletin*, 45 (1963), pp. 351-355.]

83 Lenormant established this interpretation beyond doubt: C. Lenormant, "Anciennes étoffes. De l'étoffe conservée à la couture du Mans; De l'étoffe dite de S. Mesme, à

Chinon," *Mélanges d'archéologie*, 3 (1853), pp. 116-141. More recently, L.C.J. Courajod, "Elément arabe," *Leçons professées à l'Ecole du Louvre*, Paris, 1889, I, p. 241 and J.-J. Marquet de Vasselot, "Les Influences orientales," *Histoire de l'art*, A. Michel, ed., Paris, 1905, I, pp. 395-423 and pp. 882-898, both studied the influence of Eastern models on medieval art. We have also studied these problems in a chapter of Mâle, *Religious Art in France: The Twelfth Century*, chap. IX, pp. 316-363.

84 [Recent studies trace the origins of these "inhabited scrolls" or "clambering initials" to Anglo-Saxon England, with prototypes in the art of late antiquity, although it is doubtful that any of the early associations with astronomical calendars and such were still current in the twelfth century. See T. D. Kendrick, *Late Saxon and Viking Art*, London, 1949, pp. 39-41; C. R. Dodwell, *The Canterbury School of Illumination*, pp. 10-12.]

85 [D. Jalabert, "La première flore gothique aux chapiteaux de Notre-Dame de Paris," *Gazette des beaux-arts*, 6th series, 5 (1931), pp. 283-304.]

86 E. E. Viollet-le-Duc, "Flore," *Dictionnaire raisonné de l'architecture*, Paris, 1861, V, pp. 485-524.

87 This is very evident at the cathedral of Laon.

88 [Cf. L. Behling, *Die Pflanzenwelt der mittelalterlichen Kathedralen*, Cologne, 1964, pp. 36, 46, 50-102, *passim*.]

89 Besides the article by Viollet-le-Duc already cited [n. 86], see E.-J. Woillez, "Iconographie des plantes aroïdes figurées au moyen âge en Picardie, *Mémoires de la Société des antiquaires de Picardie* (Amiens), 9 (1848), pp. 115-157; E. Lambin, *La Flore gothique*, Paris, 1893; *idem*, *Les Eglises des environs de Paris, étudiées au point de vue de la flore ornementale*, Paris, 1896; *idem*, *La Flore des grandes cathédrales de France* (Bibliothèque de la Semaine des constructeurs), Paris, 1897. [D. Jalabert, *La Flore sculptée des monuments du moyen âge en France*, Paris, 1965.]

90 Lambin, *La Flore gothique*. [See also D. Jalabert, "La Flore sculptée de la Sainte-

Chapelle," *Pro Arte*, 67-68 (1947), pp. 451-456.]

91 Beautiful examples of medieval flora are found in L. G. Adams, *Recueil de sculptures gothiques dessinées et gravées à l'eau-forte d'après les plus beaux monuments construits en France depuis le XIe jusqu'au XVe siècle*, 2 vols., Paris, 1858-1861.

92 Woillez, "Iconographie des plantes," pp. 115-157.

93 Reproduced in Begule and Guigue, *Monographie de la cathédrale de Lyon*, 2nd ser., pl. I, B.1.

94 *Ibid.*, 2nd ser., pl. I, B.3.

95 *Ibid.*, 3rd ser., pl. I, B.3.

96 *Ibid.*, 2nd ser., pl. IV, B.5.

97 *Ibid.*, 3rd ser., pl. I, A.3.

98 *Ibid.*, 3rd ser., pl. IV, A.3. [See also K. Varty, *Reynard the Fox: A Study of the Fox in Medieval English Art*, Leicester, 1967.]

99 *Album de Villard de Honnecourt*, ed. J.B.A. Lassus, Paris, 1858. [Repr. ed. P. de Laget, Marseilles, 1968. See also English translation of Lassus, edited by R. Willis with remarks by J. Quicherat, *Facsimile of the Sketch-Book of Wilars de Honecort*, London, 1859. See now H. Hahnloser, *Villard de Honnecourt*, Vienna, 1935, which will hereafter be cited, and T. Bowie, ed., *The Sketchbook of Villard de Honnecourt*, Bloomington, Ind., 1959.]

100 Ed. Lassus, pl. III. [Ed. Hahnloser, pl. III.]

101 *Ibid.*, pl. VI. [Ed. Hahnloser, pl. VII.]

102 *Ibid.*, pl. XIII. [Ed. Hahnloser, pl. XIV.]

103 *Ibid.*, pls. XLVI and L. [Ed. Hahnloser, pls. XLVII and LI.]

104 Guibert de Nogent, *De vita sua sive monodiarum*, III, xiii, Migne, *P. L.*, 156, col. 941.

105 West façade, right portal, lower part. [Aubert, *Notre-Dame de Paris, architecture et sculpture*, pl. 36. For the association of these symbols with the cult of the Virgin, see W. M. Hinkle, "The Cosmic and Terrestrial Cycles on the Virgin Portal of Notre-Dame," *Art Bulletin*, 49 (1967), pp. 291-292.]

106 Next to it is to be seen a man mounted on a fish, clearly symbolizing the sea, as at Notre-Dame of Paris.

107 [The source of inspiration for the sciapod is to be found in the Marvels of the East. See R. Wittkower, "Marvels of the East: A Study of the History of Monsters," *Journal of the Warburg and Courtauld Institutes*, 5 (1942), pp. 159-197.]

108 *De imagine mundi*, I, xi, is from the twelfth century. Migne, *P. L.*, 172, cols. 123-124.

109 The *Otia imperialia* are from the early thirteenth century: *Scriptores rerum Brunsvicensium*, ed. Leibnitz, I, pt. 2, chap. iii, p. 911.

110 *Speculum naturale*: see especially XVII, cxxix. [Graz ed., I, 1314.]

111 On the ancient origin of medieval geographic and ethnographic fables, see J. Berger de Xivrey, *Traditions tératologiques, ou récits de l'antiquité et du moyen âge en occident*, Paris, 1836.

112 The Catalan atlas was published by J.A.C. Buchon and J. Tastu, "Notice d'un atlas en langue catalane," *Notices et extraits des manuscrits de la Bibliothèque du Roi et autres bibliothèques*, 14 (1841), pt. 2, pp. 1-152.

113 Berger de Xivrey, *Traditions tératologiques*, p. 143. I think the small man who requires a ladder to mount the horse is a pygmy. [This pygmy represents Africa. See A. Katzenellenbogen, "The Central Tympanum at Vézelay," *Art Bulletin*, 26 (1944), p. 144.]

114 The mosaics in S. Marco in Venice represent the same subject. [See S. Bettini, *Mosaici antichi di San Marco a Venezia*, Bergamo, 1944, pls. IV-VII.] It is not necessary to discuss the Vézelay portal here, because it dates from the Romanesque period. It is explained in chap. IX of Mâle, *Religious Art in France: The Twelfth Century*, pp. 326-328. [See now F. Salet and J. Adhémar, *Le Madeleine de Vézelay*, Melun, 1948, pp. 113ff., and Katzenellenbogen, "The Central Tympanum at Vézelay," pp. 141-151.]

115 The beautiful monsters decorating the balustrade of the towers of Notre-Dame of Paris are the creations of Viollet-le-Duc (only the fragments of the originals had remained). He was inspired by those still in existence at Reims.

116 The hypothesis of Springer, *Uber die Quellen der Kunstdarstellungen im Mit-*

telalter, is quite inadequate. He thought that certain passages from the Psalms explain and justify these figures of monsters. For example, Psalm 21:22 (Vulgate) [22:21 (King James)]: "Save me from the lion's mouth; for thou has heard me from the horns of the unicorns"; and Isaiah 11:8: "And the suckling child shall play on the hole of the asp, and the weaned child shall put his hand on the cockatrice' den." [The images connected with Psalm 22 have been dealt with by W. Deonna, "'Salve me ex ore leonis'; à propos de quelques chapiteaux romans de la cathédrale de Saint-Pierre à Genève," *Revue belge de philologie et d'histoire*, 28 (1950), fasc. 1, pp. 479-511. For the origins of the gargoyle in the art of antiquity, see J. Baltrušaitis, *Reveils et prodiges: le gothique fantastique*, Paris, 1960, pp. 68-70. See also *idem, Le Moyen Age fantastique; antiquités et exotismes dans l'art gothique*, Paris, 1955.]

117 The Lyon reliefs (1310) are later than those of Rouen (late thirteenth century).

118 The grotesque figures on the Lyon portal are reproduced in Bégule and Guigue, *Monographie de la cathédrale de Lyon*, p. 189: right portal, 2nd ser., pl. 1, C.5; left portal, pls. II, C.3; III, C.3; IV, C.4. Those of the Portail des Libraires and the "Portail de la Calende," first reproduced by J. Adeline, *Sculptures grotesques et symboliques*, Rouen, 1879, pls. XXXIX-XCVII, have been studied by Louise Pillion. She came to the same conclusion as I, that these hybrid creatures have no meaning. See her interesting study: *Les Portails latéraux de la cathédrale de Rouen*, Paris, 1907. [For a summary of her identification, see A. Loisel, *La Cathédrale de Rouen*, Paris, 1927, pp. 87-90.]

119 Among the grotesque figures reproduced here (fig. 34), notice the phoenix included by the artist as a decorative motif.

120 J.F.-F. Champfleury, *Histoire de la caricature au moyen âge*, Paris, 1871; Adeline, *Sculptures grotesques et symboliques*; and Pillion, *Les Portails latéraux de la cathédrale de Rouen*.

121 Missal (Paris, Bibl. Ste.-Geneviève, ms. 98). The manuscript dates from 1286; the drawings are very mediocre.

122 Psalter and Book of Hours for use of St.- Amand (Paris. Bibl. Nat., ms. lat. 13260). [Paris, Bibl. Nat., *Les Manuscrits à peintures en France du XIIe au XVIe siècle*, Paris, 1955, no. 83.]

123 Hours from the north of France (Paris, Bibl. Nat., ms. lat. 14284). [*Ibid.*, no. 79.]

124 Let us also cite: Psalter for Paris use (Paris, Bibl. Ste.-Geneviève, ms. 2690), thirteenth century; Psalter and Book of Hours for Arras use (Paris, Bibl. Nat., ms. lat. 1328), thirteenth century [*ibid.*, no. 70]; Hours from the north of France (Paris, Bibl. Nat., ms. lat. 1394), fourteenth century [*ibid.*, no. 91]. [See now L.M.C. Randall, *Images in the Margins of Gothic Manuscripts*, Berkeley, 1966. Randall concludes that the aim of these marginalia was "both to divert and to elevate," p. 19.]

125 [The second ring of the seventh circle. Dante, *Inferno*, Canto XIII.]

126 This was not made sufficiently clear by Champfleury in his *Histoire de la caricature*, nor by T. Wright, *Histoire de la caricature et du grotesque dans la littérature et dans l'art* (Fr. trans.), Paris, 1875. [Published as T. Wright, *A History of Caricature and Grotesque in Literature and Art*, London, 1864.] All periods are jumbled together.

127 The drawing is reproduced by Champfleury, *Histoire de la caricature*, p. 157.

128 [For a recent discussion of the medieval sanctuary as an image of heaven, see O. von Simson, *The Gothic Cathedral, Origins of Gothic Architecture and the Medieval Concept of Order*, New York, 1956, pp. xx and *passim* (2nd ed. rev., New York, 1962; pb. ed. Princeton, 1974).]

BOOK II

1 These tragic statues of Adam and Eve are modern, but are copies of those that were there.

2 [Vincent of Beauvais, *Speculum doctrinale*, I, Graz ed., II, 2.]

3 *Ibid.*, I, ix. [Graz ed., II, 10.] Honorius of Autun developed the same idea in his *De animae exsilio et patria alias de artibus*, Migne, *P. L.*, 172, cols. 1241-1246. The idea is this: ignorance is the soul's exile; its home is wisdom to which it comes through

the liberal arts that are placed like towns along the road leading to it.

4 See Book IV, Chapter V, on the place occupied by kings in the cathedrals.

5 At Chartres, there are as many as nineteen different guilds. See Bulteau, *Monographie de la cathédrale de Chartres*, I, p. 127.

6 North side. The Semur window probably dates from the late fourteenth century.

7 Especially St.-Denis (west portal); Sens (west portal); Senlis (west portal); Chartres (old portal, north portal, window of the choir); Reims (west portal, the series is mutilated); Amiens (west portal); Notre-Dame of Paris (west portal and west rose window); Semur (north portal); Rampillon (Seine-et-Marne, west portal). The rose window at Notre-Dame of Paris, as it is reproduced in Albert Lenoir, *Statistique monumentale de Paris*, Paris, 1867, II, pl. XIX, shows several restorations, but its former state is given by F. de Lasteyrie, *Histoire de la peinture sur verre*, p. 141. [For a detailed description with diagrams of the restorations, see the study by J. Lafond in M. Aubert and others, *Les Vitraux de Notre-Dame et de la Sainte-Chapelle de Paris* (Corpus Vitraearum Medii Aevii, France I), Paris, 1959, pp. 23-34.] Didron thought he had found a third zodiac at Notre-Dame of Paris (west façade, left portal, trumeau). [See Montluisant, "Notre-Dame de Paris," pp. 213-214, an article published by Didron.] I do not agree with him. The Notre-Dame artist was not representing the Labors of the Months, but a kind of temperature scale, or true thermometer. Below, we see a man warming himself before a blazing fire; higher, a man gathers wood; a man goes for a walk wearing a cloak; then there is a curious figure with two heads and two bodies linked together, one of which is clothed, the other nude, which apparently represents the rapid changes of temperature in spring; next comes a figure clothed only in breeches, and lastly, a man completely naked. [For an identification of these figures as representing the seasons of the year, see W. M. Hinkle, "The Cosmic and the Terrestrial Cycles on the Virgin Portal of Notre-Dame," *Art Bulletin*, 49 (1967),

pp. 287-291.] On the other side of the trumeau, we find a ladder of the ages of human life.

8 Reproduced by J. Durand, "Mosaïque de Sour, III," *Annales archéologiques*, 24 (1864), pp. 205, 209. [See H. Stern, *Le Calendrier de 354; étude sur son texte et ses illustrations*, Paris, 1953, pp. 203-298.]

9 Pavements in the churches of Tournus, St.-Remi at Reims (now disappeared), St.-Bertin at Saint-Omer, and Aosta. [See H. Stern, "Mosaïques de pavement préromanes et romanes en France," *Cahiers de civilisation médiévale*, 5 (1962), pp. 13-34, esp. p. 28, pl. XI (the month of October from St.-Denis).]

10 This is Rupert's implication in *De Trinitate et operibus eius*, I, *Commentariorum in genesim*, I, xlv, Migne, *P. L.*, 167, cols. 236-237; according to him, by looking at the calendars, people were more disposed to serve God.

11 Honorius of Autun, *De imagine mundi*, II, iii, Migne, *P. L.*, 172, cols. 146-147.

12 Sicard, *Mitrale sive de officiis ecclesiasticis summa*, V, vii, Migne, *P. L.*, 213, col. 232. *Annus est generalis Christus, cujus membra sunt quatuor tempora, scilicet quatuor evangelistae. Duodecim menses hi sunt Apostoli. . . .* [See J. Daniélou, *Primitive Christian Symbols*, Baltimore, 1964, pp. 124-135.]

13 [See J. C. Webster, *The Labors of the Months in Antique and Medieval Art to the End of the Twelfth Century*, Chicago, 1938. See also H. Stern, "Représentations gallo-romaines des mois," *Gallia*, 9 (1951), pp. 21-30, and *idem*, "Poésies et représentations carolingiennes et byzantines des mois," *Revue archéologique*, 45 (1955), pp. 141-186.]

14 A. Lenoir, "Rapport sur la cathédrale de Cambray," *Mémoires de l'Académie celtique*, Paris, 4 (1809), p. 416.

15 Dupuis, *Origine de tous les cultes ou religion universelle*, III, p. 42.

16 Archivolts of the north porch. [Houvet, *Cathédrale de Chartres: Portail nord*, II, pp. 77-88. On the relation of this cycle to the Book of Job, see Katzenellenbogen, *The Sculptural Programs of Chartres Cathedral*, p. 75.]

17 West façade; portal of the Virgin; piers. [See Hinkle, "The Cosmic and the Terrestrial Cycles on the Virgin Portal of Notre-Dame," pp. 292-295.]

18 A. Le Touzé de Longuemar, "Un Mot sur quelques questions archéologiques traitées à Paris, Session de 1857," *Bulletin monumental*, 23 (1857), pp. 269-276. St.-Savin is a Romanesque church. There are no examples in Gothic churches of calendars beginning with March. [For the idea that the Byzantine series had an archetype which began with the month of March, see Stern, "Poésies et représentations carolingiennes et byzantines des mois," p. 184.]

19 See J.M.J. Louis, comte de Mas-Latrie, *Trésor de chronologie*, Paris, 1889, pp. 18-24. See also A. Giry, *Manuel de diplomatique*, Paris, 1894, p. 114 (repr. New York, 1967).

20 In Poitou, during the Middle Ages, the year began either on 25 March (Annunciation), or on Easter day, which sometimes falls in the month of March. *Ibid.*, pp. 107, 115.

21 Comte de Mas-Latrie, *Trésor de chronologie*, p. 22, says that at Amiens in the twelfth century, the year began the day before Easter, the day of the benediction of the paschal candle. Thus, we must suppose either that this was no longer the case in the thirteenth century, or that the signs had been incorrectly placed.

22 Wandalbert, monk of Prüm: L. d'Achéry, *Spicilegium collection scriptorum*, Paris, 1723, II, p. 57. [*Monumenta germaniae historica, Poetae latini medii aevi*, Munich, 1884, II, pp. 604-616.]

23 A.-N. Didron, "La Cathédrale de Reims, Occupations mensuelles et arts libéraux," *Annales archéologiques*, 14 (1854), p. 27, n.2. At Notre-Dame of Paris, the sign of Aquarius is not, in fact, visible at first glance, for it forms a part of the relief in the next arcature, which represents the sea mounted on a fish. But if one looks closely, it can be seen very clearly (fig. 30).

24 Giry, *Manuel de diplomatique*, p. 114.

25 [See W. Stubbs, ed., *The Historical Works of Gervase of Canterbury*, 2 vols., London, 1879-1880.]

26 See Cahier, "Calendriers," *Caractéristiques des saints dans l'art populaire*, I, p. 159.

27 Amiens (portal) [G. Durand, *Monographie de l'église Notre-Dame cathédrale d'Amiens*, Amiens and Paris, 1901, I, pl. xliii, fig. 42]; Chartres (old portal, north porch) [Houvet, *Cathédrale de Chartres; Portail nord*, II, pl. 77; *idem, Cathédrale de Chartres; Portail occidental ou Royal*, Chelles, 1919, pl. 33]; Notre-Dame of Paris (rose window). Many Psalters: especially Paris, Bibl. Nat., mss. lat. 1328, 238, 320, 828, 1394; Psalter of St. Louis (Paris, Bibl. de l'Arsenal, ms. 1186); Paris, Bibl. Ste.-Geneviève, mss. 2200, 2690. [For Paris, Bibl. Nat., ms. lat. 1328, see *Manuscrits à peintures*, no. 70 and V. Leroquais, *Les Psautiers latins des bibliothèques publiques de France*, II, Macon, 1941, no. 318. For Paris, Bibl. Nat., ms. lat. 238, see *ibid.*, no. 282. For Book of Hours from north of France (Paris, Bibl. Nat., ms. lat. 1394), see *Manuscrits à peintures*, no. 91 and V. Leroquais, *Les Livres d'heures manuscrits des bibliothèques publiques de France*, Paris, 1927, I, p. 225. For Paris, Bibl. de l'Arsenal, ms. 1186, see Leroquais, *Psautiers*, II, no. 255; for Paris, Bibl. Ste.-Geneviève, ms. 2690, see *ibid.*, no. 382.]

28 Isidore of Seville, *Etymologiarum*, v, xxxiii, Migne, *P. L.*, 82, col. 219: . . . *bifrons idem Janus pingitur ut introitus anni et exitus demonstretur.*

29 Portal of St.-Denis [S. McK. Crosby, *L'Abbaye royale de Saint-Denis*, Paris, 1953, pl. 23]; window at Chartres, south aisle of choir [Delaporte and Houvet, *Les Vitraux de la cathédrale de Chartres*, I, pl. xlviii]; Psalter from Paris (Paris, Bibl. de l'Arsenal, ms. 1186); Psalter (Paris, Bibl. Nat., ms. lat. 238). [See note 27.]

30 Window at Chartres [Delaporte and Houvet, *Les Vitraux de la cathédrale de Chartres*, I, pl. xlviii]; Franciscan Psalter (Paris, Bibl. Nat., ms. lat. 1076) [*Manuscrits à peintures*, no. 81]. I have not found that the sculptors adopted the invention of the painters.

31 Paris, Bibl. Nat., ms. lat. 320.

32 This is also true of the zodiac of the west rose window. [Aubert, *Notre-Dame de Paris, architecture et sculpture*, pl. 38, fig. 3. Cf. L. Pressouyre, " 'Marcius Cornator'; Note sur un groupe de représentations médiévales du mois de mars," *Mélanges*

33 Chartres, zodiac of the north porch. [Houvet, *Cathédrale de Chartres; Portail nord*, II, pl. 79.]

34 Psalter (Paris, Bibl. Nat., ms. lat. 238) twelfth century. At Soissons, in the late Middle Ages, the young men named a "prince de la jeunesse" (prince of youth) in the month of April: C. Dormay, *Histoire de la ville de Soissons*, Soissons, 1663-1664, VI, xxvi; the figure for the month of April, as the artists conceived it, often seems to be this "prince of youth." See the month of April at Rampillon (fig. 43).

35 Reims, west façade, central portal, left jamb. [H. Reinhardt, *La Cathédrale de Reims*, Paris, 1963, pl. 30.]

36 Miniatures almost always show a horseman. The baron on horseback is shown on the old portal [Houvet, *Cathédrale de Chartres; Portail occidental*, pl. 37] and in the window at Chartres [Delaporte and Houvet, *Les Vitraux de la cathédrale de Chartres*, I, pl. XLVIII], the portal at Semur, the portal at Rampillon (fig. 43). At Senlis, he holds his horse by the bridle.

37 Chartres, on the two portals [Houvet, *Cathédrale de Chartres; Portail occidental*, pl. 36; *idem, Portail nord*, II, pl. 81]. Notre-Dame of Paris, portal [Aubert, *Notre-Dame de Paris*, pl. 38.1]; the figure in the rose window at Notre-Dame of Paris is a restoration. Senlis, portal.

38 North porch. [Houvet, *Cathédrale de Chartres; Portail nord*, II, pl. 82.]

39 Paris, Bibl. Nat., ms. lat. 320.

40 *Image du monde* (Paris, Bibl. Ste.-Geneviève, ms. 2200), thirteenth century.

41 At Notre-Dame of Paris, the sign of Leo was mistakenly placed in June. [For a discussion of these misplacements, see Hinkle, "The Cosmic and the Terrestrial Cycles on the Virgin Portal of Notre-Dame," pp. 290-291.]

42 Rose window of Notre-Dame of Paris; manuscripts. At Amiens, he is fully dressed. [Durand, *Monographie de l'église de Notre-Dame cathédrale d'Amiens*, pl. XLIV, p. 51.]

43 Arcisse de Caumont had already posed this question at the Congrès des Sociétés Savantes de Paris, in 1857: does the study of zodiacs indicate changes in the seasons of harvesting and sowing? A. de Caumont, "Un Mot sur quelques questions archéologiques traitées à Paris au congrès des délégués des sociétés savantes, session de 1857," *Bulletin monumental*, 23 (1857), p. 268. Only the grape harvest seems to have been somewhat earlier. [Cf. *ibid.*, p. 275.]

44 Notre-Dame of Paris, rose window.

45 For example, the portal of Notre-Dame of Paris: unfortunately, the relief has been badly damaged (fig. 49).

46 Window [Delaporte and Houvet, *Les Vitraux de la cathédrale de Chartres*, vol. I, pl. 50] and old portal [Houvet, *Cathédrale de Chartres; Portail occidental*, pl. 80]. It is the same in manuscripts: Paris, Bibl. Nat., mss. lat. 1077, 238, 320 and Hours from the north of France (Paris, Bibl. Nat., ms. lat. 1394). [See note 27.]

47 Paris, Bibl. Nat., ms. lat. 1077.

48 Hours from the north of France (Paris, Bibl. Nat., ms. lat. 1394). [See above, n. 46.]

49 Chartres, old portal [Houvet, *Cathédrale de Chartres, Portail occidental*, pl. 35] and window [Delaporte and Houvet, *Les Vitraux de la cathédrale de Chartres*, I, pl. L]; Breviary of St. Louis (Paris, Bibl. de l'Arsenal); Paris, Bibl. Nat., mss. lat. 320, 238.

50 In the Middle Ages, the occupations of each month were summarized in four well-known verses:

Poto, ligna cremo, de vite superflua demo;

Do gramen gratum, mihi flos servit, mihi pratum;

Foenum declino, messes meto, vina propino

Semen humi jacto, mihi pasco suem, immolo porcos.

(I drink, I burn [fire]wood, I prune the vine,

I enjoy the pleasing grass, the flowers serve me, the meadow serves me,

I store the hay, I reap the harvest, I make the wine,

I sow seed on the ground, I fatten the sow, I roast the pigs.)

[For these verses, see O. Koseleff, *Die Monatsdarstellungen der französischen Plastik des 12. Jahrhunderts*, Basel, 1934, p. 69. For their incorrect attribution to Bede by L. Biadene, see Stern, "Poésies et représentations carolingiennes et byzantines des mois," p. 144.]

51 St. Augustine, *De ordine*, II, xii, Migne, *P. L.*, 32, col. 1011. [For recent studies, see E. R. Curtius, *European Literature and the Latin Middle Ages*, tr. W. R. Trask (Bollingen Series, xxxvi), New York, 1953, pp. 36ff.; A. Katzenellenbogen, "The Representation of the Seven Liberal Arts," *Twelfth-Century Europe and the Foundations of Modern Society*, eds. M. Clagett and others, Madison, Wisc., 1961, pp. 39-55.]

52 St. Augustine said that, at Milan, he had written six books on Music and one book on Grammar; he added that later he had composed treatises on Rhetoric, Geometry, Arithmetic, and Philosophy. See Augustine, *Retractationum libri duo*, I, vi, Migne, *P. L.*, 32, col. 591.

53 The attribution to Boethius of the *Ars geometria* has been questioned. [Boethius, *Euclidis Megarensis geometriae*, I-II, Migne, *P. L.*, 63, cols. 1307-1364. For the placement of the *De geometria* at the close of the transitional period in Boethius' work, see A. P. McKinlay, "Stylistic Tests and the Chronology of the Works of Boethius," *Harvard Studies in Classical Philology*, 18 (1907), pp. 123-156. On the survival of Boethius in the Middle Ages, see H. R. Patch, *The Tradition of Boethius, A Study of His Importance in Medieval Culture*, New York, 1935.]

54 Cassiodorus, Migne, *P. L.*, 70, cols. 1149-1220. [See also L. W. Jones, "The Influence of Cassiodorus on Medieval Culture," *Speculum*, 20 (1945), pp. 433-442.]

55 Isidore of Seville, *Etymologiarum*, I-III, Migne, *P. L.*, 82, cols. 73-184.

56 See the frescoes of the Liberal Arts painted by Botticelli for the Villa Lemmi, now in the Louvre. [L. Venturi, *Botticelli*, Vienna, 1937, illus. p. 18; D. Formaggio, *Botticelli*, London, 1961, pl. xxxiii.]

57 See Viollet-le-Duc, *Dictionnaire raisonné de l'architecture français du XIe au XVe siècle*, 10 vols., Paris, 1858-1868, vol. II, p. 3,

fig. 3. Martianus Capella, III, 223. Teubner edition, 1866. [*Martianus Capella*, ed. F. Eyssenhardt (B. G. Teubner, publisher), Leipzig, 1866. See now: *Martianus Capella*, ed. A. Dick, Leipzig, 1925, pp. 82-83.]

58 *Ibid.*, IV, 328. [Ed. Dick, p. 152.]

59 The commentary by Remi of Auxerre on Martianus Capella was published by E.-F. Corpet, "Portraits des arts libéraux d'après les écrivains du moyen âge. Cinquième siècle: Martianus Capella, commenté au neuvième par Remi d'Auxrre," *Annales archéologiques*, 17 (1857), pp. 89-103. [Remi's commentary has recently been re-edited by C. E. Lutz, *Remigii Autissiodorensis commentum in Martianum Capellam*, Leyden, 1962.]

60 Martianus Capella, V, 426. [Ed. Dick, pp. 210-211.]

61 *Ibid.*, VI, 580 and 587. [Ed. Dick, p. 289.]

62 *Ibid.*, VII, 729. [Ed. Dick, p. 365.]

63 *Ibid.*, VIII, 811. [Ed. Dick, pp. 428-429.]

64 *Ibid.*, IX, 909. [Ed. Dick, p. 480.]

65 Gregory of Tours, *Historia Francorum*, last chapter. [x, xxxi, Migne, *P. L.*, 71, col. 572. For translations, see Gregory of Tours, *Histoire des Francs*, tr. F. Latouche, Paris, 1965, II, p. 325, or *idem, The History of the Franks*, tr. O. M. Dalton, Oxford, 1927, II, p. 477.]

66 L. Delisle, *Le Cabinet des manuscrits de la Bibliothèque impériale*, Paris, 1868-1881, II, pp. 431, 445, 447, 454, 477, 530, 546 (St.-Amand, Cluny, Corbie, St.-Pons-de-Thomières, etc.); III, p. 57 (catalogue of the old Bibliothèque de la Sorbonne). Martianus Capella was included in the chapter library of Rouen in the twelfth century: C. de Linas, "Le Trésor et la bibliothèque de l'église métropolitaine de Rouen, au XIIe siècle," *Revue de l'art chrétien*, 36 (1886), pp. 455-467; he is mentioned twice in the old catalogue of books belonging to the chapter of Bayeux: E. Deslandes, "Le Trésor de l'église Notre-Dame de Bayeux," (also "L'Inventaire"), *Bulletin archéologique du Comité des travaux historiques et scientifiques*, 1896, p. 422. He is mentioned three times in the library of the popes of Avignon: M. Fauçon, *La Librairie des papes d'Avignon*, Paris, 1886, I, p. 185, and II, pp. 42, 94.

67 Theodulf, *Carmina*, IV, ii, *De Septem liberalibus artibus in quadam pictura depictis*, Migne, *P. L.*, 165, col. 333.

68 Alain de Lille, born about 1128, died in 1202 at Cîteaux. See B. Hauréau, "Mémoire sur la vie et quelques oeuvres d'Alain de Lille," *Mémoires de l'Académie des inscriptions et belles-lettres*, 37 (1886), pt. 1, pp. 1-27. See also M. Brial, "Alain de Lille, surnommé le docteur universel. Histoire de sa vie," *Histoire littéraire de la France*, 16 (1824), pp. 396-425. [See also M. T. d'Alverny, *Alain de Lille, Textes inédits avec une introduction sur sa vie et ses oeuvres*, Paris, 1965.]

69 In Dante, everything is more vivid: Science is Virgil, Theology is Beatrice. [For a discussion of wisdom as a unique emanation from God, see M. T. d'Alverny, "La Sagesse et ses sept filles. Recherches sur les allégories de la philosophie et des arts libéraux du IXe au XIIe siècle," *Mélanges dediées à la mémoire de Felix Grat*, Paris, 1946, I, pp. 245-278.]

70 Alain de Lille, *Anticlaudianus*, II, vii, Migne, *P. L.*, 210, col. 506. [For a fourteenth-century illustrated text of the *Anticlaudianus*, see F. Mütherich, "Ein Illustrationzyklus zum Anticlaudianus des Alanus ab Insulis," *Münchner Jahrbuch der bildenden Kunst*, 2 (1951), 3rd ser., pp. 73-88.]

71 In Alain de Lille, we find for the first time the serpent replaced by a scorpion. And we find several examples of this in art.

72 *Anticlaudianus*, III, ii, Migne, *P. L.*, 210, col. 512.

73 *Ibid.*, III, iv, Migne, *P. L.*, 220, col. 514.

74 *Ibid.*, III, v, Migne, *P. L.*, 220, col. 516.

75 *Ibid.*, III, vi, Migne, *P. L.*, 220, col. 518. Alain de Lille translated "*radius*," the word used by Martianus Capella, not by "compass" but by "measuring rule." The same interpretation is found in Remi of Auxerre, who changed "*radium*" to "*virgam geometricalem*" (geometer's ruler).

76 We should also mention the Latin poem by Baudri, abbot of Bourgueil (written before 1107), published by L. Delisle, "Poème adressé à Adèle, fille de Guillaume le Conquérant par Baudri, Abbé de Bourgueil," *Mémoires de la Société des anti-*

quaires de Normandie, 8 (1870), pp. 187-224. In describing the chamber of Countess Adele, daughter of William the Conqueror, the poet supposed that her bed was decorated with figures of the Liberal Arts. He borrowed a great many details from Martianus Capella. [See P. Abrahams, ed., *Les Oeuvres poétiques de Baudri de Bourgueil*, Paris, 1926, pp. 221-228, 249-253.]

77 [See L. J. Paetow, *The Battle of the Seven Arts, A French Poem by Henri d'Andeli, Trouvère of the Thirteenth Century*, Berkeley, 1914, and Henri d'Andeli and Jean le Teinturier, *La Bataille et le mariage des sept arts, Pièces diverses du XIIIe siècle*, ed. A. Jubinal, Paris, 1838.]

78 *Erec et Enide* (Paris, Bibl. Nat., ms. fr. 1376, fol. 143). [See *Erec et Enide, roman traduit de l'ancien français d'après l'édition de Mario Roques*, tr. R. Louis, Paris, 1954.]

79 Old portal, right door. [Houvet, *Cathédrale de Chartres: Portail occidental*, pls. 61-71. See also Katzenellenbogen, *Sculptural Programs of Chartres*, pp. 15-22.]

80 Laon, façade, on the archivolts of the left window (second band). It would be very difficult to study these figures had they not been reproduced by E. E. Viollet-le-Duc, "Arts libéraux," *Dictionnaire raisonné de l'architecture française du XIe au XVIe siècle*, Paris, 1861, II, pp. 5-8. [See L. Broche, *La Cathédrale de Laon*, Paris, 1926, ill. p. 75.] At Laon, one window (north rose) is still devoted to the Liberal Arts. It has been restored. Reproduced by Martin and Cahier, *Mélanges d'archéologie*, 4 (1856), pl. VIII. See also, Florival and Midoux, *Les Vitraux de la cathédrale de Laon*, II, pp. 47-72.

81 See the comprehensive study by J. A. Clerval, *Les Ecoles de Chartres au moyen âge du Ve au XVIe siècle* (Mémoires de la Société archéologique d'Eure et Loire, XI), Chartres, 1895. [See also R. Klibansky, "The School of Chartres," *Twelfth-Century Europe and the Foundations of Modern Society*, ed. M. Clagett and others, Madison, Wisc., 1961, pp. 3-15. For a general study of the twelfth-century schools, see G. M. Paré, A. Brunet, and P. Tremblay, *La Renaissance du XIIe siècle, Les écoles et l'enseignement*, Paris and Ottawa, 1933.]

82 Cited by John of Salisbury in his *Me-*

talogius, III, iv, Migne, *P. L.*, 199, col. 900. [See R. Klibansky, "Standing on the Shoulders of Giants," *Isis*, 26 (1936), pp. 147-149.]

83 Late eleventh century.

84 *De vita sua sive monodiarum*, III, iv, Migne, *P. L.*, 156, col. 912.

85 On Anselm of Laon, see "Onzième siècle. Etat de lettres en France pendant ce siècle," *Histoire littéraire de la France*, 7 (1746), pp. 89-90, 149.

86 These events took place in 112; Anselm died in 1117.

87 Carved on the west façade, right portal (badly damaged) [see C. Porée, *La Cathédrale d'Auxerre*, Paris, 1926, pp. 46-49] and painted on the rose of a choir window. The window was published by C. Cahier and A. Martin, *Monographie de la cathédrale de Bourges*, pt. I, *Vitraux du XIIIe siècle*, Paris, 1844, II, pl. XVII.

88 "Douzième siècle. Etat des lettres en France dans le cours de ce siècle," *Histoire littéraire de la France*, 9 (1750), p. 43.

89 Sens: west façade, central portal (reproduced in Viollet-le-Duc, *Dictionnaire raisonné*, II, pp. 3-4); Rouen: 'Portail des Libraires, trumeau (the series is mutilated and incomplete); Clermont: north façade, in the upper part (rose of the gable); Soissons: window in the apse.

90 Bull of 1231. See P.C.F. Daunou, "Discours sur l'état des lettres en France au XIIIe siècle," *Histoire littéraire de la France*, 16 (1824), p. 48.

91 Viollet-le-Duc, *Dictionnaire raisonné*, II, p. 8. Many representations of the Liberal Arts have disappeared. They were to be seen on the paving of St.-Rémi at Reims, the church of St.-Irénée at Lyon, and the cathedral of St.-Omer. See L. Deschamps de Pas, "Essai sur le pavage des églises (St. Omer)," *Annales archéologiques*, 11 (1851), p. 70.

92 This was already the case on the old portal of Chartres, where there is one of the earliest extant carved figures of Grammar (fig. 55). The tradition was still faithfully followed in the fifteenth century (fresco of Le Puy). [These frescos have been reproduced by Y. Bonnefoy and P. Devinoy, *Peintures murales de la France gothique*,

Paris, 1954, pls. 108-119.] On the Auxerre portal (fig. 53), the figures of the children are damaged.

93 The serpent, both at Laon and at Auxerre, is placed like a belt around the waist of Dialectic. On the Auxerre window, Dialectic, who is easily recognizable by the serpent around her waist, has been mistakenly called "Alimetica," or Arithmetic.

94 Paris, Bibl. Ste.-Geneviève, ms. 1041-1042, fol. lv. On the portal of Déols (Indre), she already had the sword and shield as attributes. [See J. Hubert, "L'Abbatiale Notre-Dame de Déols," *Bulletin monumental*, 86 (1927), p. 51, and A. Boinet, *Les Manuscrits à peintures de la Bibliothèque Sainte-Geneviève* (Bulletin de la Société française de réproductions de manuscrits à peintures, 5e année), Paris, 1921, pl. IX.]

95 At Auxerre, she is mistakenly called "[di]alectica." We have seen that Dialectica is, in return, called "Alimetica."

96 Manuscript of the *Hortus deliciarum*. Traced copy in the Cabinet des Estampes, in the Fonds Bastard collection. The original, which had been at Strasbourg, was burned during the bombardment of 1870. [See Herrad of Landsberg, *Hortus deliciarum*, ed. J. Walter, Strasbourg and Paris, 1952, pl. LX.]

97 Cathedral of Clermont. Window of the St.-Piat chapel at Notre-Dame of Chartres. Manuscripts: *Image du monde* (Paris, Bibl. Nat., ms. fr. 574, fol. 28), fourteenth century; *Image du monde* (Paris, Bibl. Ste.-Geneviève, ms. 2200, fol. 58v), thirteenth century. Window at Soissons.

98 *Hortus deliciarum* [ed. Walter, pl. IX] and *Image du Monde* (Paris, Bibl. Ste.-Geneviève, ms. 2200, fol. 58v).

99 Base of portal, first row, third figure. [Viollet-le-Duc, *Dictionnaire raisonné*, II, p. 3, fig. 2.]

100 On the old portal of Chartres [Houvet, *Cathédrale de Chartres: Portail occidental*, pl. 67] and the window of Laon, as in the manuscript of the *Hortus deliciarum* [ed. Walter, pl. IX], Astronomy, with eyes raised to the sky, holds a bushel measure (the attribute can no longer be seen at Chartres). Was this to be used for studying the stars by reflection, as Viollet-le-Duc

thought? [Viollet-le-Duc, *Dictionnaire raisonné*, II, p. 8.] Or does it recall that Astronomy fixes the season for sowing, as Bulteau thought? Bulteau, *Monographie de Chartres*, II, p. 77. We have not been able to find a text, and in the absence of one it is difficult to decide. [The "broken line" on the disk held by Astronomy must represent the alidade of the medieval astrolabe, used for sighting the stars particularly in regard to important dates of the year. For a description of its history, see H. Michel, *Traité de l'astrolabe*, Paris, 1947, esp. pl. III, and A. C. Crombie, *Medieval and Early Modern Science*, Garden City, N.Y., 1959, I, esp. pp. 91-95, pls. III, IV, XI. At Sens, Astronomy holds the "disk" from the top with the alidade in front of her eyes, as though she were sighting the stars. See L. Bégule, *La Cathédrale de Sens*, Lyon, 1929, p. 36, who identified the alidade. In the *Hortus deliciarum*, the object held in Astronomy's left hand might well be a cylindrical brass vessel as used in Witelo's experiments for determining the angles of refraction of light passing between air, water, and glass. See A. C. Crombie, *Robert Grosseteste and the Origins of Experimental Science*, Oxford, 1953, pp. 220ff.]

101 On the portal of Auxerre and on the famous bronze candelabrum of the cathedral of Milan (thirteenth century), Music is represented playing the zither. These are exceptions. [For the candelabrum, see O. Homburger, *Der Trivulzio-Kandelaber; ein Meisterwerk frühgotischer Plastik*, Zurich, 1949, pl. 14.]

102 There are innumerable examples. We cite only the following: Psalter for the use of Senlis (Paris, Bibl. Ste.-Geneviève, ms. 2689, fol. 124), thirteenth century, and Psalter for the use of Paris (Paris, Bibl. Ste.-Geneviève, ms. 2690, fol. 99), thirteenth century. [Leroquais, *Psautiers*, II, nos. 381 and 382, pp. 155ff.]

103 Vincent of Beauvais, *Speculum doctrinale*, XVI, XXV. [Graz ed., II, 1518.]

104 The reliefs of the façade of the cathedral of Reims (left portal, jambs), which Didron took as representations of the Liberal Arts are very obscure: Didron, "La Cathédrale de Reims, Occupations mensuelles et arts libéraux," pp. 25-32. It seems very likely to me that these numerous figures who, it is true, seem to meditate but have no clear attributes, symbolize the sciences. C. Cerf, *Histoire et description de Notre-Dame de Reims*, Reims, 1861, II, p. 102, expresses legitimate doubts.

105 Isidore of Seville, *Etymologiarum*, I, vi, Migne, *P. L.*, 82, col. 82.

106 J. A. Clerval, "L'Enseignement des arts libéraux, à Chartres et à Paris, dans la première moitié du XIIe siècle, d'après l'Heptateuchon de Thierry de Chartres," *Congrès scientifique international des catholiques*, I (1888), pp. 277-296. [Clerval notes that only the first two chapters of Donatus' works appear in the second edition of the *Heptateuchon*, and concludes that Thierry stopped the copying of Donatus because of doubts about the merit of the writings: *ibid.*, p. 284.]

107 G. Vasari, *Le vite de' piu eccellenti pittori, scultori ed architettori*, ed. G. Milanesi, Florence, 1878, I, p. 581. [Repr. ed., 1906; English translation by G. du C. de Vere, 10 vols., London, 1912-1915.] On such a point, Vasari is not altogether trustworthy. By the sixteenth century, the medieval tradition had for the most part been forgotten.

108 See Prosper Merimée's report on the paintings of Le Puy, which he himself had discovered: P. Merimée, "Les Arts libéraux au Puy," *Annales archéologiques*, 10 (1850), pp. 287-290. [See also Bonnefoy and Devinoy, *Peintures murales*, pls. 108 and 114.]

109 See Clerval, *Les Ecoles de Chartres*, p. 232.

110 Alain de Lille, *Anticlaudianus*, III, ii, Migne, *P. L.*, 210, col. 513.

111 Isidore of Seville, *Etymologiarum*, II, xxii, Migne, *P. L.*, 82, col. 140.

112 See B. Hauréau, *Histoire de la philosophie scolastique*, I, Paris, 1872, pp. 245-389 [Repr. in B. Franklin, *Research and Source Work*, ser. no. 115, New York, 1966]; and V. Cousin, "Abelard," *Fragments philosophiques, philosophie scolastique*, Paris, 1840 (2nd ed.), pp. 70-71. [For Cousin's view that Abelard also knew the *Isagoge* of Porphyry from the *Organon*, see *idem*, "Introduction," *Ouvrages inédits d'Abélard, pour servir à l'histoire de la philosophie scolastique en France*, Paris, 1836, pp. l-lvi.]

113 See Clerval, *Les Ecoles de Chartres*, p. 222. The date of 1142 given by Clerval for the composition of the *Heptateuchon* seems fairly well established. [See also Taylor, *The Medieval Mind*, II, pp. 363-364, ns. 108-109.]

114 On the probable date of the old portal of Chartres, on which the figures must have been carved about 1145, see R. de Lasteyrie, *Etudes sur la sculpture française du moyen âge*, Paris, 1902, chap. VII. See also the articles by M. Lanore, "Reconstruction de la façade de la cathédrale de Chartres au XIIe siècle, étude chronologique," *Revue de l'art chrétien*, 10 (1899), pp. 328-335 and 11 (1900), pp. 32-39. [See Katzenellenbogen, *Sculptural Programs of Chartres*, pp. 5, 106, and A. Lapeyre, *Des Façades occidentales de Saint-Denis et de Chartres aux portails de Laon*, Paris, 1960, p. 27.]

115 Cassiodorus, *De artibus ac disciplinis liberalium litterarum*, V, Migne, *P. L.*, 70, col. 1208.

116 Isidore of Seville, *Etymologiarum*, III, xvi, Migne, *P. L.*, 82, col. 163.

117 *Ibid.*, III, xvi, Migne, *P. L.*, 82, cols. 169-170.

118 Alain de Lille, *Anticlaudianus*, I, iv, Migne, *P. L.*, 210, col. 491.

119 Clerval, *Les Ecoles de Chartres*, pp. 169, 171, 190, 223.

120 Alain de Lille, *Anticlaudianus*, III, vii, Migne, *P. L.*, 210, col. 520.

121 Vasari, *Vite*, ed. Milanesi, I, p. 582.

122 Isidore of Seville, *Etymologiarum*, III, ii, Migne, *P. L.*, 82, col. 155.

123 Vincent of Beauvais, *Speculum doctrinale*, XVI, v. [Graz ed., II, 1506.]

124 Martianus Capella, VII. [Ed. Dick, p. 366.]

125 We have seen, however, that Peter Comestor and Vincent of Beauvais favored Tubal as the inventor of music.

126 Isidore of Seville, *Etymologiarum*, III, ii, Migne, *P. L.*, 82, col. 155.

127 Clerval, *Les Ecoles de Chartres*, pp. 236-238.

128 North portal.

129 Sens, west portal [W. Sauerländer, *Gothic Sculpture in France 1140-1270*, London, 1972, pl. 59]; Laon, west façade, left window; archivolts.

130 Viollet-le-Duc, *Dictionnaire raisonné*, II, p. 5, fig. 6.

131 Boethius, *De consolatione Philosophiae*, I, i, Migne, *P. L.*, 63, cols. 587-590. This is the text:

> . . . *adstitisse mihi supra verticem visa est mulier reverendi admodum vultus, oculis ardentibus et ultra communem hominum valentiam perspicacibus colore vivido atque inexhausti vigoris, quamvis ita aevi plena foret ut nullo modo nostrae crederetur aetatis, statura discretionis ambiguae. Nam nunc quidem ad communem sese hominum mensuram cohibebat, nunc vero pulsare caelum summi verticis cacumine vicebatur; quae cum altius caput extulisset, ipsum etiam caelum penetrabat respicientiumque hominum frustrabatur intuitum. Vestes erant tenuissimis filis subtili artificio, indissolubili materia perfectae quas, uti post eadem prodente cognovi, suis manibus ipsa textuerat. Quarum speciem, veluti fumosas imagines solet, caligo quaedam neglectae vetustatis obduxerat. Harum in extrema margine · π · Graecum, in supremo vero · θ · legebatur intextum. Atque inter utrasque litteras in scalarum modum gradus quidam insigniti videbantur quibus ab inferiore ad superius elementum esset ascensus. Eandem tamen vestem violentorum quorundam sciderant manus et particulas quas quisque potuit abstulerant. Et dextera quidem ejus libellos, sceptrum vero sinistra gestabut.*

[For Latin and English translation in text, see Boethius, *The Consolation of Philosophy*, tr. "I.T.," ed. H. F. Stewart (Loeb Classical Library, VII), London and New York, 1918, pp. 130-133.]

132 Description of Notre-Dame of Paris by a bishop martyr of Arzendjân in Greater Armenia; published in A. N. Didron, "Mélanges: Statuaire de Notre-Dame de Paris au XVe siècle," *Annales archéologiques*, I (1844), pp. 100-102. [This text does mention that the throne of Christ was covered with golden plaques and that the figures of the Virgin and of the blessed were painted, but there is no mention of a "golden background."]

133 Viollet-le-Duc, *Dictionnaire raisonné*, II, p. 3, fig. 3.

134 See Delisle, *Le Cabinet des manuscrits*, I, pp. 510, 512; II, pp. 429, 447, 448, 492, 495, 511, 525, 530, 547, 549; III, pp. 5, 6, 22, 38, 40, 41, 59, 60, 61, 73. (Ten copies of Boethius at the Sorbonne.) See also Fauçon, *La Librairie des papes d'Avignon*, I, p. 70 and II, p. 135. Concerning the cathedral of Laon, in particular, we are certain that Boethius was in the library of the chapter in the tenth century. See the *Catalogue général des manuscrits des bibliothèques publiques des départements*, Paris, 1849, I, p. 232, no. 439. See also B. de Montfaucon, *Bibliotheca bibliothecarum manuscripta nova*, Paris, 1739, II, p. 1292.

135 Alain de Lille borrowed several details from Boethius in his description of Philosophy, or "Prudentia." In *Anticlaudianus*, I, vii, Migne, *P. L.*, 210, col. 494, he says:

Canone sub certo dimensio nulla retardat
Corporis excursum, vel certo fine
 refrenat,
Nunc magis evadens coelestia vertice
 pulsat,
Nunc oculos frustrans coelestibus
 insidet, ad nos
Nunc redit. . . .

(No dimensions with fixed standard
 restrain
The expanse of her body or check it
 with a fixed bound;
At one time moving yet further
 outward, she strikes the heavenly
 bodies on high;
At another, evading all eyes, she sits
 amid the heavenly bodies;
At another, she returns to our side. . . .)

136 West façade, main portal. [Left side.]

137 West façade, archivolt of north window, and rose window of north transept. [See Broche, *La Cathédrale de Laon* (2nd ed.), pp. 43-44, 60.]

138 Rose window. [Second window to the right of central window of choir; see Porée, *La Cathédrale d'Auxerre*, pp. 80-81.]

139 West façade, right portal, door jamb. Medicine is placed with the figures of the Vices; consequently it had not been identified. [P. Vitry, *La Cathédrale de Reims*, Paris, 1919, I, pl. XIV.]

140 I think that Architecture also is shown on the façade of Laon: it is symbolized by a man with a board on his knees, who seems to be tracing a drawing. [For the identification of this figure as Painting, see Viollet-le-Duc, *Dictionnaire raisonné*, II, pp. 6-7, fig. 12.]

141 The trades are represented in almost the same way at Reims, north portal, archivolts of the rose window: Tubalcain is at the forge, Jabal is in his tent, etc. This is also true at the Campanile in Florence.

142 Didron, *Manuel d'iconographie chrétienne*, p. 408n. The theme of the ages of life was not unknown, however, in our French iconography of the Middle Ages. I believe they are represented on the left portal (west façade) of Notre-Dame of Paris, on the right side of the trumeau. Beginning with adolescence, there are six ages ("Infantia" is missing). [See also Hinkle, "The Cosmic and Terrestrial Cycles on the Virgin Portal at Notre-Dame," p. 287.]

143 L. Jourdain and A.-T. Duval, *Le Portail Saint-Honoré, dit de la Vierge, de la cathédrale d'Amiens*, Amiens, 1844.

144 The miniature was published by H.L.G. de Saint-Laurent, *Guide de l'art chrétien, études d'esthétique et d'iconographie*, Paris, 1873, III, p. 346.

145 *Album de Villard de Honnecourt*, pl. XLI [ed. Hahnloser, pl. 42]. The principal Wheels of Fortune have been listed by G. Heider, "Das Glücksrad und dessen Anwendung in der christlichen Kunst," *Mitteilungen der kaiserlich und königlich Zentral-Kommission* (Vienna), May, 1859, pp. 113-124. [On the Wheel of Fortune, see V. Beyer, "Rosaces et roues de fortune à la fin de l'art roman et au début de l'art gothique," *Zeitschrift für schweizerische Archäologie und Kunstgeschichte* (Festschrift für Hans Reinhardt), 22 (1962), pp. 34-43, pls. 10-11; A. Doren, "Fortuna im Mittelalter und in der Renaissance," *Vorträge der Bibliothek Warburg*, 2 (1922-1923), pp. 71-144; H. R. Patch, *The Tradition of the Goddess Fortuna*, Northampton, Mass., 1922; *idem*, *The Goddess Fortuna in Medieval Literature*, Cambridge, Mass., 1927.]

146 *Somme le Roi, Le Mireour du Monde, Manuscrit du XIVe siècle découvert dans*

les archives de la Commune de la Sarra (Mémoires et documents publiés par la Société d'histoire de la Suisse Romande, ed. F. Chavannes), Lausanne, 1846, IV, p. 67. [This volume reproduces the text of the *Mirror* version of the *Somme le Roi*. See R. Tuve, *Allegorical Imagery, Some Mediaeval Books and Their Posterity*, Princeton, 1966, pp. 57-143, *passim*. See also E. G. Millar, *An Illuminated Manuscript of La Somme le Roy, Attributed to the Parisian Miniaturist Honoré* (Roxburghe Club), Oxford, 1953, and *The Book of Vices and Virtues: A Fourteenth Century English Translation of the Somme le Roi of Lorens d'Orléans*, ed. H. Milford (Early English Text Society), Oxford, 1942.] In the twelfth century, an abbot of Fécamp, in order that the spectacle of human vicissitude would be constantly before the eyes of his monks, had a Wheel of Fortune constructed that was kept in movement mechanically. See C. de Beaurepaire, "Anciens inventaires du trésor de l'abbaye de Fécamp," *Bibliothèque de l'Ecole des Chartes*, 22 (1859), p. 154.

147 We shall see later on that the philosophers vaguely alluded to by Honorius of Autun are reduced to one: Boethius.

148 Honorius of Autun, *Speculum ecclesiae. Post Pentecosten, Dominica*, XI, Migne, *P. L.*, 172, col. 1057.

149 [Originally the name for a rhetorical figure. Cf. Curtius, *European Literature and the Latin Middle Ages*, p. 413.]

150 Boethius, *De Consolatione Philosophiae*, II: *Rotam volubile volubili orbe versamus, infima summis summa infiimis mutare gaudemus. Ascende si placet sed ea lege ne utique cum ludicri mei ratio poscet, descendere injuriam putes.* (I turn about my wheel with speed, and take a pleasure to turn things upside down. Ascend, if thou wilt, but with this condition, that thou thinkest it not an injury to descend when the course of my sport so requireth.) And: *Tu vero volventis rotae impetum retinere conaris?* . . .

> *Haec cum superba verterit vices dextra*
> *Et aestuantis more fertur Euripi,*
> *Dudum tremendos saeva proterit reges*
> *Humilemque victi sublevat fallax*
> *vultum.*

(Endeavorest thou to stay the force of the turning wheel? . . .

The pride of fickle fortune spareth none,
And, like the floods of swift Euripus borne,
Oft casteth mighty princes from their throne
And oft the abject captive doth adorn.)

[Boethius, *De Consolatione Philosophiae*, II, i, ii, Migne, *P. L.*, 163, cols. 666, 662-663. Translation from Boethius, *The Consolation of Philosophy* (Loeb Classical Library, VII), pp. 180-181, 176-177.] A passage from Alain de Lille, *Anticlaudianus*, VIII, i, Migne, *P. L.*, 210, col. 560, shows the way in which the Middle Ages took inspiration from Boethius, and outdid him. He is speaking of Fortune:

> *Praecipitem movet illa rotam, motusque laborem*
> *Nulla quies claudit.* . . .
>
>
>
> *Hos premit, hos relevat; hos dejicit, erigit illos.*
> *Summa rotae dum Cresus habet, tenet infima Codrus,*
> *Julius ascendit, descendit Magnus, et infra*
> *Sylla jacet, surgit Marius; sed cardine verso*
> *Sylla redit.* . . .

(She puts in motion the headlong wheel and no rest shuts off its straining movement. . . .

.

Some she oppresses, some relieves, some casts down, some raises up.
While Croesus has the top of the wheel, Codrus holds the bottom.
Caesar ascends, Pompey descends, and below
Sulla lies prostrate, Marius rises, yet with a turn of the pivot
Sulla returns. . . .)

151 The miniature from the *Hortus deliciarum* (twelfth century) reproduced here, shows Fortune placed outside the wheel and making it turn (fig. 61). In a late fifteenth-century manuscript of Boethius, a miniature represents the philosopher sitting in prison and talking with Philosophy, and beside them, Fortune and her wheel on which men rise and fall: *Boèce* of the Sieur de la Gruthuyse, reproduced by E. Molinier, *Les Mauscrits et les miniatures*, Paris, 1892, p. 288.

1 [Hermas, *Shepherd*, Vision III, viii. See *The Apostolic Fathers*, ed. and tr. Lake, II, pp. 46-49.]

2 Tertullian, *De spectaculis*, XXIX, Migne, *P. L.*, 1, col. 660. [Cf. ed. and tr. by T. R. Glover (Loeb Classical Library), London and Cambridge, Mass., 1953, pp. 296ff. On this subject, see A. Puech, *Prudence, étude sur la poésie latine chrétienne au IVe siècle*, Paris, 1888, p. 246.]

3 Prudentius, *Psychomachia*, Migne, *P. L.*, 60, cols. 19-90. [Cf. ed. and tr. by H. J. Thomson (Loeb Classical Library), London and Cambridge, Mass., 1949, I, pp. 274-343.]

4 [See H. Woodruff, "The Illustrated Manuscripts of Prudentius," *Art Studies*, 7 (1929), pp. 33-79; R. Stettiner, *Die illustrierten Prudentius-Handschriften*, Berlin, 1905; A. Katzenellenbogen, *Allegories of the Virtues and Vices in Medieval Art*, London, 1939; R. Tuve, "Notes on the Virtues and Vices," *Journal of the Warburg and Courtauld Institutes*, 26 (1963), pp. 264-303; Tuve, *Allegorical Imagery*, pp. 57-143.]

5 *Psychomachia*, vv. 22ff.

6 *Ibid.*, vv. 41ff.

7 This symbolic stone probably stands for Christ; the commentators interpreted it in this way.

8 *Psychomachia*, vv. 109ff.

9 *Ibid.*, vv. 178ff.

10 [*Ibid.*, vv. 311ff.]

11 *Ibid.*, vv. 455ff.

12 The verses (458-462) are worth quoting, because artists were inspired by them:
> . . . *nec sufficit amplos*
> *Implevisse sinus: juvat infercire*
> *crumenis*
> *Turpe lucrum, gravidos furtis*
> *distendere fiscos,*
> *Quos laeva celante tegit, laterisque*
> *sinistri*
> *Velat operimento.* . . .

(Nor is she content to fill her roomy pockets, but delights to stuff her base gain in money-bags and cram swollen purses to bursting with her pelf, keeping them in hiding behind her left hand under cover of her robe on the left

13 *Operatio* means of course "Works" or Charity. [*Ibid.*, v. 573.]

14 *Ibid.*, vv. 645ff.

15 [Cf. Theodulf, *Carmina*, VII, xii, Migne, *P. L.*, 55, cols. 365-366 and Walafrid Strabo, in *Monumenta germaniae historica, Poetae latini*, II, p. 408.]

16 [See Migne, *P. L.*, 210, cols. 564-574.]

17 Rutebeuf, *Oeuvres complètes de Rutebeuf trovère du XIIIe siècle recueillies et mises au jour pour la première fois*, ed. A. Jubinal, Paris, 1839, II, pp. 56-65. [Cf. *Oeuvres complètes de Rutebeuf*, eds. E. Faral and J. Bastin, 2 vols., Paris, 1959-1960.]

18 Isidore of Seville, *Sententiarum*, II, xxxvii, Migne, *P. L.*, 83, col. 638.

19 Paris, Bibl. de l'Arsenal, ms. 250.

20 Vincent of Beauvais, *Speculum historiale*, XXII, li-liii. [Graz ed., 1964, IV. 876-878, repr. of the Douai ed., 1624.]

21 Hugh of St. Victor, *Appendicis ad Hugonis opera dogmatica, De anima*, IV, Migne, *P. L.*, 177, cols. 185-188.

22 William of Auvergne, *De moribus*, Orléans ed., 1674, I, p. 119. [*Guilielmi Alverni opera omni Parisiis*, repr. ed. Frankfurt-am-Main, 1963.]

23 Paris, Bibl. Nat., ms. lat. 8318, fols. 49ff. [See Stettiner, *Prudentius-Handschriften*, pls. 1-18. Pls. 13, 14, 17, 18 ill. Vatican, Bibl. Apost., cod. reg. lat. 596, fols. 26r-27v, two missing leaves from the Paris ms.]

24 Paris, Bibl. Nat., ms. lat. 15158; e.g., observe Cupid throwing his dart, fol. 48v, and compare with Cupid, Bibl. Nat., ms. lat. 8318, fol. 58v. There is a complete study on the manuscripts with miniatures of Prudentius by Stettiner, *op. cit.*; a collection of illustrations accompany the text. Stettiner classified into families all the illustrated manuscripts of Prudentius belonging to European libraries. He also recognized that the Carolingian manuscripts were derived from a fifth-century original (pp. 152ff.). [Cf. n. 4, above.]

25 Traced copy in Paris, Bibl. Nat., Cab. des Estampes, cote A d 144a (Fonds Bastard). [Herrad of Landsberg, *Hortus deliciarum*, ed. J. Walter, pls. XXXII-XXXIII and eds. A. Straub and G. Keller, Strasbourg, 1879-1899.]

26 [L. Bréhier, "Les chapiteaux historiés de Notre-Dame-du-Port à Clermont," *Revue de l'art chrétien*, 5th ser., 42 (1912), pp. 260-262, figs. 10-12.]

27 [On the jambs of the Mantilius portal (north side of nave), see J. Warichez, *La Cathédrale de Tournai*, Brussels, 1934, I, pls. XV-XVII.]

28 N. X. Willemin, *Monuments français inédits*, Paris, 1839, pl. XLVII. [See also A. K. Porter, *Romanesque Sculpture of the Pilgrimage Roads*, Boston, 1923, VII, Parthenay: pls. 1048, 1050, 1051; Melle: pl. 1011; Civray: pls. 1122-1125.]

29 R. de Lasteyrie, "Etude archéologique sur l'église d'Aulnay," *Gazette archéologique*, 11 (1886), p. 286. [Cf. Porter, *op. cit.*, pls. 980, 984-985.]

30 See P. Deschamps, "Le combat des vertus et des vices sur les portails romans de la Saintonge et du Poitou," *Congrès archéologique*, 79 (1912), pt. 2, pp. 309-324. [Cf. Porter, *op. cit.*, VII, Fenioux: pls. 997-998; Saint-Pompain: pl. 1058.]

31 Some are still to be found in decorative art. On the so-called Crozier of Ragenfroy (probably twelfth century), see Willemin, *Monuments français inédits*, pl. XXX, and F. de Mély, "La crosse dite de Ragenfroid," *Gazette archéologique*, 13 (1888), pp. 109-123. Discord's tongue is pierced by a lance, as in Prudentius' text. [This crozier is now in the Bargello, Florence. See Swarzenski, *Monuments of Romanesque Art*, p. 76 and figs. 451-452; Cahier and Martin, *Mélanges d'archéologie*, IV, pp. 213ff. and fig. 84; Cahier and Martin, *Nouveaux mélanges d'archéologie*, I, p. 6.] On the ivory of Melissenda [now in London, British Museum] (twelfth century), see Cahier and Martin, *Nouveaux mélanges d'archéologie*, I, pp. 2-9 and pl. I, we notice the same detail and others of the same kind (Sobriety breaks Lust's teeth, etc.). [Cf. Katzenellenbogen, *Allegories of the Virtues and Vices*, p. 9 and fig. 7.]

32 West façade, left portal. [See Katzenellenbogen, *op. cit.*, p. 19 and Sauerländer, *Gothic Sculpture in France 1140-1270*, pls. 70-71.]

33 They have been carefully recorded by A. Bouxin, *La Cathédrale Notre-Dame de Laon, historique et description*, Laon, 1890, p. 64. [On the portals of Laon see further: E. Lambert, "Les portails sculptés de la cathédrale de Laon," *Gazette des beaux-arts*, 17 (1937), pp. 83-98. Another early Gothic group of Vices and Virtues has been identified at Notre-Dame-en-Vaux of Châlons-sur-Marne; see L. Pressouyre, "La colonne dite 'aux trois chevaliers' de Châlons-sur-Marne," *Bulletin de la Société nationale des antiquaires de France*, 1963, pp. 76-81, pls. IV-V.]

34 Charity is not paired with a Vice; she is represented with the poor (*Pauper*) to whom she gives alms.

35 Left portal, archivolts. [Houvet, *Cathédrale de Chartres; Portail nord (XIIIe siècle)*, I, figs. 84-87.]

36 We shall return to these attributes later, when we study the characteristics of the Virtues.

37 Notice that at Chartres they are placed beside the Beatitudes of the soul in eternal life. We shall study these statues in the chapter on the Last Judgment (Book IV, Chapter VI).

38 [See Katzenellenbogen, *Allegories of the Virtues and Vices*, p. 19 and fig. 19; Haug, *La Cathédrale de Strasbourg*, pls. 124-127.]

39 Near the entrance. [Clerestory window, north side of nave. See Haug, *ibid.*, p. 113.]

40 Lasteyrie, *Histoire de la peinture sur verre*, p. 241 has reconstructed their names: [Sapientia] (Wisdom) and Stultitia (Folly); [Justitia] (Justice) and Iniquitas (Injustice); Temperentia (Temperance) and Gula (Gluttony); Simplicitas (Simplicity) and Fraus (Fraud); Fides (Faith) and Idolatria (Idolatry); Humilitas (Humility) and Superbia (Pride); Caritas (Charity) and Invidia (Envy); Largitas (Largesse) and Avaritia (Avarice); Castitas (Chastity) and Luxuria (Lust); Concordia (Concord) and Discordia (Discord); Fortitudo (Fortitude) and Accidia (Sloth); Spes (Hope) and Desperatio (Despair).

41 *Ibid.*, p. 263. [Cf. F. Nordström, *Virtues and Vices on the 14th Century Corbels in the Choir of Uppsala Cathedral*, Stockholm, 1956.]

42 Honorius of Autun, *Scala coeli minor, seu de gradibus caritatis opusculum*, Migne, *P. L.*, 172, col. 1239; *Speculum ecclesiae, Dominica in quinquagesima, ibid.*, col. 869.

He did not invent this metaphor and was only imitating St. John Climacus. [Cf. J. R. Martin, *The Illustration of the Heavenly Ladder of John Climacus*, Princeton, 1954.]

43 [Patience, Benignity, Piety, Simplicity, Humility, Contempt of the (Material) World, Willful Poverty, Peace, Goodness, Spiritual Joy, Sufferance, Faith, Hope, Long-suffering Perseverance.]

44 Traced copy in Paris, Bibl. Nat., Cab. des Estampes, cote A d 1442 (Bastard Collection). [Ed. Walter, pl. xxxvIII.]

45 [For the development of tree imagery for Virtues and Vices, cf. Katzenellenbogen, *op. cit.*, pp. 63ff.]

46 Hugh of St. Victor, *Operum pars tertia, Opuscula mystica, De fructibus carnis et spiritus*, Migne, *P. L.*, 176, cols. 997-1000. [Cf. Katzenellenbogen, *op. cit.*, pp. 10-11.]

47 Some manuscripts have two trees, but represented in a very schematic fashion. For example, see Paris, Bibl. de l'Arsenal, ms. 1116, fols. 185v-186r (thirteenth century). [Cf. Katzenellenbogen, *op. cit.*, esp. p. 67, n.1. Trees of good and evil also appear in the *Speculum Virginum* of Conrad of Saxony; see A. Watson, "The Speculum Virginum with Special Reference to the Tree of Jesse," *Speculum*, 3 (1928), pp. 445-469. Also in the *Liber Floridus* of Lambert of St.-Omer; see L. Delisle, "Notice sur les manuscrits du 'Liber Floridus' de Lambert, Chanoine de Saint-Omer," *Notices et Extraits des Manuscrits de la Bibliothèque nationale et autres bibliothèques*, Paris, 1906; and the facsimile of the *Liber Floridus, Codex Autographus 92 Bibliothecae Universitatis Gandanensis*, ed. A. Derolez, Ghent, 1967, fol. 231v. Cf. the *Verger de Soulas* (Paris, Bibl. Nat., ms. fr. 9220). On this theme see L. Behling, "Ecclesia als Arbor Bona: zum Sinngehalt einiger Pflanzendarstellungen des 12. und frühen 13. Jahrhunderts," *Zeitschrift für Kunstwissenschaft*, 13 (1959), pp. 139-154.]

48 See F. Lajard, "Lorens (Laurentius Gallus) Frère Prêcheur," *Histoire littéraire de la France*, 19 (1838), p. 397; and P. Paris, ed., *Les Mauscrits françois de la Bibliothèque du roi*, Paris, 1836, III, p. 388. [See also Millar, *An Illuminated Manuscript of La Somme le Roy, attributed to the Parisian Miniaturist Honoré*.]

49 *Somme le Roi, Le Mireour du monde, Manuscrit du XIVème siècle découvert dans les archives de la Commune de la Sarra* (Mémoires et documents, publiés par la Société d'histoire de la Suisse Romande, IV, ed. F. Chavannes), Lausanne, 1846, p. 24.

50 *Ibid.*, p. 241. The manuscripts represent the orchard and the seven maidens. See Paris, Bibl. Mazarine, ms. 870, fol. 61v. [Millar, *Somme le Roy*, pl. xxIVb.]

51 Paris, Bibl. Ste.-Geneviève, ms. 2200, fol. 164r (the manuscript dates from 1276).

52 The names are not given, but are easy to supply, for it is obvious that these are the seven deadly sins.

53 By an odd detail, which proves how difficult it was to forget Prudentius' poem, the Virtues of the rose window of Notre-Dame of Paris, who are so calm and serene, still hold lances in their hands. See those reproduced here (figs. 76 and 80).

54 The façade of Notre-Dame of Paris dates from the early thirteenth century. The rare few documents which permit a chronology to be established are given in V. Mortet, *Etude historique et archéologique sur la cathédrale et le palais épiscopal de Paris*, Paris, 1888. Amiens and the porches of Chartres are later in date. [Work on the façade of Notre-Dame in Paris was begun about 1200; the rose window dates around 1225, and the upper gallery soon after. At Chartres the north transept porch was built between 1215 and 1230; the south transept porch was begun after 1224. The façade of Amiens was begun in 1220 and the rose window level was probably under construction about 1230. See W. Sauerländer, "Die kunstgeschichtliche Stellung des Westportale von Notre-Dame in Paris," *Marburger Jahrbuch für Kunstwissenschaft*, 17 (1959), pp. 1-56; L. Grodecki, "The Transept Portals of Chartres Cathedral," *Art Bulletin*, 33 (1951), pp. 156-167. Katzenellenbogen, *Allegories of Virtues and Vices*, pp. 75ff. and figs. 72a-73b.]

55 F. de Guilhermy, *Description de Notre-Dame cathédrale de Paris*, Paris, 1856, p. 31.

56 See Lenoir, *Statistique monumentale de*

Paris, ii, pl. xix. This plate is not altogether reliable, for several of the panels are modern. Fortunately, Lasteyrie (*Histoire de la peinture sur verre*, p. 138) enables us to know the state of the window before its restoration. [It is described in detail by J. Lafond in M. Aubert *et al.*, *Les Vitraux de Notre-Dame et de la Sainte-Chapelle de Paris* (Corpus vitraearum medii aevii, France i), Paris, 1959, pp. 23-24 and pls. 2-4.]

57 West portal, middle door, lower section. [W. Medding, *Die Westportale der Kathedrale von Amiens und ihre Meister*, Augsburg, 1930, p. 17 and figs. 32-43.]

58 South porch; the reliefs decorate the pillars of the porch. [Houvet, *Cathédrale de Chartres; Portail sud (XIIIe siècle)*, ii, pls. 44-66; E. Mâle, *Notre-Dame de Chartres*, Paris, 1948, pls. 58-59; L. Grodecki, *Chartres*, tr. K. Delavenay, New York, 1963, ills. pp. 78-79.]

59 Rose of a window in the choir (reproduced in Cahier and Martin, *Monographie de la cathédrale de Bourges*, pt. i, *Vitraux du XIIIe siècle*, study pl. xviii).

60 West façade, right portal. [L. Demaison, "Les figures des vices et des vertus au portail occidental de la cathédrale de Reims," *Bulletin monumental*, 82 (1923), pp. 130-161; Vitry, *La Cathédrale de Reims*, i, pls. xv-xvi.]

61 For example, Justice.

62 St. Paul, I Corinthians 13:13. ["So faith, hope, charity abide, these three; but the greatest of these is charity."]

63 Peter the Chanter, *Verbum abbreviatum, opus morale*, Migne, *P. L.*, 205, col. 271.

64 St. Ambrose, *De Paradiso*, i, iii, Migne, *P. L.*, 14, col. 280. He compares the four Virtues with the four rivers of Paradise. [Cf. E. Schlee, *Die Ikonographie der Paradiesesflüsse*, Leipzig, 1937, pp. 30ff.] The Phison, which flows with gold, is Prudence; the Gehon, which waters Ethiopia (whose name signifies impurity) is Temperance; the Tigris (meaning the Swift in Hebrew) is Fortitude; and the Euphrates (the Fertile) is Justice. For St. Ambrose, each of the four ages of mankind also corresponds to a virtue. The first epoch, of Abel to Noah, is the age of Prudence; the second, of Abraham to Jacob, is the age of Chastity; the

third, from Moses to the prophets, is the age of Fortitude; the fourth, which begins with Jesus Christ, is the age of Justice. The baptismal font of Hildesheim (thirteenth century) shows the four cardinal Virtues, in conformance with the doctrine of St. Ambrose. Near the Euphrates, for example, is written: *frugifer Euphrates est justitia quae notatur*. The cardinal Virtues are represented above. [On the Hildesheim font, see Panofsky, *Die deutsche Plastik des elften bis dreizehnten Jahrhunderts*, i, pp. 110-112 and ii, pl. 47.]

65 St. Augustine, *De libero arbitrio*, i, xiii, Migne, *P. L.*, 32, cols. 1235-1237, and *De Moribus Ecclesiae Catholicae*, i, xv, *ibid.*, col. 1322.

66 Isidore of Seville, *Differentiarum sive de proprietate sermonum*, ii, xxxix, Migne, *P. L.*, 133, cols. 4-95. Rabanus Maurus, *Tractatus de anima*, vi-x, Migne, *P. L.*, 110, cols. 1115-1119.

67 [Peter Lombard, *Sententiarum*, iii, xxiii-xxxvii, Migne, *P. L.*, 192, cols. 805-833.]

68 St. Thomas, *Summa theologica, secundam secundae*, quaest. i, art. i sqq. [Ed. Ottawa, iii, 1401a-1599b.]

69 See L. Jourdain and A.-T. Duval on the portals of Amiens, "Le grand portail de la cathédrale d'Amiens, les virtus et les vices," *Bulletin monumental*, 11 (1845), pp. 430-469.

70 [See Katzenellenbogen, *Allegories of the Virtues and Vices*, chap. iii on the Virtue and Vice cycle of Notre-Dame, pp. 75-81, and cf. Appendix and figs. 72a-73b.]

71 He died in 1198. [Peter the Chanter, *Verbum abbreviatum*, Migne, *P. L.*, 205, cols. 21-370; Peter Lombard, *Sententiarum, ibid.*, 192, cols. 521-962.]

72 William of Auvergne, elected bishop of Paris in 1228, died in 1249 (P.-C. F. Daunou, "Guillaume d'Auvergne, Evêque de Paris," *Histoire littéraire de la France*, 18 (1835), pp. 357-358). His works were published at Orléans in 1674, 2 vols. [Cf. repr. ed., Frankfurt-am-Main, 1963, pp. 102-260.]

73 Guillaume Péraud (Guillelmus Paraldus or Peraldus), Paris, Bibl. Ste.-Geneviève, ms. 1448.

74 For example, Paris, Bibl. Nat., ms. fr. 24429, fol. 69r and ms. fr. 17177. These are two thirteenth-century poems on the Vir-

tues. [Among the numerous early printed versions of the poems of Guillelmus Paraldus, see *Summa de virtutibus*, 2 vols., Cologne, 1479.]

75 The two books of *Fauvel*, Paris, Bibl. Nat., ms. fr. 146 (fourteenth century). [See A. Långfors, *Le Roman de Fauvel par Gervais du Bus publié d'après tous les manuscrits connus* (Société des anciens textes français), Paris, 1914, pp. 135-195; and facsimile edition with musical interpolations, P. Aubry, *Le Roman de Fauvel*, Paris, 1907.]

76 See Paris, Bibl. de l'Arsenal, ms. 903, fol. 136r (thirteenth century).

77 At first, I accepted the idea advanced by J. Lebeuf in his description of Notre-Dame of Paris (*Histoire de la ville et de tout le diocèse de Paris*, ed. H. Cocheris, Paris, 1865, p. 9). He imagined that the twelve Virtues of the portal were carved in accordance with a list found in the life of St. Geneviève, patron saint of Paris. But verification shows that the list and the sculptured reliefs do not agree. The following are the Virtues listed by the hagiographer (*Acta sanctorum*, I, *January*, Brussels, 1863, p. 139): Fides, Abstinentia, Patienta, Magnanimitas, Simplicitas, Innocentia, Concordia, Caritas, Disciplina, Castitas, Veritas, Prudentia.

78 See A. de Surigny, "Le Tabernacle de la Vièrge dans l'église d'Or San Michele," *Annales archéologiques*, 26 (1869), pp. 26-46. [Cf. K. Steinweg, *Andrea Orcagna*, Strasbourg, 1929; J. Pope-Hennessy, *Italian Gothic Sculpture*, London, 1955, p. 197 and fig. 70.]

79 We see why there are only twelve Virtues at Notre-Dame of Paris: there were only twelve places to fill below the twelve apostles. The number twelve was followed at Chartres, even though the structural disposition was different, because an accepted model was being followed. But this does not explain why one Virtue was chosen instead of another.

80 The cross was remade in the eighteenth century. Originally, there was probably also a chalice.

81 She holds the cross in her hand.

82 Faith, in the rose window of Notre-Dame of Paris, also carries a cross in a chalice, but the panel has been reworked. In Italy (door of the Baptistery of Florence, of Andrea Pisano, and the Campanile), Faith also carries the cross and chalice. [See I. Falk, *Studien zu Andrea Pisano*, Hamburg, 1940; I. Toesca, *Andrea e Nino Pisano*, Florence, 1950, fig. 53.]

83 *Fides est virtus qua creduntur quae non videntur*. Vincent of Beauvais, *Speculum morale*, bk. I, divis. XVII, pt. III [Graz ed., III, 224], after Peter Lombard [*Sententiarum*, III, xxiii, Migne, *P. L.*, 192, col. 805].

84 At Paris, the relief, restored in the eighteenth century, shows a man adoring a kind of portrait. [See H. Wentzel, "Portraits 'à l'Antique' on French medieval gems and seals," *Journal of the Warburg and Courtauld Institutes*, 16 (1953), p. 342 and pl. 348a.] At Amiens, the remains of horns lead us to think that it was not a monkey, but a demon.

85 In the illustrated romance of *Fauvel* (Paris, Bibl. Nat., ms. fr. 146, fol. 12v, fourteenth century), Idolatry holds a monkey by the hand. [Långfors, *Fauvel*, pp. 52-53.]

86 Dante, *Paradiso*, Canto XXV, vv. 67-69. [*La Divina Commedia or The Vision of Dante in Italian and English*, ed. M. Casella and tr. H. R. Cary, London, 1928, p. 297.] Peter Lombard, *Sententiarum*, III, xxvi, Migne, *P. L.*, 192, col. 811: *Est enim spes certa exspectatio futurae beatitudinis veniens ex Dei gratia et meritis praecedentibus. . . .*

87 The crown was kept only at Amiens. On the north portal of Chartres, a hand issues from the clouds to encourage Hope.

88 Peter the Chanter, *Verbum abbreviatum*, xciv, Migne, *P. L.*, 205, cols. 272-273. [Cf. Job 19:25-26.]

89 Paris (rose window), Chartres (north portal), Auxerre (rose window). [See J. Lafond, "Les vitraux de la cathédrale Saint-Etienne d'Auxerre," *Congrès archéologique*, 116 (1958), pp. 61-62; and Cahier and Martin, *Bourges*, study pl. XVII.]

90 Bégule and Guigue, *Monographie de la cathédrale de Lyon*, pp. 132ff. and fig. 45. [The medallions of the Virtues and Vices form the border of the choir window the main subjects of which illustrate scenes from the childhood of Christ.]

91 At Auxerre, as at Lyon, the names of the Virtues and Vices are written out in full.

92 [Cf. Katzenellenbogen, *Allegories of the Virtues and Vices*, fig. 72b.]

93 I Corinthians 13:13.

94 I Corinthians 13:1-3.

95 Peter Lombard, *Sententiarum*, III, xxvii, Migne, *P. L.*, 192, col. 812: *Caritas est dilectio qua diligitur Deus propter se, et proximus propter Deum, vel in Deo.*

96 See Vincent of Beauvais, *Speculum morale*, bk. I, divis. XXII, pt. III [Graz ed., III. 264]; and Peter Lombard, *Sententiarum*, III, xxxi, *op. cit.*, col. 821. In Scholastic doctrine, we find an echo of St. Paul's words: "Charity never falleth away: whether prophecies shall be made void or tongues shall cease or knowledge shall be destroyed" (I Corinthians 13:8).

97 The *Speculum morale*, according to St. Thomas, divides the effects of charity into interior and exterior. The interior effects are peace, joy and mercy; one of the exterior effects is beneficence; bk. I, divis. XXIX-XXXI, pt. III [Graz ed., III. 267-271].

98 North and south porches. [Houvet, *Portail nord*, I, pl. 86; *Portail sud*, II, pl. 45.]

99 Portal and rose window. [Aubert, *Notre-Dame de Paris*, p. 45; Aubert, *Vitraux de Notre-Dame et de la Sainte-Chapelle*, pl. 2.]

100 The same shield is shown at Chartres and at Amiens.

101 Rupert, *In Librum Ecclesiastes commentarius*, I, Migne, *P. L.*, 168, col. 1212.

102 G. de Saint-Laurent, *Guide de l'art chrétien, études d'esthétique et d'iconographie*, Paris, 1872, III, pp. 419ff., was the first to explain the attributes that Giotto gave to Charity. [See C. Gnudi, *Giotto*, Milan, 1959, fig. 137a; J. Stubblebine, ed., *Giotto: The Arena Chapel Frescoes*, New York, 1969, fig. 58.]

103 Surigny, "Tabernacle de la Vièrge," pp. 26-46. [See Steinweg, *Andrea Orcagna*, pl. XVI, 18.]

104 [Luke 10:27.]

105 See the Avarice on the west façade of the cathedral of Sens. Here she is paired with an admirable figure of Magnanimity (fig. 74), a queen who opens wide all her treasures. Thus had Alain de Lille described her, *Liber de planctu naturae*, Migne, *P. L.*, 210, col. 474. [Cf. *The Complaint of Nature by Alain de Lille*, tr. by D. M. Moffat (Yale Studies in English, 36), New York, 1908.]

106 Chartres (on the two portals), Amiens, Paris (rose window) [Aubert, *Vitraux de Notre-Dame et de la Sainte-Chapelle*, pl. 4 and p. 35]. On the portal of Notre-Dame of Paris, Avarice, restored in an unintelligent way, seems to hide her hand in her muff.

107 *. . . Nec sufficit amplos Implevisse sinus.* . . . [See n. 12, above.]

108 Copies and manuscript documents in Paris, Bibl. Nat., Cab. des Estampes (Fonds Bastard), article *Vertus*.

109 A. Duchalais, "Etudes sur l'iconologie du Moyen âge," *Bibliothèque de l'Ecole des Chartes*, 2nd ser., 5 (1848-1849), pp. 31-44.

110 Alain de Lille, *Liber de planctu naturae*, Migne, *P. L.*, 210, col. 473. The book contains several descriptions of Virtues.

111 Vincent of Beauvais, *Speculum naturale*, XX, liii: *In his non est masculinum genus aut femineum* [Graz ed., I. 1495].

112 Such a confusion might have arisen because Chastity was often represented in the thirteenth century, especially by the miniaturists, with a turtledove on her shield. Alain de Lille had already done so in his *Liber de planctu naturae*, and he explained that if the turtledove loses her mate, she will not console herself by taking another. [Migne, *P. L.*, 210, col. 473.] Several manuscripts of *La Somme le Roi* (Paris, Bibl. Mazarine, ms. 870, fol. 147r; Paris, Bibl. de l'Arsenal, ms. 6329, fol. 167v; Paris, Bibl. Nat., ms. fr. 938, fol. 120v), illustrated in the late thirteenth century and all more or less faithful copies of one original, contain representations of Chastity that conform to this formula. On a kind of round shield held in her hand, there is an image of a bird that can only be a turtledove. [See Millar, *La Somme le Roy*, pl. 12a.] Since Friar Laurent does not mention an emblem for Chastity in *La Somme le Roi*, we must grant that the miniaturists followed a workshop tradition that was firmly established at the time. This may explain why at Paris, Chartres, and Amiens, a bird was substituted for a salamander. Lastly, it is possible that medieval artists imagined the salamander as a bird. Gaston Paris has said that he found several examples of this mistake in various texts.

113 At Paris, the relief sculpture of Lust, like that of Chasity, moreover, has been completely restored. Instead of Lust, we now see a woman who seems to be holding a scale.

114 On the window of Auxerre, the rose window of Notre-Dame of Paris (fig. 77), and a window at Lyon, Lust has only a mirror as attribute. The same is the case in one of the miniatures of *La Somme le Roi* (Paris, Bibl. de l'Arsenal, ms. 6329, fol. 167v). Elsewhere, Lust seems to be holding shackles (Paris, Bibl. Nat., ms. fr. 938, fol. 120v, and Paris, Bibl. Mazarine, ms. 870, fol. 147r) (fig. 78). [See Millar, *La Somme le Roy*, pl. xxviа. Cf. G. F. Hartlaub, *Zauber des Spiegels: Geschichte und Bedeutung des Spiegels in der Kunst*, Munich, 1951, pp. 149ff. for the mirror as *Vanitas* symbol and pp. 158ff. as attribute of Prudence.]

115 See the collection of the Cluny Museum and of the Louvre. [See Koechlin, *Les Ivoires gothiques français*, vol. III, pl. CLXXXV; R. van Marle, *Iconographie de l'art profane*, The Hague, 1932, II, pp. 421-424.]

116 [Cf. E. Mâle, *Religious Art in France: The Twelfth Century*, p. 373.]

117 However, I have found another example from the early thirteenth century in the tympanum of the Last Judgment of St.-Yved at Braîne, now in the Museum at Soissons. [See A. Boinet, "Le tympan de Saint-Yved de Braisne au musée de Soissons," *Bulletin monumental*, 72 (1908), p. 457 and illus. opp. p. 456.]

118 Matthew 10:16. Peter the Chanter finds occasion to cite these words in his article on Prudence, *Verbum abbreviatum*, cxvi, Migne, *P. L.*, 205, col. 305. [Cf. Sauer, *Symbolik der Kirchengebaudes*, p. 241.]

119 The figure of Folly on the portal of Notre-Dame of Paris has been reworked. The object the fool seemed to be eating has been replaced by a trumpet on which he blows, and his scepter by a kind of torch.

120 [See E. K. Chambers, *The Mediaeval Stage*, Oxford, 1903, I, chap. xvi (Guild Fools and Court Fools), esp. pp. 384ff., with extensive bibl.]

121 I owe this explanation to Gaston Paris and to my friend Joseph Bédier.

122 This traditional figure of the fool is found in many Psalters and illustrates Psalm 53 ["The fool hath said in his heart: There is no God." (Psalm 52, Vulgate: *Dixit insipiens in corde suo: Non est Deus.*)] which concerns the foolish. See Paris, Bibl. Nat., ms. lat. 10434, fol. 65v and Paris, Bibl. Ste.-Geneviève, ms. 2689, fol. 84v. [For the Psalter illustrations, see Leroquais, *Les Psautiers, manuscrits latins des bibliothèques publiques de France*, I, pp. lxxxviff. esp. pp. xcv and cxiv, and II, pp. 93-95 and pp. 156-157.]

123 Not Temperance and Intemperance, as Jourdain and Duval thought ["Le grand portail d'Amiens," pp. 449-453].

124 At Amiens (fig. 82), Chartres (south portal), and on the north portal of Chartres, Humility holds a bird in her hand. On the portal of Notre-Dame of Paris, the bird has been restored and now resembles an eagle.

125 Rose windows of Notre-Dame of Paris and Auxerre.

126 *Somme le Roi*, Paris, Bibl. Nat., ms. fr. 938, fol. 74r. In the manuscript of the Bibl. Mazarine (ms. 870, fol. 89v), there is an error. The artist inadvertently paired Pride with Virginity, who can be identified by the Virgin on her shield and the unicorn at her feet. [For lists of illuminations in both manuscripts, see L. Delisle, *Recherches sur la librairie de Charles V*, Paris, 1907, I, p. 238 and pp. 240-241; Paris, Bibl. Nat., Exhibition Catalogue, *Les Manuscrits à peintures en France du XIIIe au XVIe siècle*, Paris, 1955, nos. 105 and 31.]

127 In the Lyon window, Pride is cast into the abyss, but for lack of space, the horse was not represented.

128 Paris, Bibl. Nat., ms. fr. 19093, fol. 3v; H. Omont, *Album de Villard de Honnecourt*, 2nd ed., Paris, 1927, pl. v. [Cf. Hahnloser, *Villard de Honnecourt*, pl. 6.]

129 See especially the Fortitude on the south porch of Chartres, which is so well balanced.

130 Vincent of Beauvais, *Speculum morale*, bk. I, dist. LXXX, pt. III [Graz ed., III, 419]. The definition was already to be found in St. Bernard. [See St. Bernard, *Exordium magnum Ordinis Cisterciensis*, dist. v, xv, Migne, *P. L.*, 185, col. 1164.]

131 Ephesians 6:10-18.

132 Hugh of St. Victor, *Appendicis ad Hugonis opera dogmatica, De anima*, IV, xiii, Migne,

P. L., 177, col. 186. The attribution to Hugh of St. Victor has been questioned, but that is of no importance here. [See Hauréau, *Les Oeuvres de Hugues de Saint-Victor*.]

133 [The medieval Bestiary treats the lion first with the opening words, "Leo the lion, mightiest of beasts, will stand up to anybody." See *The Bestiary. A Book of Beasts*, tr. and ed. by T. H. White, New York, 1959, from the twelfth-century manuscript in Cambridge, Univ. Lib., ms. ii.4.26.] The bull was another. Fortitude, on the rose window of Notre-Dame of Paris, has the head of a bull on her shield. [Aubert, *Vitraux de Notre-Dame et de la Sainte-Chapelle*, pl. 4.]

134 Proverbs 30:30. Rabanus Maurus, *De universo*, viii, i, Migne, *P. L.*, 111, cols. 217-218.

135 *De bestiis et aliis rebus*, ii, i (attributed to Hugh of St. Victor), Migne, *P. L.*, 177, cols. 56-57. [*De bestiis* could well have been written by Hugh of Fouilloi; see Hauréau, *op. cit.*, p. 169.]

136 Portal and rose window. [Aubert, *op. cit.*, pl. 1.]

137 At Chartres, the rabbit has disappeared altogether.

138 ["Cesti ressemble a celi qui n'ose entrer el sentier de bonne voie pour le limaçon qui le monstre ses cornes"] *Somme le Roi*, Lausanne ed., p. 126. See fig. 37.

139 On the façade of the *Maison du miroir* at Dijon, which dated from the thirteenth century, there was a knight fighting a snail (H. Chabeuf, "La maison du mirroir ou des chartreux à Dijon," *Revue de l'art chrétien*, 10 (1899), p. 113). Fragments of the choir screen of Chartres, preserved in the cathedral, show a knight fleeing before a snail. A manuscript (Paris, Bibl. Nat., ms. lat. 14284) shows a knight frightened by a rabbit (fig. 87). [For illustrations in manuscripts, see Randall, *Images in the Margins of Gothic Manuscripts*, pp. 137-138.]

140 At Chartres and Amiens it is a woman.

141 The figure on the rose window of Notre-Dame of Paris would seem to be a layman.

142 The opinion adopted by Jourdain and Duval, "Le grand portail d'Amiens," p. 456; Guilhermy in *Description de Notre-Dame*

cathédrale de Paris; and Bulteau [who uses the terms, *docile* and *indocile, Monographie de la cathédrale de Chartres*, Chartres, 1891, ii, p. 383].

143 Guilhermy, *op. cit.*, Bulteau, *op. cit.*, ii, p. 383.

144 Duchalais, "Etudes sur l'iconologie du moyen âge," pp. 31-44.

145 Portal and rose window [Aubert, *Vitraux de Notre-Dame et de la Sainte-Chapelle*, pl. 4].

146 Paris, Bibl. Nat., ms. fr. 146, fol. 14v (fourteenth century). [See *Manuscrits à peintures*, no. 46.]

147 The most pertinent details are the following:

> Elle cuide estre noble et sage
> Pour ce qu'elle a grant heritage,
> Mès el se dechoit et meserre,
> Car noblesce n'est pas pour terre.
> (She thinks she is noble and wise
> Because of her high birth,
> But she is deluded and misled,
> For nobility is not of the earth.)

[Långfors, *Fauvel*, pp. 62-63.]

148 Rabanus Maurus, *De universo*, vii, viii, Migne, *P. L.*, 111, cols. 201-202; and Vincent of Beauvais, *Speculum naturale*, xviii, lxix-lxx [Graz ed., i. 1364-1365].

149 Vincent of Beauvais, *ibid.* [Cf. *Isidori Hispalensis Episcopi, etymologiarum sive originum*, xii, i, 9, ed. W. M. Lindsay, Oxford, 1911.]

150 Durand, *Monographie de l'église Notre-Dame cathédrale d'Amiens*, i, pp. 334-335, noticed that at Amiens the branch is grafted. This very probably has a symbolic meaning.

151 *Anticlaudianus*, Migne, *P. L.*, 210, col. 502.

> *Virginis in dextra foliorum crine*
> *comatus,*
> *Flore tumens, fructus exspectans,*
> *ramus olivae*
> *Pubescit. . . .*
> (In the maiden's right hand is a flourishing olive branch in full leaf, bursting with blossoms, soon to bear fruit.)

152 The relief of Notre-Dame of Paris (restored) shows a quarrel between two men, but the medallion of the rose window represents a domestic quarrel similar to those shown at Chartres and Amiens. [Cf. Nordström, *Virtues and Vices*, p. 68 and fig. 18.]

153 We have followed the text of Paris, Bibl. Nat., ms. fr. 938, fol. 16v, which is clearer than that cited by Chavannes (*Somme le Roi*, Lausanne ed., p. 111) from the Lausanne manuscript.

154 Rabanus Maurus, *De universo*, VII, viii, Migne, *P. L.*, 111, col. 211: *Camelus autem aut Christi humilitatem significat. . . .* [Camels are characterized in the same way in the Bestiaries, as in the twelfth-century ms. (*The Bestiary*, ed. White, p. 29).]

155 And not Temperance, as Bulteau believed (*Monographie de Chartres*, II, p. 386).

156 *Somme le Roi*, Lausanne ed., p. 64.

157 See H. Kraus, *The Living Theatre of Medieval Art*, Bloomington and London, 1967, pp. 140ff.

158 Revelation 2:10.

159 These details can still be seen at Amiens (fig. 94) and Chartres. At Amiens, the head seems to be not the head of a lion, but of an ox.

160 Next to the last band. [Houvet, *Portail nord*, II, pls. 1-12.]

161 See Bulteau, *Monographie de Chartres*, II, p. 225.

162 See especially, Honorius of Autun, *Speculum ecclesiae*, Migne, *P. L.*, 172, col. 1020.

BOOK IV, CHAPTER I

1 [See L. Grodecki in Aubert and others, *Les Vitraux de Notre-Dame et de la Sainte-Chapelle*, pp. 71ff.]

2 There are windows containing the story of Joseph at Chartres, Bourges, Auxerre, and Poitiers. [For the windows at Chartres, see Delaporte and Houvet, *Les Vitraux de la cathédrale de Chartres*, II, pp. 395-398, clxii-clxvi.]

3 [On biblical exegesis in the Middle Ages, see C. Spicq, *Esquisse d'une histoire de l'exégèse latine au moyen âge*, Paris, 1944, chaps. III-VIII; and B. Smalley, *The Study of the Bible in the Middle Ages*, Oxford, 1952.]

4 For the veil of the temple and its symbolism, see Honorius of Autun, *Gemma animae*, xlvi, Migne, *P. L.*, 172, cols. 656-657. [See also W. Seiferth, *Synagoge und Kirche im Mittelalter*, Munich, 1964, pp. 47-51 (Engl. tr., *Synagogue and Church in the Middle Ages*, New York, 1970, p. 30).]

5 As we shall see, this is the way the Synagogue is represented in thirteenth-century art.

6 John 3:14.

7 Matthew 12:40.

8 Hebrews 9 and 7:3. ["He is without father or mother or genealogy, and has neither beginning of days nor end of life, but resembling the Son of God he continues a priest for ever."]

9 I Corinthians 10:6-11 ["Now these things are warnings for us, not to desire evil as they did. Do not be idolaters as some of them were; as it is written, 'The people sat down to eat and drink and rose up to dance.' We must not indulge in immorality as some of them did, and twenty-three thousand fell in a single day. We must not put the Lord to the test, as some of them did and were destroyed by serpents; nor grumble, as some of them did and were destroyed by the Destroyer. Now all these things happened to them as a warning, but they were written down for our instruction, upon whom the end of the ages has come"]. Galatians 4:24 ["Now this is an allegory: these women are two covenants . . ."]. I Peter 3:18-21 ["For Christ also died for sins once for all, the righteous for the unrighteous, that he might bring us to God, being put to death in the flesh but made alive in the spirit; in which he went and preached to the spirits in prison, who formerly did not obey, when God's patience waited in the days of Noah, during the building of the ark, in which a few, that is, eight persons, were saved through water. Baptism, which corresponds to this, now saves you, not as a removal of dirt from the body but as an appeal to God for a clear conscience, through the resurrection of Jesus Christ." See G. Cope, *Symbolism in the Bible and the Church*, New York, 1959, pp. 25-34].

10 [On the exegesis of Philo, see E. R. Goodenough, *By Light; The Mystic Gospel of Hellenistic Judaism*, New Haven, 1935.]

11 Origen, περὶ ἀρχῶν, IV, Migne, *P. G.*, 11, cols. 363-366.

12 *Ibid.*, col. 378.

13 Εἰς τὴν γένεσιν, Migne, *P. G.*, 12, pt. 2, col. 99.

14 *Ibid.*, col. 102.

15 [On Celsus, the Roman critic of Christianity in the second century, and Origen, see P. de Labriolle, *La Réaction païenne; Etude sur la polémique anti-chrétienne du Ier au VIe siècle*, Paris, 1950, pp. 111-169.]

16 St. Jerome, *Epistolae*, xi, *Ad vigilantium*, Migne, *P. L.*, 22, col. 603.

17 St. Augustine, *Confessionum*, vi, iv, Migne, *P. L.*, 32, cols. 721-722. [*The Confessions of Saint Augustine*, tr. E. B. Pusey (Modern Library), New York, 1949, p. 100.]

18 St. Augustine, *Sermones ad populum*, ii, vi, Migne, *P. L.*, 38, cols. 30-31.

19 *De Civitate Dei*, xv, xxvi, Migne, *P. L.*, 41, cols. 472-473. [St. Augustine, *The City of God*, tr. M. Dods (Modern Library), New York, 1950, p. 516.]

20 *Ibid.*, xvi, ii, Migne, *P. L.*, 41, cols. 477-479. [Dods tr., p. 522.]

21 *Ibid.*, xvi, xxxii, Migne, *P. L.*, 41, cols. 510-512. [Dods tr., p. 555.]

22 *Ibid.*, xvii, iv, Migne, *P. L.*, 41, cols. 526-532. [Dods tr., p. 572.]

23 *Ibid.*, xvi, xxvi, Migne, *P. L.*, 41, col. 505. [Dods tr., p. 549.] *Quid est enim quod dicitur Testamentum vetus, nisi occultatio novi? et quid est aliud quod dicitur novum, nisi veteris revelatio?* See also his treatise: *Contra Faustum Manichaeum*, Migne, *P. L.*, 42, cols. 207-518.

24 *Sermo* xxxii, iv-vi, Migne, *P. L.*, 38, cols. 197-199.

25 *De Civitate Dei*, xvi, i-ii, Migne, *P. L.*, 41, cols. 477-479. [Dods tr., pp. 521-524. On Augustine's exegesis of the Bible, see H.-I. Marrou, *Saint Augustin et la fin de la culture antique*, Paris, 1937, pp. 415-467.]

26 [Gregory the Great, *Moralium libri sive expositio in Librum B. Job*, Migne, *P. L.*, 75, cols. 509-1162; 76, cols. 9-782.]

27 [Isidore of Seville, *Mysticorum expositiones sacramentorum seu quaestiones in Vetus Testamentum*, Migne, *P. L.*, 83, cols. 207-424.]

28 Migne, *P. L.*, 113, and 114, cols. 9-752. See also the more complete 1643 edition of Antwerp. [On the authorship of the *Glossa ordinaria*, see Smalley, *Study of the Bible*, pp. 56-66.]

29 In their essay, "Douzième siècle, état des lettres en France dans le cours de ce siècle," *Histoire littéraire de la France*, 9 (1750), p. 21, the Benedictines said that for the twelfth century all the meaning of the scriptures is to be found in the *Glossa ordinaria*. Samuel Berger has remarked that, in the thirteenth century, the commentaries of the French Bible were borrowed in large part from the *Glossa ordinaria* of Walafrid Strabo: S. Berger, *La Bible française au moyen âge*, Paris, 1884, pp. 121-122.

30 Migne, *P. L.*, 175, cols. 635-750. A work long attributed to Hugh of St. Victor. [P. S. Moore, "The Authorship of the *Allegoriae super Vetus et Novum Testamentum*," *The New Scholasticism*, 9 (1935), pp. 209-225, established Richard of St. Victor as the author.]

31 *Fragmenta ex Libro Petri de Riga cui titulus: Aurora, variis in locis obiter inserta*, Migne, *P. L.*, 212, cols. 17-42.

32 William Durandus, *Rationale, Proeme*, 12. [Ed. d'Avino, p. 9, and ed. Barthélemy, i, p. 7; Engl. tr. Neale and Webb, pp. 10-11.]

33 Hugh of St. Victor, *Exegetica, In scripturam sacram, De scripturis et scriptoribus sacris*, iii, Migne, *P. L.*, 175, col. 12.

34 This method was summarized in two mnemonic verses that were very famous in the Middle Ages:

 *Littera gesta docet, quid credas
 allegoria,*
 *Moralis quid agas, quo tendas
 anagogia.*
 (Literature teaches history, allegory
 what you are to believe,
 Morality what you are to do, anagogy
 where your course points.)

[Attributed to Nicolas of Lyra (d. 1340). See Cope, *Symbolism in the Bible and the Church*, p. 19.]

35 Only one important ensemble of sculpture of this type exists. It is the series of statues on the interior of the western portals of Reims Cathedral (left portal as you enter). They represent, it is true, only the pre-figures, not the concordance. (Abraham and Isaac, Moses and the serpent, the Israelites marking their doors with the letter *tau*, the widow of Sarepta.) [The ensemble of the cloister of Notre-Dame-en-Vaux at Châlons-sur-Marne appears to have been another work of this kind. See L. Pressouyre, "Frag-

ments du cloître de Notre-Dame-en-Vaux de Châlons-sur-Marne," *L'Europe gothique XIIe-XIVe siècles*, Paris, 1968, pp. 6-15.]

36 The following pages will become clearer if the reader refers constantly to fig. 99.

37 These symbolic windows were reproduced by Cahier and Martin, *Bourges*. Besides Cahier's splendid treatise in this work, it would be well to consult Cahier, *Nouveaux Mélanges d'archéologie*, II, *Curiosités mystérieuses*, pp. 91ff. and L. Deschamps du Pas, "La pied de croix de Saint-Bertin," *Annales archéologiques*, 18 (1858), pp. 5-17. A window at Orbais (Marne), which unfortunately has been restored and part of which is modern, belongs to the symbolic windows we have just cited. [For the anticipation of this symbolism in Mosan art of the twelfth century, see P. Verdier, "Un Monument inédit de l'art mosan du XIIe siècle. La crucifixion symbolique du Walters Art Gallery," *Revue belge d'archéologie et d'histoire de l'art*, 30 (1961), pp. 115-175; and L. Grodecki, "A propos des vitraux de Châlons-sur-Marne. Deux points d'iconographie mosane," *L'Art mosan*, ed. P. Francastel, Paris, 1953, pp. 161-170.]

38 Walafrid Strabo, *Glossa ordinaria, Liber Genesis*, XXII, vv. 4, 5, 8, Migne, *P. L.*, 113, cols. 138-139.

39 *Ibid., Liber Exodus*, XII, v. 7, Migne, *P. L.*, 113, col. 218.

40 *Ibid., Liber Regum Tertius*, XVII, Migne, *P. L.*, 113, cols. 606-607.

41 *Ibid., Liber Genesis*, XLVII, 12-15, Migne, *P. L.*, 113, col. 177. See also Isidore of Seville, *Quaestiones in Vetus Testamentum*, XXXI, *De Benedictionibus patriarcharum*, Migne, *P. L.*, 83, cols. 276-277.

42 See Isidore of Seville, *op. cit.*, and the words *Jacob, Manasses,* and *Ephraim* in *Allegoriae quaedam sacrae Scripturae*, Migne, *P. L.*, 83, cols. 105, 107, 136.

43 See Cahier and Martin, *Vitraux de Bourges*, p. 25.

44 Bourges, Tours, Le Mans.

45 Bourges, Tours, Le Mans, St.-Denis, Lyon.

46 Tours (the panel has been moved and placed beside the Carrying of the Cross).

47 Cross of St.-Bertin, reproduced in Deschamps du Pas, "Le pied de croix de Saint-Bertin," p. 5 [and Mâle, *Religious Art in France: The Twelfth Century*, figs. 136, 138], and Reliquary of Tongres, in Cahier, *Nouveaux mélanges d'archéologie*, II, *Curiosités mystérieuses*, p. 91 [and Swarzenski, *Monuments of Romanesque Art*, p. 73, no. 187, figs. 424-425]. The fragment of the Le Mans window reproduced here (fig. 100) shows Moses striking the rock and raising the brazen serpent. The pelican accompanied by David (which is spoken of in the Psalms) is also related to the Crucifixion. The lions are not correctly placed; they belong beside the medallion of the Resurrection.

48 I Corinthians 10:3-4. ". . . and all ate from the same supernatural food and all drank the same supernatural drink. For they drank from the supernatural Rock which followed them, and the Rock was Christ."

49 *Glossa ordinaria, Liber Exodus*, XVII, vv. 3-4, Migne, *P. L.*, 113, col. 241.

50 *Ibid., Liber Numeri*, XXI, v. 8, Migne, *P. L.*, 113, col. 415.

51 *Ibid., Liber Genesis*, IV, v. 8, Migne, *P. L.*, 113, col. 98.

52 *Ibid., Liber Numeri*, XIII, v. 24. The *Glossa* says: *Calicem Ecclesiae propinavit.* This passage is extremely important for the history of art. This image from the *Glossa* (derived from Isidore of Seville) was portrayed by the artists. Near the cross, we see the Church filling its chalice with the blood flowing from Christ's side. [Walafrid of Strabo cites but does not repeat these words of Isidore of Seville found in *Quaestiones in Vetus Testamentum, In Numeros*, Migne, *P. L.*, 83, col. 347.]

53 *Ibid.* [Again, Walafrid of Strabo refers to his source, Isidore of Seville, *ibid.*, cols. 346-347, but does not repeat the passage.]

54 See Cahier and Martin, *Bourges*.

55 *Glossa ordinaria, Evangelium secundum Matthaeum*, XII, vv. 39-41, Migne, *P. L.*, 114, col. 128.

56 At Bourges, Le Mans.

57 This is Elisha, not Elijah to whom the Bible attributed a similar miracle. On the Le Mans window is written *Eliseus* (Elisha).

58 *Glossa ordinaria, Liber Regum*, IV, vv. 32-

37. [Isidore of Seville, *Quaestiones in Vetus Testamentum, In regum quartum,* iv, Migne, *P. L.,* 83, col. 420.]

59 *Glossa ordinaria, Liber Judicum,* xvi, v. 1, Migne, *P. L.,* 113, col. 532. [For the pertinent text, see Walafrid of Strabo's source: Gregory the Great, *Homiliarum in Evangelia,* ii, xxi, Migne, *P. L.,* 76, col. 1173.]

60 It is not necessary to discuss again the symbolic figures of the lion, pelican, and charadrius shown alongside the scenes from the Old Testament in the windows we have just cited. For them, see Book i, *Speculum naturale.* [See above, pp. 38ff.]

61 Exodus 3:2. ["And the angel of the Lord appeared to him in a flame out of the midst of a bush; and he looked, and lo, the bush was burning, yet it was not consumed."]

62 Judges 6:36-40. ["Then Gideon said to God, 'If thou wilt deliver Israel by my hand, as thou hast said, behold, I am laying a fleece of wool on the threshing floor; if there is dew on the fleece alone, and it is dry on all the ground, then I shall know that thou wilt deliver Israel by my hand, as thou has said.' And it was so. When he rose early next morning and squeezed the fleece, he wrung enough dew from the fleece to fill a bowl with water. Then Gideon said to God, 'Let not thy anger burn against me, let me speak but this once; pray, let me make trial only this once with the fleece; pray, let it be dry only on the fleece, and on all the ground let there be dew.' And God did so that night; for it was dry on the fleece only, and on all the ground there was dew."]

63 See Rabanus Maurus, *De universo,* xix, vi, Migne, *P. L.,* 111, col. 513.

64 *Glossa ordinaria, Liber Judicum,* vi, v. 37, Migne, *P. L.,* 113, col. 527.

65 St. Bernard, *De laudibus Virginis Matris, Homilia* ii, Migne, *P. L.,* 183, col. 64.

66 See A. Bouxin, *La Cathédrale de Notre-Dame de Laon,* Laon, 1890, pp. 60ff. [Cf. E. Lambert, "Les Portails sculptés de la cathédrale de Laon," *Gazette des beaux-arts,* 6th ser., 18 (1937), pp. 95-97.]

67 We have already discussed the strange Psychomachia of Laon in Book iii, *Speculum morale.* [See above, p. 106.]

68 Beside the figure is written *VELLVS.*

69 And not Susanna, as Bouxin thought.

70 The inscription says *ABACVC: AFFERENS: ESC [am].*

71 Two puzzling subjects follow: first, a figure with the inscription *PLEXV: IA: NO: MITT*; and second, a man and a child without inscription. [For a possible reading of this inscription as *ISSAC AMPLEXV: JACOB: MITTIT,* see Broche, *La Cathédrale de Laon,* 2nd ed., p. 39.]

72 *Speculum ecclesiae, In annunciatione Sanctae Mariae,* Migne, *P. L.,* 172, cols. 904-905.

73 I have translated only the essential passages.

74 The Laon artist did not represent Aaron, but only the Ark: *ARCHA DEI.*

75 The figure standing near the door is the prophet Ezekiel.

76 This is what the anointing scene, represented after Nebuchadnezzar's vision, expresses. It symbolizes the royalty of Christ. The woman shown next and accompanied by the inscription *ET: P: SECLA: FVTVRVS,* is an allusion to Christ's eternal reign. This woman is the Sibyl, as the words carved beside her prove. They were taken from the famous acrostic cited by St. Augustine in which the Sibyl foretells both the Last Judgment and the eternal reign of Christ:

Judicii signum; tellus sudore madescet.
E coelo Rex adveniet per saecla
 futurus.

(The sign of the Judgment; the earth
 grows damp with sweat
And from heaven will come forth a
 king to be for generations.)

[St. Augustine, *De Civitate Dei,* xviii, xxiii, Migne, *P. L.,* 41, col. 579 (Dods tr., p. 629).]

77 This is the subject of the first scene which shows Daniel trampling on a human-headed dragon.

78 Its horn is broken. The inscription *CAPITVR,* written beside this small figure at Laon, is the last word of Honorius' rhymed sentences:

Ad quam capiendam virgo puella in
 campum ponitur,
Ad quam veniens, et se in gremio ejus
 reclinans, capitur.

(To capture it a maid is placed in the
 field;
It comes to her, leans on her bosom,
 and is caught.)

Speculum ecclesiae, De nativitate Domini, Migne, *P. L.,* 172, col. 819.

79 *Ibid., De epiphania Domini,* Migne, *P. L.,* 172, col. 846. [On the "star of Jacob," see Daniélou, *Primitive Christian Symbols,* pp. 102-123.]

80 The figure accompanied by the mysterious inscription on the Laon portal, *IA . . . NO . . . MITT,* can perhaps be explained. It seems to me that these three words are an abbreviation of the verses recited by Virgil in the *Play of the Prophets:*

Iam nova progenies coelo demittitur alto.

(Now from high heaven is sent down a new offspring.)

[See K. Young, *The Drama of the Medieval Church,* Oxford, 1933, II, p. 136.] Thus, this figure would be Virgil himself foretelling the coming of a saviour sent from heaven. The presence of the Sibyl, who is placed beside him in the Procession, makes this hypothesis seem quite likely. It would then seem that at Laon, the sermon of Honorius was followed by the *Play of the Prophets.*

81 There is also one from the twelfth century on the porch of the church at Ydes (Cantal), which was probably built by the Templars in the second half of the twelfth century; the Annunciation is placed on one side, Daniel in the lions' den on the other, and beside him, the prophet Habbakuk, whom an angel holds by the hair. [Porter, *Romanesque Sculpture of the Pilgrimage Roads,* VIII, pls. 1221-1222.]

82 Right door. [Durand, *Monographie de l'église Notre-Dame cathédrale d'Amiens,* I, pl. XL.

83 Apse, chapel in the axis of the church (third window to the left).

84 There is little doubt that the high priest wearing the pectoral, seen in the window, is Aaron.

85 [See especially, Katzenellenbogen, *The Sculptural Programs of Chartres Cathedral,* pp. 67-76.]

86 However, we clearly recognize Abraham with Isaac at his feet, Moses carrying the brazen serpent (restored as David), Jeremiah carrying the cross, Simeon carrying the Child. The Senlis series is the earliest of all, and the others derive from it, as I tried to establish in E. Mâle, *Art et artistes du moyen âge,* Paris, 1928, pp. 209-225. [On the date of the Senlis portal as soon after 1170, see W. Sauerländer, "Die Marienkrönungsportale von Senlis und Mantes," *Wallraf-Richartz-Jahrbuch,* 20 (1958), pp. 125-135. The principal portal of the cathedral of Cambrai, destroyed at the beginning of the nineteenth century, appears to have been embellished in a similar way. The triumph of the Virgin was the theme of the tympanum and fourteen statue columns stood in the embrasures. The date of this work, however, has not been established with certainty. See J. Vanuxem, "La sculpture du XIIe siècle à Cambrai et à Arras," *Bulletin monumental,* 113 (1955), pp. 11-17; and Lapeyre, *Des Façades occidentales de Saint-Denis et de Chartres aux portails de Laon,* p. 239, n. 10.]

87 The portal of St.-Nicolas, at Amiens, was reproduced by A.-L. Millin, "Saint-Nicolas à Amiens," *Antiquités nationales,* Paris, 1796, V, pp. 1, 6. On one side, we see Abraham, Moses, Samuel with the lamb, David; on the other, Simeon with the Child, Jeremiah with the cross, probably Isaiah with a banderole, and John the Baptist. A king and a queen, no doubt Solomon and the Queen of Sheba, complete the series. [See P. Héliot, "La Collégiale Saint-Nicolas d'Amiens et l'architecture picarde," *Mélanges offerts à René Crozet,* Poitiers, 1966, II, pp. 991-992, fig. 1.]

88 [G. Chenesseau, *L'Abbaye de Fleury à Sainte-Benoît-sur-Loire,* Paris, 1931, p. 195, pls. 34, 38.]

89 See J. Gauthier, "L'ancienne collégiale de Sainte-Madeleine de Besançon et son portail à figures du XIIIe siècle," *Bulletin archéologique du Comité des travaux historiques et scientifiques,* 1895, pp. 158-168. [On the sculpture of this church, see the Catalogue of the Exhibition, *Cathédrales,* Louvre, Paris, 1962, pp. 75-77, nos. 60-62; and W. Sauerländer, *Von Senlis bis Strassburg,* Berlin, 1966, pp. 13ff. and *passim.*]

90 The mutilated statues on the south side of Lyon represent Moses, Aaron, Joshua, Gideon, and Samuel anointing David. [Cf. Bégule, *La Cathédrale de Lyon,* p. 50.]

91 Migne, *P. L.,* 83, col. 96.

92 Adam figures on the St.-Honoré portal at Amiens (fig. 110). This portal shows, after

the angels in the first band of the archivolts, Adam digging, Noah building the Ark, Melchizedek bearing the bread and wine, and Abraham preparing to sacrifice Isaac.

93 Isidore of Seville, *Allegoriae*, Migne, *P. L.*, 83, col. 99.

94 On both the portals of Reims and of Senlis, the figure holding a lamb is certainly not Abel, as has been said, but Samuel. Abel appears as a symbol of Christ on the famous niello plaque from the late twelfth century, published by A. N. Didron, "Symbolique chrétienne," *Annales archéologiques*, 8 (1848), pl. 1. [Formerly in the Debruge-Duménil collection.]

95 Isidore of Seville, *Allegoriae*, Migne, *P. L.*, 83, cols. 99, 100.

96 Noah with his ark is also shown at Amiens (fig. 110), and on the twelfth-century plaque.

97 Isidore of Seville, *Allegoriae*, Migne, *P. L.*, 83, col. 102. [For the more complete source, see Isidore's *Quaestiones in Vetus Testamentum, In Genesim*, VII, Migne, *P. L.*, 83, cols. 229-234.]

98 Melchizedek is represented at Chartres [Houvet, *Portail nord*, vol. 1, pl. 8], Amiens [Durand, *Amiens*, pl. XLVIII], and Reims in the interior of the cathedral, central portal (fig. 111).

99 Isidore of Seville, *Allegoriae*, Migne, *P. L.*, 83, col. 104.

100 I think there can be no doubt that the priest giving communion to a warrior (interior statues of Reims Cathedral) is Melchizedek. We must not be surprised to see Abraham dressed as a thirteenth-century knight. The Psalter of St. Louis (Paris, Bibl. Nat., ms. lat. 10525) represents him in the same way. [See Paris, Bibliothèque Nationale, Département de Manuscrits, *Psautier de Saint Louis*, ed. H. Omont, Paris, 1902, pl. VI, and *Manuscrits à peintures*, no. 11 and pl. A. On the symbolism of Abraham and Melchizedek, see C.-O. Nordström, *Ravennastudien; ideengeschichtliche und ikonographische Untersuchungen über die Mosaiken von Ravenna*, Stockholm, 1953, pp. 102-119.]

101 The knife is often broken.

102 *Glossa ordinaria, Liber Genesis*, XXII, vv. 9-11, Migne, *P. L.*, 113, col. 139. [See M.

Schapiro, "The Angel with the Ram in Abraham's Sacrifice: A Parallel in Western and Islamic Art," *Ars Islamica*, 10 (1943), pp. 134-147; *idem*, "An Irish-Latin Text on the Angel with the Ram in Abraham's Sacrifice," *Essays in the History of Art Presented to Rudolf Wittkower*, London, 1967, pp. 17-19; and I. S. van Woerden, "The Iconography of the Sacrifice of Abraham," *Vigiliae Christianae*, 15 (1961), pp. 214-255.]

103 Isidore of Seville, *Allegoriae*, Migne, *P. L.*, 83, col. 107.

104 North portal, statue in the right bay. [Houvet, *Portail nord*, 1, pl. 12. Some aspects of the role of Joseph in exegesis have been considered by M. Schapiro, "The Joseph Scenes on the Maximianus Throne in Ravenna," *Gazette des beaux-arts*, 40 (1952), pp. 27-38.]

105 Cahier and Martin, *Bourges*, pl. X. Cahier expressed the very probable idea that the Bourges window is fundamentally symbolic.

106 *Glossa ordinaria, Liber Genesis*, XXXVII, 1, Migne, *P. L.*, 113, cols. 164-182. [For the more complete source, see Isidore of Seville, *Quaestiones in Vetus Testamentum, In Genesim*, XXX, Migne, *P. L.*, 83, cols. 271-275.] As for the miniaturists, they explicitly associated the life of Joseph with that of Jesus. See Paris, Bibl. Nat., ms. lat. 9561, fols. 22ff. (twelfth and thirteenth centuries).

107 Isidore of Seville, *Allegoriae*, Migne, *P. L.*, 83, col. 109.

108 Isidore of Seville dwelt at length on the parallel between the lives of Moses and Christ in his *Quaestiones in Vetus Testamentum, In Exodum* and *In Leviticum, ibid.*, cols. 287-340.

109 At Chartres [Houvet, *Portail nord*, 1, pl. 8], Reims [Reinhardt, *La Cathédrale de Reims*, pl. 24], Amiens (St.-Honoré portal) [Durand, *Amiens*, pl. XLVII], Senlis (the serpent is missing).

110 St.-Honoré portal. [On the anointing of of David and his coronation in relation to the coronation of kings, see M. Schapiro, "An Illuminated English Psalter of the Early Thirteenth Century," *Journal of the Warburg and Courtauld Institutes*, 23 (1960), pp. 179-189, and K. Hoffmann, *Taufsymbolik im mittelalterliche Herrscherbild*, Düsseldorf, 1968, p. 22.]

111 At Amiens, the statues of Solomon and of the Queen of Sheba are not on the St.-Honoré portal but in the right bay of the west portal. [Durand, *Amiens*, pl. XLI.] At Chartres, the two statues are in the right bay, north portal. [Houvet, *Portail nord*, I, pl. II.] At Reims, they are paired: west portal, central bay, buttresses. [Reinhardt, *La Cathédrale de Reims*, pls. 31, 33.]

112 In the Middle Ages, the Queen of Sheba's visit to Solomon was also considered to be a prefiguration of the Adoration of the Magi. The Queen of Sheba, who came from the East, symbolizes the magi; King Solomon, seated on his throne, symbolizes Eternal Wisdom seated on the lap of Mary (Ludolf of Saxony, *Vita Christi*, chap. XI). That is why we see on the façade of Strasbourg Cathedral (central portal, gable) Solomon on his throne guarded by twelve lions, and above him, the Virgin holding the Child on her lap. [On this theme, see F. Wormald, "The Throne of Solomon and St. Edward's Chair," *De Artibus Opuscula XL, Essays in Honor of Erwin Panofsky*, New York, 1961, I, pp. 532-539, II, pls. 175-177, and a doctoral dissertation by A. D. McKenzie, *The Virgin Mary as the Throne of Solomon in Medieval Art*, New York University, 1965.

113 Isidore of Seville, *Allegoriae*, Migne, *P. L.*, 83, col. 108. [See Katzenellenbogen, *Sculptural Programs of Chartres Cathedral*, pp. 67-74.]

114 Isidore of Seville, *Allegoriae*, Migne, *P. L.*, 83, col. III.

115 *Ibid.*, Migne, *P. L.*, 83, col. 116.

116 *Le Mistère du viel testament*, ed. J. de Rothschild (Société des anciens textes français), 6 vols., Paris, 1878-1891.

117 . . . C'est seulement
 Pour figurer les Escriptures
 Et monstrer par grosses figures
 L'envye que les Juifs auront
 sus mon fils . . .
 (. . . It is only
 To prefigure the Scriptures
 And show by life-size figures
 The envy that the Jews will have
 For my Son . . .)
 (*Dialogue entre Dieu et Miséricorde, ibid.*, II, pp. 336-337, vv. 16936ff.)

118 Let us not forget that at Chartres, as in *Le Mistère du viel testament*, the stories of Judith and Esther are shown beside the stories of Samson, Tobias, and Gideon (north porch, right portal). [See Katzenellenbogen, *Sculptural Programs of Chartres Cathedral*, pp. 67-74, figs. 57-63.]

119 But let us not overlook the admirable figures of prophets of the Well of Moses at Dijon. [H. David, *Claus Sluter*, Paris, 1951, pls. 8-15.]

120 See Cahier and Martin, *Bourges*, pls. XX, XXI, XXII.

121 In the windows, the prophets are even represented with bare feet, like the apostles.

122 [This statement requires some qualification. Daniel was most frequently represented as a beardless young figure and Amos was characterized as a shepherd in the light of Jerome's preface, *Amos Pastor Rusticus*. On the early representation of the prophets as standing figures, see A. Baumstark, "Frühchristlichesyrische Prophetenillustration durch stehende Autorenbilder," *Oriens Christianus*, 3rd ser., 9 (1934), pp. 99-104.]

123 Several figures could also be cited from Reims Cathedral (interior statues on the reverse side of the central portal). We see Zephaniah with a lamp, and Habakkuk carrying the crèche. [See A. Katzenellenbogen, "Tympanum and Archivolts on the Portal of St.-Honoré at Amiens," *De Artibus Opuscula XL, Essays in Honor of Erwin Panofsky*, New York, 1961, I, pp. 280-290, II, pls. 89-91.]

124 The second band of the archivolt (fig. 110), beginning at the left, shows from bottom to top, Hosea marrying the symbolic prostitute, Joel sounding the trumpet and announcing the Last Judgment, Amos seeing fire fall from heaven, Obadiah feeding the prophets he has hidden in his house, and Jonah vomited by the whale.

125 Isidore of Seville, Migne, *P. L.*, 83, col. 130. The treatise *De ortu et obitu patrum* is completed by *Appendix XX, ibid.*, cols. 1275ff. [On the legends of the prophets and their cults, see J. Jeremias, *Heiligengräber in Jesu Umwelt, eine Untersuchung zur Volksreligion der Zeit Jesu*, Göttingen, 1958.]

126 Peter Comestor, *Historia scholastica*, Migne, *P. L.*, 198; see the death of Isaiah, *Liber IV Regum, ibid.*, cols. 1414-1415; and the death

of Jeremiah, *Historia Libri Tobiae, ibid.*, col. 1440. [See also R. Bernheimer, "The Martyrdom of Isaiah," *Art Bulletin*, 34 (1952), pp. 19-34.]

127 Reims, gallery of prophets, on the south [B. Vitry, *Notre-Dame de Reims*, Paris, 1958, fig. 8], and figures on the interior of the portals (fig. 116).

128 One of the sources could have been Isidore of Seville, *De fide catholica ex Veteri et Novo Testamento contra Judaeos*, Migne, *P. L.*, cols. 450ff. The events in the life of Christ and the dogmas of Christianity are brought together with the prophecies relating to them. On the verses most often given to the prophets by the artists, see Cahier, "Prophètes," *Caractéristiques des saints dans l'art populaire*, II, pp. 711-720.

129 *Contra Judaeos, Paganos et Arianos, Sermo de symbolo*, Migne, *P. L.*, 42, cols. 1117-1130. This is especially true of Romanesque artists.

130 M. Sepet, *Les Prophètes du Christ, Etude sur les origines du théâtre au moyen âge*, Paris, 1878. [See Mâle, *Religious Art in France: The Twelfth Century*, pp. 145-146.]

131 See J. Durand, "Monuments figurés du moyen âge exécutés d'après les textes liturgiques," *Bulletin monumental*, 14 (1888), pp. 521-550. For example, these are some of the texts written on the phylacteries of the prophets at Poitiers:

Moses: *Prophetam dabit vobis de fratribus vestris*

(He will give thee a prophet from among thy brethren.)

Jeremiah: *Post haec in terris visus est et cum hominibus conversatus est.*

(Afterward he was seen upon earth and conversed with men.)

Daniel: *Cum venerit Sanctus Sanctorum cessabit unctio.*

(When the Saints of Saints will come the anointment shall cease.)

These are the texts assigned by the Pseudo-Augustine to each prophet. [See Mâle, *Religious Art in France: The Twelfth Century*, p. 145. On the prophets at Poitiers and their connection with liturgical drama, see J. Chailley, "Du Drame liturgique aux prophètes de Notre-Dame-La-Grande," *Mélanges offerts à René Crozet*, Poitiers, 1966, II, pp. 835-841.]

132 Fig. 117 represents, at the right, Obadiah, in the center, Jonah, and at the left, Hosea. Jonah is bald, following the tradition that goes back to Eastern art. [See A. Katzenellenbogen, "Prophets of the West Façade of the Cathedral of Amiens," *Gazette des beaux-arts*, 6th ser., 40 (1952, pp. 241-260.]

133 Ezekiel 1:15-22.

134 Zephaniah 2:13-14.

135 Zechariah 5:5-11.

136 Isidore of Seville, *Appendix XX*, Migne, *P. L.*, 83, cols. 1275ff. See also, in the same volume, a summary of the prophecies: *In libros Veteris ac Novi Testamenti, Prooemia, ibid.*, cols. 166-175.

137 Isaiah 11:1-2, 10.

138 Herveus, *Commentariorum in Isaiam*, xi, Migne, *P. L.*, 181, col. 140.

139 In an article, "La Part de Suger dans la création de l'iconographie du moyen âge," *Revue de l'art ancien et moderne*, 35 (1914), pp. 91-102, I discussed the origins of the Tree of Jesse. I showed that this motif seems to have been imagined by Abbot Suger, for the earliest Tree of Jesse known is that in a window at St.-Denis, and is anterior to 1144. The Chartres window (fig. 121), is later, and a copy. See Mâle, *Religious Art in France: The Twelfth Century*, pp. 168-175. [For earlier representations of the Tree of Jesse in manuscript illustrations, see A. Watson, *The Early iconography of the Tree of Jesse*, London, 1934, pp. 77-82, and 162.]

140 See William Durandus, *Rationale*, VI, xiii and xvi. [Ed. d'Avino, pp. 415-421; 426-430, and ed. Barthélemy, III, pp. 217-233; 243-254.]

141 Why is Jesse represented as sleeping? J. Corblet, "Etude iconographique sur l'arbre de Jesse," *Revue de l'art chrétien*, 4 (1860), p. 54, gives an ingenious reason. He says, "Would this not be in analogy with Adam, who slept while God drew Eve from his side? A new Eve, redressing the sins of the first Eve, was to issue from the race of Jesse." This interpretation seems to fit in with the mystical ideas of the Middle Ages; unfortunately, no text has yet been found to justify it. [Cf. Watson, *Tree of Jesse*, chap. II, pp. 7-8.]

142 Trees of Jesse from the twelfth and thirteenth centuries are numerous: in stained

glass windows at St.-Denis, Chartres, Le Mans, the Ste.-Chapelle; in archivolts of portals at Senlis, Mantes, Laon, Chartres, Amiens, etc. We refer to the catalogue compiled by Corblet, "Etude iconographique sur l'arbre de Jesse." In the late thirteenth century, the Virgin was shown at the top of the tree, bearing the Infant Jesus in her arms. [Watson, *Tree of Jesse*, pls. *passim*.]

143 Durand, *Amiens*, p. 428, and L. Bréhier, *La Cathédrale de Reims*, Paris, 1916, pp. 125ff. [For the identification of these Galleries of Kings as symbols of *regnum* (royal authority) in harmony with *sacerdotium* (priestly authority), see Katzenellenbogen, *Sculptural Programs of Chartres Cathedral*, pp. 35-36.]

144 Paris, Bibl. Nat., ms. fr. 245, fol. 84 (fifteenth century), shows a Tree of Jesse with twenty-eight kings.

145 The calculations made by Bréhier, *La Cathédrale de Reims*, pp. 131ff., to relate the twenty-eight kings of Notre-Dame of Paris and the fifty-six kings of Reims to the succession of kings of France have produced no results. B. Guérard had provided the examples for these calculations. In the Introduction to the *Cartulaire de l'église Notre-Dame de Paris* (Collection de documents inédits sur l'histoire de France. Ser. I. Collection des cartulaires, 4 vols., Paris, 1840-1867), IV, pp. clxix-clxx, he recalled that the names of the kings of France, as we learn from a manuscript (Paris, Bibl. Nat., ms. lat. 5921, fol. 47v), were carved in the thirteenth century on the door of Notre-Dame of Paris. According to him, these names corresponded to the great statues of the façade. One simple observation destroys this argument: there are twenty-eight statues of kings at Notre-Dame of Paris, and on the door there were thirty-nine names, from Clovis to St. Louis.

146 The Virgin of Paris, already almost destroyed in 1774, was restored; that of Chartres, badly eroded by the weather, was renewed in 1855.

147 See F. Blanchard, "La Statuaire de la tour sud de la cathédrale de Soissons," *Congrès archéologique*, 78 (1911), pt. 2, p. 320.

148 The St. Ulphe of Amiens is obviously an imitation of the St. Modeste of Chartres. In the Last Judgment scene at Amiens, the frieze of angels flying above the heads of the saved and the damned is an imitation of that at Chartres. The idea of representing by large statues the scenes of the life of the Virgin, as at Amiens, originated at Chartres.

149 Some of the kings of Amiens have been restored, but others are original. Among the really authentic kings, there are two who carry rather singular scepters which terminate not in a *fleuron* but in true leaves, as if they were cut branches (fig. 124). In an earlier edition, I advanced the idea that this branch was a shoot from the Tree of Jesse. This explanation has been contested, but without accounting for the strangeness of these scepters. For my part, I have seen no others like them. For lack of any attributes or inscriptions, we are obliged to grasp at minute details, and this one continues to seem significant to me. It has also been said that it is very improbable that the kings of Judah would be represented on the façade of Amiens Cathedral since they were already represented in the archivolts of the right and central portals where the Trees of Jesse were carved. This argument is worthless. At Chartres, where a Tree of Jesse was carved in the archivolts of the north portal (Coronation of the Virgin), the kings of Judah were nevertheless represented on the south porch.

150 There are connections between the sculpture of Reims and Chartres. The archaic figures of characters from the Old Testament decorating the west façade of Reims are imitated from those at Chartres. The story of Job on the north transept of Reims is an obvious imitation of that at Chartres.

151 *Les XXII manières du vilain.* Fabliau taken from Paris, Bibl. Nat., ms. fr. 1553, fol. 514, published by A. Jubinal and E. Johanneau, *Des 25 manières de vilains, pièce du 13e siècle*, Paris, 1834. The manuscript dates from 1284. [The kings in the niches of the transept buttresses at Reims, one of whom is crowned with the imperial crown, have been identified as French kings. See Reinhardt, *Reims*, pp. 157-159. The Gallery of Kings of the west façade is also regarded as an intensification of the idea of *regnum* (see n. 143). See also W. M. Hinkle, *The Portal of the Saints of Reims Cathedral*, New York, 1965, p. 43.]

152 North side.

153 [See W. Cahn, "The Tympanum of the Portal of Saint-Anne at Notre-Dame de Paris and the Iconography of the Division of the Powers in the Early Middle Ages," *Journal of the Warburg and Courtauld Institutes*, 32 (1969), pp. 55-72.]

154 Durandus, *Rationale*, VI, xvi. [Ed. d'Avino, p. 429; ed. Barthélemy, III, pp. 243-254.]

155 See Sepet, *Les Prophètes du Christ.*

156 Many other prophets were also seen and heard: Moses, Aaron, Jeremiah, Daniel, Hosea, Joel, Obadiah, Jonah, Micah, Nahum, Zephaniah, Haggai, Zechariah, Simeon, Elizabeth, John the Baptist.

157 *Jam nova progenies coelo demittitur alto* (Now from high heaven is sent down a new offspring).

158 There was a lighted stove in the church.

159 See Sepet, *Les Prophètes du Christ*, p. 43.

160 In the famous Auch window (early sixteenth century). [M. Aubert and others, *Le Vitrail français*, Paris, 1958, p. 238, fig. 184.]

161 Statues of the choir screen, fifteenth century. [E. Mâle, *La Cathédrale d'Albi*, Paris, 1950, pls. 102-120.]

162 On the magnificence of the costume of the time, see A. Girardot, "Le drame au XVIe siècle; Mystère des Actes des Apôtres," *Annales archéologiques*, 13 (1853), pp. 16-23. In E. Mâle, *L'Art religieux de la fin du moyen âge in France*, 5th ed., Paris, 1949, pp. 35-84, I have discussed at length the connections between art and the Mystery plays. [Cf. O. Pächt, *The Rise of Pictorial Narrative in Twelfth Century England*, Oxford, 1962, pp. 33-59.]

163 The description of the windows is to be found in *De rebus in administratione sua gestis*, in *Oeuvres complètes de Suger*, ed. A. L. de La Marche, Paris, 1867, pp. 204-206. [See also *Abbot Suger on the Abbey Church of St.-Denis and Its Art Treasures*, ed. and tr. E. Panofsky, Princeton, 1946, pp. 72-77, and Mâle, *Religious Art in France: The Twelfth Century*, pp. 151-185. Cf. L. Grodecki, "Les vitraux allégoriques de Saint-Denis," *Art de France*, 1 (1961), pp. 19-46, where the medallions discussed here are considered in relation to the original ensemble.]

164 [For this medallion as originally at the summit of the "anagogical window" and to be interpreted as the revelation of the mystery of the alliance of the Old and the New Testaments, cf. *ibid.*, pp. 32-35.]

165 In fact, beside these verses:
Foederis ex arca Christi cruce sistitur ara;
Foedere majori vult ibi vita mori.
(On the ark of the Covenant is established the altar with the cross of Christ;
Here life wishes to die under a greater covenant.)
[Tr. Panofsky, *Abbot Suger*, pp. 74-75] is written: *Quadrige Aminadab*. The commentators of the Song of Songs, especially Honorius of Autun, a contemporary of Suger, explained that Aminadab, standing in the chariot, is the crucified Christ, and the four horses of the quadriga are the four evangelists: Honorius of Autun, *Expositio in Cantica Canticorum*, Migne, *P. L.*, 172, col. 462. [For the reconstruction of Suger's "anagogical window," in which this was the third medallion from the bottom and represents a complicated illustration of St. Paul's Epistle to the Hebrews, see Grodecki, "Les vitraux allégoriques de Saint-Denis," pp. 26-30.] A Limoges copper-gilt plaque, now in the Cluny Museum in Paris, also mentions Christ's triumphal chariot, whose wheels are the four evangelists. [Paris, Musée des Thermes et de l'Hôtel de Cluny, *Catalogue et description des objets d'art de l'antiquité du moyen âge et de la renaissance exposés au musée*, Paris, 1881, p. 402, no. 4991. Reproduced by A. Du Sommerard, *Les Arts au moyen âge en ce qui concerne principalement le Palais Romain de Paris, l'Hôtel de Cluny issu de ses ruines, et les objets d'art de la collection classée dans cet hôtel*, Paris, 1838-1846, IV: Album, pl. XXV, and Swarzenski, *Monuments of Romanesque Art*, no. 186, p. 73, fig. 422.]

166 [For this medallion as the initial, or bottom one in the "anagogical window" and a unique attempt to create an allegory on St. Paul's symbolic method, see Grodecki, "Les vitraux allégoriques de Saint-Denis," pp. 22-24.]

167 [Tr. Panofsky, *Abbot Suger*, pp. 74-75.] On the façade of St.-Trophime, at Arles, St.

Paul holds a banderole on which is written: *Lex Moisi celat quae sermo Pauli revelat. Nam data grana Sinai per eum sunt facta farina* (The Law of Moses conceals what the words of Paul reveal. For the grain given at Sinai through him has been made into flour). This inscription bears striking analogies to Suger's verses. In the Renaissance, the theme of the mill was replaced with that of the wine press. The patriarchs and prophets carry the grapes to the vat, the pope and the cardinals gather in the wine (window of St.-Etienne-du-Mont, and window, no longer extant, of St. Hilary at Chartres, 1520). See L. Lindet, "Les représentations allégoriques du moulin et du pressoir dans l'art chrétien," *Revue archéologique*, 3rd ser., 36 (1900), pp. 403-413, and Mâle, *L'Art religieux de la fin du moyen âge*, pt. I, iii, pp. 69-72.

168 [Cf. Grodecki, "Les vitraux allégoriques de Saint-Denis," pp. 35, 41.]

169 The famous Credo of Joinville offers an interesting example of the concordance of the two Testaments: facing the Descent into Limbo and the Resurrection, Jonah is vomited forth by the whale; facing the Last Judgment is the Judgment of Solomon which prefigures it, etc. (Paris, Bibl. Nat., ms. nouv. acq. fr. 4509). [See Friedman, *Text and Iconography for Joinville's Credo*.] Manuscripts of this kind are numerous. For example, see Paris, Bibl. Nat., ms. fr. 188, and especially Paris, Bibl. Nat., ms. nouv. acq. lat. 2129. The latter manuscript, decorated with extremely crude figures, is of German origin (1471). With one scene from the New Testament, two scenes from the Old Testament are placed in correspondence, along with two plants or animals treated as symbols. This again is the method of Honorius of Autun.

170 On this subject, see Mâle, *L'Art religieux de la fin du moyen âge en France*, pt. I, vi, pp. 273-295. [See H. Cornell, *Biblia Pauperum*, Stockholm, 1925; G. Schmidt, *Die Armenbibeln des XIV. Jahrhunderts*, Graz-Cologne, 1959; and J. Lutz and P. Perdrizet, *Speculum humanae salvationis*, 2 vols., Mulhouse, 1907.]

171 These divisions in the history of the world were often indicated in the Middle Ages.

See especially Honorius of Autun, *Expositio in Cantica Canticorum*, Migne, *P. L.*, 172, col. 460.

172 Broken.

173 Mutilated.

174 Only the foot of the chalice held by St. Peter remains.

BOOK IV, CHAPTER II

1 [See *Discours sur l'histoire universelle de Jacques-Bénigne Bossuet*, ed. A. Gasté, Paris, 1928, pp. 313-317.]

2 Among the very rare exceptions, the reliefs of Reims (interior sculptures, left portal as you enter) can be cited. We see Jesus healing the mother-in-law of Peter, and at the side, Jesus and the woman of Samaria. These sculptures are unusual in many ways: Jesus is beardless, for example. I am tempted to think that the Reims sculptures were derived from those on an Early Christian sarcophagus. [See Reinhardt, *La Cathédrale de Reims*, pp. 173-177.]

3 In the Appendix, I have enumerated the principal works devoted to the life of Christ by thirteenth-century French artists.

4 The window at Chartres in the chapel of the apse would seem to be an exception. It represents: John the Baptist and his disciples; the calling of the apostles; Jesus and Philip; Jesus and Nathaniel; the miraculous draught of fish; Jesus talking with the apostles; the Last Supper; the washing of the feet; Jesus in the Garden of Olives (the apostles sleep); Jesus arrested by the soldiers (the apostles grieve in the background); Jesus' appearance to the apostles after the Resurrection; the ascension of Christ from the midst of the apostles. It is clear that such a window is not dedicated to Christ but to the Apostolic College. In all the scenes represented, we notice the presence of one or more of the apostles. We might add that the chapel where the window is found (now the Chapel of Communion) was called the Chapel of the Apostles in the thirteenth century. See Bulteau, *Description de la cathédrale de Chartres*, p. 173. [Delaporte, *Vitraux de Chartres*, II, pls. xcii-xciv.]

5 In the Appendix, reference is made to several manuscripts.

6 Paris, Bibl. Nat., ms. lat. 17326 (thirteenth century). [*Manuscrits à peintures*, no. 13, pp. 14-15. Note should be taken of the extensive cycles in German manuscripts of the tenth and eleventh centuries, notably: the Echternach Gospels, Codex Egberti, and the Codex Aureus of Speyer. See P. Metz, *The Golden Gospels of Echternach, Codex Aureus Epternacensis*, tr. I. Schreier and P. Gorge, New York (1957); H. Schiel, *Codex Egberti der Stadtbibliothek Trier Ms. 24* (Voll-Faksimile-Ausgabe unter dem Patronat der Stadt **Trier**), 2 vols., Basel (1960); and A. Boeckler, *Das goldene Evangelienbuch Heinrichs III*, Berlin, 1933.]

7 Paris, Bibl. Nat., ms. fr. 1765 is from the fourteenth century.

8 See Appendix.

9 See Didron, *Manuel d'iconographie chrétienne*, pp. 155ff., and G. Rohault de Fleury, *La Sainte Vierge; Etudes archéologiques et iconographiques*, Paris, 1878, I, p. 85 (on the subject of Byzantine painting of the feasts of the Church, in the Vatican). The feasts adopted by the West differ slightly from those adopted by the Eastern Church. [On Eastern representations, see G. Millet, *Recherches sur l'iconographie de l'évangile*, Paris, 1916 (repr. Paris, 1960).]

10 William Durandus, *Rationale*, VII, xlii [Ed. d'Avino, p. 712; ed. Barthélemy, V, pp. 122-129]; Honorius of Autun, *Gemma animae*, III, xii-xiv, Migne, *P. L.*, 172, col. 646. [See H. Wentzel, *Christus-Johannes-Gruppen*, Stuttgart, 1960.]

11 At Lyon, the story of John the Baptist was included because they were rarely separated in the Middle Ages, and their stories were often united in the same window (window at Tours, for example), and because the death of John the Apostle was said to have occurred on the same day as the birth of John the Baptist.

12 Honorius of Autun gives the deacons' game a symbolic meaning. According to him, it signifies the glorious struggle (*palaestra*) of St. Stephen. Like a holy martyr, the winning deacon received a crown: *Gemma animae*, III, xii, Migne, *P. L.*, 172, col. 646.

13 I am inclined to believe that the interior sculptures of the portals of Reims, which at first glance seemed confused, express the same idea; for there we see, along with the prophets who foretold the birth of Christ, the Massacre of the Innocents, the story of St. Stephen, St. John and the Apocalypse, and the life of John the Baptist. [Reinhardt, *La Cathédrale de Reims*, pp. 173-177.] At Chartres (south porch, left portal, tympanum and archivolts), the Martyrdom of St. Stephen is brought together with statuettes of children bearing palms, who represent the holy Innocents. [Houvet, *Portail sud*, I, pls. 48, 53, 64.] At the Ste.-Chapelle, it is most remarkable that the window devoted to the Infancy of Christ and in which we see, consequently, the Nativity and the Massacre of the Innocents, also contains the life of St. John the Evangelist. [See Grodecki in Aubert, *Vitraux de Notre-Dame et de la Sainte-Chapelle*, pp. 185-194.] At St.-Julien-du-Sault (Yonne), a thirteenth-century window brings together the Infancy of Christ (Massacre of the Innocents), the legend of John the Evangelist, and that of John the Baptist.

14 William Durandus, *Rationale*, VI, xv. [Ed. d'Avino, p. 423; ed. Barthélemy, III, pp. 236-243.]

15 Honorius of Autun, *Gemma animae*, III, xviii, Migne, *P. L.*, 172, col. 647. Rupert, *De divinis officis per anni circulum*, III, xxiv, Migne, *P. L.*, 170, col. 84. William Durandus, *Rationale*, VI, xvi. [Ed. d'Avino, p. 429; ed. Barthélemy, pp. 243-254.]

16 These three scenes are brought together in a window at Troyes, published by A. Gaussen, *Portefeuille archéologique de la Champagne*, Bar-sur-Aube, 1861, II, pl. 1; the Temptation is added. A Limoges manuscript shows, on the same page, the Baptism of Christ and the urns of the Marriage at Cana. We reproduced this in Mâle, *Religious Art in France: The Twelfth Century*, fig. 106. [On the Adoration of the Magi, see H. Kehrer, *Die heiligen drei Könige in Literatur und Kunst*, 2 vols., Leipzig, 1908-1909.]

17 William Durandus explains at length the symbolism of fasting, of Lent, and the three temptations of Christ: *Rationale*, VI, xxxii. [Ed. d'Avino, pp. 459-464; ed. Barthélemy, III, pp. 318-325.] In manuscripts, the Temptation illustrates the beginning of Lent: Paris, Bibl. Ste.-Geneviève, ms. 102, fol. 199v (thirteenth century).

18 See Honorius of Autun, *Sacramentarium,* v, Migne, *P. L.,* 172, col. 742, and William Durandus, *Rationale,* VI, xxxii. [Ed. d'Avino, p. 460; ed. Barthélemy, III, pp. 318-325.]

19 *Ibid.,* VI, xxxix. [Ed. d'Avino, p. 469; ed. Barthélemy, III, pp. 333-338.]

20 In the window at Bourges, the Passion begins with the Entry into Jerusalem, followed by the resurrection of Lazarus. The raising of Lazarus marks the beginning of the Passion, since it was after this miracle that the Jews resolved to put Jesus to death. Giotto, in the Arena Chapel at Padua, also begins the Passion with the raising of Lazarus. [See E. H. Kantorowicz, "The 'King's Advent' and the Enigmatic Panels in the Doors of Santa Sabina," *Art Bulletin,* 26 (1944), pp. 209-231.]

21 See William Durandus, *Rationale,* VI, lxxxix [ed. d'Avino, p. 584; ed. Barthélemy, IV, pp. 225-249], and Jacob of Voragine, *Legenda aurea,* LXX. [*La Légende dorée de Jacobus de Voragine,* ed. and tr. J.-B. M. Roze, Paris, 1902, II, p. 75 (repr. Paris, 1967, I, pp. 353-354; *The Golden Legend; or, Lives of the Saints as Englished by William Caxton,* ed. F. S. Ellis, London, 1900, I, p. 106.] The serpent must have resembled the dragon surmounting the column carried by Moses at Chartres and Reims. During the procession at Chartres, tow was burned in the mouth of the dragon. See E. de B. de Lépinois, *Histoire de Chartres,* Chartres, 1854, I, Appendix, p. 549.

22 William Durandus, *Rationale,* VI. [Ed. d'Avino, p. 588; ed. Barthélemy, III, pp. 225-249.]

23 Here are several typical examples: Hours of Neville (Paris, Bibl. Nat., ms. lat. 1158) and Hours for Paris use (Paris, Bibl. Nat., ms. lat. 921) [*Manuscrits à peintures,* nos. 220, 222]; Paris, Bibl. Nat., ms. fr. 1874; Paris, Bibl. Nat., ms. fr. 13167; Paris, Bibl. Mazarine, ms. 491. With rare exceptions, the miniatures found in the Hours of the Virgin are the following: Annunciation, Visitation, Nativity, Annunciation to the Shepherds, Adoration of the Magi, Presentation in the Temple, Flight into Egypt, Coronation of the Virgin.

24 The scene of Jesus found in discussion with the doctors by his parents might also be linked with the story of the Virgin. It is sometimes found in thirteenth-century works.

25 Walafrid Strabo, *Expositio in Quatuor Evangelia, In Evangelium Lucae,* Migne, *P. L.,* 114, col. 896: *. . . positus in praesepio, id est corpus Christi super altare.* [See Katzenellenbogen, *Sculptural Programs of Chartres Cathedral,* pp. 4-24.]

26 The manuscript is now in the Vatican. The miniature, published by d'Agincourt, has been reproduced by J. C. Broussolle, *Le Christ de la Légende dorée,* Paris, n.d., p. 10.

27 The Nativity is represented in the way we have indicated in several thirteenth-century works: relief at Laon (fig. 130), window at Tours (central chapel of the apse), window at Sens (choir), windows at Lyon and Chartres, etc. It is also found in manuscripts. For example: Gospels of Ste.-Chapelle (Paris, Bibl. Nat., ms. lat. 17326), thirteenth century [*Manuscrits à peintures,* no. 13]; Paris, Bibl. Nat., ms. lat. 1077, fol. 9v (thirteenth century); London, Brit. Mus., Add. ms. 17868, fol. 16 (thirteenth-century French manuscript). We have shown that this formula must have appeared in French art before 1145: Mâle, *Religious Art in France: The Twelfth Century,* chap. III. [The rood-screen at Chartres, completed about 1235, showed a Nativity with more human relationships; see Grodecki, *Chartres,* pp. 184, 203.]

28 Preserved in the treasury of Monza are *eulogae* made of small cakes of stamped earth taken from the place where the Annunciation took place and where Adam was created: see X. Barbier de Montault, "Le Trésor de la basilique royale de Monza," *Bulletin monumental,* 49 (1883), p. 135. For 25 March, some of the old calendars have the double commemoration of the creation of Adam and the Incarnation. The idea of locating the Creation and the Annunciation in the same spot goes far back in time; it was already indicated in the Pseudo-Abdias, *Histoire de Saint Barthélemy,* IV, *Dictionnaire des apocryphes,* ed. J.-P. Migne, Paris, 1858, II, p. 154.

29 See *Glossa ordinaria, Evangelium secundum Matthaeum,* XXVII, Migne, *P. L.,* 114, col. 174: *Golgotha . . . interpretatur Calvariae, non ob calvitium Adae quem men-*

tiuntur ibi sepultum . . . (Golgotha . . . is interpreted for Calvary, not on account of the baldness of Adam whom they falsely say is buried there).

30 Windows at Angers (thirteenth century) and at Beauvais (Cahier and Martin, *Bourges*, study pl. IV) show Adam and Eve receiving the blood that flowed from the cross.

31 See Jacob of Voragine, *Legenda aurea, De inventione sanctae crucis* [ed. Roze, 1902, II, pp. 52ff.; 1967, I, pp. 341-343; tr. Caxton, III, p. 169] and Honorius of Autun, *Speculum ecclesiae, De inventione sanctae crucis*, Migne, *P. L.*, 172, cols. 741-950. See also E. P. Du Méril, *Poésies populaires latines du moyen âge*, Paris, 1847, p. 321.

32 See Walafrid Strabo, *Glossa ordinaria, Evangelium secundum Marcum*, xv, Migne, *P. L.*, 114, col. 239, and Honorius of Autun, *Hexaemeron*, VI, *De incarnatione Christi*, Migne, *P. L.*, 172, col. 266: *Et qua hora terrenus homo invasit pomum, humanum genus interempturus; eadem hora toleravit crucem et mortis amaritudinem coelestis homo, universum mundum redempturus.* (And at the same hour when the man of earth trespassed upon the fruit to destroy the human race, the man of heaven bore the cross and the bitterness of death to redeem the whole world.) See also Vincent of Beauvais, *Speculum historiale*, I, lvi [Graz ed., IV. 22] and VII, xlv [Graz ed., IV. 237]; Jacob of Voragine, *Legenda aurea, De passione Christi*, LIII [ed. Roze, 1902, I, pp. 397-398 (1967, I, p. 263); tr. Caxton, I, pp. 76-77]. The *Legenda aurea* also enumerates the great events of religious history which took place on the same day: the Annunciation, the Visitation, the death of Christ, the birth of Adam, the Fall of Adam, the death of Abel, the offering of Melchizedek, the sacrifice of Abraham. *Ibid.*, LI. [Ed. Roze, 1902, I, p. 382 (1967, I, p. 254); tr. Caxton, III, p. 100.]

33 See Walafrid Strabo, *Expositio in Quatuor Evangelia, In Evangelium Joannis*, xix, Migne, *P. L.*, 114, col. 914. The idea goes back to the Church Fathers. St. Augustine wrote: *Dormit Adam ut fiat Eva, moritur Christus ut fiat Ecclesia. Dormienti Adae fit Eva de latere; mortuo Christo lancea percutitur latus, ut profluant sacramenta quibus formetur Ecclesia.* (Adam sleeps

that Eve may be created, Christ dies that the Church may be created. From the sleeping Adam's side, Eve is created; the dead Christ's side is shattered by the lance so that there may flow forth the sacraments whereof the Church is formed.) *Tractatus. In Evangelium Joannis*, IX, Migne, *P. L.*, 35, col. 1463. See also the poem by St. Avitus, *Poematum de mosaicae historiae Gestis*, I, *De Initio Mundi*, Migne, *P. L.*, 59, col. 327. Medieval texts are numerous. See Honorius of Autun, *Speculum ecclesiae, Dominica de passione Domini*, Migne, *P. L.*, 172, col. 910, and Vincent of Beauvais, *Speculum historiale*, VII, xlvi. [Graz ed., IV. 237.]

34 Walafrid Strabo, *Expositio in Quatuor Evangelia. In Evangelium Joannis*, xix, Migne, *P. L.*, 114, col. 914. [St. Augustine, *De civitate Dei*, xv; *Quod arca quam Noe jussus est facere, in omnibus Christum Ecclesiamque significet*, Migne, *P. L.*, 41, col. 472.]

35 The Sens and Rouen windows were published by Cahier and Martin, *Bourges*, study pls. XXII and XII. See also what is said about the cycle of the two Adams: *ibid.*, pp. 205ff. The miniaturists were even bolder than the glass painters. They represented the Church issuing from the middle of Christ's right side. See Paris, Bibl. Nat., ms. fr. 9561, fols. 6r and 7v. Near the miniatures is written: *Eve qui yssi hors del costé Adam Jhucrist.* (Eve who issued from Adam's side signifies the Holy Church which issued from Christ's side.)

36 Ludolf of Saxony, *Vita Christi*, LIII.

37 The imposing idea of personifying the two doctrines is not Byzantine. C. de Linas, "Emaillerie Byzantine; La collection Svenigorodskoi," *Revue de l'art chrétien*, 4th ser., 3 (1885), p. 212, has clearly demonstrated that the two figures of the Church and the Synagogue came from Austrasia in Carolingian times. The earliest example known is in the Sacramentary of Drogo, which dates from the ninth century. [W. Köhler, *Die karolingischen Miniaturen*, Berlin, 1960, III, pl. 83c.] The source of these representations was the *De Altercatio Ecclesiae et Synagogae*, attributed to St. Augustine, Migne, *P. L.*, 42, cols. 1131-1140. [This text is now attributed to an anonymous author between 938 and 966. See B. Blumenkranz,

Les Auteurs chrétiens latins du moyen âge sur les juifs et le judaisme, Paris, 1963, pp. 222-224.] On this subject, see P. Weber, *Geistliches Schauspiel und kirchliche Kunst in ihrem Verhältnis erläutert an einer Ikonographie der Kirche und Synagoge*, Stuttgart, 1894, pp. 27-31. [For literary parallels, see M. Schlauch, "The Allegory of Church and Synagogue," *Speculum*, 14 (1939), pp. 448-464. See also Seiferth, *Synagogue and Church in the Middle Ages; passim*, and B. Blumenkranz, "Synagoga, Mutations d'un thème de l'iconographie mediévale," *Studi storici dell'Istituto storico italiano per il medio evo*, Rome, 1967.]

38 [Lamentations 5:16-17.]

39 Cahier and Martin, *Bourges*, study pl. VI.

40 For example, in the beautiful window of the cathedral of Poitiers. [Aubert, *Le Vitrail français*, pl. I.]

41 Walafrid Strabo, *Glossa ordinaria, Evangelium secundum Lucam*, XXIII, Migne, *P. L.*, 114, col. 349. According to the legend, Longinus had been blind and the blood of Christ restored his sight. We see how a dogmatic idea was responsible for what would seem to be a legend of popular origin. Manuscripts sometimes show blood spurting on Longinus' eyes. He abruptly raises his hand and seems to rub in the blood. For example, Gospel Book of Ste.-Chapelle (Paris, Bibl. Nat., ms. lat. 17326), thirteenth century.

42 *Ibid., Evangelium secundum Lucam*, XXIII, Migne, *P. L.*, 114, col. 348.

43 Isidore of Seville, *Allegoriae*, Migne, *P. L.*, 83, col. 117. See also St. Ambrose, *Expositio Evangelii secundum Lucam*, II, Migne, *P. L.*, 15, col. 1555. [See H. Coathalem, *Le Parallelisme entre la sainte vierge et l'église dans la tradition latine jusqu'à la fin du XIIe siècle* (Analecta Gregoriana, LXXIV), Rome, 1954.]

44 Jacob of Voragine, *Mariale*, I, *Sermo* 3. It was again remarked that the Virgin had not taken perfumes to the tomb on Holy Saturday because she alone had faith in the Resurrection. During those sad days, she alone was the Church.

45 [See E. Guldan, *Eva und Maria, eine Antithese als Bildmotiv*, Graz and Cologne, 1966.]

46 See St. Gregory the Great, *Homiliarum in Evangelia*, II, xxii, *Lectio S. Evang. sec. Joan.*, xx, 1-9, Migne, *P. L.*, 76, cols. 1174-1175, and Walafrid Strabo, *Glossa ordinaria, Evangelium secundum Joannem*, xx, Migne, *P. L.*, 114, col. 422. On the Saturday after Easter, the account of the two disciples running to the tomb was read from the Gospel of St. John, followed by the homily of St. Gregory the Great, which interprets the passage symbolically. See lectionary (Paris, Bibl. Ste.-Geneviève, ms. 138, fol. 6).

47 Isidore of Seville, *Allegoriae*, Migne, *P. L.*, 83, col. 130: *Duo latrones populum exprimunt Judaeorum et Gentium.* Walafrid Strabo, *Glossa ordinaria, Evangelium secundum Joannem*, xix, v. 18, Migne, *P. L.*, 114, col. 421: *Latro qui permansit in perfidia significet Judaeos. . . .*

48 Preserved by Bastard, Calques (Cabinet des Estampes). [Herrad of Landsberg, *Hortus deliciarum*, ed. Walters, pl. xxviiib.] See also in the Fonds Bastard (Cabinet des Estampes), vol. VII, a twelfth-century symbolic Crucifixion similar to that of the *Hortus deliciarum.*

49 They have been restored. There are two examples of the Church and the Synagogue at Reims on the south portal (near the rose window), and on the west portal below two pinnacles, near the cross of Christ. [Reinhardt, *La Cathédrale de Reims*, pls. 32, 34.] The Church and the Synagogue on the south portal of Strasbourg Cathedral are justly famous. [Haug, *La Cathédrale de Strasbourg*, pls. 92-95.] At St.-Seurin, in Bordeaux, the Synagogue's eyes are veiled not by a band but by the tail of a dragon, which stands behind its head. The same is true at Paris.

50 Isidore of Seville, *De fide catholica, Contra Judaeos*, Migne, *P. L.*, 83, cols. 449-538. Petrus Alfonsi, *Dialogi*, titulus XII, Migne, *P. L.*, 157, cols. 656-672. See also, in the works of Peter Damian, *Opusculum*, III, *Dialogus inter Judaeum requirentem, et Christianum e contrario respondentem. Ad eumdem honestum*, Migne, *P. L.*, 145, cols. 57-68. Weber, *Geistliches Schauspiel*, pp. 27-31, strongly relates works of art as well as certain dramatic works in which the Church and the Synagogue figure to the struggle undertaken by the medieval

Church against Judaism. Viollet-le-Duc, "Eglise," *Dictionnaire raisonné de l'architecture*, v, p. 155, went so far as to claim that the figure of the Synagogue appeared only in towns where Jews were numerous: Paris, Reims, Strasbourg, and Bordeaux. [Cf. B. Blumenkranz, "Géographie historique d'un thème de l'iconographie religieuse: les représentations de *Synagoga* en France," *Mélanges offerts à René Crozet*, Poitiers, 1966, II, pp. 1141-1157.]

51 See Ludolf of Saxony, *Passio Christi*, LXIII. Certain ancient ivory diptychs represent the Roman she-wolf before Christ on the cross. See A. F. Gori, *Thesaurus veterum diptychorum consularium et ecclesiasticorum*, Florence, 1759, III, pl. XXII (Diptych of Rambona).

52 It has often been stated (Grimoüard de Saint-Laurent, *Guide de l'art chrétien*; Barbier de Montault, *Traité d'iconographie chrétienne*, II, p. 161) that the Resurrection of Christ was not used as a subject in art until the thirteenth century, and that such representations were very rare even in the Romanesque period. However, we can cite two examples: a miniature in Paris, Bibl. Nat., ms. lat. 17325, fol. 30v (eleventh century), and a capital in the museum of Toulouse (twelfth century). The early artists had not dared to represent the mysterious Resurrection because it is not described in the Gospels; they represented only the holy women at the tomb. [See Mâle, *Religious Art in France: The Twelfth Century*, pp. 132-133, and F. Rademacher, "Zu den frühesten Darstellungen der Auferstehung Christi," *Zeitschrift für Kunstgeschichte*, 28 (1965), pp. 195-224.] Even in the thirteenth century, the ancient practice was still followed (window at Laon, chevet; window at Lyon, apse).

53 Matthew 29: 2-3. ["And behold, there was a great earthquake; for an angel of the Lord descended from heaven and came and rolled back the stone, and sat upon it. His appearance was like lightning, and his raiment white as snow."]

54 Walafrid Strabo, *Glossa ordinaria, Evangelium secundum Matthaeum*, XXVIII, Migne, *P. L.*, 114, col. 117; *Evangelium secundum Marcum*, XVI, *ibid.*, col. 241; *Evangelium secundum Lucam*, *ibid.*, col. 350.

55 [St. Augustine, *Appendix tomi quinti, Sermones suppositios, Classis prima, De Veteri et Novo Testamento*, XVI, *Rursum in Joannis caput II, 1-10 de sex hydriis aquae in nuptiis Cana Galilaeae*, Migne, *P. L.*, 39, cols. 1920-1921; and Hugh of St. Victor, *Allegoriae in Novum Testamentum, In Evangelia*, I, *De Mysteriis evangelii Sancti Joannis*, I, i, Migne, *P. L.*, 195, cols. 751-754.]

56 John the Baptist is not shown in the Canterbury window. See A. N. Didron, "La Symbolisme chrétienne, I, La vie humaine," *Annales archéologiques*, I (1844), p. 248.

57 Reproduced in Cahier and Martin, *Bourges*, pl. VI and study pl. XX.

58 Walafrid Strabo, *Glossa ordinaria, Evangelium secundum Lucam*, X, Migne, *P. L.*, 114, cols. 286-287 and Honorius of Autun, *Speculum ecclesiae, Dominica*, XIII, *post Pentacosten*, Migne, *P. L.*, 172, cols. 1059-1064. Also to be consulted: Hugh of St. Victor, *Allegoriae in Novum Testamentum*, IV, *In Lucam*, XII, Migne, *P. L.*, 175, cols. 814-815. Hugh of St. Victor's book is devoted for the most part to the interpretation of the parables; he summarizes succinctly the traditional doctrine. A great many texts were collected by Cahier and Martin, *Bourges*, pp. 191ff.

59 The creation of man and woman is not represented at Sens, but at Bourges.

60 The city of Jerusalem is placed at the top of the composition in the Sens window.

61 The Resurrection is symbolized by the Holy Women at the Tomb.

62 [Delaporte, *Vitraux de Chartres*, I, pls. XVIII-XXI.]

63 The Virgins are in a graceful rose carved on the west façade.

64 They have been restored.

65 By exception, the Virgins at Reims are on the archivolts of the north portal where the Last Judgment is found.

66 Walafrid Strabo, *Glossa ordinaria, Evangelium secundum Matthaeum*, XXV, Migne, *P. L.*, 114, cols. 164-165. The same doctrine is expressed by the other commentators of Matthew, the principal ones being: St. Hilary, Bede, Rabanus Maurus, Paschasius Radbertus, Bruno of Asti, Hugh of St. Victor (*Allegoriae in Novum Testamentum*, II, xxxiv, Migne, *P. L.*, 175, cols. 799-800).

67 [It has recently been shown that the Wise and Foolish Virgins were also associated with the cult of the Virgin Mary, as at Chartres, north transept, east portal. See Katzenellenbogen, *Sculptural Programs of Chartres Cathedral*, p. 67 and Houvet, *Portail nord*, I, pls. 84-89.]

68 Cahier and Martin, *Bourges*, p. 179.

69 Walafrid Strabo, *Glossa ordinaria, Evangelium secundum Lucam*, xv, Migne, *P. L.*, 114, cols. 311-314 and Hugh of St. Victor, *Allegoriae in Novum Testamentum*, IV, xxii, Migne, *P. L.*, 175, cols. 820-821.

70 This detail occurs in the Auxerre portal.

71 *Glossa ordinaria, Evangelium secundum Lucam*, xvi, Migne, *P. L.*, 114, cols. 316-317; and High of St. Victor, *Allegoriae in Novum Testamentum*, Migne, *P. L.*, 175, cols. 822-823.

72 *Glossa ordinaria, Evangelium secundum Lucam*, xvi, Migne, *P. L.*, 114, col. 316: *magis videtur narratio quam parabola* (it seems more a narrative than a parable).

73 Published in Cahier and Martin, *Bourges*, pl. IX.

74 However, there is one representation of the Virgin fainting at the foot of the cross in a window at Bourges devoted to the Good Samaritan. It anticipates the art of the fourteenth century.

75 [The parallel between Gothic art and scholasticism was also noted by H. Adams, *Mont-Saint-Michel and Chartres*, Boston and New York, [1904], pp. 380-383, and has been further developed by Panofsky, *Gothic Architecture and Scholasticism*.]

76 [J. B. Bossuet, *Élévations à Dieu sur tous les mystères de la religion chrétienne*, ed. E. Chavin, Paris, 1842, tr. *Elevation to God*, London (1850).]

BOOK IV, CHAPTER III

1 Jewish and Arab traditions based on the principal figures of the Old Testament are collected in the *Dictionnaire des apocryphes*, ed. J.-P. Migne, 2 vols., Paris, 1856-1858. [See also L. Ginzberg, *Legends of the Bible*, New York 1956; C. O. Nordström, "Rabbinic Features in Byzantine and Catalan Art," *Cahiers archéologiques*, 15 (1965), pp. 179-205; and *idem, The Duke of Alba's Castilian Bible*, Uppsala, 1967.]

2 [On the subject of Lilith, see L. Ginzberg, *Legends of the Jews*, Philadelphia, 1956, I, pp. 65-66; v, pp. 87-88 n.; and J. M. Hoffeld, "Adam's Two Wives," *The Metropolitan Museum of Art Bulletin*, 29 (1968), pp. 430-440.]

3 [Peter Comestor, *Historia scholastica*, Migne, *P. L.*, 198, cols. 1053-1722.] One of the apocryphal books of the Old Testament, the *Testaments of the XII Patriarchs* [Migne, *Dictionnaire des apocryphes*, I, cols. 853-936; *idem, P. G.*, 2, cols. 1037-1150; R. H. Charles, ed., *The Apocrypha and Pseudepigrapha of the Old Testament*, 2 vols., Oxford, 1964-1965, II, pp. 282-367], passages of which were cited by Vincent of Beauvais, had recently been translated from the Greek by Robert Grosseteste, Bishop of Lincoln. See *Speculum historiale*, I, cxxv. [Graz ed., IV. 45.]

4 In one of his letters to Pope Damasus on perplexing problems in the Old Testament, *Epistolae XXXVI. Ad Damasum*, Migne, *P. L.*, 22, col. 455: . . . *Lamech, qui septimus ab Adam, non sponte (ut in quodam hebraeo volumine scribitur) interfecit Cain. . . .* (Lamech, seventh in descent from Adam, accidentally killed Cain, as is written in a certain Hebrew volume.) He added nothing more.

5 Walafrid Strabo, *Glossa ordinaria, Liber Genesis*, IV, v. 23, Migne, *P. L.*, 113, col. 101: *Aiunt Hebraei Lamech diu vivendo caliginem oculorum incurrisse, et adolescentem ducem et rectorem itineris habuisse. Exercens ergo venationem, sagittam direxit quo adolescens indicavit, casuque Cain inter fruteta latentem interfecit . . . unde et furore accensus occidit adolescentem (Raban).* (The Jews tell that Lamech, by having lived for so long, incurred a darkening of his sight and kept a youth to guide and lead him on his way. Going on a hunt, he directed an arrow to where the youth indicated, and by chance killed Cain, who was concealed within the bushes. Wherefore, inflamed with rage, he slew the youth.)

6 Nicholas of Lyra wrote in the fourteenth century.

7 *Historia scholastica, Historia Libri Genesis*, xxviii, *De generationibus Cain*, Migne, *P. L.*, 198, cols. 1078-1080.

8 Arcatures of the lower part. The heads of

Cain and the child are both modern restorations.

9 Published by J.-J. Bourassé and J. Marchand, *Verrières du choeur de l'église métropolitaine de Tours*, Paris, 1849, pl. XII.

10 We cited some of these works in E. Mâle, "La Légende de la mort de Cain, à propos d'un chapiteau de Tarbes," *Revue archéologique*, 21 (1893), pp. 186-194.

11 The translation of the *Yashar* [*Book of the Just*] is given in Migne, *Dictionnaire des apocryphes*, II, cols. 1069-1310; see especially col. 1108.

12 John 21:25.

13 We know that Mohammed knew little about the life of Christ except the stories of the apocryphal Gospels.

14 J. A. Fabricius, ed., *Codex apocryphus Novi Testamenti*, 3 vols., 2nd ed., Hamburg, 1719; J. K. Thilo, ed., *Codex apocryphus Novi Testamenti e libris editis et manuscriptis, maxime gallicanis, germanicis et italicis*, Leipzig, 1832; C. von Tischendorf, ed., *Evangelia apocrypha*, 2nd ed., Leipzig, 1876. The translation of the apocryphal Gospels by Brunet is to be found, revised and completed, in Migne, *Dictionnaire des apocryphes*, vol. I. A new translation of the apocryphal Gospels by Michel and Peeters began to appear in 1911 and 1914. [C. Michel and P. Peeters, eds., *Evangiles apocryphes*, 2 vols., Paris, 1914-1924.]

15 Published for the first time by Thilo, *Codex apocryphus Novi Testamenti*, pp. 337-400. [See also Migne, *Dictionnaire des apocryphes*, I, cols. 1059-1083. Neither Hennecke, *New Testament Apocrypha*, I, pp. 410-413, nor M. R. James, *The Apocryphal New Testament*, Oxford, 1924, pp. 70-79, contains a complete English translation of this book now known as the Gospel of the Pseudo-Matthew.]

16 Fulbert of Chartres, *Sermones ad populum*, IV, Migne, *P. L.*, 141, col. 320.

17 *Speculum historiale*, VI, xciii. [Graz ed., IV. 205.]

18 *Historia ecclesiasticae francorum*, I, xxi. [Eng. ed. Dalton, II, p. 16; *ibid.*, XX, Migne, *P. L.*, 71, col. 171; see also Migne, *Dictionnaire des apocryphes*, I, cols. 1087-1138; Hennecke, *New Testament Apocrypha*, I, pp. 449-476.]

19 *Speculum historiale*, VI, lvi ff. [Graz ed., IV. 241ff.], and *Legenda aurea. De resurrectione Domini* [ed. Roze, 1902, I, pp. 421-427; 1967, I, pp. 278-281; tr. Caxton, I, pp. 92-101].

20 Ludolf of Saxony died in 1378. His book was written about 1350.

21 *Evangelium de nativitate Mariae et infantis Salvatoris*, xiv: *Tertio autem nativitatis Domini egressa est beata Maria de spelunca et ingressa est stabulum et posuit puerum in praesepio, et bos et asinun adorabant cum.* (On the third day, Mary left the cave and went to a stable and put the child in the manger, and the ox and ass adored him.) [Thilo, *Codex Apocryphus Novi Testamenti*, pp. 381-382; Migne, *Dictionnaire des apocryphes*, I, col. 1073; Eng. tr. James, *Apocryphal New Testament*, p. 74.]

22 Isaiah 1:3: *Agnovit bos possessorem suum et asinus praesepe domini sui* (The ox knows its owner, and the ass its master's crib); and Habakkuk 3:2: "ἐν μέδῳ ζώων γνωσθήσῃ (in the midst of the animals you will be recognized). We know that Jerome corrected this passage from the Alexandrian version and translated it: *In medio annorum vivifica illud* (In the midst of the years, quicken it). But the old interpretation: *In medio duorum animalium cognosceris* (In the midst of two animals will thou be known) was followed none the less. See the Sermon of the Pseudo-Augustine, published by Sepet, *Les Prophètes du Christ*; Jacob of Voragine, *Legenda aurea, De nativitate*, VI [ed. Roze, 1902, I, pp. 74-75; 1967, I, pp. 70-71; tr. Caxton, I, pp. 25-26 (abridged)]; and Ludolf of Saxony, *Vita Christi*, IX, explains the presence of the ox and the ass; the ass had carried the Virgin from Nazareth to Bethlehem; Joseph had brought the ox along so that he might sell it.

23 *O magnum mysterium et admirabile sacramentum ut animalia viderunt dominum jacentem in praesepio.* (O great mystery and wonderful sacrament when animals beheld the Lord lying in the manger.) This verse is found in thirteenth- and fourteenth-century breviaries. For example, Breviary of Poissy: Paris, Bibl. de l'Arsenal, ms. 107, fol. 107. [See V. Leroquais, *Les Bréviaires manuscrits des bibliothèques publiques de France*, Paris, 1934, II, pp. 317-319.]

24 On the reliquary of Aix-la-Chapelle, see Cahier and Martin, *Mélanges d'archéologie*, I, p. 22, pl. IIIC.

25 *Evangelium de nativitate Mariae et infantis Salvatoris*, xiiii, adapted from tr. Brunet. [Migne, *Dictionnaire des apocryphes*, I, col. 1073; James, *Apocryphal New Testament*, p. 74.]

26 *Nulla ibi obstetrix: nulla muliercularum sedulitas intercessit. Ipsa [Maria] pannis involvit infantem ipsa et mater et obstetrix fuit.* (No midwife was there, no womenly care interceded. [Mary] herself wrapped the infant in swaddling clothes, she was herself both mother and midwife.) St. Jerome, *De perpetua Virginitate Beatae Mariae. Adversus Helvidium*, Migne, *P. L.*, 23, col. 192.

27 *Legenda aurea. De Nativitate*, vi. [Ed. Roze, 1902, I, p. 69; 1967, I, p. 67; tr. Caxton, I, pp. 25-26 (this greatly abridged section omits the legend of the midwives).]

28 P. Meyer, "Notice de quelques mss. de la collection Libri, à Florence, I," *Romania*, 14 (1885), p. 515.

29 At Chartres, the midwives are not washing the Infant. [Houvet, *Portail occidental*, pl. 80.]

30 See J.-B. Thiers, *Traité des superstitions qui regardent les sacremens, selon l'Ecriture sainte, les décrets des conciles et les sentimens des saints pères et des théologiens*, Paris, 1741, and X. Barbier de Montault, "Ivoire latin du musée de Nevers," *Bulletin monumental*, 50 (1884), p. 722.

31 Ludolf of Saxony, *Vita Christi*, XI.

32 On the subject of these legends and their sources, see Migne, *Dictionnaire des apocryphes*, I, cols. 1023-1025, and II, cols. 470-471.

33 *Evangelium de nativitate Mariae et infantis Salvatoris*, xvi [*ibid.*, I, cols. 1074-1075].

34 *Legenda aurea. De innocenti*, x, and *De epiphania Domini*, xiv. [Ed. Roze, 1902, I, pp. 104-110, 147-159; 1967, I, pp. 88-92, 114-121; tr. Caxton, II, pp. 176-182; I, pp. 41-52.]

35 Later called Gaspard.

36 The legend of the magi in literature and art has been carefully studied by Kehrer, *Die heiligen drei Könige in Literatur und Kunst*. He shows that the number of magi, at first not specified, was reduced quite early by the Church Fathers to three. Origen is the first ecclesiastical writer to speak of the three magi, *In Genesim Homiliae*, xiv, 3, Migne, *P. G.*, 12, col. 238. Artists of the Early Christian era represented two, three, four, and even six magi; it was only in the sixth century that the number was established as three. Tertullian was the first to allude to their title of king, which later was always applied to the magi, and he implied that the kings of Arabia and of Sheba spoken of in the Psalms [71: 10 (Vulgate); 72: 10 (King James version)] were prefigurations of the magi; *Adversus Marcionem*, III, xiii, Migne, *P. L.*, 2, cols. 337-340; *Liber adversus Judaeos*, ix, *ibid.*, col. 619, and *De idolatria*, ix, *ibid.*, I, cols. 671-673. But it was not until the fifth century that the magi were finally established as kings in a treatise by Maximus of Turin, *Tractatus*, v. *Contra Judaeos*, Migne, *P. L.*, 57, cols. 801-802, and in the sixth century by Caesarius of Arles. However, it was only in the tenth century that artists began to represent the magi as kings with crowns on their heads; the earliest example is in the famous *Menologium* of Basil II, in the Vatican, which dates from about 976. Until then, they were shown with the Phrygian cap and full pantaloons worn by the Persians and the priests of Mithra. [On the cult of the three magi, see the catalogue of the exhibition of the Erzbischöfliches Diözesan-Museum, *Achthundert Jahre Verehrung der heiligen drei Könige in Köln, 1164-1964*, Cologne, 1964.]

37 [Bégule and Guigue, *Monographie de la cathédrale de Lyon*, p. v.]

38 [On the personification of the star as an angel, see G. Stuhlfauth, *Die Engel in der altchristlichen Kunst*, Freiburg-im-Breisgau, 1897, pp. 118-134.]

39 Gospel Book—Paris, Bibl. Nat., ms. lat. 17325 (eleventh century).

40 An eastern manuscript, the Gospel Book of Etschmiadzin, dating from about 550, contains the first instance of the three magi represented as an aged man, a middle-aged man, and a young man. [Kehrer, *Die heiligen drei Könige*, II, fig. 42.] In the West, this practice was taken up only at the end of the Carolingian period (ivory in the

museum of Lyon, about 900). [Kehrer, *Die heiligen drei Könige*, II, fig. 106.]

41 *Opera ascetica inter dubia reputate. Excerptiones Patrum Collectanea*, Migne, *P. L.*, 94, col. 541.

42 This passage from the Pseudo-Bede was certainly translated from Greek, as certain words prove (*milenus, hyacinthinus, mitrarium*). It seems to have been taken from a very ancient Guide to Painting. See Kehrer, *Die heiligen drei Könige*, I, pp. 66-75. It seems certain that the idea of assigning a different age to each of the magi came from the East. The mysterious names of the magi are first found in a Greek chronicle of the early sixth century, translated into Latin by a Merovingian monk: *Chronica minora*, ed. C. Frick, Leipzig, 1892, p. 338. The three names are given as Bithisarea, Melichior, and Gathaspa.

43 Even exact ages were given to the magi. In the Middle Ages, the oldest was said to be sixty, the youngest twenty, and the other forty; they might be said to represent the enthusiasm of youth, the maturity of middle age, and the experience of age, all rendering homage to Christ. These exact ages are given in Petrus de Natalibus, *Catalogus sanctorum et gestorum eorŭ ex diversis voluminibus collectus*, II, xlviii, *De sanctis Gaspar Balthasar et Melchior*, ed. Antonio Verlo, Vicenza, 1493 (unpaged).

44 Kehrer thought that the earliest example of a black magi-king was that of the carved tympanum of the church of Thann, dating from about 1400 (Kehrer, *Die heiligen drei Könige*, II, p. 224), but he did not notice that the head of the king is modern. The first examples appeared in the fifteenth century; they were far more numerous in Germany than in France, where they appeared much later.

45 This kind of symbolism goes back to an early age, since it is found in the Commentary of Bede on St. Matthew, *In Matthaei Evangelium expositio*, I, ii, Migne, *P. L.*, 92, col. 13.

46 L.F.A. Maury, *Essai sur les légendes pieuses du moyen âge*, Paris, 1843, p. 207, was the first to point out the Amiens reliefs, but he did not explain them.

47 *Legenda aurea, De innocenti*, x [ed. Roze, 1902, I, p. 106; 1967, I, p. 89; tr. Caxton

(abridged, this section omitted).]; Vincent of Beauvais, *Speculum historiale*, VII, xciii [Graz ed., IV. 205]; Ludolf of Saxony, *Vita Christi*, XI.

48 The town of Tharsis mentioned in the Old Testament was identified with Tarsus. [Psalms 47:8 (Vulgate); 48:7 (King James version): "With a vehement wind thou shalt break in pieces the ships of Tharsis."]

49 In Italy, until the eighteenth century, the feast of the return of the Magi was held on March first.

50 Reproduced by Lasteyrie, *Histoire de la peinture sur verre*, II, pl. xxv.

51 Fig. 144 represents, in the upper series of medallions: the Massacre of the Innocents; Herod consulting the Doctors; Micah foretelling that the Messiah would come out of Bethlehem; Balaam pointing to the star. Lower series, from right to left: the Magi awakened by the angel; the Magi returning by sea; the ships of Tarsus set on fire; Herod giving the order to burn the ships.

52 *Legenda aurea. De innocenti*, x (adapted from *La Légende dorée*, tr. Brunet, Paris, 1843). [Ed. Roze, 1902, I, p. 109; 1967, I, p. 91; tr. Caxton, II, p. 180.]

53 Peter Comestor, *Historia scholastica, Historia evangelica*, xvi, Migne, *P. L.*, 198, col. 1546, according to Josephus. See also Vincent of Beauvais, *Speculum historiale*, VI, c [Graz ed. IV. 208], and *Legenda aurea. De innocenti*, x [ed. Roze, 1902, I, p. 110; 1967, I, p. 90; tr. Caxton, II, p. 181].

54 *L'Evangile de l'enfance*, Migne, *Dictionnaire des apocryphes*, I, cols. 989, 995. [*Evangelium de nativitate Mariae et infantis Salvatoris*, xviii-xix, *ibid.*, cols. 1075-1076; *Extracts from the Arabic Infancy Gospel*, tr. in Hennecke, *New Testament Apocrypha*, I, pp. 408-409; and *Extracts from the Gospel of Pseudo-Matthew, ibid.*, pp. 410-411.]

55 *Speculum historiale*, VI, xciii. [Graz ed., IV. 205.]

56 *Legenda aurea, De innocenti*, x. [Ed. Roze, 1900, I, pp. 104-110; 1967, I, pp. 88-92; tr. Caxton, II, pp. 176-182, abridged.]

57 *Histoire de la nativité de Marie et de l'enfance du Sauveur*, xxiii, Migne, *Dictionnaire des apocryphes*, I, col. 1078. [*Extracts from the Gospel of Pseudo-Matthew,*

tr. in Hennecke, *New Testament Apocrypha*, I, pp. 412-413.]

58 [Isaiah 19:1.]

59 Published by Hucher, *Vitraux peints de la cathédrale du Mans*, pl. IX. The window is in the chapel of the Virgin, and is dedicated to the Infancy of Christ.

60 *Evangelium de nativitate Mariae et infantis Salvatoris*, xx and xxi. [Migne, *Dictionnaire des apocryphes*, I, cols. 1076-1077; *Extracts from the Gospel of Pseudo-Matthew*, tr. in Hennecke, *New Testament Apocrypha*, I, pp. 411-412.]

61 *Speculum historiale*, VI, xciii. [Graz ed., IV. 206.]

62 See especially, Honorius of Autun, *Speculum ecclesiae*, Migne, *P. L.*, 172, col. 837 (he calls the tree persicus), and *Legenda aurea, De innocenti*, x. [Ed. Roze, 1902, I, p. 106; 1967, I, p. 89.]

63 In Cahier and Martin, *Bourges*, study pl. VIII.

64 Bourassé and Marchand, *Verrières de Tours*, pl. VII. At Chartres (old portal, capital), there is no tree, but the Virgin holds a palm branch in her hand.

65 See especially, Hours of Neville—Paris, Bibl. Nat., ms. lat. 1158 (fourteenth century), and Book of Hours for Paris use—Paris, Bibl. Nat., ms. lat. 921 (fifteenth century). [*Manuscrits à peintures*, nos. 220, 222.]

66 *De quelques miracles que l'enfant Jésus fit en sa jeunesse*, Lyon, n.d., 29 leaves (Paris, Bibl. Nat.). [On the legend of the Holy Family with the wheat, see H. Wentzel, "Die 'Kornfeldlegende,'" *Aachener Kunstblätter*, 30 (1965), pp. 131-143.]

67 *Evangelium de nativitate Mariae . . .*, xxii. [See *Histoire de la nativité de Marie et de l'enfance du Sauveur*, Migne, *Dictionnaire des apocryphes*, I, col. 995; *Extracts from the Arabic Infancy Gospel*, Hennecke, *New Testament Apocrypha*, I, pp. 408-409.] The good and bad thieves are named Titus and Dummachus.

68 The good thief is not always represented, and we should guard against thinking so. In the window of the chevet of Laon, the figure accompanying the Holy Family is James, son of St. Joseph, mentioned in the Apocrypha; Greek artists often represented him.

69 [Matthew 18:3.] Vincent of Beauvais, *Speculum historiale*, VII, xxiv. [Graz ed., IV. 229.]

70 See Ademarus, *Epistola de Apostolatu Sancti Martialis*, Migne, *P. L.*, 141, col. 95 (eleventh century). Pseudo-Bonaventura, *Meditationes vitae Christi*, lv. [See *Meditations on the Life of Christ*, tr. I. Ragusa; ed. R. B. Green, Princeton, 1961 (repr. 1975), p. 310. On the attribution of the *Meditations*, see *ibid.*, p. lxxii.] Ludolf of Saxony, *Passio Christi*, liii. The tradition concerning St. Martial was accepted by the Church; I have found it in a manuscript lectionary of the twelfth century (Paris, Bibl. Ste.-Geneviève, ms. 554, fol. 69v).

71 Zacchaeus does not seem to have been identified with Amadour until the fifteenth century. See E. Albe, *Les Miracles de Notre-Dame de Roc-Amadour au XIIe siècle*, Paris, 1908, p. 28.

72 [For a historical study of Early Christian communities and martyrs in Gaul, see E. Graiffe, *La Gaule chrétienne à l'époque romaine*, 3 vols., Paris, 1947; and J. Daniélou and H.-I. Marrou, *Nouvelle histoire de l'église*, I. *Des origines à Saint Grégoire le Grand*, Paris, 1963.]

73 Bourassé and Marchand, *Verrières de Tours*, pl. IV.

74 Florival and Midoux, *Vitraux de Laon*, II, pl. XIX. Florival was surprised at the presence of a thirteenth apostle with nimbus. This is not an apostle, but a disciple who can only be St. Martial. [The scene of the Last Supper depicts only twelve apostles. However, Mâle's observation pertains to the ensuing scene showing the Washing of Feet, where Jesus appears in the midst of thirteen figures with nimbuses, *ibid.*, p. 15 and pl. xx.]

75 Honorius of Autun, *Speculum ecclesiae, De nativitate Domini*, Migne, *P. L.*, 172, col. 834; Vincent of Beauvais, *Speculum historiale*, VII, xi. [Graz ed., IV. 224.] Pseudo-Bonaventura, *Meditationes*, xxi. [Tr. and ed., Ragusa and Green, xx, p. 147.] On this legend, see Johannes Molanus, *De historia sacrarum imaginum et picturarum*, III, xx. [Ed. Paquot (see above, Preface, n. 1).]

76 The nimbus has been repainted, but we can be sure that it was not first put there by a modern restorer.

77 I have found one in a fourteenth-century manuscript: Paris, Bibl. Nat., ms. fr. 1765, fol. 6. Only one of the betrothed pair has a nimbus, as a Notre-Dame.

78 *De laudibus beatae Mariae Virginis*, I, vii. This anonymous work was inserted into the works of Albertus Magnus. [*Opera omnia*, eds. A. and E. Borgnet, Paris, 1898, XXXVI, p. 50.]

79 Fortunatus' expression is:
[crux] *Arbor decora et fulgida,*
ornata regis purpura . . .

[*Carminum*, II, vi, *Opera poetica, Monumenta germanica historica*, IV. *Auctorum antiquissimorum*, pt. I, Berlin, 1881, p. 34. For a thorough study of the Poitiers window, see R. Grinnell, "Iconography and Philosophy in the Crucifixion Window at Poitiers," *Art Bulletin*, 28 (1946), pp. 171-196.]

80 *Lamentatio in passionem Christi*, Migne, *P. L.*, 184, col. 769 (attributed to St. Bernard).

81 Pseudo-Bonaventura, *Meditationes*, lxv [tr. and ed., Ragusa and Green, lxxviii, p. 333]; Ludolf of Saxony, *Passio Christi*, lxiii.

82 Vincent of Beauvais, *Speculum historiale*, VIII, xlvi [Graz ed., IV. 237.] Ludolf, *Passio*, xlvi. The centurion is given the name Longinus in the Gospel of Nicodemus, x. [Migne, *Dictionnaire des apocryphes*, I, col. 1113; the earlier texts translated in Hennecke, *New Testament Apocrypha*, I, p. 459, and James, *Apocryphal New Testament*, p. 104, do not name the centurion.]

83 Vincent of Beauvais, *Speculum historiale*, VII, xlii [Graz ed., IV. 236]: Ludolf, *Passio*, lxiii.

84 Vincent of Beauvais, *Speculum historiale*, VII, xlii [Graz ed., IV. 236]: Ludolf, *Passio*, lxiii. In the work of medieval writers, we find this mnemonic verse:
Ligna crucis: palmes, cedrus, cupressus,
oliva
Until the nineteenth century, survivals of these ancient legends were to be found in the charcoal-burners' guild. See C.-G. Simon, *Etude historique et morale sur le compagnonnage et sur quelques autres associations d'ouvriers depuis leur origine jusqu'à nos jours*, Paris, 1853. However, the tradition of the four kinds of wood of the cross is in contradiction to the tradition of the tree of paradise preserved in the *piscina probatica*.

85 Vincent of Beauvais, *Speculum historiale*, VII, xliv. [Graz ed., IV. 237.]

86 Window at Reims; *Album* of Villard de Honnecourt (thirteenth century). [Hahnloser, *Villard de Honnecourt*, pl. 26.]

87 Carolingian ivories show the Earth and the Sea present at the death of Christ. [For the iconography of the chalice, see V. H. Elbern, *Die eucharistische Kelch im frühen Mittelalter*, Berlin, 1964, pp. 77ff.]

88 Hours of Metz: Paris, Bibl. de l'Arsenal, ms. 570, fol. 31v (early fourteenth century) [*Manuscrits à peintures*, no. 99]; Paris, Bibl. Nat., ms. fr. 183, fol. 9v (thirteenth century).

89 Cahier and Martin, *Bourges*, pl. v.

90 H. Martin, *Legende de Saint Denis*, Paris, 1908, pl. VII; the manuscript dates from 1317. [Yves, monk of Saint-Denis, Life of Saint Denis—Paris, Bibl. Nat., ms. fr. 2090-2092; see *Manuscrits à peintures*, no. 33, pp. 22-24.]

91 A window at Bourges (fifteenth century) shows St. Dionysius observing the eclipse. In the following section, we see the altar raised to an unknown god.

92 Life of St. Denis (Paris, Bibl. Nat., ms. nouv. acq. fr. 1098). The manuscript was published by H. A. Omont, *Vie et histoire de Saint Denys*, Paris, 1906, pl. II. [See also *Manuscrits à peintures*, no. 5. For the possible origin of this theme in Carolingian art, see A. M. Friend, "Carolingian Art in the Abbey of St. Denis," *Art Studies*, I (1923), pp. 67-75, and *idem*, "Two Manuscripts of the School of St. Denis," *Speculum*, I (1926), pp. 59-70.]

93 Vincent of Beauvais, *Speculum historiale*, VII, lx [Graz ed., IV. 243]. *Legenda aurea*, liii. [Ed. Roze, 1900, I, pp. 409-427; 1967, I, pp. 271-281; tr. Caxton, I, pp. 86-101.]

94 According to Tischendorf, "Prolegomena," *Evangelia apocrypha*, pp. liv ff., the Gospel of Nicodemus may date from the second century. [See also Migne, *Dictionnaire des apocryphes*, I, cols. 1087-1102, and more recent discussions of the problem of the dating of the various recensions by Hennecke, *New Testament Apocrypha*, I, pp. 444-448 and James, *Apocryphal New Testament*, pp. 94-95.]

95 Gospel of Nicodemus, tr. adapted from Brunet. [Migne, *Dictionnaire des apocryphes*, I, cols. 1131-1134, paraphrase; Hennecke, *New Testament Apocrypha*, I, pp. 470-476.]

96 [These widely quoted verses are from I Corinthians 15:55.] We must also accept Vincent of Beauvais' claim that St. Paul alluded to the descent into hell in another passage of his Epistles (Colossians 2:15): *Expolians, inquit, principatus et potestates scilicet infernales . . .* (He disarmed the principalities and powers and made a public example of them, triumphing over them in him . . . [King James version]). See *Speculum historiale*, VII, xlix. [Graz ed., IV. 239.]

97 The legend even became a part of the literature in the vulgar tongue. It is found in French manuscripts of the Passion. See E. Cosquin, "Contes populaires lorrains recuellis dans un village du Barrois, II," *Romania*, 6 (1877), p. 226. It was also the subject of separate poems; see M. Mila y Fontanals, "De la poésie popular gallega," *Romania*, 6 (1887), p. 51.

98 The source of this monstrous mouth will be discussed later.

99 The examples are too numerous to cite. It will suffice to mention a window at Bourges (Cahier and Martin, *Bourges*, pl. v), and a window at Tours (Bourassé and Marchand, *Verrières de Tours*, pl. VIII).

100 For example, in the Spanish Chapel of Sta. Maria Novella, at Florence. [E. Borsook, *The Mural Painters of Tuscany from Cimabue to Andrea del Sarto*, London, 1960, pl. 37.]

101 One or two figures without attributes were sometimes placed beside Adam and Eve. Demons were usually present at Christ's victory. On the tympanum of St.-Yved-de-Braîne (now in the museum of Soissons), the devil has chains around his neck, feet, and hands. Reproduced by E. Fleury, *Antiquités et monuments du département de l'Aisne*, Paris, 1882, IV, p. 23, fig. 549. [See also P. Vitry, *French Sculpture during the Reign of Saint Louis, 1226-1270*, Florence and New York, 1929, pl. 5.]

102 *Legenda aurea. De resurrectione*, liii. [Ed. Roze, 1902, I, pp. 420-421; 1967, I, pp. 277-278; tr. Caxton, I, p. 96.] Compare the order of appearances in the *Golden Legend* and at Notre-Dame of Paris, and notice that it is the same. We have explained above that the Paris reliefs were related to the liturgy of the week following Easter.

103 *Legenda aurea, ibid*. [Ed. Roze, 1902, I, p. 418; 1967, I, p. 276; tr. Caxton, I, p. 94.] At Notre-Dame of Paris, there is a scene placed alongside the appearence of Christ to St. Peter in the tomb that seems quite singular (fig. 151). John and Peter have come to the tomb. Peter is first to enter and he sees Christ resurrect in the tomb. We can understand this scene only if we have read the *Golden Legend*. Jacob of Voragine said: "He appeared to Peter, but we know neither when nor where. It was perhaps when Peter went to the sepulcher with John . . ; or when Peter entered the tomb alone; or it might have been in the grotto that is now called Gallicantus." We see that the artist discarded the first hypothesis altogether, but he was not able to choose between the other two. The appearance of Christ to St. Peter, without indication of the place, is mentioned in Luke 24:34: "The Lord has risen indeed, and has appeared to Simon!" and by St. Paul, I Corinthians 15:5: ". . . and that he appeared to Cephas, then to the twelve." [See John 1:42: ". . . Jesus looked at him and said, 'So you are Simon the son of John? You shall be called Cephas' (which means Peter)."]

104 To cite examples: the Last Supper is represented in this way in the windows devoted to the Passion at Bourges [Cahier and Martin, *Bourges*, pl. v], Laon [Florival and Midoux, *Vitraux de Laon*, II, pl. XIX], and Tours; and in the following manuscripts: Paris, Bibl. Nat., ms. lat. 1077 (thirteenth century), and a Paris Psalter—Paris, Bibl. Nat., ms. nouv. acq. lat. 1392, fol. 81 (first half of the thirteenth century). [See Leroquais, *Les Psautiers*, II, pp. 137ff.]

105 Cahier and Martin, *Bourges*, study pl. VIII. [See also the mid-twelfth-century capital at Autun, D. Grivot and G. Zarnecki, *Gislebertus, Sculptor of Autun*, New York, 1961, pl. 11.]

106 Hucher, *Vitraux du Mans*, pl. IX.

107 [A recent study suggests that the origin of the three nail Crucifixion was in the liturgical drama, the source of which was originally Byzantine; see G. Cames, "Recherches sur

les origines du crucifix à trois clous," *Cahiers archéologiques*, 16 (1966), pp. 185-202.]

108 We have discussed the origins of these artistic formulas in Mâle, *Religious Art in France: The Twelfth Century*, chap. II.

109 This formula appeared on the tympanum of St.-Gilles at a date that cannot be much earlier than 1180. It is found again, in somewhat clearer form, at St.-Trophime in Arles. The sculptor of the left portal of the façade of Laon Cathedral, who was working in the early thirteenth century did not conform to it completely. [M. Aubert, *French Sculpture at the Beginning of the Gothic Period, 1140-1235*, Florence and New York, 1929, pl. 65.] It is only on the north portal of Chartres (fig. 152) that we find the formula in its final established form. [See R. Hamann, *Die Abteikirche von St. Gilles und ihre kunstlerische Nachfolge*, Berlin, 1955, I, pp. 358-372; II, pl. 37. On the completion of the sculpture of the west façade of St.-Gilles by 1129, see *ibid.*, I, p. 181.]

110 The artists who created this new form of the Adoration of the Magi were inspired by liturgical drama. The characteristic gesture of the king who raises his arm to point to the star came from the liturgical drama of the twelfth century. In the Play of the Magi of Limoges, there is this stage direction: *Unus eorum elevat manum ostendentem stellam* (One of them raises his hand to point to a star); and in the Besançon play: *Rex ostendes stellam aliis* (The king pointing out a star to the others). The action of the aged kneeling magus is also indicated in the Laon drama: *Accedunt magi et genuflexo primus dicit . . .* (The magi approach, and the first, on bended knee, speaks). On this subject, see Mâle, *Religious Art in France: The Twelfth Century*, pp. 143-144.

111 The following are examples. Sculpture: choir screen at Notre-Dame at Paris (fig. 143). Windows: Sens (apse) [Cahier and Martin, *Bourges*, study pls. XV and XVI]; Tours [Bourassé and Marchand, *Verrières de Tours*, pl. VII]. Ivories: Louvre, A 34, A 35, A 40, 51, 54 (diptychs from the fourteenth and early fifteenth centuries); Paris, Cluny Museum, no. 1074 (fourteenth cen-

tury), no. 232 (fourteenth century), no. 1077 (fourteenth century). Manuscripts: Psalter from Paris—Paris, Bibl. Nat., ms. lat. 10434 (mid-thirteenth century); Psalter from Arras—Paris, Bibl. Nat., ms. lat. 1328 (c. 1300); Book of Hours—Paris, Bibl. Nat., ms. lat. 1394 (second half of the fourteenth century) [*Manuscrits à peintures*, nos. 10, 70, 91]; Paris, Bibl. Ste.-Geneviève, ms. 103, fol. 18v (fourteenth century); Paris, Bibl. Ste.-Geneviève, ms. 1130, fol. 175 (fourteenth century); Franciscan Psalter-Book of Hours—Paris, Bibl. de l'Arsenal, ms. 280 (second half of the thirteenth century) [*ibid.*, no. 67]; Breviary of Caen—Paris, Bibl. de l'Arsenal, ms. 279 (thirteenth century) [see below, n. 157]; Paris, Bibl. de l'Arsenal, ms. 595 (fourteenth century); Paris, Bibl. de l'Arsenal, ms. 572 (late fourteenth or early fifteenth century). The type was somewhat changed in this last manuscript. The youngest of the three kings points to the star.

112 Choir screen at Notre-Dame of Paris (this part dates from the late thirteenth century). Windows of Lyon (Cahier and Martin, *Bourges*, study pl. VIII), Châlons-sur-Marne (*ibid.*, pl. XII), Sens (*ibid.*, study pls. XV and XVI). Manuscripts: Paris, Bibl. Nat., ms. lat. 1077 (thirteenth century); Book of Hours—Paris, Bibl. Nat., ms. lat. 1394, fourteenth century; Paris, Bibl. Nat., ms. fr. 1765 (fourteenth century); Paris, Bibl. de l'Arsenal, ms. 288 (fourteenth century); Paris, Bibl. de l'Arsenal, ms. 595 (fourteenth century). This attitude of St. Joseph appeared in art in the second half of the twelfth century.

113 Tours, window (Bourassé and Marchand, *Verrières de Tours*, pl. VII). Manuscripts: Psalter-Book of Hours for Arras use—Paris, Bibl. Nat., ms. lat. 1328 (thirteenth century); Book of Hours—Paris, Bibl. Nat., ms. lat. 1394 (fourteenth century) [*Manuscrits à peintures*, nos. 70, 91]. Choir screen at Notre-Dame of Paris (fig. 155).

114 [On medieval pattern books, see R. W. Scheller, *A Survey of Medieval Model Books*, Haarlem, 1963.]

115 More rarely, the left foot.

116 Sometimes each carried a torch.

117 These are examples: window at Bourges (Cahier and Martin, *Bourges*, pl. I), window

of Le Mans (Hucher, *Vitraux du Mans*, pl. 10), St.-Géréon of Cologne (Cahier and Martin, *Bourges*, study pl. XII). Manuscripts: Psalter from Paris—Paris, Bibl. Nat., ms. nouv. acq. lat. 1392 (thirteenth century); Paris, Bibl. Ste.-Geneviève, ms. 102, fol. 255 (thirteenth century); Metz Hours—Paris, Bibl. de l'Arsenal, ms. 570, fol. 41v (early fourteenth century).

118 Bégule and Guigue, *Monographie de la cathédrale de Lyon*, p. 72, rightly conjectured, from contours that are still visible, that one of the mutilated portals of the cathedral of Lyon (west façade, right portal) was dedicated to the Virgin.

119 Only the evening Angelus, and at the end of the thirteenth century. See A. Vacant and E. Mangenot, eds., *Dictionnaire de théologie catholique*, Paris, 1909, I, pt. 1, p. 1278, article: "Angélus."

120 On the daily Office of the Virgin, which is monastic in origin, see P. Batiffol, *Histoire du bréviaire romain*, Paris, 1894, p. 162. [Engl. tr. A.M.Y. Baylay, *History of the Roman Breviary*, London and New York, 1912, pp. 147-148.]

121 Attributed without reason to Albertus Magnus. [*Opera omnia*, ed. Borgnet, vol. XXXVI. Along with the *Biblia Mariana* and the *Mariale*, this is listed as a definitely spurious work for which the correct attribution has not been ascertained. See "Albert the Great," *New Catholic Encyclopedia*, New York, 1967, I, p. 258.]

122 Attributed, also without proof, to St. Bonaventure. [Now attributed to Conrad of Saxony. See *Speculum beatae Mariae Virginis Fr. Conradi a Saxonia*, ed. Fathers of the College of S. Bonaventura, Quaracchi, 1904, pp. vi-viii.]

123 [St. Bernard, *Sermones in Cantica Canticorum*, Migne, *P. L.*, 183, cols. 785-1198.] During the entire Middle Ages, moreover, Mary was taken to be the fiancée of the Song of Songs. See Honorius of Autun, *Sigillum beatae Mariae ubi exponuntur Cantica Canticorum*, Migne, *P. L.*, 156, cols. 537-578; Peter Comestor, *Sermo XXIX, In festo assumptionis B. Virginis Mariae*, Migne, *P. L.*, 198, cols. 1784-1788; Alain de Lille, *Elucidatio in Cantica Canticorum*, Migne, *P. L.*, 210, cols. 51-110. Also, on the day of the Nativity (sometimes the day of

the Assumption of the Virgin), the Song of Songs was read. Examples: Lectionary—Paris, Bibl. Ste.-Geneviève, ms. 138, fol. 223 (thirteenth century); Lectionary—Paris, Bibl. Ste.-Geneviève, ms. 131, fol. 186 (thirteenth century); Lectionary—Paris, Bibl. Ste.-Geneviève, ms. 125, fol. 148 (thirteenth century).

124 St. Bernard, *Sermo, Item de beata Maria Virgine*, Migne, *P. L.*, 184, col. 1016. Gautier de Coincy seems to have been thinking of St. Bernard when he wrote, in the Prologue to his *Miracles de Nostre Dame* (A. E. Poquet, ed., *Les Miracles de la Sainte Vierge*, Paris, 1857):

Elle est la fleur, elle est la rose,
En cui habite, en cui repose
Et jour et nuit Sainz Espriz

.

C'est la douceur, c'est la rousée
Dont toute riens est arousée;
C'est la dame, c'est la pucèle.

.

C'est la fontaine, c'est le doiz
Dont sourt et viens miséricorde,
C'est li tuyans, c'est li conduiz,
Par où tout bien est aconduiz,
C'est la royne des archanges,
C'est la pucèle à cui li anges
Le haut salu dist et porta.
(She is the flower, she is the rose
In her lives, in her reposes
Day and night the Holy Spirit.

.

She is gentleness, she is the dew
In which all things are bathed;
She is the lady, she is the maiden.

.

She is the fountain, she is the source
From which mercy rises and flows,
She is the conduit, she is the channel
Through which all good comes,
She is queen of the archangels,
She is the maiden to whom the angels
Spoke and brought the heavenly
 greeting.)
[See also A. Salzar, *Die Sinnbilder und Beiworte Mariens in der deutschen Literatur und lateinischen Hymnenpoesie des Mittelalters*, Linz, 1893.]

125 The *Biblia Mariana*, attributed to Albertus Magnus, also traces Mary through the Old Testament. [Albertus Magnus, *Opera*

omnia, ed. Borgnet, xxxvii, pp. 365-443. See n. 121.]

126 He thought that *Ave* came from the privative prefix *a* and *vae* which signifies unhappiness. Mary heard *Ave* three times, so that the three maledictions (*vae! vae! vae!*) of the eagle of the Apocalypse might be effaced (*Speculum beatae Mariae*, lect. ii, *Opera omnia* of St. Bonaventure, vol. vi, Mainz, 1609). [Quaracchi ed., 1904, pp. 12-24. See n. 122.] The same doctrine is found in the *De laudibus beatae Mariae*, i, i [incorrectly] attributed to Albertus Magnus. [*Opera omnia*, ed. Borgnet, xxxvi, p. 7. See also W. Molsdorf, *Christliche Symbolik der mittelalterlichen Kunst*, 2nd ed., Leipzig, 1926, pp. 137-138.]

127 *Speculum beatae Mariae*, lect. xi. [Quaracchi ed., 1904, p. 159.]

128 *De laudibus beatae Mariae*, vii, vii, in the works of Albertus Magnus, *Opera quae hactenus haberi potuerunt*, ed. P. Jammy, vol. xx, Lyon, 1651. [*Opera omnia*, ed. Borgnet, xxxvi, pp. 384-390.]

129 *De laudibus beatae Mariae*, i, v. [*Ibid.*, p. 39.]

130 *Speculum beatae Mariae*, lect. iii. [Quaracchi ed., 1904, pp. 25-43.]

131 *Speculum beatae Mariae*, lect. xiii. [*Ibid.*, pp. 178-189]; see also *De laudibus beatae Mariae*, vi, xiii. [*Opera omnia*, ed. Borgnet, xxxvi, pp. 353-360.] The famous antiphon *Salve Regina*, which perhaps dates from the late eleventh century, should not be overlooked.

132 [On the early iconography of the royalty theme, see M. Lawrence, "Maria Regina," *Art Bulletin*, 7 (1925), pp. 150-161.]

133 The two tympanums are from the same school. [Mâle himself observed that they were not by the same artist. See Mâle, "Le Portail Sainte-Anne à Notre-Dame de Paris," *Art et artistes du moyen âge*, pp. 188-191.]

134 At Paris, it was broken; the scepter we see today is modern.

135 Florival and Midoux, *Vitraux de Laon*, i, pl. i.

136 *De laudibus beatae Mariae*, x, ii. [Albertus Magnus, *Opera omnia*, ed. Borgnet, xxxvi, p. 457.]

137 This can be clearly seen on the Ste.-Anne

Portal and in the window at Chartres. In the Laon window, which is slightly later, the attitude is already less solemn. [On the Virgin as *Sedes Sapientiae*, see esp. Katzenellenbogen, *Sculptural Programs of Chartres Cathedral*, pp. 15-22.]

138 On the subject, see Mâle, *L'Art religieux de la fin du moyen âge*, pt. i, iv.

139 *De laudibus beatae Mariae*, iii, xii. [Albertus Magnus, *Opera omnia*, ed. Borgnet, xxxvi, pp. 156-159.]

140 Window at Freiburg-im-Breisgau (Cahier and Martin, *Bourges*, study pl. xii).

141 On representations of the Mother of Sorrows, see Mâle, *L'Art religieux de la fin du moyen âge en France*, pt. i, iii.

142 *Ibid.*, pt. i, v.

143 *Ab initio et ante saecula creata sum.* Paris, Bibl. de l'Arsenal, mss. 106 and 107.

144 In his poem on the Conception, Wace tells this strange story of Fanuel. On this subject, see Cosquin, "Contes populaires lorrains recueillis dans un village du Barrois, ii," p. 235. See also P. Douhaire, *Cours sur les apocryphes* (L'Université catholique, iv and v), Paris, 1838.

145 These are Vincent of Beauvais' mnemonic verses on the three husbands:

Anna viros habuit Joachim, Cleophae, Salomeque;
Tres parit: has ducunt Joseph, Alphaeus, Zebedaeus;
Christum prima; Joseph, Jacobum cum Simone Judam
Altera; quae restat Jacobum parit atque Joannem.

(*Speculum historiale*, vi, vii.) The three husbands were Joachim, Cleophas, and Salome, whom Anna married successively by order of an angel, and by whom she had three daughters, the three Marys. The three Marys were the mothers of Jesus, the two James, Major and Minor, and Simon, Jude, John, and Joseph the Just.

146 Window at Bourges (the rest is devoted to St. John the Evangelist).

147 The abbess Hrotswitha put the first two into Latin verse. [*Historia nativitatis laudabilisque conversationis Intactae Dei Genitricis*, Migne, *P. L.*, 137, cols. 1065-1080.]

148 Cited by Jacob of Voragine, *Legenda aurea. De Annuntiatione* [ed. Roze, 1902, i, p. 373;

149 Vincent of Beauvais, however, twice cited the Gospel of the Pseudo-Matthew (*Speculum historiale*, VI, lxvi and lxxii). [Graz ed., IV. 195, 198.] He called the *Evangelium de nativitate Mariae et infantis Salvatoris* the *Liber Jacobi*, because the story begins with these words: "I, James, son of Joseph, filled with the fear of God, have written." The *Liber Jacobi*, of which Vincent of Beauvais speaks, must not be confused with the *Protevangelium* of James. [From which it derives. See James, *Apocryphal New Testament*, pp. 38, 70, 73.]

150 The *Protevangelium* of James may be ignored, for in it there is no mention of the golden gate which our artists always represented. The same is true of the *Evangelium de nativitate Mariae*, for in this text, when Anna meets Joachim she is not accompanied by her servant, nor is Joachim accompanied by his shepherds—figures which our artists, and especially Italians of the Trecento, loved to represent. [See J. Lafontaine-Dosogne, *Iconographie de l'enfance de la Vierge dans l'empire byzantin et en occident*, vol. II, Brussels, 1965.]

151 [*Histoire de la nativité de Marie et de l'enfance du Sauveur*, I, ii, Migne, *Dictionnaire des apocryphes*, I, col. 1061.]

152 *Ibid.*, II. [Migne, *Dictionnaire des apocryphes*, I, cols. 1061-1062.]

153 *Ibid.*, III. [Migne, *Dictionnaire des apocryphes*, I, cols. 1062-1063.]

154 *Ibid.*, III. [Migne, *Dictionnaire des apocryphes*, I, col. 1064.]

155 Fulbert of Chartres, *Sermones ad Populum*, IV, Migne, *P. L.*, 141, col. 320.

156 *Idem, Sermo V*, Migne, *P. L.*, 141, cols. 324-325. The same is found in Honorius of Autun, *De nativitate sanctae Mariae, Speculum ecclesiae*, Migne, *P. L.*, 172, col. 1000.

157 Paris, Bibl. Ste.-Geneviève, ms. 131 (Coutances or St.-Lô ?) (thirteenth century). Breviary of Caen—Paris, Bibl. de l'Arsenal, ms. 279, fol. 465v (thirteenth century). [Leroquais, *Bréviaires*, II, pp. 338.]

158 For the description, see Bulteau, *Chartres*, II, pp. 36-40. [Houvet, *Portail occidental*, pls. 75-77; Lafontaine-Dosogne, *Iconographie de l'enfance de la Vierge*, pl. II.]

159 Badly damaged.

160 The Le Mans window, reproduced here (fig. 163), represents in the lower part Joachim driven from the temple, the Virgin presented at the temple, then the Virgin ascending the steps of the temple, the meeting at the Golden Gate, an angel conversing with the Virgin in the temple, and the Virgin in majesty.

161 The meeting at the Golden Gate is shown in windows devoted to the Infancy of Christ (Le Mans, Beauvais). [Hucher, *Vitraux du Mans*, pl. x.]

162 See E. Hucher, "L'Immaculée Conception figurée sur les monuments du moyen âge et de la renaissance," *Bulletin monumental*, 21 (1855), pp. 145-148; and G. Rohault de Fleury, *La sainte Vierge*, Paris, 1878, I, p. 33. [See also M. L. D'Ancona, *The Iconography of the Immaculate Conception in the Middle Ages and Early Renaissance*, New York, 1957.] The confraternity of the Immaculate Conception, established at St.-Séverin, seems to have adopted in the thirteenth century the emblem of the meeting at the Golden Gate.

163 St. Bernard, *Epistolae*, clxxiv. *Ad Canonicos Lugdunenses. De conceptione S. Mariae*, Migne, *P. L.*, 182, cols. 332-335.

164 Small cloister of Sta. Maria Novella, at Florence.

165 *Histoire de la nativité de Marie et de l'enfance du Sauveur*, vi. [Migne, *Dictionnaire des apocryphes*, I, cols. 1065-1066.]

166 [Chartres, window of Thibault VI and the vine dressers, Delaporte, *Vitraux de Chartres*, I, pl. XLV; Notre-Dame, west façade, St. Anne Portal, Aubert, *Notre-Dame de Paris*, pl. 29.]

167 Window of the money changers. It is almost entirely devoted to the apocryphal story of the Virgin. [Hucher, *Vitraux du Mans*, pl. v.] Several scenes are obscure in meaning (the three young girls before a king; the imprisoned girl to whom a man is speaking from the other side of a wall). However, I think that the panel representing the three girls before a king is a translation of the verse: *Adducentur regi virgines*

from Psalm 44:15 (Vulgate) [45:14 (King James version)], which was read at the feast of the Virgin. This is what William Durandus tells us, *Rationale*, v, ii, 38. [Ed. d'Avino, p. 334; ed. Barthélemy, iii, p. 27.]

168 *Histoire de la nativité de Marie et de l'enfance du Sauveur*, viii. [Migne, *Dictionnaire des apocryphes*, i, cols. 1066-1067.] The Gospel of the Birth of Mary, vii, says that the rod flowered and a dove perched on it. [*Ibid.*, i, col. 1054; James, *Apocryphal New Testament*, pp. 79-80.]

169 The earliest examples are found in fourteenth-century Italian art: one of the rejected suitors raises his hand against St. Joseph. [Lafontaine-Dosogne, *Iconographie de l'enfance de la Vierge*, ii, pp. 141-142.] On the marriage of the Virgin, there is a curious difference between the French and Italian formulas. In France, the betrothed pair simply join hands; in Italy, Joseph places a ring on the Virgin's finger. That is because Italy has boasted, since the tenth century, of possessing the betrothal ring of the Virgin. It was long preserved at Chiusi, but in 1473 it was stolen and taken to Perugia, where it has remained. [*Ibid.*, ii, fig. 71.]

170 Bégule and Guigue, *Lyon*, p. 116, fig. 12. See also Cahier and Martin, *Bourges*, study pl. viii. Among details that surprise, let us cite the thirteenth-century windows at Lyon, in which the Virgin lies on a pallet as in Byzantine miniatures, and the holy women walk toward a round tomb very similar to that found in Carolingian ivories.

171 The angel appeared to her for the first time at the well. *Evangelium de nativitate Mariae et infantis Salvatoris*, ix. [Migne, *Dictionnaire des apocryphes*, i, col. 1068.] Very early ivories represented the scene. [See W. F. Volbach, *Elfenbeinarbeiten der Spätantike und des frühen Mittelalters*, 2nd ed., Mainz, 1952, figs. 140, 142, 145.]

172 *Evangelium de nativitate Mariae et infantis Salvatoris*, ix. [Migne, *Dictionnaire des apocryphes*, i, col. 1069.]

173 Rohault de Fleury, *La sainte Vierge*, i, pls. vii, ix, x, xi.

174 *Evangelium de nativitate Mariae et infantis Salvatoris*, viii. [Migne, *Dictionnaire des apocryphes*, i, col. 1068.]

175 He was inspired by an Eastern model. [See J. Hayward and L. Grodecki, "Les vitraux de la cathédrale d'Angers," *Bulletin monumental*, 124 (1966), pp. 13-17, fig. p. 16.]

176 *Nazareth interpretatur flos. Unde dicit Bernadus, quod flos nasci voluit de flore, in flore et floris tempore, Legenda aurea*, li, *De Annuntiatione*. [Ed. Thilo, 1846, p. 217; ed. Roze, 1902, i, p. 374; 1967, i, p. 249; tr. Caxton, iii, p. 97, abridged, omitted this passage.]

177 Cahier and Martin, *Bourges*, study pls. xv-xvii.

178 The following are examples: Paris, Bibl. Ste.-Geneviève, ms. 102, fol. 291v (thirteenth century); and Paris, Bibl. Ste.-Geneviève, ms. 103 (fourteenth century): in this example, the flower, indeterminate until this time, is a lily. Breviary of Caen (Paris, Bibl. de l'Arsenal, ms. 279, fols. 54 and 382), fourteenth century.

179 *Evangelium de nativitate Mariae et infantis Salvatoris*, xii. [Migne, *Dictionnaire des apocryphes*, i, col. 1070. See also Bettini, *Mosaici antichi di San Marco a Venezia*, pl. xlv.]

180 *Legenda aurea, De natali sancto Johannis Baptistae*, lxxxvi (after Peter Comestor) [ed. Roze, 1902, ii, p. 154; 1967, i, p. 403; tr. Caxton, iii, p. 257]; and Ludolf of Saxony, *Vita Christi*, vi.

181 Window of St.-Père at Chartres (fourteenth century).

182 Senlis (tympanum of the portal), fig. 174; Chartres (tympanum of the central door, north façade), fig. 167; Reims (gable of the central portal) [Reinhardt, *Reims*, pl. 41]; Laon (central portal) [Sauerländer, *Gothic Sculpture*, fig. 48]; Bourges (at the right of the central portal); Sens (west façade, south portal) [E. Chartraire, *La Cathédrale de Sens*, Paris, 1934, illus. p. 77]; Rouen (in the pignon above the rose window of the Portail de la Calende); Auxerre (façade; tympanum of the left door) [Porée, *Auxerre*, illus. p. 67]; Paris (façade; tympanum of the left door) [Aubert, *Notre-Dame de Paris*, pls. 33, 34, 35]; Noyon (right portal, tympanum barely visible); Meaux (right portal). Windows also give a place of honor to the Coronation of the Virgin: Lyon (central window of the apse) [fourteenth century]; Troyes (window of the apse). [See R. Suter-Raeber, "Die Marienkrönung der Kathedrale von Lausanne und die verschie-

denen Typen des Marienkrönung im 12 und frühen 13 Jahrhundert," *Zeitschrift für Schweizerische Archäologie und Kunstgeschichte*, 23 (1963-1964), pp. 197-211; Sauerländer, "Die Marienkröngsportale von Senlis und Mantes," pp. 115-162; on the Virgin as the Church and the Bride of Christ, see Katzenellenbogen, *Sculptural Programs of Chartres Cathedral*, pp. 56-61; see also Mâle, *Religious Art in France: The Twelfth Century*, pp. 184ff.]

183 Paris: left door (west façade); "Porte Rouge" (tympanum), fig. 175; reliefs of the north wall.

184 Tympanum of the left portal of the west façade, and reliefs of the north wall.

185 This letter, as several details such as borrowings from the works of Pope Leo the Great prove, cannot have been written by St. Jerome. It cannot be earlier than the seventh century.

186 Lectionary—Paris, Bibl. Ste.-Geneviève, ms. 554, fol. 163 (twelfth century); Lectionary—Paris, Bibl. Ste.-Geneviève, ms. 555, fol. 223 (twelfth century); Lectionary—Paris, Bibl. Ste.-Geneviève, ms. 131, fol. 147v (thirteenth century); Lectionary—Paris, Bibl. de l'Arsenal, ms. 162, fol. 181v (twelfth century), and Breviary of Caen—Paris, Bibl. de l'Arsenal, ms. 279, fol. 319v (fourteenth century).

187 *Livre du Passage de la bienheureuse vierge Marie, écrit par saint Jean*, Migne, *Dictionnaire des apocryphes*, ii, cols. 503-542, gives the translation of the Arabic manuscript. [See also James, *Apocryphal New Testament*, pp. 194ff.]

188 Gregory of Tours, *Libri miraculorum*, i, *De gloria beatorum martyrum*, Migne, *P. L.*, 71, col. 708.

189 Jacob of Voragine, *Legenda aurea, De Assumptione*. [Ed. Roze, 1902, ii, pp. 514-518; 1967, ii, pp. 86-88; tr. Caxton, iv, pp. 234-237.] Vincent of Beauvais, *Speculum historiale*, vii, lxxv. [Graz ed., iv. 298.] He ends by saying: *Haec historia licet inter apocriphas scripturas reputetur, pia tamen videtur esse ad credendum* ... (This story, though considered part of the Apocrypha, yet seems to be piously worthy of belief). [*Idem*, lxxix, Graz ed., iv. 250.] This was indeed the sentiment of the Middle Ages.

190 Seventy-two, according to another tradition which seemed less probable to Jacob of Voragine.

191 *Legenda aurea, De Assumptione* (adapted from tr. Brunet). [See above, n. 189.]

192 Chapel of the Virgin.

193 Window of the chevet.

194 [See Künstle, *Ikonographie der christlichen Kunst*, i, pp. 564-570; and O. Sinding, *Mariae Tod und Himmelfahrt*, Christiania, 1903. On the date of the Senlis portal, see above Book iv, Chapter i, n. 86.]

195 *Legenda aurea, De Assumptione*. [Ed. Roze, 1902, ii, pp. 422-423; 1967, ii, p. 90; tr. Caxton, iv, p. 240. On the legend of the Jews who disturbed the funeral of the Virgin, see also K. Simon, "Die Grabtragung Maria," *Städel-Jahrbuch*, 5 (1926), pp. 75-98.]

196 Lectionary—Paris, Bibl. Ste.-Geneviève, ms. 131, fol. 147 (thirteenth century); Breviary of Caen—Paris, Bibl. de l'Arsenal, ms. 279, fol. 319v (fourteenth century). These miniatures, which represent the funeral ceremonies for the Virgin in very abridged form, are often to be found in lectionaries for the Feast of the Assumption. The strange thing is that they illustrate the letter attributed to St. Jerome condemning these apocryphal traditions.

197 St.-Ouen (south portal) [A. Masson, *L'Eglise abbatiale Saint-Ouen de Rouen*, Paris, 1927, ill. p. 151]; Paris (north wall).

198 The examples are numerous. A twelfth-century ivory, Paris, Cluny Museum, no. 1049, represents the Death of the Virgin. Jesus still holds the soul of his mother in his arms, while an angel flies toward heaven carrying the same soul. [A. Goldschmidt and K. Weitzmann, *Die byzantinischen Elfenbeinskulpturen*, Berlin, 1934, ii, no. 174 and pl. lix. On this pictorial device, see also Pächt, *Rise of Pictorial Narrative*, pp. 6-8; 14-16.]

199 Fragment of the lintel of the former portal, preserved in the church. It is possible that the badly damaged tympanum of Senlis represented the Entombment of the Virgin. [Sauerländer, *Gothic Sculpture*, pl. 42.] In this version, the Entombment might well have been combined with the Death of the Virgin, since we can see two angels carrying her soul. In manuscripts, Psalter of St. Louis and Blanche of Castille (Paris, Bibl.

de l'Arsenal, ms. 1186), there are representations of the Entombment of the Virgin dating from the beginning of the thirteenth century. [H. Martin, *Les Joyaux de l'Arsenal*, I. *Psautier de Saint Louis et de Blanche de Castille*, Paris, 1910, pl. xxxv.]

200 *Legenda aurea, De Assumptione.* [See above, n. 195.]

201 Viollet-le-Duc, *Dictionnaire raisonné de l'architecture*, IX, p. 372.

202 The same is true of the Amiens tympanum (west façade), which in so many ways is like the tympanum of Notre-Dame of Paris. [Durand, *Amiens*, pl. XLII.]

203 Plaster cast in the Trocadéro. [Paris, Musée National des monuments français.]

204 Sens (Cahier and Martin, *Bourges*, study pl. xv); Troyes (*ibid.*, pl. XIII).

205 *Legenda aurea, De Assumptione.*

206 This curious aureole appears on the Sens portal (fig. 168), the portal of St.-Thibault (Côte d'Or), and of Notre-Dame of Paris (fig. 173). On the portal of Bourges, the Virgin's shroud carried by angels is in the form of an aureole.

207 Archeological documents of the Comte de Bastard, vol. III, fol. 21 (Paris, Bibl. Nat., Cabinet des Estampes). However, there is one ancient example in France of the Virgin throwing her belt to St. Thomas, on the tympanum of the church of Cabestany (Pyrénées-Orientales), which dates from the twelfth century. See J. Salvadou, "Le Tympan de Cabestany," *Bulletin monumental*, 95 (1936), p. 239. [For the master of Cabestany, see M. Durliat, "L'Oeuvre du 'Maître de Cabestany,'" *La Sculpture romane en Roussillon*. Perpignan, 1954, IV, pp. 6-49. This master is now thought to have been of Italian origin; see G. Zarnecki, "A Sculptured Head Attributed to the Maître de Cabestany," *Burlington Magazine*, 106 (1964), pp. 536-539.]

208 *Astitit regina a dextris ejus, in vestitu desaurato*: Psalm 44:10 (Vulgate) [45:9 (King James version)]. This text was included in Books of Hours of the Virgin: see Hours of Notre-Dame (Paris, Bibl. Ste.-Geneviève, ms. 274, fol. 27).

209 *Posuit in capite coronam de lapide pretioso*: Psalm 20:4 (Vulgate) [21:3 (King James version)].

210 We have said elsewhere that it was probably Suger who first had the Coronation of the Virgin represented. He had given to the old cathedral of Paris a window showing the Triumph of the Virgin, which was no doubt her coronation. See Mâle, "La Part de Suger dans la création de l'iconographie du moyen âge," p. 346, and *idem, Religious Art in France: The Twelfth Century*, pp. 183ff.

211 These admirable sculptures, masterpieces of the school of the Ile-de-France, can be studied closely at the Musée du Trocadéro. [Paris, Musée National des monuments français.]

212 [G. Bazin, *Italian Painting in the XIVth and XVth Centuries*, Paris, 1938, pl. 1.]

213 *Paradiso*, Canto XXXI, vv. 130-132. [*La Divina Commedia*, ed. Casella, p. 318.]

214 The same formula was used at the cathedral of Poitiers (the angels' arms are broken, and the crown has disappeared), on the portal of Moutier-St.-Jean (Côte d'Or), at Mouzon (Ardennes), and in Spain at the cathedral of Léon. [It is now believed that the work on the Coronation portal at Notre-Dame began soon after 1200; see above, Book III, n. 54. The so-called "Porte Rouge" at Notre-Dame was begun before 1271; see R. Branner, *St. Louis and the Court Style*, London, 1965, p. 104. Longpont was not begun before 1225; see W. Sauerländer, "Die kunstgeschichtliche Stellung der Westportale von Notre-Dame in Paris," *Marburger Jahrbuch für Kunstwissenschaft*, 17 (1959), p. 47.]

215 This formula appeared in manuscripts long before it was used in monumental art: Psalter of St. Louis and Blanche of Castille (Paris, Bibl. de l'Arsenal, ms. 1186) [Martin, *Joyaux de l'Arsenal*, I, pl. xxxv]; Scenes from the Life of Christ from St.-Martial de Limoges, published by A. Comte de Bastard-d'Estang, *Histoire de Jésus-Christ en figures. Gouaches du XIIe au XIIIe siècle conservées jadis à la collégiale de Saint-Martial de Limoges*, Paris, 1879 (late twelfth century). [This manuscript is now in New York, Pierpont Morgan Library, M. 44. See "Exhibition of Illuminated Manuscripts Held at the New York Public Library," The Pierpont Morgan Library, New York, 1933-1934, no. 35.]

216 At the château of La Ferté-Milon, a fourth formula for the Coronation of the Virgin, dating from the late fourteenth century, was the formula adopted by the late Middle Ages: the Virgin kneels before Christ to receive the crown. Here, the thought has changed; the artist wished to express the Virgin's humility, not her grandeur.

217 *"Advocato nostra." In antiphonam Salve regina, Sermo I* (a sermon inserted into the works of St. Bernard), Migne, *P. L.*, 184, col. 1061. See also the sermon of St. Bernard for the octave of the Ascension. [*Sermones de sanctis, Dominica infra octavam assumptionis b. v. Mariae*, Migne, *P. L.*, 183, cols. 429-438.]

218 *Speculum beatae Mariae*, lect. xiv. [Quaracchi ed., 1904, p. 191.]

219 *Paradiso*, Canto XXXIII, vv. 12-15. [Ed. Casella, p. 322. Cf. Peter Brieger and Millard Meiss, *Illuminated Manuscripts of the Divine Comedy* (Princeton, 1969), vol. I, pp. 207-208, and vol. II, pls. 517-521, on the illustrations of Canto XXXIII and their interpretation.]

220 On collections of miracles before that of Gautier de Coincy and their Latin sources, consult the very complete catalogue that Mussafia has published since 1866 in the proceedings of the Academy of Vienna. A. Mussafia, "Studien zu den mittelalterlichen Marienlegenden," *Sitzungsberichte der Kaiserlichen Akademie der Wissenschaften in Wien* (phil.-hist. Klasse), 1 (1886), pp. 917-994; 2 (1888), pp. 5-92; 3 (1891), pp. 1-85; 4 (1898), pp. 1-74. [See also M. V. Gripkey, *The Blessed Virgin as Mediatrix in the Latin and Old French Legends Prior to the Fourteenth Century*, Washington, 1938.]

221 Hugh Farsit, *Libellus de miraculis beatae Mariae virginis in urbe Suessionensi*, Migne, *P. L.*, 179, cols. 1777-1800.

222 Herman the Monk, *De miraculis S. Mariae laudunensis, Appendix ad Librum III Guiberti de vita sua*, Migne, *P. L.*, 156, cols. 963-1018.

223 [*Le Livre des miracles de Notre-Dame de Chartres écrit en vers, au XIIIe siècle par Jehan le Marchant*, ed. G. Duplessis, Chartres, 1855.]

224 A damaged window of the cathedral of Chartres (south aisles) shows a Virgin venerated by pilgrims (no doubt the famous Virgin of Chartres). [Delaporte, *Vitraux de Chartres*, I, pp. 191-192, pls. XXX, XXXI, has definitely identified the lower panels as related to the book of *Les Miracles de Notre Dame de Chartres*.] The rest of the window has several episodes from the story of Theophilus. Perhaps some of the miracles of Notre-Dame de Chartres were also shown there. There is no doubt that certain windows were dedicated to the miracles of Notre-Dame. Joinville says that he had windows painted in his chapel of Joinville and "ès verrières de Blahecourt" (in the windows of Blécourt), containing the story of one of his companions who fell into the sea on his return from the crusade and whom the Virgin saved by holding him up by his shoulders. [*Joinville and Villehardouin. Chronicles of the Crusades*, ed. M.R.B. Shaw, Baltimore, 1963, p. 326.]

225 On the north portal (fig. 178) and among the reliefs on the north wall (fig. 179).

226 In a section of the window at Laon, as at Beauvais, Troyes, and Le Mans, we see humble people carrying a fish to Theophilus. This was simply a workshop tradition. [This scene has been interpreted as an offering by a vassal or tenant; see Florival and Midoux, *Vitraux de Laon*, IV, p. 31.] I have found no mention of this detail in the *Legenda aurea. De nativitate beatae Mariae Virginis* [ed. Roze, 1902, III, pp. 25-26; 1967, II, pp. 181-182; tr. Caxton, V, pp. 109-110], nor in the sermon of Honorius of Autun, who simply says: *sibi divicias affluere* (*Speculum ecclesiae. De assumptione Sanctae Mariae*, Migne, *P. L.*, 172, col. 992). Neither is it found in the poems devoted to Theophilus by Marbodius (*Historia Theophili metrica*, Migne, *P. L.*, 171, cols. 1593-1604) and Hrotswitha (*Lapsus et conversio Theophili vicedomini*, Migne, *P. L.*, 137, cols. 1101-1110), nor in the chronicle of Sigebert of Gembloux, who told this story (*Chronica*, Migne, *P. L.*, 160, col. 102).

227 Theophilus' adventure is given the date 535. [On the legend of Theophilus, see also H. H. Weber, *Studien zur deutschen Marienlegende der Mittelalters am Beispiel des Theophilus*, Hamburg, 1966; and K. Plen-

zat, *Die Theophiluslegende in den Dicht- ungen des Mittelalters*, Berlin, 1926.]

228 [Paul, Deacon of Naples, *Praefatio Inter- pretis, Vita Sanctae Mariae Aegyptiacae*, Migne, *P. L.* 73, col. 671; for Hrotswitha and Marbodius, see above n. 227; *Oeuvres complètes de Rutebeuf*, ed. A. Jubinal, Paris, 1839, II, pp. 79-105.]

229 *De assumptione Sanctae Mariae*, Migne, *P. L.*, 172, col. 993.

230 U. Chevalier, *Poésie liturgique tradition- nelle de l'église catholique en occident*, Tournai, 1894, p. 134.

231 The following are the subjects used at Paris (fig. 178): (1) Theophilus becomes "Sa- tan's man"; (2) he supplants his bishop (a small devil stands beside him); (3) he prays in the church; (4) the Virgin snatches the parchment from Satan; (5) the bishop shows the parchment to the people. The exterior relief (fig. 179) represents: (1) the devil, with his claw on Theophilus' shoulder, seizes the parchment; (2) Theo- philus at prayer; (3) the Virgin snatching the parchment from Satan.

232 Hucher, *Vitraux du Mans* (not paginated) ["Cinquième lancette," 21st page of text.]

233 Gregory of Tours, *Libri miraculorum*, I. *De gloria beatorum martyrum*, IX, X, XI, Migne, *P. L.*, 71, cols. 713-717.

234 This famous miracle was later placed at Bourges.

235 [See Gripkey, *The Blessed Virgin Mary as Mediatrix*, pp. 1-4.]

236 See especially, Lectionary—Paris, Bibl. Ste.- Geneviève, ms. 554, fols. 163v ff. (twelfth century), and Lectionary—Paris, Bibl. Ste.- Geneviève, ms. 555, fols. 223 ff. (twelfth century). Vincent of Beauvais used the mir- acles of the columns and of the Jewish child in the *Speculum historiale*, VII, lxxxi. [Graz ed., IV. 250.] He also placed them after the story of the Assumption.

237 The Lectionaries of Le Mans Cathedral have not been preserved. See *Catalogue général des manuscrits des bibliothèques publiques de France*, vol. XX, Paris, 1893.

238 The following is a detailed listing of the scenes shown in the window of the chapel of the Virgin (fig. 180): (1) the money changers (donors of the window); (2) workmen try to raise the columns; (3) the

Virgin appears to the sleeping architect and shows him the three school children (one holds a book); (4) the school children raise a column; (5) (fig. 181) the Virgin pours wheat into three receptacles (beside the nimbus of the Virgin is written *Sancta Maria*); (6) the monks come to their ab- bot; (7) the Virgin places gold on the altar; (8) St. Gregory of Tours (his name is writ- ten *Gregorius*) holds up before a house an object surmounted by a flame, which is no doubt the reliquary that extinguished the flames and which seems to be carrying away the last sparks of fire; (9) a house from which tall flames rise (perhaps the same as the preceding, or perhaps it is the church of Marciacum from which a daz- zling light had shone); (10) two figures kneeling before the Virgin who dominates the entire composition.

239 Chapel of the Virgin; it is this one that we have reproduced here in two parts (figs. 180 and 181).

240 Window of the triforium of the choir (thirteenth window).

241 [Hucher, *Vitraux du Mans*, 47th page of text (not paginated).]

242 Vincent of Beauvais, *Speculum historiale*, XIV, xliii [Graz ed., IV. 556-557].

243 *Legenda aurea*, Life of St. Julian. The sim- ilarity of names caused Jacob of Voragine to add this legend after the Life of St. Julien. [Ed. Roze, 1902, I, pp. 247-248; 1967, I, p. 173; tr. Caxton, III, pp. 15-16.]

244 See P. Meyer, "Notice sur un manuscrit d'Orléans contenant d'anciens miracles de la Vierge en vers français," *Notices et extraits des manuscrits de la Bibliothèque nationale et autres bibliothèques*, 34 (1895), pp. 31-56.

245 Triforium of the choir: fourth and twelfth windows.

246 *Speculum ecclesiae, In purificatione Sanctae Mariae*, Migne, *P. L.*, 172, col. 852.

BOOK IV, CHAPTER IV

1 Vincent of Beauvais, *Speculum historiale*, XXI, xxii (Maxentius); xxiv (Melanius); lxxxii (Leonard). [Graz ed., IV. 825, 826, 844.]

2 The Fulcran family came from Languedoc

(St. Fulcran of Lodève); the Foucauds from Burgundy (St. Foucaud of Auxerre); the Gérauds from Cantal (St. Géraud d'Aurillac); the Leonards or Liénards from the Limousin (St. Leonard is the great saint of the Limousin); the Lubins from Chartres, etc. On this subject, see Giry, *Manuel de diplomatique*, p. 368.

3 See A. Forgeais, *Collection de plombs historiés trouvés dans la Seine*, II. *Enseignes de pèlerinages*, Paris, 1863, pp. i-iii, 73-89, 177-179.

4 See J.-G. Bulliot and F. Thiollier, *La Mission et le culte de Saint Martin d'après les légendes et les monuments populaires dans le pays Eduen*, Paris and Autun, 1892, pp. 365-392.

5 In the Midi of France and northern Spain.

6 Even today, the relief of St. Christopher is at the entrance of the cathedral of Amiens. The gigantic statues of St. Christopher at Auxerre and at Notre-Dame of Paris date from the fifteenth and sixteenth centuries.

7 On the saints who protected cattle, see E. Rolland, *Faune populaire de la France*, v. *Les mammifères domestiques*, pt. 2, Paris, 1883, pp. 111-112.

8 The virtues attributed to saints were often based on childish puns. St. Lié cured rickety children, St. Fort fortified them, St. Vât made them walk, and St. Claire cured diseases of the eyes.

9 See M. Germain, *Histoire de l'abbaye royale de Notre-Dame de Soissons*, Paris, 1675, III, i. The tomb of St. Drausin is now in the Louvre.

10 See A. Le Roux de Lincy, *Le Livre des proverbes français*, 2nd ed., Paris, 1859, I, pp. 121, 118, 124.

11 See Cahier, "Calendrier," *Caractéristiques des saints dans l'art populaire*, I, pp. 169-171.

12 Gervase of Tilbury, *Otia imperialiae*, 3rd pt., xxxiv. [*Scriptores Rerum Brunsvicensium*, ed. Leibnitz, p. 972.]

13 See J.-B. Pardiac, "Notice sur les cloches de Bordeaux et en particulier sur celle de l'église Notre-Dame," *Bulletin monumental*, 24 (1858), pp. 227-273.

14 Johannus Molanus, *De historia sacrarum imaginum et picturarum*, II, xxxiii, *Theologiae cursus completus*, XXVII, pp. 84-87 [ed. Paquot].

15 On plants named for saints, see the work by Jean Bauhin, *De plantis a divis sanctisve nomen habentibus*, Basle, 1591. St. Marcoul cured scrofula. It was said that it was he who had transmitted this privilege to the kings of France; consequently, after their coronation, they went to the priory of Corbeny (near Laon) to venerate the tomb of the saint.

16 See Batiffol, *Histoire du Bréviaire romain*, chap. IV, pp. 193ff. [Tr. Baylay, pp. 155-173.]

17 Jacob of Voragine, Dominican, bishop of Genoa, was born about 1230 and died about 1298.

18 The saints' legends are told in the order of the ecclesiastical calendar and begin with the period of Advent.

19 The Bollandists in their preface, *Acta sanctorum*, eds. H. Delehaye and others, Paris, 1863ff., I, p. 44, and Molanus, II, xxvii, *Theologiae cursus completus*, XXVII, p. 76: *Tolerat [Ecclesia] legendam auream Jacobi de Voragine quam alii plumbeam vocant* (The Church supports the golden legend of Jacobus de Voragine which others call "leaden").

20 *Legenda aurea*, ed. J.G.T. Graesse, Dresden and Leipzig, 1846; French translation, *La Légende dorée*, tr. G. Brunet, 2 vols., Paris, 1843. Teodore de Wyzewa has made a more recent translation, Paris, 1902. [The de Wyzewa translation is not a complete text and often gives a paraphrase of the original version. It is for this reason that we cite the J.-B. Roze translation, which however, contains only a few chapters from the Supplement to the *Legenda aurea*. Whenever necessary, reference to the Supplement will be given in the Latin edition, Graesse, 1846. The English translation by Caxton although often abridged will also be cited throughout for lack of a better English version. See Book IV, Chapter II, n. 21.]

21 [On the lives of the saints, see H. Delehaye, *Les Légendes hagiographiques*, 3rd ed., Brussels, 1927.]

22 The legend of St. Eustace was a favorite of medieval artists (windows at Sens, Auxerre, Le Mans, and Tours). At Chartres, three windows are devoted to St. Eustace,

and one relief on the south porch. [See L. Grodecki, "Le maître de Saint-Eustache de la cathédrale de Chartres," *Gedenk-schrift Ernst Gall*, eds. M. Kühn and L. Grodecki, Munich, 1965, pp. 171-194.]

23 *Legenda aurea*, tr. Brunet, II, p. 75. [Ed. Roze, 1902, I, pp. 451-460; 1967, I, pp. 296-301; tr. Caxton, III, pp. 125-134.] St. George is twice represented at Chartres (statue of the south porch, and window in the nave); in the upper windows of the choir, a second window, now destroyed, seems to have been dedicated to St. George. See Bulteau, *Description de la cathédrale de Chartres*, p. 210 [Katzenellenbogen, *Sculptural Programs of Chartres Cathedral*, pl. 69; Delaporte, *Vitraux de Chartres*, III, pls. CCLXVII and CCLXIX]; at Lyon, two reliefs are devoted to him. [Bégule and Guigue, *Monographie de la cathédrale de Lyon*, p. 178.]

24 *Legenda aurea, De Sancto Christophoro.* [Ed. Roze, 1902, II, pp. 283-291; 1967, II, pp. 7-12; tr. Caxton, IV, pp. 111-119.] Window of Strasbourg. The images of St. Christopher multiplied in the late Middle Ages.

25 [*Legenda aurea*, ed. Roze, 1902, II, pp. 224-230; 1967, I, pp. 445-448; tr. Caxton, IV, pp. 48-53.]

26 [*Legenda aurea*, ed. Roze, 1902, II, pp. 230-236; 1967, I, pp. 448-452; tr. Caxton, VI, pp. 205-212. See also O. Pächt, C. R. Dodwell and F. Wormald, *The St. Albans Psalter*, London, 1960, pp. 126-146.]

27 [*Legenda aurea*, ed. Roze, 1902, II, pp. 291-298; 1967, II, pp. 12-16; tr. Caxton, IV, pp. 120-127. See also L. Massignon and others, *Les Sept Dormants d'Éphèse (Ahl-al-Kahf) en Islam et en chrétienté; Recueil documentaire iconographique*, 4 fasc., Paris, 1955-1958.]

28 The legend of St. Gontran, and of several other saints we shall discuss in this chapter, does not appear in the *Golden Legend*; but I have already said that the name Golden Legend is a convenient title for all the collections of saints' lives in use during the Middle Ages.

29 St. Patrick changed a king of Ireland into a fox. [*De S. Patricio, Acta sanctorum*, VIII, 2 March, p. 567.]

30 The miracle of the three school children brought back to life by St. Nicholas was, as we shall see, of popular origin.

31 Very early, painters confused St. Gerasimus with St. Jerome, to whom they gave the lion as companion.

32 Is it necessary to say that the glass painters of the thirteenth century had already made most of their windows before Jacob of Voragine composed his book? But all of the *Golden Legend* was to be found in lectionaries and in the *Speculum historiale* of Vincent of Beauvais.

33 Some windows are devoted to the lives of local saints not found in the *Golden Legend*, and to Old Testament figures (Noah and Joseph). All these subjects are dealt with in Bulteau, *Description de la cathédrale de Chartres*, III, pp. 204-302. More recently a remarkable book on the windows of Chartres Cathedral has been written by Delaporte, *Les Vitraux de la cathédrale de Chartres*. The text volume is accompanied by three volumes of Houvet's plates. [See also Grodecki, *Chartres, passim.*]

34 We call attention to the admirable St. Paul in the Musée de Toulouse (fourteenth century). [See M. Aubert, *La Sculpture française au moyen âge*, Paris, 1947, pp. 403-404.]

35 We refer particularly to the art of the second half of the thirteenth century. The art of the early thirteenth century was still inexperienced in representing individual character.

36 Or perhaps this is St. Denis, for the name of the martyr is not certain. [This figure on the left portal of the west façade of Reims Cathedral has been correctly identified as St. Denis by Hinkle, *The Portal of the Saints of Reims Cathedral*, pp. 15-16, fig. 11. In regard to the partial decapitation of St. Denis, see S. McK. Crosby, *The Abbey of St.-Denis 475-1122*, New Haven and London, 1942, p. 39.]

37 See fig. 191, which represents the embrasure of the right portal, south façade, of Chartres. First we see St. Martin, and beneath his feet, the dogs stopped by his word when they were about to capture a rabbit. Then St. Jerome holding the Bible; beneath his feet, the blindfolded Synagogue tries in vain to read a banderole (the text of the Scriptures) which it no longer understands. Next is St. Gregory the Great; a dove (the head is broken) rests on his shoulder; be-

neath his feet, his secretary writes behind a curtain. He seems to look through an opening, as the legend tells, and see with astonishment that the dove is speaking into the pope's ear (fig. 192).

38 We shall return to this later in this chapter.

39 The small winged dragon often seen above the chalice of St. John symbolizes the strength of the poison.

40 Cahier, "Oie," *Caractéristiques des saints,* II, pp. 578-580, has fully explained the emblem of the goose. See also A. Lecoy de la Marche, *Saint Martin,* Tours, 1881, pp. 649-651 [2nd ed., 1890, p. 606]. The goose of St. Martin is carved on the portal of St.-Martin of Worms. The goose is also shown on the seal of a canon of St.-Martin of Tours.

41 Lectionary (Paris, Bibl. de l'Arsenal, ms. 162, fol. 220), twelfth century.

42 It is probable that the Acts of St. Denis were rewritten, like those of many other saints, between the ninth and the eleventh centuries. On this subject, see Cahier, *Caractéristiques des saints,* II, pp. 761-767.

43 Dominican breviary (Paris, Bibl. de l'Arsenal, ms. 193, fols. 64ff.), fourteenth century. Each lesson of the breviary resembles a compartment of a window. [Leroquais, *Bréviaires,* II, pp. 322-323.]

44 In one window at Le Mans, the three children wear the habits of clerks. This was because St. Nicholas was the patron saint of the clerks; later the three children were shown with the tonsure of clerks. [Chapel of the Virgin in the chevet, thirteenth lancet.]

45 Cahier and Martin, *Bourges,* study of the window of St. Nicholas.

46 When Italian merchants brought his body to Bari.

47 The legend of the three children brought back to life by St. Nicholas became very popular in the thirteenth century because it was used in the religious theater. A manuscript from Orléans (late twelfth century) has preserved a little drama written in Latin about the miracle of the saint. The manuscript came from the monastery of Fleury, where it was played by the pupils whose patron was St. Nicholas. See E. du Meril, *Les Origines latines du théâtre moderne,* Paris, 1849, pp. 262-266 [facs. ed., Leipzig and Paris, 1897]. A similar miracle was performed, beginning in the twelfth century, by the pupils of the Abbey of Einsiedeln in Switzerland. See W. Creizenach, *Geschichte des neueren Dramas,* Halle, 1893, I, pp. 104-106. [See also K. Young, *Drama of the Medieval Church,* II, pp. 307-360.]

48 The Bollandists had already perceived this explanation of the legend of St. George, *Acta sanctorum,* April, III, p. 104, which Saint-Laurent, *Guide de l'art chrétien,* V, p. 282, and Cahier "Femme," *Caractéristiques des saints,* I, pp. 407-408, have presented with more clarity.

49 At the very height of the Middle Ages, St. Bertrand of Comminges was thought to have killed a dragon. Cahier ingeniously supposed that the legend arose from the designs covering the coffer in which his relics were preserved. These designs in fact represent people fighting with dragons. *Ibid.,* I, p. 318.

50 In the beginning, the story of the dragon was a pious metaphor used by clerics, the proof being that the dragon is usually guarding a fountain which seems to be the symbol of baptism.

51 *Legenda aurea, De Sancta Genovefa* simply says that a candle blown out by the wind was relit in her hand. [Ed. Graesse, ccxvi, p. 924; tr. Caxton, III, p. 293 (ed. Roze does not include this chapter).] The statue at Notre-Dame is a restoration.

52 Cahier, *Caractéristiques des saints,* I, p. 197. The same legend is told of another Flemish saint, Ste. Wivine (twelfth century).

53 See V. Advielle, *Histoire de l'ordre hospitalier de Saint-Antoine de Viennois et de ses commanderies et prieurés,* Paris, 1883.

54 See J. Collin de Plancy, *Dictionnaire critique des reliques et des images miraculeuses,* Paris, 1821, I, p. 33; and Cahier, *Caractéristiques des saints,* II, p. 705. [See also Le Roux de Lincy, *Le Livre des proverbes français,* I, pp. 43-44.]

55 Cahier, *Caractéristiques des saints,* I, p. 362. The yarn no doubt symbolized the intestines. St. Erasmus was known at l'Huys under the popular name of St. Agrapard.

56 *Ibid.,* I, p. 308.

57 [First cited, Preface, n. 14.]

58 Cahier's dictionary supersedes some once valuable works, such as G. Helmsdorfer, *Christliche Kunstsymbolik und Ikonographie*, Frankfurt am Main, 1839; A. Jameson, *Sacred and Legendary Art*, 2 vols., London, 1849; and L.-J. Guénebault, *Dictionnaire iconographique des figures, légendes et actes des saints*, Paris, 1850.

59 However, we learn from it that buckle makers had celebrated the feast of St. Leonard as early as the thirteenth century, and that the masons had fines paid to the chapel of St. Blaise (St. Blaise remained the patron saint of masons in the following centuries). [G.-B. Depping, ed., *Reglemens sur les arts et métiers de Paris, rédigés au XIIIe siècle, et connus sous le nom du "Livre des Métiers" d'Etienne Boileau*, Paris, 1837, pp. 60, 107.]

60 See especially R. de Lespinasse, *Les Métiers et corporations de la ville de Paris*, Paris 1879-1897, vols. I and II, in the Histoire Générale de Paris published by the city.

61 The mixture of glue and sawdust used to stop up holes and cover imperfections in wood was called "the brain of St. Anne." See Forgeais, *Plombs historiés*, I. *Méreaux des corporations de métiers*, pp. 91-93.

62 Cahier, "Patrons," *Caractéristiques des saints*, II, p. 634.

63 Lespinasse, *Métiers et corporations*, I, p. 251; and Cahier, *Caractéristiques des saints*, II, p. 610.

64 Forgeais, *Plombs historiés*, I, p. 63. [Forgeais gives the nativity of Virgin as the patron saint's day.]

65 *Ibid.*, p. 45.

66 See Cahier, *Caractéristiques des saints*, I, pp. 156-157 ("Calembour") and II, p. 634 ("Patron").

67 Forgeais, *Plombs historiés*, I, pp. 32-33.

68 *Ibid.*, p. 146.

69 C. de Linas, "Note sur un attribut de Saint Joseph," *Mémoires de la Société nationale des antiquaires de France*, 45 (1884), p. 104, thought he had correctly pointed out that on a thirteenth-century chasse from Limoges now in the Vatican, St. Joseph, patron saint of carpenters, carried a cane like the one journeymen of the Devoir still carried fifty years ago on their rounds of France. Such an intention seems rather pre-mature for the thirteenth century, but it is not outside the bounds of possibility.

70 Collin de Plancy, "Proverbes," *Dictionnaire critique des reliques*, II, p. 464.

71 The apostles of the portal of Notre-Dame of Paris are restorations.

72 See P. Batiffol, *Anciennes littératures chrétiennes, La littérature grecque*, Paris, 1897, p. 41.

73 Especially in the Acts of St. Thomas, a gnostic work in which marriage is condemned. See E. Renan, *L'Eglise chrétienne*, Paris, 1879, pp. 523-525. The apocryphal acts of the apostles were published by C. von Tischendorf, *Acta apostolorum apocrypha*, Leipzig, 1851; many were translated by Brunet in *Dictionnaire des apocryphes*, ed. Migne, vol. II. The Acts of Peter and the Acts of Paul were published in the *Apocryphes du Nouveau Testament*, a collective enterprise under the direction of J. Bousquet and J. Amann, Paris, 1913-1922. [For a comprehensive view of the apocryphal literature related to the New Testament with translations of the important texts, see James, *Apocryphal New Testament*; and Hennecke, *New Testament Apocrypha*.]

74 The Latin text of the Pseudo-Abdias was published by Fabricius, *Codex apocryphus Novi Testamenti*, vol. I. [There is no modern edition.]

75 For example, antiphonary and lectionary (Paris, Bibl. Ste.-Geneviève, ms. 1270), twelfth century; it contains the entire apocryphal history of St. John, and the struggle of St. Peter and St. Paul against the magician at Rome (fol. 155). See also lectionary (Paris, Bibl. Ste.-Geneviève, ms. 132), twelfth century, for the complete apocryphal story of St. James (fol. 127v).

76 Isidore of Seville, *De ortu et obitu Patrum*, lxviii-lxxx, Migne, *P. L.*, 83, cols. 149-153. The second part of the book, devoted to the apostles, was written later than Isidore of Seville; see L. Duchesne, "Saint Jacques en Galice," *Annales du Midi*, 12 (1900), p. 156.

77 The legend of St. Peter is given with that of St. Paul in a window at Bourges (Cahier and Martin, *Bourges*, pl. XIII); at Chartres (window of the choir) [Delaporte, *Vitraux de Chartres*, IV, pp. 284-290, I, pls. LXXVI-LXXXVIII]; at Lyon (Chapel of St. Peter)

[Bégule and Guigue, *Lyon*, pp. 104-107]; at Sens (chapel in the apse, damaged and restored); at Poitiers (near the chevet); at Troyes (cathedral, apse); and in two windows at Tours (one in a chapel of the apse, another in the choir). [On Roman and Byzantine pictorial traditions for representing the legends of St. Peter and St. Paul, see O. Demus, *The Mosaics of Norman Sicily*, London, 1949, pp. 294-299.]

78 The window at Bourges represents this last scene.

79 *Legenda aurea, De sancto Petro; De sancto Paulo*. [Ed. Roze, 1902, II, pp. 172-222, 1967, I, pp. 414-444; tr. Caxton, IV, pp. 12-46.]

80 The window at Chartres shows St. Paul resurrecting Patroclus.

81 This is a misunderstanding of the inscription *Semoni Deo Sanco*. Semo Sancus was an ancient Sabine god.

82 *Legenda aurea, De sancto Petro*. [Ed. Roze, 1902, II, pp. 179-180; 1967, I, pp. 418-419; tr. Caxton, IV, pp. 17-18.] This episode is shown in a window at Chartres and in another at Angers.

83 Windows at Bourges and at Lyon.

84 Windows at Bourges, Chartres, and Tours. Rose window at Reims dedicated to St. Peter. Window at Poitiers. Window in St.-Père at Chartres (upper windows of the choir, fourteenth century).

85 The famous episode of *Domine, quo vadis?* is represented in a section of windows at Bourges, Chartres, Lyon, Narbonne, and in a relief of the portal of Lyon cathedral. [Bégule and Guigue, *Lyon*, pp. 175-176.]

86 See the crucified St. Peter of the cathedral of Rouen ("Portail des Libraires"), plaster cast in the Trocadéro. [Paris, Musée des Monuments français, cat. no. 610.]

87 *Legenda aurea, De sancto Paulo*. [Ed. Roze, 1902, II, pp. 200-201; 1967, I, p. 431; tr. Caxton, IV, p. 33.] The episode of Plautilla's veil is shown in the window at Chartres.

88 Works of art inspired by Acts are so rare that we have had to attach this study of the apostles, not to the chapter on the New Testament, but to the chapter on the *Golden Legend*. Among the rare works inspired by Acts are two windows at Notre-Dame

of Dijon dedicated to St. Peter, one window at Semur in the chapel of the Virgin also dedicated to St. Peter (St. Peter before the judge; St. Peter in prison; St. Peter delivered by the angel). At Auxerre, there is a window devoted to Sts. Peter and Paul, fragments of which have been dispersed in other windows (it shows: St. Peter's net filled with fish, Ananias and Sapphira, St. Paul at Malta stung by a viper). At Amiens, a window of the chapel of the Virgin shows the story of St. Stephen and the Conversion of St. Paul according to Acts 9:19. Also found on the lintels of the right and left portals of the façade of Reims Cathedral: left portal, St. Paul stricken on the road to Damascus; right portal, St. Paul struck with blindness and cured by Ananias.

89 Migne, *Dictionnaire des apocryphes*, II, cols. 759-815.

90 See the episodes of the shipwreck, *ibid.*, col. 762, and of St. John the servant at the baths, *ibid.*, col. 765.

91 Published by Michael Neander at Basle in 1567. Prochorus, *De Iohane theologo et evangelista historia. S. Castalione interprete, Catechesis Martini Lutheri parva, Greco-latina postremum recognita*, Basle, 1567.

92 Windows at Chartres [Delaporte, *Vitraux de Chartres*, pp. 160-164, pls. X-XIII]; Bourges [Cahier and Martin, *Bourges*, pl. XV]; and the Ste.-Chapelle [Aubert, *Vitraux de Notre-Dame et de la Sainte-Chapelle*, pp. 207-215].

93 *Legenda aurea, De sancto Johanno*. [Ed. Roze, 1902, I, p. 95; 1967, I, p. 83; tr. Caxton, II, pp. 164-165.] Windows at Chartres, the Ste.-Chapelle, and Tours (upper windows of the choir).

94 Windows at Chartres and Bourges. Medieval alchemists, because St. John had changed stones into gold, said that he had the secret of the Philosophers' Stone. "Adam, Chanoine regulier de Saint-Victor de Paris," *Histoire littéraire de la France*, 15 (1820), p. 42.

95 This is the episode that was most often represented, and was the reason why St. John was given the chalice he carries. Windows at Bourges, Chartres, Tours, Troyes (window in the apse), the Ste.-Chapelle, St. Julien-du-Sault (see Gaussen, *Portefeuille archéologique de la Champagne*, II, pl. VIII),

Reims (in the small rose of the window of the choir devoted to St. John), Reims (relief of the south wall, near the west portal devoted to the Apocalypse).

96 Chartres, Bourges, Tours, Reims, St.-Julien-du-Sault, Lyon (window of the apse). In the Lyon window, the death of St. John is the only borrowing from the apocryphal Gospels; the rest is devoted to St. John's vision on Patmos. The scene, which was carved in the upper part of the tympanum of the left portal of the cathedral of Rouen is, as L. Pillion ("Un Tympan de porte à la cathédrale de Rouen. La mort de Saint Jean l'Evangéliste," *Revue de l'art chrétien*, 47 [1904], pp. 181-189) has shown, the mysterious death of St. John the Evangelist (fig. 198). The other part of the tympanum is devoted to Herod's Feast and the Beheading of John the Baptist.

97 St. Augustine, *Contra Faustum*, xxii, lxxix, Migne, *P. L.*, 42, col. 452. In the legend of St. Thomas, he recognized the work of the Manichaeans.

98 *Legenda aurea, De sancto Thoma.* [Ed. Roze, 1902, i, pp. 53-64; 1967, i, pp. 57-64; tr. Caxton, ii, pp. 138-148.]

99 The legend of St. Thomas is reproduced in detail in the windows of Chartres (choir), Bourges (radiating chapels), Tours (choir, upper windows). The entire tympanum of the north portal of the church of Semur is devoted to it. Permit me to point out especially the portal of Semur, because the meanings of the scenes decorating it have not before been understood. Local archeologists have seen in it the story of the murder of Dalmace, assassinated by the order of Robert, Duke of Burgundy. See J. Ledeuil, *Notice sur Semur-en-Auxois*, Semur, 1884, p. 56. *Le Guide Joanne* (Bourgogne et Morvan), ed. A. Joanne, Paris, 1892, p. 172, says that it has to do with the conversion of the population to Christianity. The following is the proper interpretation of the various scenes filling the tympanum (fig. 199): upper band (at the left): St. Thomas puts his hand into Christ's side; the provost of King Gundoferus meets St. Thomas (accompanied by a disciple) in the square of Caesarea; St. Thomas in a boat sailing toward India. Lower band (at the right): a feast, a dancer

walks on her hands; a dog carries the hand of the butler in its mouth; St. Thomas receives the orders of King Gundoferus; instead of building the palace, he distributes Gundoferus' treasures to the poor: one of the poor is seated on a stool, another holds a gourd and is a very pronounced negroid type; St. Thomas in prison; St. Thomas speaks with a kneeling person whose head is now missing. This might be Gundoferus, although the robe seems to be that of a woman, and if that is the case, perhaps she is Migdonia who went to him to ask his forgiveness because he had been put in prison for her sake. Why should so important a place have been given to the legend of St. Thomas in the church of Semur? No doubt the church possessed a relic of the saint, but documents are lacking. One of the portals of the cathedral of Poitiers (façade, right portal) is also dedicated to St. Thomas. The lower section shows the incredulity of St. Thomas; above, the apostle is shown distributing the treasures of King Gundoferus to the poor; at the top, angels carry the mystical palace that St. Thomas erected in heaven. See A. Rhein, "Poitiers, Cathédrale Saint-Pierre," *Congrès archéologique*, 79 (1912), p. 264, and E. Maillard, *Les Sculptures de la cathédrale de Poitiers*, Poitiers, 1921, pp. 115-121.

100 *Legenda aurea, De sancto Jacobo Major.* [Ed. Roze, 1902, ii, pp. 268-283; 1967, i, pp. 471-480; tr. Caxton, iv, pp. 97-111.] Windows of Bourges (choir). [Cahier and Martin, *Bourges*, pl. xv.] Chartres (choir, at the left, fig. 200); Auxerre (right aisle, near the choir); two windows at Tours (one in a chapel of the choir, the other in the upper windows of the choir).

101 *Legenda aurea, De sancto Simone et Juda.* [Ed. Roze, 1902, iii, pp. 223-234; 1967, ii, pp. 299-305; tr. Caxton, vi, pp. 72-81.] Windows at Chartres (choir) and window at Reims (rose of the St. Jude window, in the choir).

102 *Legenda aurea, De sancto Andrea.* [Ed. Roze, 1902, i, pp. 18-35; 1967, i, pp. 37-47; tr. Caxton, ii, pp. 94-109.] The Pseudo-Abdias (Migne, *Dictionnaire des apocryphes*, ii, cols. 57-106, at the word: *André*). Window of Troyes (apse); window of Auxerre (left aisle).

103 Pseudo-Abdias (Migne, *Dictionnaire des*

apocryphes, II, cols. 149-162, article "Saint Barthélemy"), and *Legenda aurea, De sancto Bartholomaei.* [Ed. Roze, 1902, II, pp. 481-495; 1967, II, pp. 125-133; tr. Caxton, V, pp. 31-44.] The mantle ornamented with precious stones is found only in Romanesque art.

104 On this subject, see the well-documented chapter devoted to St. Peter and St. Paul by Saint-Laurent, *Guide de l'art chrétien,* chap. V, and *idem,* "Aperçu iconographique sur Saint Pierre et Saint Paul," *Annales archéologiques,* 23 (1863), pp. 26-44, 138-144, 264-277; 24 (1864), pp. 93-103, 161-173, 238-248, 264-271; 25 (1865), pp. 24-33, 202-222.

105 In the Eastern Church, St. John was almost always represented as bearded. The Lyon window dedicated to St. John shows the apostle with a full beard at the time of his death (fig. 197). Another proof of the strange Byzantine influence we notice in the windows of Lyon.

106 See particularly, *Legenda aurea, De sancto Bartholomaei.* [Ed. Roze, 1902, II, p. 487; 1967, II, pp. 128-129; tr. Caxton, V, p. 37.]

107 In the thirteenth century, the cross of St. Andrew is almost always a Latin cross, and not an X-shaped cross.

108 There was unanimity in the thirteenth century. See the chart on pp. 308-309. The St. Bartholomew of Amiens once held a knife that was replaced by an axe when the statue was restored. See G. Durand, *Amiens,* I, p. 329.

109 Judging by the style of the statues, the series of monumental apostles of the south portal of Chartres is one of the earliest that we possess. We have reproduced only half of them. [See Grodecki, *Chartres,* pp. 52-53, 58-59.]

110 The Amiens chalice has been restored, but the attribute seems to have existed before the restoration. See G. Durand, *Amiens,* I, p. 324. On the reliquary containing the great relics of Aix-la-Chapelle (Cahier and Martin, *Mélanges d'archéologie,* I, p. 20), St. John carries the tub into which he was plunged at the Porta Latina, but this example was not followed.

111 As on the north portal of Reims, one of the earliest of the cathedrals and on the portal at Amiens (fig. 202). [Sculpture on the north transept of Reims may have begun soon after 1210; see Hinkle, *Portal of the Saints of Reims,* pp. 5-6. For a reproduction of St. James, see Reinhardt, *Reims,* fig. 27, where St. James is wrongly identified as St. Bartholomew.]

112 Portal of "La Couture" at Le Mans, portal at Bayonne (fig. 203).

113 If, however, the square is not a cross that has been broken. [The restored mason's square held by St. Thomas at Amiens is a T-square, whereas thirteenth-century architects and masons used an L-shaped square with the distinctive characteristic of an obtuse interior angle. On this subject, see B. G. Morgan, *Canonic Design in English Medieval Architecture,* Liverpool, 1961, p. 55, and L. Shelby, "Medieval Masons' Tools, II. Compass and Square," *Technology and Culture,* 6 (1965), pp. 236-248. See also G. Durand, *Amiens,* I, pp. 326-327, on the problematic restoration of the attribute.]

114 St. Mathias is the apostle who was substituted for Judas in the Apostolic College. He is very seldom represented. In his place, artists almost always placed St. Paul, who was not one of the twelve.

115 See J. Corblet, *Hagiographie du diocèse d'Amiens,* 5 vols., Paris, 1869-1875.

116 The stone of St. Nicaise was still venerated in the cathedral in the seventeenth century, and was enclosed by a grill. Cerf, *Histoire et description de Notre-Dame de Reims,* I, p. 375.

117 A relief also represents the death of St. Nicaise (fig. 205). St. Eutropia, according to the story by Flodoard, struck the murderer of her brother. [Flodoard, *Histoire de l'église métropolitaine de Rheims,* ed. F.-P.-G. Guizot (Collection des mémoires relatif à l'histoire d France, V-VI, Paris, 1824, p. 20.]

118 The figure beside St. Remi is not Clovis, as it is usually said to be, but Job, whose story is told in the tympanum. I have written on this at length in E. Mâle, "La Cathédrale de Reims," *Gazette des beaux-arts,* 5th ser., 3 (1921), pp. 73-88, and *idem,* "Nouvelle étude sur la cathédrale de Reims," *Art et artistes du moyen âge,* pp. 238-240.

119 The story of St. Remi is oddly mingled (third band from the bottom) with the story of Job. It is impossible not to recognize Job on the dungheap, his three friends, and his wife who holds her nose. The messenger sent to tell Job of his ruin is also shown. Nothing in Flodoard, *Histoire de l'église métropolitaine de Rheims*, from which all the scenes on the tympanum were taken, justifies Job's presence there. The relief is interesting nonetheless, for it is clearly imitated from that of the north façade of Chartres (tympanum of the right portal), which represents the same subject. Some of the details are identical. Here we see the bonds uniting the art of Reims and Chartres. [For the relation of this theme to the cult of St. Remi and in general to the Church Triumphant, see Hinkle, *Portal of the Saints at Reims*, pp. 53-63.]

120 The portal of St. Guillaume was rebuilt in the sixteenth century after the tower crumbled.

121 Left portal (west façade). The statues have been restored, but they were mentioned by Lebeuf before their restoration. Lebeuf, *Histoire de la ville et de tout la diocèse de Paris*, I, p. 8. The original reliefs beneath the statues still exist (decapitation of St. Denis, St. Geneviève and her mother).

122 Copy. The original is in Paris, Musée de Cluny.

123 This well at Chartres had long been famous and was called *Puits des Saints-Forts* (see Bulteau, *Monographie de Chartres*, I, p. 16). The statues of St. Potentien and St. Modeste are on the north porch; a window also is devoted to them (second chapel of the choir, at the left).

124 Window of the choir and relief of the south portal.

125 Window of the left aisle.

126 Relief and large statue of the south portal.

127 These were deciphered by L. Pillion, *Les Portails latéraux de la cathédrale de Rouen*, Paris, 1907, pp. 106ff.

128 This is the Portal of St. Anne. I have tried to prove (E. Mâle, "Le Portail Sainte-Anne à Notre-Dame de Paris," *Revue de l'art ancien et moderne*, 2 [1897], pp. 231-246) that the tympanum dates from the time of Maurice de Sully, and that it was preserved, because we see there the images of the founding bishop of the cathedral and of King Louis VII; see also *idem*, "Le Portail Sainte-Anne à Notre Dame de Paris," *Art et artistes du moyen âge*, pp. 188-208. [See further W. Cahn, "Tympanum of the Portal of Saint-Anne."]

129 See Lebeuf, *Histoire de la ville et de tout le diocèse de Paris*, I, p. 7, and Mortet, *Etude historique et archéologique sur la cathédrale et le palais épiscopal de Paris du VIe au XIIe siècle*, pp. 29 n. 2, and 39. Lebeuf rightly remarked that the statues of St. John the Baptist, St. Denis, and St. Stephen, on the left portal of the façade of Notre-Dame of Paris were "like memorials to the two small adjacent churches, St. Jean and St. Denis, and of the former church of St. Etienne" (*ibid.*, I, p. 8). All these churches were annexes to Notre-Dame. This was the case with several cathedrals where the complex of buildings included a church of Notre-Dame, a church of St. John the Baptist (baptistery), and a church dedicated to the protomartyr St. Stephen. [See J. Hubert, "Les Origines de Notre-Dame de Paris," *Huitième centenaire de Notre-Dame de Paris* (Bibliothèque de la Société d'histoire ecclésiastique de la France), Paris, 1967, pp. 1-22.]

130 U. Chevalier, *Poésie liturgique traditionnelle de l'église catholique en occident*, Tournai, 1894, pp. lxv ff. (introduction).

131 To the left of the spectator, but at the right of Christ who occupies the trumeau of the central door.

132 See Bulteau, *Monographie de Chartres*, II, p. 287.

133 Collin de Plancy, *Dictionnaire critique des reliques*. [A comprehensive publication of the inventories of medieval church treasuries is under way. See B. Bischoff, *Mittelalterliche Schatzverzeichnisse*, I. *Von der Zeit Karls des Grossen bis zum Mittel des 13. Jahrhunderts*, Munich, 1967.]

134 P.-E.-D. Riant, *Exuviae sacrae Constantinopolitanae*, 3 vols., Geneva, 1877-1904. Also, *idem*, "Des dépouilles religieuses enlevées à Constantinople au XIIIe siècle et des documents historique nés de leur transport en occident," *Mémoires de la Société nationale des antiquaires de France*, 36 (1875), pp. 1-214.

135 Cahier and Martin, *Mélanges d'archéologie,* I, pp. 8-12.

136 As, for example, at St.-Martin of Tours. It was necessary to make room for the crowds to see the tomb and to walk around it.

137 See E. Viollet-le-Duc, "Reliquaire," *Dictionnaire raisonné du mobilier français,* Paris, 1871, I, pp. 210-232. [See also J. Braun, *Das christliche Altargerät in seinem Sein und in seiner Entwicklung,* Munich, 1932.]

138 Donations to reliquaries were made in wills. Noble ladies and clerks gave pearls and golden necklaces to the reliquary of the "Sainte Chemise" at Chartres. See E. de Lépinois and L. Merlet, *Cartulaire de Notre-Dame de Chartres,* Chartres, 1865, III, pp. 58, 93, 141, 150.

139 [On the Ste.-Chapelle as a reliquary, see R. Branner, "The Painted Medallions in the Sainte-Chapelle in Paris," *Transactions of the American Philosophical Society,* new ser., 58 (1968), pt. 2, pp. 5-9; and *idem, St. Louis and the Court Style,* pp. 56-59.]

140 John Calvin, *Traité des reliques ou avertissement très utile . . .* (reprinted by Collin de Plancy, *Dictionnaire critique des reliques,* III, p. 280).

141 Guibert de Nogent, well before Calvin, at the height of the Middle Ages, had expressed doubts, it is true, about the authenticity of certain relics. His book, *De sanctis et eorum pignoribus,* especially bk. III (Migne, *P. L.,* 156, cols. 651-666), was directed against the monks of St.-Médard, who claimed to possess a tooth of Christ. It is scarcely necessary to say that the entire body of Christ was glorified at the moment of the Resurrection. He speaks, and not without a touch of irreverence, about the two heads of John the Baptist, one preserved at St.-Jean-d'Angély and the other at Constantinople: *Quid ergo magis ridiculum super tanto homine praedicetur, quam si biceps esse ab utrisque dicatur?* (What more ridiculous statement could be made about so great a man than if he be declared by both to be two headed?) *Ibid.,* I, iii, 2, Migne, *P. L.,* 156, cols. 624-626. [On the criticism of false relics, see K. Schreiner, " 'Discrimen veri ac falsi,' Aussätze und Formen der Kritik in der Heiligen und Reliquienverehrung des Mittelalters," *Archiv für Kulturgeschichte,* 48 (1966), pp. 1-53.]

142 One of these pouches is reproduced in B. de Montfaucon, *Les Monumens de la monarchie françoise,* Paris, 1730, II, pl. XXXI.

143 A list of these relics was given by Riant, "Des Dépouilles religieuses," pp. 177-211.

144 C. D. Du Cange wrote a *Traité historique du chef de saint Jean-Baptiste,* Paris, 1665, to establish the authenticity of the Amiens relic.

145 This window, half of which is dedicated to John the Baptist and the other half to St. George, is now in the chapel of John the Baptist.

146 Proof that this latter work was really inspired by the Amiens relic is that one of the reliefs represents Herodias striking the head of John the Baptist with a knife. On the skull preserved at Amiens, the mark of the knife was pointed out; no legend mentions such a mark.

147 See S.-J. Morand, *Histoire de la Sainte-Chapelle royale du palais,* Paris, 1790, pp. 40-41, 47.

148 Lépinois, *Cartulaire de Notre-Dame de Chartres,* III, pp. 89, 178. Riant, *Exuviae sacrae Constantinopolitanae,* II, p. 73.

149 See Bulteau, *Monographie de Chartres,* I, p. 128.

150 Lépinois, *Cartulaire de Notre-Dame de Chartres,* I, p. 60.

151 [On the identification of this statue as St. Maurice, see Y. Delaporte, "Saint Maurice et sa statue à la cathédrale de Chartres, *Bullètin de la Société archéologique d'Eure et Loire,* 20 (1954), pp. 75-81.]

152 Haute-Garonne; below St.-Bertrand-de-Comminges.

153 B. Bernard, "Découverte de reliques dans l'autel de l'église de Valcabrère," *Bulletin monumental,* 52 (1886), pp. 501-508.

154 S. Roulliard, *Parthénie, ou Histoire de la très auguste église de Chartres,* Paris, 1609, p. 140.

155 This is not the window of the Lord Jesus, as Bulteau calls it, but the window of the apostles. [Bulteau, *Monographie de Chartres,* III, pp. 270-271.]

156 Were not the two windows of St. Martin

and St. Sylvester, now in neighboring windows, intended for this chapel? Have they not been misplaced?

157 See E. Duseval, *Visite à la cathédrale d'Amiens*, ed. J.B.M. Roze, Amiens, 1853, p. 55.

158 *Ibid.*, p. 60.

159 Several others could be cited. A chapel of the collegiate church of St.-Tudual, at Laval, was decorated with a window representing the life of St. Tudual, because the relics of this saint were in this chapel. See A. de Barthélemy, "Le reliquaire de Saint Tudual à Laval," *Bulletin monumental*, 51 (1885), pp. 453-458. At Clermont, the windows of the chapels in the apse devoted to the legends of St. George, St. Austremoine, St. Mary Magdalene, etc., are in the chapel named for these saints. See E. Thibaud, *De la Peinture sur verre*, Clermont, 1835, p. 18, and Lasteyrie, *Histoire de la peinture sur verre*, I, pp. 205-206. [See also H. Du Ranquet, *Les Vitraux de la cathédrale de Clermont-Ferrand*, Clermont-Ferrand, 1932, and *idem, La Cathédrale de Clermont-Ferrand*, 2nd ed., Paris, 1928, pp. 95-97.]

160 Sometimes the upper panel, especially if surmounted by a small rose.

161 This window disappeared in 1773; it was replaced by a clear window. However, the rose showing a magnificent St. Louis in the costume of a knight still exists. He is mounted on a white horse and holds the azure pennon sprinkled with golden fleurs-de-lis. See Bulteau, *Description de la cathédrale de Chartres*, p. 208 and Montfaucon, *Monumens de la monarchie françoise*, II, pl. XXI. [A similar representation of St. Louis appears in a rose in the choir at Chartres. See Lasteyrie, *Histoire de la peinture sur verre*, I, p. 63; II, pl. XXVI.]

162 The window no longer exists, but it was described in the last century by Pintard in a manuscript now in the Bibliothèque de Chartres. See Bulteau, *Description de la cathédrale de Chartres*, p. 207. It gives the inscription: *Rex Castiliae.* The figure of St. Ferdinand was published by Montfaucon, *Monumens de la monarchie françoise*, II, pl. XXIX.

163 Bourassé and Marchand, *Verrières de Tours*, p. 51.

164 It disappeared in 1788, but it was described in Pintard's manuscript. See Bulteau, *Description de la cathédrale de Chartres*, p. 206. It is strange that in the thirteenth and fourteenth centuries donors rarely gave the image of their own patron saints, for this became the rule in the fifteenth and sixteenth centuries. For example, the west rose window of the cathedral of Auxerre (sixteenth century), contains eight saints; Sts. James, Christopher, Claude, Sebastian, Nicholas, Charlemagne, John, Eugene, given by the canons Jacques Vautrouillet, Christophe Chaucuard, Claude de Bussy, Sébastian Le Royer, Nicolas Cochon, Charles Legeron, Jean Chevallard, Eugène Motel, who bore the cost of the window. See G. Bonneau, *Vitraux d'Auxerre*, p. 9. [See also *idem*, "Description des verrières de la cathédrale d'Auxerre," *Bulletin de la Société des sciences historiques et naturelles de l'Yonne*, 39 (1885), pp. 299-301.] Fifteenth- and sixteenth-century windows at Bourges offer many examples of the same practice. See A. Des Meloizes, *Vitraux peints de la cathédrale de Bourges postérieurs au XIIIe siècle*, Paris, 1891-1897.

165 St. Anthony, superior of the monasteries of the Thebaid where monks earned their living by weaving baskets, was the patron saint of basket makers in the Middle Ages.

166 The first two of these windows are known today only through Pintard's description. See Bulteau, *Description de la cathédrale de Chartres*, p. 210.

167 At Chartres, another of the upper windows (at the left) represents St. Eustace and was also given by a knight, the Seigneur de Beaumont-sur-Rilles. See F. de Mély, "Etude iconographique sur les vitraux du treizième siècle de la cathédrale de Chartres," *Revue de l'art chrétien*, 38 (1888), p. 417.

168 William Durandus, *Rationale*, IV, xvi. [Ed. d'Avino, p. 184; ed. Barthélemy, II, pp. 101ff.]

169 It was natural that there was a special cult of Thomas à Becket at Chartres, for one of its late twelfth-century bishops (1176-1180), John of Salisbury, had been at Canterbury when the sainted bishop was assassinated. He gathered several drops of his blood into two phials, and gave them to the cathedral of Chartres (Lépinois, *Cartulaire de Notre-*

Dame de Chartres, III, pp. 201-202). John of Salisbury wrote a Life of St. Thomas à Becket. [*Vita sancti Thomae,* Migne, *P. L.,* 190, cols. 195-208. For this and other biographies, see J. C. Robertson, *Materials for the History of Thomas Becket, Archbishop of Canterbury,* London, 1876, II, pp. 299-322. See also T. Borenius, *St. Thomas Becket in Art,* London, 1932.]

170 E. de Lépinois, *Histoire de Chartres,* Chartres, 1854-1858, I, pp. 384ff., and II, pp. 555-627 (Appendix).

171 A.-D., marquis de Pastoret, *Ordonnances des rois de France de la troisième race jusqu'au 1514,* Paris, 1835, XIX, p. 663.

172 Lasteyrie, *Histoire de la peinture sur verre,* pp. 75-76. The inscription was published in facsimile by Mély, "Etude iconographique sur les vitraux de Chartres," p. 422. Certain words and fragments of words have been misplaced. *VIN* and *CENT* belong together, making the word *VINCENT*; *DO* and *ERÊT* should also be brought together to read *DOERÊT.* [Cf. Delaporte, *Vitraux de Chartres,* I, pp. 319-326, II, pls. CXI-CXIV.]

173 It is quite certain that a corporation or religious confraternity might have several patron saints. In 1882, frescoes were found in the church of St.-Michel-de-Vaucelles, at Caen, representing Sts. Michael, John the Baptist, Peter, Paul, James, Christopher, Martin, Mathurin, Eustace, Catherine, Andrew, Nicholas, Sebastian, and Anne. A document, dated 1446, proves that there had been a confraternity of St. Michael in that church, and that not only was St. Michael venerated as its patron, but the other saints whose images occur in the frescoes were venerated also. See E. de Beaurepaire, "Peintures du XVIe siècle nouvellement découvertes dans l'église Saint-Michel-du-Vaucelles à Caen," *Bulletin monumental,* 49 (1883), pp. 689-707.

174 There are two at Tours, one at Bourges, and one at Auxerre.

175 See the article by J.-V. Le Clerc, "Aimeric Picaudi de Parthenai. Cantique et itinéraire des pèlerins de Saint-Jacques de Compostelle," *Histoire littéraire de la France,* 21 (1847), pp. 272-292, and of L. Delisle, "Note sur le recueil intitulé 'De miraculis sancti Jacobi,'" *Le Cabinet historique,* 2nd

ser., 24 (1878), pp. 1-9. The error arose in the Middle Ages because, in the early twelfth century, Pope Calixtus II had been especially devoted to the cult of St. James, and made obligatory the feast of the Translation of St. James (3 January) and of the Miracles of St. James (9 October). See *De sancto Jacobo apostolo in Gallaecia habiti, Sermo* II, Migne, *P. L.,* 163, col. 1391.

176 See J. Bédier, *Les Légendes épiques; Recherches sur la formation des chansons de gestes,* Paris, 1913, III, pp. 88-91, and Mâle, *Religious Art in France: The Twelfth Century,* chap. VIII.

177 Bk. IV, a real guide for travelers, was first published by F. Fita y Colomé and J. Vinson, *Le Codex de Saint-Jacques de Compostelle,* Paris, 1882. It has been republished by J. Vielliard, *Le Guide du pèlerin de Saint-Jacques de Compostelle,* 3rd ed., Mâcon, 1938 (repr. 1963). [On the pilgrimage to Santiago de Compostela, see also Y. Bottineau, *Les Chemins de Saint-Jacques,* Paris and Grenoble, 1964.]

178 It is quite remarkable that the church of Ste.-Foy at Conques, St.-Sernin at Toulouse, and Santiago de Compostela are almost identical. The church of St.-Martial at Limoges, which pilgrims to Santiago visited, was similar to three mentioned above. It no longer exists. See C. de Lasteyrie, *L'Abbaye de Saint-Martial de Limoges, étude historique, économique et archéologique,* Paris, 1901. On this subject, see Mâle, *Religious Art in France: The Twelfth Century,* chap. VIII. [See further K. J. Conant, *Carolingian and Romanesque Architecture, 800-1200,* Baltimore, 1959, pp. 91-103.]

179 See A. Lavergne, *Les Chemins de Saint-Jacques en Gascogne,* Bordeaux, 1887; see also J.-B. Pardiac, *Histoire de S. Jacques le Majeur et du pèlerinage de Compostelle,* Bordeaux, 1863, pp. 131-156.

180 See Fita y Colomé, *Codex,* p. 18.

181 Their motto was: *Rubet sanguine Arabum.*

182 B. Guérard, *Cartulaire de l'abbaye de Saint-Père de Chartres* (Collection de documents inédits sur l'histoire de France), Paris, 1840, II, p. 648.

183 See Le Clerc, "Aimeric Picaudi de Parthenai," p. 280 and X. de Bonnault d'Houet, *Le Pèlerinage d'un paysan picard à Saint-*

Jacques de Compostelle au XVIIIe siècle, Montdidier, 1890. [See also E. R. Labande, "Recherches sur les pèlerins dans l'Europe des XIe et XIIe siècles," *Cahiers de civilisation médiévale*, 1 (1958), pp. 339-347.]

184 See C. Ouin-Lacroix, *Histoire des anciennes corporations d'arts et métiers et des confréries religieuses de la capitale de la Normandie*, Rouen, 1850, p. 473, and Forgeais, *Plombs historiés*, IV, *Imagerie religieuse*, p. 151 and III, *Variétés numismatiques*, p. 105.

185 Lebeuf, *Histoire de la ville et de tout le diocèse de Paris*, I, p. 127, and II, p. 310.

186 H. Bordier, "La Confrérie des pèlerins de Saint-Jacques et ses archives," *Mémoires de la Société de l'histoire de Paris et de l'Ile-de-France*, 1 (1875), pp. 186-228; 2 (1876), pp. 330-397. We also know, of course, the Confraternity of the Pilgrims of St. James of Rouen fairly well from late documents. See Ouin-Lacroix, *Histoire des anciennes corporations d'arts et métiers*, pp. 473-475.

187 Second window of the choir, on the left, upper window.

188 Cahier and Martin, *Bourges*, pl. XV.

189 Bourassé and Marchand, *Tours*, pl. III.

190 The story, attributed to Pope Calixtus II, passed into the *Golden Legend: Legenda aurea, De sancto Jacobo major*. [Ed. Roze, 1902, II, pp. 276-277; 1967, I, pp. 476-477; tr. Caxton, IV, pp. 105-106], and into the *Speculum historiale* of Vincent of Beauvais, XXVI, xxxiii [Graz ed., IV. 1066].

191 [The characterization of St. James as a pilgrim would seem to follow the iconography of Christ as a traveler in Emmaus scenes, which was already established in the twelfth century. As Mâle himself has suggested (Mâle, *Religious Art in France: The Twelfth Century*, p. 140), this iconographic type may have reflected liturgical drama. For a more recent statement on this question, see Pächt, Dodwell, and Wormald, *The Saint Albans Psalter*, pp. 74-79.]

192 On the confraternities of St. Martin, see L. Blancard, "Rôle de la confrérie de Saint-Martin de Canigou," *Bibliothèque de l'Ecole des Chartes*, 42 (1881), p. 5, and Lecoy de La Marche, *Saint Martin*, pp. 647-648; 2nd ed., p. 603. For the confraternities organized by the pilgrims of St. Nicholas, see Forgeais, *Plombs historiés*, III. *Variétés numismatiques*, p. 105.

193 Fragments of a window dedicated to St. Nicholas have been found in the loft of the cathedral of Troyes. See J. Laroche, "Iconographie de saint Nicolas," *Revue de l'art chrétien*, 34 (1891), p. 116.

194 Proof of the antiquity of the cult of St. Nicholas is given by J. de l'Isle, *Histoire de la vie, du culte, de la translation des reliques et des miracles de S. Nicolas, évêque de Myre*, Nancy, 1745, p. 64.

195 Peter Damian, *Sermones ordine mensium servato, Sermo* lix, Migne, *P. L.*, 144, col. 835.

196 De l'Isle, *Histoire de la vie . . . de S. Nicolas*, p. 125.

197 Right portal (fig. 215). The tympanum is dedicated to both St. Nicholas and St. Martin. Represented on the right is the miracle of St. Nicholas' tomb from which the aromatic oil flowed, and, below, St. Nicholas throwing a purse into the house of the poor man whose poverty obliged him to sell his three daughters. At the left, St. Martin gives half his cloak to a beggar, and above, Christ appears to St. Martin in his sleep (St. Martin's valet lies beside him). [On the relation of these scenes to the Last Judgment, see Katzenellenbogen, *Sculptural Programs of Chartres Cathedral*, p. 81.]

198 In the chapel of the Virgin, in the apse, left window. See A. Pigeon, "Un vitrail de la cathédrale de Beauvais représentant la vie de Saint Martin de Tours," *Gazette des beaux-arts*, 3rd ser., 14 (1895), pp. 233-242.

199 Lecoy de La Marche, *Saint Martin*, p. 647 (2nd ed., p. 603).

200 There were horseshoes nailed to the door of the church of St.-Martin at Amiens. We may still see them on the door of the little church of Palalda (Pyrénées-Orientales): Lecoy de La Marche, *Saint Martin*, pp. 643-644 (2nd ed., p. 601); and on the door of the church at Chablis (Yonne). This church was a dependency of the Abbey of St.-Martin of Tours, and for a time in the ninth century contained relics of St. Martin.

BOOK IV, CHAPTER V

1 See E. Boutaric, "Vincent de Beauvais et la connaissance de l'antiquité classique au XIIIe siècle," *Revue des questions histori-*

ques, 17 (1875), pp. 1-57. [See further, E. R. Curtius, *European Literature and the Latin Middle Ages,* tr. Trask, New York, 1953, and E. K. Rand, "The Classics in the Thirteenth Century," *Speculum,* 4 (1929), pp. 249-269.]

2 Didron, *Manuel d'iconographie chrétienne,* pp. 148-150.

3 *Ibid.,* p. 151.

4 However, in the thirteenth century, an artist decorated the fountain basin of the St.-Denis cloister (now in the courtyard of the Ecole des Beaux-Arts) with the figures of Jupiter, Juno, Hercules, wood spirits, fauns, Diana, Neptune, Ceres, Bacchus, Pan, Venus, Paris, and Helen. In their childlike paganism, several of these images are not without charm. Neptune wears a fish as a hat, and the wood spirit's hair is of oak leaves. On the subject of the traces of antiquity found in medieval art, see A. H. Springer, "Das Nachleben der Antike im Mittelalter," *Bilder aus des Neuern Kunstgeschichte,* vol. 1, Bonn, 1867, pp. 1-28. See also E. Müntz, "La tradition antique chez les artistes du moyen âge," *Journal des savants,* 72 (1887), pp. 629-642, 73 (1888), pp. 40-50, 162-177. [On the St.-Denis basin, see W. Sauerländer, "Art antique et sculpture autour de 1200," *Art de France,* 1 (1961), pp. 47-56, and J. Adhémar, *Influences antiques dans l'art du moyen âge français; Recherches sur les sources et les thèmes d'inspiration,* London, 1939, pp. 265-266, 286, pl. xxxii. Cf. J. Seznec, *The Survival of the Pagan Gods,* tr. Sessions, New York, 1953, and E. Panofsky, *Renaissance and Renascences in Western Art,* 2 vols., Stockholm, 1960, with bibl.]

5 Five reliefs, dating from the late thirteenth or early fourteenth century, are devoted to the legend of Aristotle. Two are on the façade of Lyon Cathedral: see F. de Guilhermy, "Sculpture chrétienne. Fabliaux représentés dans les églises. Lai d'Aristote," *Revue générale de l'architecture et des travaux publics,* 1 (1840), cols. 393-394, and *idem,* "Iconographie des fabliaux. Aristote et Virgile," *Annales archéologiques,* 6 (1847), p. 145; see also Bégule and Guigue, *Monographie de la cathédrale de Lyon,* pl. B 2. The third decorates the "Portail de la Calende" of Rouen Cathedral: see Adeline, *Sculptures grotesques et symboliques,* pl. xxxix. The fourth is a capital of the nave of the church of St.-Pierre, at Caen: see E. de

Beaurepaire, *Caen illustré,* Caen, 1896, p. 180. The fifth is on a thirteenth-century choir stall at Lausanne: see A. Ramé, "Notes d'un voyage en Suisse," *Annales archéologiques,* 16 (1856), p. 47. On this fable, see J. Bédier, *Les Fabliaux: Etudes de littérature populaire et d'histoire littéraire du moyen âge,* Paris, 1893, pp. 170-177 [5th ed., 1925, pp. 204-212].

6 Vincent of Beauvais did not know the story of Campaspe. He speaks of Aristotle (*Speculum historiale,* III, lxxxii-lxiv [Graz ed., IV. 113] and of Alexander (*ibid.,* IV, i ff. [Graz ed., IV. 117-237 *passim*]). The fable does not appear in the Latin history of Alexander: Lambert of St.-Omer, *Liber floridus* (Paris, Bibl. Nat., ms. lat. 8865), thirteenth century. [*Manuscrits à peintures,* no. 7.]

7 It is found in Johannes Herolt, *Sermones discipuli de sanctis: cum promptuario exemplorum,* London, 1510, taken from Jacques de Vitry.

8 Portal of Amiens: the wolf and the stork, the crow (or perhaps the cock) and the fox.

9 Vincent of Beauvais (*Speculum historiale,* III, viii) recorded several of Aesop's fables because he said that they would be useful to preachers. [Graz ed., IV. 90.]

10 Beaurepaire, *Caen illustré,* p. 179.

11 D. Comparetti, *Virgilio nel medio evo,* vol. II, 2nd ed., Florence, 1896, p. 290. [See now G. F. Koch, "Virgil im Korbe," *Festschrift für Erich Meyer zum sechzigsten Geburtstag 29 Oktober 1957,* Hamburg, 1957, pp. 105-121.]

12 Vincent of Beauvais, who told many of the prodigies attributed to Virgil the Magician, did not include this adventure (*Speculum historiale,* VI, lxi, lxii [Graz ed., IV. 193-194]).

13 We are not speaking here of articles intended for domestic use, on which figures from antiquity were represented: the fountain of the Bibliothèque Nationale on which Statius' story of Achilles is told (M. Prou, "Bassin de bronze du XIe ou du XIIe siècle, représentant la jeunesse d'Achille," *Gazette archéologique,* 11 (1886), pp. 38-43); a thirteenth-century ivory with [Aristotle and Campaspe] and the story of Pyramus and Thisbe (L. Lersch, "Die Irrungen der Liebe. Mittelalterliches Elfenbeinrelief in Aachen," *Jahrbücher des Vereins von Alterthumsfreunden in Rhein-*

lande, II (1847), pp. 123-141; pl. v); a thirteenth-century fountain showing Campaspe on Aristotle's back (Bégule and Guigue, *Lyon*, p. 203); a thirteenth-century ivory with the same subject (B. de Montfaucon, *Antiquité expliquée et représentée en figures*, vol. III, pt. 2, Paris, 1722, pl. CXCIV), etc. Such objects do not belong to religious art. Nor do we speak of the legend of Alexander rising to heaven carried by two griffins, nor of Trajan dispensing justice to the widow, because these subjects never once occur in French cathedrals. They are particular to Italy and Germany. Alexander is found at S. Marco in Venice (J. Durand, "Légende d'Alexandre le Grand," *Annales archéologiques*, 25 (1865), pp. 141-158), at Anagni, on a dalmatic (X. Barbier de Montault, "Trésor d'une cathédrale. Inventaire de Boniface VIII," *Annales archéologiques*, 18 [1858] p. 26), at Basel and Freiburg-im-Breisgau (Cahier and Martin, *Nouveaux Mélanges d'archéologie*, I, pp. 165ff.). [See also G. Cary, *The Medieval Alexander*, ed. D.J.A. Ross, Cambridge, 1956.] The justice of Trajan is carved on the Ducal Palace at Venice.

14 Lactantius, *Divinarum Institutionum*, I. *De falsa religione deorum*, Migne, *P. L.*, 6, cols. 141-148. [See below, note 28 and E. Mâle, *L'Art religieux de la fin du moyen âge en France*, 3rd ed., Paris, 1925, pp. 253-279.

15 St. Augustine, *De Civitate Dei*, XXIII, Migne, *P. L.*, 41, cols. 579-581; [tr. Dods, p. 638.]

16 Isidore, *Etymologiarum*, VIII, viii, Migne, *P. L.*, 82, cols. 309-310.

17 Bede, *Sibyllinorum Verborum interpretatio (Dubia et Spuria)*, Migne, *P. L.*, 90, cols. 1181-1186.

18 Vincent of Beauvais, *Speculum historiale*, II, c, ci, cii. [Graz ed., IV. 79-80.] French poets of the thirteenth century adopted the number of ten sibyls. See Paris, Bibl. Nat., ms. fr. 25407 (thirteenth century).

19 *Speculum historiale*, II, cii. [Graz ed., IV. 80.] What Vincent of Beauvais said about the fame of the Erythraean Sibyl was borrowed from Isidore of Seville, *Etymologiarum*, VIII, viii, Migne, *P. L.*, 82, cols. 309-310.

20 St. Augustine, *De Civitate Dei*, XVIII, XXIII, Migne, *P. L.*, 41, col. 579. [Tr. Dods, p. 629.]

21 Day of wrath and terror looming,

Heavens and earth to ash consuming—
Seer's and Psalmist's true foreboding!
These are the opening words of the sequence in the Mass for the Dead in the Western Church. This translation is from *The Missal in Latin and English Being the Text of the Missale Romanum*, London, Burns Oates and Washbourne, 1950. The usual attribution of authorship to Thomas of Celano is now doubted and the poem credited to an unknown thirteenth-century Franciscan. See F.J.E. Raby, *A History of Christian Latin Poetry from the Beginnings to the Close of the Middle Ages*, 2nd ed., London, 1953, pp. 443-50, and p. 485. Cf. F.J.E. Raby, *The Oxford Book of Medieval Latin Verse*, Oxford, 1959, pp. 392, 498, n. 259.

22 The figure of the sibyl is carved inside the cathedral on the choir screen, in accordance with Burgundian usage.

23 A plaster cast is in the Trocadéro (Paris, Musée des monuments français, no. 120). The head is missing. In her hand she holds tablets resembling the Tables of the Law.

24 Bouxin, *La Cathédrale Notre-Dame de Laon*, p. 72.

25 Consistory hall. [See E. Castelnuovo, *Un pittore italiano alla corte di Avignone; Matteo Giovannetti e la pittura in Provenza nel secolo XIV*, Turin, 1962, pp. 110-120, fig. 101.]

26 See above, Book IV, Chapter I (The Old Testament), p. 167.

27 Didron, *Manuel d'iconographie chrétienne*, p. 150.

28 In a Latin thesis (E. Mâle, *Quomodo Sibyllas recentiores artifices repraesentaverint*, Paris, 1899), I have demonstrated that medieval Italy also knew, besides the Erythraean Sibyl, the Tiburtine Sibyl who was made famous by the legend of the *Ara coeli*. She was said to have shown the Virgin and Child to the emperor Augustus. The legend was local to Rome, but the rest of Christendom knew it also. Consequently, it is not surprising to find the two sibyls at Soissons, in the Tree of Jesse window (upper windows of the choir, thirteenth century). *Sibylla* is written beside each. However, we see at once that the second sibyl was placed there to balance the other. The Tree of Jesse has two perfectly symmetrical main branches; a king corresponds to a king, a

prophet to a prophet, and thus the composition required another sibyl. [L. Grodecki, "Un vitrail démembré de la cathédrale de Soissons," *Gazette des beaux-arts*, 6th ser., 42 (1953), pp. 169-176.] I noted the same detail at Notre-Dame of Paris. The archivolt of the left portal (west façade) also forms a Tree of Jesse. The first band is devoted to the prophets, and the second to the kings of Judah. Now among the kings of Judah, two crowned women are paired and seem to be sibyls, as at Soissons. The names, once written on phylacteries, have disappeared.

29 Chrestien Legouais de Saint-More (near Troyes), *Le Roman des fables d'Ovides le Grand* (Paris, Bibl. de l'Arsenal, ms. 5069), early fourteenth century. The translation and commentary are in French verse. The Bibliothèque Nationale has six manuscripts of Legouais: Paris, Bibl. Nat., mss. fr. 373, 374, 870, 871, 872, 24306. On Legouais, see G. Paris, "Chrétien Legouais et autres traducteurs ou imitateurs d'Ovide," *Histoire littéraire de la France*, 29 (1885), pp. 455-525. [See F. Munari, *Ovid im Mittelalter*, Zurich, 1960, and S. Viarre, *La Survie d'Ovide dans la littérature scientifique des XIIe et XIIIe siècles*, Poitiers, 1966.]

30 Paris, Bibl. de l'Arsenal, ms. 5069, fol. 21.

31 *Ibid.*, fol. 27.

32 *Ibid.*, fol. 111.

33 *Ibid.*, fol. 177.

34 Jubé from Limoges (cast at Trocadéro, Paris, Musée des monuments français). Piper pointed out some of these correspondences in his *Mythologie und Symbolik der christlichen Kunst von der altesten Zeit bis ins sechzehnte Jahrhundert*, vol. I, Weimar, 1847, pp. 91, 143-157. [See A. Cloulas-Brousseau, "Le Jubé de la cathédrale de Limoges," *Bulletin de la Société archéologique et historique du Limousin*, 90 (1963), pp. 101-188.]

35 Pilasters of the tomb of Philippe de Commines (Ecole des Beaux-Arts).

36 In the famous painting attributed to Jean Cousin: *Eva prima Pandora*. [See now, D. and E. Panofsky, *Pandora's Box; The Changing Aspects of a Mythical Symbol*, New York, 1956 (2nd ed. rev., Princeton, 1962; pb., 1978); A. Chastel, *Art et humanisme à Florence au temps de Laurent le Magnifique. Etude sur la Renaissance et l'humanisme platonicien*, Paris, 1959.]

37 Prologue to *Gargantua*. [*All the Extant Works of François Rabelais*, tr. S. Putnam, vol. I, New York, 1929, p. 18.] Friar Wolf is the English Dominican Thomas Walleys, author of a book entitled, *Metamorphosis ovidiana moraliter*, Paris, 1515. Such a book is completely within the medieval tradition.

38 Cerf, *Reims*, II, p. 290.

39 These statues, misunderstood until now, have been correctly explained for the first time by Cerf, *ibid.*, pp. 160ff.

40 See Bréhier, *La Cathédrale de Reims*, pp. 127-128.

41 We know that the windows of the north aisle at Strasbourg represent German emperors.

42 See above, p. 173.

43 B. Montfaucon, *Monumens de la monarchie française*, vol. I, Paris, 1729, pp. 51-56. Montfaucon, of course, was deceived by inscriptions that had been painted on the phylacteries of the kings, probably in the seventeenth century. He had read "Chlodomirus" in Roman and "Chlo(tari)us." Before him, Ruinart had pointed out the same names, and said: *Quas quidem litteras, etsi forte primariis substitutae videantur, antiquissimas tamen esse ipsa characterum forma et viridis color fere penitus detritus probant* (Although these letters perhaps seem substitutes for the original, nevertheless the very form of the characers and the green color, almost completely rubbed away, prove that they are very old). T. Ruinart, *Sancti Gregori Turonensis opera omnia*, Paris, 1699, col. 1371. Ruinart was not wrong in thinking that these inscriptions had been substituted for others. At the cathedral of Le Mans, where one of the old inscriptions was found beneath a coat of paint in 1841, "Salomo" was written on one of the phylacteries of a king. [See J. Vanuxem, "The Theories of Mabillon and Montfaucon on French Sculpture of the Twelfth Century," *Journal of the Warburg and Courtault Institutes*, 20 (1957), pp. 45-58.]

44 The statue is of David.

45 Montfaucon, *Monumens de la monarchie française*, vol. I, pls. VIII, IX, XV and XVI.

46 On the subject, Mâle, *Religious Art in France: The Twelfth Century*, chap. XI, pp. 391ff.

47 To study the statues of St.-Germain-des-Prés and of Notre-Dame of Paris, we are obliged to refer to the poor drawings of Montfaucon and Ruinart. [Montfaucon's drawings made possible the identification of one of the two fragmentary statue columns from the St. Anne Portal of Notre-Dame of Paris, now in the Cluny Museum. See the catalogue of the exhibition at the Louvre, by M. Aubert and others, *Cathédrales, sculptures, vitraux, objets d'art, manuscrits des XIIe et XIIIe siècles*, Paris, 1962, p. 31 and figs. 10, 11.]

48 Bulteau, *Monographie de Chartres*, II, pp. 65-67. [The puzzling figures which the eighteenth century identified as "Berthe aux grands pieds," have been explained by P. Quarré, "Moyen Age. Eglise Saint-Bénigne. Le Thème de la reine pedauque aux portails du XIIe siècle," *Mémoires de la Commission des antiquités de la Côte-d'Or*, 25 (1959-1962), pp. 56-58.]

49 Bulteau, *Monographie de Chartres*, II, pp. 194, 197, 201-202.

50 The supposed statues of Philip Augustus and Richard the Lion Hearted disappeared during the Revolution. Bulteau's description was based on the manuscript (now in Bibl. de Chartres, ms. 1099) that Brillon prepared for Montfaucon.

51 One of them seems to be carrying a cross, and in fact, David foretold the Passion. The statues supposedly of the Count of Boulogne and Mahaut (fig. 223) could very well be David's father, Jesse, and his wife. Jesse is represented in a relief on the socle and is named YSHI by an inscription.

52 It was thought that St. Louis, his mother Blanche of Castile, and his wife Marguerite of Provence were shown at the feet of the Virgin and St. Peter in a window of the church of Moulineaux, near Rouen. This is an error. The crowns worn by the figures are modern. J. Lafond, *Journal de Rouen*, March 30, 1919.

53 See L. Courajod and P.-F. Marcou, *Musée de sculpture comparée (moulages). Palais du Trocadéro. Catalogue raisonée*, Paris, 1892, pp. 46ff.

54 The exceptions are very rare. However, here is curious evidence of one, recently discovered. Before 1793, there was a large statue of a king (restored) on the left portal of the façade of Notre-Dame of Paris. Lebeuf, *Histoire de la ville et de tout le diocèse de Paris*, I, p. 9, mentions this king, but does not call him by name. In 1884, Delaborde published a document dating from 1410 which relates to this statue: H. F. Delaborde, "Le procès du chef de Saint Denis en 1410," *Mémoire de la Société de l'histoire de Paris et de l'Ile de France*, 11 (1884), p. 363. It has to do with a "procès du chef de saint Denys" and says: ". . . il appert par le portail senestre de l'église de Paris, vers Saint Jehan le Rond, ou quel, en grans et anciens ymages de pierre eslevez, est l'ymage du roy Philippe le Conquérant, figuré en jeune aage, pour ce qu'il fut couronné au xiiije an de son aage; lequel monstre l'imaige de Monsiegneur saint Denis portant son chef demi tranchié, et aussi les ymages de Notre-Dame, de saint Estienne, de saint Jehan Baptiste, etc., en démontrant que les reliques dessus dictes qu'il avoit données à la dicte église de Paris estoient des sains dont il morte les ymages." (There is to be seen on the left portal of the church of Paris, on the side toward St.-Jean-le-Rond, among large and ancient stone images, the image of the King Philip the Conqueror as a young man, because he was crowned when he was thirteen years old; there is also the image of Monseigneur St. Denis carrying his half-severed head, and also, the images of Notre-Dame, St. Stephen, St. John the Baptist, demonstrating that the relics mentioned above, which he had given to the said church of Paris, were those of the saints whose images are shown.) Thus, the statue at Notre-Dame of Paris would be that of Philip-Augustus, and would have been erected in his lifetime. Such evidence must be treated with caution. In the fifteenth century, the traditions of great religious art were beginning to be forgotten; it was perfectly possible to be mistaken about a work of the thirteenth century. [On the identification of the statue as Philip Augustus, see W. Hinkle, "The King and the Pope on the Virgin Portal of Notre-Dame," *Art Bulletin*, 48 (1966), pp. 1-13. On *regnum* and *sacerdotium*, see *idem*, *The Portal of the Saints of Reims Cathedral*, pp. 28-43, and Katzenellenbogen, *Sculptural Programs of Chartres*, pp. 35ff.] Let us point out, however, that there indeed seem to be three historical figures represented in the upper windows of the apse of the cathedral of Troyes. One is

an unknown emperor (*IMPERATOR*, the inscription says), another is a king (R)*EX PHILIPP.* (no doubt Philippus), which could be Philip Augustus; the third is a bishop (Eps. Herve), no doubt bishop Herve, who died in 1223. Lastly, it is thought that Pope Clement V (Bertrand de Goth, once archbishop of Bordeaux) is represented on the trumeau of the north portal of the cathedral of Bordeaux. But the head is a restoration.

55 *Speculum historiale*, xxi, iv-xxxiv, *passim*; xxiv, i-l, *passim*; xxv, xcvii-ciii. [Graz ed., iv, 819-829; 962-979; 1036-1038.]

56 The Charlemagne window has been published by the authors of the great monograph on Notre-Dame of Chartres: Delaporte and Houvet, *Vitraux de Chartres*, i, 313-319; ii, pls. civ-cx, and by A. N. Didron, "Mélanges et nouvelles: Charlemagne et Roland," *Annales archéologiques*, 24 (1864), pp. 349-351. E. Lévy and J.-B. Capronnier, *Histoire de la peinture sur verre*, Brussels, 1860, pl. x, reproduced the panel showing Constantine's dream. Lasteyrie described the window at Chartres in his *Histoire de la peinture sur verre*, pp. 76-77; he thought it was the history of Charles the Bald. Bulteau, *Description de la cathédrale de Chartres*, p. 237, however, recognized Charlemagne, but he made several mistakes. P. Durand, *Monographie de la cathédrale de Chartres. Explication des planches*, Paris, 1881, pp. 162-165, is more accurate, but he also was mistaken on certain points. [See also E. G. Grimme, "Das Karlsfenster in der Kathedrale von Chartres," *Aachener Kunstblätter*, 20 (1960-1961), pp. 11-24, and R. Lejeune and J. Stiennon, *La Légende de Roland dans l'art du moyen âge*, Brussels, 1966, pp. 192-199.]

57 G. Paris, *Histoire poétique de Charlemagne*, Paris, 1865, p. 55. J. Coulet, *Etudes sur l'ancien poème français du voyage de Charlemagne en orient*, Montpellier, 1907, showed that the legend of a journey by Charlemagne to the Holy Land appeared for the first time in the tenth century, in a work by Benoît, a monk of Mt. Soracte. But Bédier, *Légendes épiques*, iv, pp. 122-137, has shown that the legend as we know it came from St.-Denis.

58 On the *Chronique de Turpin*, see *ibid.*, iii. pp. 68-75.

59 Charlemagne was canonized on 28 December 1164. On the Aix-la-Chapelle compilation, see Paris, *Histoire poétique*, p. 63. [On the cult of Charlemagne and his posthumous reputation generally, see W. Braunfels, ed., *Karl der Grosse*, iv, *Das Nachleben*, Düsseldorf, 1967, and H. Hoffmann, *Karl der Grosse im Bilder der Geschichtschreibung des fruhen Mittelalters, 800-1250*, Berlin, 1919.]

60 Paris, Bibl. Nat., mss. lat. 4895 A and 6187.

61 For reproductions of certain of the scenes decorating the reliquary of Aix-la-Chapelle, see E. Müntz, *Etudes iconographiques et archéologiques sur le moyen âge*, Paris, 1887, pp. 85ff. ("La légende de Charlemagne dans l'art"). [On the shrine of Charlemagne, see now E. G. Grimme, *Aachener Goldschmiedekunst im Mittelalters von Karl dem Grossen bis zu Karl V*, Cologne, 1957, pp. 38-48; pls. 8-14.]

62 The lower panel tells us that the window was given by the furriers' guild.

63 Paris, Bibl. Nat., ms. lat. 6187, fols. 16ff. The text of the *Voyage en Orient* is also given in Vincent of Beauvais, *Speculum historiale*, xxiv, iv-v. [Graz ed., iv. 963-964.]

64 Paris, Bibl. Nat., ms. lat. 6187, fols. 53ff., and Vincent of Beauvais, *Speculum historiale*, xxiv, vi-xxi. [Graz ed., iv. 964-970.]

65 See *Acta sanctorum*, September, i, pp. 302-303, and Vincent of Beauvais, *Speculum historiale*, xxiii, cxl. [Graz ed. iv. 948.] The Latin legend speaks, not of Charlemagne, but of a king called Carolus, who is perhaps Charles Martel. Very early, however, Charlemagne became the hero of the legend in popular poetry. People therefore wanted to know what sin Charlemagne had committed and imagined that he had had incestuous intercourse with his sister; see Paris, *Histoire poétique*, p. 378, and the Introduction to Guillaume de Berneville, *La Vie de Saint Gilles par Guillaume de Berneville: poème du XIIe siècle*, ed. G. Paris (Société des anciens textes français), Paris, 1881.

66 *Crimen mortale convertitur in veniale*
 Egidio Karolum crimen pudet edeire
 (sic) solum,
 Illud enim tanti gravat Egidio celebranti
 Angelus occultum perhibet reseratque
 sepultum.
 (A mortal sin is transformed into a
 venial one,
 The one sin which Charlemagne is
 ashamed to tell Gilles,

So heavily does it weigh upon him.
While Gilles celebrates Mass,
An angel reveals the secret and
uncovers what had been buried.)
[The inscription in its abbreviated Latin form is legible in H. Schnitzler, *Rheinische Schatzkammer*, II. *Die Romanik*, Düsseldorf, 1959, pl. 41.]

67 Cahier, *Caractéristiques des saints*, II, p. 778 n. 9. The Pseudo-Turpin places Roland among the elect. When dying, the warrior cried out that he already saw paradise: *Iam Christo donante intueor, quod oculus non vidit, nec auris audivit, . . . quod praeparavit Deus diligentibus se* (Now, thanks to Christ, I behold what no eye has seen, no ear heard, what God has held in store for those cherishing Him). [*Speculum historiale*, XXIV, xix; Graz ed., IV. 969.]

68 Codex of Compostela, bk IV, viii; [Vielliard, *Guide de pèlerin*, pp. 78-79], and Bonnault d'Houet, *Pèlerinage d'un paysan picard*, p. 192.

69 It is probable that there was another window showing the history of Charlemagne at St.-Denis, if we are to judge by the fragments published by Montfaucon, *Monumens de la monarchie françoise*, I, pl. XXV. As at Chartres, there are the messengers of Constantine arriving before Charlemagne (*nuncii Constantini ad Carolum Parisiis*) and the meeting between Charlemagne and Constantine at the gates of Constantinople. The scepter of Charles V, in the Louvre, should also be pointed out; it shows St. James appearing to Charlemagne, the miracle of the flowering lances, and the death of Charlemagne. A. Darcel, *Notice des emaux et de l'orfèvrerie* (Musée National du Louvre, Département de la sculpture du moyen âge et de la renaissance et des temps modernes, série D), Paris, 1867; E. Molinier, *Supplément au catalogue du M. Darcel*, Paris, 1891, p. 570.

70 The combat between Robert Courte-Heuse and the Emir Corbaran is, in fact, a creation of popular epic poetry and is found in the Chanson d'Antioche. See G. Paris, "Robert Courte-heuse à la première croisade," *Académie des inscriptions et belles-lettres, comptes rendus*, 4th ser., 18 (1890), pp. 207-212. See also F. de Mely, "La croix des premiers croisés," *Revue de l'art chrétien*, 33 (1890), p. 300 n. 3.

71 Each town is named: *Nicena civitas, Antiochia, Irem* (Jerusalem).

72 Montfaucon, *Monumens de la monarchie françoise*, I, pl. L.

73 On the subject of this window, see Lasteyrie, *Histoire de la peinture sur verre*, p. 159, and Guilhermy, *Description de la Sainte-Chapelle*, p. 60. The window is the first on the right as you enter: only nineteen panels are old: the entire story of the discovery of the True Cross is modern. [Cf. Aubert, *Vitraux de Notre-Dame et de la Sainte Chapelle de Paris*, pp. 295-309.]

74 Montfaucon, *Monumens de la monarchie françoise*, II, p. 156.

75 *Ibid.*, pl. XX.

76 They date from the fourteenth century. A manuscript from Peiresc, now at Carpentras, has preserved several drawings of them. St. Louis appears with nimbus. See A. H. Longnon, *Documents parisiens sur l'iconographie de Saint Louis*, Paris, 1882, pp. 14-15, pl. I. I have discussed these frescoes in E. Mâle, "La Vie de Saint Louis racontée par les peintres du XIVe siècle," *Art et artistes du moyen âge*, pp. 246-262.

77 A priori, we should be on guard against interpreters (however ingenious they may be) who claim to find thirteenth-century historical episodes in cathedrals. For my part, I am not inclined to accept the claim of F. de Verneil, "Les bas-reliefs de l'Université à Notre-Dame de Paris," *Annales archéologiques*, 26 (1869), pp. 96-106, that the famous reliefs on the south portal of Notre-Dame of Paris (fig. 227) represent an episode in the history of the university. So insignificant a subject as student battles scarcely merits so honorable a place, even if we suppose that the bishop, the head of the university, wished to recall in this way the supreme authority invested in him. The supposed revolts of the students, their expulsions, and punishments are perhaps episodes in the life of a saint whom no one has been able to identify. [Cf. Kraus, *The Living Theater of Medieval Art*, pp. 3-21, and M. Aubert, *La Cathédrale de Notre-Dame de Paris; Notice historique et archéologique*, Paris, 1945, pp. 148-149.] I have the same reservation about the figures of emperors, kings, and barons that are pointed out in foreign cathedrals. The equestrian statue in the cathedral of Bamberg,

called the statue of Conrad IV, was still called St. Stephen of Hungary in the last century. And that is its true name. See A. Weese, *Die Bamberger Domskulpturen, ein Beitrag zur Geschichte der deutschen Plastik des XIII. Jahrhunderts,* Strasbourg, 1897, p. 126. [Cf. H. von Einem, "Fragen um den Bamberger Reiter," *Studien zur Geschichte der Europäischen Plastik. Festschrift Theodor Müller,* Munich, 1965, pp. 55-62.

BOOK IV, CHAPTER VI

1 Vincent of Beauvais, *Speculum historiale, Epilogus,* cviii. [Graz ed., IV. 1324.] On the awaiting of the end of the world in the Middle Ages, see E. Wadstein, *Die eschatologische Ideengruppe, Antichrist-Weltsabbat-Weltende-Weltgericht,* Leipzig, 1896. [On the work of Joachim of Fiore, see also L. Tondelli, *Il libro delle figure dell'abate Gioachino da Fiore,* 2 vols., 2nd ed., Turin, 1953, and H. Grundmann, *Studien über Joachim von Floris,* Leipzig, 1927 pp. 56-115.]

2 Vincent of Beauvais, *Speculum historiale, Epilogus,* cviii. [Graz ed., IV. 132. On Hildegarde of Bingen, see H. Liebeschütz, *Das Allegorische Weltbild der Heiligen Hildegard von Bingen,* Berlin, 1930, pp. 136-155.]

3 Vincent of Beauvais, *Speculum historiale, Epilogus,* cvii. [Graz ed., IV. 1324.]

4 New calculations made during the course of the thirteenth century placed the end of the world in the year 1300. F. Lajard, "Jean de Paris, Dominicain," *Histoire littéraire de la France,* 25 (1869), p. 258.

5 [On the Last Judgment in art and its sources, see B. Brenk, *Tradition und Neuerung in der christlichen Kunst des ersten Jahrtausends. Studien zur Geschichte des Weltgerichtsbildes.* Vienna, 1966; and W. Sauerländer, "Uber die Komposition des Weltgerichts-Tympanons in Autun," *Zeitschrift für Kunstgeschichte,* 29 (1966), pp. 261-294.]

6 Revelation 4:3-6.

7 T. von Frimmel, *Die Apokalypse in der Bilderhandschriften des Mittelalters,* Vienna, 1885, pointed out the existence of a third school represented by the Apocalypses of Trier and Bamberg. More recently, Petit attempted to constitute another group of

Apocalypses, which he called the Flemish group (Apocalypses of Valenciennes, Cambrai, Namur, and the Escorial). See M. Petit, "Less apocalypses manuscrites du moyen âge, et les tapisseries de la cathédrale d'Angers," *Le Moyen Age,* 9 (1896), pp. 49-62. The question is far from having been thoroughly explored. The two groups we have mentioned (Spanish and Anglo-Norman), which have long been studied, are beginning to be fairly well known. [For the Spanish series, see W. Neuss, *Die Apokalypse des hl. Johannes in der altspanischen und altchristlichen Bibelillustration,* 2 vols., Münster-in-Westphalia, 1931. On the Carolingian group represented by the Apocalypses of Trier, Valenciennes, Cambrai, and Paris, Bibl. Nat., ms. nouv. acq. lat. 1132, see Neuss, *ibid.,* pp. 248ff., and the catalogue of the exhibition of the Bibliothèque Nationale, *Les Manuscrits à peintures en France du VIIe au XIIe siècle,* Paris, 1954, p. 41, nos. 96, 97, 98. See also H. Wölfflin, *Die Bamberger Apokalypse,* 2nd ed., Munich, 1921. For the Anglo-Norman group and the typology of Apocalypse illustrations generally, see M. R. James, *The Apocalypse in Art,* London and Oxford, 1931.]

8 L. Delisle, *Mélanges de paléographie et de bibliographie,* Paris, 1880, pp. 117-1148.

9 Paris, Bibl. Nat., ms. lat. 8878 (eleventh century). [See now the facsimile reproductions in E. A. van Moé, *L'Apocalypse de Saint-Sever manuscrit latin 8878 de la Bibliothèque nationale (XIe siècle),* Paris, 1943.] In Mâle, *Religious Art in France: The Twelfth Century,* chap. I, I have discussed the profound influence of the St.-Sever manuscript on art. [Cf. M. Schapiro, "Two Romanesque Drawings in Auxerre and Some Iconographic Problems" *Studies in Art and Literature for Belle da Costa Greene,* Princeton, 1954, pp. 331-349.]

10 Paris, Bibl. Nat., ms. lat. 8878, fol. 141. [Moé, *Apocalypse de Saint-Sever,* pl. 16.]

11 *Ibid.,* fol. 202. [*Ibid.,* pl. 24.]

12 Revelation 6:1-2.

13 Paris, Bibl. Nat., ms. lat. 8878, fol. 109; each of the apocalyptic beasts in turn takes St. John by the hand. [Moé, *Apocalypse de Saint-Sever,* pl. 8.]

14 On this subject, see Paris, *Les Manuscrits*

françois de la Bibliothèque du roi, vol. III, pp. 371-379; A. F. Didot, *Des Apocalypses figurées, manuscrites et xylographiques* (2nd app. to *Catalogue raisonné des livres de la bibliothèque de M. Ambroise Firmin Didot*), Paris, 1870, p. 28; Berger, *La Bible française au moyen âge,* pp. 78-79, and app.; Delisle, "Livre d'images," p. 284; and especially, Delisle's preface to L. Delisle and P. Meyer, *L'Apocalypse en français au XIIIe siècle (Bibl. Nat. fr. 403)* (Société des anciens textes français), Paris, 1901, pp. I-CXCVII [repr. ed., New York, 1965].

15 Paris, Bibl. Nat., ms. fr. 403.

16 Some of the manuscripts in the Bibliothèque Nationale deriving from ms. fr. 403 are: Paris, Bibl. Nat., mss. lat. 688, 14410, 10474 and mss. fr. 375, 13096, 9574. Even the mediocre Paris, Bibl. Nat., ms. fr. 1768 is related: St. John looks at the scene of the Apocalypse from a kind of chapel, as in ms. fr. 403; in Paris, Bibl. de l'Arsenal, ms. 5214.

17 See the proof in Didot, *Apocalypses figurées.* [See also G. Bing, "The Apocalypse Block-Books and their Manuscript Models," *Journal of the Warburg and Courtauld Institutes,* 5 (1942), pp. 143-158.]

18 The Spanish monks had imagined a kind of Japanese monster with only one head and several horns: Paris, Bibl. Nat., ms. lat. 8878, fols. 51 and 52v. [Moé, *Apocalypse de Saint-Sever,* pl. 6.]

19 Paris, Bibl. Nat., ms. fr. 403, fol. 19. [Delisle and Meyer, *L'Apocalypse en français au XIIIe siècle,* fol. 19.]

20 *Ibid.,* fol. 6.

21 See P. Mérimée, *Notice sur les peintures de Saint-Savin,* Paris, 1845, Atlas, pl. III. [See also I. Yoshikawa, *L'Apocalypse de Saint-Savin,* Paris, 1939.]

22 [Cf. R. Freyhan, "Joachism and the English Apocalypse," *Journal of the Warburg and Courtauld Institutes,* 18 (1955), pp. 211-244, who see a relationship between the archetypal manuscript of the group, New York, Morgan Library, M. 524, and the *Liber Floridus,* dated 1120 and written by Lambert of St.-Omer, *ibid.,* p. 218. A facsimile of this manuscript has been reproduced in *Liber Floridus, Codex Autographus 92 Bibliothecae Universitatis Gandanensis,* ed. A. Derolez, Ghent, 1967.]

23 See L. de Farcy, *Histoire et description des tapisseries de la cathédral d'Angers,* Lille, 1889 (with plates). The tapestries were given to the cathedral in 1480 by King René. [See also R. Planchenault, *L'Apocalypse d'Angers,* Paris, 1966.]

24 See A. Giry, "Cinquième exposition de l'union centrale des beaux-arts appliqués à l'industrie. La tapisserie de l'Apocalypse de Saint-Maurice d'Angers," *L'Art,* 4 (1876), pp. 301-307.

25 Petit, "Les Apocalypses manuscrites du moyen âge et les tapisseries de la cathédrale d'Angers," pp. 49-62.

26 Delisle, preface to *L'Apocalypse en français au XIIIe siècle,* pp. CLXXVI-CXCI.

27 West façade, south side. [Vitry, *Cathédrale de Reims,* I, pls. VI, LXXXII.]

28 West façade, right portal. [*Ibid.,* I, pl. LXXVII; Sauerländer, *Gothic Sculpture in France,* pls. 223-225.]

29 In this connection, it should be said that the presence of the statue of St. John the Evangelist on the portal of the façade at Reims is explained by the fact that the Apocalypse was represented on that façade. Not far from the statue of St. John is the statue of St. Helena, because the story of the discovery of the True Cross had been carved on the neighboring buttress. St. Helena, moreover, had been adopted by Champagne because the Abbey of Hautvillers claimed to possess her body. I have discussed this more fully in Mâle, "La Cathédrale de Reims," p. 73 and *idem,* "Nouvelle étude sur la cathédrale de Reims," *Art et artistes du moyen âge,* pp. 237-238. [See also Reinhardt, *Reims,* pp. 169-170.]

30 Interior portal (archivolts); Paris, Bibl. Nat., ms. fr. 403, fol. 19v. [Delisle and Meyer, *L'Apocalypse en français au XIIIe siècle,* fol. 19v.]

31 Exterior portal; ms. fr. 403, fol. 36v. [*Ibid.,* fol. 36v.]

32 Interior portal; ms. fr. 403, fol. 10v. [*Ibid.,* fol. 10v.]

33 Exterior portal; ms. fr. 403, fol. 37. [*Ibid.,* fol. 37.]

34 See Didot, *Apocalypses figurées.*

35 The manuscript contains other miracles (for example, the pebbles changed into gold).

36 Delisle has shown that the woodcut Apocalypses of the fifteenth century were copied from manuscripts of the first Anglo-Norman family, of which Paris, Bibl. Nat., ms. fr. 403 is the most notable example. It also seemed to Delisle that the fifteenth-century artist had copied not ms. fr. 403 itself, but an Apocalypse similar to those preserved in the Bodleian Library, Oxford, and belonging to the same family. [Delisle, *L'Apocalypse en français au XIIIe siècle*, p. cxcv.]

37 On Dürer's Apocalypse and its influence, see Mâle, *L'Art religieux de la fin du moyen âge*, 2nd ed., pp. 443ff. [See also E. Panofsky, *Albrecht Dürer*, Princeton, 1943, I, pp. 51-59; II, pp. 36-37.]

38 Cahier and Martin, *Bourges*, pl. VIII and pp. 220ff.

39 Revelation 4:6.

40 Anselm of Laon, *Enarrationes in Apocalypsin*, iv, Migne, *P. L.*, 162, col. 1517.

41 *Idem*, iv, *ibid.*, col. 1518.

42 *Idem, ibid.*, cols. 1518-1519. Here Anselm of Laon made the calculation that we have already mentioned. Twenty-four, he said, is composed of two times twelve. Now twelve is obtained by multiplying three, the number of the Trinity, by four, the number of Earth. Thus, the numbers twelve and twenty-four symbolize the Church announcing the Truth to the world.

43 *Idem*, xix, Migne, *P. L.*, 162, cols. 1568-1572.

44 Matthew 24:25.

45 I Corinthians 15:52. ". . . in a moment, in the twinkling of an eye, at the last trumpet. For the trumpet will sound, and the dead will be raised imperishable, and we shall be changed."

46 I have made a study of these capitals: E. Mâle, "Les Chapiteaux romans du musée de Toulouse et l'école toulousaine du XIIe siècle," *Revue archéologique*, 3rd ser., 20 (1892), pp. 28-35; 176-197. It is the gesture of Christ showing his wounds that is particular to southern art. [P. Mesplé, *Toulouse, Musée des Augustins, Les Sculptures romanes*, Paris, 1961, no. 119.]

47 On this transmission, see Mâle, *Religious Art in France: The Twelfth Century*, chap. v, pp. 176ff. and chap. IX, p. 409. [See also

Crosby, *L'Abbaye royale de Saint-Denis*, pp. 36-37.]

48 Honorius of Autun, *Elucidarium sive Dialogus de summa totius christianae theologiae*, Migne, *P. L.*, 172, cols. 1109-1176.

49 The *Elucidarium*, as the preface proves, is a youthful work which must have been written about 1100. [See also J. A. Endres, *Honorius Augustodunensis, Beitrag zur Geschichte des geistigen Lebens im 12. Jahrhundert*, Kempten and Munich, 1906, pp. 22-26.]

50 "Honoré, prestre et scholastique de l'église d'Autun, ensuite solitaire," *Histoire littéraire de la France*, 12 (1763), pp. 167-169. The *Elucidarium* of Honorius of Autun was translated into French under the title of *Lucidaire* (Paris, Bibl. de l'Arsenal, ms. 3516, fol. 144). See P. Meyer, "Notice sur le manuscrit II. 6. 24 de la bibliothèque de l'Université de Cambridge, vi, Le *Lucidaire* traduit par Gillebert de Cambres," *Notices et extraits des manuscrits de la Bibliothèque nationale et autres bibliothèques*, 32 (1888), pp. 72-81.

51 *Speculum historiale, Epilogus*, cvi-cxxix. [Graz ed., IV. 1323-1332.] The Last Judgment is also set forth in the *Speculum morale*, II, pt. II. [Graz ed., III. 757-809.]

52 St. Thomas, *Summa theologica*, Supplement to pt. 3 (Antwerp ed., 1612, vol. XIII, pp. 164ff.). [Ottawa ed., v. 335a-513b.]

53 *Legenda aurea*, i, *De adventu domini*. [Ed. Roze, 1902, I, pp. 7-18; 1967, I, pp. 30-37; tr. Caxton, I, pp. 12-25.]

54 *Speculum historiale, Epilogus*, cxi [Graz ed., IV. 1325-1326], and *Legenda aurea*, i [see above, n. 53]. The fifteen premonitory signs of the end of the world (overflowing of the seas, earthquakes, etc.) were not given plastic form until the fifteenth century (woodcuts in Books of Hours). See Mâle, *L'Art religieux de la fin du moyen âge*, 2nd ed., p. 440.

55 The statuettes in the archivolts were reproduced at Amiens, but are much less beautiful.

56 Honorius of Autun, *Elucidarium*, xi and xii, Migne, *P. L.*, 172, cols. 1164-1165. The idea that the dead would be resurrected and triumph over death at the very same hour that Christ had triumphed over death

for all mankind is one of those parallels so often created by the medieval mind.

57 Matthew 24:30.

58 Vincent of Beauvais, *Speculum historiale, Epilogus*, cxii. [Graz ed. IV. 1326.]

59 *Legenda aurea*, i. [Ed. Roze, 1902, I, pp. 13-14; 1967, I, pp. 34-35; tr. Caxton, I, p. 20.]

60 St. Thomas, *Summa theologica*, Supplement to pt. 3, *Quaestiones* xc, art. II. [Ottawa ed., v. 4-34a.]

61 The metaphor seems to have come from St. John Chrysostom. It was used by Honorius of Autun, *Elucidarium*, III, xii, Migne, *P. L.*, 172, col. 1165; Vincent of Beauvais, *Speculum historiale, Epilogus*, cxii. [Graz ed., IV. 1326]; and *Legenda aurea*, i. [See above, n. 59. See also R. Berliner, "Arma Christi," *Münchner Jahrbuch fur bildenden Kunst*, 3rd ser., 6 (1955), pp. 35-152.]

62 *Elucidarium*, III, xiii, Migne, *P. L.*, 172, col. 172; *Legenda aurea*, i. [Ed. Roze, 1902, I, pp. 13-14; 1967, I, p. 34; tr. Caxton, I, p. 20.] *Speculum historiale, Epilogus*, cxii. [Graz ed., IV. 1326.]

63 Cathedral, Royal Portal.

64 *Elucidarium*, III, xii, Migne, *P. L.*, 172, col. 1164.

65 In Italy, John the Evangelist was replaced by John the Baptist at Christ's side. Here we recognize the influence of Byzantine art, which for a long time had represented the Virgin and John the Baptist interceding with Christ; the Greeks called this the Prayer, *Deesis*. In France, the Last Judgment of Reims (north portal) also has the Precursor in the place of the apostle.

66 At Burgos (north portal), the Virgin and John, placed at the right and left of Christ, are not kneeling. They stand, but they bow their heads. [See F. B. Deknatel, "The Thirteenth-Century Gothic Sculpture of the Cathedrals of Burgos and León," *Art Bulletin*, 17 (1935), pp. 243-289.]

67 At St.-Sulpice-de-Favières, the Parisian arrangement is used, but Christ is standing instead of being seated, and—unique exception—instead of showing his wounds, he shows the chalice which he holds in his left hand. The idea of sacrifice and redemption is clearly expressed, but not in a traditional way.

68 At Bourges, the figures are disposed as at Paris, but they have canopies above their heads, as at Amiens.

69 At St.-Seurin, the Parisian arrangement is imitated exactly; at the cathedral, the central group is conceived as at Notre-Dame of Paris, but the rest of the composition differs from the prototype. The same is true at Dax. [Sauerländer, *Gothic Sculpture in France*, pls. 308-309.]

70 At Ferrara, the general disposition is the same as at Paris, but two details are Italian: John the Evangelist is replaced by John the Baptist, and Christ lowers his arms instead of raising them. [*La Cattedrale di Ferrara, 1135-1935*, Verona, 1935, pl. xxxii.]

71 Matthew 24:31: *Mittet angelos suos cum tuba* (. . . and he will send out his angels with a loud trumpet call. . . . And Paul, I Corinthians 15:52: *Canet enim tuba et mortui resurgent* (For the trumpet will sound, and the dead will be raised).

72 At Reims and at Bourges. At Reims, the pagans issue from their cinerary urns. [Aubert, *La Sculpture française au moyen âge*, illus. pp. 257-259; 282-283.]

73 This is the expression, taken from Paul, that is used by Honorius of Autun and Vincent of Beauvais. [I Corinthians 15:52: "in the twinkling of an eye."]

74 At St.-Urbain of Troyes, however (late thirteenth-century Last Judgment, cast at the Trocadéro), there are two skulls.

75 Honorius of Autun, *Elucidarium*, III, xi, Migne, *P. L.*, 172, col. 1165; and Vincent of Beauvais, *Speculum historiale, Epilogus*, cxiii. [Graz ed., IV. 1326.] The Last Judgment at Notre-Dame of Paris has two resurrected dead that are clothed. But all that part of the tympanum has been restored in our time. Nevertheless, certain figures of the original tympanum (Paris, Musée de Cluny) are clothed. This an execption.

76 Vincent of Beauvais, *loc. cit.*

77 Vincent of Beauvais, *loc. cit.*; Honorius of Autun, *Elucidarium*, III, xi, Migne, *P. L.*, 172, col. 1164. Honorius of Autun states the same doctrine in his *De adventu domini, Speculum ecclesiae*, Migne, *P. L.*, 172, col. 1186: *Resurgent autem omnes mortui ea aetate et mensura qua Christus resurrexit, scilicet XXX annorum, tam in-*

fans unius noctis qual aliquis nongentorum annorum. (Moreover the dead will arise with the same age and size as Christ when resurrected, that is to say 30 years of age, the infant of one night no less than someone ninety years old.) In general, it was believed in the Middle Ages that Christ was resurrected at the age of thirty-three. However, several Church Doctors were of St. Augustine's opinion that Christ lived only thirty years (*Contra Faustem Manichaeum*, XII, xiv, Migne, *P. L.*, 42, col. 262); the reason he gave is that the ark was thirty cubits in height.

78 Except for a bishop.

79 Matthew 29:38, and Honorius of Autun, *Elucidarium*, III, xiii, Migne, *P. L.*, 172, col. 1166.

80 This was the oldest way of representing it; it was used in the Romanesque period. Beneath the God of the Apocalypse surrounded by the four animals, we see the twelve apostles both at St.-Trophime of Arles and on the old portal of Chartres. Which proves once again that the great apocalyptic figure of Romanesque churches is indeed that of God the Judge.

81 *Legenda aurea*, i. [Ed. Roze, 1902, I, p. 15; 1967, I, p. 35; tr. Caxton, I, p. 22.]

82 Nowhere is the scene with its popular humor better done than on the portal of Conques. [Porter, *Romanesque Sculpture*, IV, pl. 400.]

83 See A. Maury, "Recherches sur l'origine des représentations figurées de la psychostasie ou pèsement des âmes et sur les croyances qui s'y rattachaient," *Revue archéologique*, I (1844), pp. 291-295.

84 Augustine, *Sermo* CCLXVI, *In vigiliis Pentecostes*, Migne, *P. L.*, vol. 38, cols. 1225-1229; Johannes Molanus, *De historia sacrarum imaginum et picturarum*, II, xxiii, would have it that all the representations of the Middle Ages and the Renaissance derived from this passage from St. Augustine.

85 Cited by Vincent of Beauvais, *Speculum historiale, Epilogus*, cxviii. [Graz ed., IV. 1328.]

86 See Mâle, *Religious Art in France: The Twelfth Century*, pp. 413-414.

87 The lamb is original but the head of the "damned soul" is a restoration.

88 A. Saint-Paul, *Histoire monumentale de la France*, Paris, 1883, p. 90. The cult of St. Michael on hilltops has been studied by A. Crosnier, "Culte aérien de Saint Michel," *Bulletin monumental*, 28 (1862), pp. 693-700. [See also J. V. Radot, "Note sur les chapelles hautes dédiées à Saint Michel," *Bulletin monumental*, 88 (1929), pp. 453-478.]

89 See J. Lebeuf, *Dissertation sur les anciens cimetières*, and *idem, Histoire de la ville et de tout le diocèse de Paris*, ed. Cocheris, I, p. 106. He mentions a chapel of St. Michael in the Cimetière des Innocents.

90 St. Michael is represented carrying the soul of a dead person on a tomb of the thirteenth century in the Musée archéologique lorrain in Nancy. See L. Germain de Maidy, "Images de Saint Michel psychopompe, sur des tombeaux," *Mémoires de la Société d'archéologie lorraine et du musée historique lorrain*, 1909, pp. 134-138.

91 Matthew 25:32-33. "Before him will be gathered all the nations and he will separate them one from another as a shepherd separates the sheep from the goats, and he will place the sheep at his right hand, but the goats at the left."

92 Tympanum of St.-Yved-de-Braîne, in the Musée municipal in Soissons.

93 Notably at Reims, Chartres, and Bourges (portal and window of the Last Judgment, in the choir).

94 Job 41:1, 14, 19-20, 31.

95 Job 41:1, and Gregory, *Moralium libri sive expositio in librum B. Job*, Migne, *P. L.*, 76, col. 680.

96 Odo of Cluny, *Moralium in Job*, XXXIII, Migne, *P. L.*, 133, cols. 490-491.

97 Bruno of Asti, *Expositio in Job*, xl, Migne, *P. L.*, 164, col. 686.

98 Honorius of Autun, *Speculum ecclesie*, Migne, *P. L.*, 172, col. 937.

99 [J. Zellinger, "Der geköderte Leviathan im *Hortus deliciarum* des Herrad von Landsbergs," *Historisches Jahrbuch*, 45 (1925), pp. 161-177.]

100 Bruno of Asti, *Expositio in Job*, Migne, *P. L.*, 164, cols. 688-689.

101 Thomas Aquinas, *Summa theologica*, Supplement to pt. III, Quaest. XCVII, art. II. [Ottawa ed., 492b.]

102 Vincent of Beauvais, *Speculum historiale, Epilogus,* cxx. [Graz ed., IV. 1329.]

103 Honorius of Autun, *Elucidarium,* III, xv, Migne, *P. L.,* 172, col. 1169.

104 Revelation 7:13.

105 Fra Salimbene, in painting the portrait of St. Louis, described him in this way: . . . *gracilis, macilentus convenienter et longus habens vultum angelicum et faciem gratiosam* (unadorned, suitably thin and tall, having an angelic expression and a face full of grace). [*Cronica fratris Salimbene de Adam ordinis minorum,* ed. O. Holder-Egger (*Monumenta germaniae historica, Scriptorum,* XXXII), Hanover, 1905-1913, p. 222 (repr. ed., Hanover, 1963).]

106 At Conques, in the twelfth century, Charlemagne was thought to have been one of the benefactors of the abbey, and the monks of St. Benedict were thought to be those in the first ranks of the elect. [Aubert, *La Sculpture française au moyen âge,* illus. pp. 118-119.]

107 It is to be seen at Reims, Chartres, Bourges, Amiens, and Rouen (Portail des Libraires).

108 Revelation 2:10.

109 Notably at Amiens, Bourges, Le Mans (La-Couture).

110 On the subject of the keys of St. Peter, see Peter Lombard, *Sententiarum,* IV. dist. xviii: *Claves istae non sunt corporales, sed spiritualis, scilicet discernendi scientia, et potentia judicandi, id est, ligandi et solvendi . . .* (These keys are not physical but spiritual, that is to say the knowledge to discern and the power to judge, i.e. to bind and to unravel). Migne, *P. L.,* 192, col. 885.

111 Cahier and Martin, *Bourges,* pl. III.

112 I Corinthians 2:9.

113 Examples: Laon, Chartres, Notre-Dame of Paris, Reims (fig. 252), Bourges, relief (fig. 251) and window, Rampillon (fig. 246), St.-Urbain of Troyes.

114 Thomas Aquinas (*Summa theologica,* pt. III, Quaest. LVII, art. II) says expressly that Abraham's bosom is the place of repose for the just.

115 Honorius of Autun, *Elucidarium,* III. xv, Migne, *P. L.,* 172, col. 1168.

116 The *Liber de beatitudine coelestis patriae* seems to have been written by the monk Eadmer of Canterbury, and not by St.

Anselm, but it is only a recapitulation of a sermon by St. Anselm. (See Migne, *P. L.,* 159, cols. 587-606 and *Operum S. Anselmi Censura,* Migne, *P. L.,* 158, col. 47.)

117 Honorius of Autun, *Elucidarium,* III, xviii, Migne, *P. L.,* 172, col. 1169, and *idem, Speculum ecclesiae, In Pentecosten, ibid.,* col. 961.

118 St. Bernard, *De villico iniquitatis,* Migne, *P. L.,* 184, col. 1025.

119 St. Thomas, *Summa theologica,* supplement to pt. III, Quaest. xcv, art. v. [Ottawa ed., 171b-473b.]

120 St. Bonaventura, *Diaeta Salutis,* x, ii, *De gloria Paradisi,* iv. [*Opera omnia,* ed. I. Jeiler, Clara Aqua (Quaracchi, 1882-1902, p. 354.]

121 Or in any case, the author of the *Speculum morale,* whoever he was. *Speculum morale,* II, pt. IV [Graz ed., III. 841-860].

122 Honorius of Autun, *Elucidarium,* III, xviii, Migne, *P. L.,* 172, col. 1170.

123 Porch, right bay; first band of the archivolts.

124 A. N. Didron, "Statuaire des cathédrales de France," *Annales archéologiques,* 6 (1847), pp. 48-59.

125 F. d'Ayzac, *Les Statues du porche septentrional de Chartres et les quatre animaux mystiques, attributs des quatre évangélistes,* Paris, 1849.

126 It was Innocent III himself who applied this passage from the scriptures to the bishop wearing the mitre: *De sacro altaris mysterio,* I, xliv, Migne, *P. L.,* 217, col. 790.

127 The examples are many: posts of the central portal of St.-Denis and of Sens; archivolts of Laon, Amiens, Notre-Dame of Paris, Bourges (surrounding the rose window above the tympanum), Reims, Priory of Longpont-sur-Orges, (Essonne), etc. [See Sauerländer, *Gothic Sculpture in France,* pls. I, 60, 145, 160, 243.] Elsewhere, we have discussed the symbolism of this parable fully enough for there to be no need to go over it again here.

128 Matthew 3:10; Vincent of Beauvais, *Speculum historiale, Epilogus,* cxviii. [Graz ed., IV. 1328.] The two trees (as well as the wise and foolish virgins) appear also on the portal of Longpont (fig. 255). [On the "arbor bona," see above Book III, n. 47.]

1 *Syn. Nicaena*, II. P. Labbe and G. Cossart, eds., *Sacrosancta concilia*, Venice, 1728-1733, vol. VIII, col. 831.

2 He wrote on a page of his album: *Illud bresbiterium (presbyterium) invenerunt Vlardus de Hunecourt et Petrus de Corbia inter se disputando* (That council did Villard de Honnecourt and Peter of Corbia found by disputing between themselves).

3 On the subject of the condition of artists in the Middle Ages, several valuable documents have been brought to light by J. Quicherat, *Mélanges d'archéologie et d'histoire; archéologie du moyen âge*, Paris, 1886. The artists who carved the jubé of the cathedral of Troyes, in 1382, were treated as simple workmen. They worked from sunup until sundown, "until the hour when they had supper." One of the masters of the works, Henri de Bruxelles, married a girl from Troyes in 1384. The ceremony caused him to lose a day's work; the canon deducted it from his pay. Quicherat, "Notice sur plusieurs registres de l'oeuvre de la cathédrale de Troyes," *ibid.*, p. 208.

4 [See E. Panofsky, ed. and tr., *Abbot Suger on the Abbey Church of St. Denis and Its Art Treasures*, Princeton, 1946 (2nd ed. rev., ed. Gerda Panofsky-Soergel, 1979).]

5 P. Guignard, *Mémoires fournis aux peintures pour une tapisserie de Saint-Urbain de Troyes*, Troyes, 1851, p. IX.

6 Guignard, *loc. cit.* The anonymous cleric drew especially on the *Speculum historiale* of Vincent of Beauvais, and the *Chronicae* of St. Antoninus, but he also knew other writers.

7 The Latin was taken from Vincent of Beauvais.

8 We see that Viollet-le-Duc remembered Victor Hugo's phrase.

9 Viollet-le-Duc, *Dictionnaire raisonné de l'architecture*, VIII, pp. 144ff.

10 On the associations of laborers who worked on cathedrals, see K. Schnaase, "Les Franc-Masons du moyen âge," *Annales archéologiques*, II (1851), pp. 325-334. We learn that German freemasons, still in the late fifteenth century, were required to take communion once a year under penalty of expulsion.

11 This indeed was the medieval definition of the Church. The act by which the chapter of the Abbey of Saint-Ouen decided to continue work on the church begins: *Urbem beatam Jerusalem, quae aedificatur ut civitas non saxorum molibus sed ex vivis lapidibus, quae virtutum soliditate firmatur et sanctorum societate nunquam dissolvenda extruitur, sacro sancta militans Ecclesia mater nostra per manu factam et materialem basilicam repraesentat* (A blessed city of Jerusalem, which is built as a state not with masses of rocks but with living stones, which is made strong by the solidity of its virtues and, by virtue of the company of saints is constructed never to come apart, such does the sacrosanct church militant, our mother, display through a corporeal basilica made by man's hand). Quicherat, *Mélanges d'archéologie et d'histoire*, p. 217. Jean de Jandun, who in 1323 described Notre-Dame of Paris, said in speaking of the chapel of the Virgin, which is behind the choir: "When you entered, you would have thought you had been taken up to heaven and placed in one of the most beautiful chambers of Paradise." *Eloges de Paris*, A.J.V. Le Roux de Lincy and L. M. Tisserand, eds., *Paris et ses historiens au XIVe et XVe siècles* (*Histoire générale de Paris*, VI), Paris, 1867, pp. 1-79.

12 On people's eagerness to work on cathedrals, see the letter of Hugh, archbishop of Rouen, Migne, *P. L.*, 192, col. 1133, and the letter of Haimon, abbot of St.-Pierre-sur-Dives: L. Delisle, "Lettre de l'Abbé Haimon, sur la construction de l'église de Saint-Pierre-sur-Dive, en 1145," *Bibliothèque de l'Ecole des Chartes*, 5th ser., 1 (1859-1860), pp. 113-139.

13 It would be interesting to draw up statistics on the great medieval works destroyed in 1562 by the wars of religion, in the eighteenth century by the cathedral chapters, in 1793 by the Revolution, and at the beginning of the nineteenth century by the *Bande noire*. We would then understand what prodigious power we had during the Middle Ages.

BIBLIOGRAPHY

Achéry, Luc d'. *Spicilegium collectio scriptorum.* 3 vols. Paris, ed. of 1723.

Adams, Henry. *Mont-Saint-Michel and Chartres.* Boston and New York [1904].

Adams, L. G. *Recueil de sculptures gothiques dessinées et gravées a l'eauforte d'après les plus beaux monuments construits en France depuis le XIe jusqu'au XVe siècle.* 2 vols. Paris, 1858-1861.

Adeline, Jules. *Sculptures grotesques et symboliques.* Rouen, 1879.

Adhémar, Jean. *Influences antiques dans l'art du moyen âge français; Recherches sur les sources et les thèmes d'inspiration.* London, 1939.

Advielle, Victor. *Histoire de l'ordre hospitalier de Saint-Antoine de Viennois et de ses commanderies et prieurés.* Paris, 1883.

Aelianus (Aelian). *On the Characteristics of Animals,* tr. A. F. Scholfield (Loeb Classical Library). 3 vols. London and Cambridge, 1958-1959.

Alain de Lille. *The Complaint of Nature by Alain de Lille,* tr. D. M. Moffat (Yale Studies in English, 36). New York, 1908.

Albe, Edmond. *Les Miracles de Notre-Dame de Roc-Amadour au XIIe siècle.* Paris, 1908.

Albertus Magnus. *Opera omnia,* eds. Auguste and Emile Borgnet. 38 vols. Paris, 1890-1899.

———. *Opera quae hactenus haberi potuerunt,* ed. Petri Jammy. 21 vols. Lyon, 1651.

Alverny, Marie Thérèse d'. *Alain de Lille, Textes inédits avec une introduction sur sa vie et ses oeuvres.* Paris, 1965.

———. "La Sagesse et ses sept filles. Recherches sur les allégories de la philosophie et des arts libéraux du IXe au XIIe siècle," *Mélanges dediées à la mémoire de Felix Grat,* I, Paris, 1946, pp. 245-278.

Ameisenowa, Zofja. "Animal-Headed Gods, Evangelists, Saints and Righteous Men," *Journal of the Warburg and Courtauld Institutes,* 12 (1949), pp. 21-45.

Andeli, Henri d' and Jean le Tainturier. *La Bataille et le mariage des sept arts, Pièces diverses du XIIIe siècle,* ed. Achille Jubinal. Paris, 1838.

Annales archéologiques, ed. A. N. Didron. 28 vols. Paris, 1844-1881.

Auber, Charles Auguste. *Histoire de la cathédrale de Poitiers.* 2 vols. Poitiers, 1848-1849.

———. "Histoire et théorie du symbolisme religieux, I. Du symbolisme chez les anciens," *Revue de l'art chrétien,* 10 (1866), pp. 121-135.

———. *Histoire et théorie du symbolisme religieux avant et depuis le christianisme.* 4 vols. Paris and Poitiers, 1870-1872.

Aubert, Marcel. *La Cathédrale de Notre-Dame de Paris, Notice historique et archéologique.* Paris, 1945.

———. *French Sculpture at the Beginning of the Gothic Period, 1140-1225.* Florence and New York, 1929.

———. *Notre-Dame de Paris: architecture et sculpture.* Paris, 1928.

———. *La Sculpture française au moyen âge.* Paris, 1947.

——— and others. *Le Vitrail français.* Paris, 1958.

——— and Michele Beaulieu. *Encyclopédie photographique de l'art; Sculptures du moyen âge au musée de Louvre.* Paris, 1948.

———, Louis Grodecki, Jean Lafond, and Jean Verrier. *Les Vitraux de Notre-Dame et de la Sainte-Chapelle de Paris* (Corpus vitrearum medii aevi, France I). Paris, 1959.

Aubry, Pierre. *Le Roman de Fauvel.* Paris, 1907.

St. Augustine. *The City of God,* tr. Marcus Dods (Modern Library). New York, 1950.

———. *The Confessions of Saint Augustine,* tr. Edward B. Pusey (Modern Library). New York, 1949.

———. *De libero arbitrio,* ed. W. M. Green (Corpus scriptorum ecclesiasticorum latinorum, LXXIV). Vienna, 1956.

———. *Expositions on the Book of Psalms,* tr. A. C. Coxe (*A Select Library of Nicene and Post-Nicene Fathers of the Christian Church,* ed. P. Schaff, 1st ser., VIII). Oxford and New York, 1886 (repr. Grand Rapids, 1956).

———. *On Free Choice of Will,* tr. A. S. Benjamin and L. H. Hackstaff. Indianapolis, 1964.

———. *On Music,* ed. and tr. R. C. Taliaferro

(Classics of the St. John's Program). Annapolis, 1939.

Avery, Myrtilla. *The Exultet Rolls of South Italy*, Princeton, London and The Hague, 1936, 11 (plates).

Ayzac, Félicie d'. "Mémoire sur trente-deux statues symboliques observées dans la partie haute des tourelles de Saint-Denys," *Revue générale de l'architecture et des travaux publics*, 7 (1847), pp. 65-81.

——. *Les Statues du porche septentrional de Chartres et les quatre animaux mystiques, attributs des quatre évangélistes.* Paris, 1849.

——. "Symbolisme; de la déviation dans l'axe absidial de plusieurs églises; de l'attitude et de l'inclinaison vers la droite imprimée aux crucifix du moyen âge; et de la plaie également marquée au coté droit de ces derniers dans les oeuvres d'art antérieures au dix-septième siècle," *Revue de l'art chrétien*, 4 (1860), pp. 590-604, and 5 (1861), pp. 29-56; 77-90.

——. "De la Zoologie composite (c'est-à-dire imaginaire et complexe) dans les oeuvres de l'art chrétien avant le XIVe siècle," *Revue de l'art chrétien*, 4 (1886), pp. 13-36.

Bacon, Roger. *Opus Maius of Roger Bacon*, ed. Robert Belle Burke. Oxford and Philadelphia, 1928 (rev. ed. New York, 1962).

Baisier, Léon. *The 'Lapidaire Chrétien,' Its Composition, Its Influence, Its Sources.* Washington, 1936.

Baltrušaitis, Jurgis. *Le Moyen Age fantastique: antiquités et exotismes dans l'art gothique.* Paris, 1955.

——. *Reveils et prodiges: le gothique fantastique.* Paris, 1960.

——. "Villes sur arcatures," *Urbanisme et architecture; Etudes ecrites et publiées en l'honneur de Pierre Lavedan*, Paris, 1954, pp. 31-40.

Barbier de Montault, Xavier, "Ivoire latin du musée de Nevers," *Bulletin monumental*, 50 (1884), pp. 703-735.

——. *Traité d'iconographie chrétienne.* 2 vols. Paris, 1890.

——. "Le trésor de la basilique royale de Monza," *Bulletin monumental*, 49 (1883), pp. 129-155.

——. "Trésor d'une cathédrale. Inventaire de Boniface VIII," *Annales archéologiques*, 18 (1858), pp. 18-32.

——. "Le trésor du dôme d'Aix-La-Chapelle," *Bulletin monumental*, 43 (1877), pp. 209-239.

Barthélemy, Anatole de. "Le reliquaire de Saint Tudual à Laval," *Bulletin monumental*, 51 (1885), pp. 453-458.

Bastard-d'Estang, Auguste, comte de. "Crosse de Saint-Amand de Rouen," *Travaux du Comité des travaux historiques et scientifiques*, 1857, pp. 521-539.

——. *Etudes de symbolique chrétienne.* Paris, 1851.

——. *Histoire de Jésus-Christ en figures. Gouaches du XIIe au XIIIe siècle conservées jadis à la collégiale de Saint-Martial de Limoges.* Paris, 1879.

Batiffol, Pierre. *Anciennes littératures chrétiennes; la littérature grecque.* Paris, 1897.

——. *History of the Roman Breviary*, tr. M. Y. Baylay. London and New York, 1912.

Baudri de Bourgueil. *Les Oeuvres poétiques de Baudri de Bourgueil (1046-1130)*, ed. Phyllis Abrahams. Paris, 1926.

Baumstark, Anton. "Frühchristliche-syrische Prophetenillustration durch stehende Autorenbilder," *Oriens Christianus*, 3rd ser., 9 (1934), pp. 99-104.

Bazin, Germain. *Italian Painting in the XIVth and XVth Centuries.* Paris, 1938.

Beaujouan, Guy. "Le symbolisme des nombres à l'époque romane," *Cahiers de civilisation médiévale*, 4 (1961), pp. 159-169.

Beaurepaire, Charles de. "Anciens inventaires du trésor de l'abbaye de Fécamp," *Bibliothèque de l'Ecole des Chartes*, 20 (1859), p. 154.

Beaurepaire, Eugene de. *Caen illustré.* Caen, 1896.

——. "Peintures du XVIe siècle nouvellement découvertes dans l'église Saint-Michel-de-Vaucelles à Caen," *Bulletin monumental*, 49 (1883), pp. 689-707.

Bédier, Joseph. *Les Fabliaux: Etudes de littérature populaire et d'histoire littéraire du moyen âge.* Paris, 1893 (5th repr. ed. Paris, 1925).

——. *Les Légendes épiques; recherches sur la formation des chansons de geste.* 4 vols. Paris, 1908-1913.

Bégule, Lucien. *La Cathédrale de Sens, son architecture, son décor*, Lyon, 1929.

—— and M.-C. Guigue. *Monographie de la cathédrale de Lyon.* Lyon, 1880.

Behling, Lottlisa. "Ecclesia als Arbor Bona:

zum Sinngehalt einiger Pflanzendarstellungen des 12. und frühen 13. Jahrhunderts," *Zeitschrift für Kunstwissenschaft*, 13 (1959), pp. 139-154.

————. *Die Pflanzenwelt der mittelalterlichen Kathedralen*. Cologne, 1964.

Beigbeder, Olivier. "Symbolisme des chapiteaux de la nef d'Anzy-le-Duc," *Gazette des beaux-arts*, 60 (1962), pp. 381-399.

Berger, Samuel. *La Bible française au moyen âge*. Paris, 1884.

Berger de Xivrey, Jules. *Traditions tératologiques, ou récits de l'antiquité et du moyen âge en occident*. Paris, 1836.

Berliner, Rudolf. "Arma christi," *Münchner Jahrbuch für bildenden Kunst*, 3rd ser., 6 (1955), pp. 35-152.

Bernard, Bertrand. "Découverte de reliques dans l'autel de l'église de Valcabrère (Haute-Garonne)," *Bulletin monumental*, 52 (1886), pp. 501-508.

Berneville, Guillaume de. *La Vie de Saint Gilles par Guillaume de Berneville: poème du XIIe siècle*, ed. Gaston Paris (Société des ancien textes français), Paris, 1881.

Bernheimer, Richard. "The Martyrdom of Isaiah," *Art Bulletin*, 34 (1952), pp. 19-34.

Bettini, Sergio. *Mosaici antichi di San Marco a Venezia*. Bergamo, 1944.

Beyer, Victor. "Rosaces et roues de fortune à la fin de l'art roman et au début de l'art gothique," *Zeitschrift für schweizerische Archäologie und Kunstgeschichte* (Festschrift für Hans Reinhardt), 22 (1962), pp. 34-43.

Biebel, F. "The 'Angelot' of Jean Barbet," *Art Bulletin*, 32 (1950), pp. 336-344.

Bing, Gertrude. "The Apocalypse Block-Books and Their Manuscript Models," *Journal of the Warburg and Courtauld Institutes*, 5 (1942), pp. 143-158.

Birch, Walter de Gray and Henry Jenner. *Early Drawing and Illuminations. An Introduction to the Study of Illustrated Manuscripts; with a Dictionary of Subjects in the British Museum*. London, 1879.

Bischoff, Bernard. *Mittelalterliche Schatzverzeichnisse, 1. Von der Zeit Karls des Grossen bis zum Mitte des 13. Jahrhunderts*. Munich, 1967.

Blancard, Louis. "Rôle de la confrérie, de Saint-Martin de Canigou," *Bibliothèque de l'Ecole des Chartes*, 42 (1881), pp. 5-7.

Blanchard, Fernand. "La statuaire de la tour sud de la cathédrale de Soissons," *Congrès archéologique*, 78 (1911), pp. 317-323.

Bliemetzrieder, Franz P. "L'oeuvre d'Anselme de Laon et la littérature théologique contemporaine, 1. Honorius d'Autun," *Recherches de théologie ancienne et médiévale*, 5 (1933), pp. 275-291.

Bloomfield, Morton W. *The Seven Deadly Sins*. East Lansing, Mich., 1952.

Blumenkranz, Bernard. *Les Auteurs chrétiens latins du moyen âge sur les juifs et le judaisme*. Paris, 1963.

————. *Le Juif médiéval au miroir de l'art chrétien*. Paris, 1966.

————. "Géographie historique d'un thème d'iconographie religieuse: les représentations de *Synagoga* en France," *Mélanges offerts à René Crozet*, Poitiers, 1966, II, pp. 1141-1157.

————. "Synagoga, Mutations d'un thème de l'iconographie médiévale," *Studi storici de l'Istituto storico italiano per il medio evo*, Rome, 1967.

Bober, Harry. "An Illustrated Medieval School-Book of Bede's 'De Rerum Natura,'" *Journal of the Walters Art Gallery*, 19-20 (1956-1957), pp. 65-97.

————. "In Principio: Creation before Time," *De Artibus Opuscula XL, Essays in Honor of Erwin Panofsky*, New York, 1961, pp. 13-28.

Boeckler, Albert. *Das goldene Evangelienbuch Heinrichs III*. Berlin, 1933.

Boethius. *The Consolation of Philosophy*, tr. "I.T.," ed. H. F. Stewart (Loeb Classical Library, VII). London and New York, 1918.

Boinet, Amédée. *Les Manuscrits à peintures de la bibliothèque Ste.-Geneviève*. (Bulletin de la Société française de reproductions de manuscrits à peintures, 5). Paris, 1921.

————. "Le tympan de Saint-Yved de Braisne au musée de Soissons," *Bulletin monumental*, 72 (1908), pp. 455-460.

Bollandus, Joannes. *Acta Sanctorum*, eds. Hippolyte Delahaye and Joannes Carnandet. 71 vols. Paris, 1863ff.

St. Bonaventure. *Opera omnia*. 11 vols. Clara Aqua, 1882-1902.

————. *Opera omnia*, ed. C. Boccafuoco. 7 vols. Mainz, 1609.

Bond, Francis. *Fonts and Font Covers*. London, 1908.

Bonnault d'Houët, Xavier, baron de. *Le Pèlerinage d'un paysan picard à Saint-Jacques de*

Compostelle au XIIIe siècle. Montdidier, 1890.

Bonneau, Gustav. "Descriptions des verrières de la cathédrale d'Auxerre," *Bulletin de la Société des sciences historiques et naturelles de l'Yonne*, 39 (1885), pp. 296-348.

Bonnefoy, Yves and Pierre Devinoy. *Peintures murales de la France gothique*. Paris, 1954.

Bordier, Henri. "La Confrérie des pèlerins de Saint-Jacques et ses archives," *Mémoires de la Société de l'histoire de Paris et de l'Ile-de-France*, 1 (1875), pp. 186-22; 2 (1876), pp. 330-397.

Borenius, Tancred. *St. Thomas Becket in Art*. London, 1932.

Borsook, Eve. *The Mural Painters of Tuscany from Cimabue to Andrea del Sarto*. London, 1960.

Bossuet, Jacques-Bénigne. *Discours sur l'histoire universelle de Jacques-Bénigne Bossuet*, ed. Armand Gasté. Paris, 1928.

———. *Elevations à Dieu sur tous les mystères de la religion chrétienne*, ed. Emile Chavin. Paris, 1842 (Engl. tr. *Elevation to God*, London [1850]).

Bottineau, Yves. *Les Chemins de Saint-Jacques*. Paris and Grenoble, 1964.

Bourassé, Jean-Jacques and J. Marchand. *Verrières du choeur de l'église métropolitaine de Tours*. Paris, 1849.

Bousquet, J. and J. Amann, eds. *Apocryphes du Nouveau Testament*. 2 vols. Paris, 1913-1922.

Boutaric, Edgard. "Vincent de Beauvais et la connaissance de l'antiquité classique au XIIIe siècle," *Revue des questions historiques*, 17 (1875), pp. 1-57.

Bouxin, Auguste. *La Cathédrale de Notre-Dame de Laon, historique et description*. Laon, 1890.

Bowie, Theodore, ed. *The Sketchbook of Villard de Honnecourt*. Bloomington, Ind., 1959.

Branner, Robert. "The Painted Medallions in the Sainte-Chapelle in Paris," *Transactions of the American Philosophical Society*, new ser., 58 (1968), pt. 2, pp. 5-9.

———. *St. Louis and the Court Style in Gothic Architecture*. London, 1965.

Braun, Josef. *Das christliche Altargerät in seinem Sein und in seiner Entwicklung*. Munich, 1932.

———. *Die liturgische Gewandung im Occident und Orient nach Ursprung und Entwicklung, Verwendung und Symbolik*. Freiburg-im-Breisgau, 1907.

Braunfels, Wolfgang, ed. *Karl der Grosse, Lebenswerk und Nachleben*. 5 vols. Düsseldorf, 1965-1968.

Bréhier, Louis *La Cathédrale de Reims*. Paris, 1916.

———. "Les chapiteaux historiés de Notre-Dame du Port à Clermont étude iconographique, 1," *Revue de l'art chrétien*, 5th ser., 42 (1912), pp. 249-262.

Breiger, Peter, Millard Meiss, and Charles S. Singleton. *Illuminated Manuscripts of the Divine Comedy*. 2 vols. Princeton, 1969.

Brenk, Beat. *Tradition und Neuerung in der christlichen Kunst des ersten Jahrtausends. Studien zur Geschichte des Weltgerichtsbildes*. Vienna, 1966.

Brial, M.-J.-J. "Alain de Lille, surnommé le docteur universel. Histoire de sa vie," *Histoire littéraire de la France*, 16 (1824), pp. 396-425.

Broche, Lucien. *La Cathédrale de Laon*. Paris, 1926 (2nd ed., Paris, 1954).

Broussolle, Jules César. *Le Christ de la légende dorée*. Paris, n.d.

Buchon, J.A.C. and J. Tastu. "Notice d'un atlas en langue catalane," *Notices et extraits des manuscrits de la Bibliothèque du Roi et autres bibliothèques*, 14 (1841), pt. 2, pp. 1-152.

Bühler, Curt. "The Apostles and the Creed," *Speculum*, 28 (1935), pp. 335-339.

Bulliot, Jacques-Gabriel and Felix Thiollier. *La Mission et le culte de Saint Martin d'après les légendes et les monuments populaires dans le pays Eduen*. Paris and Autun, 1892.

Bulteau, Marcel-Joseph. *Description de la cathédrale de Chartres*. Chartres, 1850.

———. *Monographie de la cathédrale de Chartres*. 3 vols. Chartres, 1887-1901.

Burger, William and A. N. Didron, "Iconographie du palais ducal à Venise," *Annales archéologiques*, 17 (1857), pp. 69-88; 193-216.

Cabrol, Fernand and Henri Leclerq. *Dictionnaire d'archéologie chrétienne et de liturgie*. 15 vols. Paris, 1907-1954.

Cahier, Charles. *Caractéristiques des saints dans l'art populaire*. 2 vols. Paris, 1866-1868.

——— and Arthur Martin. *Mélanges d'archéologie, d'histoire et de littérature*. 4 vols. Paris, 1847-1856.

———. *Monographie de la cathédrale de Bourges*, pt. 1. *Vitraux du XIIIe siècle*. 2 vols. Paris, 1841-1844.

————. *Nouveaux Mélanges d'archéologie, d'histoire et de littérature sur le moyen âge.* 4 vols. Paris, 1874-1877.

Cahn, Walter, "The Tympanum of the Portal of Saint-Anne at Notre-Dame de Paris and the Iconography of the Division of the Powers in the Early Middle Ages," *Journal of the Warburg and Courtauld Institutes,* 32 (1969), pp. 55-72.

Cames, Gérard. "Recherches sur les origines du crucifix à trois clous," *Cahiers archéologiques,* 16 (1966), pp. 185-202.

Cary, George. *The Medieval Alexander,* ed. David J. A. Ross. Cambridge, 1956.

Castelnuovo, Enrico. *Un pittore italiano alla corte di Avignone; Matteo Giovannetti e la pittura in Provenza nel secolo XIV.* Turin, 1962.

La cattedrale di Ferrara, 1135-1925. Verona, 1935.

Caumont, Arcisse de. "Un mot sur quelques questions archéologiques traitées à Paris au congrès des délégués des sociétés savantes, Session de 1857," *Bulletin monumental,* 23 (1857), pp. 241-281.

Cerf, Charles. *Histoire et description de Notre-Dame de Reims.* 2 vols. Reims, 1861.

Chabeuf, Henri. "La maison du miroir ou des chartreux à Dijon," *Revue de l'art chrétien,* 4th ser., 10 (1899), pp. 112-118.

Chailley, Jacques. "Du drame liturgique aux prophètes de Notre-Dame-la-Grande," *Mélanges offerts à René Crozet,* Poitiers, 1966, II, pp. 835-841.

Chambers, E. K. *The Medieval Stage.* 2 vols. Oxford, 1903.

Champfleury, Jules F.-F. *Histoire de la caricature au moyen âge.* Paris, 1871.

Chardin, Ferdinand. "Notice sur deux bas-reliefs de la cathédrale de Strasbourg," *Revue archéologique,* 10 (1853), pp. 591-602; 648-655.

Charles, R. H., ed. *The Apocrypha and Pseudepigrapha of the Old Testament.* 2 vols. Oxford, 1964-1965.

Chartraire, Eugène. *La Cathédrale de Sens.* Paris, 1934.

Chastel, André. *Art et humanisme à Florence au temps de Laurent le Magnifique. Etude sur la renaissance et l'humanisme platonicien.* Paris, 1959.

Chenesseau, Georges. *L'Abbaye de Fleury à Saint-Benoît-sur-Loire.* Paris, 1931.

Chevalier, Ulysse. *Poésie liturgique traditionelle de l'église catholique en occident.* Tournai, 1894.

Clerval, Jules Alexandre. *Les Ecoles de Chartres au moyen âge du Ve au XVIe siècle (Mémoires de la Société archéologique d'Eure et Loire,* XI). Chartres, 1895.

————. "L'Enseignement des art libéraux à Chartres et à Paris dans la première moitié du XIIe siècle, d'après l'Heptateuchon de Thierry de Chartres," *Congrès scientifique international des catholiques,* 1 (1888), pp. 277-296.

Cloulas-Brousseau, Annie. "Le jubé de la cathédrale de Limoges," *Bulletin de la Société archéologique et historique du Limousin,* 90 (1963), pp. 101-188.

Coathalem, Hervé. *Le Parallelisme entre la sainte vierge et l'église dans la tradition latine jusqu'à la fin du XIIe siècle* (Analecta Gregoriana, LXXIV). Rome, 1954.

Collin de Plancy, Jacques. *Dictionnaire critique des reliques et des images miraculeuses.* 3 vols. Paris, 1821-1822.

Collinet-Guérin, Marthe. *Histoire du nimbe des origines aux temps modernes.* Paris, 1961.

Collon-Gevaert, Suzanne, Jean Lajeune and Jacques Stiennon. *Art roman dans la vallée de la Meuse aux XIe et XIIe siècles.* Brussels, 1962.

Cologne, Erzbischöfliche Diozesan-Museum. *Achthundert Jahre Verehung der heiligen Dreikönige in Koln 1164-1964.* Cologne, 1964.

Comparetti, Domenico. *Virgilio nel medio evo.* 2 vols., 2nd ed., Florence, 1896.

Conant, Kenneth J. *Carolingian and Romanesque Architecture, 800-1200* (The Pelican History of Art). Harmondsworth and Baltimore, 1959.

————. *Cluny: Les églises et la maison du chef d'ordre.* Mâcon, 1968.

Congrès archéologique de France, 28e session; Séances générales tenues à Reims, 1861 (Société française d'archéologie). Paris, 1862.

Conrad of Saxony. *Speculum Beatae Mariae Virginis Fr. Conradi a Saxony,* eds. Fathers of the College of S. Bonaventura. Quaracchi, 1904.

Cope, Gilbert. *Symbolism in the Bible and the Church.* New York, 1959.

Corblet, Jules. "Etude iconographique sur l'arbre de Jesse," *Revue de l'art chrétien,* 4 (1860), pp. 4-61, 113-181.

Corblet, Jules. *Hagiographie du diocèse d'Amiens*. 5 vols. Paris, 1869-1875.

Cornell, Hendrik. *Biblia pauperum*. Stockholm, 1925.

Corpet, E.-F. "Portraits des arts libéraux d'après les écrivains du moyen âge. Cinquième siècle: Martianus Capella, commenté au neuvième par Remi d'Auxerre," *Annales archéologiques*, 17 (1857), pp. 89-103.

Corpus Christianorum: Continuatio mediaevalis. 176ff. vols. Turnholt, 1953ff.

Cosquin, Emmanuel. "Contes populaires lorrains recueillis dans un village du Barrois, II," *Romania*, 6 (1877), pp. 212-246.

Coulet, Jules. *Etudes sur l'ancien poème français du voyage de Charlemagne en orient*. Montpellier, 1907.

Coulton, George Gordon. *Life in the Middle Ages*. 4 vols. Cambridge, 1928-1930 (repr. Cambridge, 1967).

Courajod, Louis. *Leçons professées à l'Ecole du Louvre*. 3 vols. Paris, 1889-1903.

Cousin, Victor. *Fragments philosophiques, philosophie scolastique*. 2nd ed., Paris, 1840.

—————. *Ouvrages inédits d'Abélard, pour servir à l'histoire de la philosophie scolastique en France*. Paris, 1836.

Cox, J. C. *Pulpits, Lecterns and Organs in English Churches*. London and New York, 1915.

Creizenach, Wilhelm. *Geschichte des neueren Dramas*, I. *Mittelalter und Frührenaissance*. Halle, 1893.

Croce, Benedetto. *History: Its Theory and Practice*, tr. D. Ainslie. New York, 1921.

Crombie, Alastair Cameron. *Medieval and Early Modern Science*. 2 vols. 2nd ed., Cambridge, Mass., 1963.

—————. *Robert Grosseteste and the Origins of Experimental Science*. Oxford, 1953.

Crosby, Sumner McKnight. *L'Abbaye royale de Saint-Denis. Cent trente photographies de Pierre Devinoy*. Paris, 1953.

—————. *The Abbey of St.-Denis 475-1122*. London and New Haven, 1942.

Crosnier, Augustin. "Culte aérien de Saint Michel," *Bulletin monumental*, 28 (1862), pp. 693-700.

—————. *Iconographie chrétienne*. Paris, 1848.

Crozet, René. "Les premières représentations anthropo-zoomorphiques des évangélistes (VIe-IXe siècles)," *Etudes mérovingiennes*, Paris, 1953, pp. 53-63.

—————. "Les quatre évangélistes et leurs symboles, assimilations et adaptations," *Les Cahiers techniques de l'art*, 4 (1962), pp. 5-26.

Curtius, Ernst Robert. *European Literature and the Latin Middle Ages*, tr. Willard R. Trask (Bollingen Series, XXXVI). New York, 1953 (pb. ed., Princeton, 1973).

D'Ancona, Mirella Levi. *The Iconography of the Immaculate Conception in the Middle Ages and the Early Renaissance*. New York, 1957.

Daniélou, Jean. *Primitive Christian Symbols*. Baltimore, 1964.

—————— and Henri-Irenée Marrou. *Nouvelle histoire de l'église*, I. *Des origines à Saint Gregoire le Grand*. Paris, 1963.

Dante. *La Divina Commedia or the Vision of Dante in Italian and English*, ed. M. Casella, tr. H. R. Cary. London, 1927.

Darcel, Alfred. "Le Bénitier de la cathédrale de Milan; symbolisme des évangélistes," *Annales archéologiques*, 17 (1857), pp. 139-150.

Daunou, Pierre-Claude F. "Discours sur l'état des lettres en France au XIIIe siècle," *Histoire littéraire de la France*, 16 (1824), pp. 1-254.

—————. "Guillaume d'Auvergne, Evêque de Paris," *Histoire littéraire de la France*, 18 (1835), pp. 357-385.

—————. "Vincent de Beauvais, auteur du *Speculum maius* terminé en 1526," *Histoire littéraire de la France*, 18 (1835), pp. 449-519.

Daux, Camille. "La flore monumentale du cloître abbatial de Moissac," *Revue de l'art chrétien*, 19 (1876), pp. 45-100.

David, Henri. *Claus Sluter*. Paris, 1951.

De Bruyne, Edgar. *Etudes d'esthétiques médiévales*. 3 vols. Bruges, 1946.

De Clerc, Joseph-Victor. "Aimeric Picaudi de Parthenai. Cantique et itinéraire des pèlerins de Saint-Jacques de Compostelle," *Histoire littéraire de la France*, 21 (1847), pp. 272-292.

Deknatel, Frederick B. "The Thirteenth Century Gothic Sculpture of the Cathedrals of Burgos and Léon," *Art Bulletin*, 17 (1935), pp. 243-289.

Delaborde, H.-François. "Le procès du chef de Saint Denis en 1410," *Mémoire de la Société de l'histoire de Paris et de l'Ile de France*, 11 (1884), pp. 297-409.

Delaporte, Yves. "Saint Maurice et sa statue à la cathédrale de Chartres," *Bulletin de la Société archéologique d'Eure et Loire*, 20 (1954), pp. 75-81.

——— and Etienne Houvet. *Les Vitraux de la cathédrale de Chartres*. 4 vols. Chartres, 1926.

Delehaye, Hippolyte. *Les Légendes hagiographiques*. 3rd ed., Brussels, 1927 (Engl. tr. D. Attwater, *The Legends of the Saints*. New York, 1962).

Delisle, Leopold. *Le Cabinet des manuscrits de la Bibliothèque impériale*. 3 vols. Paris, 1868-1888.

———. "Lettre de l'abbé Haimon, sur la construction de l'église de Saint-Pierre-sur-Dive, en 1145," *Bibliothèque de l'Ecole des Chartes*, 5th ser., 1 (1859-1860), pp. 113-139.

———. "Livres d'images," *Histoire littéraire de la France*, 31 (1893), pp. 213-285.

———. *Mélanges de paléographie et de bibliographie*. Paris, 1880.

———. "Note sur le recueil initulé 'De miraculis sancti Jacobi,'" *Le Cabinet historique*, 2nd ser., 24 (1878), pp. 1-9.

———. "Notice sur les manuscrits du 'Liber Floridus' de Lambert, Chanoine de Saint-Omer," *Notices et extraits des manuscrits de la Bibliothèque nationale et autres bibliothèques*, Paris, 1906.

———. "Poème adressé à Adele, fille de Guillaume le Conquérant par Baudri, abbé de Bourgueil," *Mémoires de la Société des antiquaires de Normandie*. 3rd ser., 8 (1870), pp. 187-224.

———. *Recherches sur la librairie de Charles V*. 2 vols. Paris, 1907.

———. "Traités divers sur les propriétés des choses," *Histoire littéraire de la France*, 30 (1888), pp. 355-388.

Delisle, Leopold and Paul Meyer. *L'Apocalypse en français au XIIIe siècle (Bibl. Nat. fr. 403)* (Société des anciens textes français). Paris, 1901 (repr. New York, 1965).

Demaison, Louis. "Les figures des vices et des vertus au portail occidental de la cathédrale de Reims," *Bulletin monumental*, 82 (1923), pp. 130-161.

Demus, Otto. *The Mosaics of Norman Sicily*. London, 1949.

Deonna, W. " 'Salve me ex ore leonis'; à propos de quelques chapiteaux romans de la cathédrale de Saint-Pierre à Genève," *Revue belge de philologie et d'histoire*, 28 (1950), fasc. 1, pp. 479-511.

Depping, Georges-Bernard, ed. *Réglemens sur les arts et métiers de Paris, rédigés au XIIIe siècle, et connus sous le nom du "Livre des Métiers" d'Etienne Boileau*. Paris, 1837.

Derolez, Albert, ed. *Liber Floridus Codex Autographus 92 Bibliothecae Universitatis Gandanensis*. Ghent, 1967.

Deschamps, Paul. "Le combat des vertus et des vices sur les portails romans de Saintonge et du Poitou," *Congrès archéologique*, 79 (1912), pt. 2, pp. 309-324.

Deschamps de Pas, Louis. "Essai sur le pavage des églises antérieurement au quinzième siècle," *Annales archéologiques*, 11 (1851), pp. 65-71.

———. "Le Pied de croix de Saint-Bertin," *Annales archéologiques*, 18 (1858), pp. 5-17.

Deslandes, Eucher. "Le trésor de l'église Notre-Dame de Bayeux," *Bulletin archéologique du Comité des travaux historiques et scientifiques*, 1896, pp. 340-450.

Des Méloizes, Albert. *Vitraux peints de la cathédrale de Bourges postérieurs au XIIIe siècle*. Paris, 1891-1897.

Detzel, Heinrich. *Christliche Ikonographie*. 2 vols. Freiburg-im-Breisgau, 1894-1896.

Dictionnaire de théologie catholique, eds. Alfred Vacant and Eugène Mangenot (completed by E. Amann). 15 vols. Paris, 1909-1950.

Didot, Ambroise Firmin. *Des Apocalypses figurées, manuscrites et xylographiques* (2nd app. to *Catalogue raisonné des livres de la bibliothèque de M. Ambroise Firmin-Didot*). Paris, 1870.

Didron, A. N. "Bronzes et orfèvrerie du moyen âge," *Annales archéologiques*, 19 (1859), pp. 5-221.

———. "La cathédrale de Reims, occupations mensuelles et arts libéraux," *Annales archéologiques*, 14 (1854), pp. 25-32.

———. "Encensoirs et parfums," *Annales archéologiques*, 4 (1846), pp. 293-311.

———. "Iconographie des cathédrales. Création de l'homme et de la femme," *Annales archéologiques*, 11 (1851), pp. 148-156.

———. *Manuel des oeuvres de bronze et d'orfèvrerie du moyen âge*, Paris, 1859.

———. "Mélanges et nouvelles: Charlemagne et Roland," *Annales archéologiques*, 24 (1864), pp. 349-351.

———. "Mélanges: Statuaire de Notre-Dame

de Paris au XVᵉ siècle," *Annales arché-ologiques*, 1 (1844), p. 56.

———. "Les planètes," *Annales archéologiques*, 17 (1857), pp. 300-303.

———. "Symbolique chrétienne," *Annales ar-chéologiques*, 8 (1848), pp. 1-16.

Didron, Adolphe-Napoléon. *Iconographie chré-tienne; Histoire de Dieu*. Paris, 1843 (Engl. tr. E. J. Millington, Christian Iconography. 2 vols. London, 1851 [repr. New York, 1965]).

———. *Manuel d'iconographie chrétienne grecque et latine avec une introduction et des notes, traduit du manuscrit by-zantin, Le guide de la peinture, par le Dr. Paul Durand*. Paris, 1845.

———. "Statuaire des cathédrales de France," *Annales archéologiques*, 6 (1847), pp. 48-59.

D'Irsay, S. *Histoire des universités françaises et étrangères, 1. Moyen âge et renaissance*. Paris, 1933.

Dodwell, Charles R. *The Canterbury School of Illumination 1066-1200*. Cambridge, 1954.

Doren, Alfred. "Fortuna im Mittelalter und in der Renaissance," *Vorträge der Bibliothek Warburg*, 2 (1922-1923), pp. 71-144.

Dormay, Claude. *Histoire de la ville de Sois-sons*. Soissons, 1663-1664.

Dornseiff, Franz. *Das Alphabet in Mystik und Magie*. Berlin, 1925.

Douhaire, Philippe. *Cours sur les apocryphes*. (L'Université catholique, iv-v). Paris, 1838.

Du Cange, Charles D. *Traité historique du chef de saint Jean-Baptiste*. Paris, 1665.

Duchalais, Adolphe. "Etudes sur l'iconologie du moyen âge," *Bibliothèque de l'Ecole des Chartes*, 2nd ser., 5 (1848-1849), pp. 31-44.

———. "Explication de quelques bas-reliefs de la cathédrale de Paris," *Mémoires de la Société royale des antiquaires de France*, 16 (1842), pp. 190-206.

Duchesne, Louis. *Origine du culte chrétien*. Paris, 1889 (Engl. tr. M. L. McClure, *Christian Worship: Its Origin and Evolu-tion*. 5th ed., London and New York, 1927).

———. "Saint Jacques en Galice," *Annales du midi*, 12 (1900), pp. 145-179.

Du Méril, Edélestand P. *Poésies populaires latines du moyen âge*. Paris, 1847.

Dupuis, Charles-François. *Origine de tous les cultes, ou Religion universelle*. 7 vols. Paris, 1795 (2nd ed., 10 vols. Paris, 1835-1836).

Durand, Georges. *Monographie de l'église No-tre-Dame cathédrale d'Amiens*. 2 vols. Paris, 1901-1903.

Durand, Julien. "Légende d'Alexandre le Grand," *Annales archéologiques*, 25 (1865), pp. 141-158.

———. "Monuments figurés du moyen âge ex-écutés d'après les textes liturgiques," *Bul-letin monumental*, 14 (1888), pp. 521-550.

———. "Mosaïque de Sour," *Annales arché-ologiques*, 23 (1863), pp. 278-282; 24 (1864), pp. 5-10; 205-210.

Durand, Paul. *Monographie de la cathédrale de Chartres. Explication des planches*. Paris, 1881.

Durandus, William. *Rationale divinorum offici-orum*. Lyon, 1672. Ed. V. d'Avino. Naples, 1859. Tr. and ed. C. Barthélemy, *Rational ou Manuel des divins offices de Guillaume Durand*, 5 vols. Paris, 1854. Engl. ed. of Book 1: *The Symbolism of Churches and Church Ornaments*, tr. and ed. J. M. Neale and B. Webb, Leeds, 1843 (repr. New York, 1973). Fr. ed. of Book 1: *Du Sym-bolisme dans les églises du moyen âge*, Tours, 1847.

Du Ranquet, Henri. *La Cathédrale de Cler-mont-Ferrand*. 2nd ed. Paris, 1928.

———. *Les Vitraux de la cathédrale de Cler-mont-Ferrand*. Clermont-Ferrand, 1932.

Durliat, Marcel. *La Sculpture romane en Rous-sillon*. 4 vols. 2nd ed., Perpignan, 1950-1954.

Duseval, Eugène. *Visite à la cathédrale d'Ami-ens*, ed. J.B.M. Rose. Amiens, 1853.

Eicken, Heinrich von. *Geschichte und System der mittelalterlichen Weltanschauung*. Stutt-gart, 1887.

Einem, Herbert von. "Fragen um den Bam-berger Reiter," *Studien zur Geschichte der Europäischen Plastik, Festschrift Theodor Müller*, Munich, 1965, pp. 55-62.

Elbern, Victor. *Die eucharistische Kelch im frü-hen Mittelalter*. Berlin, 1964.

Endres, Joseph A. *Honorius Augustodunensis, Beitrag zur Geschichte des geistigen Leb-ens im 12. Jahrhundert*. Kempten and Mu-nich, 1906.

Erec et Enide, roman traduit de l'ancien fran-çais d'après l'édition de Mario Roquis, tr. René Louis. Paris, 1954.

Evans, Joan and Mary S. Serjeantson, eds. *Eng-lish Medieval Lapidaries*. Oxford, 1933.

Fabricius, Johann Albert, ed. *Codex apocryphus Novi Testamenti.* 3 vols. 2nd ed., Hamburg, 1719.

Falk, Ilse. *Studien zu Andrea Pisano.* Hamburg, 1940.

Farcy, Louis de. *Histoire et description des tapisseries de la cathédrale d'Angers.* Lille, 1889.

Fauçon, Maurice. *La Librairie des papes d'Avignon.* 2 vols. Paris, 1886-1887.

Fita y Colomé, Fidel and J. Vinson. *Le Codex de Saint-Jacques de Compostelle.* Paris, 1882.

Fleury, Edouard. *Antiquités et monuments du département de l'Aisne.* 4 vols. Paris and Laon, 1877-1882.

Flodoard of Rheims. *Histoire de l'église métropolitaine de Rheims,* ed. F.-P.-G. Guizot (Collection des mémoires relatif à l'histoire de France, v-vi). Paris, 1824.

Florival, Andrien M. D. de and Etienne Midoux. *Les Vitraux de la cathédrale de Laon.* 2 vols. Paris, 1882-1891.

Forgeais, Arthur. *Collection de plombs historiés trouvés dans la Seine,* ii. *Enseignes de pèlerinages.* Paris, 1863.

Formaggio, Dino. *Botticelli.* London, 1961.

Fortunatus. *Opera poetica* (Monumenta Germanica historica, auctorum antiquissimorum, iv, pt. i). Berlin, 1881.

Freyhan, Robert. "Joachism and the English Apocalypse," *Journal of the Warburg and Courtauld Institutes,* 18 (1955), pp. 211-244.

Frick, Karl, ed. *Chronica minora.* Leipzig, 1892.

Friedman, L. J. *Text and Iconography for Joinville's Credo.* Cambridge, Mass., 1958.

Friend, Albert M. "Carolingian Art in the Abbey of St. Denis," *Art Studies,* i (1923), pp. 67-75.

———. "Two Manuscripts of the School of St. Denis," *Speculum,* i (1926), pp. 59-70.

Frimmel, Theodor von. *Die Apokalypse in der Bilderhandschriften des Mittelalters.* Vienna, 1885.

Gabriel, A. L. *The Educational Ideas of Vincent of Beauvais.* Notre-Dame, 1956.

Gaignières, François Roger. *Les Dessins d'archéologie de Roger de Gaignières,* ed. Joseph Guibert. 3rd ser., 8 vols. Paris, 1911-1914.

Gaussen, Alfred. *Portefeuille archéologique de la Champagne.* 2 vols. Bar-sur-Aube, 1861.

Gauthier, Jules "L'ancienne Collégiale de Saint-Madeleine de Besançon et son portail à figures du XIIIe siècle," *Bulletin archéologique du Comité des travaux historiques et scientifiques,* 1895, pp. 158-168.

Gautier de Coincy. *Les Miracles de la Sainte Vierge,* ed. Alexandre Eusèbe Poquet. Paris, 1857.

Gengaro, Maria Luise, Francesca Leoni and Gemma Villa, eds. *Codici decorati e miniati dell'Ambrosiana, Ebraici e Greci.* Milan, 1959.

Germain, Michel. *Histoire de l'abbaye royale de Notre-Dame de Soissons.* Paris, 1675.

Germain de Maidy, Léon. "Images de Saint Michel psychopompe sur des tombeaux," *Mémoires de la Société d'archéologie lorraine et du musée historique lorrain,* 9 (1909), pp. 134-138.

Gervase of Canterbury. *The Historical Works of Gervase of Canterbury,* ed. William Stubbs. 2 vols. London, 1879-1880.

Gervase of Tilbury. *Otia imperialia* (Scriptores rerum Brunsvicensium, i), ed. G. W. von Leibnitz. Hanover, 1707.

Ghellinck, Joseph de. *L'Essor de la littérature latine au XIIe siècle.* 2 vols. Brussels, 1946.

Ghyka, M. C. *Philosophie et mystique du nombre.* Paris, 1952.

Gimpel, J. *Les Bâtisseurs des cathédrales.* Paris, 1958 (Engl. tr. C. F. Barnes, Jr., *The Cathedral Builders.* New York, 1961).

Ginzberg, Louis. *Legends of the Bible.* New York, 1956.

———. *Legends of the Jews.* 7 vols. Philadelphia, 1925-1947 (abridged ed., Philadelphia, 1956).

Girardot, Auguste Théodore, "Le Drame au XVIe siècle; Mystère des actes des apôtres," *Annales archéologiques,* 13 (1853), pp. 16-23.

Giry, Arthur. "Cinquième exposition de l'union centrale des beaux-arts appliqués à l'industrie. La tapisserie de l'Apocalypse de Saint-Maurice d'Angers," *L'Art,* 4 (1876), pp. 301-307.

———. *Manuel de diplomatique.* Paris, 1894 (repr. New York, 1967).

Glossa ordinaria (Migne, *Patrologiae Cursus Completus,* Paris, 1879, vol. 113), traditionally assigned to Walafrid Strabo.

Gnudi, Cesare. *Giotto.* Milan, 1959.

Goldschmidt, Adolph and Kurt Weitzmann. *Die byzantinischen Elfenbeinskulpturen des X-XIII Jahrhunderts.* 2 vols. Berlin, 1930-1934.

Goodenough, Edwin R. *By Light; The Mystic Gospel of Hellenistic Judaism.* New Haven, 1935.

Gori, Antonio Francesco. *Thesaurus veterum diptychorum consularum et ecclesiasticorum.* 3 vols. Florence, 1759.

Grabar, André and Carl Nordenfalk. *Romanesque Painting from the Eleventh to the Thirteenth Century,* tr. Stuart Gilbert. (Skira ed.) New York, 1958.

Graiffe, Elie. *La Gaule chrétienne à l'époque romaine.* 3 vols. Paris, 1947.

Gregory of Tours. *Histoire des Francs,* tr. Robert Latouche. 2 vols. Paris, 1963-1965 (Engl. tr. O. M. Dalton, *The History of the Franks.* 2 vols. Oxford, 1927).

Grimme, Ernst Günther. *Aachener Goldschmiedekunst im Mittelalters von Karl dem Grossen bis zu Karl V.* Cologne, 1957.

———. "Das Karlsfenster in der Kathedrale von Chartres," *Aachener Kunstblätter,* 20 (1960-1961), pp. 11-24.

Grinnell, Robert. "Iconography and Philosophy in the Crucifixion Window at Poitiers," *Art Bulletin,* 28 (1946), pp. 171-196.

Gripkey, Mary Vincentine. *The Blessed Virgin as Mediatrix in the Latin and Old French Legends Prior to the Fourteenth Century* (Catholic University of America Studies in Romance Language and Literature). Washington, 1938.

Grivot, Denis and George Zarnecki. *Gislebertus, Sculptor of Autun.* New York, 1961.

Grodecki, Louis. *Chartres,* tr. K. Delavenay. New York, 1963.

———. *Ivoires français.* Paris, 1947.

———. "Le Maître de Saint-Eustache de la cathédrale de Chartres," *Gedenkschrift Ernst Gall,* eds. M. Kuhn and L. Grodecki, Munich, 1965, pp. 171-194.

———. "A propos des vitraux de Châlons-sur-Marne. Deux points d'iconographie mosane," *L'Art mosan,* ed. Pierre Francastel, Paris, 1953, pp. 161-170.

———. "The Transept Portals of Chartres Cathedral," *Art Bulletin,* 33 (1951), pp. 156-167.

———. "Un vitrail démembré de la cathédrale de Soissons," *Gazette des beaux-arts,* 6th ser., 42 (1953), pp. 169-176.

———. "Les vitraux allégoriques de Saint-Denis," *Art de France,* 1 (1961), pp. 19-46.

Grossman, Ursula. "Studien zur Zahlensymbolik des Frühmittelalters," *Zeitschrift für Katholische Theologie,* 76 (1954), pp. 19-54.

Grundmann, Herbert. *Studien über Joachim von Floris.* Leipzig, 1927.

Gruter, Jan. *Inscriptiones antiquae totiva orbis romani.* Amsterdam, 1707.

Guénebault, Louis-Jean. *Dictionnaire iconographique des figures, légendes et actes des saints.* Paris, 1850.

Guéranger, Prosper. *L'Année liturgique.* 9 vols. 1841-1866. (Engl. ed., *The Liturgical Year,* tr. Laurance Shepherd, Dublin, 9 vols., 1870-1871.)

Guérard, Benjamin Edme Charles, ed. *Cartulaire de l'abbaye de Saint-Père de Chartres* (Collection de documents inédits sur l'histoire de France. Ser. 1. Collection des cartulaires, I-II). Paris, 1840.

———. *Cartulaire de l'église Notre-Dame de Paris* (Collection de documents inédits sur l'histoire de France. Ser. 1. Collection des cartulaires, IV-VII). Paris, 1840-1867.

Guignard, Philippe. *Mémoires fournis aux peintres pour une tapisserie de Saint-Urbain de Troyes.* Troyes, 1851.

Guilhermy, Ferdinand de. *Description de Notre-Dame cathédrale de Paris.* Paris, 1856.

———. *Description de la Sainte-Chapelle.* Paris, 1887.

———. "Iconographie des fabliaux. Aristote et Virgile," *Annales archéologiques,* 6 (1847), pp. 145-155.

———. "Sculpture chrétienne. Fabliaux représentés dans les églises. Lai d'Aristote." *Revue générale de l'architecture et des travaux publics,* 1 (1840), cols. 385-396.

Guldan, Ernst. *Eva und Maria, eine Antithese als Bildmotiv.* Graz and Cologne, 1966.

Hahnloser, Hans. *Villard de Honnecourt. Kritische Gesamtausgabe des Bauhüttenbuches Ms. fr. 19093 der Parisier Nationalbibliothek.* Vienna, 1935.

Hamann, Richard. *Die Abteikirche von St. Gilles und ihre künstlerische Nachfolge.* Berlin, 1955.

Harnack, Adolf. *Geschichte der altchristlichen Litteratur bis Eusebius.* 2 vols. Leipzig, 1893-1904.

Hartlaub, G. F. *Zauber des Spiegels; Geschichte*

und Bedeutung des Spiegels in der Kunst. Munich, 1951.

Haskins, C. H. *The Renaissance of the Twelfth Century.* Cambridge, Mass., 1927.

Haug, Hans and others. *La Cathédrale de Strasbourg.* Strasbourg, 1957.

Hauréau, Berthélemy. *Histoire de la philosophie scolastique.* 3 vols. Paris, 1872-1880.

————. "Mémoire sur la vie et quelques oeuvres d'Alain de Lille," *Mémoires de l'Académie des inscriptions et belles-lettres,* 37 (1886), pt. 1, pp. 1-27.

————. *Les Oeuvres de Hugues de Saint-Victor: essai critique.* Paris, 1886 (repr. Frankfurt-am-Main, 1963).

Hayward, Jane and Louis Grodecki. "Les vitraux de la cathédrale d'Angers," *Bulletin monumental,* 124 (1966), pp. 13-17.

Heider, Gustav. "Das Glücksrad und dessen Anwendung in der christlichen kunst," *Mitteilungen der kaiserlich und königlich Zentral-kommission* (Vienna), May 1859, pp. 113-124.

Heimann, Adelheid. "Trinitas Creator Mundi," *Journal of the Warburg and Courtauld Institutes,* 2 (1938-1939), pp. 42-52.

Helbig, Jules. "Madame Félicie d'Ayzac," *Revue de l'art chrétien,* 4 (1886), pp. 1-12.

Héliot, Pierre. "La Collégiale Saint-Nicolas d'Amiens et l'architecture picarde," *Mélanges offerts à René Crozet,* Poitiers, 1966, II, pp. 985-992.

Helmsdorfer, Georg. *Christliche Kunstsymbolik und Ikonographie.* Frankfurt, 1839.

Hennecke, Edgar. *New Testament Apocrypha,* ed. W. Schneemelcher and R. McL. Wilson. 2 vols. Philadelphia, 1963-1965.

Hermas. *The Shepherd,* tr. and ed. K. Lake, *The Apostolic Fathers* (Loeb Classical Library, II). London and New York, 1913; tr. and ed. R. Joly. "Le Pasteur Hermas," *Sources chrétiennes,* 53 (1958), pp. 99-113.

Herolt, Johannes. *Sermones discipuli de sanctis: cum promptuario exemplorum,* London, 1510.

Herrad of Landsberg. *Hortus deliciarum,* ed. A. Straub and G. Keller. Strasbourg, 1879-1899.

————. *Hortus deliciarum,* ed. Joseph Walter. Strasbourg and Paris, 1952.

Hilka, Alfons, ed. *Eine altfranzösische moralisierende Bearbeitung des Liber de monstruosis hominibus orientis aus Thomas van Cantimpré, De naturis rerum, nach der einzigen Handschrift (Paris, Bibl. Nat., ms. fr. 15106).* Berlin, 1933.

Hinkle, William M. "The Cosmic and the Terrestrial Cycles on the Virgin Portal of Notre-Dame," *Art Bulletin,* 49 (1967), pp. 287-296.

————. "The King and the Pope on the Virgin Portal of Notre-Dame," *Art Bulletin,* 48 (1966), pp. 1-13.

————. *The Portal of the Saints of Reims Cathedral.* New York, 1965.

Hippeau, Celestin. "Le Bestiaire divin de Guillaume, clerc de Normandie, trouvère du XIIIe siècle," *Mémoires de la Société des antiquaires de Normandie,* 9 (1851), pp. 317-476.

Histoire littéraire de la France, ed. Antoine Rivet de la Grange and others. 38 vols. Paris, 1733-1949.

Hoffeld, Jeffrey M. "Adam's Two Wives," *The Metropolitan Museum of Art Bulletin,* 26 (1968), pp. 430-440.

Hoffmann, Heinrich. *Karl der Grosse im Bilder des Geschichteschreibung des frühen Mittelalters, 850-1250.* Berlin, 1919.

Hoffmann, Konrad. *Taufsymbolik im mittelalterlichen Herrscherbild.* Düsseldorf, 1968.

Holder-Egger, Oswald, ed. *Cronica fratris Salimbene de Adam ordinis minorum* (Monumenta Germaniae historica scriptorum, XXXII). Hanover, 1905-1913 (repr. Hanover, 1963).

Holt, Elizabeth. *A Documentary History of Art.* 2 vols. New York, 1957.

Homburger, Otto. *Der Trivulzio-Kandelaber; ein Meisterwerk frühgotischer Plastik.* Zurich, 1949.

Hopper, Vincent F. *Medieval Number Symbolism.* New York, 1938.

Houvet, Etienne. *Cathédrale de Chartres; Portail nord (XIIIe siècle).* 2 vols. Chelles, 1919.

————. *Cathédrale de Chartres; Portail Occidental ou royal (XIIe siècle).* Chelles, 1919.

————. *Cathédrale de Chartres; Portail sud (XIIIe siècle).* 2 vols. Chelles, 1919 (repr. Chelles, 1926).

Hubert, Jean. "L'Abbatiale Notre-Dame de Déols," *Bulletin monumental,* 86 (1927), pp. 5-66.

————. "Les Origines de Notre-Dame de Paris," *Huitième centenaire de Notre-Dame de Paris* (Bibliothèque de la Société d'histoire

ecclésiastique de la France), Paris, 1967, pp. 1-22.

Hucher, Eugène. "L'Immaculée Conception figurée sur les monuments du moyen âge et de la renaissance," *Bulletin monumental*, 21 (1855), pp. 145-148.

——. *Vitraux peints de la cathédrale du Mans*. Paris and Le Mans, 1865.

Hugh of Saint Victor. *Eruditionis didascalicae*, VII, iv, Migne, *P. L.*, 176, col. 814. Tr. Jerome Taylor, *Didascalicon, A Medieval Guide to the Arts*. New York, 1961.

——. *Selected Spiritual Writings*, tr. by a Religious of C.S.M.V. New York, 1962.

Isidore of Seville. *Isidori Hispalensis episcopi etymologiarum sive originum*, ed. Wallace Martin Lindsay. Oxford, 1911.

l'Isle, Joseph de. *Histoire de la vie, du culte, de la translation des reliques et des miracles de St. Nicolas, évêque de Myre*. Nancy, 1745.

Jacob of Voragine. *The Golden Legend, or Lives of the Saints as Englished by William Caxton*, ed. F. S. Ellis. 7 vols. London, 1900 (repr. London, 1931-1935).

——. *La Légende dorée*, ed. Gustave Brunet. 2 vols. Paris, 1843.

——. *Legenda Aurea*, ed. Johann Georg Theodor Graesse. Dresden and Leipzig, 1826.

——. *La Légende dorée de Jacobus de Voragine*, ed. and tr. J.-B.M. Roze. 2 vols. Paris, 1902 (repr. Paris, 1967).

——. *La Légende dorée*, tr. Téodor de Wyzewa. Paris, 1929.

Jalabert, Denise. *La Flore sculptée des monuments du moyen âge en France*. Paris, 1965.

——. "La Flore sculptée de la Sainte-Chapelle," *Pro Arte*, 67-68 (1947), pp. 451-456.

——. "La première flore gothique aux chapiteaux de Notre-Dame de Paris," *Gazette des beaux-arts*, 5 (1931), pp. 283-304.

James, Montague Rhodes. *The Apocalypse in Art*. London and Oxford, 1931.

——. *The Apocryphal New Testament*. London and Oxford, 1924 (corrected ed. London and Oxford, 1953).

——. "Pictor in Carmine," *Archaeologia or Miscellaneous Tracts Relating to Antiquity*, 94 (1951), pp. 139-166.

Jameson, Anna. *Sacred and Legendary Art*. 2 vols. London, 1849.

Jantzen, Hans. *Ottonische Kunst*, Munich, 1947.

Jean le Marchant. *Le Livre des miracles de Notre-Dame de Chartres écrit en vers, au XIIIe siècle par Jehan le Marchant*, ed. G. Duplessis. Chartres, 1855.

Jeremias, Joachim. *Heiligengraber in Jesu Umwelt, eine Untersuchung zur Volkreligion der Zeit Jesu*. Göttingen, 1958.

Joanne, Adolphe, ed. *Le Guide Joanne. Bourgogne et Morvan*. Paris, 1892.

[Jean, sire de] Joinville and Geffroi de Villehardouin. *Chronicles of the Crusades*, ed. Margaret R. B. Shaw. (Penguin Books), Baltimore, 1963.

Jones, Leslie Weber. "The Influence of Cassiodorus on Medieval Culture," *Speculum*, 20 (1945), pp. 433-442.

Jourdain, Louis and Antoine-Theophile Duval. "Le grand portail de la cathédrale d'Amiens, les vertus et les vices," *Bulletin monumental*, 11 (1845), pp. 430-469.

——. *Le Portail Saint-Honoré, dit de la Vierge, de la cathédrale d'Amiens*. Amiens, 1844.

Jubinal, Achille and Eloi Johanneau, eds. *Des 25 manières de vilains, pièce du 13e siècle*. Paris, 1834.

Jungmann, Joseph A. *The Early Liturgy*. Notre Dame, Ind., 1959.

Kantorowicz, Ernst. "Gods in Uniform," *Proceedings of the American Philosophical Society*, 105 (1961), pp. 368-393 (repr. in *Selected Studies*. New York, 1965, pp. 7-24).

——. "The 'King's Advent' and the Enigmatic Panels in the Doors of Santa Sabina," *Art Bulletin*, 26 (1944), pp. 209-231.

Katzenellenbogen, Adolf. *Allegories of the Virtues and Vices in Medieval Art*. London, 1939.

——. "The Central Tympanum at Vézelay, Its Encyclopedic Meaning and Its Relations to the First Crusade," *Art Bulletin*, 26 (1944), pp. 141-151.

——. "Prophets of the West Façade of the Cathedral of Amiens," *Gazette des beaux-arts*, 6th ser., 40 (1952), pp. 241-260.

——. "The Representation of the Seven Liberal Arts," *Twelfth-Century Europe and the Foundations of Modern Society*, ed. Marshall Clagett and others, Madison, Wisc., 1961, pp. 39-55.

——. *The Sculptural Programs of Chartres Cathedral*. Baltimore, 1959.

————. "Tympanum and Archivolts on the Portal of St.-Honoré at Amiens," *De Artibus Opuscula XL; Essays in Honor of Erwin Panofsky*, New York 1961, pp. 280-290.

Kehrer, Hugo. *Die heiligen drei Könige in Literatur und Kunst*. 2 vols. Leipzig, 1908-1909.

Kendrick, Thomas D. *Late Saxon and Viking Art*. London, 1949.

Kisch, Guido. "The Yellow Badge in History," *Historia Judaica*, 19 (1957), pp. 89-146.

————. "The School of Chartres," *Twelfth-Century Europe and the Foundations of Modern Society*, ed. Marshall Clagett and others, Madison, Wisc., 1961, pp. 3-15.

Klibansky, Raymond. "Standing on the Shoulders of Giants," *Isis*, 26 (1936), pp. 147-149.

Koch, Georg F. "Virgil im Korbe," *Festschrift für Erich Meyer zum sechzigsten Geburtstag 29 Oktober 1957*, Hamburg, 1957, pp. 105-121.

Koechlin, Raymond. *Les Ivoires gothiques français*. 3 vols. Paris, 1924.

Köhler, Wilhelm. *Die karolingischen Miniaturen*. 4 vols. Berlin, 1930-1971.

Koseleff, Olga. *Die Monatsdarstellungen der französischen Plastik des 12. Jahrhunderts*. Basel, 1934.

Kraus, Franz Xavier. *Geschichte der christliche Kunst*. 2 vols. Freiburg-im-Breisgau, 1896-1908.

Kraus, Henry. *The Living Theater of Medieval Art*. Bloomington and London, 1967.

Krautheimer, Richard. "Introduction to an 'Iconography of Medieval Architecture,'" *Journal of the Warburg and Courtauld Institutes*, 5 (1942), pp. 1-33 (repr. *Studies in Early Christian, Medieval and Renaissance Art*, New York, 1969, pp. 115-150).

Künstle, Karl. *Ikonographie der christlichen Kunst*. 2 vols. Freiburg-im-Breisgau, 1926-1928.

Labande, Edmond René. "Recherches sur les pèlerins dans l'Europe des XIe et XIIe siècles," *Cahiers de civilisation médiévale*, 1 (1958), pp. 339-347.

Labbe, Philippe and G. Gossart, eds. *Sacrosancta concilia*. 21 vols. Venice, 1728-1733.

Labriolle, Pierre de. *La Réaction païenne; Etude sur la polémique anti-chrétienne du Ier au VIe siècle*. Paris, 1950.

Lafond, Jean, "Les Vitraux de la cathédrale Saint-Etienne d'Auxerre," *Congrès archéologique*, 116 (1958), pp. 60-75.

Lafontaine-Dosogne, Jacqueline. *Iconographie de l'enfance de la Vierge dans l'empire byzantin et en occident*. 2 vols. Brussels, 1964-1965.

Lajard, Felix. "Jean de Paris, Dominicain," *Histoire littéraire de la France*, 25 (1869), pp. 244-270.

————. "Lorens (Laurentius Gallus) Frère Prêcheur," *Histoire littéraire de la France*, 19 (1838), pp. 397-405.

Lambert, Elie. "Les portails sculptés de la cathédrale de Laon," *Gazette des beaux-arts*, 17 (1937), pp. 83-98.

Lambin, Emile. *Les Eglises des environs de Paris, etudiées au point de vue de la flore ornamentale*. Paris, 1896.

————. *La Flore gothique*. Paris, 1893.

————. *La Flore des grandes cathédrales de France* (Bibliothèque de la semaine des constructeurs). Paris, 1897.

Lammers, Walther. *Geschichtsdenken und Geschichtsbild im Mittelalter*. Darmstadt, 1961.

Långfors, Arthur, ed. *Le Bestiaire d'amour en vers par Richard de Fournival*. Helsinki, 1924.

————. *Le Roman de Fauvel par Gervais du Bus publié d'après tous les manuscrits connus* (Société des anciens textes français). Paris, 1914.

Lanore, Maurice. "Reconstruction de la façade de la cathédrale de Chartres au XIIe siècle, étude chronologique," *Revue de l'art chrétien*, 10 (1899), pp. 328-335.

Lapeyre, André. *Des Façades occidentales de Saint-Denis et de Chartres aux portails de Laon*. Paris, 1960.

Laroche, Jules. "Iconographie de saint Nicolas," *Revue de l'art chrétien*, 34 (1891), pp. 104-119.

Lasteyrie, Charles de. *L'Abbaye de Saint-Martial de Limoges, étude historique, économique et archéologique*. Paris, 1901.

Lasteyrie, Ferdinand de. *Histoire de la peinture sur verre d'après ses monumens en France*. 2 vols. Paris, 1853-1857.

Lasteyrie, Robert de. "La Déviation de l'axe des églises, est-elle symbolique?" *Mémoires de l'Institut national de France, Académie des inscriptions et belles-lettres*, 37 (1906), pt.

2, pp. 277-308, and *Bulletin monumental*, 69 (1905), pp. 422-459.

———. "Etude archéologique sur l'église d'Aulnay (Charente-Inférieure)," *Gazette archéologique*, 11 (1886), pp. 277-292.

———. "Etudes sur la sculpture française du moyen âge," *Monuments Piot*, 8 (1902).

——— and Eugène Lefèvre-Pontalis. *Bibliographie générale des travaux historiques et archéologiques publiés par les sociétés savantes*. 6 vols. Paris, 1888-1918.

Lauchert, Friedrich. *Geschichte des Physiologus*. Strasbourg, 1889.

Lauer, Philippe. *Les Enluminures romanes des manuscrits de la Bibliothèque nationale*. Paris, 1927.

Launay, N. de. "Mélanges: Les artistes parisiens au moyen âge," *Revue de l'art chrétien*, 46 (1896), pp. 207-213, 394-401.

Laurière, Jules de. "Chronique," *Bulletin monumental*, 47 (1881), pp. 312-314.

Lavergne, Adrien. *Les Chemins de Saint-Jacques en Gascogne*. Bordeaux, 1887.

Lawrence, Marion. "Maria Regina," *Art Bulletin*, 7 (1925), pp. 150-161.

Lebeuf, Jean. *Dissertations sur l'histoire ecclésiastique et civil de Paris*. 3 vols. Paris, 1739-1741.

———. *Histoire de la ville et de tout le diocèse de Paris*, ed. H. Cocheris. Paris, 1865.

Lecler, André and Jules de Verneilh. *La Vierge ouvrante de Boubon*. Limoges, 1898.

Leclerc, J.-V. "Aimeric Picaudi de Parthenai. Cantique et itinéraire des pèlerins de Saint-Jacques de Compostelle," *Histoire littéraire de la France*, 21 (1847), pp. 272-292.

Lecoy de la Marche, Albert. *Saint-Martin*. Tours, 1881 (2nd ed., 1890).

Ledeuil, Justin. *Notice sur Semur-en-Auxois*. Semur, 1884.

Leibeschütz, Hans. *Das allegorische Weltbild der heiligen Hildegard von Bingen*. Berlin, 1930 (repr. Darmstadt, 1964).

Leibnitz, G. W. von, ed. *Scriptores Rerum Brunsvicensium*. 3 vols. Hanover, 1707-1711.

Lejeune, Rita and Jacques Stiennon. *La Légende de Roland dans l'art du moyen âge*. Brussels, 1966.

Le livre des miracles de Notre-Dame de Chartres écrit en vers, au XIIIᵉ siècle par Jean le Marchant. Georges Duplessis, ed., Chartres, 1855.

Lemoine, M. "L'Oeuvre encyclopédique de Vin-cent de Beauvais," *La Pensée encyclopédique* (UNESCO), Neuchâtel, 1966, pp. 77-85.

Le Noble, Alexandre. "Notice sur le Hortus deliciarum, encyclopédie manuscrite, composée au douzième siècle, par Herrade de Landsberg," *Bibliothèque de l'Ecole des Chartes*, 1 (1839-1840), pp. 239-261.

Lenoir, Albert. *Architecture monastique*. 2 vols. Paris, 1852-1856.

———. *Statistique monumentale de Paris*. 2 vols. Paris, 1867.

Lenoir, Alexandre. *Description historique et chronologique des monumens de sculpture réunis au musée des monumens français*. 6th ed. (Year x), Paris, 1802.

———. "Rapport sur la cathédrale de Cambray," *Mémoires de l'Académie celtique*, Paris, 4 (1809), pp. 412-419.

Lenormant, Charles. "Anciennes étoffes. De l'étoffe conservée à la couture du Mans; De l'étoffe dite de S. Mesme, à Chinon," *Mélanges d'archéologie*, 3 (1853), pp. 116-141.

Le Pasteur Hermas, tr. and ed. R. Joly, *Sources chrétiennes* 53 (1958), pp. 99-133.

Lepinois, Ernest de Bouchère de and Lucien Merlet. *Cartulaire de Notre-Dame de Chartres*. 3 vols. Chartres, 1862-1865.

———. *Histoire de Chartres*. 2 vols. Chartres. 1854-1858.

Leroquais, Victor. *Les Bréviaires manuscrits des bibliothèques publiques de France*. 2 vols. Paris, 1934.

———. *Les Livres d'heures manuscrits des bibliothèques publiques de France*. 3 vols. Paris, 1927.

———. *Les Psautiers manuscrits latins des bibliothèques publiques de France*. 2 vols. Macon, 1940-1941.

Le Roux de Lincy, Antoine. *Le Livre des proverbes français*. 2 vols. Paris, 1859.

——— and L. M. Tisserand, eds. *Paris et ses historiens au XIVe et XVe siècles* (Histoire générale de Paris, VI), Paris, 1867.

Lersch, Laurenz. "Die Irrungen der Liebe. Mittelalterliches Elfenbeinrelief in Aachen," *Jahrbücher des Vereins von Alterthumsfreunden in Rheinlande*, 11 (1847), pp. 123-14.

Lespinasse, René de. *Les Métiers et corporations de la ville de Paris* (Histoire générale de Paris, I and II). Paris, 1879-1897.

Le Touzé de Longuemar, Alphonse. "Un Mot sur quelques questions archéologiques trai-

tées à Paris, Session de 1857." *Bulletin monumental*, 23 (1857), pp. 269-279.

Lévy, Edmond and Jean-Baptiste Capronnier. *Histoire de la peinture sur verre*. Brussels, 1860.

Liebeschütz, Hans. *Das Allegorische Weltbild der Heiligen Hildegard von Bingen* (Studien der Bibliothek Warburg, 16), Berlin, 1930.

Linas, Charles de. "Emaillerie byzantine; La collection Svenigorodskoi," *Revue de l'art chrétien*, 4th ser., 3 (1885), pp. 203-218.

——. "Note sur un attribut de Saint Joseph," *Mémoires de la Société nationale des antiquaires de France*, 1884, p. 104.

——. "Le Trésor et la bibliothèque de l'église métropolitaine de Rouen au XIIe siècle," *Revue de l'art chrétien*, 36 (1886), pp. 455-467.

Lindet, Léon. "Les Représentations allégoriques de moulin et du pressoir dans l'art chrétien," *Revue archéologique*, 3rd ser., 36 (1900), pp. 403-413.

Loisel, Armand. *La Cathédrale de Rouen*. Paris, 1927.

Longnon, Auguste H. *Documents parisiens sur l'iconographie de Saint-Louis*. Paris, 1882.

Lubac, Henri de. *Corpus mysticum, l'eucharistie et l'église au moyen âge. Etude historique.* Paris, 1944.

Lübke, Wilhelm. *Geschichte der Plastik*. 2 vols. Leipzig, 1871.

Ludolf of Saxony. *Vita Christi*, ed. L. M. Rigollot. Paris, 1870.

Lutz, Cora Elizabeth. *Remigii Autissiodorensis commentum in Martianum Capellam*. Leyden, 1962.

Lutz, Joseph and Paul Perdrizet. *Speculum Humanae Salvationis*. 2 vols. Mulhouse, 1907.

Maillard, Elisa. *Les Sculptures de la cathédrale de Poitiers*. Poitiers, 1921.

Mâle, Emile. *Art et artistes du moyen âge*. Paris, 1928 (re-ed. Paris, 1968).

——. *L'Art religieux après le Concile de Trente*. Paris, 1932. (Bollingen Eng. ed. forthcoming.)

——. *L'Art religieux de la fin du moyen âge en France*. 5th ed. Paris, 1929. (Bollingen Eng. ed. forthcoming.)

——. *La Cathédrale d'Albi*. Paris, 1950.

——. La Cathédrale de Reims," *Gazette des beaux-arts*, 5th ser., 3 (1921), pp. 73-88.

——. "Les Chapiteaux romans du musée de Toulouse et l'école toulousaine du XIIe siècle," *Revue archéologique*, 3rd ser., 20 (1892), pp. 28-35; 176-197.

——. "La Légende de la mort de Cain, à propos d'un chapiteau de Tarbes," *Revue archéologique*, 21 (1893), pp. 186-194.

——. *Notre-Dame de Chartres*. Paris, 1948.

——. "La Part de Suger dans la création de l'iconographie du moyen âge," *Revue de l'art ancien et moderne*, 35 (1914), pp. 91-102.

——. *Quomodo Sibyllas recentiores artifices repraesentaverint*. Paris, 1899.

——. *Religious Art in France: The Twelfth Century, A Study of the Origins of Medieval Iconography*, ed. Harry Bober, tr. Marthiel Mathews. (Bollingen Series xc:1.) Princeton, 1978.

——. *Rome et ses vieilles églises*. Paris, 1942 (Engl. tr. D. Truxton, *The Early Churches of Rome*. London, 1960).

Marchand, J. and Jean-Jacques Bourrassé. *Verrières du choeur de l'église métropolitaine de Tours*. Paris, 1849.

Marquet de Vasselot, J.-J. "Les influences orientales," *Histoire de l'art*, ed. A. Michel, Paris, 1905, 1, pp. 395-423, 882-889.

Marle, Raimond van. *Iconographie de l'art profane au moyen âge et à la renaissance*. 2 vols. The Hague, 1931-1932.

Marrou, Henri-Irenée. *Saint Augustin et la fin de la culture antique*. Paris, 1937.

Martianus Capella, ed. Francis Eyssenhardt. Leipzig, 1866.

Martianus Capella, ed. Adolphus Dick. Leipzig, 1925.

Martin, Henry. *Les Joyaux de l'Arsenal*, 1. *Psautier de Saint Louis et de Blanche de Castille*. Paris, 1910.

——. *La Légende de Saint Denis*. Paris, 1908.

Martin, John Rupert. *The Illustration of the Heavenly Ladder of John Climacus*. Princeton, 1954.

Mas-Latrie, Jacques M. J. Louis, comte de. *Trésor de chronologie*. Paris, 1889.

Massignon, Louis, and others. *Les Sept Dormants d'Ephèse (Ahl-al-Kahf) en Islam et en chrétienté. Recueil documentaire iconographique.* 4 fasc. Paris, 1955-1958.

Masson, André. *L'Eglise abbatiale Saint-Ouen de Rouen*. Paris, 1927.

Maury, Alfred. *Essai sur les légendes pieuses du moyen âge*. Paris, 1843.

——. "Recherches sur l'origine des repré-

sentations figurées de la psychostasie ou pèsement des âmes et sur les croyances qui s'y rattachaient," *Revue archéologique*, 1 (1844), pp. 291-295.

McCulloch, Florence. *Medieval Latin and French Bestiaries.* Chapel Hill, N.C., 1960.

McKinlay, Arthur P. "Stylistic Tests and the Chronology of the Works of Boethius," *Harvard Studies in Classical Philology*, 18 (1907), pp. 123-156.

Medding, Wolfgang. *Die Westportale der Kathedrale von Amiens und ihre Meister.* Augsburg, 1930.

Meditations on the Life of Christ, an Illustrated Manuscript of the Fourteenth Century, Paris, Bibliothèque Nationale, ms. ital. 155, tr. Isa Ragusa, ed. Rosalie B. Green. Princeton, 1961 (repr. and pb. ed., 1975).

Meer, Frederick van der. *Maiestas Domini: Théophanies de l'apocalypse dans l'art chrétien.* Rome and Paris, 1938.

———— and Christine Mohrmann. *Atlas of the Early Christian World.* 2nd ed. London, 1966.

Megenberg, Konrad von. *Von der Sel; eine Übertragung aus dem Liber de proprietatibus rerum des Bartholomäus Anglicus,* ed. Georg Steer. Munich, 1966.

Mély, Fernand de. "La croix des premiers croisés," *Revue de l'art chrétien*, 33 (1890), pp. 297-306.

————. "La crosse dite de Ragenfroid," *Gazette archéologique*, 13 (1888), pp. 109-123.

————. "Etude iconographique sur les vitraux du treizième siècle de la cathédrale de Chartres," *Revue de l'art chrétien*, 38 (1888), pp. 413-429.

————. *Les Lapidaires de l'antiquité et du moyen âge.* 3 vols. Paris, 1898.

Menzel, Wolfgang. *Christliche Symbolik.* 2 vols. Regensburg, 1856.

Méril, Edelstand du. *Les Origines latines du théâtre moderne.* Paris, 1849 (facs. ed., Leipzig and Paris, 1897).

Merimée, Prosper. "Les Arts libéraux au Puy," *Annales archéologiques*, 10 (1850), pp. 287-290.

————. *Notice sur les peintures de Saint-Savin.* Paris, 1845.

Mesplé, Paul. *Toulouse, Musée des Augustins, Les sculptures romanes.* Paris, 1961.

Metz, Peter. *The Golden Gospels of Echternach, Codex aureus Epternacensis,* transl. Ilse Schreier and Peter Gorge. New York [1957].

Meyer, Paul. "Notice de quelques mss. de la collection Libri, à Florence, I," *Romania*, 14 (1885), pp. 484-548.

————. "Notice sur le manuscrit II. 6. 24 de la bibliothèque de l'Université de Cambridge, vi, *Le Lucidaire* traduit par Gillebert de Cambres," *Notices et extraits des manuscrits de la Bibliothèque nationale et autres bibliothèques*, 32 (1888), pp. 72-81.

————. "Notice sur un manuscrit d'Orléans contenant d'anciens miracles de la Vierge en vers français," *Notices et extraits des manuscrits de la Bibliothèque nationale et autres bibliothèques*, 34 (1895), pp. 31-56.

Michel, Charles and P. Peeters, eds. *Evangiles apocryphes.* 2 vols. Paris, 1914-1924.

Michel, Henri. *Traité de l'astrolabe.* Paris, 1947.

Michelet, Jules. *Histoire de France.* 11 vols. (vols. VII-XVII). Paris, 1855-1867.

Migne, J.-P., ed. *Dictionnaire des apocryphes,* tr. Gustave Brunet. 2 vols. Paris, 1856-1858.

————. *Patrologia cursus completus, Series graeca.* 161 vols. Paris, 1857-1904.

————. *Patrologia cursus completus, Series latina.* 217 vols. Paris, 1844-1905.

Mila y Fontanals, M. "De la poésie popular gallega," *Romania*, 6 (1877), pp. 47-75.

Milford, H., ed. *The Book of Vices and Virtues: A Fourteenth Century English Translation of the Somme le Roi of Lorens d'Orléans* (Early English Text Society). Oxford, 1942.

Millar, Eric George, ed. *An Illuminated Manuscript of La Somme le Roy, attributed to the Parisian Miniaturist Honoré* (Roxburghe Club). Oxford, 1953.

Millet, Gabriel. *Recherches sur l'iconographie de l'Evangile.* Paris, 1916 (repr. Paris, 1960).

Millin, Aubin Louis. *Antiquités nationales.* 7 vols. Paris. 1790-1799.

Missale Romanum, The Missal in Latin and English, Being the text of the Missale Romanum, London, Burns Oates and Washbourne, 1950.

Moé, Emile A. van. *L'Apocalypse de Saint-Sever, Manuscrit latin 8878 de la Bibliothèque nationale (XIe siècle).* Paris, 1943.

Möller, K. "Abendmahl," *Reallexikon zur deutschen Kunstgeschichte* (ed. O. Schmitt). Stuttgart, 1937, I, cols. 28-41.

Molanus, Johannes. *De historia sacrarum imaginum et picturarum* (1580), ed. J. N. Paquot. Louvain, 1771.

Moléon, L. de (J.-B. Le Brun des Marettes). *Voyages liturgiques de France.* Paris, 1718.

Molinier, Emile. *Histoire générale des arts appliqués à l'industrie du 5e à la fin du 18e siècle, 1. Ivoires.* Paris, 1896.

———. *Les Manuscrits et les miniatures.* Paris, 1892.

Molsdorf, Wilhelm. *Christliche Symbolik der mittelalterlichen Kunst.* 2nd ed., Leipzig, 1926.

Montfaucon, Bernard de. *Antiquité expliqué et representée en figures.* 5 vols. Paris, 1722.

———. *Bibliotheca bibliothecarum manuscriptorum nova.* 2 vols. Paris, 1739.

———. *Les Monumens de la monarchie françoise.* 5 vols. Paris, 1729-1733.

Montluisant, Gobineau de. "Notre-Dame de Paris," *Annales archéologiques,* 21 (1861), pp. 137-147, 210-221.

Monumenta Germaniae Historica, Poetae latini medii aevi. 5 vols. Munich, 1880-1939.

Moore, Philip S. "The Authorship of the *Allegoriae super Vetus et Novum Testamentum,*" *The New Scholasticism,* 9 (1935), pp. 209-225.

Morand, Jerome. *Histoire de la Sainte-Chapelle royale du palais.* Paris, 1790.

Morgan, Bernard George. *Canonic Design in English Medieval Architecture.* Liverpool, 1961.

Mortet, Victor. *Etude historique et archéologique sur la cathédrale et le palais épiscopal de Paris.* Paris, 1888.

Mougeot, George. "La Verrière de la rédemption à Saint-Jean; Histoire d'une restauration," *La Revue d'histoire de Lyon,* 1 (1902), pp. 207-222.

Müller, Werner. *Die heilige Stadt.* Stuttgart, 1961.

Munari, Franco. *Ovid im Mittelalter.* Zurich, 1960.

Müntz, Eugene. *Etudes iconographiques et archéologiques sur le moyen âge.* Paris, 1887.

———. "La Tradition antique chez les artistes du moyen âge," *Journal des savants,* 72 (1887), pp. 629-642; 73 (1888), pp. 40-50, 162-177.

Mussafia, Adolf. "Studien zu den mittelalterlichen Marienlegenden," *Sitzungsberichte der Kaiserlichen Akademie der Wissenschaften in Wien* (Phil.-hist. klasse), 1 (1886), pp. 917-994; 2 (1888), pp. 5-92; 3 (1891), pp. 1-85; 4 (1898), pp. 1-74.

Mütherich, Florentine. "Ein Illustrationzyklus zum Anticlaudianus des Alanus ab Insulis," *Münchner Jahrbuch der Bildenden Kunst,* 3rd ser., 2 (1951), pp. 73-88.

Neuss, Wilhelm. *Die Apokalypse des hl. Johannes in der altspanischen und altchristlichen Bibelillustration.* 2 vols. Münster-in-Westphalia, 1931.

New Catholic Encyclopedia (Catholic University of America). 15 vols. New York [1967].

New York, The Pierpont Morgan Library. *Exhibition of Illuminated Manuscripts Held at the New York Public Library,* New York, 1933-1934.

Nordström, Carl Otto. *The Duke of Alba's Castilian Bible.* Uppsala, 1967.

———. "Rabbinic Features in Byzantine and Catalan Art," *Cahiers archéologiques,* 15 (1965), pp. 179-205.

———. *Ravennastudien: ideengeschichtliche und ikonographische Untersuchungen über die Mosaiken von Ravenna.* Stockholm, 1953.

Nordström, Folke. *Virtues and Vices on the 14th Century Corbels in the Choir of Uppsala Cathedral.* Stockholm, 1956.

Omont, Henri. *Album de Villard de Honnecourt.* 2nd ed., Paris, 1927.

———. *Vie et histoire de Saint Denys.* Paris, 1906.

Ouin-Lacroix, Charles. *Histoire des anciennes corporations d'arts et métiers et des confréries religieuses de la capitale de la Normandie.* Rouen, 1850.

Pächt, Otto. *The Rise of Pictorial Narrative in Twelfth Century England.* Oxford, 1962.

———. Charles R. Dodwell and Francis Wormald. *The St. Albans Psalter (Albani Psalter).* London, 1960.

Paetow, Louis John. *The Battle of the Seven Arts, A French Poem by Henri d'Andeli, Trouvère of the Thirteenth Century.* Berkeley, 1914.

Panofsky, Dora and Erwin. *Pandora's Box. The Changing Aspects of a Mythical Symbol.* (Bollingen Series LII.) New York, 1956 (rev. ed., 1963; pb. ed., Princeton, 1978).

Panofsky, Erwin, ed. and tr. *Abbot Suger on the Abbey Church of St.-Denis and Its Art Treasures*. Princeton, 1946 (2nd ed., rev. and ed. by Gerda Panofsky-Soergel, Princeton, 1979).

——. *Albrecht Dürer*. 2 vols. 3rd ed., Princeton, 1948.

——. *Die deutsche Plastik des elften bis dreizehnten Jahrhunderts*. Munich, 1924.

——. *Gothic Architecture and Scholasticism*. Latrobe, Pa., 1951.

——. *Renaissance and Renascences in Western Art*. 2 vols. Stockholm, 1960.

Pardiac, Jean-Baptiste. *Histoire de S. Jacques le Majeur et du pèlerinage de Compostelle*. Bordeaux, 1863.

——. "Notice sur les cloches de Bordeaux et en particulier sur celle de l'église Notre-Dame," *Bulletin monumental*, 24 (1858), pp. 227-273.

Paré, Gerard M., A. Brunet and P. Tremblay. *La Renaissance du XIIe siècle, Les écoles et l'enseignement*. Paris and Ottawa, 1933.

Paris, Bibliothèque Nationale. *Catalogue générale des manuscrits latins*, ed. Philippe Lauer. 4 vols. Paris, 1939-1953.

——. Bibliothèque Nationale. *Les Manuscrits françois de la Bibliothèque du roi*, ed. Paulin Paris. 7 vols. Paris, 1836-1848.

——. Bibliothèque Nationale. *Psautier de Saint-Louis*, ed. Henri Omont. Paris, n.d. [1902].

——. Bibliothèque Nationale. Exhibition Catalogue. *Manuscrits à peintures du XIIe au XVIe siècle*. Paris, 1955.

Paris, Musée national du Louvre. Exhibition Catalogue. *Cathédrales, sculptures, vitraux, objets d'art, manuscrits des XIIe et XIIIe siècles*, eds. Marcel Aubert and others. Paris, 1962.

——. Musée national du Louvre. Département de la sculpture du moyen âge et de la renaissance et des temps modernes, série D. *Notice des émaux et de l'orfèvrerie*, ed. Alfred Darcel. Paris, 1867. (Supplement by E. Molinier, Paris, 1891.)

——. Musée des Thermes et de l'Hôtel de Cluny. *Catalogue et description des objets d'art de l'antiquité, du moyen âge, et de la renaissance exposés au musée*. Paris, 1881.

——. Palais du Trocadéro. Louis Courajod and P.-Frantz Marcou. *Musée de sculpture comparée (moulages), Catalogue raisonné*. Paris, 1892.

Paris, Gaston. "Chrétien Legouais et autres traducteurs ou imitateurs d'Ovide," *Histoire littéraire de la France*, 29 (1885), pp. 455-525.

——. *Histoire poétique de Charlemagne*. Paris, 1865.

——. "Robert Courte-heuse à la première croisade," *Académie des inscriptions et belles-lettres, comptes rendus*. 4th ser., 18 (1890), pp. 207-212.

Pascal, Jean-Baptiste. *Institutions de l'art chrétien*. 2 vols. Paris, 1856.

Pastoret, Claude Emmanuel Joseph Pierre, marquis de. *Ordonnances des roys de France de la troisième race recueillies par ordre chronologique*. 21 vols. Paris, 1723-1849.

Patch, Howard Rollin. *The Goddess Fortuna in Medieval Literature*. Cambridge, Mass., 1927.

——. *The Tradition of Boethius. A Study of His Importance in Medieval Culture*. New York, 1935.

——. *The Tradition of the Goddess Fortuna*. Northampton, Mass., 1922.

Petit, Maxence. "Les apocalypses manuscrites du moyen âge et les tapisseries de la cathédrale d'Angers," *Le Moyen Age*, 9 (1896), pp. 49-62.

Petrus de Natalibus. *Catalogus sanctorum et gestorum eorū ex diuersis voluminibus collectus*, ed. Antonio Verlo, Vicenza, 1493.

Pez, Bernhard. *Thesaurus anecdotorum novissimus seu veterum monumentorum*. Augsburg, 1721.

Pigeon, Amédée. "Un vitrail de la cathédrale de Beauvais représentant la vie de Saint-Martin de Tours," *Gazette des beaux-arts*, 3rd ser., 14 (1895), pp. 233-242.

Pillion, Louise. *Les Portails latéraux de la cathédrale de Rouen*. Paris, 1907.

——. "Un Tympan de porte à la cathédrale de Rouen. La mort de Saint Jean l'Evangéliste," *Revue de l'art chrétien*, 47 (1904), pp. 181-189.

Piper, Ferdinand. *Einleitung in die monumentale Theologie*. Gotha, 1867.

——. *Mythologie und Symbolik der christlichen Kunst von der ältesten Zeit bis ins sechzehnte Jahrhundert*, vol. 1, pts. 1 and 2. Weimar, 1847.

Pitra, Jean-Baptiste, ed. *Spicilegium Solesmense*. 4 vols. Paris, 1852-1858.

Planchenault, René. *L'Apocalypse d'Angers*. Paris, 1966.

Plenzat, Karl. *Die Theophiluslegende in den Dichtungen des Mittelalters* (Germanische Studien, 43). Berlin, 1926.

Pliny the Elder. *Historia naturalis*, ed. and tr. H. Rackham, W.H.S. Jones and D. E. Eichholz (Loeb Classical Library). 10 vols. London and Cambridge, Mass., 1938-1963.

Pope-Hennessy, John. *Italian Gothic Sculpture*. London, 1955.

Porée, Charles. *La Cathédrale d'Auxerre*. Paris, 1926.

Porter, Arthur Kingsley. *Romanesque Sculpture of the Pilgrimage Roads*. 10 vols. Boston, 1923.

Pougnet, J. "Théorie et symbolisme des tons de la musique grégorienne," *Annales archéologiques*, 26 (1869), pp. 380-387; and 27 (1870), pp. 32-50, 150-175, 287-338.

Pressouyre, Léon. "La Colonne dite 'aux trois chevaliers' de Châlons-sur-Marne," *Bulletin de la Société nationale des antiquaires de France*, 1963, pp. 76-81.

———. "Fragments du cloître de Notre-Dame-en-Vaux de Châlons-sur-Marne," *L'Europe gothique XIIe-XIVe siècles*, Paris, 1968, pp. 6-15.

———. " 'Marcius Cornator.' Note sur un groupe de représentations médiévales du mois de mars," *Mélanges d'archéologie et d'histoire*, 77 (1965), pp. 395-473.

Prou, Maurice. "Bassin de bronze du XIe ou du XIIe siècle, représentant la jeunesse d'Achille," *Gazette archéologique*, 11 (1886), pp. 38-43.

Prudentius. *Collected Works*, ed. H. J. Thompson (Loeb Classical Library). 2 vols. London and Cambridge, 1949.

Puech, A. *Prudence, étude sur la poésie latine chrétienne au IVe siècle*. Paris, 1888.

Quarré, Pierre. "Moyen Age. Eglise Saint-Bénigne. Le Thème de la reine pedauque aux portails du XIIe siècle," *Mémoires de la Commission des antiquités de la Côte-d'Or*, 25 (1959-1962), pp. 56-58.

Quicherat, Jules. *Fascimile of the Sketchbook of Wilars de Honecort, an Architect of the Thirteenth Century*, tr. Robert Willis. London, 1859.

———. *Mélanges d'archéologie et d'histoire; archéologie du moyen âge, Mémoires et fragments réunis par Robert de Lasteyrie*. Paris, 1886.

Rabelais, François. *All the Extant Works of François Rabelais*, tr. Samuel Putnam. 3 vols. New York, 1929.

Raby, F.J.E. *A History of Christian Latin Poetry from the Beginnings to the Close of the Middle Ages*. 2d ed., London, 1953.

———. *The Oxford Book of Medieval Latin Verse*. Oxford, 1959.

Rademacher, Franz. "Zu den frühesten Darstellungen der Auferstehung Christi," *Zeitschrift für Kunstgeschichte*, 28 (1965), pp. 195-224.

Radot, Jean Valery. "Note sur les chapelles hautes dédiées a Saint-Michel," *Bulletin monumental*, 88 (1929), pp. 453-478.

Ramé, Alfred. "Notes d'un voyage en Suisse," *Annales archéologiques*, 16 (1856), pp. 49-64.

Rand, Edward K. "The Classics in the Thirteenth Century," *Speculum*, 4 (1929), pp. 249-269.

Randall, Lilian M. C. *Images in the Margins of Gothic Manuscripts*. Berkeley, 1966.

Rashdall, Hastings. *The Universities of Europe in the Middle Ages*, rev. eds. F. M. Powicke and A. B. Emden. 3 vols. Oxford, 1936.

Reallexikon zur deutschen Kunstgeschichte, eds. Otto Scmitt, Ernst Gall and L. H. Heydenreich. 6 vols. Stuttgart, 1948-1973.

Reinhardt, Hans. *La Cathédrale de Reims*. Paris, 1963.

Reinsch, Robert. *Le Bestiaire: Das Thierbuch des normannischen Dicters Guillaume le Clerc*. Leipzig, 1892.

Renan, Ernest. *L'Eglise chrétienne*. Paris, 1879.

Rhein, André. "Poitiers, Cathédrale Saint-Pierre," *Congrès archéologique*, 79 (1912), pp. 252-270.

Riant, Paul-Edouard-Didier. "Des dépouilles religieuses enlevées à Constantinople au XIIIe siècle et des documents historiques nés de leur transport en occident." *Mémoires de la Société national des antiquaires de France*, 36 (1875), pp. 1-214.

———. *Exuviae sacrae Constantinopolitanae*. 3 vols. Geneva, 1877-1904.

Richard de Fournival. *Le Bestiaire d'amour suivi de la réponse de la dame*, ed. Célestin Hippeau. Paris, 1860.

Robertson, James C. *Materials for the History of Thomas Becket, Archbishop of Canterbury*. 4 vols. London, 1876-1879.

Rohault de Fleury, Georges. *La Sainte Vierge;*

Etudes archéologiques et iconographiques. 2 vols. Paris, 1878.

Rolland, Eugène. *Faune populaire de la France,* v. *Les mammifères domestiques.* Paris, 1883.

Rolt, C. E. *Dionysius the Areopagite on the Divine Names and the Mystic Theology.* London and New York, 1940.

Rooth, Erik. "Kleine Beiträge zur Kenntnis des sogenannten Honorius Augustodunensis," *Studia neophilogica,* 12 (1939-1940), pp. 120-135.

Rothschild, James de, ed. *Le Mistère du Viel Testament* (Société des anciens textes français). 6 vols. Paris, 1878-1891.

Rottmanner, P. Odilo, O.S.B. Review of Jean-Baptiste Pitra, ed., *Spicilegium Solesmense* (Paris, 1883-1884), in *Le Bulletin critique,* 1 February, 1885, 6, pp. 47-52.

Rouilliard, Sébastien. *Parthénie, ou Histoire de la très auguste église de Chartres.* Paris, 1609.

Ruinart, Thierry. *Sancti Gregori Turonensis opera omnia.* Paris, 1699.

Rutebeuf. *Oeuvres complètes de Rutebeuf, trovère du XIIIe siècle recueillies et mises au jour pour la première fois,* ed. Achille Jubinal. 2 vols. Paris, 1839.

———. *Oeuvres complètes de Rutebeuf,* eds. E. Faral and J. Bastin. 2 vols. Paris, 1959-1960.

Saintenoy, Paul. "Prolégomènes à l'étude de la filiation des fonts baptismaux depuis les baptistères jusqu'au XVIe siècle," *Annales de la Société d'archéologie de Bruxelles,* 5 (1891), pp. 5-33, 243-281; 6 (1892), pp. 69-158.

Saint-Laurent, Henri de Grimouard de. "Aperçu iconographique sur Saint Pierre et Saint Paul," *Annales archéologiques,* 23 (1863), pp. 26-44, pp. 138-144, 264-277; 24 (1864), pp. 93-103, 161-173, 238-248, 264-271; 25 (1865), pp. 24-33, 202-222.

———. *Guide de l'art chrétien, étude d'esthétique et d'iconographie.* 6 vols. Paris, 1872-1875.

Saint-Paul, Anthyme, *Histoire monumentale de la France.* Paris, 1883.

———. "Les Irrégularités de plan dans les églises," *Bulletin monumental,* 70 (1906), pp. 129-155.

Salet, Francis and Jean Adhémar. *La Madeleine de Vézelay.* Melun, 1948.

———. "Nouvelle note sur les statues d'apôtres de la Sainte-Chapelle," *Bulletin monumental,* 112 (1954), pp. 357-364.

———. "Les Statues d'apôtres de la Sainte-Chapelle, conservées au musée de Cluny," *Bulletin monumental,* 109 (1951), pp. 135-156.

Salvadou, Jean. "Le Tympan de Cabestany," *Bulletin monumental,* 95 (1936), pp. 239-240.

Salzar, Anselm. *Die Sinnbilder und Beiworte Mariens in der deutschen Literatur und lateinischen Hymnenpoesie des Mittelalters.* Linz, 1893.

Sauer, Joseph. *Symbolik des Kirchengebäudes und seiner Ausstattung in der Auffassung des Mittelalters.* Freiburg-im-Breisgau, 1924.

Sauerländer, Willibald. "Art antique et sculpture autour de 1200," *Art de France,* 1 (1961), pp. 47-56.

———. *Gothic Sculpture in France 1140-1270.* London, 1972.

———. "Uber de Komposition des Weltgerichts-Tympanons in Autun," *Zeitschrift für Kunstgeschichte,* 29 (1966), pp. 261-294.

———. "Die kunstgeschichtliche Stellung des Westportale von Notre-Dame in Paris, ein Beitrag zur Genesis des hochgotischen Stiles in der Französischen Skulptur," *Marburger Jahrbuch für Kunstwissenschaft,* 17 (1959), pp. 1-56.

———. "Die Marienkrönungsportale von Senlis und Mantes," *Wallraf-Richartz Jahrbuch,* 20 (1958), pp. 125-135.

———. *Von Senlis bis Strassburg.* Berlin, 1966.

Schachner, N. *The Medieval Universities.* New York, 1938.

Schapiro, Meyer. "On the Aesthetic Attitude in Romanesque Art," *Art and Thought: Issued in Honour of Dr. Ananda K. Coomaraswamy,* London, 1947, pp. 130-150.

———. "The Angel with the Ram in Abraham's Sacrifice: A Parallel in Western and Islamic Art," *Ars Islamica,* 10 (1943), pp. 134-147.

———. "The Bowman and the Bird on the Ruthwell Cross and Other Works: The Interpretation of Secular Themes in Early Medieval Religious Art," *Art Bulletin,* 45 (1963), pp. 351-355.

———. "An Illuminated English Psalter of the Early Thirteenth Century," *Journal of the Warburg and Courtauld Institutes,* 23 (1960), pp. 179-189.

———. "An Irish-Latin Text on the Angel with the Ram in Abraham's Sacrifice," *Essays in the History of Art Presented to Rudolf Wittkower*, London, 1967, pp. 17-19.

———. "The Joseph Scenes on the Maximianus Throne," *Gazette des beaux-arts*, 40 (1952), pp. 27-38.

———. "Two Romanesque Drawings in Auxerre and Some Iconographic Problems," *Studies in Art and Literature for Belle da Costa Greene*, Princeton, 1954, pp. 331-349.

Scheller, R. W. *A Survey of Medieval Model Books*. Haarlem, 1963.

Schiel, Hubert. *Codex Egberti der Stadtbibliothek Trier, Ms. 24* (Voll-Faksimile Ausgabe unter dem Patronat der Stadt Trier). 2 vols. Basel, 1960.

Schiller, Gertrud. *Ikonographie der christlichen Kunst*. 2 vols. Gütersloh, 1969 (Eng. tr., *Iconography of Christian Art*, Greenwich, Conn., 1971).

Schlauch, Margaret. "The Allegory of Church and Synagogue," *Speculum*, 14 (1939), pp. 448-464.

Schlee, E. *Die Ikonographie der Paradiesesflüsse*. Leipzig, 1937.

Schlosser, Julius von. *Schriftquellen zur Geschichte der karolingischen Kunst* (Quellenschriften für Kunstgeschichte und Kunsttechnik des Mittelalters und der Neuzeit, Neue Folge, IV). Vienna, 1892.

Schmidt, Gerhard. *Die Armenbibeln des XIV. Jahrhunderts*. Graz and Cologne, 1959.

Schnaase, Karl. "Les Franc-Masons du moyen âge," *Annales archéologiques*, 11 (1851), pp. 325-334.

Schnitzler, Hermann. *Rheinische Schatzkammer*, II. *Die Romanik*. Düsseldorf, 1959.

Schreiner, Klaus. " 'Discrimen veri ac falsi,' Aussätze und Formen der Kritik in der Heiligen und Reliquienverehrung des Mittelalters," *Archiv für Kulturgeschichte*, 48 (1966), pp. 1-53.

Segre, Cesar, ed. *Li Bestiaires d'Amours de Maistre Richart de Fornival e li Response du Bestiaire*. Milan, 1957.

Seiferth, Wolfgang. *Synagoge und Kirche im Mittelalter*. Munich, 1964. (Engl. tr. *Synagogue and Church in the Middle Ages*. New York, 1970.)

Sepet, Marius. *Les Prophètes du Christ, Etude sur les origines du théâtre au moyen âge*. Paris, 1878.

Seznec, Jean. *The Survival of the Pagan Gods; The Mythological Tradition and its Place in Renaissance Humanism and Art* (Bollingen Series, XXXVIII), tr. Barbara F. Sessions. New York, 1953.

Shelby, Lon. "Medieval Masons' Tools, II. Compass and Square," *Technology and Culture*, 6 (1965), pp. 236-248.

Simon, Claude-Gabriel. *Etude historique et morale sur le compagnonnage et sur quelques autres associations d'ouvriers depuis leur origine jusqu'à nos jours*. Paris, 1853.

Simon, Karl. "Die Grabtragung Maria," *Städel Jahrbuch*, 5 (1926), pp. 75-98.

Simson, Otto von. *The Gothic Cathedral, Origins of Gothic Architecture and the Medieval Concept of Order*. (Bollingen Series XLVIII), New York, 1956 (2nd. ed. rev. 1962; pb. ed., Princeton, 1974).

Sinding, Olav. *Mariae Tod und Himmelfahrt, ein Beitrag zur Kenntnis der frühmittelalterlichen Denkmäler*. Christiania, 1903.

Singleton, Charles S. *Dante Studies*. 2 vols. Cambridge, Mass., 1954-1958.

———. *An Essay on the Vita Nuova*. Cambridge, Mass., 1949.

Smalley, Beryl. *The Study of the Bible in the Middle Ages*. Oxford, 1952.

Somme le Roi. Le Mireour du Monde, Manuscrit du XIVème siècle découvert dans les archives de la Commune de la Sarra (Mémoires et documents, publiés par la Société d'histoire de la Suisse Romande, IV), ed. Felix Chavannes. Lausanne, 1846.

Sommerard, Alexandre du. *Les Arts au moyen âge en ce qui concerne principalement le Palais Romain de Paris, l'Hôtel de Cluny issu de ses ruines, et les objets d'art de la collection classée dans cet hôtel*. 4 vols. Paris, 1838-1846.

Spicilegium Solesmense, see: Pitra, Jean-Baptiste, ed.

Spicq, Ceslaus. *Esquisse d'une histoire de l'exégèse latine au moyen âge*. Paris, 1944.

Springer, Anton Heinrich. *Bilder aus der Neuern Kunstgeschichte*. 2 vols. Bonn, 1867-1886.

———. *Uber die Quellen der Kunstdarstellungen im Mittelalter* (Berichte über die Verhandlungen der Koniglich Sächsischen Gesellschaft der Wissenschaften zu Leipzig, Ph.-hist. Kl., XXXI 1-40). Leipzig, 1879.

Steinweg, Klara. *Andrea Orcagna*. Strasbourg, 1929.

Stern, Henri. *Le Calendrier de 354. Etude sur*

son texte et ses illustrations. Paris, 1953.

————. "Mosaïques de pavement préromanes et romanes en France," *Cahiers de civilisation médiévale,* 5 (1962), pp. 13-33.

————. "Poésies et représentations carolingiennes et byzantines des mois," *Revue archéologique,* 45 (1955), pp. 141-186.

————. "Représentations gallo-romaines des mois," *Gallia,* 9 (1951), pp. 21-30.

Stettiner, Richard. *Die illustrierten Prudentius-Handschriften.* Berlin, 1905.

Stiennon, Jacques. "La miniature dans le diocèse de Liège aux XIe et XIIe siècles," *L'Art mosan; Mémoires et exposés de Joseph de Borchgrave d'Altena,* ed. Pierre Francastel. Paris, 1953, pp. 90-101.

Strabo, Walafrid: see *Glossa ordinaria.*

Stubblebine, James, ed. *Giotto: The Arena Chapel Frescoes.* New York, 1969.

Stuhlfauth, Georg. *Die Engel in der altchristlichen Kunst.* Freiburg-im-Breisgau, 1897.

Suger. *Oeuvres complètes de Suger,* ed. A. Lecoy de La Marche (Société d'histoire de France, 101). Paris, 1867.

Surigny, Alfred de. "Le Tabernacle de la Vierge dans l'église d'Or San Michele," *Annales archéologiques,* 26 (1869), pp. 26-46.

Suter-Raeber, Regula. "Die Marienkrönung der Kathedrale von Lausanne und die verschiedenen Typen des Marienkrönung im 12 und frühen 13 Jahrhundert," *Zeitschrift für Schweizerische Archäologie und Kunstgeschichte,* 23 (1963-1964), pp. 197-211.

Swarzenski, Hanns. *Monuments of Romanesque Art: The Art of Church Treasures in North-Western Europe.* London and Chicago, 1954.

Taylor, Henry Osborn. *The Medieval Mind.* 2 vols. 2nd ed., London, 1914. (repr. Cambridge, Mass., 1949).

Tertullian. *De spectaculis,* ed. and tr. T. R. Glover (Loeb Classical Library). London and Cambridge, 1953.

Thibaud, Emile. *De la Peinture sur verre.* Clermont, 1835.

Thiers, Jean-Baptiste. *Traité des superstitions qui regardent les sacremens, selon l'Ecriture sainte, les décrets des conciles et les sentimens des saints Pères et des théologiens.* Paris, 1741.

Thilo, Johann Karl, ed. *Codex apocryphus Novi Testamenti e libris editis et manuscriptis,* *maxime gallicanis, germanicis et italicis.* Leipzig, 1832.

Thoby, Paul. *Le Crucifix, des origines au Concile de Trente, Etude iconographique.* Nantes and Paris, 1959 (Supplement, 1963).

St. Thomas Aquinas. *Summa theologica* (Institute of Medieval Studies). 5 vols. Ottawa, 1941-1953.

Tischendorf, Constantin von. *Acta Apostolorum Apocrypha extriginta antiquis codicibus graecis.* Leipzig, 1851.

————. *Bibliorum Codex Sinaiticus Petropolitanus, IV. Novum Testamentum cum Barnaba et Pastore.* St. Petersburg, 1862.

————. *Evangelia apocrypha.* Rev. ed., Leipzig, 1876 (repr. Hildesheim, 1966).

Toesca, Ilaria. *Andrea e Nino Pisano.* Florence, 1950.

Tolnay, Charles de. "The Music of the Universe; Notes on a Painting by Bicci di Lorenzo," *Journal of the Walters Art Gallery,* 6 (1943), pp. 83-104.

Tondelli, Leone. *Il libro delle figure dell'abate Giaochino da Fiore.* 2 vols. Turin, 1953.

Tuve, Rosamond. *Allegorical Imagery; Some Mediaeval Books and Their Posterity.* Princeton, 1966.

————. "Notes on the Virtues and Vices," *Journal of the Warburg and Courtauld Institutes,* 26 (1963), pp. 264-303.

Usener, Karl H. "Renier von Huy und seine kunstlerische Nachfolge," *Marburger Jahrbuch für Kunstwissenschaft,* 7 (1933), pp. 77-134.

Vanuxem, Jacques. "La sculpture du XIIe siècle à Cambrai et à Arras," *Bulletin monumental,* 113 (1955), pp. 11-17.

————. "The Theories of Mabillon and Montfaucon on French Sculpture," *Journal of the Warburg and Courtauld Institutes,* 20 (1957), pp. 45-58.

Van Woerden, Isabel Speyart. "The Iconography of the Sacrifice of Abraham," *Vigiliae Christianae,* 15 (1961), pp. 214-255.

Varty, Kenneth. *Reynard the Fox: A Study of the Fox in Medieval English Art.* Leicester, 1967.

Vasari, Giorgio. *Le Vite de' più eccellenti pittori, scultori ed architetti,* ed. G. Milanesi. 9 vols. Florence, 1878-1885 (Engl. tr. Gaston du C. de Vere [Medici Society]. 10 vols. London, 1912-1915).

Venturi, Lionello. *Botticelli*. Vienna, 1937.

Verdier, Philippe. "Un Monument inédit de l'art mosan du XIIe siècle. La crucifixion symbolique du Walters Art Gallery," *Revue belge d'archéologie et d'histoire de l'art*, 30 (1961), pp. 115-175.

Verneil, Felix de. "Les bas-reliefs de l'Université à Notre-Dame de Paris," *Annales archéologiques*, 26 (1869), pp. 96-106.

Viarre, Simon. *La Survie d'Ovide dans la littérature scientifique des XIIe et XIIIe siècles*. Poitiers, 1966.

Vielliard, Jeanne. *Le Guide du pèlerin de Saint Jacques de Compostelle; texte latin du XIIe siècle*. Macon, 1938 (3rd ed., 1963).

Villard de Honnecourt, ed. J.B.A. Lassus. Paris, 1858 (repr. ed. Paul de Laget. Marseilles, 1968).

Vincent de Beauvais (Vincentius Bellovacensis). *Speculum quadruplex sive Speculum maius*. 4 vols. ed. Douai, 1624 (facs. ed. Graz, 1964).

Viollet-le-Duc, Eugène Emmanuel. *Dictionnaire raisonné de l'architecture française du XIe au XVIe siècle*. 10 vols. Paris, 1858-1868.

——. *Dictionnaire raisonné du mobilier français de l'époque carlovingienne à la renaissance*. 6 vols. Paris, 1871-1875.

Vitry, Bernard. *Notre-Dame de Reims*. Paris, 1958.

Vitry, Paul. *La Cathédrale de Reims, architecture et sculpture*. 2 vols. Paris, 1919.

——. *French Sculpture during the Reign of Saint Louis, 1226-1270*. Florence and New York, 1929.

Vitzthum, Georg. *Die Pariser Miniaturmalerei*. Leipzig, 1907.

Vogel, Cyrille. "Sol Aequinoctialis: Problèmes et technique de l'orientation dans la culte chrétien," *Revue des sciences religieuses*, July-Dec., 1962, pp. 175-211.

Volbach, W. F. *Elfenbeinarbeiten der Spätantike und des frühen Mittelalters*. 2nd ed., Mainz, 1952.

Wadstein, Ernst. *Die eschatologische Ideengruppe, Antichrist-Weltsabbat-Weltende-Weltgericht*. Leipzig, 1896.

Walberg, Emmanuel, ed. *Le Bestiaire de Philippe de Thaün*. Paris and Lund, 1900.

Warichez, Joseph. *La Cathédrale de Tournai*. 2 vols. Brussels, 1934-1935.

Watson, Arthur. *The Early Iconography of the Tree of Jesse*. London, 1934.

——. "The Speculum Virginum with Special Reference to the Tree of Jesse," *Speculum*, 3 (1928), pp. 445-469.

Weber, Hans Heinrich. *Studien zur deutschen Marienlegende der Mittelalters am Beispiel des Theophilus*. Hamburg, 1966.

Weber, Paul. *Geistliches Schauspiel und kirchliche Kunst in ihrem Verhaltnis erläutert an einer Ikonographie der Kirche und Synagoge*. Stuttgart, 1894.

Webster, James Carson. *The Labors of the Months in Antique and Medieval Art to the End of the Twelfth Century*. Chicago, 1938.

Weese, Arthur. *Die Bamberger Domskulpturen, ein Beitrag zur Geschichte der deutschen Plastik des XIII. Jahrhundert*. Strasbourg, 1897.

Wentzel, Hans. *Christus-Johannes-Gruppen*. Stuttgart, 1960.

——. "Die 'Kornfeldlegende,'" *Aachener Kunstblätter*, 30 (1965), pp. 131-143.

——. "Portraits 'à l'antique' on French Medieval Gems and Seals," *Journal of the Warburg and Courtauld Institutes*, 16 (1953), pp. 342-350.

Wenzel, Seigfried. "The Seven Deadly Sins; Some Problems of Research," *Speculum*, 43 (1968), pp. 1-22.

White, T. H., ed. and tr. *The Bestiary. A Book of Beasts* (Twelfth-Century Latin Bestiary, Cambridge, University Library, ms. II.4.26). New York, 1960.

Willemin, Nicholas Xavier. *Monuments français inédits*. Paris, 1839.

William of Auvergne. (Guilielmi Alverni). *Opera omni parisiis*. 2 vols. Orleans, 1674 (repr. Frankfurt-am-Main, 1963).

William the Norman. *The Bestiary of Guillaume le Clerc*, tr. George C. Druce. London, 1936.

Wittkower, Rudolf. "The Marvels of the East," *Journal of the Warburg and Courtauld Institutes*, 5 (1942), pp. 159-197.

Woillez, Eugene J. "Iconographie des plantes aroïdes figurées au moyen âge en Picardie," *Mémoires de la Société des antiquaires de Picardie* (Amiens), 9 (1848), pp. 115-157.

Wölfflin, Heinrich. *Die Bamberger Apokalypse*. 2nd ed., Munich, 1921.

Woodruff, Helen. "The Illustrated Manuscripts of Prudentius," *Art Studies*, 7 (1929), pp. 33-79.

Wormald, Francis. "The Throne of Solomon and St. Edward's Chair," *De Artibus Opus-*

*cula XL, Essays in Honor of Erwin Pan-
ofsky*, New York, 1961, pp. 532-539.
Wright, Thomas. *A History of Caricature and
Grotesque in Literature and Art*. London,
1864.

Yoshikawa, Itsuji. *L'Apocalypse de Saint-Savin*.
Paris, 1939.
Young, Karl. *The Drama of the Medieval
Church*. 2 vols. Oxford, 1933.
Zarnecki, George. "A Sculptured Head Attrib-
uted to the Maître de Cabestany," *Burling-
ton Magazine*, 106 (1964), pp. 536-539.
Zellinger, Johannes. "Der geköderte Leviathan
im Hortus deliciarum des Herrad von
Landsbergs," *Historisches Jahrbuch*, 45
(1925), pp. 161-177.

LIST OF ILLUSTRATIONS

INDEX

Library of Congress Cataloging in Publication Data

Mâle, Émile, 1862-1954.
 Religious art in France, the thirteenth century.

 (Bollingen series ; 90)
 Translation of 9th ed. : L'art religieux du
XIIIe siècle en France.
 Bibliography: p.
 Includes index.
 1. Christian art and symbolism—Medieval, 500-
1500—France. 2. Art, French. 3. Art, Gothic—
High Gothic—France. I. Title. II. Series.
N7949.A1M3513 1983 704.9′482′0944 82-11210
ISBN 0-691-09913-8